American Spoons

Souvenir and Historical

Dorothy T. Rainwater
and Donna H. Felger

1469 Morstein Road, West Chester, Pennsylvania 19380

Revised and Enlarged

Copyright © 1990 by Dorothy Thornton Rainwater and Donna
Hodges Felger.
Library of Congress Catalog Number: 90-61799.

Dust jacket design and color plates by Tim Scott.
Printed in the United States of America.
ISBN: 0-88740-266-6

For a free catalog write to:

Schiffer Publishing, Ltd.
1469 Morstein Road
West Chester, Pennsylvania 19380

Published by Schiffer Publishing, Ltd.
1469 Morstein Road
West Chester, Pennsylvania 19380
Please write for a free catalog.
This book may be purchased from the publisher.
Please include $2.00 postage.
Try your bookstore first.

Contents

Acknowledgments

Without the generous assistance of friends, librarians, historical societies, company representatives, and many others, this book could not have been written.

Grateful acknowledgment is made to James Merna, Administrative Assistant, United States Patent Office, for his persistent efforts in securing copies of patent drawings, many of which are not available in public Search Room files. The following, also in the Patent Office, were helpful and unfailing in good humor while ferreting out the hundreds of patent drawings; Robert L. Burch; Durwood D. Kidwell; William G. Lanham, Jr.; and Raymond Wahlen.

The generosity of Donald S. McNeil, Editor of *Jewelers' Circular-Keystone*, for permission to use material from the *Jewelers' Weekly, Jewelers' Circular*, and *Souvenir Spoons of America*, merits particular appreciation.

E. P. Hogan, of the Historical Library, The International Silver Company, was most generous in permitting use of the notes of the late W. G. Snow concerning silver manufacturers, and in supplying all of the information and illustrations relative to the newspaper promotional campaigns which sold so many millions of State Seal and President Series spoons. Special acknowledgment is made for his always cheerful response to requests for assistance.

The response of the following librarians, libraries, historical societies, and other institutions to requests for information, whether through the writers' personal visits or correspondence, was most gratifying:

Caroline Adams, Society for the Preservation of New England Antiquities, Boston, Mass.; Katharine C. Ambre, Galena Historical Society, Ill.; Sally Andrews, Rockford Public Library, Ill.; Marion B. Appleton, Seattle Public Library, Wash.; Mrs. Manon B. Atkins, Oklahoma Historical Society, Oklahoma City; James M. Babcock, Burton Historical Collection, Detroit Public Library, Mich.; Catherine M. Bagdon, The Welles-Turner Memorial Library, Glastonbury, Conn.; Mildred Baumann, The Lincoln Library, Springfield, Ill.; Robert Baumruk, Chicago Public Library, Ill.; Gilbert L. Bean Braintree Historical Society, Inc., South Braintree, Mass.; Dorothy Beck, Dartmouth College Libraries, Hanover, N.H.; Ann Benson, New Jersey Historical Society, Newark; Dorothy W. Benson, Westerly Public Library, R.I.; Mary M. Bertelsen, Hall Memorial Library, Ellington, Conn.; Blair County Historical Society, Altoona, Pa.; June Bogatz, Curtis Memorial Library, Meriden, Conn.; Roberta Bonnoit, Charleston County Library, S.C.; Louise Borchelt, Evanston Public Library, Ill.; Jean Bowen, Kansas City Library, Mo.; Gervis Brady, Director, Stark County Historical Society, Canton, Ohio; Beverly J. Brager, Madison Public Library, Wis.; Bridgeport Public Library, Conn.; Jerry Brockway, Manager, Tampa News Bureau, Tampa, Fla.; Philip C. Brooks, Harry S Truman Library, Independence, Mo.; Henry D. Brown, Director, Detroit Historical Commission, Mich.; Walter L. Brown, Arkansas Historical Association, Fayetteville; Buck Lodge Library, Adelphi, Md.; Marion L. Buckner, San Diego Public Library, Cal.; Dean Burgess, Portsmouth Public Library, Va.; Mary Kay Burns, New Orleans Public Library, La.; Mrs. Clyde H. Butler, Curator, Lakewood Historical Society, Ohio; Margaret Calhoun, Alexandria City Public Library, Va.; California History Foundation, Univ. of the Pacific, Stockton; Robert Cato, DAR National Society Museum, Washington, D.C.; Margaret L. Chapman, Florida Historical Society, Tampa; Chautauqua County Historical Society, Westfield, N.Y.; James Cheevers, U.S. Naval Academy Museum, Annapolis, Md.; George M. Chinn, Director, Kentucky Historical Society, Frankfort; J. D. Cleaver, Museum Curator, Oregon Historical Society, Portland; Lauretta M. Cloherty, City of Cambridge Public Library, Mass.; Dorothy M. Connolly, Salem Public Library, Mass.; Janson L. Cox, Director, Oneida Historical Society, Utica, N.Y.; Julia L. Crawford, Free Library of Philadelphia, Pa.; Carol Crosby, Wayne County Historical Society, Honesdale, Pa.; Charles F. Cummings, Public Library of Newark, N.J.; Lucille R. Cunningham, Director, Free Public Library, Hoboken, N.J.; Jack Daball, City of Jackson Public Library, Mich.; Isabel M. Dearolf, Chamber of Commerce of Reading and Berks County, Pa.; Rubye DeBois, Noble County Public Library, Albion, Ind.; Katherine A. DeFries, Pikes Peak Regional District Library, Colorado

Springs; Linda K. deGrand, Center for Research Libraries, Chicago, Ill.; Mrs. Theodore P. de Treville, Augusta-Richmond County Public Library, Ga.; *Detroit News*, Mich.; Robert DiBartolomeo, Curator, Oglebay Institute Museum, Wheeling, W. Va.; Richard H. Dillon, Sutro Library, San Francisco, Cal.; H. Donnelly, Arlington Public Library, N.J.; Diane Duryea, *Yachting Magazine*, N.Y.; Della L. Dye, Utah State Historical Society, Salt Lake City; Janet M. Edwards, Pittsfield Public Library, Mass.; Marc Eisen, Free Public Library of East Orange, N.J.; Laura A. Ekstrom, State Historical Society of Colorado, Denver; Gwendolyn Elliott, Public Library, Mt. Clemens, Mich.; Mary G. Ellis, Newton Free Library, Mass.; Enoch Pratt Free Library, Baltimore, Md.; Ethal Evans, Curator, Society of California Pioneers, San Francisco; Fitchburg Historical Society, Mass.; Franklin J. Fitzpatrick, Order of Elks, Chicago, Ill.; Flagg Township Library, Rochelle, Ill.; Lois C. Foresman, Fitchburg Public Library, Mass.; Marvin E. Fowler, George Washington Masonic National Memorial Association, Alexandria, Va.; Katharine Freeland, Plymouth Public Library, Mass.; Mildred E. Fretz, Cleveland Public Library; Doris E. Friedman, Eau Claire Public Library, Wis.; Charles H. Gabriel, First Church of Christ Scientist, Boston; Rev. Maynard Geiger, OFM, Archivist, Franciscan Theological Seminary, Franciscan Fathers, Santa Barbara, Cal.; Charles E. Gelette, Jr., Old Colony Historical Society, Taunton, Mass.; Dorothy Ginn, Free Public Library, Atlantic City, N.J.; Mildred T. Giusti, Providence Public Library, R.I.; Vern C. Gray, Curator, McLean County Historical Society, Bloomington, Ill; Eileen Green, Carnegie Public Library, Sault Ste. Marie, Mich.; Frank L. Green, Washington State Historical Society, Tacoma; George B. Griffenhagen, American Pharmaceutical Association, Washington, D.C.; Elfriede Gudelius, Tacoma Public Library, Wash.; Virginius C. Hall, Jr., Virginia Historical Society, Richmond; Katherine Halverson, Wyoming State Archives & Historical Dept., Cheyenne; Darlene E. Hamilton, Bellingham Public Library, Wash.; Opal Harber, Public Library, Denver, Colo.; Luella Harlan, Peoria Historical Society, Ill.; Mrs. F. C. Harrington, Jr., Missouri Historical Society, St. Louis; Jane R. Hayward, Village Library of Farmington, Conn.; M. Hilburn, Joliet Public Library, Ill.; Helen B. Hill, Manitou Springs Public Library, Colo.; Robert E. Hoag, St. Paul Public Library, Minn.; Sohei Hohri, N.Y. Yacht Club; H. Hobart Holly, Braintree Historical Society, Mass.; Margery H. Howard, Cary Memorial Library, Lexington, Mass.; Milo B. Howard, Jr., State of Alabama, Dept. of Archives and History, Montgomery; Mary D. Hudgins, Garland County Historical Society, Hot Springs, Ark.; Thomas V. Hull, The American Legion, Indianapolis, Ind.; Dolores Huttner, American Medical Association, Chicago, Ill., Indianapolis Historical Society, Ind.; Francine Inman, Public Library, Washington, D.C.; Juanita C. Jackson, New Britain Public Library, Conn.; J. Stewart Johnson, Curator, Newark Museum, N.J.; Ruth M. Keating, N.Y. State Historical Association, Cooperstown; Hendrine Kleinjan, Alameda Free Library, Cal.; LaVern Kohl, Great Falls Public Library, Mont.; Esther Klugiewicz, Erie Public Library, Pa.; Jeannine Kreyenbuhl, Director, Ohio County Public Library, Wheeling, W. Va.; John H. Kuony, Director, Oshkosh Public Museum, Wis.; Isabelle Laughlin, Troy Public Library, N.Y.; Mrs. A. H. Leeds, Yonkers Historical Society; N.Y.; Library of Congress; Vera L. Lindsley, Haverhill Public Library, Mass.; Heber E. Long, Director, Louisiana State Exhibit Museum, Shreveport; Carol Macht, Curator, Cincinnati Art Museum, Ohio; Gudrun Mangelsen, Univ. of Kentucky, Lexington; Elizabeth R. Martin, Ohio Historical Society, Columbus; Peter A. Masley, Congressional Administrative Assistant, Washington, D.C.; Robert C. Mattes, Curator, Lackawanna Historical Society, Scranton, Pa.; Mrs. E. C. McCormick, Mason Library, Great Barrington, Mass.; Irene McCreery, Maumee Valley Historical Society, Toledo, Ohio; McKeldin Library, Univ. of Maryland, College Park; Frances McLoughlin, Public Library of Fort Wayne and Allen County, Ind.; Emily A. McMaster, Curator, Clinton County Historical Association Plattsburgh, N.Y.; Ridgway McNallie, Buffalo and Erie County Public Library, N.Y.; Keith Melder, Curator, Div. of Political History, Smithsonian Institution, Washington, D.C.; Susan Mickelsen, Univ. of Utah Museum of Fine Arts, Salt Lake City; Weston Morrill, Historian, First Church of Christ Congregational, Pittsfield, Mass.; Mary Morrow, Corpus Christi Public Libraries, Tex.; John Mullane, Public Library of Cincinnati and Hamilton County, Ohio; Marion Murra, McClelland Public Library, Pueblo, Colo.; National Archives, Washington, D.C.; Mary Lois Nelson, Free Public Library, Council Bluffs, Ia.; New York Public Library; Grace D. Nicholas, Gen. Fed. of Women's Clubs, Washington, D.C.; Patricia O'Connell, The American Legion, Washington, D.C.; Mildred C. O'Connor, Boston Public Library, Mass.; Lillian Oshushek, Camden Free Public Library, N.J.; Allan R. Ottley, California State Library, Sacramento; Mary J. Owens, Duluth Public Library, Minn.; David D. Palmer, President, Palmer College of Chiropractic, Davenport, Ia.; William C. Parker, President, Campbell Historical Museum, Camden, N.J.; Barbara S. Partridge, Town

of Brookline Public Library, Mass.; Mrs. John Pepper, County-City Library, Sweetwater, Tex.; Camille M. Perrault, Worcester Public Library and Central Mass. Regional Library; Robert C. Pettitt, Nebraska State Historical Society, Lincoln, Loretta E. Phaneuf, Free Public Library, New Bedford, Mass.; Virginia H. Pinkerton, Norfolk Public Library, Va.; Harriette M. Pirnie, Exeter Public Library, N.H.; Dan R. Pollard, Fresno County Historical Society, Cal.; Prince George's County Regional Library, Hyattsville, Md.; Geneva B. Pullen, Lexington Public Library, Ky.; Historical Society of Reading and Berks County, Pa.; Reading Public Library, Pa.; Walter B. Remley, Montgomery County Historical Society, Crawfordsville, Ind.; Rhinelander Public Library, Wis.; Mrs. G. P. Roberts, Jr., President, San Joaquin Genealogical Society, Stockton, Cal.; Siegfried Rosenberg, The Jewish Museum, N.Y.; George M. Sanders, Imperial Council of the Ancient Arabic Order of the Nobles of the Mystic Shrine, Chicago, Ill.; Helen Sayre, First Church of Christ Scientist, N.Y.C.; Vivian J. Scheidemantel, Associate Curator, The Art Institute of Chicago, Ill.; Jacquelyn Scott, St. Louis County Historical Society, Duluth, Minn.; Salt Lake City Public Library, Utah; Sandra Shuler, Oklahoma County Libraries, Oklahoma City; Glenn B. Skillin, Maine Historical Society, Portland Olive M. Smythe, Bangor Public Library, Me.; Dena Snodgrass, Jacksonville Historical Society, Fla.; Robert O. Sondrol, Melrose Public Library, Mass.; Paul G. Sotirin, Milwaukee Public Library, Wis.; Paul Spence, Illinois State Historical Library, Springfield; Mrs. Herman Stanley, National W.C.T.U., Evanston, Ill.; Mrs. L. B. Stephens, Montgomery Public Library, Ala.; George R. Stewart Birmingham Public Library, Ala.; R. W. Stewart, Free Public Library, Jersey City, N.J.; Charles R. Stott, Grand Commandery of Knights Templar of Colo., Denver; Ida Taggart, New Hampshire Historical Society, Concord; Grace Thornburg, Ft. Collins Public Library Colo.; Mrs. John L. Tillman, Curator, Historical Society of Dauphin County, Harrisburg, Pa.; Elizabeth Tindall, St. Louis Public Library, Mo.; Allan M. Trout, *The Courier-Journal, Louisville Times*, Frankfort, Ky.; U.S. Soldiers' Home, Washington, D.C.; Mary E. Valentine, Thayer Public Library, Braintree Mass.; Joseph S. Van Why, Curator, Stowe-Day Foundation, Hartford, Conn.; Rowell L. Waller, Attleboro Public Library, Mass.; Lorena P. Weatherly Waltham Public Library, Mass.; R. Margaret Webber, President, Mass. W.C.T.U., Boston; Alene Lowe White, Western Reserve Historical Society, Cleveland, Ohio; Marilyn White, Oak Park Public Library, Ill.; Marjorie F. Williams, Niagara Falls Public Library, N.Y.; Aldis Wilmann, Mt. Vernon Public Library, N.Y.; Louise Wood, Indiana State Library, Indianapolis; Mary H. Wood, Brownsville Public Library, Pa.; Richard Wright, President, Erie County Historical Society, Pa.; Richard M. Wright, President, Onondaga Historical Association, Syracuse, N.Y.; Stanley Clarke Wylie, Jr., Dayton and Montgomery County Public Library, Ohio; Vera D. Young, Pawtucket Public Library, R.I.

A special note of gratitude is due the following officials of silver manufacturers and other business firms for their assistance:
Mrs. Carroll Bedsaul, Homestake Mining Company, Lead, S.D.; Richard F. Charles, Hamilton Watch Company, Lancaster, Pa.; J. Spencer Daly, General Foods Corp., White Plains, N.Y.; Grace Ellis, Pabst Brewing Company, Milwaukee, Wis.; Michael C. Fina, Michael C. Fina Co., N.Y.C.; Charles Freer (Reed & Barton), Basking Ridge, N.J.; The Gillette Safety Razor Company, Boston, Mass.; Paul W. Happold, Manager, E. J. Towle Company, Seattle, Wash.; W. M. Higgins, The Robbins Company, Attleboro, Mass.; Ann Holbrook, The Gorham Company, Providence, R.I.; G. E. Hoyt, Knox Gelatin, Inc., Johnstown, N.Y.; William T. Hurley, Jr., Vice President -Sales, Reed & Barton Silversmiths, Taunton, Mass.; S. Kirk Millspaugh, Executive Vice President, Samuel Kirk & Son, Inc., Baltimore, Md.; Clayton H. Lange, Manager, Pub. Rel., The Sherwin-Williams Co., Cleveland, Ohio; Tom Langenfeld, The Pillsbury Company, Minneapolis, Minn.; Tony Pizzo, Midulla Importing Company, Tampa, Fla.; Arthur L. Roy, Manager— Advertising, Towle Silversmiths, Newburyport, Mass.; William E. Ruser, Ruser Jewels, Beverly Hills, Cal.; Dorothy R. Scott, The Prudential Insurance Company of America, Newark, N.J.; David T. Snyder, Brown Shoe Company, St. Louis, Mo.; Lottie Thompson, Tiffany & Co., N.Y.; Elmer J. Towle, President, E.J. Towle Company, San Francisco, Cal.; Sally Wallace, Wallace Silversmiths, Division of Hamilton Watch Co., Wallingford, Conn.; Russell Woodward, The Gorham Company, Providence, R.I.; Pauline Yarossi, Waltham Precision Instruments, Inc., Waltham, Mass.

The following collectors and individuals loaned spoons to be photographed, loaned old company catalogs from which pages have been reproduced, and gave assistance in a myriad of ways:
Myra Adams, University City, Mo.; Mr. and Mrs. Carl Almgren, El Segundo, Cal.; Margaret Alves, Shelton, Conn.; Mary Anderson, Kingsport, Tenn.; Lillian C. Baker, Mt. Clemens, Mich.; Nathalie Caron, Salem, Mass.; Chauncey Cassidy, Great Falls, Mont.; John T. Challoner, Oshkosh, Wis.; Charles Clulee, Wallingford, Conn.; Larry C. Daubert,

Preface to Second Edition

Baltimore, Md.; Ralph Dexter, Pawtucket, R.I.; Josephine P. Driver, Newburyport, Mass.; Kimberly B. Felger, College Park, Md.; Virginia P. Glover, Needham, Mass.; Pearl Gunnerson, Winter Park, Fla.; Dean C. Hamilton, Baltimore, Md.; Vivian Hicks, Royse City, Tex.; Beulah Hodgson, Vancouver, Wash.; Helen Hoegsberg, Coronado, Cal.; John Lamar Kimbell, Shreveport, La.; W.G. Martin, New Orleans, La.; Joan D. Mebane Short Hills, N.J.; Floy Mitchell, Boca Raton, Fla.; Arthur Peterson, Silver Springs, Md.; Barbara A. Pickman, Mt. Clemens, Mich.; Princess Grace Rainier, Monaco; Ray Reed, Bethesda, Md.; Mrs. G.P. Roberts, Jr., Stockton, Cal.; Winifred Rowe, Shullsburg, Wis.; Gertrude Schmidt, Long Beach, Cal.; Russell O. Schmitz, Silver City, N.M.; Isabel Schrader, Mt. Shasta, Cal.; Astrid Schumacker, Bicknell, Ind.; Ray Schuster, El Paso, Tex.; Edwin Selkregg, North East, Pa..; Philip Shaffner, Chicago, Ill.; C.S. Sherwood, III, Portsmouth, Va.; Jerome Stanbury, College Park, Md.; Ethel Stewart, Jersey City, N.J.; Sam B. Stocking, Jr., Tacoma, Wash.; Louisette Levy-Soussan, Secretary to S.A.S. Princess Grace Rainier, Monaco; Gertrude Swanson, Mendota, Ill.; Charles P. Taft, Cincinnati, Ohio; Louise Toler, Sweetwater, Tex.; Mrs. F. Gregory Troyer, Honolulu; Noel D. Turner, Chicago, Ill.; Dorothy Ullrich, Evanston, Ill.; Vincent M. Vesely, Silver City, N.M.; Mrs. J.T. Womble, Abilene, Tex.; Louis Zuckerman, Columbus, Ohio.

The writers wish to acknowledge the generosity of R. Champlin Sheridan, Jr., President of Everybodys Press, for permission to reprint certain trademarks from *American Silver Manufacturers*.

Special acknowledgment is made to A. Christian Revi, Editor, *Spinning Wheel* magazine, for permission to use material written by the senior author expressly for that publication-and for the personal attention given this project.

The encouragement given by Richard B. Alleman, retired President of Everybodys press, merits special note.

Charles and Margery Cridland, President and Editor, respectively, of Thomas Nelson & Sons, merit particular appreciation for helpful criticism and suggestions relative to the original manuscript.

The difficulty of photographing silver is well known. The technical ability of H Ivan Rainwater is evident in the photographs, all of which are his work except where otherwise noted.

Finally, the enthusiastic support and encouragement of the writers' husbands, Ivan and Carl, is gratefully acknowledged. Scientists both, they were diligent proofreaders and also offered many valuable suggestions.

Twenty years ago, when *American Spoons* was first published, we were appalled when the then publisher told us how many thousand copies he had had printed. Privately, we felt that his grandchildren would be peddling them as we thought the subject would have limited appeal. Surprisingly, that first edition soon sold out and was followed by two more printings and has been out-of-print for several years. Now, because of the encouragement of Peter and Nancy Schiffer, Schiffer Publishing, Ltd., this new, enlarged edition became possible.

We found after the publication of the first edition that we had acquired hundreds of new friends—collectors who not only share an interest in the spoons themselves but also share their knowledge and experience. It is to some of these that we are deeply in debt. The first edition of American Spoons was based primarily on those which were patented or copyrighted. Patent papers rarely identified the subject matter represented on the spoons. This edition provides an opportunity to make correct identifications. It is to these friendly collectors, Stanley Basist, Terry Boughn, Levings Brown, Hilda Bryson, Dorothy Goldman, Mabel Lawler, Chris McGlothlin, Joe Unger and Diane Zinn, we are indebted for identifications, information and the loan of spoons to be photographed. Diana Cramer, editor, SILVER magazine, merits special mention for her continued support and enthusiasm.

We are deeply grateful for the cheerful cooperation of the Schiffer staff, especially Jean Cline and Ellen J. (Sue) Taylor for the layout and Timothy Scott for the design of the dust jacket and color plates.

Dorothy T. Rainwater
Donna H. Felger

Gibney

Design for silver forks and
Patented Dec 4 1844.

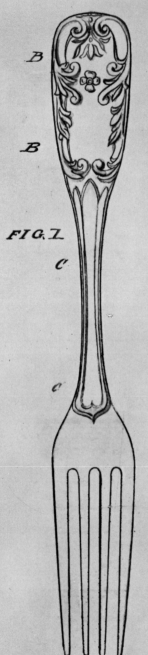

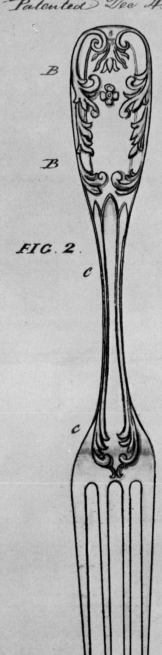

FIG. 1.

FIG. 2.

A new Design for silver manufacture of Forks, Spoons
Ladles, Butter knives, Dessert knives & Fish knives
by Michael Gibney, New York.

Introduction

Most of the spoons in this volume were granted a patent by the United States Patent Office. Collectors who have wondered when their spoons were first made will find some clues by consulting the dates patents were granted. The actual date of first sale, in the absence of company records, is almost impossible to determine as a few were not patented until they had been on the market for some time. Contemporary advertising provides further clues, especially for those thnts, trademarks, and copyrights causes confusion. A patent is a grant by the government to the inventor of exclusive rights to his *invention* for seventeen years, throughout the United States. Patent laws provide for the granting of design patents to any person who has invented any new, original, and ornamental *design* for an article. The design patent protects only the appearance of an article, not its structure. Design patents are granted for three and a half, seven, or fourteen years, depending on the amount of fee paid.

Trademarks are related to the name or symbols used in trade with goods to indicate their source or origin. Trademark rights prevent others from using the same name on the same goods, but do not prevent others from making the same goods without using the trademark.

Copyright protects the writings of an author against copying literary, dramatic, musical, and artistic works, and applies to the *form* of expression rather than the subject matter. Copyrights are registered in the Copyright Office in the Library of Congress. The Patent Office has nothing to do with copyrights.

The patent system in the United States is derived from England where patents were first granted during the reign of Queen Elizabeth I. They were issued not only for new inventions, but also applied to exclusive monopolies for the manufacture and sale of common commodities. Abuses of this practice led to a statute, in 1623, against monopolies, but which recognized the validity of patents for new inventions. This system was brought to America and the first American patent appears to have been for an invention of a process for manufacturing salt, granted by the Massachusetts Bay Colony in 1641.

After Independence, patents were granted by the individual states—the drawbacks of this system are apparent. Federal jurisdiction was the obvious answer. The first patent law of the United States was enacted April 10, 1790. The first patent issued under this law was to Samuel Hopkins of Vermont, on July 31, 1790, for a "process for making pot and pearl ashes." No copy of it has been found. A patentee who makes or sells patented articles is required to mark the articles with the word "Patent" and the number of the patent. The penalty for failure is that the patentee may not recover damages from an infringer. The marking of an article as patented when it is not patented is against the law and subject to a penalty.

The terms "Patent Applied For" or "Patent Pending" have no legal effect, but only give information that an application has been filed. Patent protection does not start until the actual grant of the patent.

Patent applications must be accompanied by a drawing for all inventions and designs except in the case of the composition of matter or processes—though they are also useful in the latter. This requirement is subject to certain rigid specifications relating to the size and kind of paper, ink, character of lines, shading, and other qualities that affect the reproduction characteristics. Had these requirements been in effect when the Tiffany Indian Dance Spoons were patented, all twenty-four of the designs could have been included. The faded photographs now on file are the sole record and in the case of the second set are too dim to be reproduced. Even the first set required so much retouching that they were virtually redrawn. On the other hand, the earliest spoon design representative of a place or person, granted to Myron H. Kinsley in 1881, is a clear, sharp line

1. Design Patent No. 26, granted to Michael Gibney, New York City, Dec. 4, 1844; the first granted in the United States for a flatware design.

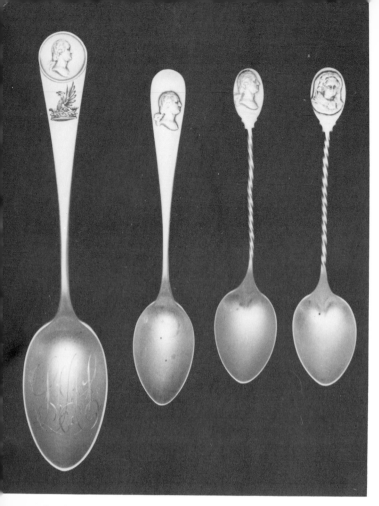

2. GEORGE and MARTHA WASHINGTON spoons whose designs were registered as trademarks of M. W. Galt, Washington, D.C. The two spoons on the left are stamped, "M. W. Galt Bro. & Co." All four bear the fleur-de-lis in a shield trademark of Davis & Galt, Philadelphia, Pa. (Collection of Helen Hoegsberg, Coronado, Cal.)

drawing, the character of which will remain as long as the paper exists. Hatching and shading are now limited to oblique parallel lines not less than one twentieth of an inch apart. The Mount Vernon and President's House spoons designed by Edwin Harris may be compared with the George Washington spoon designed by William H. Jamouneau. The former, even when greatly reduced, reproduce clearly while the latter has lost detail through unwise use of almost solid shading.

Patent Office illustrations are now prepared by patent illustrators. This is a specialized field centered in Washington, D.C. The illustrator must be able to grasp the inventor's idea, interpret it, and render it so that it will be understandable.

The first patent in the United States for *making* spoons was granted to Thomas Bruff, Easton, Maryland, on September 17, 1801. Bruff, the fourth silversmith in the family line to bear the name Thomas, and who had inherited the silversmithing shop that belonged to his father, advertised in

Chestertown, Maryland, 1791-1803. He was a member of a family in which there are recorded nine or ten silversmiths, the first of whom was Thomas, son of Charles Bruff, London goldsmith, who settled in Talbot County on the Eastern Shore of Maryland in 1668. All records concerning Bruff's and many other early patents have been lost. All that can be determined is that the patent concerned the manufacturing of spoons.

There are tantalizing but sketchy references in Patent Office files relating to methods of manufacturing spoons by casting or by swaging, for machines used in manufacturing silver spoons, and for spoons of various sheet metals. Until the 1840s, there are few records remaining except the listing by name, with only the vaguest clues given concerning the kinds of spoons made or even to the residence of the inventor.

These early patents all concern methods of manufacture. It was not until 1844 that the first *design* for flatware was patented. Design Patent No. 26 (Fig. 1) was granted on December 4, 1844, to Michael Gibney silversmith in New York, listed in city directories for 1836 to 1845. The torn and faded page now on file in the National Archives represents the first design patent granted for "forks, spoons, ladles, butter knives, dessert knives."

As the demand for "fancy" handles grew, so did the number of design patents. They increased yearly, reaching the greatest numbers in the 1890s when, in each year of that decade, more design patents for spoons were granted than during the entire period from 1790 to 1873. The large number of souvenir spoon designs patented in those years accounted for much of the increase; and, as the souvenir spoon craze spent itself, the number of design patents dropped sharply.

The first patented spoon design commemorating a place or person—that is, a souvenir spoon—found in Patent Office records is the Niagara Falls Suspension Bridge spoon patented by Myron H. Kinsley in 1881 (see Page 282).

Spoons bearing the likenesses of George Washington, made for M. W. Galt of Washington, D.C., were first issued May 11, 1889. The Martha Washington spoons followed on October 1, 1889 (Fig. 2). The two designs were not patented, but were registered as trademarks (Fig. 3) of the Galt company on May 3, 1890. These were popular designs; many thousands of them were sold each year.

The spoons generally credited with launching the souvenir spoon craze, the Salem Witch spoons (Fig. 4), also were not patented. The Witch trademark was registered January 13, 1891 (Fig. 5). The Witch design was used by the Daniel Low company on scissors, bookmarks, hat pins, pencils, brooches,

3. Martha (U.S. Pat. No. 18,080) and George Washington (U.S. Pat. No. 18,081) medallions registered as trademarks for M. W. Galt Bro. & Co., May 3, 1890.

5. Salem Witch trademark registered by Daniel Low & Co., Jan. 13, 1891 (U.S. Pat. No. 18,838).

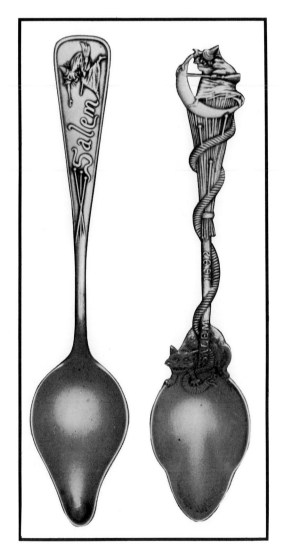

4. SALEM WITCH spoons. *Left:* The first Witch design. Marked: "PAT. MCH. 3, 91 STERLING D. LOW." Durgin trademark. No record of a patented design could be found in Patent Office. *Right:* Second Witch design. Marked: "DANL LOW STERLING." Gorham trademark.

6. Susan B. Anthony trademark registered by Millie B. Logan, Rochester, N.Y., Nov. 17, 1891 (U.S Pat No. 20,375); Moll Pitcher trademark registered by Wm. F. Newhall, Lynn, Mass., June 23, 1891 (U.S. Pat. No. 19,751); Adirondack trademark registered by Ferdinand C. Lamy, Saranac Lake, N.Y., Oct. 25, 1892 (U.S. Pat. No. 21,899); Old Constitution trademark registered by J. H. Hutchinson & Co., Portsmouth, N.H., June 30, 1891 (U.S. Pat. No. 19,770).

thimbles, stick pins, watch fobs, and, of course, the two Witch spoon designs. (See also Page 360.)

Patent Office records contain numerous other examples of spoons that are not patented designs, but are registered as trademarks of the companies for whom they were made (Fig. 6). A few spoons were covered by patent grants; the designs being registered also as trademarks (Figs. 7 & 8).

Many spoons are marked "Copyright" and are registered in the Copyright Office in the Library of Congress (Figs. 9 & 10). No attempt has been made to locate all of these, since illustrations of them are not available in the Copyright Office. In many instances, the copyright applies to the advertising or to a story connected with the spoons.

Designs were sometimes submitted to the Patent Office as sketches by an individual not connected with silver manufacturing, but who later sent them to a manufacturer. Following the refinement and elaboration of the designs by professional designers and die sinkers, the final design often bore little or no resemblance to the original sketch. See pages: 114, 118, 123). This, and the fact that many Patent Office drawings do not include the names of persons or

7. Whittier's Birthplace trademark registered by H. G. Hudson, Amesbury, Mass., Aug. 4, 1891. Design patent granted to Henry L. Dole, Haverhill, Mass., for spoons with Whittier's Birthplace design, Mar. 3, 1891 (U.S. Pat. No. 19,959).

8. America's Cup trademark registered by Kent & Stanley, Providence, R.I., May 1, 1894 (U.S. Pat. No. 24,618). Two America's Cup design patents granted to Harry H. Cabot, Bristol, R.I., and assigned to Kent & Stanley, Apr. 17, 1894.

have adopted new trademarks periodically and have marked their wares accordingly.

A number of companies did not do their own die sinking, but had dies made by others, after which they stamped and completed the spoons themselves.

The greater number of design patents for spoons were granted to people connected in some way with silver manufacturing or with the jewelry business. Among the exceptions some interesting occupations are found. The Whaling spoon (see Page 668) for instance, was the idea of Captain Jesse Tucker Sherman, one of the last of the New Bedford whaling captains.

Collectors will find popular spoon designs adapted for use all over the country. Several palm-tree designs have used for places from Florida to Hawaii. Floral designs and emblem "blanks" have been adapted for a number of purposes.

Contemporary advertising often states that certain designs were made in only one size. After wide acceptance, those same designs would often be made in several other sizes; in sterling, plated silver, copper, or brass.

places commemorated, presented problems in identification of the spoons. Only through contemporary advertising or by patent dates stamped on the back could positive identification be made.

Several of the large silver manufacturers designed and made spoons for the exclusive sale by individuals, companies, or organizations. The manufacturer's trademark may or may not be on the spoons. Generally, when a name is impressed, it is the name of the jeweler or other distributor; manufacturer's trademarks are usually embossed. However, exceptions are common.

An incorrect patent date may be found stamped on the back, possibly the result of confusion as to when the patent took effect.

It is not unusual to find exactly the same spoon design bearing different trademarks. In some cases, the dies for making the spoons were sold and new trademarks used by the new owners. Some companies

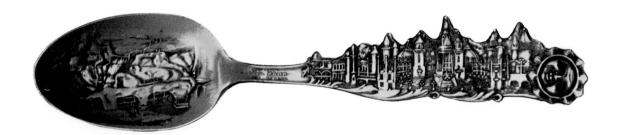

9. SKYLINE spoon, Luna Park, Coney Island, Brooklyn, N.Y. Marked: "COPYRIGHT 1907 F. S. & S. M."

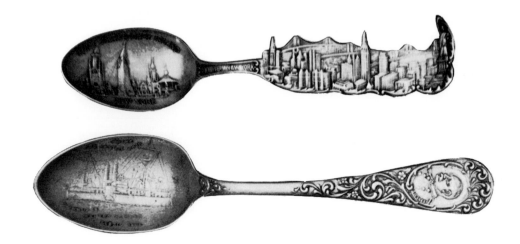

10. *Left:* SKYLINE of New York City; marked: "COPYRIGHT 1911 F. S. & S. M." *Right:* BATTLESHIP MAINE; marked: "(Star) Al (Star) COPYRIGHT."

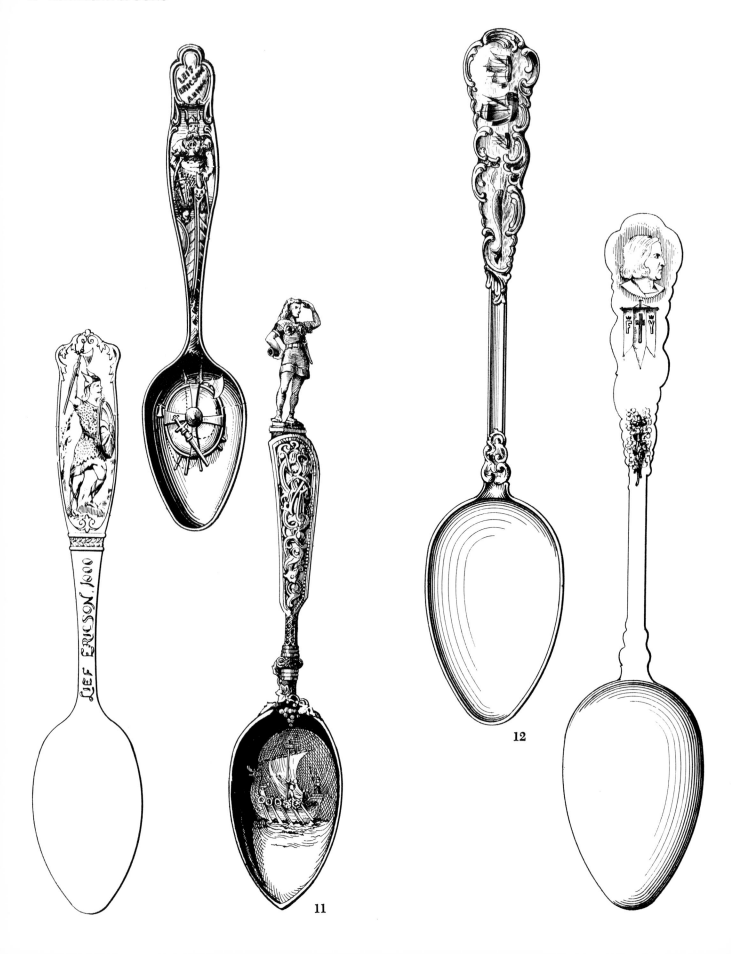

11

12

The American Trail of History

The American trail of history often leads into blind alleys and detours, but the central theme plods along a steady course to the development of a great nation.

Leif Ericsson

Leif Ericsson (Fig. 11), in the year 1000, became the first Viking explorer to set foot on the New World. The story of his explorations on the land and the abundance of food and timber found there is told in *Groenlendinga Saga*.

The adventures of this Norse mariner have captured the imaginations of archaeological and historical scholars as well as school boys. Several locations indicating establishment of Norse settlements have been found on the coasts of Labrador, Newfoundland, and as far south as New England. Archaeological evidence points to the presence of these explorers, but the exact location of Leif Ericsson's brief stay has not yet been determined.

11. *Left to right:* LEIF ERICSON 1000, Austin F. Jackson, Taunton, Mass. June 2, 1891 (U.S. Pat. No. 20,812). Assigned to Reed & Barton. Manufactured by Reed & Barton. LEIF ERICSON, George P. Tilton, Newburyport, Mass. May 19, 1891 (U.S. Pat. No. 20,732). Assigned to Towle Manufacturing Company. Towle Manufacturing Company trademark. LEIF ERICSON, Seth Frederick Low, Salem, Mass. Aug. 11, 1891 (U.S. Pat. No. 20,978). Manufactured by the Gorham Corporation.

12. COLUMBUS, William A. Montague, Duluth, Minn. Aug. 1, 1893 (U.S. Pat. No. 22,660). The Spanish ships during the time of Columbus had an official name, usually that of a saint. The sailors, however, called the ships by a nickname, *Santa Maria* was *La Gallega,* "The Galician." The second ship in Columbus' famous fleet was the *Santa Clara,* universally known by her nickname *Nina,* because she belonged to the Nino family of Palos. The *Pinta's* real name is not known. Her nickname was probably derived from a former owner named Pinto. Made for the Columbian Exposition. Spoon #12

Christopher Columbus

In all four of his voyages Columbus (Fig. 12) glimpsed only a small part of the continent of North America; he was convinced that he had found that long-sought Northwest Passage to Asia.

There is something prophetic in the fact that his parents named him Cristoforo, after the patron saint of travelers. Certainly, it had a great influence on his decision to leave the family trade of weaving. He was a dreamy and very religious little boy, who saw in his name a sign that he was destined to spread the Christian religion.

Not much is known of his early life except that he had little formal education. While in his twenties, he and his brother, Bartholomew, set up a chartmaking establishment. Whenever a ship returned from a long voyage, they invited the master or pilot to dine with them. From such associations, the two brothers obtained new data to correct and to extend the scope of existing charts.

Columbus was an intensely religious man. The failure of the Crusades and the forced evacuation of the Christians from the Holy Land rankled within him. He dreamed of finding wealth to raise an army that would send the Turks reeling back to central Asia.

Because a dribble of gold and silver, precious stones, silk, fine cottons, drugs, and perfumes had reached Europe from Asia by caravans, Columbus, like everyone else, believed Asia to be a land of great riches. His dream was to find an ocean passage to these riches.

He sailed from above the Arctic Circle almost to the Equator, and from the eastern Aegean to the outer Azores; he learned practical navigation, and read geography avidly; and finally he reached the status of master mariner.

He was forty-one years old when he finally obtained backing for his project from King Ferdinand and Queen Isabella of Spain.

On August 3, 1492, he began the voyage of exploration that led, not to the discovery of a Northwest Passage, but to a whole New World.

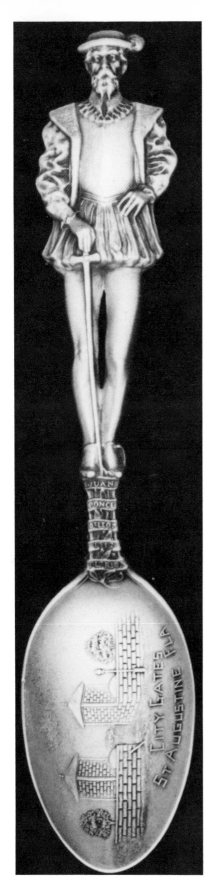

13. JUAN PONCE DE LEON. Marked: "EL UNICO."
Watson & Newell trademark. (Collection of Pearl
Gunnerson, Winter Park, Fla.)

14. COAT OF ARMS OF SPAIN, Damon Greenleaf &
Joseph Crosby, Jr., Jacksonville, Fla. Aug. 22, 1893 (U.S.
Pat. No. 22,717). Manufactured by the Wm. B. Durgin Co.
The design on this spoon implies that the cross and the
crown together established American colonies for Spain,
i.e., St. Augustine in 1565. Enameled in appropriate
colors. Marked: "STERLING PAT'D AUG. 22, '93." Also
found with British marks for Birmingham, England,
1892-93; maker, L & S.

Florida

The discoveries of Columbus inspired a generation
of explorers who crossed the Atlantic to find that
Columbus had been wrong; he had not discovered
Asia but had found a wild and impenetrable barrier
to it. In 1513 the Spanish explorer Juan Ponce de
Léon (Fig. 13), while searching for the mythical
Bimini Island and the Fountain of Youth, discovered
Florida (Figs. 14 & 15).

In 1565 Don Pedro Menéndez de Avilés, Captain
General of the Spanish fleet, founded St. Augustine
(Fig. 16), the first white settlement on the continent
of North America.

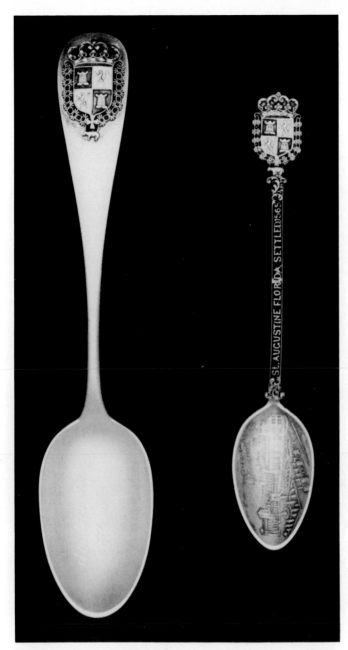

15. COAT OF ARMS OF SPAIN—ST. AUGUSTINE.
Left: marked: "STERLING GREENLEAF & CROSBY."
Durgin trademark. *Right:* marked: "GREENLEAF &
CROSBY STERLING." (Collection of Pearl Gunnerson,
Winter Park, Fla.)

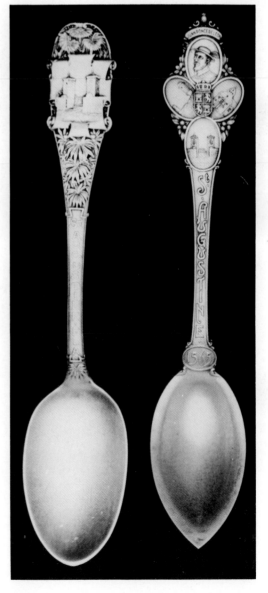

16. ST. AUGUSTINE. Both marked: "Greenleaf & Crosby
STERLING." Durgin trademark. (Collection of Pearl
Gunnerson, Winter Park, Fla.)

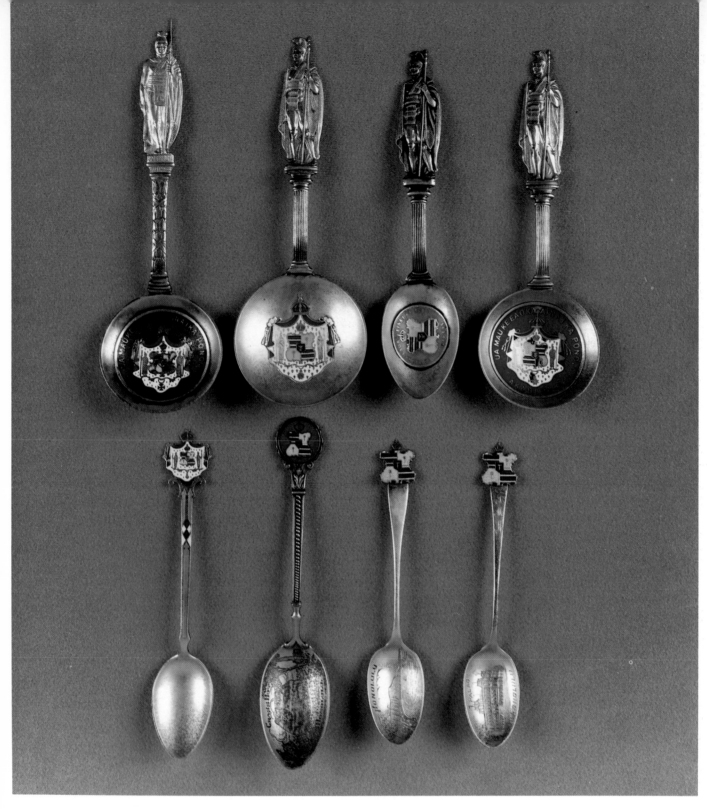

Top row, left to right:

KAMEHAMEHA I. Hawaiian coat of arms used on the Hawiian *akahi dala,* (one dollar) shown in the bowl. Marked: Sterling/ S. & B. S. F. CAL. (Schaezlin & Burridge, San Francisco, California)

KAMEHAMEHA I. Hawaiian coat of arms. Marked: Sterling/ H.F. Wichman.

KAMEHAMEHA I. Hawaiian *hapaha* (1883 Hawaiian quarter) in the bowl. Marked: Sterling. These three were made from dies cut by the Gorham Company.

KAMEHAMEHA I. *akahi dala* in the bowl. Marked: CMR within a diamond (Charles M. Robbins Company mark used before 1900).

Bottom row, left to right:

HAWAIIAN COAT OF ARMS. Marked: Charles M. Robbins, mark used 1900-1925/Sterling/ H.F. Wichman.

HAWAIIAN COAT OF ARMS. Grass hut and Honolulu in the bowl. Marked: Sterling.

HAWAIIAN COAT OF ARMS. Honolulu and Waikiki Beach and Diamond Head in the bowl. Marked: Sterling.

HAWAIIAN COAT OF ARMS. Iolani Palace, Honolulu, in the bowl. Built 1879-82, it housed the last royal rulers of Hawaii. Marked: Sterling. In addition to the sterling marks on the latter two, there is a mark, possibly a maker's mark, which has been obliterated.

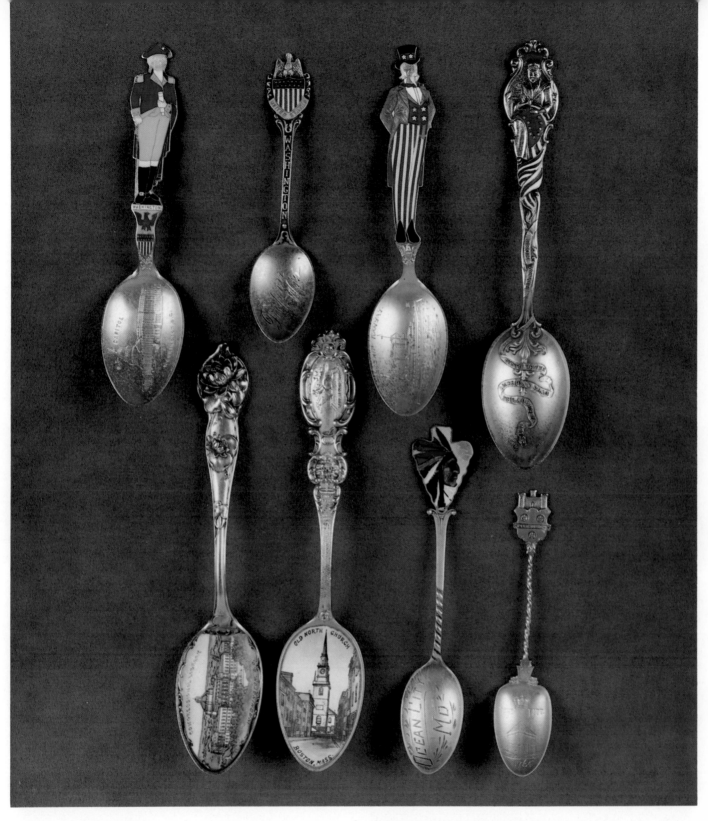

Top row, left to right:

FULL FIGURE GEORGE WASHINGTON. U. S. Capitol, Washington, D. C. in bowl. Marked: Sterling/T. E. Ogham.

UNITED STATES SEAL on handle, Ripon, Wisconsin engraved in bowl. Shepard Mfg. Co. trademark/Sterling.

FULL FIGURE UNCLE SAM. U. S. Battleship *Kansas* engraved in bowl. Shepard Mfg. Co trademark/Sterling.

BETSY ROSS AND FLAG on handle. "Birth of the American Flag, Philadelphia" on ribbon scroll in bowl. Old House/239 Arch Street on back. Marked: Pat 1898/Sterling.

Bottom row, left to right:

CONGRESSIONAL LIBRARY/ Washington, D. C. in bowl. Paye & Baker trademark/Sterling.

OLD NORTH CHURCH/Boston; Mass. in bowl. Paul Revere on horseback on handle. Faheuil Hall/Public Library/Old North Church/The Hub/Old State House/Minute Man/Boston on back. Alvin Mfg. Co. trademark/Sterling.

INDIAN. Ocean City, Maryland engraved in bowl. Marked: L. D. A./Sterling.

PITTSBURGH on handle. Fort Pitt/1761 in bowl. Pat 1891/E. P. Roberst & Sons/Sterling.

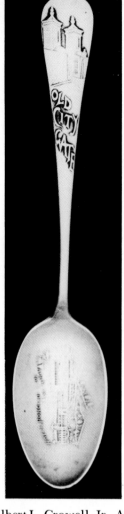

17. OLD CITY GATE, Gilbert L. Crowell, Jr., Arlington, N.J. June 7, 1892 (U.S. Pat. No. 21,601). Assigned to Greenleaf & Crosby, Jacksonville, Fla. Dominick & Haff trademark.

18. PONCE DE LEON HOTEL, "Old City Gate." Marked: STERLING GREENLEAF & CROSBY PATENT." Durgin trademark.

19. PALM TREE, Palm Beach, Fla. Marked: "GREEN-LEAF & CROSBY." Made by Gorham. (Both collection of Pearl Gunnerson, Winter Park, Fla.)

20. PALM BEACH—LAKE WORTH, FLORIDA. Marked: "STERLING GREENLEAF & CROSBY PAT. 1893." Dominick & Haff trademark.

The only walled city in the United States, St. Augustine remained under Spanish control until 1763, when, with the rest of Florida, it was ceded to England. The Old City Gate (Fig. 17) is the sole remains of the city walls built in 1620 of coquina stone.

Established as a military post, St. Augustine saw little development until, in the 1880s, Henry M. Flagler decided to make it into a winter resort. He built the Ponce de Léon Hotel, a highly ornate structure that still stands (Fig. 18).

Early explorers found strange plant and animal life (Figs. 19-22) in Florida. Present-day visitors to Florida will find alligators at the famous Alligator Farm near St. Augustine; they will also find many of the oldest historic sites in the nation (Fig. 23).

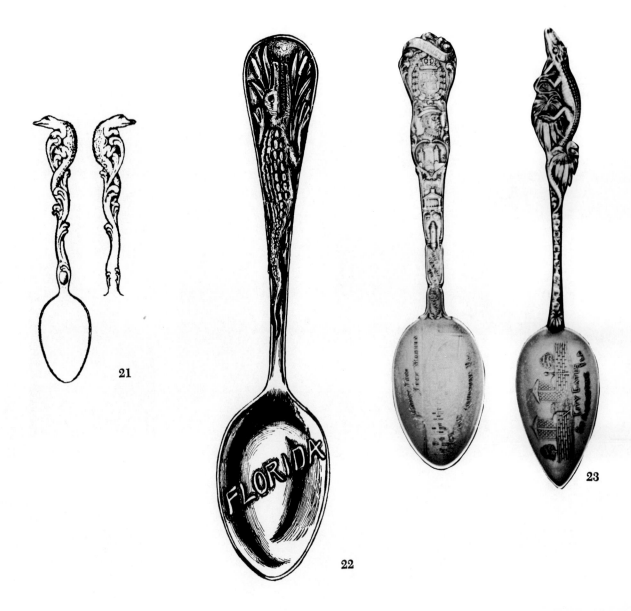

21. ALLIGATOR, Gilbert L. Crowell, Jr., Arlington, N.J. May 24, 1892 (U.S. Pat. No. 21.560). Assigned to Damon Greenleaf & Joseph Hayden Crosby, Jr., Jacksonville, Fla. Dominick & Haff trademark. Marked: "Greenleaf & Crosby."

22. FLORIDA ALLIGATOR, W. H. Jamouneau, Newark, N.J. Jan. 12, 1892 (U.S. Pat. No. 21,296). Manufactured by the Alvin Corporation.

23. *Left:* ST. AUGUSTINE, Courtyard, Fort Marion, Fla., in bowl. Marked: "STERLING." *Right:* ALLIGATOR, City Gates, St. Augustine, Fla. Marked: "EL UNICO STERLING." Watson & Newell trademark. (Collection of Pearl Gunnerson, Winter Park, Fla.)

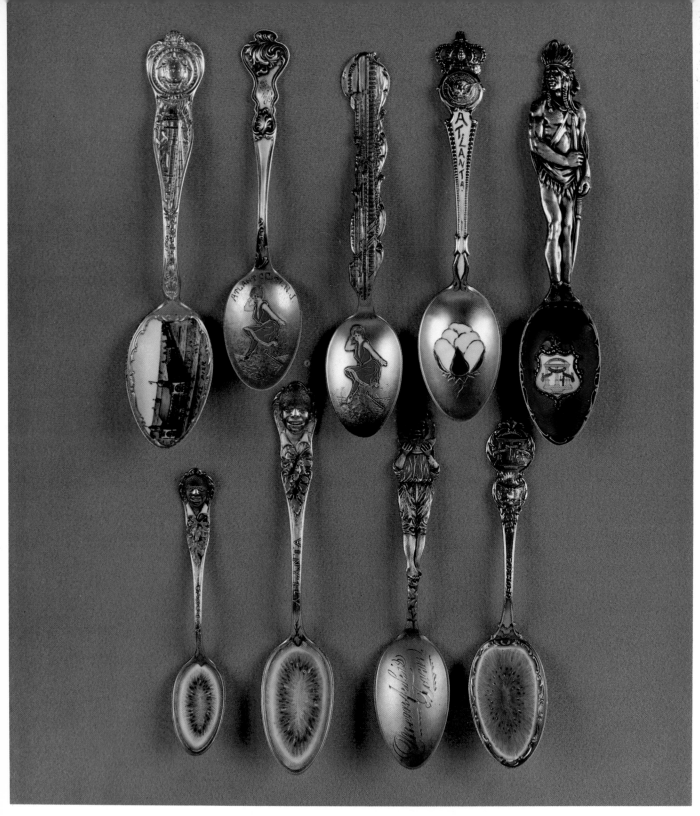

Top row, left to right:

ATLANTIC CITY SEAL and **PIER.** Steel Pier in bowl. Push chair/bathers/Absecon Lighthouse on back. Paye & Baker trademark/Sterling.

ATLANTIC CITY, N. J. Bathing beauty in bowl. Paye & Baker trademark/Sterling.

ATLANTIC CITY SYKLINE. Bathing beauty in bowl. Absecon Lighthouse/Sail boat/ Atlantic City on back. Paye & Baker trademark/Sterling.

COTTON STATE INTERNATIONAL EXPOSITION/Sept. 12th to Dec. 31st./Atlanta on handle/Cotton boll in bowl. Maier & Berkle/Pat. App'd for.

FULL FIGURE INDIAN/GEORGIA SEAL. Watson, Newell trademark/Sterling.

Bottom row, left to right:

NEGRO BOY/ATLANTA Watermelon in bowl. Gorham trademark/Sterling/ Charles W. Crankshaw.

NEGRO BOY/ATLANTA. Watermelon in bowl. Gorham trademark/Sterling/Charles W. Crankshaw/ Copyright 1895.

FULL FIGURE NEGRO eating watermelon. Marked: Sterling.

GEORGIA STATE SEAL. Watermelon in bowl. Paye & Baker trademark/Sterling.

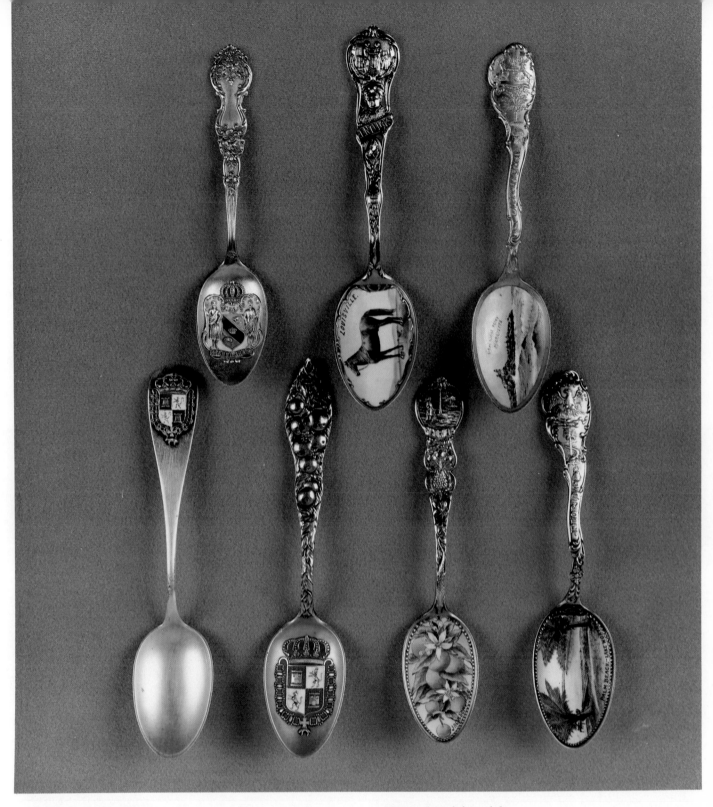

Top row, left to right:

MARDI GRAS (Mardi Gras, Shrove Tuesday, is the last day before Lent. The day is observed in New Orleans, Mobile, and Memphis with processions and other entertainment.) Sterling/ Shepard Mfg. Co. trademark.

KENTUCKY STATE SEAL/Louisville, Kentucky/Thorough-bred race horse in bowl. (Louisville is the home of the Kentucky Derby, second leg of the prestigious Trip Crown.) State Capitol/Old Kentucky Home/Daniel Boone Monument in bowl. Paye & Baker trademark/ Sterling.

MICHIGAN STATE SEAL. Light House Point, Marquette in bowl. Sterling/Shepard Mfg. Co., trademark.

Bottom row, left to right:

ST. AUGUSTINE/Coat of arms of Spain. Durgin trademark/ Sterling/Greenleaf & Crosby.

COAT OF ARMS OF SPAIN in bowl, symbol of St. Augustine, Florida, it commemorates the city's founding in 1565 by Don Pedro Menéndez de Avilés, Captain General of the Spanish fleet. Shepard Mfg. Co., trademark/Sterling.

FLORIDA STATE SEAL. Oranges in bowl. Marked: Sterling.

FLORIDA. Eagle, palm tree and pineapple above the word "Florida" on handle. Palm Beach/Lake Worth in bowl. Shepard Mfg. Co., Sterling.

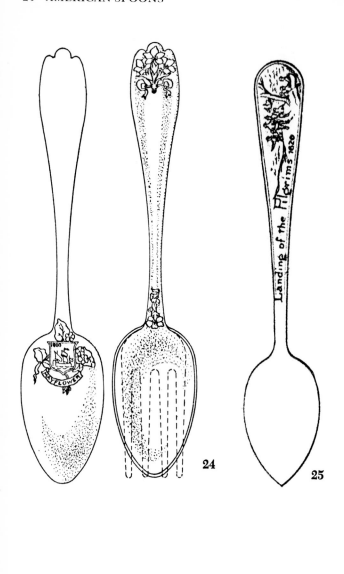

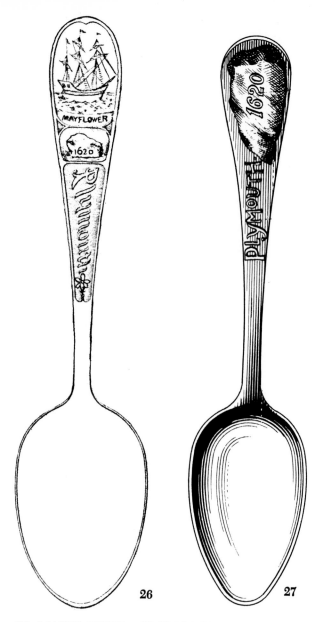

24. MAYFLOWER, George P. Tilton, Newburyport, Mass. Nov. 3, 1909 (U.S. Pat. No. 40,372). Assigned to the Towle Manufacturing Company. State flower of Massachusetts—Arbutus (Mayflower).

25. LANDING OF THE PILGRIMS, Frank M. Whiting, North Attleboro, Mass. June 9, 1891 (U.S. Pat. No. 20,826). Frank M. Whiting & Co. trademark.

26. MAYFLOWER—PLYMOUTH ROCK, William A. Bates, Winchester, Mass. Mar. 10, 1891 (U.S. Pat. No. 20,576).

27. PLYMOUTH ROCK, George Gooding and Benjamin W. Gooding, Plymouth, Mass. Apr. 7, 1891 (U.S. Pat. No. 20,664). Manufactured for Codding Bros. & Heilborn. Towle Co. trademark.

The Mayflower

After exploring the outer end of Cape Cod and finding it unsuitable for settlement, the weary group of Separatists, whom we now call Pilgrims because of their wanderings, entered Cape Cod Bay and decided to settle on Plymouth Harbor. The company of one hundred two colonists aboard the *Mayflower* (Figs. 24 & 25), thirty-five from Leyden rest "a very mixed lot" from Southhampton, were too occupied with the harsh conditions to make any note of the symbolism of their landing. There on Christmas Day, 1620, they started building their first "common house."

Plymouth Rock

No contemporary account mentions that the Pilgrims landed on a rock and there is some doubt that they did. Easily the most conspicuous object on the flat curved shoreline, Plymouth Rock (Figs. 26 & 27) could not have gone unnoticed. But it is hard to

imagine them taking the risk of battering the ship when within a hundred yards was a wide sheltering inlet.

Plymouth Rock's existence was first recorded in 1715 in the town boundary records as only "a great rock."

The Sons of Liberty were the first to realize its symbolic potential. When they dug down to move the rock (December 22, 1774), it split in two—a symbol, some patriots felt, of the division between England and the colonies. The upper portion of the rock was moved to the Town Square. There it stayed until 1834 when it was moved again to the front of Pilgrim Hall.

The lower portion of the famous rock lay for many years embedded in the surface of a commercial wharf. Visitors were puzzled by the presence of *two* Plymouth Rocks. To end this confusion, in 1880 the Pilgrim Society again moved the upper section and this time united it with the lower part.

During the Tercentenary Celebration, the base was lowered and the upper portion firmly cemented to the lower. Plymouth Rock was at last located where twice a day high tide lapped its base.

The legend of the landing has grown through more than three centuries. But, this myth, if it is a myth, is based at least on a profound truth. As each American makes his pilgrimage to this stepping stone to freedom, he takes with him the reality that all of us are here because someone took a step forward, whether on Plymouth Rock or Ellis Island, and felt a sustaining firmness under foot.

Plymouth Courtship

Priscilla Mullins was a vivacious girl of eighteen when she boarded the *Mayflower* with her parents and her brother. They were an aristocratic French family by the name of Molines or Molyneux, who had left their feudal castle in Normandy, gone to England, then to Holland, and finally to America in search of religious freedom.

Priscilla must have been a robust young lady for she assumed her full share of responsibilities as nurse during the epidemic of influenza and pneumonia that left her an orphan in the new land.

John Alden had joined the Mayflower company at almost the last minute to fill the need for a cooper stipulated in chartering of the ship. He had practiced his craft in Southampton and during the voyage made repairs on the ship.

A tall, fair-haired man of quiet and unassuming manner, John was virtually a stranger to the elders of the company until almost the day of their sailing. He came to fill a place of honor and esteem in the colony and for more than fifty years was a colonial magistrate. At the time of his death he was the last surviving signer of the Mayflower Compact.

John and Priscilla were married in 1622 (Figs. 28-31). They had eleven children and at the time of their deaths, both in the year of 1686, they were survived by one hundred forty-four descendants.

Five presidents—John and John Quincy Adams, Zachary Taylor, Ulysses Grant, and William Howard Taft—were descended from the prolific and longlived Aldens. So was the poet Henry Wadsworth Longfellow, who immortalized their romance.

The basic facts, though well embellished, in Longfellow's poem about the courtship of John and Priscilla are true. His version was based on one told by Priscilla's great-great-granddaughter who died in 1845 at the age of one hundred. It was a story already the subject of popular ballads and legends. The tradition, as recounted by Longfellow, that John Alden had previously pleaded the cause for Miles Standish is unfounded, though it is true Miles had courted her and had been refused.

Miles Standish

Miles Standish (Fig. 32) was born in Lancashire, England, about 1584, of a wealthy, aristocratic family. Little is known about his early life. All the pages on the old parish registers that might furnish data have been destroyed or rendered undecipherable by the rubbing of pumice stone over the entries. His American descendants believe this destruction of records was made in an effort to deprive him of his inheritance. Two branches of the Standish family, one at Standish Hall and one at Duxbury Hall, engaged in endless wrangling. This was possibly one of the reasons Miles Standish left England. He joined the Separatist colony at Leyden though he did not belong to that communion.

Because of his experience in martial affairs and his talents as a linguist, his leadership was invaluable as the captain or military defender of the colony. Besides his military commission, he also held the post of assistant to the governor and was later treasurer of the colony.

When Priscilla rejected him, he proposed marriage to Barbara, the younger sister of Rose, his first wife who had died a month after the Plymouth landing.

In 1625 he moved a few miles from Plymouth to Duxbury, named after his ancestral seat in England. Here he lived for more than thirty years in a modest cottage he built on Captain's Hill.

Boston, Massachusetts

The Boston Elm (Fig. 33), an old elm tree on Boston Common, was a remnant of the native forest. Its branches witnessed many fateful events in American history; the hanging of a witch, Quaker meetings, punishment of Indian rebels, the first fatal

Top row, left to right:
COLORADO SKYLINE, Capitol, Denver, Colorado in bowl. Smelter/miners in mine on back. Marked: Sterling.
STATE SEAL OF MONTANA, State Capitol, Helena Montana in bowl. Joseph Seymour trademark/Sterling.
VIRGINIA STATE SEAL soldered onto a pattern handle. State Capitol, Richmond, Virginia in bowl. Marked: Sterling.
STATE CAPITOL, ALBANY, NEW YORK in bowl. Paye & Baker trademark/Sterling.

Bottom row, left to right:
CHICAGO EAGLE in bowl. Shepard trademark/Sterling.
CHICAGO SEAL in bowl. City of Chicago incorporated 4th March 1837/Government bldg/Art Institute/Indian monument/Foster Hall, Chicago University/Grant Monument on handle. Joseph Seymour trademark/Sterling/C. D. Peacock.
ILLINOIS STATE SEAL on handle. Old Fort Dearborn, 1812, Chicago in bowl. Sterling/Shepard trademark.

Top row, left to right:

NEW YORK, BROOKLYN BRIDGE in bowl. Paye & Baker trademark/Sterling.

NEW YORK STATE SEAL/GRANT'S TOMB/SOLDIER'S & SAILOR'S MONUMENT/NEW YORK on handle. New York and Brooklyn Bridge in bowl. Brooklyn Bridge/Statue of Liberty/Park Row Bldg./Egyptian Obelisk on back. Marked: Sterling.

NEW YORK STATE SEAL/NIAGARA FALLS/NEW YORK on handle. Brooklyn Bridge in bowl. Gorham trademark/Sterling/H946.

NEW YORK/GRANT'S TOMB Gorham trademark/Sterling/Pat 1897/K.

Bottom row, left to right:

NEW YORK SKYLINE. Statue of Liberty/New York Harbor in bowl. "First settlement 1614/Incorporated under the name of New Amsterdam 1652" on back. Paye & Baker trademark/Sterling.

BUFFALO/INDIAN on handle. Niagara Falls/Pan American Exposition 1901 in bowl. Niagara Falls on back. Joseph Seymour trademark/Sterling/American Souvenir Co.,/Buffalo, N.Y.

NIAGARA FALLS in bowl. Pat'd. NSV.17 '06/Frank M. Whiting Co. trademark/Sterling.

NEW YORK STATE SEAL/GRANT'S TOMB/SOLDIER'S & SAILOR'S MONUMENT/FLATIRON BLDG/NEW YORK on handle. Flat Iron Bldg.? New York City in bowl. Brooklyn Bridge/Statue of Liberty/Park Row Bldg/Obelisk on back. Marked: Sterling.

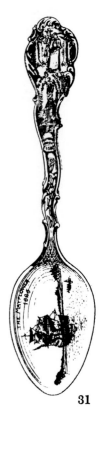

28. PRISCILLA, William B. Durgin, Concord, N.H. Mar. 24, 1891 (U.S. Pat. No. 20,591). Manufactured by Wm. B. Durgin & Co.

29. JOHN ALDEN & PRISCILLA, Henry E. Washburn, Plymouth, Mass. Aug. 13, 1895 (U.S. Pat. No. 24,535). Marked: "H. E. Washburn." No trademark.

30. PLYMOUTH COURTSHIP, Benjamin W. Gooding and George Gooding, Plymouth, Mass. June 21, 1898 (U.S. Pat. No. 28,885). Manufactured by Codding Bros. & Heilborn.

31. PRISCILLA AND JOHN, Benjamin D. Loring, Plymouth, Mass. Apr. 18, 1905 (U.S. Pat. No. 37,405). Shepard Manufacturing Co.

worth of tea into Boston Harbor. This action resulted in the closing of Boston Harbor, the dispatching of British troops to Concord to seize the military supplies stored there by the colonists, and Paul Revere's famous ride to alert the countryside that the British were on the way.

Boston was founded by John Winthrop and a group of colonists when they arrived there in 1630. Two years later it became the capital of the Massachusetts Bay Colony. Boston Harbor (Fig. 35), at the mouths of the Charles and Mystic rivers, is an important port. From the earliest days it has been a center of commerce. The State House on Beacon Street was designed by Charles Bulfinch and erected 1795-1798. The gilded dome, which remains unchanged, is the outstanding feature of the building.

Chelsea, Massachusetts, was founded as a trading post by Samuel Maverick in 1624, and was known by the Indian name of Winnisimmet (Fig. 37). It was part of Boston until it was set off as a separate township in 1739.

New York State

When Henry Hudson, an English navigator employed by the Dutch East India Company to search for a Northwest Passage to Asia, explored the coast of North America in 1609, he gave the world its first knowledge of the island of Manhattan. He sailed up the river now bearing his name, but shallowing waters near present-day Albany forced him to turn back. Though his discoveries helped to prove that no feasible Passage existed, his reports convinced Amsterdam merchants that the fur trade would be profitable.

The quickly organized New Netherland Company sent its first ship the following year. Trading posts were established as far up the river as Albany.

In 1624 a new Dutch West India Company placed a few families on the site of Albany. They built Fort Orange and traded for furs with the Iroquois who came from the Mohawk Valley.

A year later the company established Fort Amsterdam on Manhattan Island. The arrival of the *Sea Mew* at Manhattan on May 4, 1626, bringing Peter Minuit as director-general of New Netherland is generally regarded as the founding date of New York City. The fort was completed in 1628 and, with the arrival of a new governor in 1633, the little town of Fort Amsterdam received the name of New Amsterdam (Fig. 38).

In 1664 the Duke of York sent a fleet to seize the town from the Dutch. Taken without bloodshed, the Dutch colony became an English possession and the settlement was renamed in honor of the Duke of York.

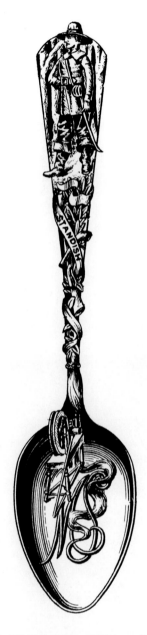

32. MILES STANDISH, William B. Durgin, Concord, N.H. Apr. 14, 1891 (U.S. Pat. No. 20,674). Wm. B. Durgin & Co. trademark.

duel in Boston meetings of the Sons of Liberty when they hanged effigies of Tories, and the preaching of evangelists. It was blown down in 1876.

Before the American Revolution, Boston was the center of strong resistance in Massachusetts to repressive measures and to taxation by the British. When cargos of East India Company tea arrived in Boston in 1773, citizens demanded that it be sent back to England. When it was finally determined that only direct action would serve, a group of men disguised as Indians (Fig. 34) swept down to the docks, boarded the ships, and dumped £18 thousand

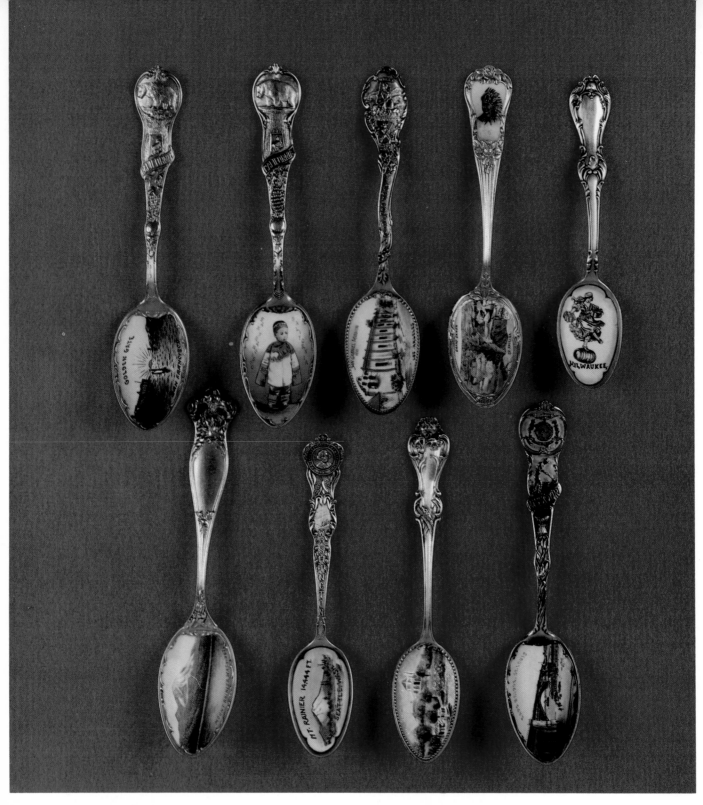

Top row, left to right:

CALIFORNIA BEAR/California. Golden Gate in bowl. Eureka (State motto)/Grapes/1849/Miner on back. Paye & Baker trademark/Sterling.

CALIFORNIA BEAR/California. Chinese boy/San Francisco in bowl. Paye & Baker trademark/Sterling.

CALIFORNIA STATE SEAL/Miner/California on handle. San Gabriel Mission/1771/Los Angeles in bowl. Shepard Mfg. Co. trademark/Sterling.

INDIAN on handle. **GRAND CANYON OF ARIZONA** in bowl. Sterling/No. 65/Joseph Seymour trademark.

MILWAUKEE GIRL dancing on beer barrel in bowl. Sterling Manchester Mfg. Co. trademark.

Bottom row, left to right:

MT. RAINIER, WASHINGTON in bowl. Paye & Baker trademark/Sterling.

WASHINGTON STATE SEAL on handle. Mt. Rainier/14,444 ft./Seattle, Washington SterlinR/Manchester Mfg. Co., trademark.

RESIDENCE OF JOHN J. MITCHELL/Lake Geneva in bowl. Shepard Mfg. Co. trademark/Sterling.

MISSOURI STATE SEAL/Missouri on handle. Eads Bridge/St. Louis in bowl. State Capitol on back. Paye & Baker trademark/Sterling.

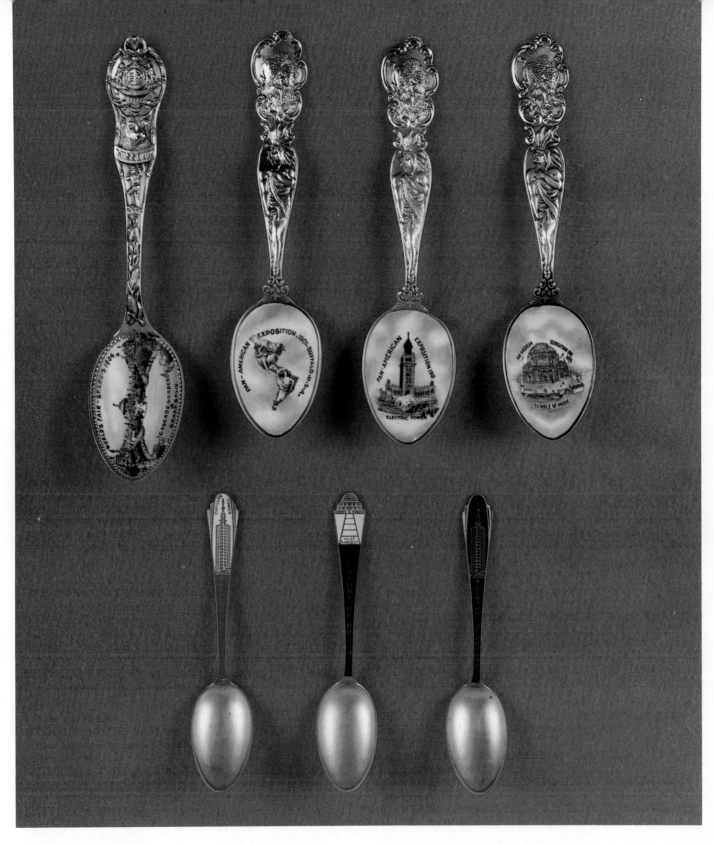

Top row, left to right:

MISSOURI STATE SEAL on handle. World's Fair, St. Louis 1904/Cascade Gardens & Grass Basin in bowl. Shepard Mfg. Co. trademark/Sterling.

BUFFALO & INDIAN on handle. Pan-American Exposition, Buffalo, U.S.A. Official/Niagara Falls on back. Sterling/Pat. American Souvenir Co., Buffalo, N. Y. Gold Washed.

BUFFALO & INDIAN on handle. Pan-American Exposition, Electric Tower in bowl Marked as above. Gold washed.

BUFFALO & INDIAN on handle. Pan-American Exposition, Temple of Music in bowl. Marked as above.

Bottom row, left to right:

A CENTURY OF PROGRESS/ADLER PLANETARIUM Chicago 1933-1934 on back.

A CENTURY OF PROGRESS/CARILLON TOWER Chicago 1933-1934 on back.

A CENTURY OF PROGRESS/CARILLON TOWER Chicago 1933-1934 on back.

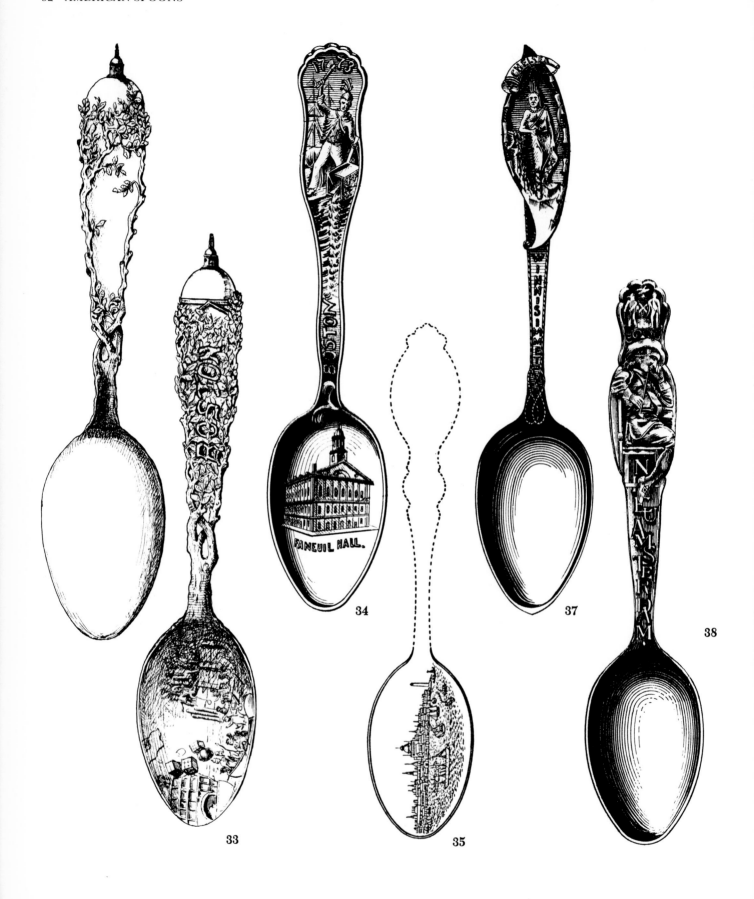

Liberty Enlightening the World, better known as the Statue of Liberty, stands in New York Harbor, beckoning to the millions who have sought refuge from the Old World and welcoming home the American traveler.

This gigantic statue was a gift from the people of France to the people of the United States in honor of the one hundredth anniversary of the signing of the Declaration of Independence (Figs. 39-41).

It was designed by Frédéric Auguste Bartholdi and built in Paris in the late 1870s and early '80s from a model by that French sculptor. It was made of huge sheets of hammered copper welded over an iron framework engineered by Gustave Eiffel, whose famous tower would rise in Paris a few years later.

After its completion, the statue was dismantled, packed into 214 wooden crates, and shipped across the Atlantic. In June 1885 it was unloaded on Bedloe's Island and on October 28, 1886, was unveiled to the accompaniment of much ceremony. President Cleveland was among the speakers. The celebration started at ten o'clock in the morning and continued until the sunset gun went off on Governor's Island. A steady rain fell all the while but failed to discourage the crowd. The fireworks had to be postponed a few nights because of the weather, but the Goddess of Liberty had officially taken her stand at the entrance to America's great harbor.

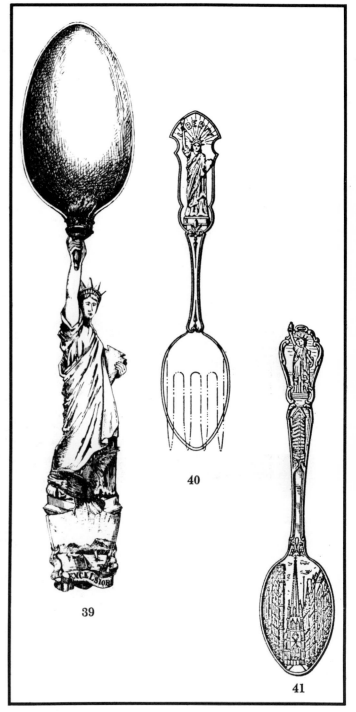

33. THE BOSTON ELM, George W. Shiebler, Brooklyn, N.Y. June 23, 1891 (U.S. Pat. No. 20,859). George W. Shiebler & Co. winged-S trademark.

34. BOSTON TEA PARTY, George P Tilton, Newburyport, Mass. May 19, 1891 (U.S. Pat. No. 20,731). Assigned to Towle Manufacturing Company. Towle Manufacturing Company trademark. Faneuil Hall, "Cradle of Liberty," was built and given to the city of Boston by Peter Faneuil in 1742.

35. BOSTON HARBOR, George E. Homer, Boston. Nov. 1 1904 (U.S. Pat. No. 37,201).

37. CHELSEA WINNISIMMET, Charles J. W. Addison, Chelsea, Mass. Apr. 28, 1891 (U.S. Pat. No. 20,689). Manufactured by Wm. B. Durgin Co. exclusive to Addison Bros. Marked: "Addison Bros." Wm. B. Durgin Co. trademark.

38. NEW AMSTERDAM, Charles Osborne, N.Y.C. July 7, 1891 (U.S. Pat. No. 20,910). Assigned to Whiting Mfg. Co. Manufactured by the Whiting Mfg. Co.

39. STATUE OF LIBERTY, George W. Shiebler, Brooklyn, N.Y. July 7, 1891 (U.S. Pat. No. 20,920). Marked: "Pat.'d July 7, 1891." George W. Shiebler & Co. winged-S trademark.

40. STATUE OF LIBERTY, Ben Shane, Milwaukee, Wis. Dec. 13, 1918 (U.S. Pat. No. 52,831).

41. NEW YORK, William C. Codman, Providence, R.I. Nov. 7, 1905 (U.S. Pat. No. 37,640). Assigned to the Gorham Corporation. Trinity Church, N.Y.C., lies on Broadway and faces the man-made canyon of Wall Street.

Brooklyn now has the largest population of the five boroughs of New York City (Fig. 42). It was colonized as "Breuckelen" under Dutch rule in 1636, named for a village in the Province of Utrecht, Holland.

In 1867 the famous Brooklyn Bridge over the East River, considered the crowning achievement of John A. Roebling, was begun. In 1869, after completing all the plans, Roebling died from an accidental fall during the final surveys. His son, Col. Washington A. Roebling, continued the work even after he was disabled by the paralyzing caisson disease, directing the work from his room on Columbia Heights. On May 24, 1883, the completed bridge was dedicated—an engineering triumph. It was the first suspension bridge using steel wire for the cables and steel for the suspended structure.

The Old Brooklyn Church was the first church erected in the "City of Churches." It was built in 1776 and stood on what is now Fulton Street (Fig. 43).

An impressive arch (Fig. 44) commemorating Civil War heroes is situated at the north entrance to Prospect Park on the Grand Army Plaza in central Brooklyn.

Albany (Figs. 45 & 46), capital of the State of New York, is located on the site where Fort Orange was erected in 1623. During the days of Dutch rule, the city had several names, one of the best known being "Beverwyck," which means "Town of Beavers," recalling the fur trade of early days. The city was chartered in 1686, with Peter Schuyler the first mayor. Albany is the oldest city in the United States still operating under its original charter.

The New York State Capitol is Albany's most imposing building. The granite structure occupies a commanding position on top of a hill and covers three acres. The exterior design is reminiscent of a huge French château.

Philadelphia, Pennsylvania

Philadelphia (Figs. 47 & 48), the Birthplace of the Nation, is often called the "City of Brotherly Love." It was settled in 1681 by Captain William Markham and a small band of colonists sent out by William Penn. Penn arrived the following year, laid out the streets, and named the city. By 1685 the population of the new settlement had reached 7,200, and Philadelphia ranked first among colonial cities in education, the arts, sciences, commerce, and industry.

It was in Philadelphia that the first Continental Congress met in September 1774; and the second in the following year. In Philadelphia, Washington accepted command of the army, and there the Declaration of Independence was adopted.

The city was captured by the British in 1777 and occupied by them for many months. Valley Forge, where Washington and the Continental Army spent the bitter winter of 1777-78, is only 20 miles west of Philadelphia.

Independence Hall, where the Declaration of Independence and the Constitution were signed, the Second Continental Congress met, and where Washington accepted the role of Commander-in-Chief, was acquired by the city in 1818 and is now part of Independence National Historical Park.

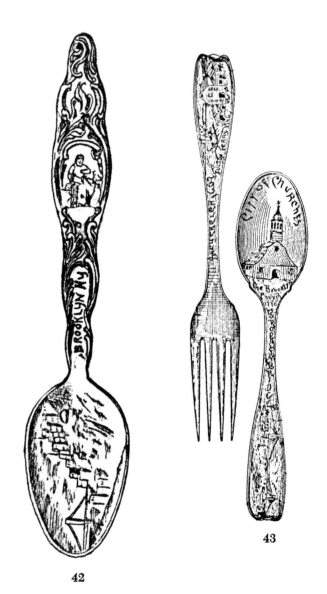

42

43

42. BROOKLYN HEIGHTS, George W. Dimmick, Brooklyn, N.Y. Apr. 28, 1891 (U.S. Pat. No. 20,701). Assigned to James Hart, Ltd. Whiting Mfg. Co.

43. CITY OF CHURCHES, Caleb Cushing Adams, Brooklyn, N.Y. Apr. 12, 1892 (U.S. Pat. No. 21,460). Manufactured by the Gorham Corporation. Marked: "C. C. Adams & Co." "Pat. Appl. For." also "A. A. Webster Co." The design on the fork handle was used for the back of the spoon.

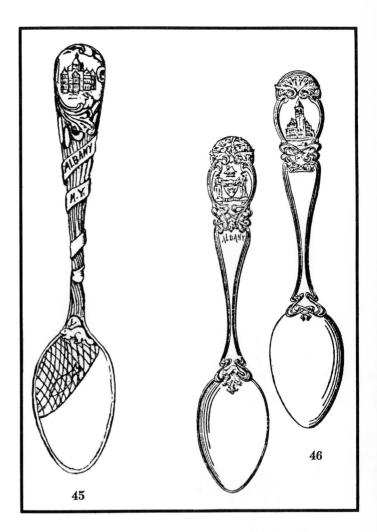

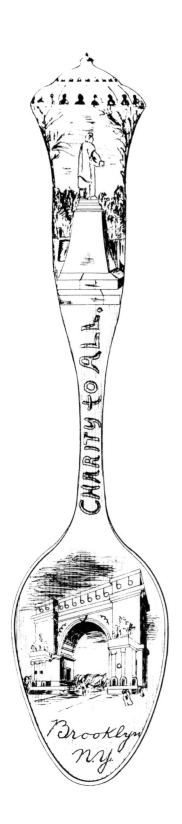

44. MEMORIAL ARCH, George W. Dimmick, Brooklyn, N.Y. June 2, 1891 (U.S. Pat. No. 20,801). Assigned to James H. Hart, Ltd., Brooklyn.

45. ALBANY—BEVERWYCK, Robert D. Williams, Albany, N.Y. May 5, 1891 (U.S. Pat. No. 20,711). Manufactured by the Gorham Corporation, also Frank W. Smith Silver Co. Marked: "W. H. Williams & Son." Albany, capital of New York, is situated on the site where Fort Orange was erected in 1623. "Beverwyck" recalls the fur trade of early days.

46. ALBANY, Charles Selkirk, Albany, N.Y. Sept. 3, 1907 (U.S. Pat. No. 38,783).

The Liberty Bell, ordered from England in 1751, and the inkstand used by the delegates who signed the Declaration are among the national treasures preserved there.

Washington, D.C.

The site of Washington (Figs. 49 & 50), capital of the nation, was chosen by George Washington and accepted by Congress in 1790, thereby establishing the Federal District of Columbia.

The need to establish a central place for the government of the United States was felt during the Confederation period, but the selection of a

47

48

49

50

51

47. PHILADELPHIA, George P. Tilton, Newburyport, Mass. May 19, 1891 (U.S. Pat. No. 20,733). Assigned to the Towle Manufacturing Co. and bears their trademark.

48. LIBERTY BELL. Marked: "STERLING. PAT. APD. FOR. BAILEY, BANKS & BIDDLE." Wm. B. Durgin Co. trademark.

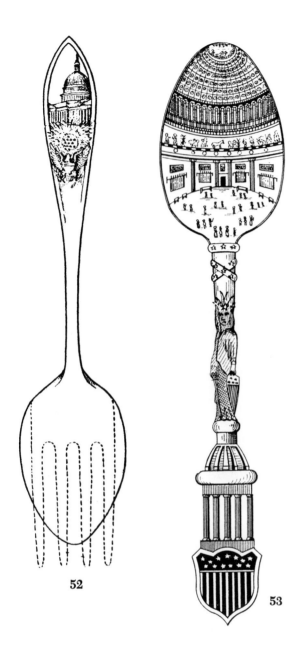

52

53

49. WASHINGTON CITY, Robert Leding, Washington, D.C. Nov. 18, 1890 (U.S. Pat. No. 20,339). Marked: "Moore & Leding" "Pat. Nov. 1890."

50. WASHINGTON ROSE, William M. Davis, Washington, D.C. Aug. 2, 1904 (U.S. Pat. No. 37,058). The American Beauty rose is the official flower of Washington, D.C.

51. WASHINGTON D.C. 1732-1799, Ira H. Johannes, Washington, D.C. June 30, 1891 (U.S. Pat. No. 20,902).

52. U.S. CAPITOL, George E. Nerney, Attleboro, Mass. Feb. 11, 1913 (U.S. Pat. No. 43,554). Robbins Co. trademark.

53. UNITED STATES CAPITOL, Erwin C. Baumgras, Washington, D.C. Apr. 7, 1891 (U.S. Pat. No. 20,665).

permanent site was delayed because of sectional conflicts. Finally, offers by Maryland and Virginia to cede to the federal government sufficient land to form a ten-mile square were laid before Congress.

Compelling thoughts in the minds of Washington and others who favored the site on the Potomac River were not only that the city would be on a navigable stream far enough from the sea to be safe from enemy attack, but that the Potomac would eventually become part of a central waterway, linking the Atlantic Ocean to the Ohio River. Thus direct communication between the national capital and the western country beyond the Allegheny Mountains would be afforded.

The exact location for the District of Columbia was chosen by President Washington who had previously sold all his lands in the vicinity. The area included Georgetown, which in the latter part of the eighteenth century was a thriving seaport.

In 1789, the site for the Capitol building was chosen by Washington with the help of Major Pierre Charles L'Enfant, the French architect selected to plan the city.

The original plans for the Capitol building (Figs. 51 & 52) were drawn up by Dr. William Thornton in 1790. Benjamin H. Latrobe, Charles Bulfinch, and Thomas U. Walter were the principal architects responsible for the work in the early nineteenth century. The building has undergone many changes, including a taller dome ingeniously constructed of an inner and outer shell to allow for contraction and expansion.

The Statue of Freedom that surmounts the Capital dome was designed by Thomas Crawford, nineteenth-century sculptor (Fig. 53). On December 2, 1863, the great bronze head of the statue was bolted into place. Crawford had originally designed his "Armed Liberty" as a woman wearing the liberty cap of emancipated slaves in Roman times. In 1856, he changed her name to "Freedom" and her headdress to a helmet trailing eagle feathers. The change in headdress, which has caused many people to think it a statue of Pocahontas, was made because the official then in charge of Capitol architecture objected to the liberty cap as "the badge of the freed slave" and "inappropriate to a people who were born free...." That official was Jefferson Davis, future President of the Confederacy.

The Washington Monument (Fig. 54), memorial to the leader of the Revolution and first President of the United States, stands on the site personally selected by the man whom it honors.

In 1783 the Continental Congress resolved to erect a statue to honor General Washington, but because of more urgent demands, this, as well as later proposed monuments, was never built.

In 1833 a design by Robert Mills, who had already designed the Washington Monument in Baltimore and who later designed the Treasury, Patent Office, and Post Office buildings in Washington, was selected.

Mills' design was for a 600-foot obelisk with a circular, colonnaded Greek temple base. A central portico was to have a colossal toga-clad statue of Washington driving a battle chariot. Funds for this elaborate structure, fortunately perhaps, were not available but work on the obelisk began. The cornerstone was laid July 4, 1848.

Steady progress was made until the shaft reached the height of 152 feet. Then, in 1854, construction virtually ceased for twenty-five years. All during the Civil War, the monument stump stood as a reminder of the break between the states while the grounds held a slaughterhouse and cattle pens.

In 1876, the centennial year of Independence, Congress provided the funds for the completion and maintenance of the monument. Army engineers discovered that the rubble base could not support the weight of the proposed height. They removed weakened sections and strengthened others—carrying out their operations so skillfully that the shaft settled only two inches.

The capstone was set in place at last on December 6, 1884; it was not until 1888 that the public could climb the stairs or ride the slow steam hoist to peer through the eight observation windows. In 1901 an electric elevator replaced the earlier steam model. This, too, was replaced by improved models in 1929 and in 1959.

The interior walls of the monument are set with 190 memorial blocks from around the world. These are best seen by those among the two million visitors each year who choose to climb the 898 steps rather than ride the elevator.

The White House

Though George Washington never slept here, he chose the site and approved the graceful Georgian design for a President's mansion (Fig. 55) to be erected on Washington City's most commanding prospect, known as Jenkins Hill.

Two architectural competitions were held, one for the design of the Capitol and one for the President's House. The award for the latter was given in July of 1792 to James Hoban, an Irish architect living in Charleston, South Carolina.

It was based mainly on Palladian architecture popular in mid-eighteenth-century Europe. Hoban's principal departure in traditional floor plan was the great oval room, today called the Blue Room.

Work on the President's House proceeded slowly. It was not until November 1, 1800, that John Adams,

the second President of the United States, moved into the still unfinished building.

The White House, as it is now called, was never completed according to Hoban's plans. The ever-changing styles of living, increasing needs for space, and the personalities of the occupants have given it the quality of a living link with the past.

The National

The design for this spoon (Figs. 56 & 57) was submitted to the Patent Office as shown, with the eagle and shield of the national coat of arms, above which is a Liberty Cap. When the spoons were produced, some had in the bowl a representation of the marble statue of Washington by the American sculptor, Horatio Greenough. Greenough's classical concept of Washington is a 20-ton seated, bare-chested figure. This statue so shocked the public when it was unveiled in the rotunda of the Capitol, about 1841, that it was soon removed. For many years it stood on the grounds exposed to the weather until it was transferred to the basement of the Smithsonian Institution. There it remained in relative obscurity until, in 1964, it was established in a place of honor in the new Museum of History and Technology.

Soldiers' Home

The United States Soldiers' Home (Fig. 58) was established in Washington by an act of Congress on March 3, 1851. The original funds came in part from the tribute levied in Mexico City by General Winfield Scott.

The Home is still in operation. Both men and women of the Regular Army and Air Force are eligible for admission. Twenty years of service or discharge for disability in line of duty are required. Commissioned service is not counted. The Home has been supported by pay deductions, fines and forfeitures, and from unclaimed estates of deceased enlisted personnel.

54. WASHINGTON MONUMENT, George E. Nerney, Attleboro, Mass. Feb. 11, 1913 (U.S. Pat. No. 43,547).

55. WHITE HOUSE, Edwin Harris, Washington, D.C. Mar. 31, 1891 (U.S. Pat. No. 20,658). Manufactured by the Wm. B. Durgin Co.

56. NATIONAL, Reuben Harris, Washington, D.C. Apr. 14, 1891 (U.S. Pat. No. 20,675). Howard clover mark. Marked: "R. Harris & Co."

57. NATIONAL, as manufactured.

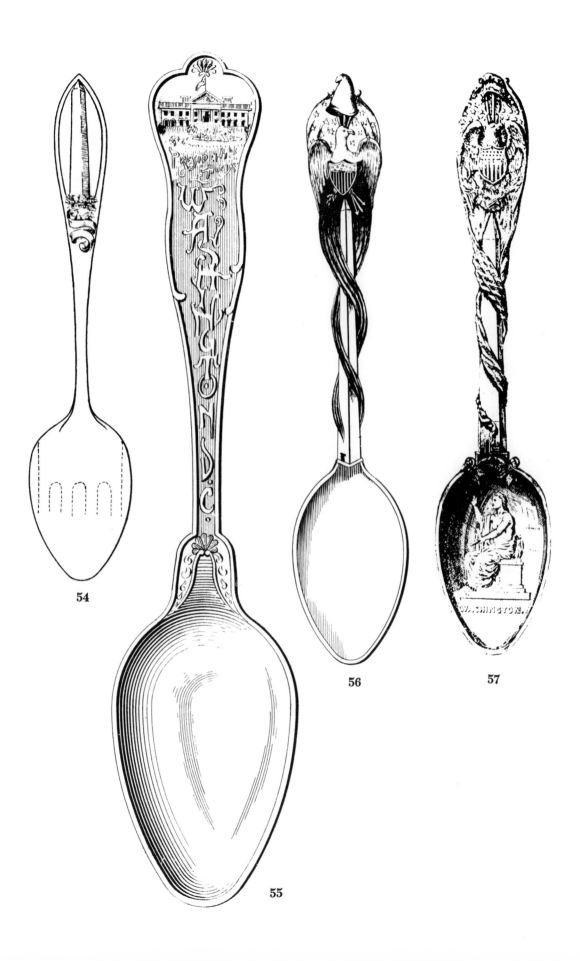

54

55

56

57

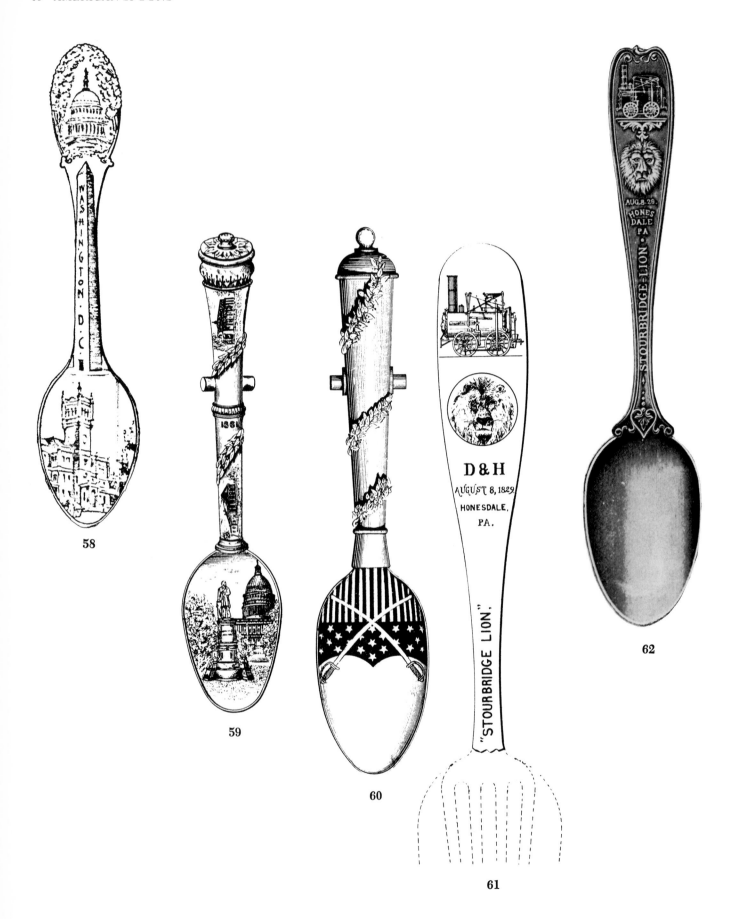

58

59

60

61

62

Historical Cannon

This spoon represents the cannon which fired the first shot at Fort Sumter, Charleston Harbor, South Carolina, April 12, 1861 (Figs. 59 & 60). Mount Vernon, home of George Washington, and Arlington, home of General Robert E. Lee, are on the handle. The Capitol forms a background for the Garfield Memorial Statue.

In the bowl (Fig. 60) is an adaptation of the escutcheon from the coat of arms of the United States. The original design had seven white stripes, six red ones, and no stars.

Stourbridge Lion

The Stourbridge Lion (Figs. 61 & 62), named for the manufacturing town in England where it was built, was the first steam locomotive ever to run on a railroad in America. This great event in industrial progress took place in Honesdale, Pennsylvania, a town named for Philip Hone, president of the Delaware and Hudson Canal and Railroad Company.

In an attempt to replace mules for the hauling of coal cars, the English locomotive was imported. It made its first run on August 8, 1829. It proved too heavy for the tracks and was retired from service.

The Lion which decorated the front of the boiler was a copy of Rosa Bonheur's famous painting.

A replica of the locomotive is housed in Honesdale and an electric model is on display at the Wayne County (Pa.) Historical Society Museum. The original "Lion" is in the Museum of History and Technology, Washington, D.C.

Pittsburgh, Pennsylvania

On a site (Figs. 63 & 64) previously selected for the British (*ca.* 1753) by George Washington, the French built Fort Duquesne in 1754. They held the fort against attacks by the British until 1758. In that year,

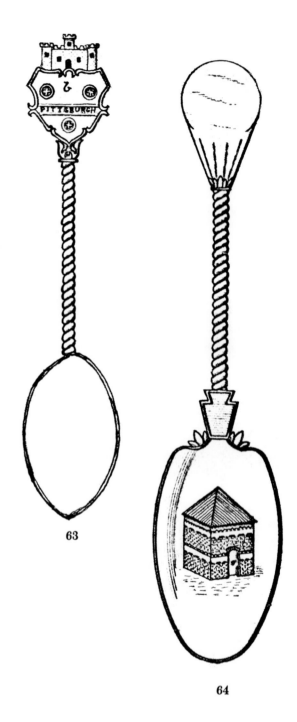

63

64

58. SOLDIERS' HOME, Charles A. Goldsmith, Washington, D.C. Sept. 29, 1891 (U.S. Pat. No. 21,072). Designed and patented by M. Goldsmith & Son, Washington D.C. according to the *Jewelers' Weekly*.

59. HISTORICAL CANNON, Henry H. Jacobs, Washington, D.C. June 9, 1891 (U.S. Pat. No. 20,822). Manufactured by the Gorham Corporation exclusive to Jacobs Bros., Washington, D.C.

60. CANNON, Erwin C. Baumgras, Washington, D.C. Mar. 31, 1891 (U.S. Pat. No. 20,655). Bowl enamelled. Assigned to Jacobs Brothers, Washington, D.C.

61. STOURBRIDGE LION, Charles Petersen, Honesdale, Pa. June 2, 1891 (U.S. Pat. No. 20,816). The Gorham Corporation trademark.

62. STOURBRIDGE LION, as manufactured.

63. FORT PITT, Steele F. Roberts, Allegheny, Pa. May 5, 1891 (U.S. Pat. No. 20,708). Manufactured by the Gorham Corporation and exclusive in Pittsburgh to J. C. Grogen. Marked: "E. P. Roberts & Sons." Gorham Corporation trademark.

64. FORT PITT, Steele F. Roberts, Allegheny, Pa. May 5, 1891 (U.S. Pat. No. 20,712). Manufactured by the Gorham Corporation.

63-64. As manufactured. See page 19.

65

66

67

68

69

70

General John Forbes, with a well-equipped army which included the young provincial officer, George Washington, marched on the fort. Realizing that resistance was futile, the French blew up their powder magazine, destroyed the fort, and withdrew before the British arrived. The British flag was raised and the abandoned spot was named Pittsburgh, honoring William Pitt, Prime Minister of England. A temporary fort was erected immediately and a permanent structure, named Fort Pitt, was begun the following year about 200 yards from the site of the old French fort. Fort Pitt was completed in 1761 and a redoubt was added in 1764. This redoubt, now called the Blockhouse, is all that remains of Fort Pitt.

The original settlement was at the point where the Allegheny and Monongahela rivers meet to form the Ohio. This land, now known as the "Golden Triangle," is the center of Pittsburgh's business district.

Charter Oak

Charles II, in 1662, granted Connecticut towns a liberal charter giving them more independence than most of the other colonies. James II did not share his predecessor's views regarding self-government and sent Sir Edmund Andros to demand the surrender of the charter. Andros arrived in Hartford in 1687, and according to tradition, as he was sitting at a meeting of the Assembly, all candles were suddenly

extinguished and the charter passed through the window to Captain Joseph Wadsworth, who hid it in a great oak tree (Figs. 65-67). Historical evidence does not support the story, but Wadsworth evidently did hide the charter somewhere, because in 1715 the General Court awarded him twenty shillings for "faithful and good service, especially in securing the duplicate Charter of this Colony when our Constitution was struck at."

Both copies of the charter still exist. The better copy is in the State Library and the other in the Connecticut Historical Society in Hartford.

Charter Oak! Charter Oak, Ancient and Fair, is the title of a ballad, the title page of which became the subject of a Currier & Ives print.

The Charter Oak was destroyed by a storm in 1856. Its estimated age was then 800 years. A section of the trunk is preserved in the Connecticut Historical Society. Other portions were kept or sold for small souvenirs.

Nutmeg

Connecticut is known as the "Nutmeg State" from the facetious charges that these ingenious Yankees made and sold wooden nutmegs in place of genuine ones (Fig. 68). This nickname was earned, no doubt, for Yankee excellence in manufacturing a variety of products and Yankee shrewdness in trading.

Westerly, Rhode Island

Westerly (Fig. 69), is situated in a region noted for Westerly granite on the Pawcatuck River and the Connecticut border, about 35 miles southwest of Providence. The town was founded in 1661 as Misquamicut by settlers from Newport, and was incorporated as Westerly in 1669. Here Oliver Hazard Perry built gunboats before the War of 1812.

Watch Hill Point, southwest of Westerly, overlooked the scene of a tragedy in 1872, when the steamer *Metis* was wrecked. The hull was never raised and the loss of life never accurately determined. The daring lifesavers from Watch Hill who manned life boats in an effort to rescue the unfortunate victims were awarded gold medals (Fig. 70) by the United States Government.

Jefferson's Rock

Thomas Jefferson, in 1783, described the panoramic view of the point where the Shenandoah and Potomac rivers come together (at Harpers Ferry, West Virginia), as "...worth a trip across the Atlantic." At the summit of a trail, whose steps are cut from the living rock, is Jefferson's Rock (Fig. 71). From this vantage point above the town can be seen nature's gateway to a river-carved passage through the mountains.

65. CHARTER OAK, Ernest Schall, Hartford, Conn. Mar. 17, 1891 (U.S. Pat. No. 20,584). Marked: "E. Schall" "Pat. D. '91 Hartford." Dominick & Haff trademark. The coat of arms of the city of Hartford, the hart at the ford, is on the handle of Fig. 65 and in the bowl of Fig. 67. The acorn commemorates the Charter Oak Tree.

66. CHARTER OAK, Frederick H. Sloan, Hartford, Conn. Mar. 24, 1891 (U.S. Pat. No. 20,625). Manufactured by Wm. B. Durgin & Co. exclusive to Hansel, Sloan & Co., Jewelers.

67. CHARTER OAK, William H. Watrous, Hartford, Conn. Sept. 22, 1891 (U.S. Pat. No. 21,052). Rogers Anchor trademark. Silverplate.

68. NUTMEG, Frederick H. Sloan, Hartford, Conn. Mar. 3, 1891 (U.S. Pat. No. 20,537). Marked: "H S. & Co." "Pat. Mar. 3, '91." Geo. W. Shiebler & Co. winged-S trademark.

69. WESTERLY—WASHINGTON STATUE, Edwin Nathan Denison, Westerly, R.I. Oct. 31, 1893 (U.S. Pat. No. 22,859). The equestrian statue of General George Washington made of Westerly granite.

70. WESTERLY, RHODE ISLAND, Edwin Nathan Denison, Westerly, R.I. July 7, 1891 (U.S. Pat. No. 20,915). Made in six different sizes.

71

72

73

74

71. JEFFERSON'S ROCK—HARPERS FERRY, Estell M. Black, Harpers Ferry, W. Va. Oct. 25, 1892 (U.S. Pat. No. 21,920). The building in the bowl is the fire engine house of the U.S. Arsenal raided by John Brown in October 1859.

72. SCOTCH-IRISH, Samantha I. Logan, Louisville, Ky. Jan. 19, 1892 (U.S. Pat. No. 21,304).

73. CINCINNATUS, Charles F. Goettheim, Cincinnati, Ohio. Nov. 3, 1891 (U.S. Pat. No. 21,142). Manufactured by the Gorham Corporation exclusive to A & J Plant. Tyler Davidson Fountain, honoring a prominent businessman, has been a favorite meeting place since its erection in 1871.

74. OLD FORT SNELLING, John H. & William H. Bullard, St. Paul, Minn. June 16, 1891 (U.S. Pat. No. 20,841). Marked: "Bullard Bros." Wm. B. Durgin Co. trademark.

75. FORT SNELLING. From *Harper's Weekly*, May 11, 1895.

One of the few water-level gateways through the Blue Ridge Mountains, the gap was the theater of important events from colonial times to the Civil War. Exciting developments in early America's transportation and industrial revolution took place there.

Peter Stephens, a trader, was the first settler in 1733. Fourteen years later, a millwright named Robert Harper purchased "Peter's Hole" and established a ferry and built a mill. Around these enterprises a small village grew. George Washington visited the place and thought it "the most eligible spot on the river" for a federal armory. Congress authorized the establishment of a gun factory there. Its first arms were completed in 1801 and by 1810 it was turning out 10,000 muskets a year.

The 1830s brought a spirited race between the Chesapeake and Ohio Canal, being built from Washington, D.C., and the Baltimore and Ohio Railroad, which started at Baltimore. Their goal was Cumberland, Maryland, and after that the Ohio Valley. The canal reached Harpers Ferry more than a year ahead of its rival, but only the railroad pushed on to the Ohio Valley; the canal stopped at Cumberland. An unusual feature of the railroad here is a Y-shaped bridge. Sheer bluffs on either side of the Potomac precluded gradual curving of the tracks approaching the crossing. Curves were built into the bridge instead.

During the Civil War Harpers Ferry, as a town occupied by both sides, suffered destruction of its industrial life and never fully recovered.

The original site of the town, being at river level, has been subject to disastrous floods. Now, the business district and home sites have been moved to a higher elevation and Harpers Ferry National Monument preserves a number of historic structures.

Scotch-Irish

Among the first settlers in the uncharted wilderness beyond the Blue Ridge were the Scotch-Irish. Defiant and aggressive, they seldom neglected an opportunity to better themselves. Believers in freedom and equality (Fig. 72), and resenting class distinction, they made a significant contribution to the democratization of the United States. The thistle from the Scottish emblem and the shamrock of Ireland symbolize the union of these two groups to form a people with the strength to conquer a wilderness.

Cincinnati, Ohio

Cincinnati (Fig. 73) was founded in 1788. It was first named Losantiville, a complicated combination of Latin, Greek, French, and Delaware Indian, meaning "town opposite the mouth of the Licking River." Trouble with the Indians in the Northwest Territory prompted the federal government to make this the site of Fort Washington in 1789, the most pretentious military establishment of the Territory. In 1790 a new governor arrived and laid out Hamilton County, naming it after Alexander Hamilton.

The straggling community was renamed Cincinnati, after the Society of Cincinnati, oldest military society in America. The society, formed after the Revolutionary War, was named for the illustrious Roman general, Lucius Quinctius Cincinnatus, who was called from the plow to lead the army and, after victory, returned to the plow, refusing all honors the Roman senators sought to bestow upon him.

Cincinnati began as part of the Miami Purchase. Its importance as a trading center was established in early days. The city's great development came with the opening of the Miami Canal in 1827, connecting Cincinnati and Middletown, Ohio. The opening of the canal aided commerce and provided water power for manufacturing. The building of railroads from about the middle of the nineteenth century increased prosperity.

Fort Snelling, Minnesota

After the Louisiana Purchase in 1803, Lieutenant Zebulon M. Pike led an expedition to explore the new lands for the federal government. From the Indians he bought a site near the confluence of the Mississippi and Minnesota rivers for a military post which was built in 1819. This post was later named Fort Snelling (Fig. 74). Its chief purpose was to protect American fur traders from raids of hostile Indians.

The Round Tower, erected in 1820, and said to be the oldest building in Minnesota, is still standing (Fig. 75).

Solomon Juneau

Solomon Juneau (Fig. 76), a French Canadian who is usually regarded as the founder of Milwaukee, Wisconsin, found only an Indian village at a fur-trading post in the area called Millieke when he joined Jacques Vieau in 1818. He built a cabin on the east side of the Milwaukee River and, in 1819, bought out Vieau.

A settlement grew up around Juneau's cabin and was the nucleus of Juneautown. Byron Kilbourn, a New Englander who arrived in 1835, laid out another settlement, Kilbourntown, on the west side of the river. George H. Walker, a Southerner, in the same year established a third village, Walker's Point. After a period of rival development, the three settlements incorporated in 1846 as the City of Milwaukee. Juneau was elected the first mayor.

Alexander Scott, who came to Milwaukee in 1839,

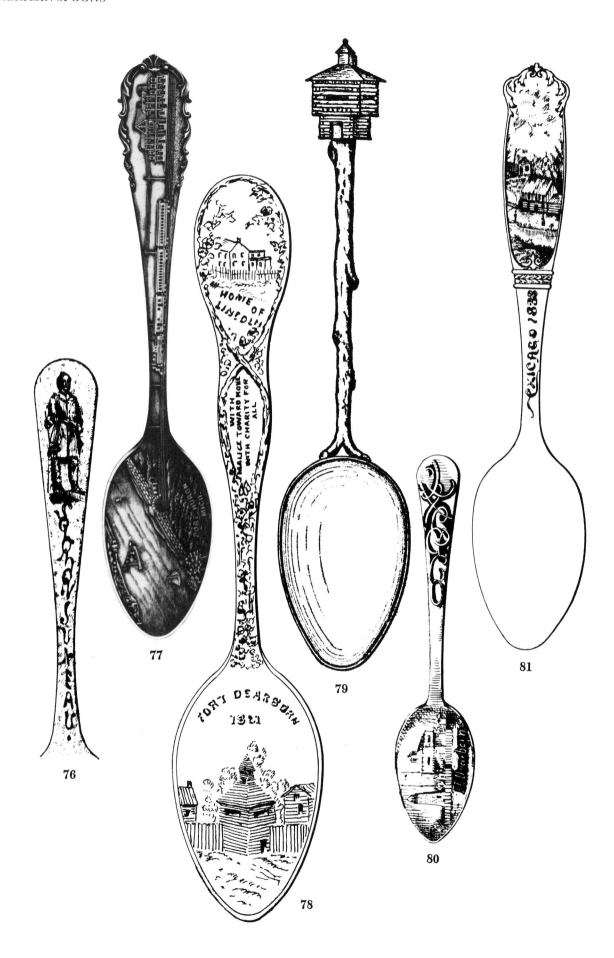

played the largest single role in its development into a major city through his establishment of a bank at a time when banking was unconstitutional in Wisconsin. His certificates of deposit were the soundest bank-notes in the West in the mid-nineteenth century. He was also instrumental in the development of Wisconsin's railroads.

Shipbuilding became one of Milwaukee's important industries. This was followed by growth of a wheat market and wheat port, manufacture of machinery, meat packing, brewing, and the making of leather products.

The International—Port Huron

Port Huron, Michigan, on the two great waterways, Lake Huron and the St. Clair River, was connected in 1891 with its twin city, Port Sarnia, Ontario, by a tunnel (Fig. 77) 2.18 miles long. They are now linked by an international bridge. Both cities are leading industrial centers.

Fort Dearborn—Chicago, Illinois

Joliet and Marquette, in 1673, were the first white men known to have visited the site of Chicago. During the era of exploration, the easy portage from Lake Michigan to the Mississippi River at this point was to the advantage of adventurers, missionaries, and government agents.

The first permanent cabin was built about 1779 by Jean Baptiste Point du Sable. It later became the home of the first permanent white settler, John Kenzie.

In 1804 Fort Dearborn (Figs. 78-81), a blockhouse and stockade, was built. The fort was evacuated in 1812 because of the increasing unfriendliness of the Indians. On the morning of their departure, the evacuees were attacked and more than fifty were slain and all the rest captured. A number of captives were later killed by the Indians.

A second Fort Dearborn was built in 1816-17. Indian trade continued during the first twenty years of the nineteenth century, but the demands of private trading operations forced the closing of the government factor in 1822.

In 1830 the town of Chicago was laid out, and by 1833 provisions were made for the removal of all Indians. By 1836 Fort Dearborn itself was abandoned. The site is partly occupied at present by The Chicago Motor Club building. It is possible to trace the outline of old Fort Dearborn, now marked by bronze strips set into the sidewalk just south of the Michigan Avenue Bridge over the Chicago River.

Chicago Onion

"Chicago" is derived from an Indian word meaning "wild onion" (Fig. 82). In the late seventeenth and early eighteenth centuries, the site was a portage of the river that the Indians called "River of the Wild Onion." The Indian name was spelled in various ways, one being "Checa-gou." The area is thought to have been covered with fields of this wild vegetable.

Porkopolis

Chicago is the largest livestock market and meat packing center in the world. Among its nicknames are "Packing Town," "Pork City," and (Fig. 83) "Porkopolis."

Chicago, Illinois

Nothing illustrates more readily the growth of Chicago into a sophisticated modern city than a comparison between the rustic fur-trading post and the elaborate "Gay Nineties" lettering of this Chicago spoon (Fig. 84).

Frog Town

In its early days, Toledo, Ohio (Fig. 85), named for a city in Spain, was called "Frog Town." The nickname came from the many frogs that inhabited the swamp land surrounding the city.

It was also called "Corn City," from the vast quantities of corn and other grains shipped from there.

A profusion of lotus plants grow in the marshlands around Toledo. Seeds sent to a Toledoan from Egypt were supposed to have started the beds. The frog was an inhabitant of the lotus beds and Toledoans like to think that the frog sits upon a lotus bud instead of a pumpkin or buckeye. "Lotus City" was another nickname applied to the city.

76. SOLOMON JUNEAU, Arthur K. Camp, Milwaukee, Wis. July 7, 1891 (U.S. Pat. No. 20,913). Manufactured by the Wm. B. Durgin Co. exclusive to Stanley & Camp.

77. INTERNATIONAL, Barrett & Goulding, Port Huron, Mich. Manufactured by Howard Sterling Company in oxidized or gilt. (*Jewelers' Weekly*, June 28, 1893.)

78. FORT DEARBORN, Henry A. Spaulding, Chicago, Ill. Sept. 15, 1891 (U.S. Pat. No. 21,041). Assigned to Spaulding & Co., Chicago. Manufactured by the Gorham Corporation exclusive to Spaulding & Co.

79. FORT DEARBORN, Ebenezer K. MacGillivray, Chicago, Ill. June 2, 1891 (U.S. Pat. No. 20,796).

80. FORT DEARBORN, Harry I. Clulee, Wallingford, Conn. Aug. 18, 1891 (U.S. Pat. No. 20,994). Assigned to R. Wallace & Sons Mfg. Co. and has their trademark.

81. CHICAGO 1833, Austin F. Jackson, Taunton, Mass. June 2, 1891 (U.S. Pat. No. 20,811). Assigned to Reed & Barton. Reed & Barton trademark.

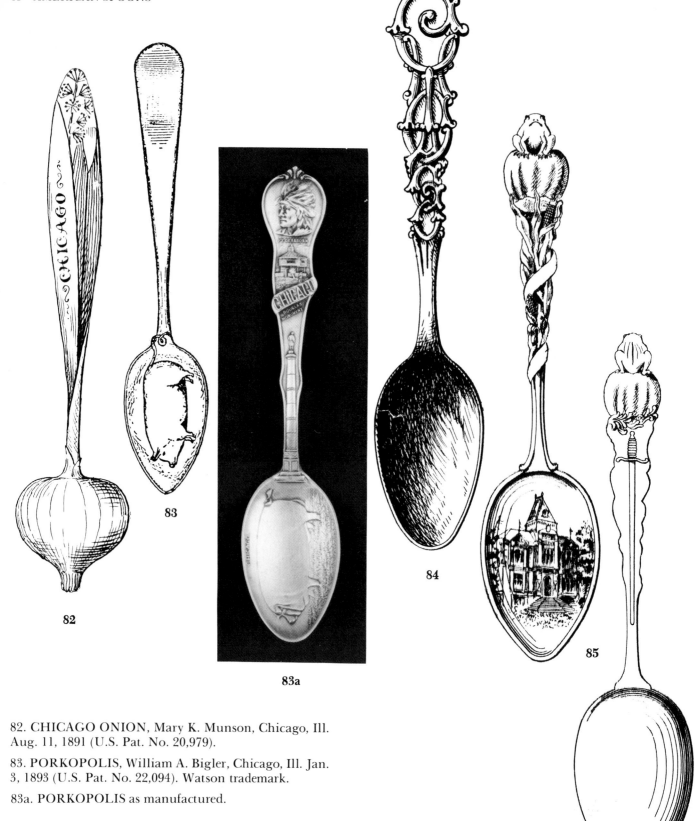

82

83

83a

84

85

82. CHICAGO ONION, Mary K. Munson, Chicago, Ill. Aug. 11, 1891 (U.S. Pat. No. 20,979).

83. PORKOPOLIS, William A. Bigler, Chicago, Ill. Jan. 3, 1893 (U.S. Pat. No. 22,094). Watson trademark.

83a. PORKOPOLIS as manufactured.

84. CHICAGO, John W. Maillot, North Attleboro, Mass. Apr. 4, 1893 (U.S. Pat. No. 22,318). Assigned to F. M. Whiting & Co. F. M. Whiting & Co. trademark.

85. FROG TOWN, Jacob J. Freeman, Toledo, Ohio. May 2, 1893 (U.S. Pat. No. 22,376). Marked: "J. J. Freeman." Howard Sterling Co. trademark.

The building in the bowl of the spoon is the Toledo Soldiers' Memorial Hall, built in 1886 and razed in 1955.

The sword is representative of both the fine steel blades for which Toledo, Spain is famous and for the newspaper, the *Toledo Blade,* which began in 1835.

Show Me

Missouri (Fig. 86) took its name from an Algonquin Indian word meaning "town of the great canoes." Its nickname, the "Show Me State," is generally believed to have been derived from a speech made by Willard D. Vandiver at Philadelphia in 1889. In his talk Vandiver said, "I'm from Missouri, and you've got to show me."

Bye and Bye—Oklahoma Territory

Through the urgings of President Jackson in 1830, Congress ordered the forcible removal of all eastern Indians to the west of the Mississippi River. In exchange for their land in the East, these Indians, later called the Five Civilized Tribes, received land in the West that comprised practically all of present-day Oklahoma.

A peace treaty was made with indigenous tribes whereby they promised not to make war on whites or others who were traveling through, and particularly not to molest Indians from the East who wished to hunt there. But the constant influx of Indians from the East and the complete lack of understanding on the part of Congress led to chaos that lasted until Oklahoma became a state in 1907.

The Civil War added its devastating effects. Factions of each tribe had served in Confederate forces, and for this defection the Five Tribes were compelled to surrender the western half of their domain, at a price of from fifteen to thirty cents an acre. The land thus ceded to the government became Oklahoma Territory (Figs. 87 & 88). The eastern half continued as Indian Territory, home of the Five Civilized Tribes.

Though prohibited by law from entering Indian country, whites filtered in; the lack of federal law created a haven for outlaws. The necessity for law and order increased as railroad and other commercial interests assaulted tribal integrity.

It was apparent that the two territories must be admitted as one state—an action bitterly opposed by Indians of the Five Civilized Tribes. They met and adopted a constitution for a state, which they proposed to call Sequoyah. Separate statehood was refused. It was not until November 16, 1907, after years of promises, that the proclamation for the State of Oklahoma, combining both Oklahoma Territory and Indian Territory, was signed by President Theodore Roosevelt.

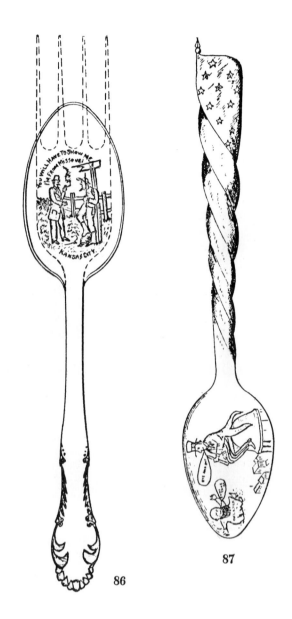

86. SHOW ME, Paul Margolis & Henry Metzger, Kansas City, Mo. Nov. 22, 1904 (U.S. Pat. No. 37,241).

87. BYE & BYE—OKLAHOMA TERRITORY, John R. Bookwalter, Oklahoma, Okla. Terr. Mar. 6, 1906 (U.S. Pat. No. 37,866).

Oklahoma State Seal

The Oklahoma State Seal (Fig. 89) was designed by a committee appointed by the Oklahoma constitutional convention. It is a combination of six seals; one for the Indian Territory and the five tribal seals of the Five Civilized Tribes.

A large star on a circle represents Oklahoma; it is surrounded by forty-five smaller stars, indicating that Oklahoma was the forty-sixth state admitted to the Union.

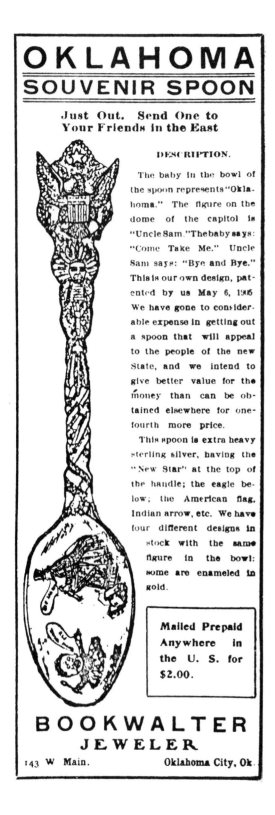

OKLAHOMA SOUVENIR SPOON

Just Out. Send One to Your Friends in the East

DESCRIPTION.

The baby in the bowl of the spoon represents "Oklahoma." The figure on the dome of the capitol is "Uncle Sam." The baby says: "Come Take Me." Uncle Sam says: "Bye and Bye." This is our own design, patented by us May 6, 1905. We have gone to considerable expense in getting out a spoon that will appeal to the people of the new State, and we intend to give better value for the money than can be obtained elsewhere for one-fourth more price.

This spoon is extra heavy sterling silver, having the "New Star" at the top of the handle; the eagle below; the American flag, Indian arrow, etc. We have four different designs in stock with the same figure in the bowl; some are enameled in gold.

Mailed Prepaid Anywhere in the U. S. for $2.00.

BOOKWALTER
JEWELER
143 W Main. Oklahoma City, Ok.

88. Contemporary advertisement of BYE & BYE—OKLAHOMA TERRITORY spoon. (*Sturm's Oklahoma Magazine*, Vol. 3, No. 2, Oct. 1906.) Note that the advertisement gives a date ten months before the Patent Office date.

Elk Tooth

The French Canadian explorers, the Verendrye brothers, who found themselves near the Big Horn Mountains in 1743, were probably the first white men to see Wyoming. In 1807, the northwestern corner of the state, now Yellowstone National Park, was explored by John Colter, a member of the Lewis and Clark Expedition.

Cheyenne, the capital, was founded in 1867 by officers of the U.S. Army and engineers of the Union Pacific Railroad. The wild and colorful reputation it developed is revived each year during the Cheyenne Frontier Days celebration.

Some of the most beautiful mountain scenery in the country is in Wyoming. In these mountains are big game animals—pronghorn antelope, mule deer, moose, bear, and mountain sheep. The largest herd of elk (Fig. 90) in the United States is found in the Jackson Hole country.

Oregon Trail

Jason Lee (Fig. 91) was an American Methodist Episcopal missionary and pioneer. He established the first permanent settlement (now Salem) in Oregon and Oregon Institute (now Willamette University), the oldest institution of higher learning in the Pacific Northwest.

Lee was born June 28, 1803, in Stanstead, Quebec, then considered part of Vermont. In 1830 he was selected by the New England Conference of the Methodist Church to establish a mission for the conversion of the Flathead Indians. He joined an overland expedition and reached Fort Vancouver (Portland) in September 1834. There he was persuaded to move on to a safer locality.

In 1835 he established a mission station and school north of the present city of Salem but the site proved to be unhealthful. In 1840 the establishment was moved 12 miles to the south. There the missionaries immediately set up a sawmill and gristmill along a creek within the boundaries of what is now Salem. In 1841 they erected a building to be used as an Indian manual-training school on what is now the campus of Willamette University. The following year Jason Lee was instrumental in founding Oregon Institute, now Willamette University.

Rhododendron

The rhododendron (*Rhododendron macrophyllum*) state flower of Washington, is a western variety whose natural beauty is one of the attractions of the Pacific Northwest (Fig. 92).

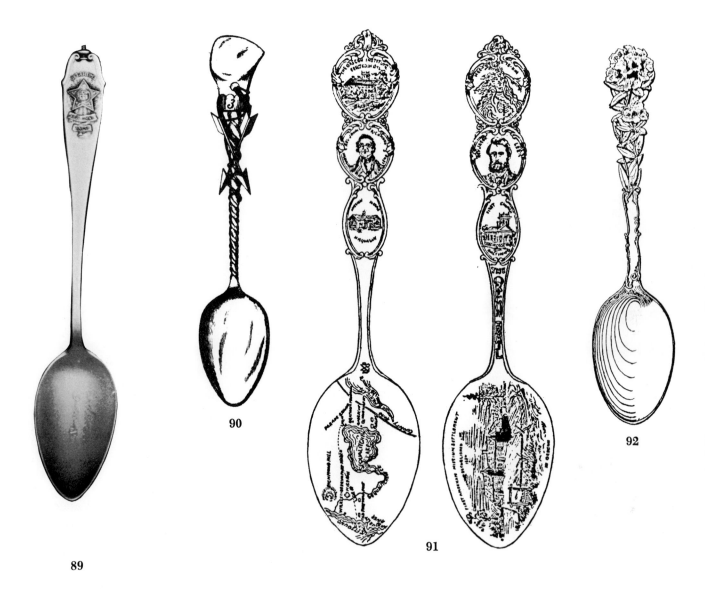

89. OKLAHOMA STATE SEAL, George E. Nerney, Attleboro, Mass. Jan. 17, 1911 (U.S. Pat. No. 41,089). Marked: "Sterling Patented." The Robbins Co. trademark. The patent date refers to a stock pattern.

90. ELK TOOTH, Hugo E. Buechner, Cheyenne, Wyo. June 20, 1893 (U.S. Pat. No. 22,545). Towle trademark.

91. OREGON TRAIL, Albert Atwood, Seattle, Wash. Sept. 22, 1908 (U.S. Pat. No. 39,555). *Front;* HEE-OHKS-TE-KIN; Rev. Jason Lee; Church built 1842. *Back:* Oregon Institute, Salem; Rev. John P. Richmond; Nisqually 1841; Mission Church, Nisqually. Joseph Mayer & Bros. trademark.

92. RHODODENDRON, George B. Stocking, Tacoma, Wash. Dec. 20, 1892 (U.S. Pat. No. 22,060). Manufactured by Joseph Mayer & Bros. The word "RHODODEN-DRON" was used as a trademark by the George B. Stocking Co.

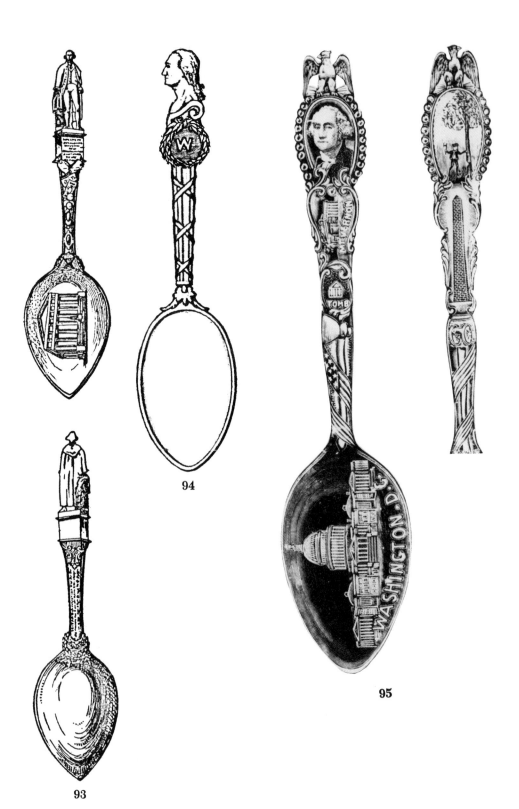

93

94

95

96

Chapter Two
Fathers of Freedom

George Washington

A new nation had just been born when, on April 30, 1789, George Washington, standing on the balcony of Federal Hall on Wall Street (Figs. 93 & 94) in New York, took the oath of office as the first President of the United States. He was sworn in by New York's chancellor, Robert Livingston. Federal Hall was the first Capitol of the United States. On its site is now the United States Subtreasury Building, which is called Federal Hall National Memorial.

Since the beginning of history there has never been an office to compare with the Presidency of the United States. It is the unique creation of men with

93. WASHINGTON'S INAUGURATION, Justus Verschuur, Jersey City, N.J. Feb. 7, 1893 (U.S. Pat. No. 22,195). Assigned to Simpson, Crawford & Simpson, N.Y. Inscribed on front handle: *Erected By Voluntary Subscription By Chamber of Commerce State of New York Nov. 26, 1883*. The building in the bowl is City Hall. Inscribed on handle back: *On This Site in Federal Hall April 30, 1789, George Washington Took the Oath as the First President of the United States of America*. No trademark.

94. GEORGE WASHINGTON, Jacob Karr, Washington, D.C. June 9, 1891 (U.S. Pat. No. 20,823).

95. GEORGE WASHINGTON, F. M. Van Etten, N.Y.C. At the top of the handle is the American eagle, a portrait of George Washington based on Gilbert Stuart's famous painting, the mansion and the tomb at Mount Vernon, the fabled hatchet and the American flag and in the bowl a view of the east front of the Capitol. The reverse side shows the familiar episode of the cherry tree, the Washington Monument and a mounted of the handle is the American eagle, a portrait of George Washington based on Gilbert Stuart's famous painting, the mansion and the tomb at Mount Vernon, the fabled hatchet and the American flag and in the bowl a view of the east front of the Capitol. The reverse side shows the familiar episode of the cherry tree, the Washington Monument and a mounted cannon. Campbell-Metcalf Silver Co. trademark.

96. GEORGE WASHINGTON, Richard E. Acton, Alexandria, Va. Sept. 6, 1892 (U.S. Pat. No. 21,835). Watson-Newell trademark.

the political vision to dare an experiment against a long history of tyranny. To the unprecedented task of organizing this experiment that would govern thirteen individual states, preserve their separate integrities, yet bind them into one nation, came a new kind of man (Fig. 95).

Washington, like other colonial landholders, was a combination of rugged pioneer and cultured gentleman. He was born into a Virginia planter family, and his early training was that requisite for an eighteenth-century Virginia gentleman. Within this exterior of "country squire" was a man of great physical strength and courage—a man who had stood, figuratively, if not literally, straight and tall in the bow of a small boat so his men could see their leader.

Washington was a vestryman of the parish at the time Old Christ Church (Fig. 96), Alexandria, Virginia, was planned. He purchased Pew No. 60; it is now marked with a silver plate bearing his signature. The inside of the church remains the same as when it was completed by John Carlyle in 1773.

The Washington family title to Mount Vernon dates from the grant in 1674 of 5,000 acres to John Washington, great-grandfather of George, and Nicholas Spencer. This tract was divided in 1690; the Washington half eventually passing to George Washington.

Of Mount Vernon (Figs. 97-99), Washington said, "No estate in United America is more pleasantly situated...." More than a million people each year visit the home, which Washingtom compared to "a well resorted tavern," and look out over the wide sweep of the Potomac River and beyond to the Maryland hills.

Washington was born to Augustine and Mary Ball Washington at a more modest plantation, Wakefield, overlooking Popes Creek in Westmoreland County, Virginia. While he was still quite small the family moved up the Potomac to Little Hunting Creek tract, the present site of Mount Vernon. Later, a third home was established at Ferry Farm on the Rappahannock River, near Fredricksburg.

In 1740 Augustine Washington deeded the Little

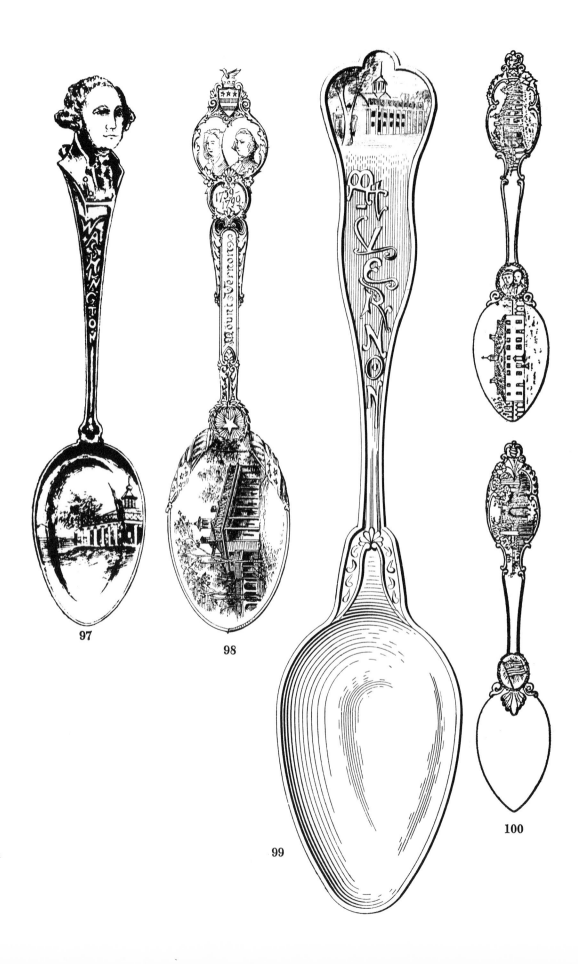

97

98

99

100

Hunting Creek Plantation to his son, Lawrence, who married and settled on the estate, renaming it in honor of Admiral Vernon, under whom he had served.

Two years after the death of Lawrence Washington, George purchased his sister-in-law's life interest in Mount Vernon. In 1759 he married the charming and wealthy widow, Martha Dandridge Custis. In anticipation of this event the structure was repaired and enlarged from one and one-half to two and one-half stories. For fifteen years George and Martha Washington lived there the life they both loved best—that of peaceful southern planters.

Shortly before the Revolution, Washington had made plans for additions at each end of the house, but these were not completed until 1787. Among the last additions were the high-columned piazza, extending the full length of the house on the river-front side, and a weather vane for the cupola. Appropriately enough, the vane was a dove of peace. With its dependencies, the kitchen, storehouse and butler's quarters, greenhouse, spinning house, icehouse, smokehouse, laundry house, and other buildings that gave the plantation its village-like character, Mount Vernon appeared just as we see it today.

When Washington retired from public life in 1797 he returned to Mount Vernon (Fig. 100), but he enjoyed less than three years of retirement on the estate he loved so well. Here he died on December 14, 1799.

A few months before his death, Washington selected the site for a new family burial vault at Mount Vernon. In his will were explicit instructions for a simple burial there (Fig. 101).

Congress immediately resolved that a marble monument be erected to his memory within the city of Washington. A crypt was provided under the Capitol dome, but it was never occupied. Honoring his wish to lie at the plantation, with Martha beside him, Washington's heirs abided by the intent so implicit in his will (Figs. 102 & 103).

Abraham Lincoln

On February 12, 1809, in Hardin County, Kentucky, a boy was born and named Abraham after his grandfather who had been killed by Indians only twenty-three years earlier. In 1811 the Lincoln family moved to another log cabin ten miles distant. Near here, Lincoln first attended school, walking four miles to take advantage of the meager education that was offered.

Five years later the family moved to Indiana but, like many other restless frontier families, their stay there was brief. Only Nancy Hanks Lincoln, Abraham's mother remained—in the lonely grave marked now by a simple stone.

In 1830 Thomas Lincoln, with his new wife and family, crossed the Wabash River into Illinois and settled on a farm a few miles from Decatur. The following year Abraham Lincoln left home to spend several years in New Salem—by 1840 this small town had almost ceased to exist. In his New Salem years, Lincoln had educated himself in law, had developed an interest in politics, had been a storekeeper and postmaster, had run for the state legislature, and had joined the militia to fight in the Black Hawk War.

In 1837 Lincoln settled in Springfield, Illinois, to practice law in the new capital. Here he lived for twenty-four years and here he said farewell to the only home (Fig. 104) he ever owned when he left it to move to Washington, D.C. as President-elect.

New Salem has been rebuilt as a memorial park. In Illinois, the Lincoln Log Cabin State Park, south of Charleston; the Lincoln Log Cabin Courthouse in Decatur; Lincoln's home in Springfield; the Lincoln National Monument there, and the Bloomington Monument (Fig. 105) in Bloomington are among the memorial sites maintained. The state Republican Party was organized in Bloomington when Lincoln made his famous "lost" speech there.

Ulysses S. Grant

A reluctant West Pointer, Ulysses S. Grant (Fig. 106) had resigned from the Army and failed in several business ventures when, during the Civil War, he was appointed by the Governor of Illinois to command an unruly volunteer regiment. Grant made such an impression with his command that in less than three years Lincoln appointed him General-in-Chief of the Army. Had he retired then, his reputation would be untarnished. Instead he went on to become President of the United States. A

97. GEORGE WASHINGTON—MOUNT VERNON, William H. Jamouneau, Newark, N.J. July 14, 1891 (U.S. Pat. No. 20,943). Manufactured by the Alvin Corporation.

98. MOUNT VERNON, U.S. Pat. No. 20,657). Marked: Sterling Pat. Mch. 31, '91 Moore & Leding.

99. MOUNT VERNON, Robert Leding, Washington, D.C. Mar. 31, 1891 (U.S. Pat. No. 20,650). Manufactured by the Gorham Corporation. Marked: "Pat. Mch. 31, '91 Moore & Leding." From several designs submitted, this one was chosen in May, 1891 by the Mount Vernon Association. Spoons were first sold on the sightseeing boat that carried visitors to and from Mount Vernon and Washington, D.C.

100. MOUNT VERNON, Henry H. Evertsen, Meriden, Conn. May 9, 1899 (U.S. Pat. No. 30,715). Assigned to Wilcox & Evertsen, Meriden. Manufactured by Wilcox & Evertsen.

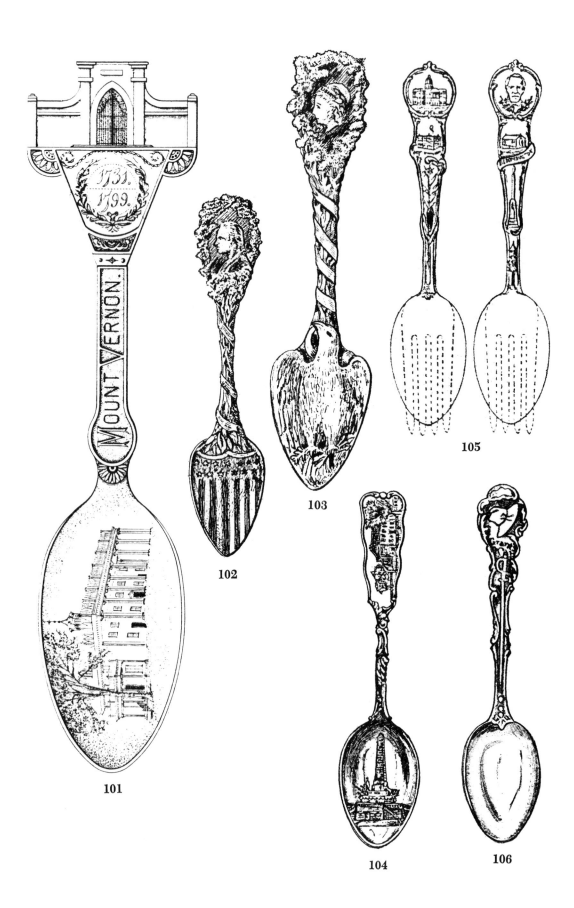

101

102

103

104

105

106

dynamic leader on the battlefield, he was unsuccessful as President.

Grant knew nothing of politics and allowed himself to be duped by two most unscrupulous stock manipulators and railroad speculators, Jay Gould and Jim Fisk, who tried to corner the gold market. His association with Messrs. Gould and Fisk left him open to charges of incompetence and corruption. His second term in office was tarnished by even more corruption and scandal.

After he retired from the Presidency, he became a partner in a New York banking firm which went bankrupt. Grant knew he was dying of cancer of the throat, yet every day he put on his black silk hat (Fig. 107) and sat on the veranda of his cottage near Saratoga, N.Y., where he had gone for his health, to greet the crowds who came to see him. In an effort to provide funds for his family, he wrote his memoirs for publication. He died soon after its completion.

Grant's tomb is a mausoleum of solid white granite on Riverside Drive in New York City (Fig. 108). The tomb was designed by John H. Duncan and was built with funds raised by popular subscription. It was dedicated on April 27, 1897, by President William McKinley.

James A. Garfield

James A. Garfield (Fig. 109), the last of the "log cabin Presidents," was born in Cuyahoga County, Ohio. He was left fatherless at two. Through his love of learning and determination to obtain an education, he earned enough to put himself through Williams College in Massachusetts. After his graduation, he returned to Western Reserve Eclectic

101. MOUNT VERNON—WASHINGTON'S TOMB, Alice J. Dempsey, Washington, D.C. Apr. 7, 1891 (U.S. Pat. No. 20,666).

102. GEORGE WASHINGTON, John S. Rathbone, Mystic, Conn. Dec. 6, 1892 (U.S. Pat. No. 22,030). The bowl design is an adaptation of the escutcheon of the coat of arms of the United States.

103. MARTHA WASHINGTON, John S. Rathbone, Mystic, Conn. Dec. 6, 1892 (U.S. Pat. No. 22,031). An American eagle forms the bowl.

104. LINCOLN, William C. Sommer, Springfield, Ill. Dec. 6, 1892 (U.S. Pat. No. 22,034). Manufactured by the Gorham Corporation. Marked: "Sommer & Pierik," jewelers.

105. BLOOMINGTON, Joseph E. Straker, Jr., Attleboro, Mass. Mar. 15, 1904 (U.S. Pat. No. 36,852). Assigned to the Watson & Newall Co.

106. GRANT'S HAT, Lida M. Webb, Galena, Ill. Dec. 1, 1891 (U.S. Pat. No. 21,193). Gorham Co. trademark.

107. GRANT'S HAT. Spoon made for twelfth annual birthday dinner at the Americus Republican Club, Pittsburgh, Pa., Apr. 27, 1898. Marked: "H. B. & Co. STERLING." (Collection of Pearl Gunnerson, Winter Park, Fla.)

Institute (later Hiram College) as professor of Latin and Greek. Within a year he was its president.

Garfield was elected to the Ohio Senate in 1859 and later served for eighteen years in Congress.

Elected President as a dark-horse candidate in 1880, he immediately showed signs of being a strong executive. He was in office less than four months when he was mortally wounded by a shot fired by an embittered attorney who had sought a consular post. He died about six weeks later.

Grover Cleveland

Grover Cleveland (Figs. 110-113), the twenty-second and twenty-fourth President of the United States, was the only man ever elected to two non-consecutive terms. He was a bachelor when first elected but married Frances Folsom, daughter of his former law partner, while in office.

He was born in New Jersey, one of nine children of a Presbyterian minister. His formal education was limited, but he managed to study law and to establish himself as a scrupulously honest officeholder.

Through his efforts many improvements in government were made: civil service reform became a reality; he stood firmly against high protective tariffs; he barred special favors to any economic groups; he vetoed fraudulent pension claims; he investigated western land holdings of railroads; and he signed the Interstate Commerce Act, the first law attempting federal regulation of the railroads—all of which led to his defeat in 1888.

When elected again in 1892, Cleveland faced an acute national depression. He dealt directly with the Treasury crisis, forced repeal of silver legislation, and halted the railroad labor strike. Throughout a difficult period he remained an honest, independent man.

After he left office he lived in retirement in Princeton, New Jersey.

Benjamin Harrison

Benjamin Harrison (Figs. 114-116) was a grandson of a President and great-grandson of a signer of the Declaration of Independence. In the presidential campaign of 1888, Harrison capitalized on the famous family name, but though he carried this distinguished name into the White House, historians agree he added little distinction to it during his stay there.

Harrison was only five feet, six inches tall. His opponents called him "Little Ben," his backers replied that he was big enough to wear the hat of his grandfather, "Old Tippecanoe."

William McKinley

William McKinley (Figs. 117-119) was born in Niles, Ohio, in 1843. He attended Allegheny College briefly; at thirty-four he won a seat in Congress. His pleasing personality and kind and gentle manner enabled him to rise rapidly.

Under his presidential administration there was a decided increase in business prosperity, principally because of a high protective tariff. But McKinley did not win a place in the hearts of his fellow Americans as a champion of the people. Huge industrial combinations developed through favorable associations. By 1889 the Senate was called the "millionaire's club." A Wall Street banker was the presiding officer, and ranking Senators represented lumber, oil, railroad, silver, gold, insurance, utility, and manufacturing interests.

When McKinley was re-elected for a second term, big business interests felt secure for another four years. But his assassination, only six months after his re-election, cut short this era of free-wheeling big business.

While standing in line at a reception at the Pan-American Exposition in Buffalo, New York, September 6, 1901, McKinley was shot twice by Leon Czolgosz, an anarchist, and died six days later (Figs. 120 & 121).

Theodore Roosevelt

The progressive Governor of New York, Theodore Roosevelt, had been shoved into the post of Vice President in the hopes that this "political graveyard" would take him out of circulation. But when McKinley was assassinated, Roosevelt, then not

108. GRANT'S TOMB, Vincent Tommins, Hoboken, N.J. June 8, 1897 (U.S. Pat. No. 27,163).

109. GARFIELD MEMORIAL, Webb C. Ball, Cleveland, Ohio. June 23, 1891 (U.S. Pat. No. 20,845). Marked: "Webb C. Ball, Cleveland. Sterling. Pat'd." Portrait of Garfield in shield.

110. GROVER CLEVELAND, John Larson & James M. Van Slyke, Madison, Wis. Sept. 13, 1892 (U.S. Pat. No. 21,855). Manufactured by the Gorham Corporation exclusive to John Larson & Co.

111. CLEVELAND CAMPAIGN RECORD, Eugene Clayton Bernheim, Washington, D.C. Jan. 3, 1893 (U.S. Pat. No. 22,093). Assigned to Carl Petersen, Washington, D.C.

112. GROVER CLEVELAND, Eugene Clayton Bernheim, Washington, D.C. Dec. 27, 1892 (U.S. Pat. No. 22,082). Assigned to John H. Flanagan, Washington, D.C.

113. CLEVELAND FAMILY, Nannie G. Davis, Washington, D.C. Jan. 26, 1892 (U.S. Pat. No. 21,312). The first child of Grover and Frances Cleveland was Ruth, born in 1891.

108

109

110

111

112

113

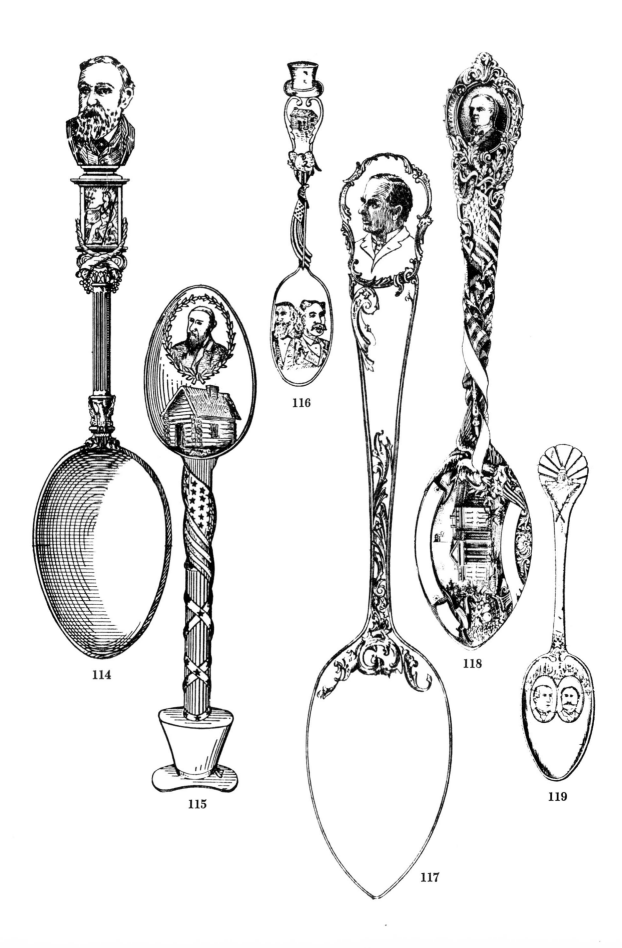

114

115

116

117

118

119

quite forty-three, became the youngest president in the nation's history (Fig. 122).

Few men in American history have captured the popular imagination as did this progressive reformer and fighter. He was certainly the most colorful and the most controversial President since Lincoln, the most versatile since Jefferson.

Roosevelt struck out against the huge trusts, the railroads, the food and drug industries, and those who tapped the natural resources of public lands without government regulation. His first spectacular victory was the forcing of the dissolution of a great railroad combine in the Northwest.

Roosevelt launched the United States into world politics. He acquired the Panama Canal Zone and aided the construction of the canal, so vital to communication between the Atlantic and Pacific.

For his efforts in ending the Russo-Japanese War, he was awarded the Nobel Peace Prize. To show off America's growing strength, he sent U.S. battleships, "the Great White Fleet," on a cruise around the world. No man ever enjoyed the Presidency more. He would have loved being President the rest of his life.

A blustery man, with great affection for his children, he was a nature lover and conservationist, and championed the vigorous outdoor life.

While in the South to settle a border dispute between Louisiana and Mississippi, Roosevelt went on a hunting trip. He refused to shoot a bear cub because it was so small. A cartoonist made use of this incident, comparing it to the border dispute. The caption for his cartoon was "Drawing the line in Mississippi." A candy store owner fashioned a toy bear resembling the one in the cartoon and displayed it in his store window (Figs. 123-125). "Teddy's Bear" became a classic toy and led to the growth of one of the nation's largest present-day toy manufacturers. Teddy Bears appeared on everything a child could use, wear, play with, or own.

William Howard Taft

William Howard Taft, twenty-seventh President of the United States was born in 1857 in Cincinnati, Ohio.

Taft was a jovial man with a brilliant legal mind who much preferred law to politics. He served with distinction as chief civil administrator of the Philippines and as Secretary of War under Theodore Roosevelt, whom he succeeded as President.

Following his years in the White House, he became Professor of Law at Yale University. In 1921, President Harding appointed him Chief Justice of the Supreme Court—a post that meant more to him than the Presidency. Taft was the only man ever to hold both offices (Figs. 126-128).

114. BENJAMIN HARRISON, John Larson & James M. Van Slyke, Madison, Wis. Sept. 13, 1892 (U.S. Pat. No. 21,854). Manufactured by the Gorham Corporation exclusive to John Larson & Co.

115. GRANDPA'S HAT, Hallie L. Wright, Washington, D.C. July 26, 1892 (U.S. Pat. No. 21,737).

116. GRANDPA'S HAT, Bertha Meyer, Kansas City, Mo. Aug. 2, 1892 (U.S. Pat. No. 21,739). Whitelaw Reid was his running mate, in the unsuccessful attempt to be re-elected in 1892.

117. THE McKINLEY SPOON, Walter H. Deuble, Canton, Ohio. Mar. 3, 1896 (U.S. Pat. No. 25,204). Marked: "Walter H. Deuble." No trademark.

118. WILLIAM McKINLEY, George R. Pohl, Washington, D.C. Feb. 23, 1897 (U.S. Pat. No. 26,668). Assigned to Robert Leding.

119. McKINLEY & HOBART, Norman T. MacFerron, Allegheny, Pa. Jan. 11, 1898 (U.S. Pat. No. 28,154). Garrett Augustus Hobart was Vice President under McKinley 1897-99.

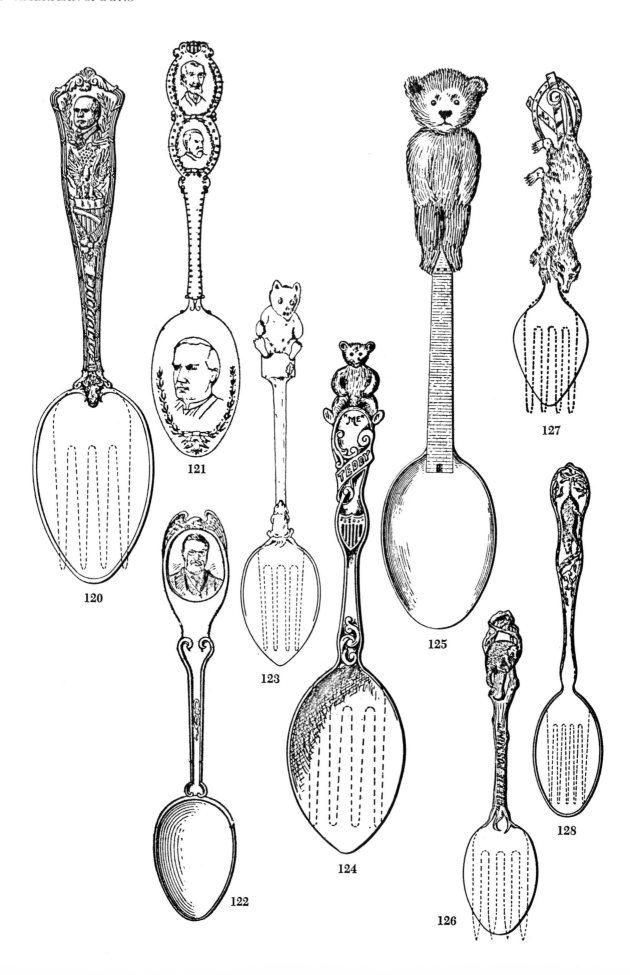

120

121

122

123

124

125

126

127

128

120. MCKINLEY MEMORIAL, William C. Codman, Providence, R.I. Jan. 7, 1902 (U.S. Pat. No. 35,556). Assigned to Gorham Mfg. Co. Manufactured by the Gorham Corporation. Marked: H 133 Sterling.

121. THREE MARTYRED PRESIDENTS, Louis Sievert, Fort Wayne, Ind. Dec. 3, 1901 (U.S. Pat. No. 35,359). Marked: "W.J.&S. Co. PAT. DEC. 3, 1901." Also made in plated silver and marked: "N.F. SILVER CO. 1877 PAT. DEC. 3, 1901."

122. TEDDY ROOSEVELT, Celia Levison, Cleveland, Ohio. Aug. 27, 1912 (U.S. Pat. No. 42,944).

123. TEDDY BEAR, Gustave F. Kolb, Mt. Vernon, NY. Apr. 9, 1907 (U.S. Pat. No. 38,511). Assigned to the Mauser Mfg. Co. Marked: "STERLING PAT. '07." No trademark.

124. TEDDY, William C. Bowlen, Providence, R.I. July 9, 1907 (U.S. Pat. No 38,656). Assigned to Rockford Silver Plate Company, Rockford, Ill. July 9, 1907.

125. WASHINGTON MONUMENT TEDDY, Carroll A. Edmonston, Washington, D.C. Aug. 4, 1907 (U.S. Pat. No 38,745). Watson Company trademark.

126. BILLIE POSSUM, Henrik Hillbom, Wallingford, Conn. May 18, 1909 (U.S. Pat. No. 39,990). Assigned to R. Wallace & Sons Mfg. Co. Souvenir spoons, postcards, and other political campaign memorabilia depict Taft as "Billie Possum."

127. BILLIE POSSUM, Jeanne S. Woods, N.Y.C. May 18, 1909 (U.S. Pat. No. 39,991). Mt. Vernon Silversmiths trademark.

128. BILLIE POSSUM, William A. Jameson, Niagara Falls, N.Y. Nov. 16, 1909 (U.S. Pat. No. 40,351).

Chapter Three
Extra! Extra! Read All About It!

One of the most successful advertising campaigns of the twentieth century began not to sell spoons, but to sell newspapers.

Moses L. Annenberg, of Chicago, Illinois, generally referred to as "Moe," thought up a new plan to be used for increasing newspaper and magazine circulation. He first approached The International Silver Company with his idea in 1913 or early 1914 and outlined it to them.

129

129. GOLDEN ROD, Gustave Strohhaker, Wallingford, Conn. Feb. 23, 1915 (U.S. Pat. No. 47,017). Assigned to The International Silver Company, Meriden, Conn. The Golden Rod State Series was made in teaspoons, dessert spoons and sugar shells. Marked: "Wm. Rogers Mfg. Co." or "Wm. Rogers & Son. A A" "PAT. FEB. 23, 1915."

130. International Souvenir Spoon Co. ad, *The New York Times*, Jan. 14, 1915. (Courtesy E. P. Hogan, The International Silver Company Historical Library)

For the would-be purchaser, the plan was simple. The consumer, for fifteen cents and a coupon *cut out of the newspaper*, obtained a Wm. Rogers & Son plated silver teaspoon decorated with a State Seal (Fig. 129). Up until this time most souvenir spoons had been obtainable only in sterling silver. This was the first opportunity to collect an interesting series of spoons at smaller cost.

The distribution of the spoons was through news dealers who received one half to two cents per spoon as well as profiting by increased sales of newspapers.

The plan was first tried in Milwaukee where initial orders for 600 dozen spoons of each of a few states were distributed. Advertisements announcing the appearance of the coupon necessary to obtain each State spoon were placed in the newspapers. The Milwaukee response was so tremendous that Annenberg moved his campaign to New York, running full-page or page-and-a-half advertisements under the company name "International Souvenir Spoon Company" (Fig. 130). The campaign began in New York in August 1914 and was extended after that to at least one city in most of the states.

The response to this advertising was immediate and almost overwhelming. During the last four months of 1914, Annenberg purchased from The International Silver Company 1,030,176 spoons. In 1915, January to May inclusive, he purchased 5,200,848. After that time the demand lessened.

Production of the spoons at The International Silver Company was planned six or eight weeks in advance of need. When they began, it was with the idea of filling orders for 250,000 spoons per week. Scheduling shipments of the various State Seal spoons to their destinations required a great deal of thought and careful planning. The demand for the spoons was much greater than first anticipated, and Annenberg's instructions on the number needed were vague. Production ran only slightly ahead of shipments most of the time. It was necessary to have the right spoons in a given city on the given Sunday when a particular State Seal spoon would be advertised.

Though The International Silver Company

NEW YORK State Souvenir SPOONS

Only 11c Each

Guaranteed Extra Heavy Silver Plate on 18% Nickel Silver Base

These Spoons specially made for R. H. Macy & Co. by R. Wallace & Sons' Mfg. Co., well-known Silversmiths and makers of the celebrated "1835 Wallace" ware.

They have all the appearance of **Sterling Silver** because they are made by one of the largest manufacturers of **Sterling Silver** in this country.

We absolutely guarantee these Spoons to be plated with 50 dwts. of pure silver (999-1000 fine) to the gross, and that the design, workmanship and finish are fully equal to any other State souvenir spoon now being offered.

The following printed guarantee goes with each spoon:

> **WE GUARANTEE**
> **THAT THIS STATE SOUVENIR SPOON**
> stamped "Wallace A1" is made by us; that the base is 18% solid nickel silver and that it is plated with a heavy plate of pure silver 999-1000 fine, (50 dwt. to the gross.) We hereby agree to replace free of charge any spoon that does not give satisfactory service to the purchaser.
> **R. WALLACE & SONS MFG. CO.**

Following the distribution of the New York State Souvenir Spoons, R. H. Macy & Co. will distribute Souvenir Spoons of other States in the Union—New Jersey, Connecticut, Massachusetts, and Colorado, following in rapid succession.

Delivered free within our regular wagon delivery limits, or add 2c postage to any point in the United States. **MAIN FLOOR, BROADWAY.**

132

131. Oneida Community State Seal spoon ad, *New York American,* Jan. 17, 1915. (Courtesy E. P. Hogan, The International Silver Company Historical Library)

132. R. Wallace & Sons State Seal series made for R. H. Macy & Co. ad., *The Sun,* Jan. 24, 1915. Federal State Silverware Co., Inc., State Seal series ad, *St. Louis Globe-Democrat,* Feb. 7, l915. (Courtesy E. P. Hogan, The International Silver Company Historical Library)

benefited from the large-volume sales which enabled them to produce the spoons at a modest cost, to keep up with the demand they had to use the facilities of five of their plants, sometimes on a twenty-four-hour basis.

Payment for the State Seal spoons was in small amounts—fifteen cents, sometimes in currency, often in stamps. Annenberg's problem was to dispose of these stamps so that the proceeds could be used to pay for the advertising in newspapers and for the millions of spoons he was selling. Some of the stamps were sent to Meriden, Connecticut, home of The International Silver Company. However, the postmaster at Meriden soon objected, as it reduced his receipts. Naturally, he was not credited with stamps not purchased through his office. (Post Offices are ranked in class according to total receipts The loss on sales of several million stamps in a small town could result in lowering the Post Office rank.) Annenberg then made arrangements to dispose of millions of stamps to some of the western mail-order houses who bought them at a slight discount of face value.

The unprecedented success of this promotional campaign had predictable results. In a' matter of weeks, similar promotions were started (Figs. 131 & 132). State Seal spoons were offered with other newspaper coupons—the spoons being made by other companies—sometimes at lower prices (Figs. 133-135). These offers were extended to include magazines and State Seal spoons were also used as premiums to advertise various items of food (Figs. 136 & 137).

Beginning about 1930 (?), a series of President commemorative spoons was used in newspaper promotional campaigns (Figs. 138 & 139). This series, which includes all the Presidents of the United States, except President Johnson and President Nixon, is not now a promotional item. However, the entire series is still available through a retail outlet, and is widely advertised.

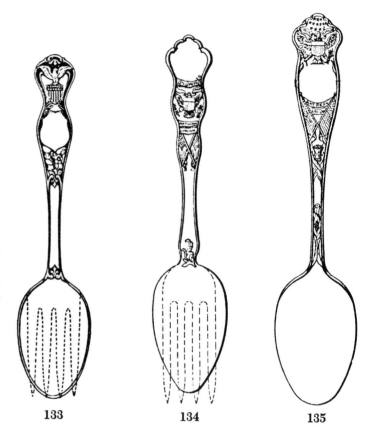

133 134 135

133. STATE SEAL SERIES, Grosvenor N. Allen, Oneida, N.Y. Mar. 9, 1915 (U.S. Pat. No. 47,065). Assigned to Oneida Community, Ltd. Marked: "Oneida Community AlX."

134. STATE SEAL SERIES, Henry L. Wallace, Wallingford, Conn. June 1, 1915 (U.S. Pat. No. 47,414). "E Pluribus Unum" on handle. Marked: "R. Wallace & Sons."

135. STATE SEAL SERIES, George H. Pinney, South Manchester, Conn. June 15, 1915 (U.S. Pat. No. 47,470). Assigned to Williams Brothers Mfg. Co., Glastonbury, Conn.

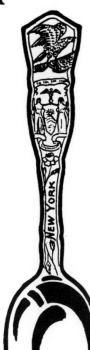

Peek's Perfect Tea (Vacuum-cleaned)

"Is pure tea and it is good tea. It is a blend of Ceylon and India leaves that are grown up on the highlands, thousands of feet above sea level, consequently it is of the best quality.

"Before it is packed it is cleaned by a vacuum process that removes about two pounds of fluff for every hundred pounds of tea. This fluff, which is left on most teas, is a rank insoluble substance which when steeped in the cup yields a muddy, astringent and objectionable flavor."

Alfred W. McCann,

Pure Food Expert New York Globe

Peek's Tea can be had in Orange Pekoe, Formosa Oolong, English Breakfast and Mixed.

2 oz., 10c
5 oz., 25c
10 oz., 50c
16 oz., 75c

Illustration Actual Size.

136

137

136. 1881 Rogers State Seal series, ad, *New Haven Evening*. June 6, 1915. (Courtesy E. P. Hogan, The International Silver Company Historical Library)

137. STATE SEAL SERIES, William A. Jameson, Niagara Falls, N.Y. May 18, 1915 (U.S. Pat. No. 47,362). "In God We Trust" on handle. Marked: "1881 (R) Rogers (R) A1."

138. Newspaper ad (Name of paper to be added) supplied for promotion of the President series. (Courtesy E. P. Hogan, The International Silver Company Historical Library)

139. One of the original order blanks for the President series. (Courtesy E. P. Hogan, The International Silver Company Historical Library)

Chapter Four
Our Defenders

Lexington—Concord Minutemen

Before the Revolutionary War, civilian volunteers were organized and trained to bear arms. They were called Minutemen because they were prepared to fight "at a minute's notice."

An Act of the Provincial Congress, November 23, 1774, provided for reorganization of the Massachusetts militia, one third of whom were to be Minutemen. They fought side by side with the regular militia at Lexington and Concord on April 19, 1775.

The device of a Minuteman was adopted as the town seal of Lexington, Massachusetts (Fig. 140), and at Concord Bridge stands a statue of a Minuteman (Fig. 141). This statue was the first fine work of the American sculptor, Daniel Chester French, who also did the well-known Lincoln statue for the Lincoln Memorial, Washington, D.C.

Sergeant Jasper

Sergeant William Jasper was born of Scotch-Irish parents in the pine hills of South Carolina. He volunteered for service at the outbreak of the Revolution and was first assigned to regular duty in September 1775.

On June 28, 1776, when a British fleet from Halifax bombarded Fort Moultrie, South Carolina (then called Fort Sullivan), a cannonball shattered the flagstaff of the fort. Jasper's daring rescue of the flag and his resolute stand with it until a new flagstaff could be provided inspired his mates and led to the first decisive American victory (Fig. 142).

Fort Ticonderoga—Ethan Allen

Fort Ticonderoga was built in 1755, as Fort Carillon, by the French. It is located at a strategic site (Fig. 143) between Lake George and Lake Champlain in New York State. The fort controlled all military and economic waterway connections between Canada and the American colonies. It acquired its present name when it was captured by the British in 1759.

Ethan Allen and his Green Mountain Boys of Revolutionary War fame took the fort from the British in 1775, and the following year Benedict Arnold assembled the first American fleet there.

Burgoyne recaptured the fort for the British in 1777. All the buildings were burned and all the fortifications abandoned. It was never garrisoned again.

Fort Ticonderoga has been restored as a museum through the interest and support of John H. G. Pell, whose family has sponsored historical restorations in the area since 1816.

Israel Putnam

General Israel Putnam (Fig. 144), American hero, was one of the few experienced colonial soldiers at the beginning of the Revolutionary War. Putnam was a vigorous opponent of the British, a leader in the Sons of Liberty, and Chairman of the Brooklyn (Connecticut) Committee of Correspondence.

Putnam had served his country at various times from 1755 to 1763. In that latter year he was sent out against the Indians of the frontier who, under Pontiac, were menacing Detroit. Peace restored, he returned to his farm where he remained in retirement until 1775.

When the news of Lexington reached him, he is said to have been plowing and, like Cincinnatus (Fig. 145) of Roman times, he turned loose the oxen and took up the sword. He hurried to Cambridge, where he joined the colonial soldiers (Fig. 146).

Springfield Armory—Rifles

Springfield, Massachusetts, was first settled in 1636, across the river from its present site, in the area called Agawam. Though the settlement was moved to the east bank of the Connecticut River to avoid trouble with the Indians, it was almost completely destroyed by fire during King Philip's War in 1675. The town was quickly rebuilt.

In 1777 an arsenal was established there; this became an important source of supplies for the Continental Army during the Revolutionary War.

The Springfield Armory, commissioned by Act of Congress in 1794, brought the first influx of skilled workers to the town and gave initial impulse to its industrial development. The Armory was designated

140

141

142

as a National Historic Landmark in 1963. The Springfield M-1903 rifle of World War I, the Garand Ml rifle of World War II, and the M14 rifle and M79 grenade launcher for use in Viet Nam were developed here. The ornamental iron fence around the Armory is made of recast Revolutionary and Civil War cannons (Figs. 147-149).

Washington's Headquarters

Washington's Headquarters in Newburgh, New York (Fig. 150), is also known as the Hasbrouck House. The house, built in 1750 and expanded in 1770, was used by Washington as his headquarters from April 1, 1782, until August 19, 1783, when a proclamation of Congress announced the close of hostilities.

The land on which the house stands was first occupied by Michael Wygant, one of the little group of Palatines who, in 1709, fled the devastating wars of continental Europe and found asylum on the banks of the Hudson. The property passed to the Mynderse family in 1724; the widow of Joseph Hasbrouck bought it in 1749. Her son Jonathan built the first section of the present building. A southeast section was added before 1770 and in that same year an addition, extending the length of the west wall of both earlier sections, was built.

In this house, General Washington, on August 7, 1782, proposed the establishment of the nation's best-known military award, the sections, was built.

In this house, General Washington, on August 7, 1782, proposed the establishment of the nation's best-known military award, the "Order of the Purple Heart."

Washington—End of the Revolution

Washington faced the problems of negligent commissaries, somnolent quartermasters, and incompetent officers as the Revolutionary War dragged on into years. It was Washington, and probably he alone, who kept the cause alive.

Cornwallis was well entrenched at Yorktown, Virginia, in 1781, when the combined forces of

140. LEXINGTON MINUTEMAN, Ellery I. Garfield, Lexington, Mass. June 23, 1891 (U.S. Pat. No. 20,846). Sold only by Daniel Low, Salem, Mass. Frank W. Smith Co. trademark.

141. CONCORD MINUTEMAN, Ellery I. Garfield, Lexington, Mass. June 30, 1891 (U.S. Pat. No. 20,896). Manufactured by Wm. B. Durgin Co. exclusive to Daniel Low, Salem, Mass.

142. SERGEANT JASPER, H. Blanchard Dominick, N.Y.C. June 30, 1891 (U.S. Pat. No. 20,862). Assigned to James Allen & Co., Charleston, S.C. Manufactured by Dominick & Haff for James Allan & Co.

Washington and Rochambeau, with financial aid from the French commander, joined Lafayette at Williamsburg. This mass movement of ill-equipped American troops to converge on Yorktown proceeded overland by long marches, and by water in little schooners, open barges, and derelict ferries. By the end of September, French and American troops had surrounded Yorktown, making British surrender inevitable. On October 17, 1781, Cornwallis requested a parley. Though the Treaty of Paris was not to be signed until two years later, America's flag now waved free (Fig. 151).

Perry's Victory on Lake Erie and Macdonough's Victory on Lake Champlain

On Lake Erie, September 10, 1813, and on Lake Champlain, September 11, 1814, the most colorful and decisive sea battles of the War of 1812 were fought.

In 1813 the British were in control of Lake Erie. All American attempts to invade Canada had met with disaster. At Erie, Commodore Oliver Hazard Perry (Figs. 152 & 153) took command of the American fleet which had been created literally from green timbers of the forest. Aboard his flagship, the brig *Lawrence*, flying a flag reading "Don't Give Up the Ship" (now in the U.S. Naval Academy, Annapolis, Md.), Perry set out with eight other ships to meet the British. When the *Lawrence* was put out of action, Perry seized his flag and transferred to the *Niagara* (Fig. 154). Raking at close range, he sailed through the enemy line, and after fifteen minutes of his cannonade, the British surrendered. It was then that Perry sent his famous message to General William Henry Harrison: "We have met the enemy and they are ours."

The victory of Commodore Thomas Macdonough (Fig. 155) over a superior British fleet on Lake Champlain the following year, accompanied by an American victory on land, thwarted invasion from the north and was probably the most important naval action of the war.

Popular imagination was stirred by artists' conceptions of "The Great Sea War," and these battles fought by "wooden ships and iron men" were the subject of innumerable paintings. Many were later engraved by printmakers and widely circulated.

Baltimore, Maryland

In the War of 1812, the deciding action was the Battle of Baltimore, when Maryland militia alone held back the sea and land forces of Great Britain. The battle for Baltimore began on September 12, 1814; two days later the invaders had been chased away in their ships. When the last shots had been fired at North Point (Figs. 156 & 157), and the final

rockets had burst over Fort McHenry, forty-one of the defenders had given their lives. A year later, as a memorial to them, Baltimore began construction of a monument. Paid for by public subscription, it was completed in 1825. The monument, oldest war memorial in the nation, still stands. "The Star-Spangled Banner," written September 14, 1814, by Francis Scott Key, is still sung in gratitude to those who fell in Baltimore and other fields of battle.

Jackson Monument

The Battle of New Orleans (Fig. 158) was the last important land engagement between the United States and Great Britain in the War of 1812. It was fought at Chalmette Battlefield, a few miles east of New Orleans, Louisiana, on January 8, 1815, fifteen days after Great Britain and the United States had made peace. Events at Baltimore and Plattsburg had persuaded the British to sign a peace treaty at Ghent on Christmas Eve, 1814, but the news did not reach New Orleans in time to stop Pakenham's attack on the city. Though Andrew Jackson, the American commander, was ill and exhausted by campaigns against the Creek Indians, he mustered an army and won the greatest American victory of the war.

143. FORT TICONDEROGA—ETHAN ALLEN, Henry C. Peirsons, Troy, N.Y. June 16, 1891 (U.S. Pat. No. 20,843). Assigned to F. W. Sim & Co., Troy.

144. GENERAL PUTNAM, George E. Shaw, Putnam, Conn. Sept. 22, 1891 (U.S. Pat. No. 21,058). Manufactured by the Gorham Corporation. GEN. PUTNAM registered as trademark for the George E. Shaw Co., June 16, 1891.

145. ISRAEL PUTNAM, James R. Stevens, Hartford, Conn. May 19, 1891 (U.S. Pat. No. 20,727). Assigned to Ernst Schall. Manufactured by the Gorham Corporation. The wolf's head symbolizes Putnam's bravery when he entered a cave and killed a wolf that had been terrorizing early settlers in Connecticut. The old English crest of the Putnam family is a wolf's head, making the symbol doubly appropriate.

146. ISRAEL PUTNAM, Ernst Schall, Hartford, Conn. Apr. 28, 1891 (U.S. Pat. No. 20,704). According to legend, Putnam escaped British troops at Horseneck, Conn., an American outpost, when he dashed on horseback downhill. 145. & 146. were combined in one spoon.

147. SPRINGFIELD RIFLE, Frank E. Ladd, Springfield, Mass. June 28, 1892 (U.S. Pat. No. 21,655). Manufactured by the Gorham Corporation.

148. RIFLE, Lucile Webb Banks, Columbus, Miss. July 5, 1904 (U.S. Pat. No. 37,022).

149. CROSSED RIFLES, Joseph E. Straker, Jr., Attleboro, Mass. Aug. 4, 1903 (U.S Pat. No. 36,472). Assigned to Watson & Newell; carries Watson & Newell trademark.

150. WASHINGTON'S HEADQUARTERS, (registered trademark), W. H. Lyon, jeweler. Jan. 27, 1891 (U.S. Pat. No. 18,906). Contemporary advertising states that W. H. Lyon patented this spoon. Actually, it was protected by a trademark consisting of the drawing of Washington's Headquarters as shown on the handle. Frank W. Smith Co. trademark.

151. WASHINGTON, George P. Tilton, Newburyport, Mass. Feb. 16, 1892 (U.S. Pat. No. 21,357). Assigned to Towle Manufacturing Company. New York, held by the British since 1776, watched as on Nov. 25, 1783, the Crown troops finally embarked and set sail for Nova Scotia or for England.

Davy Crockett—The Alamo

Davy Crockett, famous frontiersman, was a hunter, scout, soldier, writer, and Congressman. He is also known for the humorous tall tales he told about himself.

Crockett was among the 181 Americans beseiged in the Alamo at San Antonio, Texas, (Fig. 159) by 5,000 Mexicans. The Americans fought to the last man; Crockett died in the final assault on March 6, 1836.

The Lost Cause

The Great Seal of the Confederacy (Fig. 160) was adopted at the third session of the Congress of the Confederacy in 1862. Its description is as follows: "...the seal of the Confederate States shall consist of a device representing an equestrian statue of Washington (after the statue that surmounts his monument in the Capitol square at Richmond), surrounded with a wreath composed of the principal agricultural products of the confederacy: cotton, tobacco, sugar cane, corn, wheat, and rice—and having around its margin the words: 'The Confederate States of America; Twenty-second February, Eighteen Hundred and Sixty-two,' with the following motto: 'Deo Vindice.'"

The meaning of the symbols is clear: Washington, a Southerner, owned slaves—and God favors our cause.

The seal, of sterling silver, 3½ inches in diameter and weighing three pounds, was made in England by Mr. J. S. Wyon, official seal-maker to Queen Victoria, and required several weeks to engrave. The cost of engraving the seal and the press for working it was 80 guineas.

The seal was affixed as a symbol of sovereignty on a large number of documents that went abroad and a few appointments of high ranking Confederate officials.

Stonewall Jackson's Birthplace

Thomas Jonathan ("Stonewall") Jackson was born in 1824 in Clarksburg, Virginia, now West

152

153

154

155

156

157

Virginia (Fig. 161). He received very little formal education but through hard work secured an appointment to the U.S. Military Academy. He graduated in the upper third of his class.

Though Jackson favored preservation of the Union, he went with Virginia when the state seceded. From his refusal to admit defeat at Bull Run, he acquired his nickname, "Stonewall."

Fortress Monroe—Hampton Roads

Fort Monroe, in Virginia, was begun in 1819 and finished in 1834. The present fort is actually the third fort on the same site and was designed by one of Napoleon's marshals. It is shaped like a seven-pointed star and is surrounded by a moat.

Hampton Roads was the scene (battle of the *Monitor* and the *Merrimac* on March 8, 1862—the first encounter between iron-clad vessels in the history the world (Fig. 162).

Lee Monument

The General Lee Monument (Fig. 163), erected in Lee Circle, New Orleans, Louisiana, honors one of the greatest soldiers in history, Robert E. Lee,

152. COMMODORE PERRY, Ralph L. Snow, Pawtucket, R.I. Sept. 23, 1913 (U.S. Pat. No. 44,694). Assigned to Paye & Baker Mfg. Co. Manufactured by Paye & Baker Mfg. Co.

153. COMMODORE PERRY MONUMENT, George E. Nerney, Attleboro, Mass. May 13, 1913 (U.S. Pat. No. 44,022). Perry's Victory and International Peace Memorial National Monument on an island in Lake Erie. Established in 1936 to preserve the memory of Perry's victory and peace between Great Britain and the United States.

154. PERRY'S VICTORY, Herman T. Jarecki & George A. Disque, Erie, Pa. June 30, 1891 (U.S. Pat. No. 20,897). "Perry Transferring His Flag at the Battle of Lake Erie," famous painting by W. H. Powell, now hangs in the Capitol at Washington. The scene shows the transfer of the flag. Perry's 12-year-old brother, a midshipman, beside him in the sternsheets.

155. BATTLE OF PLATTSBURG, Charles J. Dale, Plattsburg, N.Y. Feb. 2, 1904 (U.S. Pat. No. 36,763).

156. BALTIMORE, John C. C. Justis, Baltimore, Md. May 19, 1891 (U.S. Pat. No. 20,726). Manufactured by Shiebler. Marked: "Justis & Armiger." Also found marked: "James R. Armiger."

157. BATTLE OF NORTH POINT, John W. Mealy, Baltimore, Md. Sept. 15, 1891 (U.S. Pat. No. 21,043). Assigned to Hennegen, Bates & Co. Manufactured by Dominick & Haff. Marked: "Hennegen, Bates & Co." One of the most important of many monuments giving Baltimore the name "Monumental City" is the Battle Monument in Battle Square. Erected in memory of those who fell in defense of Baltimore at the battle of North Point and the bombardment of Fort McHenry.

Commander-in-Chief of the Confederate forces in the Civil War. He was not only loved and revered by all Southerners, but respected and admired by Northerners for his gentlemanly conduct, devotion to duty, and gentleness of nature.

Lee graduated in 1829 from West Point, ranking second in his class. He served with distinction in the Mexican War.

In 1852 he was appointed superintendent of the Military Academy at West Point. As such he brought the Academy up to a position where it ranked with the best in Europe.

Not a slave-owner himself, Lee was opposed to the secession of Virginia and declared that "save in defence of my native State, I never desire again to draw my sword." After the grim years of the war, Lee refused offers promising large financial returns. Instead, he went to Lexington, Virginia, to help rebuild little Washington College—now Washington and Lee University—at an annual salary of $1,500.

Confederate Monument

The Confederate Monument at the north entrance to the capitol in Montgomery, Alabama, was erected in memory of Southern soldiers and sailors. The marble shaft has bronze bas-reliefs at the base, and at its top a bronze figure symbolizing patriotism (Fig. 164).

The Alabama state capitol was designed after the national Capitol in Washington, D.C., and has a ninety-seven-foot white dome. It was built in 1851 and served as the Capitol of the Confederacy during the Civil War.

Confederate Soldier

Monument of Confederate soldier (Fig. 165).

Old Abe

Old Abe, the country's most famous eagle, was caught by an Indian named Blue Sky who took him home and tamed him. Blue Sky sold the eagle to a white man for five bushels of corn. Early in the Civil War, the Eighth Wisconsin Volunteers purchased him, for $2.50, to have a real live "bird of freedom" mascot.

The eagle took a real fancy to a soldier named Jimmie McGinnis. When the regiment was on the march, Jimmie carried the eagle beside the color bearer. In the state capital, the bird was named "Old Abe" for President Lincoln (Fig. 166).

Old Abe loved soldiers marching and bands playing. He liked to sit on an officer's horse to watch a parade. Sounds of battle excited him. He went through four years of war; he was in twenty-two battles, and after every one of them, returned to his own regiment.

After the war Old Abe was given to the state of Wisconsin and lived in the State House in Madison for fifteen years. In 1876 Jimmie McGinnis took him to the Centennial Exposition in Philadelphia where he was greatly admired by thousands of visitors.

Jimmie remained his keeper until the bird died of old age in 1881. The skin was stuffed and Old Abe was set on his perch in the State House in Madison, looking as though he might spring up at any moment and soar far up into the sky at the first battle cry.

General Sherman

William Tecumseh Sherman, U.S General in the Civil War (Fig. 167), was the world's first modern man of war. He was a great commander who evolved fresh strategic techniques. Concepts developed from study of his operations influenced World War II.

Most outstanding was his ability to see and exploit the mechanical and scientific developments that changed conditions of warfare.

At sixteen, Sherman was appointed to West Point. Though he ranked high scholastically, his many demerits for slovenly appearance and nonconformity placed him far down the class list.

In wartime, grim, unrelenting, careless and unkempt in dress, Sherman's habit of rough living and lack of regard for outward appearance strongly appealed to the troops under his command.

The havoc wrought during his famous "March to the Sea" left a legacy of bitterness in the South that is still alive.

158. JACKSON MONUMENT, Alvan M. Hill, New Orleans, La. May 19, 1891 (U.S. Pat. No. 20,722). Manufactured by the Gorham Corporation. Marked: "Pat April 25 '91" "A. M. Hill." Chalmette Monument and Chalmette National Historical Park commemorate the Battle of New Orleans.

159. DAVY CROCKETT—THE ALAMO, Joseph A. Hughes, Corpus Christi, Tex. Aug. 23, 1892 (U.S. Pat. No. 21,783).

160. THE LOST CAUSE, Joseph H. Crosby, Jr., Jacksonville, Fla. Feb. 5, 1895 (U.S. Pat. No. 23,983). Manufactured by the Gorham Corporation. The flag is enameled. Marked: "STERLING Greenleaf & Crosby" Gorham Corporation trademark.

161. STONEWALL JACKSON'S BIRTHPLACE, Fernando A. Robinson & Benjamin F. Robinson, Clarksburg, W. Va. Mar. 8, 1892 (U.S. Pat. No. 21,374).

162. FORTRESS MONROE—HAMPTON ROADS, Calder S. Sherwood, Portsmouth, Va. June 23, 1891 (U.S. Pat. No. 20,858). Gorham Corporation trademark and Wm. B. Durgin Co. trademark.

Grant, Sherman & Sheridan

Philip Henry Sheridan graduated from the U.S. Military Academy (Fig. 168) at West Point and served with distinction in several Civil War battles. In 1863 he distinguished himself in the Battle of Chickamauga (Georgia) and in the Battle of Chattanooga (Tennessee) where he attracted the attention of General Grant. He continued to serve in the U.S. Army and in 1883 succeeded Sherman as General-in-Chief.

Sheridan was short and stout and held the trust of his soldiers who called him *Little Phil.*

Gettysburg Battlefield

The Battle of Gettysburg, Pennsylvania, on July 1, 2 and 3, 1863 (Fig. 169), was one of the most terrible battles in history; losses of men totaled about 53,000. Union forces were under the command of General George Gordon Meade, who had received his military education at West Point.

Winfield Scott Hancock was ordered by Meade to take command at Gettysburg and to report whether battle should be given at that point. After giving a favorable report to Meade, Hancock proceeded to organize his forces. On July 3rd Hancock was shot from his horse; recovered and was back in service by March of the following year.

In 1880 he was a candidate for the Presidency but was defeated by James A. Garfield.

Soldiers' Memorial Arch

The Soldiers' Memorial Arch was erected on the Plaza in front of the State House in Concord, New Hampshire. The cornerstone was laid on May 14th and the capstone put in place June 17th, 1892, without ceremony (Fig. 170). It was estimated that 10,000 people were present at the dedication of the memorial which took place July 4, 1892.

Battleship Maine—Captain Sigsbee

Charles Dwight Sigsbee (Fig. 171), U.S. Navy officer, was born in Albany, New York. He was in command of the battleship *Maine* when she was destroyed by an explosion in Havana Harbor in 1898. Sigsbee's wise dispatches did much at the time to avert immediate reprisals. He rendered distinguished service during the Spanish-American War as commander of the *Saint Paul*. In 1900-02 he was chief officer of naval intelligence; in 1903, as commander of the navy yard at League Island, Pennsylvania, he was promoted to rear admiral. In 1904-05 he commanded the South Atlantic squadron, and in 1905-06 the second division of the North Atlantic fleet. He retired in 1907 and died July 19, 1923.

163

164

165

166

167

168

564

565

566

564. RECUERDO HABANA, Manuel Carranza, Havana, Cuba. Dec. 22, 1891 (U.S. Pat. No. 21,256). Manufactured by the Gorham Corporation.

565. RECUERDO HABANA, Manuel Carranza, Havana, Cuba. Dec. 22, 1891 (U.S. Pat. No. 21,257). Manufactured by the Gorham Corporation.

566. MORRO CASTLE, Manuel Carranza, Havana, Cuba. Dec. 22, 1891 (U.S. Pat. No. 21,258). Manufactured by the Gorham Corporation. Located on the east side of the Havana Harbor entrance, Morro Castle was built by the Spanish between 1589-97.

163. LEE MONUMENT, Alvan M. Hill, New Orleans, La. May 19, 1891 (U.S. Pat. No. 20,723). Marked: "Pat. Apr 25 '91." "A. M. Hill." No trademark.

164. CONFEDERATE MONUMENT, Charles Leonidas Ruth, Montgomery, Ala. Nov. 10, 1891 (U.S. Pat. No. 21,166).

165. CONFEDERATE SOLDIER, Harry M. Moses, Richmond Va. Nov. 15, 1892 (U.S. Pat. No. 21,987). Assigned to H. M. Moses Co., Richmond.

166. OLD ABE, James Mears Van Slyke, Madison, Wis. July 19, 1892 (U.S. Pat. No. 21,717). Manufactured by the Gorham Corporation exclusive to J. Larson & Co.

167. GENERAL SHERMAN, John H. Johnston, N.Y.C. Apr. 7, 1891 (U.S. Pat. No. 20,668). Manufactured by the Wm. B. Durgin Co.

168. GRANT, SHERMAN & SHERIDAN, William F. Michael, Philadelphia, Pa. Aug. 11, 1891 (U.S. Pat. No. 20,990). Manufactured by the Wm. B. Durgin Co.

Victory

The Spanish-American War (Figs. 172, 564, 565, 566) was a brief one, waged by Spain and the United States in the spring and summer of 1898. The direct cause was the sinking of the *U.S.S. Maine* in Havana Harbor by an explosion, the cause of which has never been proven.

The first action of the war was in Manila Bay in the Philippines. Meanwhile, in Cuba, a combined sea and land operation was under way. Theodore Roosevelt (Fig. 173), in command of the volunteer cavalry regiment, the Rough Riders, led the assault on San Juan Hill and became one of the most colorful personalities of the war.

The acquisition of colonial possessions by the United States brought about many changes in American foreign policy. There was a rebirth of cordial relations between Great Britain and the United States (Figs. 174-188).

169

170

171

172

173

Indianapolis Soldiers' and Sailors' Monument

Ground was broken for the Indianapolis (Indiana) Soldiers' and Sailors' Monument (Fig. 189) in 1889, but when the spoon commemorating it was patented and first issued in 1891, the monument was not finished. Finally completed in 1901, the monument stands 285 feet high, in the heart of the city. It is surmounted by a thirty-eight-foot statue of Victory.

World War I

At the outbreak of World War I, Germany had not only vastly superior numbers of troops but had also both heavy and light arms with which she was abundantly supplied. She had expected to win the war quickly, but when this did not happen the nation wearied of war. Germany had also under-estimated the ability of the United States to mobilize and transport troops to the fighting ground (Figs. 190 & 191).

When the United States entered the war in April 1917, she had only 200,000 troops. Within eighteen months more than 2,000,000 troops were on the scene, and they continued to arrive at the rate of 70,000 a week. By the time the armistice was signed, more than 4,000,000 men were in the service.

World War I was fought mainly with established types of weapons. The principal difference, as compared with earlier wars, lay largely in methods of attack and defense. Aircraft (Fig. 192) was used for scouting and replaced the cavalry that had been so prominent a feature in earlier conflicts.

Deutschland

The idea of being able to travel under-water is almost as old as man's aspiration to fly through the air. Unlike the airplane, which is now primarily for commercial use, the submarine has remained principally a warship. However, during World War

169. GETTYSBURG BATTLEFIELD, Gustave A. Schlecter, Reading, Pa. Dec. 15, 1891 (U.S. Pat. No. 21,239). Manufactured by the Wm. B. Durgin Co.

170. SOLDIERS' MEMORIAL ARCH, James C. Badger, Concord, N.H. Aug. 16, 1892 (U.S. Pat. No. 21,777).

171. BATTLESHIP MAINE, Willis O. Hart, Unionville, Conn. May 17, 1898 (U.S. Pat. No. 28,629). Marked: "(star) Al (star) COPYRIGHT."

172. VICTORY, William A. Brown, N.Y.C. Sept. 20, 1898 (U.S. Pat. No. 29,354) Manufactured by the Gorham Corporation.

173. TEDDY ROOSEVELT, William A. Brown, N.Y.C. Nov. 15, 1898 (U.S. Pat. No. 29,661).

174. ANGLO-AMERICAN, William A. Brown, N.Y.C. Sept. 20, 1898 (U.S. Pat. No. 29,355). Manufactured by the Gorham Corporation.

I, two submarines, the *Deutschland* (Fig. 193) and the *Bremen*, were built in Germany and sent to the United States for medical supplies.

West Point Cadet

West Point, New York, has been an important military post since Revolutionary times and has been continuously occupied by troops since January 20, 1778.

The Military Academy was founded following the Act of March 16, 1802, and its formal opening was on July 4th of that year.

The site of the academy, on the west bank of the Hudson River, commanding an excellent view of both water and mountains, is of exceptional beauty.

Among the graduates who have added fame to the school were: Ulysses S. Grant, Robert E. Lee, William T. Sherman, "Stonewall" Jackson, John J. Pershing, Dwight D. Eisenhower, Douglas MacArthur, James A. Van Fleet, Matthew B. Ridgway, Alfred M. Gruenther, and Lauris Norsstad.

Cadets (Fig. 194) receive appointments from United States Senators or Congressmen, through the armed forces, as sons of deceased veterans, as graduates of honor military schools, or by appointment by the Secretary of the Army if they are sons of Medal of Honor winners. Cadets of certain foreign countries also receive instruction there.

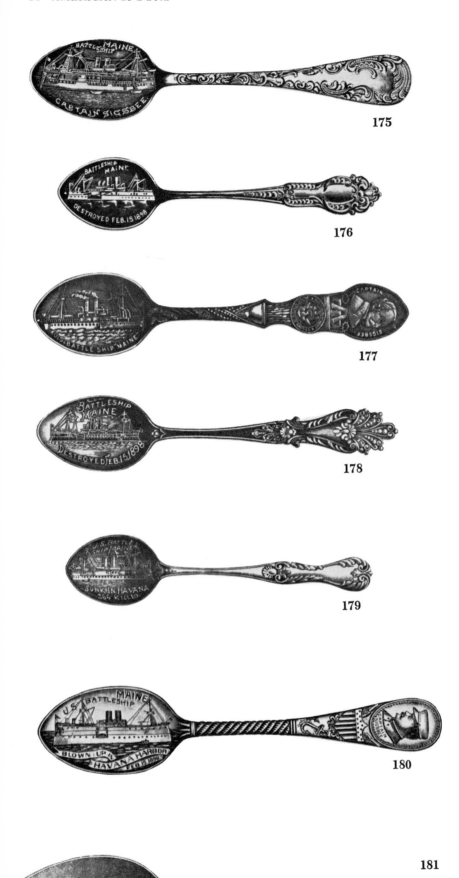

175

176

177

178

179

180

181

175. BATTLESHIP MAINE—CAPTAIN SIGSBEE, Henry Bruml & Co., N.Y.C. Made with and without a gilt bowl. *Jewelers' Weekly*, Apr. 27, 1898.

176. BATTLESHIP MAINE, O. E. Bell Company, Cincinnati, Ohio, and Simmons & Paye, Providence, R.I. Made in small and large coffee sizes and tea size with plain or enameled handles. *Jewelers' Weekly*, April 27, 1898.

177. BATTLESHIP MAINE—CAPTAIN SIGSBEE, George E. Homer, Boston, Mass. Handle bears the seal of the Navy Department. Made in sterling in coffee and tea sizes. *Jewelers' Weekly*, Apr. 27, 1898.

178. BATTLESHIP MAINE, George E. Homer, Boston, Mass. Made in sterling in coffee size. *Jewelers' Weekly*, Apr. 27, 1898.

179. BATTLESHIP MAINE, George E. Homer, Boston, Mass. Made in sterling in coffee size. *Jewelers' Weekly*, Apr. 27, 1898.

180. BATTLESHIP MAINE—CAPTAIN SIGSBEE, George E. Homer, Boston, Mass. Made in plated silver. *Jewelers' Weekly*, Apr. 27, 1898.

181. U.S. WARSHIP MAINE—CAPTAIN SIGSBEE, Upson & Hart Company, Unionville, Conn. Made in tea size in sterling silver, "gold metal," and "nickel silver." *Jewelers' Weekly*, Apr. 27, 1898.

182. ADMIRAL DEWEY-FLAG-SHIP *OLYMPIA*, Wm. A. Rogers, N.Y.C. Marked: "STANDARD." *Jewelers' Weekly*, May 18, 1898.

183. ADMIRAL DEWEY—FLAG-SHIP *OLYMPIA*, Henry Bruml & Co., N.Y.C. *Jewelers' Weekly*, May 18, 1898.

184. BATTLESHIP MAINE, Simmons & Paye, Providence, R.I. Coffee size. *Jewelers' Weekly*, May 18, 1898.

185. ADMIRAL DEWEY, Frank M. Whiting & Co., North Attleboro, Mass. Made in sterling silver in tea and coffee sizes with an oxidized finish. The crossed flags and portrait are enameled. *Jewelers' Weekly*, May 18, 1898.

All silverplate

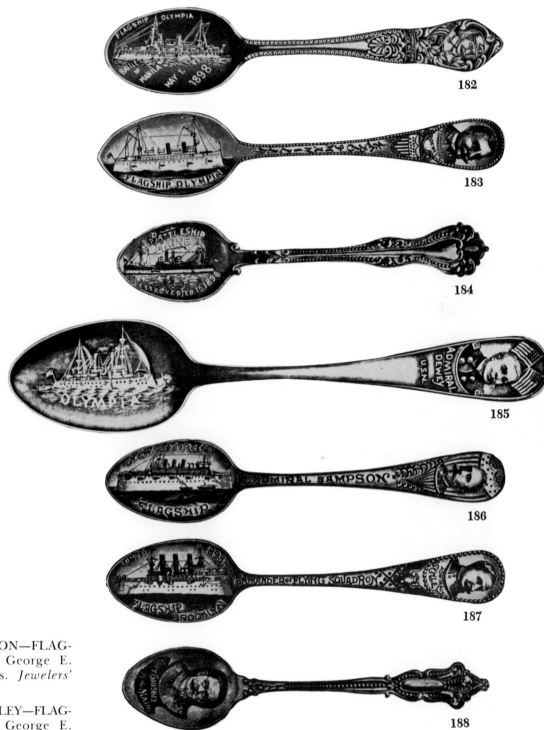

182

183

184

185

186

187

188

186. ADMIRAL SAMPSON—FLAG-SHIP *NEW YORK*, George E. Homer, Boston, Mass. *Jewelers' Weekly*, June 15, 1898.

187. COMMODORE SCHLEY—FLAG-SHIP *BROOKLYN*, George E. Homer, Boston, Mass. *Jewelers' Weekly*, June 15, 1898.

188. CAPT. SIGSBEE, Simmons & Paye, Providence, R.I. Also produced similar spoons in honor of Naval Constructor Hobson, Admiral Sampson, and Commodore Schley. *Jewelers' Weekly*, June 15, 1898.

All silverplate

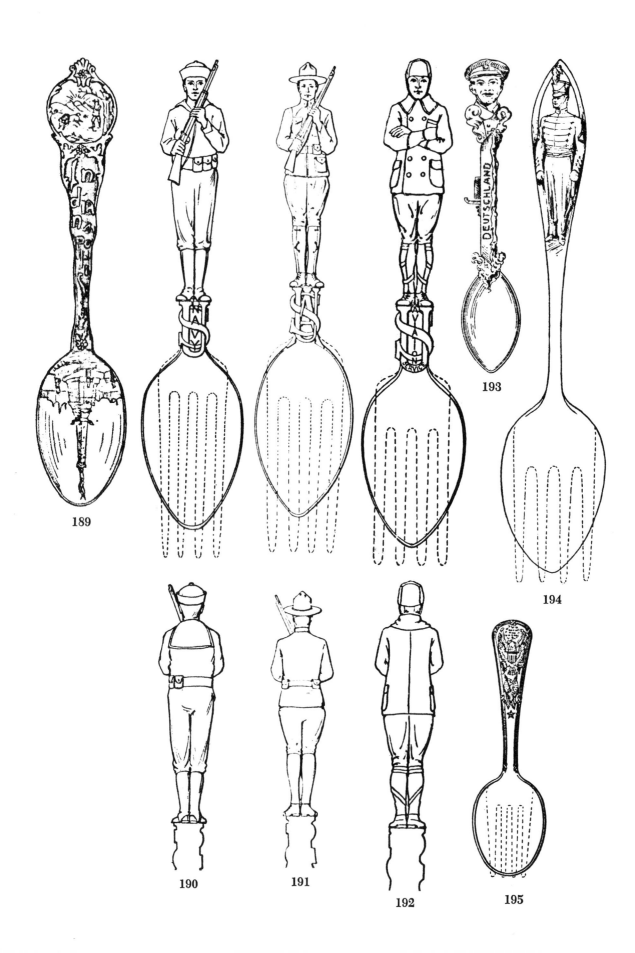

189

190

191

192

193

194

195

Patriotic Baby Spoon

In wartimes of a generation or more ago, a baby spoon with symbols of patriotism (Fig. 195), by which a child might absorb some love of country along with his breakfast porridge, was considered a thoughtful and very proper gift.

189. INDIANAPOLIS SOLDIERS & SAILORS MONUMENT, Julius C. Walk, Indianapolis, Ind. Sept. 29, 1891 (U.S. Pat. No. 21,079). Assigned to Bingham & Walk. Manufactured by Dominick & Haff and carries their trademark. Marked: "Bingham & Walk."

190. USN—SAILOR, Frederick Schwinn, Attleboro, Mass. Oct. 16, 1917 (U.S. Pat. No. 51,396). Made in sterling; later in bronze.

191. USA—SOLDIER, Frederick Schwinn, Attleboro, Mass. Oct. 16, 1917 (U.S. Pat. No. 51,397). Combination Robbins trademark—patented.

192. USA—AVIATOR, Frederick Schwinn, Attleboro, Mass. June 4, 1918 (U.S. Pat. No. 52,082).

193. DEUTSCHLAND, George R. Ploetz, N.Y.C. Apr. 17, 1917 (U.S. Pat. No. 50,628).

194. WEST POINT CADET, George E. Nerney, Attleboro, Mass. Feb. 18, 1913 (U.S. Pat. No. 43,576). Watson Company trademark.

195. PATRIOTIC BABY SPOON, Harrison Hebbard, East Orange, N.J. June 18, 1918 (U.S. Pat. No. 52,113). Assigned to Dominick & Haff.

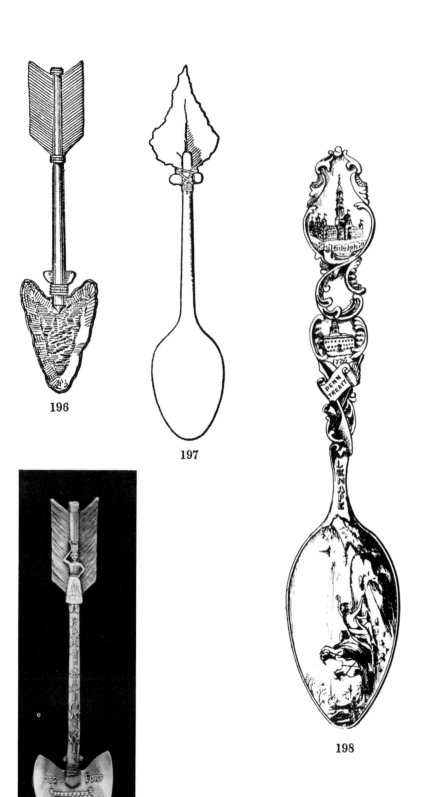

196

197

198

199

196a.

200

Chapter Five
Teepees and Tom-Toms

Evidence from several lines of study supports the conclusion that American Indians did not originate in the New World. No skeletal remains of an extremely early date nor of a physical type significantly different from modern Indian types have been found here.

Nomadic hunters, fishermen, and food gatherers of Mongoloid stock in Asia came to this continent by way of the Bering Strait about eleven thousand years ago. There was little contact with the former stock, therefore, they developed certain characteristics of their own. Though they share the coarse black hair, dark skin color, and shovel-shaped incisor teeth of their Asiatic forebears, there is great physical diversity in head shape, nose form, and body height. American Indian languages show even greater diversity.

The oldest archaeological evidence of culture in North America is the Folsom site in New Mexico where geologic evidence places it at the end of the last glacial period. Carbon 14[*]dating for this period is

196. ARROW, Victor Bogaert, Lexington, KY. Nov. 7, 1899 (U.S. Pat. No. 31,779). Marked: "Patented Nov. 7, 1899. V. Bogaert." When manufactured, though not shown on the patent drawing, is the figure of a woman carrying a bucket of water. Below that is the inscription BRYAN STATION, KY. The spoon commemorates the daring women who risked their lives to bring water to the fort when it was under siege by a force of Canadians and Indians in Aug. 1782.

196a. Bryan Station as manufactured.

197. ARROWHEAD, Sylvester George Stevens, Duluth, Minn. Aug. 25, 1925 (U.S. Pat. No. 68,066).

198. LENAPE—PENN TREATY, Alfred H. Peiffer. Philadelphia, Pa. (U.S. Pat. No. 21,409). Assigned to Simons Bros. & Co. Manufactured by Dominick & Haff. Marked: "S. Pat Mar. 15, '92." Also marked: "STERLING S PAT. MAR. 15, '92."

199. JOHN HARRIS, Charles Ross Boas, Harrisburg, Pa. Nov. 3, 1903 (U.S. Pat. No. 36, 613).

200. HENRY HUDSON ENTERING NEW YORK BAY, Charles Barclay, Lead, S.D. June 27, 1893 (U.S. patent 22,558).

roughly 8500 B.C. corresponding closely to the Carbon 14 date of 8000 B.C. for the Folsom material itself.

The way of life of the first migrants was simple, though they had brought with them the use of chipped stone tools, projectiles (Figs. 196 & 197), and the use of fire. As they spread over the continent into different types of environment, their ways of life became diversified. Some lived in settled towns and villages; many developed complex political, economic, religious, and artistic forms of expression. Village economy was based largely on intensive farming, hunting, or fishing. Others lived simple nomadic lives, following wild game and gathering wild food.

White men brought with them a pattern of life different from Indian groups. Opposing conceptions of property ownership resulted in encounters between the two races. The pressure created by the first European settlements pushed the eastern woodland Indians westward, causing conflict with those already living there. As Indian groups, in wave after wave, were pushed west from the shaded woodlands into the sunlight of open plains, they adopted the prairie way of life.

The Delaware Indians were an important Algonquin tribe which, in colonial times, occupied the entire Delaware River basin of eastern Pennsylvania, southeastern New York, and most of New Jersey and Delaware. They were called "grandfathers" by other Algonquins; their own name for their tribe was Leni-Lenape, meaning "real men" (Fig. 198).

When the Swedes settled in Delaware in 1638, they upheld Indian titles to the land to secure their own possession against the Dutch. The treaty which William Penn made with the Indians of Pennsylvania in 1682 was well kept during his lifetime (Fig. 199).

Successive treaties and the encroachment of the Union Pacific Railroad in the West eventually drove the Indians from their homelands.

* Because carbon 14 is produced in the atmosphere at a constant rate by cosmic radiation, all living things contain radioactive carbon. After the death of a plant or animal, the amount of radioactivity decreases, making it possible to determine the age of organic material by measuring the remaining radioactivity.

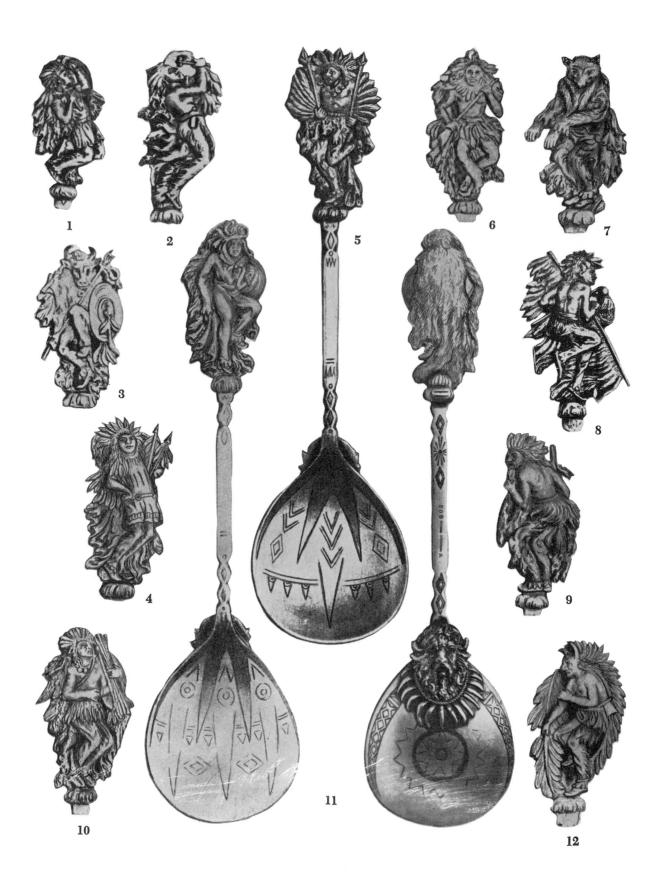

1

2

5

6

7

3

4

8

9

10

11

12

Henry Hudson Entering New York Bay

In 1609 Henry Hudson, then in the employ of the Dutch East India Company, sailed up the river now bearing his name.

The scene (Fig. 200) depicted here appears to be based on a painting by Edward Moran, prominent marine artist of Philadelphia. The painting is one of a series of thirteen which the artist himself called the "Marine History of the United States." Moran began the series which he considered the most important in his career in 1885, when his popularity was at its height. He continued to work on it until shortly before his death in 1901. The paintings were first exhibited at the Metropolitan Museum of Art in New York; later they were presented to Philadelphia's Fairmount Park Commission. They now hang in the United States Naval Academy in Annapolis, Maryland.

Indian War Dances

From the time of Walter Raleigh's first colonial efforts to today's prospective tourist who is stockpiling color film for next summer's picture-taking of the Chamber-of-Commerce-sponsored Indian pow-wows, American Indian dances have fascinated travelers.

The first artist to paint American Indians was the remarkable John White who accompanied Raleigh's first colony (under Sir Richard Grenville), in 1585. Seventy-five of White's watercolors are still in existence; several of them depict Indian dances.

The purpose of early artists was to record what they saw, as they saw it, to make an authentic report to the backers of explorations who wanted to know what the land looked like, about the plants and animals, and the appearance and customs of the people.

After the Louisiana Purchase and the opening of the Territory for exploration and settlement, artists were always engaged as essential members of each expedition.

202. INDIAN DANCES, Charles T. Grosjean, N.Y.C., Assignor to Tiffany & Company. Feb. 17, 1885 (U.S. Pat. No. 15,831). Design patents, illustrating 24 spoons with Indian dances, were granted to Charles T. Grosjean and assigned to Tiffany & Co. Two sets of 12 each had been submitted under one design patent application. This was revised so that a patent was granted covering each set separately. All twelve of the first and larger designs are illustrated. Only one (no. 3) of the second set is shown. The dances in the second set are:

1. Full-dressed warrior	7. Pipe dance
2. Lacrosse player	8. Bow dance
3. Indian maid (shown)	9. Club dance
4. Bear dance	10. Discovery dance
5. War dance	11. Medicine dance
6. Buffalo dance	12. Coyote dance

201. INDIAN DANCES, Charles T. Grosjean, N.Y.C., Assignor to Tiffany & Company. Feb. 10, 1885 (U.S. Pat. No. 15,785):

1. Scalp dance	7. Bear dance
2. Medicine dance	8. Pipe dance
3. Buffalo dance	9. Coon dance
4. Chief dance	10. Beggar dance
5. Slave dance	11. Bull dance
6. Discovery dance	12. Eagle dance

203. INDIAN PIPE DANCE. Marked: "Tiffany & Co. Sterling M." (Photo courtesy Helen Hoegsberg, Coronado, Cal.)

The influence of nineteenth-century romanticism was evident in the work of the artists who accompanied expeditions throughout the West, but their job was primarily that of reporters. Being basically artists, though, each added an individuality to his work. Among nineteenth-century artists who recorded Indian life of North America were George Catlin, Karl Bodmer, Alfred Jacob Miller, Captain Seth Eastman, Albert Bierstadt, and Paul Kane.

George Catlin painted the Bull Dance (American bison) of the Mandans in 1832. Another form of bison worship practiced by the Plains Indians was the so-called "medicine circles," painted by Miller near the Platte River in the late 1830s.

Each of these artists has a place in the story of nineteenth-century painting, and each has left a valuable historical record, otherwise lost, of people and customs.

The much-faded photographs in the Patent Office—the only record of the spoons designed by Charles T. Grosjean (Figs. 201 & 202) for the Tiffany Company—were not accompanied by any reference to locality or tribe represented, but the pieces are as faithfully drawn as any of Karl Bodmer's meticulous renderings of costumes and artifacts (Fig. 203).

Chief Oshkosh

Oshkosh (Fig. 204) was named a chief of the Menominee by United States commissioners in order to gain his assent to a treaty in 1827. The city of Oshkosh, Wisconsin, founded about that date as a trading post, was later renamed in honor of the local chief.

All American Indian

Two patents for almost identical All American Indian spoons were issued (Figs. 205 & 206) on July 14, and August 2, 1891, respectively. They are truly "All American" as they can be found with embossed or engraved designs in the bowls representing places all across the nation—and Canada (Fig. 207). Some of the trademarks found on them are: P. W. Ellis & Co., Toronto, Canada; Howard & Son; and R. Wallace & Sons.

Two other Indian spoons (Figs. 208 & 209) which have been used to commemorate many places all over America are found in several sizes; some of these show the Indian's skin color in a bronze tone.

Indian Totem

The handle with fish, bear, and raven (Fig. 210) is an adaptation of the totem pole concept developed by the Northwest Coast Indians; the birchbark canoe appears to be of the type characteristic of the Chippewas whose territory extended from Lake Huron westward to the Dakotas.

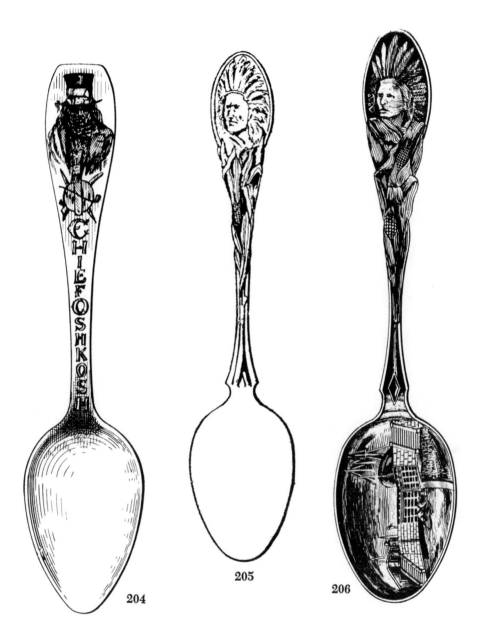

204. CHIEF OSHKOSH, Harry I. Birely, Oshkosh, Wis. Nov. 3, 1891 (U.S. Pat. No. 21,153).

205. ALL AMERICA INDIAN, Charles C. Wientge, Providence, R.I. July 14, 1891 (U.S. Pat. No. 20,947). Assigned to Howard & Son Co.

206. ALL AMERICA INDIANS. (a) Marked: "R W S Co. STERLING L D A." (R. Wallace & Sons); (b) Marked: "R W S Co. STERLING" (R. Wallace & Sons); Edward Todd & Co. trademark; (c) Marked: "STERLING." Ellis Co. maple leaf trademark.

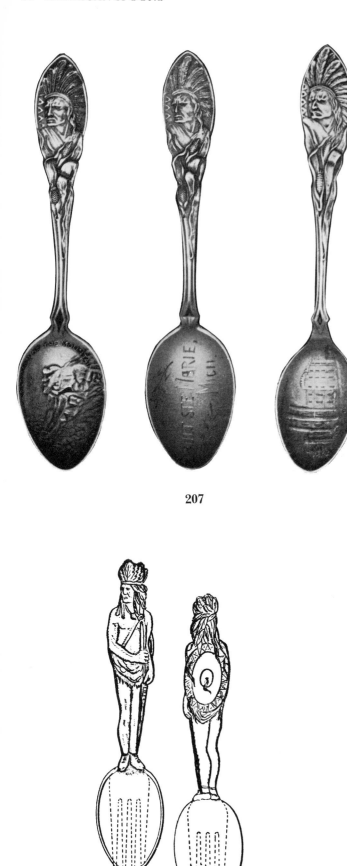

207

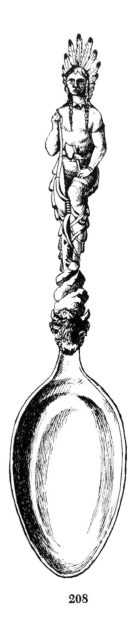

208

210

209

207. ALL AMERICA INDIAN, Otto Supe, Sault Ste. Marie, Mich. Aug. 2, 1892 (U.S. Pat. No. 21,740). Silverplate.

208. NORTH AMERICAN INDIAN, William E. Wood, Philadelphia, Pa. Sept. 22, 1891 (U.S. Pat. No. 21,061). Assigned to Peter I. Krider Co.

209. INDIAN, Joseph E. Straker, Jr., Attleboro, Mass. Sept. 22, 1903 (U.S. Pat. No. 36,561). Assigned to Watson & Newell.

210. INDIAN TOTEM, Lucile Bentz, Seattle, Wash. Mar. 10, 1914 (U.S. Pat. No. 45,367).

Chapter Six
Winning the West

California Miners

The accidental discovery of gold at Sutter's Mill in the Sacramento Valley of California turned all eyes westward. An impatient multitude, equipped with picks and shovels or bare hands, went West to behold the glittering vision of a new El Dorado.

John Augustus Sutter, a Swiss immigrant, ruled over the California estate of 49,000 acres which he had received from the Mexican government (Fig. 211). In the summer of 1847 he sent a crew of men to build a sawmill on his land. When water was turned into the millrace January 24, 1848 to wash it clean of debris, James Marshall, the carpenter in charge, saw the yellow flecks that eventually drew gold seekers to California (Fig. 212).

Sutter was concerned that the discovery would disturb the serenity of his empire and begged his men to keep it secret for six weeks until spring planting was completed. Though the secret was not completely kept, there was little excitement until Sam Brannan, operator of a store in Sutterville, saw an opportunity to make more money from gold seekers than the seekers themselves would find. With a bottle of gold dust in his hands, he walked the streets of San Francisco shouting about the discovery. This was the signal for a kind of gold rush never before recorded. Almost overnight San Francisco became a deserted village. People everywhere became hysterical and left their jobs. Crops went unharvested. Ranches were deserted. The gold fever spread from California west to Hawaii and east to the Atlantic.

A few men found gold enough to become wealthy; most worked harder than ever before in their lives and barely broke even; others just went broke.

Big strikes of placer gold (Fig. 213) were largely phenomena of the early part of the gold rush. By 1852 all the rivers had been prospected; the big strikes made. Mining became big business, necessitating tremendous capital investments in mining equipment. By hydraulic mining, gold could be recovered from low-grade placer deposits. Deep shafts were sunk into the mountains (Figs. 214 & 215). Gold seekers continued to arrive, though in smaller numbers; many, discouraged, turned to day labor or farming (Fig. 216), while others headed through the passes of the Sierra Nevada with pick and pan and burro—off in search of still another El Dorado. (Fig. 217).

Colorado Miners

Most of Colorado was acquired by the United States in the Louisiana Purchase in 1803. Colonel Zebulon M. Pike led the first American party of exploration in 1806, penetrating the mountains north and west of present-day Colorado Springs and Pueblo and discovering the peak which bears his name. Trading posts were established by fur traders in the 1830s, and Fremont led exploring parties into the Rocky Mountains between 1842 and 1853. The real rush of settlement came with the discovery of gold.

In the fall of 1858, when gold was found in the hills west of Denver (Figs. 218 & 219), thousands headed for the goldfields. Tent city mining camps sprang up overnight; they became busy towns and villages; then settled to ghost towns when the mines played out. Fabulous wealth was acquired by some; fortunes vanished as gold mining declined.

For years Colorado miners had ignored outcroppings of silver ore which they did not know how to work. Silver cannot be "panned" like gold. But, as gold diggings played out, miners began to turn to silver mines (Fig. 220).

Until the great Leadville strikes in 1878, Georgetown was the most productive silver camp in Colorado. The most spectacular strikes, one of which was developed as the Iron Silver Mine, were made along the California Gulch. People poured in and the city of Leadville, made up of tents, shelters of pine boughs, restaurants with French chefs, beer gardens, temperance societies, gambling saloons, and grocery stores, was born and populated overnight. Throughout the mountains other silver camps boomed. Ouray, Silverton (Fig. 221) ("we may not have gold, but we have silver by the ton"), Placerville, and Telluride were among them.

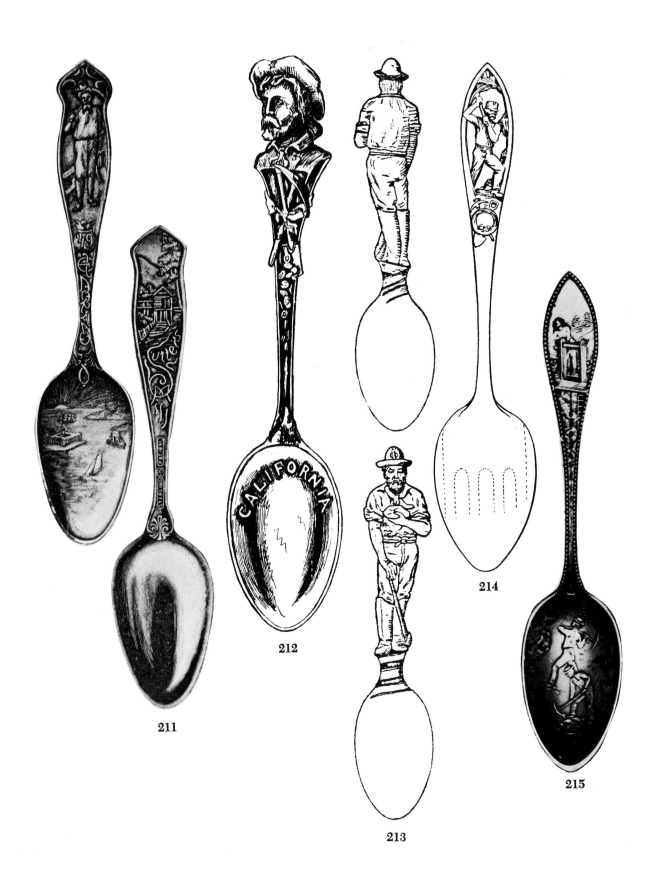

211

212

213

214

215

211. EL DORADO—SUTTERS MILL, George P. Tilton, Newburyport, R.I. Feb. 16, 1892. Assigned to the Towle Manufacturing Co. Marked: "Pat. 1891." Towle Manufacturing Co. trademark.

212. CALIFORNIA MINER, William H. Jamouneau, Newark, N.J. June 30, 1891 (U.S. Pat. No. 20,871). Alvin Manufacturing Co.

213. MINER, Joseph E. Straker, Jr., Attleboro, Mass. June 16, 1903 (U.S. Pat. No. 36,362). Assigned to the Watson & Newell Co. Found with Roden Bros. Ltd., Toronto, Canada, mark also.

214. MINER, George E. Nerney, Attleboro, Mass. Feb. 11, 1913 (U.S. Pat. No. 43,552).

215. MINERS AT WORK. Marked: "925/1000 Copyrighted" Towle Manufacturing Company trademark. Made in sterling and copper.

216. HARVEST, Silver Flat Ware Company, Unionville, Conn. *Jewelers' Weekly*, Jan. 1, 1896. Marked: "Mountain Gold Co." Silverplate.

217. ROCKY MOUNTAIN, Julius Eichenberg, Providence, R.I. *Jewelers' Weekly*, Mar. 14, 1894. Silverplate.

218. MINER'S SHOVEL, Frederick F. Horn, Colorado Springs, Colo. Feb. 21, 1893 (U.S. Pat. No. 22,229). Handle is agate. Sterling.

219. MINER'S SHOVEL, Frederick F. Horn, Colorado Springs, Colo. July 18, 1893 (U.S. Pat. No. 22,629). Handle is agate. Marked: "Patented Sterling."

220. WINDLASS, Eugene L. Deacon, Denver, Colo. Oct. 21, 1902 (U.S. Pat. No. 36,115).

A Souvenir of Harvest.

The Silver Flat Ware Company, Unionville, Conn., has added to the list of symbols of the year's changes a new silver harvest spoon.

In the bowl is etched the figure of a

SILVER FLAT WARE COMPANY.

reaper at sunset. The stem is consistently decorated with stalks of bearded wheat, and the handle with an etched sheaf and sickle.

216

217

218

219

220

In 1892 the silver boom came to a dramatic end with the repeal of the Sherman Act which had obliged the U.S. Treasury to buy silver at $2 an ounce. The nation-wide "panic of '93" hastened the end.

Two years before the collapse of the silver boom, gold again became the center of interest with the discovery of a great field along Cripple Creek, just behind Pikes Peak. This field reached its peak of production in 1901 when more than $24 million in gold was mined. Production declined slowly without the sudden crash of the silver camps.

Today the mining of gold and silver contributes more than $16 million dollars annually to Colorado's economy, but mining is now carried on by scientific methods; the colorful mining camps are part of a glamorous past.

Cowboys

After the Civil War, new wealth was discovered in the West—gold on the hoof. The cattlemen's empire began in Texas. Ancestors of the longhorn were brought to the New World by the Spaniards some 450 years ago. Strays, mixed with scrub cattle brought in by settlers, produced the coarse-haired, tall, and bony longhorn cattle (Figs. 222 & 223).

Cattle kings built their empires overnight. Profits were enormous, but overgrazing and drought toppled the "cowboy kings," and with them went the rip-roaring western cowtowns (Fig. 224).

Ironically, the initial success of the cattle industry on the plains led the way for the "sodbuster" or farmer, for it discredited the myth of the "Great American Desert." Settlers swarmed onto the plains in search of a better life. From around 1870 until the

221. SMELTER CITY, George Freund, Durango, Colo. May 9, 1893 (U.S. Pat. No. 22,406).

222. ROPER UP, Joseph Mayer, Seattle. Wash. Oct. 27, 1908 (U.S. Pat. No. 39,636). Joseph Mayer & Bros. crossed-tools trademark.

223. WESTERN GIRL, Joseph Mayer, Seattle, Wash. Oct. 27, 1908 (U.S. Pat. No. 39,637). Joseph Mayer & Bros. crossed-tools trademark.

224. COWBOY, Joseph E. Straker, Jr., Attleboro, Mass. Dec. 22, 1903 (U.S. Pat. No. 36,688). Assigned to the Watson & Newell Co.

225. WILD WEST, Julia E. Officer, Council Bluffs, Ia. Nov. 3, 1891 (U.S. Pat. No. 21,154).

226. FORT ROBINSON, Charles Elliot Winslow, Ft. Robinson, Neb. June 27, 1893 (U.S. Pat. No. 22,562). Fort Robinson was established in 1874 to quell Sioux Indians whose hostility was engendered by broken promises of land grants.

turn of the century, there occurred the greatest migration in United States history. Railroads, which carried farmers to prairie outposts at reduced prices, sold them cheap land, and then quickly raised freight rates, were largely responsible for this mass movement. Then, in 1873, Joseph Glidden twisted together two strands of wire with a spur entwined and produced barbed wire. The days of the cowboy (Fig. 225) on the open range and the Plains Indian, dependent on the herds of bison (Fig. 226), were gone forever; "civilization" had come to the West, had seen, and had conquered.

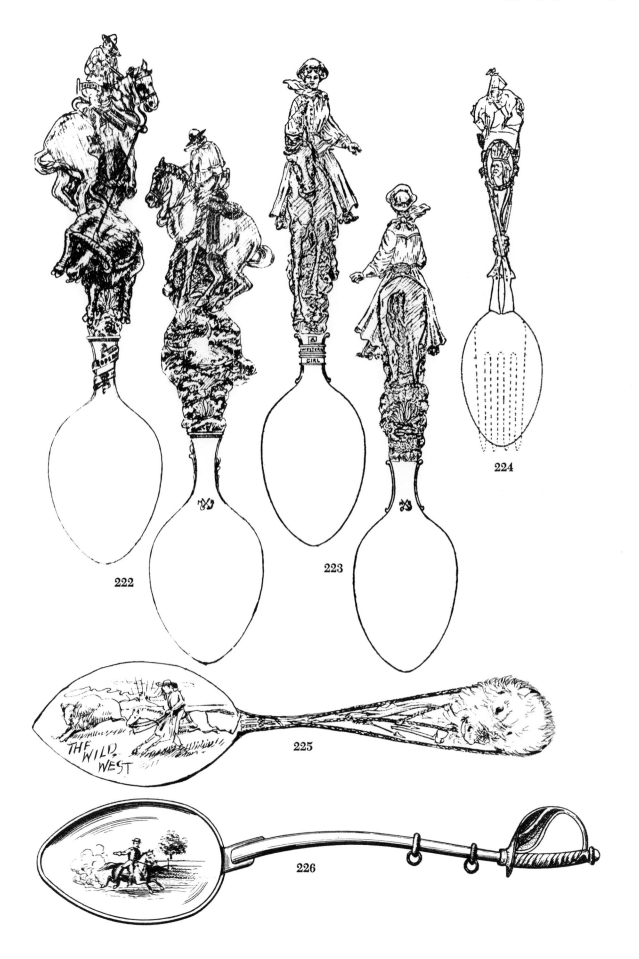

222

224

223

225

226

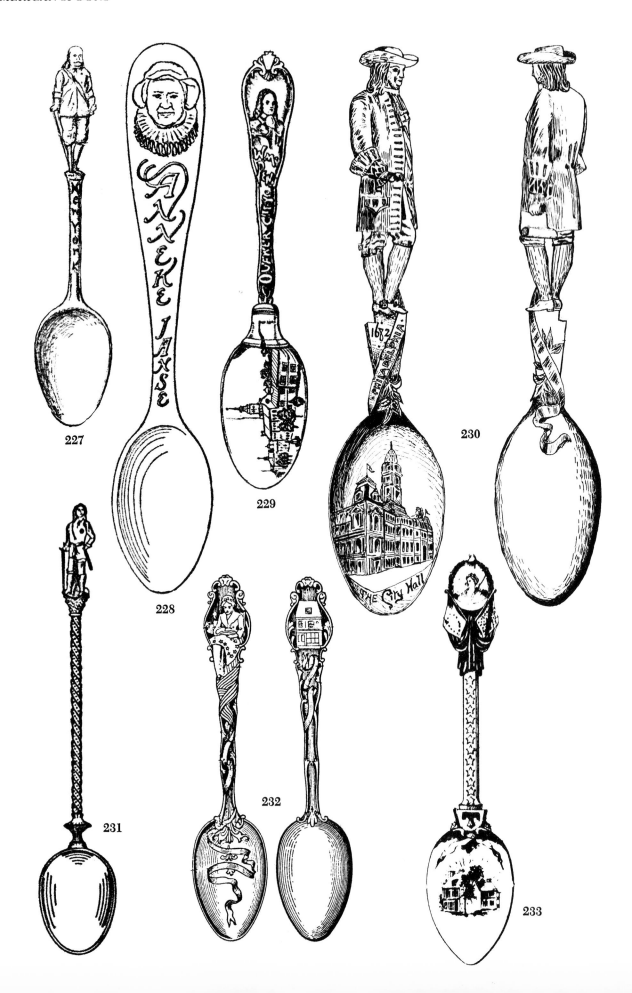

Chapter Seven
Faces of the Times

Peter Stuyvesant

Peter Stuyvesant (Fig. 227), last Dutch governor of New York, was born in West Friesland, the Netherlands, in 1592. He saw military service in the West Indies, lost a leg in an unsuccessful campaign against the Portuguese island of Saint Martin, and returned to the Netherlands in 1644. The following year he was appointed director-general of New Netherland by the Dutch West India Company. He ruled the New World colony with an iron hand.

The efforts of the Dutch to establish feudalistic colonies were not well accepted by Dutch settlers. Vassalage did not fit the frontier, nor did the colonists care for Stuyvesant's tyranny. In 1664, when four English ships dropped anchor off Manhattan, the settlers remembered the Governor's efforts to prevent representative government and surrendered to the English with little protest.

227. PETER STUYVESANT, John H. Johnston, N.Y.C. Feb. 3, 1891 (U.S. Pat. No. 20,494). Manufactured by the Wm. B. Durgin Co. The statuette is based on an old woodcut of Peter Stuyvesant.

228. ANNEKE JANS (JANSE), Benjamin Marsh & Frederick W. Hoffman, Albany, N.Y. July 7, 1891 (U.S. Pat. No. 20,924). Manufactured by the Wm. B. Durgin Co. Marked: "Sterling Pat'd Marsh & Hoffman."

229. WILLIAM PENN—QUAKER CITY, Gilbert L. Crowell, Jr. Arlington, N.J. June 23, 1891 (U.S. Pat. No. 20,844). Assigned to C. R. Smith & Son, Philadelphia, Pa.

230. WILLIAM PENN, James Frederick Thomas, Philadelphia, Pa. Aug. 11, 1891 (U.S. Pat. No. 20,987). Assigned to James E. Caldwell & Co. and manufactured for them exclusively by the Gorham Corporation.

231. CADILLAC, Henry M. Wright, Detroit, Mich. July 21, 1891 (U.S. Pat. No. 20,959). Controlled by Wright, Kay & Co., Detroit.

232. BETSY ROSS—BETSY ROSS HOUSE, William A. Brown, N.Y.C. Nov. 15, 1898 (US. Pat. No. 29,662). Howard trademark.

233. BETSY ROSS—BETSY ROSS HOUSE, Charles H. Weisgerger, Philadelphia, Pa. July 9, 1901 (U.S. Pat. No. 37,747).

Stuyvesant retired to his farm or *bouwerij* (from which the name of the street, The Bowery, is derived), where he died in 1672. He was buried in the vaults of St. Mark's Church.

Stuyvesant was one of the mock-heroic characters in Washington Irving's *Knickerbocker's History of New York.*

Anneke Jans

In 1630 Anneke Jans (Fig. 228) came from Holland to New Netherland with her husband, Roeloff Jansen. In 1636 Jansen secured a sixty-two-acre land grant which reached from the Hudson River to present-day Broadway, and from Warren Street to a point near Desbrosses Street.

At the time of her second husband's death, Anneke Jans obtained a patent right to the tract in her own name. Her heirs sold the tract to the English Governor Lovelace in 1671. Later the property was confiscated by the English government on the grounds that three of Anneke's heirs' signatures were omitted from the document. It was deeded to Trinity Church Corporation in 1705; since that time, it has been the subject of numerous suits by Anneke's heirs.

William Penn

William Penn (Figs. 229 & 230), founder of Pennsylvania, was born in London in 1644, son of Vice-Admiral Sir William Penn.

Penn had strong religious convictions by the age of eleven, and became a staunch Quaker in Ireland in 1666 when he was sent by his father to manage his large Irish estates. Throughout the remainder of his life there was no faltering in his Quaker beliefs.

As the result of young William's Quaker leanings his father drove him from home and the two were not reconciled until 1670 when the Admiral, on his deathbed, endorsed his son's beliefs.

In 1675 Penn's thoughts turned to America where he hoped to establish a haven for Quakers. He had inherited from his father a claim of great value from Charles II. In payment thereof he received a grant of land in America which eventually became the State of Pennsylvania.

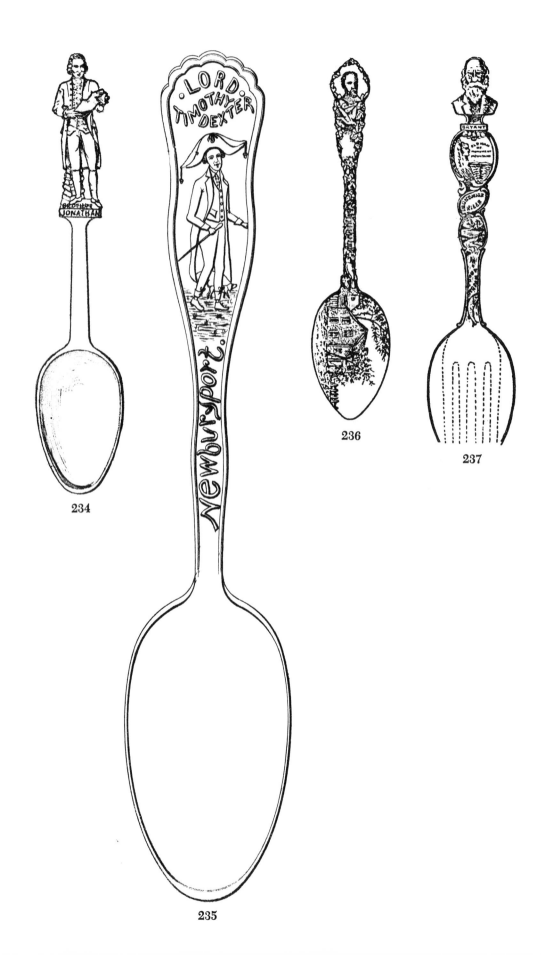

234

235

236

237

On this grant, Penn established a colony, and was himself responsible for framing its laws. One feature to which he adhered firmly was that of religious freedom. He is best remembered for his treaty with the Indians which, according to Voltaire, was the only treaty "never sworn to and never broken."

Difficulties arose in the colonies after Penn went back to England in 1684, and years of turmoil exhausted his large fortune. He spent his last years in England and died there in 1718.

Antoine Cadillac

The French colonist Antoine de la mothe Cadillac (Fig. 231) was born in Gascony around 1658. He left France in 1683 to live in Nova Scotia and Maine.

In 1694 he received command of Mackinac (Michigan), but three years later, when the French abandoned their western posts, he returned to France. In 1701 he obtained a grant for the Detroit area and led a large group of settlers to establish a colony there.

In 1711 King Louis XIV recalled him to France and appointed him Governor of Louisiana. Failing to establish a prosperous settlement in that region, he returned to France again in 1716, this time for good. He lived in Gascony until his death in 1730.

Betsy Ross

Elizabeth Griscom Ross was born January 1, 1752, in Philadelphia. For a time she attended a Friend's school, then worked as a seamstress in an upholstery shop until she eloped to Gloucester, New Jersey, with John Ross. Shortly afterward, John opened his own upholstery shop on Arch Street in Philadelphia. Ross, who served in the local militia, lost his life in 1776, when a store of gunpowder he was guarding exploded. Betsy continued to carry on the shop alone.

234. BROTHER JONATHAN, David Mayer, Hartford, Conn. June 30, 1891 (U.S. Pat. No. 20,904). Manufactured by the Gorham Co. exclusive to David Mayer.

235. LORD TIMOTHY DEXTER, William B. Jones, Newburyport, Mass. Feb. 10, 1891 (U.S. Pat. No. 20,509). Towle Manufacturing Company trademark (T enclosing lion). Marked: "W. P. Jones" Wm. P. Jones signed specification sheet of patent as a witness.

236. JOHN HOWARD PAYNE, Marshall 0. Roberts, Washington, D.C. Feb. 14, 1893 (U.S. Pat. No. 22,212). In the bowl is Payne's East Hampton, Long Island, boyhood home, which was the inspiration for "Home, Sweet Home."

237. WILLIAM CULLEN BRYANT, Isaac G. Perry & Frank F. Fulcher, Great Barrington, Mass. July 7, 1908 (U.S. Pat. No. 39,398). Manufactured by Rogers, Lunt & Bowlen.

According to tradition, a committee, headed by General George Washington, visited Betsy Ross (Figs. 232 & 233) at her home in June 1776 and requested her to make a flag in accordance with a design which they gave her. General Washington wanted six-pointed stars in the flag, but Betsy is said to have persuaded him to use five-pointed ones.

This design for the stars-and-stripes flag was adopted by Congress June 14, 1777.

It is doubtful that Betsy Ross actually made the first American flag, but it is known that she did make other flags.

Brother Jonathan

For nearly two centuries, "Brother Jonathan" (Fig. 234) has been used as a symbol of the people of the United States. Jonathan Trumbull, Governor of Connecticut from 1769 to 1784, and a vigorous supporter of the colonial cause during the Revolution, guided and encouraged Connecticut industry in supplying food and munitions to the army, maintaining close contact with General Washington to learn the army's needs. Washington trusted him implicitly and consulted him often in times of emergency. Once, when Washington needed ammunition desperately, he remarked "We must refer the matter to Brother Jonathan." From that day, Trumbull was known as "Brother Jonathan."

Washington's frequent use of this expression caused it to come into popular use; later it was applied to the people of the United States in general.

Lord Timothy Dexter

Timothy Dexter, born in Malden, Massachusetts, January 22, 1747, a leather-worker of small means, aspired to wealth and position and achieved notoriety through his eccentricities. Dexter married a wealthy widow and by frugality and wise investments became a man of substance.

Many of his efforts to attain social prominence were peculiar, indeed. One of his oddly constructed residences was adorned with more than forty life-size statues of famous personages; one of himself was included.

Another example of his eccentricity was the pamphlet he wrote entitled *A Pickle for the Knowing Ones*, published in 1802. He omitted all punctuation marks from the text and on the last page supplied an abundance of marks, instructing readers to "peper and solt it as they plese."

"Lord" (Fig. 235) Timothy Dexter was truly a legend in his own time. He died at Newburyport, Massachusetts, October 23, 1806.

John Howard Payne

John Howard Payne, American playwright,

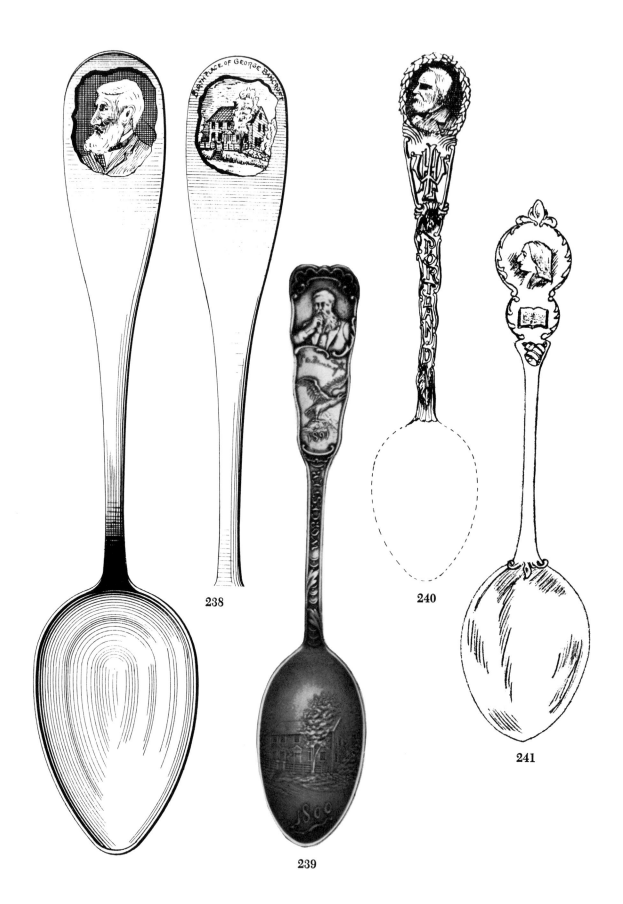

238

239

240

241

diplomat, and actor, was immortalized for his lyrics to the song "Home Sweet Home" (Fig. 236). These words were written as part of an opera which he adapted from the play *The Maid of Milan*, or *Clari*.

Clari was first produced in London in 1823 at Covent Garden. Payne received little money for either the song or the opera.

Payne was born in New York City and became an actor at age sixteen. He went to London in 1820 and was once put in prison for debt there after the failure of one of his theatrical enterprises. He collaborated with Washington Irving on some plays and wrote or translated more than sixty himself. Only *Clari* was a big success.

Payne died in 1852. His body was brought to the United States in 1883 and buried in Washington, D.C. During the burial ceremony, a choir of 1,000 voices sang "Home Sweet Home."

The original manuscript is owned by the Eastman School of Music, Rochester, New York.

William Cullen Bryant

William Cullen Bryant, American poet and editor (Fig. 237), was born in Cummington, Massachusetts, in 1794. He attended Williams College and practiced law in Great Barrington, Massachusetts, from 1816 to 1825, and then retired to devote all of his time to writing. Nearby Monument Mountain, memorialized by Bryant, affords one of the best views of the Berkshire Hills.

Because he was inspired by Wordsworth's philosophy and writings, and was himself such a great nature poet, he was sometimes called the "American Wordsworth." He was also called "Father of American Poets."

Probably his most quoted work is *Thanatopsis*, a poem in blank verse.

238. GEORGE BANCROFT, Haverley Brooks Swart, Worcester, Mass. Mar. 31, 1891 (U.S. Pat. No. 20,653). Manufactured by the Gorham Corporation. Marked: "K. A. Knowlton Pat. 1885." This date refers to the patent of the pattern outline, not to the Bancroft souvenir.

239. GEORGE BANCROFT, as manufactured.

240. LONGFELLOW, Jonathan Ambrose Merrill and Albion Keith, Portland, Ore. Aug. 25, 1891 (U.S. Pat. No. 21,017). Manufactured by the Wm. B. Durgin Co. Marked: "PAT. APD. FOR. J. A. MERRILL & CO." Wm. B. Durgin Co. trademark.

241. LONGFELLOW, Fred J. Knorr & Alice S. Kuhn, Bloomington, Ill. Feb. 8, 1904 (U.S. Pat. 36,779). Made also with Christ, John Wesley, Lincoln, and various others on the handle.

George Bancroft

George Bancroft (Figs. 238 & 239), the Founding Father of the historical profession, was the most successful of all American historians. Born in Worcester, Massachusetts, in 1800, he began his *History of the United States* at the age of thirty-two. Almost thirty editions were published and were best sellers between 1834 and 1890. Bancroft lived in an age when historians wrote for people rather than for other historians.

In addition to being considered "Dean of Historians" of his day, he founded the United States Naval Academy, was American Envoy Extraordinary and Minister Plenipotentiary to London and Berlin, and founded a prep school. He wrote many presidential speeches, including Andrew Johnson's first message as President in 1865.

When Bancroft died in 1891, President Harrison ordered the flags of official Washington at half-mast, honoring him as no other American historian has ever been honored, in life or in death.

Henry Wadsworth Longfellow

The American poet, Henry Wadsworth Long- fellow (Fig. 240) was born February 27, 1807, in Portland, Maine. His ideal childhood and excellent education lead him into a cultural life. From 1854, he devoted himself wholly to writing (Fig. 241).

Although Longfellow's popular reputation is that of a poet, he must also be remembered as having an important place in the history of American literature because of his eminent services as a translator and transmitter of Old World culture to America.

Whittier's Birthplace

John Greenleaf Whittier was born in 1807 at Haverhill, Massachusetts (Fig. 242). His Quaker faith strongly influenced his life and poetry.

Whittier's education was meager. At age fourteen, when a teacher read Robert Burns' poems to him, he was inspired to write verse himself. His first work to be published was accepted by the Newburyport *Free Press*, sent there by his sister. By 1843 Whittier was recognized as one of the country's leading poets. Though later his reputation declined somewhat, he still remained the fresh, unspoiled poet of children and country people. *Snow-Bound* is considered one of his best works.

Whittier was also an editor and reformer. In 1836 he moved to Amesbury, about eight miles northeast of Haverhill, where he remained until his death in 1892.

Hannibal Hamlin

Hannibal Hamlin was born in Paris Hill, Maine, on August 27, 1809. He was raised on his father's

farm and studied and practiced law in Hampden. He became active politically early in his career.

Hamlin represented Hampden in the state legislature, was elected to Congress in 1842 and to the Senate in 1848. He was elected governor of Maine but had served less than a month when he returned to the U.S. Senate.

In 1860 he became the vice president under Abraham Lincoln, serving through Lincoln's first term in office. He continued in politics until his retirement in 1882.

He died July 4, 1891, in Bangor, Maine (Fig. 243). Bangor was called the "Lumber City" because of the enormous lumber industry developed there in the nineteenth century.

Pope Leo XIII

Pope Leo XIII was born Gioacchino Vincenzo Pecci, at Carpineto Romano, Italy, March 2, 1810.

Following his election as pontiff, he chose to be called Leo XIII (Fig. 244). One of his most important contributions was reconciling the church with the spirit of the nineteenth century. He was a humanist of wide and deep culture, able to grasp his era in all its aspects. His view was that societies must work for the common good, respecting the rights of religion and the dignity of the human person.

The universal mourning following his death in Rome, July 20, 1903, was eloquent testimony to the esteem accorded him by people of all faiths.

P. T. Barnum

Phineas Taylor Barnum (Fig. 245), American showman, was born at Bethel, Connecticut, July 5, 1810, and died in Bridgeport, Connecticut, April 7, 1891. The greatest showman of all time, he was an astute businessman as well.

Barnum, the son of a Bethel storekeeper, opened a small shop of his own, but, unable to settle down as a country storekeeper, he turned to other things. Some of his ventures did not turn out well. In 1834 he moved his family to New York where he tried several ways to earn a living, at first with little success. Then in 1835 he heard of Joyce Heth, a colored woman, reputed to be the nurse of George Washington. He purchased Joyce Heth for $1,000 and advertised her as a curiosity. The receipts from this enterprise soon amounted to $1,500 a week.

He opened the American Museum of Curios in 1842, exhibited the midget, General Tom Thumb, brought Jenny Lind to the United States for a concert tour and, in 1871, opened "The Greatest Show on Earth."

This enterprise in exhibiting curiosities finally led to the opening of the Barnum and Bailey Circus. This was purchased by Ringling Brothers in 1907.

Bridgeport was the home of P. T. Barnum and the site where the Barnum Festival is still an annual event.

Harriet Beecher Stowe

Harriet Beecher Stowe (Figs. 246 & 247) was born June 14, 1811, in Litchfield, Connecticut. Daughter of Lyman Beecher, a staunch Colonist conservative, she married Professor Calvin E. Stowe in 1836.

During her residence in Cincinnati, Ohio, from 1833 to 1850, she became an ardent abolitionist. Receiving encouragement from her brother and her husband, she wrote *Uncle Tom's Cabin* or *Life Among the Lowly*. It was first published in 1851-52 as a serial in an anti-slavery paper, the *National Era*, in Washington, D.C. Her other writings include *The Pearl of Orr's Island* (1862); *Oldtown Folks* (1869); and her collected works, *The Writings of Harriet Beecher Stowe* (1896), in sixteen volumes.

She was elected to the Hall of Fame in 1910.

Elihu Burritt-The Learned Blacksmith

American reformer, Elihu Burritt, was born December 8, 1811, at New Britain, Connecticut, and died March 7, 1879. He was educated in common schools and at age sixteen was apprenticed as a blacksmith (Fig. 248).

Reading the Scriptures in their original languages led him to philological studies. By his diligence, he was able to understand works in several languages.

Burritt moved to Worcester, Massachusetts, where he could use the library at the Antiquarian Society, and while plying the trade of blacksmith, he founded and edited the *Christian Citizen*, a weekly newspaper advocating international peace.

In 1846 Burritt went to Europe where he established the League of Universal Brotherhood. Through his efforts, the Brussels Peace Congress was held in 1848. He returned to the United States in 1851 and the following year founded *Citizen of the World* at

242. WHITTIER'S BIRTHPLACE, Henry L. Dole, Haverhill, Mass. Mar. 3, 1891 (U.S. Pat. No. 20,543). Wm. B. Durgin Co. trademark. Marked: "PAT'D H. L. DOLE." Similar spoons marketed by H. G. Hudson, Amesbury, Mass. are covered by trademarks in Hudson's name and were also made by the Wm. B. Durgin Co.

243. THE HAMLIN, Bernhard Pol, Bangor, Me. July 21, 1891 (U.S. Pat. No. 20,961). No trademark.

244. POPE LEO XIII, Gilbert L. Crowell, Jr., Arlington, N.J. Dec. 29, 1891 (U.S. Pat. No. 21,265). Assigned to Dominick & Haff.

245. P. T. BARNUM, Edwin M. Parker, Bridgeport, Conn. July 7, 1891 (U.S. Pat. No. 20,914). Assigned to Parker & Davis, Bridgeport. Shiebler trademark.

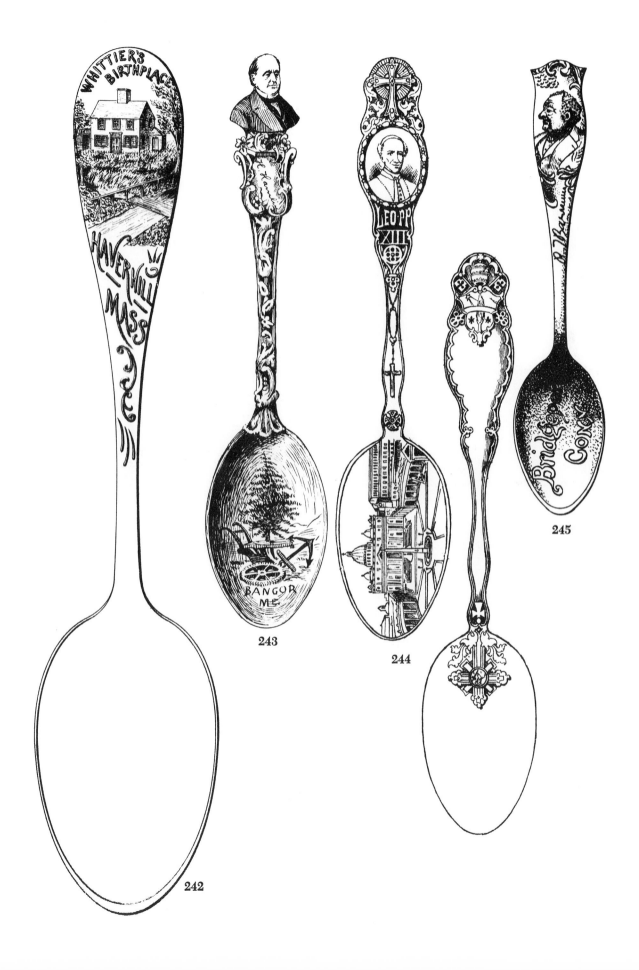

242

243

244

245

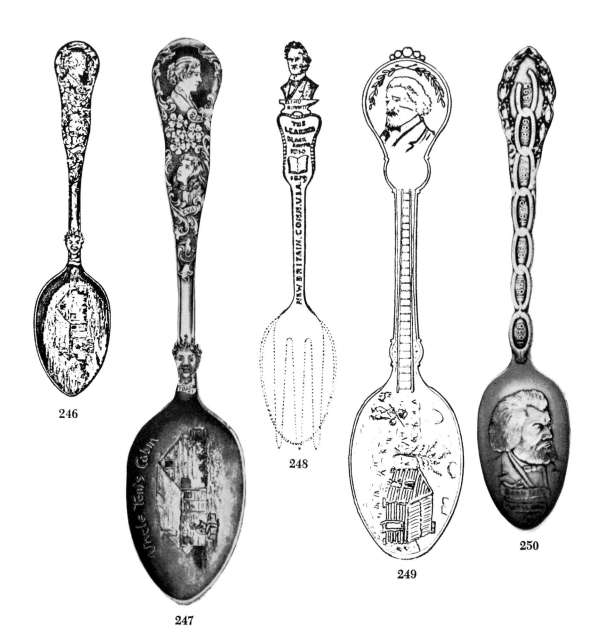

246

247

248

249

250

246. HARRIET BEECHER STOWE, Isabella Beecher Hooker, Hartford, Conn. Dec. 27, 1898 (U.S. Pat. No. 29,866). Watrous Mfg. Co. crescent-W trademark. Uncle Tom's Cabin is in the bowl.

247. HARRIET BEECHER STOWE, as actually manufactured.

248. THE LEARNED BLACKSMITH, George H. Dyson, New Britain, Conn. May 24, 1904 (U.S. Pat. No. 36,927).

249. FREDERICK DOUGLASS, William H. Purdy & Leonard C. Peters, Providence, R.I. Apr. 23, 1895 (U.S. Pat. No. 24,228). No trademark. Log cabin birthplace in bowl.

250. FREDERICK DOUGLASS, as manufactured. Unmarked. Plated silver teaspoon.

Philadelphia, which promoted emancipation. During the next ten years he lectured in the United States and abroad, promoting the peace cause.

His writings included: *Sparks from the Anvil* (1848); *Ten Minute Talks* (1873); *Chips from Many Blocks* (1878).

Frederick Douglass

Frederick Douglass (Figs. 249 & 250), American journalist and lecturer, was born in February 1817 at Tuckahoe, Maryland. His mother was a Negro slave, his father unknown.

In 1832 Douglass was sold to a Baltimore ship-builder and escaped six years later. Self-educated, he changed his name from Frederick Augustus Bailey to Douglass.

After showing real talent as an orator at an anti-slavery convention held in Nantucket, Massachusetts, in 1841, Douglass was employed by the Anti-Slavery Society as a lecturer. During a successful European lecture tour his freedom was bought.

He published his *Autobiography* in 1845 and revised and enlarged it in 1882. In addition to lecturing and writing, he edited a journal, was appointed secretary of the commission to San Domingo, and acted as U.S. Minister to Haiti.

Walt Whitman

Walt Whitman (Fig. 251) was born May 31, 1819, at West Hills, Long Island, New York. He moved to Brooklyn in 1823 where he attended school, and at age thirteen, was apprenticed in a newspaper and print shop. He continued in the newspaper field until 1848 when he began work on the poems for *Leaves of Grass*, first published in 1855. This work was received unfavorably by contemporary American reviewers though later it was recognized as a masterpiece.

During the Civil War, Whitman volunteered his services in army hospitals, supporting himself by acting as a newspaper correspondent. His war experiences were later recorded in *Drum-Taps* (1865).

Recognition of Whitman's work was won readily in Europe, but it came slowly in the United States.

In January 1873 he was stricken with paralysis; thereafter he lived in Camden, New Jersey, until his death, March 26, 1892.

George W. Childs

George William Childs (Fig. 252) was born May 12, 1829, in Baltimore, Maryland. He was a partner in the firm of Childs & Peterson which published Elisha Kent Kane's *Arctic Explorations*. This work became remarkably popular, partially because of Child's skillful use of publicity.

In 1864 he bought the *Philadelphia Ledger* in

partnership with A. J. Drexel; from this he built a considerable fortune.

Childs wrote *Recollections of General Grant* in 1885 and *Recollections by George W. Childs* five years later. He was also a banker, philanthropist, and civic leader.

He died February 3, 1894, in Philadelphia.

James G. Blaine

Statesman James G. Blaine (Figs. 253 & 254); born in West Brownsville, Pennsylvania, was an influential political leader for many years.

After graduating from Washington College in Pennsylvania, Blaine settled in Maine. In 1854 he became part owner of the Kennebec *Journal* and later the editor of the Portland *Advertiser*. Having established himself as a supporter of the new Republican party, he was elected to the state legislature in 1858.

Robert G. Ingersoll dubbed him the "Plumed Knight" and nominated him for President of the United States in 1876. This nomination he did not win. After several other unsuccessful attempts, he succeeded in gaining the Republican nomination for President in 1884; he was narrowly defeated in the election by Grover Cleveland. From 1889 to 1892, he served as Secretary of State in President Benjamin Harrison's cabinet. He continued his political life, once again unsuccessfully seeking the Presidential nomination in 1892. He died the following year.

Robert Ingersoll

Robert Green Ingersoll (Figs. 255 & 256) was an American writer, lawyer, and politician. He was born in Dresden, New York, in 1833.

During the Civil War, Ingersoll served as a colonel in the Eleventh Illinois Cavalry. He was attorney general of Illinois from 1867 to 1869. Ingersoll entered politics as a Democrat but, following the war, he became a prominent Republican.

For almost thirty years he was a center of controversy because of his attacks on popular Christian beliefs. He lectured on his creed of agnosticism, practiced law, and wrote; his publications included: *The Gods and Other Lectures* (1876), *Some Mistakes of Moses* (1879), and *Great Speeches* (1887).

Leslie Keeley

Dr. Leslie Enraught Keeley was born in Kings County, Ireland, in 1834.

At the outbreak of the Civil War he volunteered as a medical cadet. During a leave of absence, he continued his medical studies and obtained his M.D. degree in Chicago, Illinois, at Rush Medical College. Returning to the army, he attained the rank of major.

251

252

253

254

251. WALT WHITMAN, Theophilus Bear, Camden, N.J. Sept. 20, 1927 (U.S. Pat. No. 73,475)

252. GEORGE W. CHILDS, William F. Michael, Philadelphia, Pa. Sept. 15, 1891 (U.S. Pat. No. 21,040). Assigned to Bailey, Banks & Biddle. Manufactured by the Wm. B. Durgin Co. and controlled by Bailey, Banks & Biddle.

253.* JAMES G. BLAINE, Joseph H. Kaiser, Brownsville, Pa. Sept. 22, 1891 (U.S. Pat. No. 21,054).

254.* JAMES G. BLAINE, as manufactured.

* 253 & 254 have been seen with Gorham, Durgin and Peter Krider trademarks.

255. ROBERT INGERSOLL, Otto Wettstein, Rochelle, Ill. Feb. 2, 1892 (U.S. Pat. No. 21,334). Manufactured by the Gorham Corporation Marked: "Otto Wettstein."

256. ROBERT INGERSOLL, as manufactured.

257. KEELEY CURE, Will F. Holbrook, Seward, Neb. Apr. 26, 1892 (U.S. Pat. No. 21,496). Dr. Leslie E. Keeley on the handle tip is followed by the emblem of the Keeley League—the K in horseshoe, enclosed in belt.

258. LESLIE E. KEELEY, Illinois State Historical Library, Springfield, Ill. (Photography by Camera Shop, Springfield, Ill.)

259. Advertisements from Scribner's Magazine, 1916.

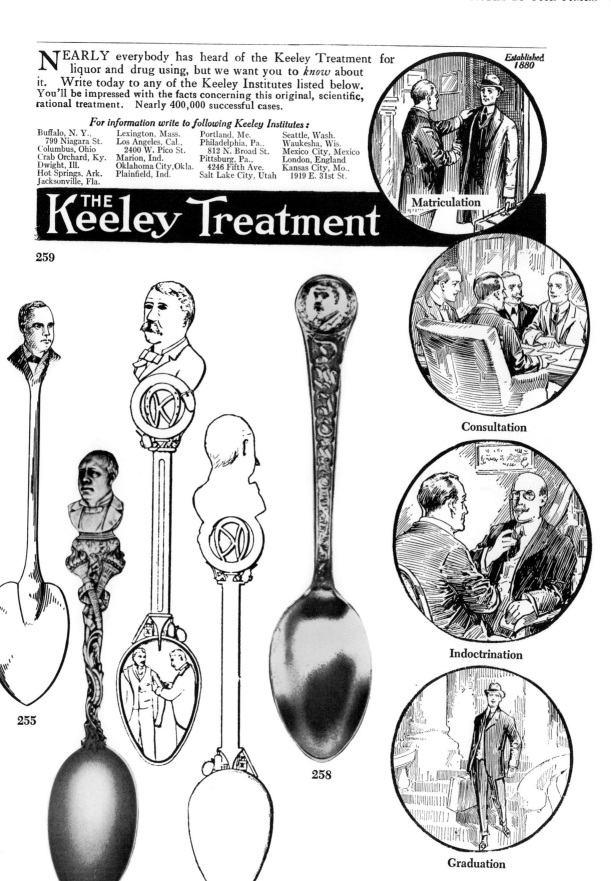

259

255

256

257

258

At the close of the war Keeley settled at Cheona, Illinois, but in less than a year he moved to Dwight, Illinois.

Leslie Keeley was one of the first (Fig. 257) to act logically and persistently upon the assumption that drunkenness is a disease. He declared his ability to cure drunkenness and drug addiction by giving an internal remedy at stated intervals and by the administration of hypodermic solutions. At first the "Keeley treatment" was taken by patients at home. After several years, it was deemed preferable to take the cure at establishments known as "Keeley Institutes" (Figs. 258 & 259). The first of these was founded in Dwight, Illinois, in 1880.

In 1891 the late Joseph Medill of the Chicago *Tribune* brought public attention to the Keeley Institutes by publishing results of his investigation of the system.

With his famed slogan, "Drunkenness is a disease and I can cure it," and with injections of his secret gold chloride, Kelley amassed a fortune of over $1 million. He died in Los Angeles, February 21, 1900.

In 1891 the Keeley League was established, composed of "graduates" of the Keeley Cure. It is said to have attained a membership of 30,000 at its peak and held seven national conventions for the some 300 local Leagues.

An auxiliary, known as the "Woman's Keeley League," was formed in 1893 for the purpose of aiding in Keeley League work.

Susan B. Anthony

Susan B. Anthony (Fig. 260), born in 1820 in Adams, Massachusetts, was active in the anti-slavery movement and in the abstinence movement before the Civil War. After the war, she devoted her time entirely to campaigning and lecturing for the woman suffrage movement. She organized The National Woman Suffrage Association in 1869, and presided as president from 1892 to 1900.

Phillips Brooks

Phillips Brooks (Fig. 261), American Protestant Episcopal bishop, was born December 13, 1835, at Boston. He graduated from Harvard with honors in 1858, and entered the Episcopal Theological Seminary at Alexandria, Virginia.

Brooks was influential in removing prejudice against a denomination that had never been popular in New England. His teachings attracted a large following, strengthening considerably the Episcopal Church in America.

The Church of the Advent in Philadelphia was his first charge. Two years later he became a rector of Holy Trinity Church, also in Philadelphia, and in 1869 he was called to Holy Trinity Church in Boston. There he remained until his election as Bishop of Massachusetts in 1891. He died in 1893.

He was the author of several hymns, including the lovely Christmas carol, *O Little Town of Bethlehem*. It has been said that he was inspired to write this hymn while looking down over Bethlehem one Christmas Eve.

Cleopatra-Sarah Bernhardt

Cleopatra, as played by "the Divine Sarah" Bernhardt (Fig. 262) about 1891, was the inspiration for the design of many objects, including spoons. It also influenced women's dress styles.

Born Rosine Bernard, in Paris, October 22, 1845(?), Sarah was considered one of the great actresses of all France. She enjoyed her enormous stage success for nearly sixty years. In 1914, nine years before her death, she was made a member of the Legion of Honor.

Luther Burbank

Luther Burbank (Figs. 263 & 264) was born March 7, 1849, on a farm near Lancaster, Massachusetts. As a young boy, he developed an interest in both mechanics and nature, the latter stimulated by the works of Charles Darwin.

Burbank moved to Santa Rosa, California, where he could grow plants all year. While working at odd jobs, including gardening, to support his widowed mother, he used his spare time to experiment with plants. In time, he acquired a small nursery of his own. As his success grew, he acquired more land. During the succeeding years, he carried on as many as 3,000 experiments at one time. The first practical result of his plant experiments was the Burbank potato.

In 1893 he sold his nursery and established his famous Santa Rosa experimental farm. During his lifetime, he developed more than 220 new varieties of

260. SUSAN B. ANTHONY. Marked: "STERLING REGISTERED TRADEMARK." Frank W. Smith Silver Co., Inc. trademark.

261. PHILLIPS BROOKS, George E. Homer, Boston, Mass. May 30, 1893 (U.S. Pat. No. 22,480). Manufactured by Howard & Son, Co. Marked: "PAT. APPLIED FOR GEO. E. HOMER. Trinity Church, Boston, Mass.," in the bowl.

262. CLEOPATRA, William H. Jamouneau, Newark, N.J. July 14, 1891 (U.S. Pat. No. 20,942). Manufactured by the Alvin Corporation.

263. LUTHER BURBANK, Ernest F. Rueckert, Providence, R.I. Dec. 12, 1905 (U.S. Pat. No. 37,724). Assigned to John Hood, Santa Rosa, Cal. Marked: "John Hood."

260

261

262

263

264. LUTHER BURBANK, as manufactured.

trees, vegetables, fruits, flowers, and grasses, and became known as the "Plant Wizard." He died at his Santa Rosa home, April 11, 1926.

Edwin Booth

Edwin Thomas Booth (Fig. 265) was born near Bel Air, Maryland, November 13, 1833. The fourth son of actor Junius Brutus Booth, Edwin made his first stage appearance in 1849 in spite of his father's disapproval.

One of his most celebrated roles was Hamlet which ran 100 nights in 1864-65.

After his brother, John Wilkes Booth, assassinated Abraham Lincoln, Edwin retired temporarily, returning to the stage in 1866.

Edwin Booth played in many Shakespearean roles during his acting career and is generally considered the greatest American actor of the nineteenth century. He died in New York City on June 7, 1893.

John Heyl Vincent

The Chautauqua Literary & Scientific Circle (Figs. 266) was founded in 1874 by Dr. John Heyl Vincent, American Methodist bishop, and L. Miller. Dr. Vincent served as chancellor from 1878 to 1900.

The society took its name from Lake Chautauqua, New York, where its first meetings were held out-of-doors in a grove.

The Chautauqua Institution, a nonsectarian organization, provides a varied program of symphony concerts, lectures, plays, and other cultural programs by persons of renown during July and August each year. There are schools of religion, art, crafts, and music. Its summer school, oldest in the nation, affords Syracuse University credits.

Daniel D. Palmer

The principles of chiropractic are ancient. Hippocrates, the Father of Healing, Galen, and other physicians of ancient Greece and Rome were

265. EDWIN BOOTH, Benjamin B. Freeman, Cambridge, Mass. Mar. 6, 1894 (U.S. Pat. No. 23,098). Reverse: "I shall not look upon his like again," *Hamlet*, Act I, Scene II. Marked: "Boston. Freeman & Taylor."

266. CHAUTAUQUA LITERARY & SCIENTIFIC CIRCLE, John Wells King, Jamestown (Chautauqua County), N.Y. July 7, 1891 (U.S. Pat. No. 20,909). Manufactured by George W. Shiebler & Co. Shiebler winged-S trademark. Controlled by Phillips & Armitage, Jamestown, N.Y. Reverse: scenic view includes a University Building and steamboat.

267. DANIEL D. PALMER—OFFICIAL CHIRO-PRACTIC, Newton J. Baxter, Parnassus, Pa. Aug. 10, 1909 (U.S. Pat. No. 40,210).

265

266

267

268 268a

518

familiar with it, as were ancient Egyptians, Hindus, and Chinese.

The chiropractic principle was rediscovered by Daniel D. Palmer (Fig. 267) in 1895. Three years later, he established the Palmer School of Chiropractic in Davenport, Iowa. After 1903 this school was continued by his son, Bartlett Joshua Palmer. As of 1968, the president of the Palmer College of Chiropractic was David D. Palmer, grandson of the founder.

Fridtjof Nansen

Fridtjof Nansen, explorer, was born in Froen, Norway, October 10, 1861 (Fig. 268).

In 1893 Nansen sailed aboard the *Fram,* expecting that upon entering the polar ice around the New Siberian Islands the ship would drift eastward, south of the pole, and eventually come out on the east side of Greenland. When he reached the latitude 83° 59′ N, Nansen and a companion, equipped with sledges, dogs, and kayaks, left the *Fram,* and took to the ice. On April 8, 1895, he reached a higher latitude than had ever previously been attained. He then proceeded southward to Franz Josef Land where he spent the winter.

Many honors were conferred upon him for this exploit. He was also awarded the 1921-22 Nobel Peace Prize for his post-war relief activities.

Admiral Cologny

Admiral Cologny (Fig. 518) (spelled Cologni on the spoon) was a French soldier, and after a brilliant military career he was made Admiral of France in 1552. On the banner at the bottom of bowl reverse is LaRochelle 1689. Around the upper-edge of bowl is "Our Rochelle, The Fair Rochelle, Proud City of the Waters." This refers to New Rochelle, New York.***

268. NANSEN, Christian O. Ostbye, Providence, R.I. June 22, 1897 (U.S. Pat. No. 27,235). Assigned to the Gorham Corporation. Gorham Corporation trademark. Fig. 268a. Nansen as manufactured.

518. ADMIRAL COLOGNY, Mary A. Fisher, New Rochelle, N.Y. May 16, 1893 (U.S. Pat. No. 22,438). Howard Co. trademark.

269. ANTIQUE HEADS. *Jewelers' Weekly,* Jan. 6, 1892.

THE STERLING COMPANY,

No. 7 EDDY STREET, PROVIDENCE, R. I.

NUMBER

COFFEE SPOON.

ANTIQUE HEADS.

TWELVE

PATTERNS.

JULIUS CÆSAR

AJAX

ALEXANDER

MEDUSA

HERCULES

HOMER

ARMINIUS

HANNIBAL

CICERO

MINERVA

HECTOR

VENUS DE MILO

TRADE MARK

322.

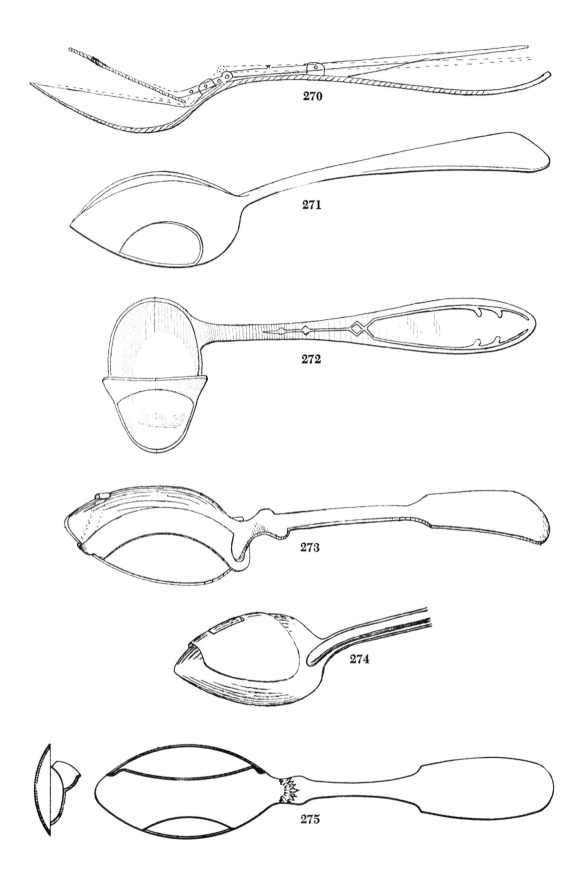

Chapter Eight
Soup Strainers

Through the ages the beard has been important in the lives of men. Centuries before the beginning of the Christian era, men sought to remove their facial adornment. Bronze razors, still retaining a fair degree of keenness, have been found in tombs of ancient Egyptians, for the clean-shaven face was to them a badge of caste and distinction.

Alexander the Great commanded his soldiers to shave to prevent the enemy from seizing them by the beard. Peter the Great banished whiskers in an effort to make his barbaric nobles more civilized.

The Saxons wore walrus mustaches. William the Conqueror and his Normans were clean shaven, but the fierce Norsemen clung to flowing beards as evidence of strength and manhood.

In the time of Queen Elizabeth I, men spent hours perfuming, starching, curling with irons and quills, and dusting with orris powder the beards that were the subject of invective Puritan pamphlets.

Not until the Restoration (1660) did the razor come into daily use in England. Wigs of curls and ringlets then became the fashion for males. Charles II, who had returned from exile in the French Court, had a strong influence on men's fashions. He wore curls and a tiny mustache. His brother, who later became James II, was clean shaven. From the time of James II until the Battle of Waterloo in 1815, beards disappeared.

Some of the early explorers and first settlers of America wore whiskers or even full beards. When permanent settlements were made in the latter part of the seventeenth century and elegance of social order was established, wigs became fashionable and facial foliage was no longer cultivated.

All of the signers of the Declaration of Independence and of the Constitution were clean shaven. Of our first eight Presidents of the United States, all but James Monroe wore what were later known as sideburns, but none before Lincoln wore either beard or mustache—and Lincoln grew *his* beard between his nomination and inauguration.

There are several theories to explain the sudden flowering of hirsute adornments among American men. One is that following the war with Mexico (1846-47), men of the Army and Navy cultivated mustaches. The Gold Rush followed soon after with emphasis on the Far West. Pioneering days began all over again. Men found it difficult to shave in rugged surroundings, and there was the added feeling that hairiness indicated virility. In Victorian households a beard was a badge of authority.

With the exception of McKinley, all the Presidents from Grant through Taft had mustaches—four of them also being bearded. Facial hair was worn by men in all walks of life. Medical men adopted the beard as an occupational badge of professional competence. It is impossible to imagine Joseph Lister, founder of aseptic surgery, in the operating room without his hirsute adornments. Now, however, many medical men have discarded facial foliage in favor of sanitary operating masks. Most of the beards in surgery are those attached to patients.

Beards and mustaches, when worn, were cherished and pampered. While in vogue, great numbers of brushes, combs, curlers, dyes, oils, waxes, and

270. Earliest mustache spoon design found in U.S. Patent Office. U.S. Pat. No. 75,139, patented Mar. 3, 1868, by Solon Farrer, N.Y.C. A spring lifts the hinged cover for cleaning.

271. U.S. Pat. No. 135,141, patented Jan. 21, 1873, by Ellen B. A. Mitcheson, Philadelphia, Pa.

272. Winged and inclined mustache guard was the feature of the spoon patented Sept. 11, 1877 (U.S. Pat. No. 195,067), by Roger Williams, Yonkers, N.Y. Assigned to himself and Robert J. Anderson, N.Y.C.

273. Albert Furniss, Meriden, Conn., claimed his mustache guard, patented Nov. 13, 1877 (U.S. Pat. No. 197,028), could be "carried by the traveler and attached to a cup or spoon."

274. Davis G. Williams, Port Huron, Mich., patented this mustache spoon with sidehinged cover, July 10, 1883 (U.S. Pat. No. 280,985).

275. The projecting flange on the cover lifted the mustache, according to Isaac Warren Parmenter, N.Y.C., who patented it Jan. 1, 1884 (U.S. Pat. No. 291,394).

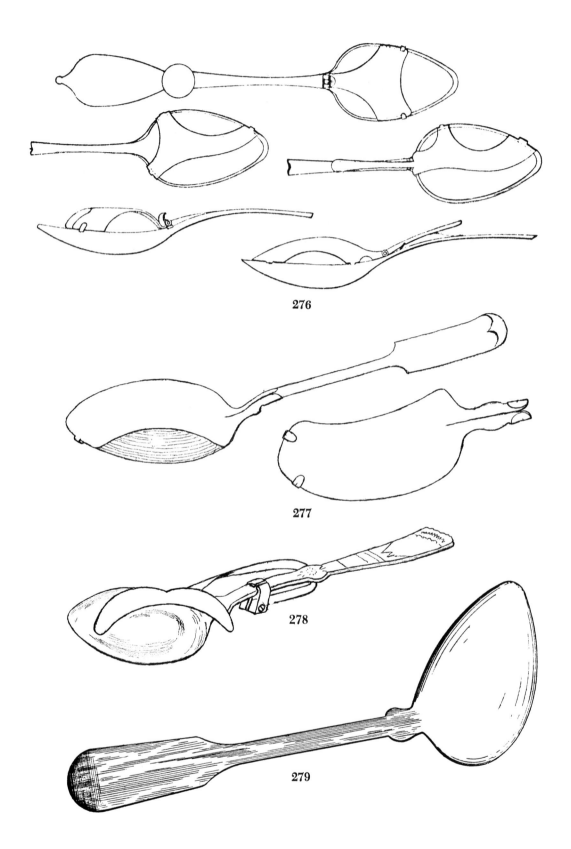

276

277

278

279

276. Patented by Julius Bergfels, Newark, N.J., May 6, 1884 (U.S. Pat. No. 298,159), and assigned to William H. Bergfels, this spoon features a variety of cover plates that may be pivoted and may also be provided with a spring-operated hinged arm.

277. Removable plate, patented by Lewis B. France, Denver, Colo., Aug. 4, 1885 (U.S. Pat. No. 323,802), was widely advertised in magazines.

278. Detachable mustache guard for the traveler. U.S. Pat. No. 411,988, patented Oct. 1, 1889, by May Evans Harrington, Oakland, Cal.

279. The "Etiquette" Spoon, patented July 8, 1890 (U.S. Pat. No. 431,914), by Isaac N. Plotts, Philadelphia, Pa.

THE "ETIQUETTE" SPOON.

Patented August 8, 1890.

The most perfect Moustache Spoon ever made.

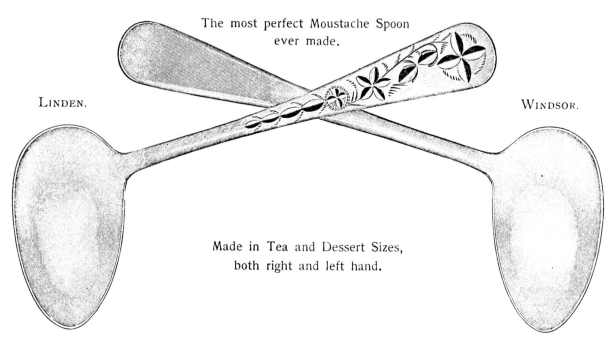

LINDEN.

WINDSOR.

Made in Tea and Dessert Sizes, both right and left hand.

280. Plotts' "Etiquette" spoon, marked "1847 Rogers Bros. ETIQUETTE PAT. 7● 8● 1890," and featured in their (undated) catalog.

mustache cups and spoons were devised (Figs. 270-290).

The whiskers vogue began to phase out around the mid-1880s. By 1885 to 1890, only the mustache was popular; by World War I, that too, had largely disappeared.

The decline of whiskers has been attributed partly to the hero worship of Richard Harding Davis, the well-barbered, strong-chinned, celebrated journalist. As star reporter of the New York *Sun*, Davis was the embodiment of a young man's dreams of early success. His friend, Charles Dana Gibson, famous

illustrator, used Dick's fresh, young, clean-shaven face as a model. He was the perfect companion to the cool, detached, and elegant Gibson Girl (Fig. 291).

Whiskers fell, and among the beneficiaries was King Camp Gillette, who conceived the idea of the safety razor in 1895 and first sold it commercially in 1904.

Before the safety razor was invented, men visited a barber shop every two or three days, or honed and stropped a straight-edged razor at home, enduring the inevitable nicks and cuts.

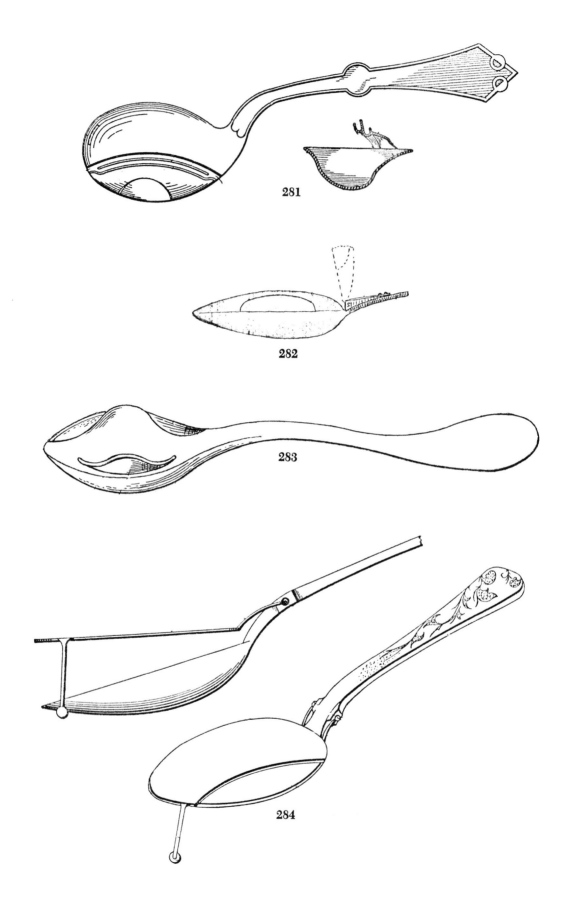

281

282

283

284

285

286

281. William S. O'Brien, San Francisco, Cal., patented this mustache spoon with curved handle and flanged cover, Aug. 11, 1891 (U.S. Pat. No. 457,748).

282. Mustache cap, patented by Phebe C. Goodwin, Boston, Mass., Sept. 27, 1892 (U.S. Pat. No. 483,379), has a spring hinge so that "spoon and cap can be cleansed.

283. James Frank Hilyard, Rancocas, N.J., patented this spoon Feb. 7, 1893 (U.S. Pat. No. 22,197); the flaring cover raised the mustache.

284. On Apr. 10, 1894 (U.S. Pat. No. 518,116), Carl A. Quentell, New Orleans, La., patented this spoon; a projection below the bowl automatically lifts the guard when dipped into a bowl of soup.

285. William F. Zapf, Cleveland, Ohio, patented this mustache spoon on Jan. 14, 1896 (U.S. Pat. No. 553,093), and assigned one-half to Charles B. Mann. The removable cover is thumb operated.

286. Sliding mustache guard patented by George A. Ring, Chicago, Ill., Mar. 28, 1899 (U.S. Pat. No. 621,944).

Since the dawn of civilization, no radical advance had been made in the method of removing a man's facial hair until the inventive genius of Gillette gave the world a safety razor with an inexpensive, replaceable blade that made shaving easy, comfortable, safe, and popular.

Currently, beards and mustaches are enjoying minor favor, especially among young men.

The one full beard, beloved by young and old, is worn by that portly gentleman with a twinkle in his eye—Santa Claus.

287

288

NOISELESS SOUP SPOON

NOISELESS SOUP SPOON

289

287. Mustache spoon with "tubular discharge-spout," patented Feb. 14, 1899 (U.S. Pat. No. 619,363), by Hugh Stevenson, N.Y.C.

288. Jesse A. Crandall, Brooklyn, N.Y., patented this spoon for "mustache wearers or for those apt to spill." The detachable cover has two lugs; one fits into a slot at the base of the handle, the other snaps over the end of the spoon. Assigned to Francis Raymond, Kings County, N.Y., Aug. 13, 1901 (U. Pat. No. 680,648).

289. NOISELESS SOUP SPOON, patented by Sterling H. Campbell (no relation to the famous soup firm), St. Louis, Mo., July 18, 1911 (U.S. Pat. No. 41,588).

290. Types of beards and mustaches reproduced from *The Gillette Blade,* courtesy the Gillette Company.

291. THE GREATEST GAME IN THE WORLD—HIS MOVE. Richard Harding Davis and the Gibson Girl, in *The Weaker Sex,* Charles Dana Gibson, *Charles Scribner's Sons,* 1903.

The windbreakers

The popular Burnside whiskers

Mid-Victorian Thackeray wore 'em.

The Viennese boulevardier

The immortal imperial

Showing the German influence

A real Vandyke

Egyptian chin stave was false

Here's the Assyrian aristocrat

What the Roman soldier had to comb out

The chiloolah of ould Erin

Beau Broadway of the 'seventies

The Mormon underslung pompadour

Here's the crop in full maturity

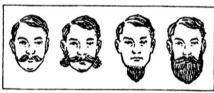

Street-car conductors used to issue transfers on which passengers were identified by types of beards and mustaches

Uncle Sam—and the goatee!

Luxurious Lord Dundreary type

THE GREATEST GAME IN THE WORLD—*HIS MOVE.*

292

293

294

295

296

Chapter Nine
Farms, Factories, and Plantations

Braintree, Massachusetts

Braintree, an industrial suburb of Boston (Fig. 292), is known for its manufacturing of shoes, rubber goods, and abrasive products. In its early days, Braintree was called Monoticut (meaning "abundance") by the Indians.

American Waltham Watch Company

The city of Waltham, Massachusetts, lies about nine miles west of Boston on the Charles River. For many years the city depended largely on the American Waltham Watch Company (Fig. 293) for employment. In 1957, when the watch division became a separate corporation called the Waltham Watch Company of Delaware, the old Waltham Watch Company's name was changed to Waltham Precision Instruments, Inc. Watches are no longer manufactured; aircraft clocks, elapsed time indicators, and other precision timing mechanisms, however, are being manufactured.

292. SHOE SALESMAN, Dean Southworth, Braintree, Mass. Apr. 12, 1892 (U.S. Pat. No. 21,463).

293. WALTHAM, Guy M. Spear, Waltham, Mass. & Austin T. Sylvester, Newtonville, Mass. June 2, 1891 (U.S. Pat. No. 20,789). The first spoon shown was manufactured. The drawing of the second spoon was cancelled Apr. 25, 1891.

294. COMMERCIAL TRAVELLERS HOME ASSOCIATION, Francis C. Hamilton, Syracuse, N.Y. July 17, 1894 (U.S. Pat. No. 23,462). Marked: "PATENTED July 17, 1894 by F. C. HAMILTON. NIAGARA SILVER CO. STERLING."

295. COMMERCIAL TRAVELLERS HOME ASSOCIATION, Benjamin T. Ash, Binghamton, N.Y. Oct. 16, 1894 (U.S. Pat. 23,689). Binghamton, N.Y. on handle. Cornerstone laid Oct. 19, 1894. Grand Lodge of Free and Accepted Masons, State of N.Y. In bowl: Commercial Travelers Home Association.

296. COMMERCIAL TRAVELLERS HOME ASSOCIATION, Seward D. Schenck, Binghamton, N.Y. Oct. 16, 1894 (U.S. Pat. No. 23,690). Marked: "STERLING Pat. Ap'd For."

Commercial Travellers Home Association

Spoons made to commemorate the opening of the Commercial Travellers Home Association (Figs. 294-296) are souvenirs of a dream that never materialized.

The Commercial Travellers fraternity had, for many years, discussed the need for a home for indigent members. The first definite action was taken on March 12, 1891, when a number of that group who were staying at the same hotel in Jamestown, New York, began a discussion that resulted in further meetings and the eventual formation of a charter committee.

Several sites were offered, but the citizens of Binghamton, New York, offered 100 acres of land and $15,000 in cash. Contracts were let, roadways laid out, and the foundation begun. On October 9, 1894, the cornerstone was laid with great celebration.

The reason the home was not built is not known, but apparently the group could not obtain enough money to complete the job.

On December 16, 1966, a Binghamton Public Works crew retrieved the 1,200-pound cornerstone from the crumbling foundation where it had been placed seventy-two years previously during what some authorities of that time called "the most auspicious occasion" in the history of Binghamton. The stone was removed to a site in front of City Hall and the land, once given to the Commercial Travellers, has been acquired by the city for residential use.

Sunny Jim—Force Cereal

Sunny Jim was one of the earliest breakfast cereals produced by the Force Food Company of Buffalo and New York City. The Sunny Jim trademark (Fig. 297) was registered January 24, 1905 (Figs. 298 & 299).

Buster Brown—Brown Shoe Company

The Brown Shoe Company was founded by George Warren Brown, A. L. Bryan, and J. B. Desnoyers in 1878. The business began in a small, two-story building on the St. Louis, Missouri, waterfront, taking the name Bryan, Brown & Company. Starting

The Autobiography of "Sunny Jim"

VIG-OR VIM "FORCE" Made him "Sunny Jim"
Per-fect Trim
adds daily deposits to health

IT WAS a girl who wrote the first, now famous, jingle of "Sunny Jim," and it was her girl chum who made the first drawing of the quaint figure which is so well-known. I am indebted to these two young women for my introduction to the public. This is the first jingle about me that was ever written, and is, therefore, the first chapter of my metrical biography :

"Jim Dumps was a most unfriendly man
Who lived his life on the hermit plan.
He'd never stop for a friendly smile,
But trudged along in his moody style,
'Till 'Force' one day was served to him —
Since then they call him 'Sunny Jim.' "

And this is the way it was served up to the public, who soon saw it in their newspapers, in the street cars, and on the walls and fences from New York to San Francisco —

It was through this verse and others like it, telling of the transformation of myself from Jim Dumps into "Sunny Jim," that the world became familiar with me and, as a consequence, with the food that made me sunny.

Almost as soon as I appeared thus as an apostle of the gospel of sunshine, came the demand for more verses and pictures dealing with my experiences.

It became necessary to call in the aid of other writers and illustrators — and soon nearly all of the popular contributors of verse and pictures whose names fill the contents tables of the magazines were engaged in furnishing chapters from my eventful life.

298. *The Ladies' Home Journal,* November 1903.

"Sun-ny Jim"

297. SUNNY JIM, trademark for breakfast foods, the Force Food Company, N.Y.C. and Buffalo, N.Y. registered Jan. 24, 1905 (U.S. Pat. No. 44,025).

299. SUNNY JIM. Marked: "N. F. Silver Co. 1877 (star)."

with five skilled shoemakers from New York, the company produced 150 pairs of shoes (only women's at that time) daily and achieved sales of $110,000 in the first year.

A few years later the name was changed to Brown-Desnoyers Shoe Company, and in 1893 to the Brown Shoe Company.

At the 1904 St. Louis World's Fair, the Brown Shoe Company received the only Double Grand Prize award to a shoe exhibitor. The Buster Brown Shoe (Fig. 300) line was introduced at the Fair and is now the oldest brand name in the children's shoe field. Rights to the name, Buster Brown, were obtained from F. W. Outcault, originator of the Buster Brown cartoon strip.

Prudential Company

When the Prudential Company began its insurance business in 1875 in Newark, New Jersey, it was called, "The Prudential Friendly Society." Two years later the name was changed to its present form.

John F. Dryden, secretary, was the driving force in the little stock company at the outset. It had taken Mr. Dryden years to convince others of his idea—insurance was needed in small amounts which working men could buy for a few cents a week, but finally, on October 13, 1875, the Prudential Friendly Society launched its first Weekly Premium insurance campaign. The bearded gentlemen of the audit department kept a close check on income and expenses, with the help of gas lights, high stools, and quill pens. In 1915 Prudential was changed from a stock to a mutual company.

Construction of the first Prudential Building at Broad and Bank Streets in Newark, New Jersey, began September 2, 1890, and was completed early in 1892. A parade and housewarming were held on December 2, 1892, with more than two thousand Prudential men in attendance. Badges bearing the date, December 2, 1892, were worn, and bamboo canes with pictures of four Senior Officers inserted in the head of each cane were carried. The festivities were inaugurated with a banquet at Delmonico's, New York, on December 1st, where these spoons were presented to guests as souvenirs (Figs. 301 & 302).

Horseshoe Bend—Altoona, Pennsylvania

Altoona, Pennsylvania, was settled in 1768 but saw very little growth until 1854 when the Pennsylvania Railroad line was completed westward into the city. Altoona became a division operating point and center for manufacture and repair for the railroad. The present shops are said to be the largest of their kind in the world. The railroad climbs the mountains there at a grade of ninety feet to the mile. Four miles west of Altoona is famous "Horeshoe Bend" (Fig. 303) which is recognized as one of the scenic wonders of the United States.

Connellsville Coke

Connellsville, Pennsylvania, was named for its founder, Zachariah Connell. Originally the site of a Shawnee Indian village, it was settled in 1770, incorporated as a borough in 1806, and chartered as a city in 1911. Once the center of an extensive coke-producing area, Connellsville (Fig. 304) is now a railroad center for the Baltimore & Ohio Railroad; its foremost industry is glassmaking.

Tampa Cigar

The first cigar factory established in the United States was at Suffield, Connecticut, in 1812. Between 1840 and 1875, cigar production from leaf tobacco was established in Florida.

Though cigar manufacture has become highly mechanized, the skilled hand-roller continues to take pride in his craftsmanship. Tampa (Fig. 305) manufactures more handmade cigars today than any other city in the world.

Citrus Fruit

Citrus fruits, cultivated for thousands of years, are native to tropical and subtropical southeast Asia. Long before their scientific value as a rich source of vitamins had been established, they were carried on long voyages to prevent scurvy. Columbus is believed to have planted the first citrus seeds in the Western Hemisphere between 1493 and 1496. Citrus fruits reached Florida (Fig. 306) by 1565; they were introduced into Arizona in 1707, and into California in 1769 (Fig 307).

Not too many years ago, oranges were considered a luxury in most American homes, and until the late 1800s, grapefruit were considered only ornaments (Fig. 308).

Buckeye

Among the finest of ornamental shade trees is the buckeye, native species of the horse-chestnut genus. There are six species of the buckeyes in the United States; five in the eastern part of the country and one in California. Only two of the native species reach sufficient size to be important in forestry (Fig 309).

Big Alice

The wealth of coal, iron ore, and limestone found in the Birmingham, Alabama, area has made it the greatest iron and steel manufacturing center in the South.

In 1879 Col. H. F. DeBardeleben and T. T. Hilman formed the Alice Furnace Co. Within the city limits

300

301

302

303

300. BUSTER BROWN, William A. Jameson, Niagara Falls, N.Y. Oct. 11, 1904 (U.S. Pat. No. 37,167). Marked: "EXTRA COIN SILVER PLATE."

301. PRUDENTIAL INSURANCE BUILDING, Benjamin J. Mayo, Newark, N.J. Nov. 17, 1891 (U.S. Pat. No. 21,175). The Gorham Corporation trademark. The patented handle design was not used. Gorham's famous "Versailles" pattern was used for this spoon.

302. THE PRUDENTIAL INSURANCE CO. OF AMERICA. Marked: "COPYRIGHTED." Gorham Corporation trademark. (Courtesy of The Prudential Insurance Company of America, Newark, N.J.)

303. HORSESHOE BEND, William W. Rudisill, Altoona, Pa. Jan. 5, 1892 (U.S, Pat. No. 21,284).

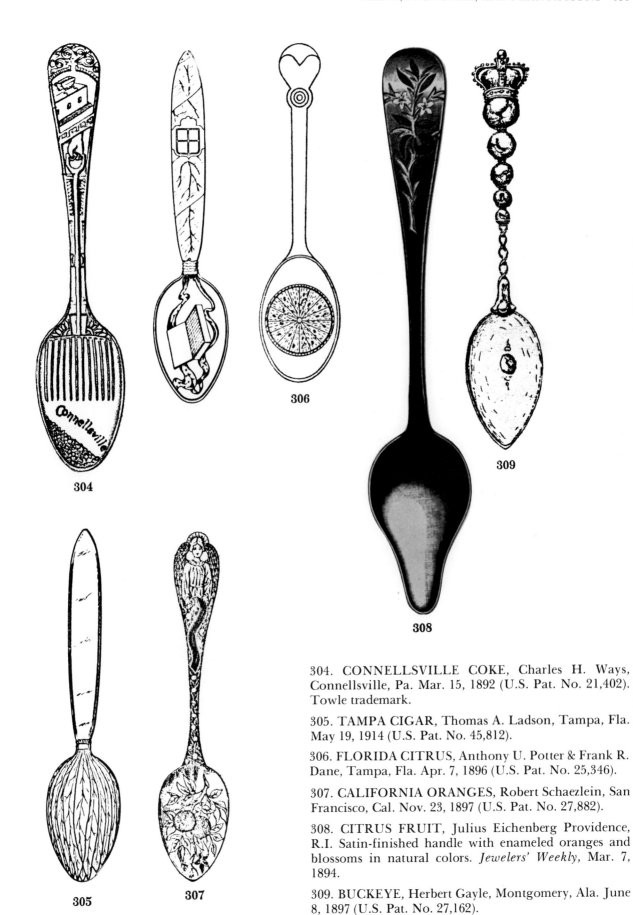

304

306

309

308

305 307

304. CONNELLSVILLE COKE, Charles H. Ways, Connellsville, Pa. Mar. 15, 1892 (U.S. Pat. No. 21,402). Towle trademark.

305. TAMPA CIGAR, Thomas A. Ladson, Tampa, Fla. May 19, 1914 (U.S. Pat. No. 45,812).

306. FLORIDA CITRUS, Anthony U. Potter & Frank R. Dane, Tampa, Fla. Apr. 7, 1896 (U.S. Pat. No. 25,346).

307. CALIFORNIA ORANGES, Robert Schaezlein, San Francisco, Cal. Nov. 23, 1897 (U.S. Pat. No. 27,882).

308. CITRUS FRUIT, Julius Eichenberg Providence, R.I. Satin-finished handle with enameled oranges and blossoms in natural colors. *Jewelers' Weekly*, Mar. 7, 1894.

309. BUCKEYE, Herbert Gayle, Montgomery, Ala. June 8, 1897 (U.S. Pat. No. 27,162).

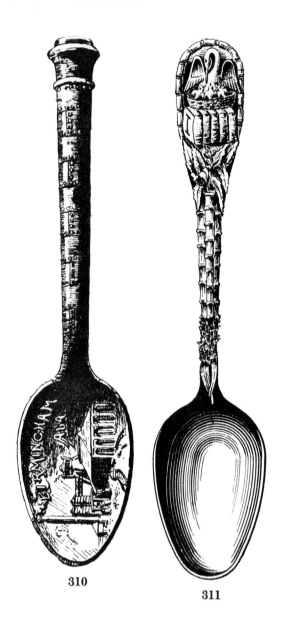

310

311

312

313

310. BIG ALICE, Harry Mercer, Birmingham, Ala. Nov. 3, 1891 (U.S. Pat. No 21,144.) Marked: "STERLING Pat. Ap'd for Harry Mercer." Similar spoon for Ironton, Ohio, has Paye and Baker trademark.

311. LOUISIANA, Maurice Scooler, New Orleans, La. Apr. 28, 1891 (U.S. Pat. No 20,698). Marked: "M. Scooler Pat. 1891. Wm. B. Durgin Co. trademark.

312. SHERWIN-WILLIAMS. Marked "STERLING." No trademark. (Collection of Pearl Gunnerson, Winter Park, Fla.)

313. For many years the Sherwin-William trademark was a chameleon mounted on an artist's palette. The second trademark was used around the turn of the century and evolved into the present (third) one. Close observation of the third will reveal that the world is askew, with its axis almost horizontal instead of vertical. The company wants its paint flowing from Cleveland, Ohio, their head-quarters, instead of from the North Pole.

of Birmingham, ground was broken for erection of the first furnace, "Alice No. 1," September 29, 1879. The furnace, with its sixty-three by fifteen-foot stack, was blown-in November 23, 1880. A record for that time, Alice No. 1's average daily output for the first year was fifty-three tons of foundry iron.

In 1881 the Alice Furnace Co. erected a second blast furnace, "Alice No. 2," more commonly called "Big Alice" (Fig. 310). This furnace established a twenty-four-hour production record for the South of 150 tons in 1886.

The success of the Alice Furnace Co. was significant in the development of the Birmingham district. It convinced Northern capital that the manufacture of iron with coke was practical.

Little Alice was dismantled in 1905, Big Alice, in 1929, but neither furnace is soon to be forgotten.

Louisiana—Pelican State

Louisiana, nicknamed the "Pelican State" because of the pelicans which live along the Gulf Coast, was named by the explorer, La Salle, in honor of King Louis XIV of France. The name, Louisiana, means "land of Louis."

The state seal (Fig. 311), with the pelican's head turned to its left and a nest of three young and its motto, "Union, Justice and Confidence," was adopted in 1902. The state flag also features a pelican feeding its young.

Louisiana's warm climate and fertile soil have long made it one of the most important agricultural states, its key products being cotton, sugar cane, and rice.

Sherwin-Williams Company

The present Sherwin-Williams Company, formed at Cleveland, Ohio, in 1866, grew from the partnership of Henry A. Sherwin, Truman Dunham, and G. 0. Griswold. Originally, only the ingredients for making paint were sold—white lead, oil, turpentine, pigments, etc.; customers mixed their own paint.

Henry Sherwin's main interest was to manufacture a ready-mixed paint while his partners were more interested in the linseed oil business. In 1870 the partnership dissolved, with Sherwin retaining the paint portion of the business.

Edward P. Williams joined Sherwin as a partner in Sherwin, Williams & Co. In 1880 the first "ready-to-apply" packaged paint was offered for sale; four years later the company was incorporated as The Sherwin-Williams Co.

The first Sherwin-Williams trademark was a chameleon mounted on an artist's palette. About the turn of the century a second trademark was used, which evolved into the familiar "Cover the Earth" trademark (Figs. 312 & 313). This symbol was conceded to be more than a modest exaggeration when adopted in 1905, since the company did very little exporting at the time. Walter H. Cottingham, Sherwin's general manager, suggested that the company adopt the symbol and "make it come true." A company tradition was born, and today "Cover the Earth" is registered in sixty six countries throughout the world.

La Belle Chocolatiére

La Belle Chocolatiére (Fig. 314), trademark of Baker's Chocolate, now a product of General Foods Corporation, is based on a painting, *La Belle Chocolatiére de Vienne*, by Jean-Etienne Liotard. It is said to be the portrait of a beautiful waitress (Fig. 315) in a Viennese chocolate shop. A young Austrian prince fell in love with her, and after they became engaged, he had her portrait painted as he had first seen her—serving chocolate.

In 1862, Henry L. Pierce, at that time owner of the Baker Company, had the painting copied to hang in the company offices. It was first used as a trademark for Walter Baker Chocolate in 1872. The painting now hangs in the General Foods offices in Dover, Delaware.

Albion, Indiana

The first farmers of North America were the Indians. Long before the coming of the white men, they had been raising beans, pumpkins, peppers, tobacco, and most of all, maize or Indian corn. This was most fortunate for the pioneers who arrived here in the early 1600s, for without the corn which they obtained from the Indians, the settlers in Jamestown and Plymouth would have starved during their first few winters in America.

Albion, Indiana (Fig. 316) is an agricultural city.

The Pabst Brewing Company

The Stanley and Camp Co. of Milwaukee, Wisconsin, had a souvenir spoon made which they named "Pabst" in honor of Captain Fred Pabst who had played an important role in the development of the city of Milwaukee, as well as being president of the Pabst Brewing Company (Figs. 317-319).

Jell-O

The history of gelatin desserts began in 1845 when Peter Cooper, inventor and patron of the arts and sciences, patented a gelatin dessert. However, he did nothing with the patent.

In 1895, Pearl B. Wait, manufacturer of cough medicine in LeRoy, New York, developed an adaptation of Cooper's gelatin dessert. His wife, May Davis Wait, coined the name "Jell-O," and production started early in 1897.

Registered
U. S. Pat. Office

314. LA BELLE CHOCOLATIERE. Registered trademark for Walter Baker Chocolate, first used in 1872.

315. LA BELLE CHOCOLATIERE.

The first campaign to advertise Jell-O Gelatin Dessert was launched in 1902. The "Jell-O Girl" made her debut two years later. The original was Elizabeth King, daughter of an artist who worked for the company's advertising agency. Her photograph appeared in magazine advertisements and store displays all over the country. In 1908 the "Jell-O Girl" was modernized by Rose O'Neill (of "Kewpie Doll" fame) and used as part of the package design (Fig. 320).

Saturday Night—Mount Clemens, Michigan

Mount Clemens, Michigan, was laid out in 1818 by Christian Clemens, for whom it was named. For some years, its main industry was the production of casks for the whalers of New Bedford, Massachusetts. A business drop-off was felt when whaling declined. In 1868, however, water from the local mineral springs was found to have medicinal properties; ever since, Mount Clemens (Fig. 321) has been a popular health resort.

The first mention of the use of bathtubs in the United States dates back to the early 1820s. During the 1830s an innovation took place in Philadelphia when the Stephen Girard Estate built a row of model homes, each having a bathtub. The Schuylkill Water Works provided the water supply for these at a rate of three dollars per year, per tub. An effort was made to ban tubs on the grounds that they were unsanitary; nevertheless Philadelphia and many other cities continued to install them.

In 1851, Harper and Gillespie of Philadelphia installed the first bathtub in the White House for President Fillmore.

Kalamazoo, Michigan

Originally called Bronson after its founder, Titus Bronson, Kalamazoo, Michigan, is an industrial center in a fertile agricultural region. The valley of the Kalamazoo River is well known for its production of celery (Fig. 322).

Knox Gelatine, Inc.

Charles B. Knox revolutionized gelatine cookery by placing on the market a granulated gelatine. Formerly, it had come in sheets which the housewife dissolved, or was made at home from beef bones—a laborious process.

The Knox Company celebrated its Diamond Jubilee at the 1964 World's Fair (Figs. 323-325).

Towle's Log Cabin Maple Syrup

The Towle Maple Syrup Company was founded by Patrick J. Towle, a wholesale grocer in Chicago. In 1887, he moved to St. Paul, Minnesota.

Mr. Towle had first blended coffee successfully;

316

317

318

316. RAT, Harman P. Rogers, Albion, Ind. July 6, 1909 (U.S. Pat. No. 40,122).

317. PABST, Arthur K. Camp, Milwaukee, Wis. Aug. 11, 1891 (U.S. Pat. No. 20,989).

318. PABST, Arthur K. Camp, Milwaukee, Wis. Aug. 11, 1891. Manufactured by the Wm. B. Durgin Co. (Courtesy of the Pabst Brewing Company, Milwaukee, Wis.)

319. Set of six Pabst spoons from the estate of Capt. Fred Pabst. (Courtesy of the Pabst Brewing Company, Milwaukee, Wis.)

320. JELL-O GIRL. No trademark.

321

322

323

321. SATURDAY NIGHT, George Chambers & Robert J. Stewart, Mount Clemens, Mich. May 8, 1906 (U.S. Pat. No. 37,989). Marked: "STERLING C & S Co."

322. KALAMAZOO CELERY, Frank P. D'Arcy, Kalamazoo, Mich. Dec. 6, 1892 (U.S. Pat. No. 22,029).

323. KNOX GELATINE. Used as an advertising premium.

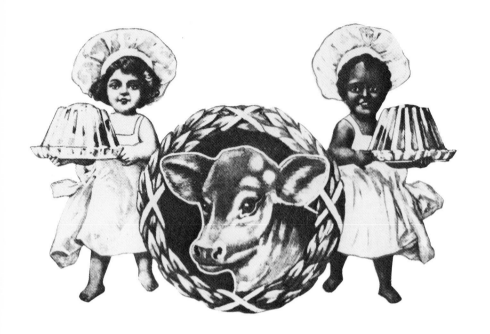

327

324. An early Knox Gelatine trademark. (Courtesy of Knox Gelatine, Inc., Johnstown, N.Y.)

325

325. KNOX GELATINE trademark (No. 47,652 registered Nov. 14, 1905, used since Oct. 8, 1890.

326. TOWLE'S LOG CABIN, James William Fuller, St. Paul, Minn. Feb. 18, 1896 (U.S. Pat. No. 25,169). No trademark.

327. TOWLE'S LOG CABIN. *Ladies' Home Journal,* Apr. 1904.

328. TOWLE'S LOG CABIN. Marked: "Towle, St. Paul, U.S.A. Pat. Jan. 14 '08."

326

328

later he blended maple and cane sugars into a formula which is still being used today, with improvements only in its processing (Figs. 326 & 327).

Patrick Towle's admiration for Abraham Lincoln led to the name, "Log Cabin" for his maple syrup and its cabin-shaped container. He and his associate J. W. Fuller, made the first tin log cabinshaped container by hand. The original handmade cans had paper labels bearing the trade name, "Towle's Log Cabin Maple Syrup" (Fig. 328).

In 1927 The Towle Maple Syrup Co. became the seventh member of the General Foods family.

The Pillsbury Company

Charles A. Pillsbury and two partners went into the flour milling business in 1869. The firm of Charles A. Pillsbury & Company was organized in 1871, with Charles A., his brother, father, and an uncle assuming complete ownership.

The Pillsbury Best trademark, the famous "XXXX" was adopted in 1872 (Figs. 329 & 330). Its roots go back almost 2,000 years to the early Christian era when, shortly after the death of Christ, millers and bakers adopted a XXX symbol for bread, each cross representing one of the crosses on Calvary. Medieval millers continued to use the XXX mark even after the original symbolism was lost. Charles A. Pillsbury heard the legend and said, "If three Xs mean the best, then we'll add another just to show that Pillsbury's Best is really THE best."

Duluth, Minnesota

Pierre Esprit Radisson and Médart Chouart, sieur de Groseilliers, French fur traders and explorers in the seventeenth century, visited the area which is now Duluth, Minnesota. Following them, Daniel Greysolon, Sieur Duluth or Dulhut, a French explorer, held a great Indian council at the same site in 1679 and raised the French flag. Other traders followed him. By 1817, a fur-trading post had been established there by John Jacob Astor.

The area was ceded by the Indians in 1855, plotted as the city of Duluth in 1856, and incorporated in 1870. The Duluth ship canal was cut through Minnesota Point in 1871.

Of the total iron-ore production of the United States, 87 percent comes from the Lake Superior district, most of which is from the great Minnesota iron-ore ranges north of Duluth (Fig. 331). The ore is brought from the Vermilion, Cuyuna, and Mesabi ranges of northeastern Minnesota and shipped to steel mills in lower lake ports.

Duluth shares the second largest port in the U.S. with Superior, Wisconsin, and has a harbor which can handle from 50 to 75 million tons a year, more

329 **330**

329. PILLSBURY spoon. Minnesota Historical Society, St. Paul, Minn. The Pillsbury Company trademark is featured in the bowl. The word "Pillsbury's" was first used in 1871 and the trademark about 1872. Gorham Co.

330. PILLSBURY spoon. Manufactured by the Gorham Corporation. Marked: "J. S. Allen & Co." In the bowl "Convention Hall and Exposition Building." (Collection of Astrid Schumacker, Bicknell, Ind.)

331

332

than 9,000 shiploads. Minnesota's iron ore and wheat are exported; coal is imported.

Joliet, Illinois

Joliet, Illinois, lies about 40 miles southwest of Chicago and is an industrial and trading center. Settled by Charles Read in 1831 and incorporated in 1836, the town, "Juliet," became the county seat of Will County. In 1845 it was renamed for Louis Joliet (Fig. 332), the Canadian explorer.

Avery

While a prisoner in Andersonville Prison during the Civil War, Robert H. Avery, Union soldier, conceived the idea for a corn planting machine. At the end of the war, he returned to his home in Galesburg, Illinois, and in 1869 produced a working model of the machine.

He and his brother formed a partnership under the firm name, R. H. & C. M. Avery and began the manufacture of the Avery Corn Planter. His machine gained a good reputation (Figs. 333 & 334).

In 1882, to facilitate the shipping of the machines, the business was moved to Peoria, Illinois. The Avery line was increased to include cultivators, small tools, and threshers. The firm name was changed to Avery Planter Company in 1883, then to Avery Mfg. Company in 1900. The company was purchased by Westinghouse in 1966; it now manufactures train brakes under the name W. E. B. Co.

Round Oak Stoves

Dowagiac, Michigan, which lies 35 miles southwest of Kalamazoo, is a tourist and summer resort as well as an industrial city. It was founded in 1838; the name, Dowagiac, is derived from the Indian, meaning, "place of many fishes."

In 1867 Philip D. Beckwith of Dowagiac fashioned the first Round Oak Stove (Figs. 335 & 336) for his own use. The next year he made several for a company in exchange for scrap iron; by 1869 he had

333. AVERY MANUFACTURING COMPANY. Reverse: "Avery Company 1919" and "Motor-Farming, Threshing and Road Building Machinery." Manufactured by Wm. Rogers & Son. (Collection of Astrid Schumacker, Bicknell, Ind.)

334. AVERY trademark, Avery Manufacturing Company, Peoria, Ill. Registered July 16, 1907 (U.S. Pat. No. 64,009).

335. ROUND OAK STOVE, George G. Greenburg, Chicago, Ill. June 2, 1903 (U.S. Pat. No. 36,342). "Round Oak Stoves, Ranges, Furnaces" appears on the reverse with "S. D. Childs & Co., Chicago." No trademark.

336. ROUND OAK STOVES. Marked: "S. D. CHILDS & CO., CHICAGO."

331. DULUTH, Chauncey E. Richardson, Duluth, Minn. June 7, 1892 (U.S. Pat. No. 21,602).

332. JOLIET, Chester B. Shepard, Melrose, Mass. Apr. 3, 1906 (U.S. Pat. No. 37,932). Assigned to George E. Feagans, Joliet, Ill. Shepard Mfg. Co.

AVERY
334

333

335

336

337

338

339

340

341

342

337. KANSAS CITY, Eugene G. E. Jaccard, Kansas City, Mo. June 2, 1891 (U.S. Pat. No. 20,804). Assigned to the Jaccard Watch & Jewelry Company, Kansas City, Mo. Manufactured by the Gorham Corporation exclusive to Jaccard Watch and Jewelry Company.

338. FORT COLLINS SUGAR BEET, Horace G. Petty, Fort Collins, Colo. Oct. 30, 1906 (U.S. Pat. No. 38,300). Marked: "PAT. OCT. 30-06-HGP STERLING."

339. BEEHIVE STATE, Leo Hollander, Salt Lake City, Utah. June 28, 1892 (U.S. Pat. No. 21,656).

340. CALIFORNIA BEAR, John Clulee, Wallingford, Conn. May 24, 1910 (U.S. Pat. No. 40,703). Assigned to Baldwin Jewelry Co., San Francisco. Manufactured by R. Wallace & Sons Mfg. Co.

341. L'ANGELUS, William B. Durgin, Concord, N.H. Apr. 21, 1891 (U.S. Pat. No. 20,686). Manufactured by the Wm. B. Durgin Co.

342. LARKIN SOAP MFG. CO. advertisement.

established the Round Oak Stove business employing a crew of eight.

The first stoves were wood-burning and exceptionally efficient. The Round Oak's reputation spread, and with some additions and improvements, the heating stove was adapted to burn soft coal. With the guarantee to burn any kind of fuel, sales became nationwide.

Kansas City, Missouri

Kansas City is Missouri's second largest city, the market place and manufacturing center for a vast area of the West and Southwest. It lies on the state's western boundary at the point where the Kansas River enters the Missouri River.

Large industries have developed out of the rich agricultural lands surrounding the city. It is a big livestock market and meat-packing center.

343

344

345

Kansas City's cable-car lines are said (in 1891) to have been the largest in the world (Fig. 337).

Fort Collins, Colorado

Fort Collins, Colorado, was organized in 1873. It is the center of production of sugar beets (Fig. 338) in Colorado, the nation's second largest sugar-beet producing state.

Livestock, especially cattle and sheep, are raised in large numbers in the area.

The Beehive State

Utah, "The Beehive State," takes its nickname from a symbol of the Church of Latter-Day Saints, whose leader, Brigham Young (Fig. 339), led the Mormons to Great Salt Lake in July 1847. Deseret, a word from the Book of Mormon, meaning "the

343. LARKIN. No trademarks. Some with gold-washed bowls.

344. AMERICAN DIAMOND INDUSTRY. *Jewelers' Weekly*, Apr. 1, 1896.

345. DENNIS THE MENACE. Marked: "© H R P Old Company Plate IS."

honeybee," was the name originally given to the territory.

The beehive was used on the territorial seal of Utah in 1850; it now appears on the Utah state seal. The name "Utah" is derived from the Ute Indian word meaning "people of the mountains."

California Bear

The name "California" is generally conceded to have come from a popular Spanish romance, *Las*

346 347 348 349

346. WOODY WOODPECKER. Marked: "© W. L. P. OLD COMPANY PLATE IS"

347. TONY THE TIGER. Marked: "© ® KELLOGG CO. OLD COMPANY PLATE IS 1965"

348. HUCKLEBERRY HOUND. Marked: "© H ●B P OLD COMPANY PLATE IS"

349. YOGI BEAR. Marked "© H ●B P OLD COMPANY PLATE IS."

sergas de Esplandiän, whose heroine was called Califia.

Its state flag was born from the "Bear Flag Revolt," an uprising of settlers against the Mexican government which took place at the Cosumnes River in 1846 (Fig. 340). The present-day flag was adopted in 1911; an earlier one, similar to it, included a star in the upper left corner, a bear in the center, and "California Republic."

The state seal includes 31 stars representing the number of states upon California's admission; the Goddess Minerva, typifying the political birth of California (which never went through the stage of being a territory); a California grizzly bear (now extinct), feeding upon clusters of grapes; a sheaf of wheat and a bunch of grapes, representing agriculture and horticulture; a miner; a ship, standing for commercial greatness; the snow-clad peaks of Sierra Nevada; and the Greek motto, "Eureka" (I Have Found It).

L'Angelus

The well-known painting, *L'Angelus,* by Jean Francois Millet (Fig. 341) portrays a peasant woman praying in the field.

Millet, a precocious youth, was born in a small French village in 1814. He studied in Paris, and during his mature period he concentrated on figure studies and groups at work, all relating to the religious and family life of the farm worker.

Larkin Soap Manfacturing Company

The Larkin Soap Manufacturing Company, Buffalo, New York, had its beginnings in 1875. Later, John D. Larkin and his brother-in-law, Elbert Hubbard, formed a partnership, with Larkin responsible for manufacturing and Hubbard in charge of sales promotion.

Hubbard introduced the idea of giving premiums to customers. Among the first of these was a set of six "solid silver" teaspoons. The ads stated "A REWARD OF $150 if the spoons are not what is known as the best quality of Solid Silver" (Fig. 342). Mr. Larkin knew nothing of the ads until customers complained that the spoons were "German silver" and not sterling as they had been led to believe. To each customer, Mr. Larkin sent solid sterling spoons with a letter of explanation and apology. He was noted for his integrity, and no false advertising was ever used by the company again (Fig. 343).

American Diamond Industry

A gift of Daniel Arthur, vice president of the Arthur Company of New York, to Miss Arthur, assistant treasurer, the spoon is a sterling sugar shell. It is in the "Luxembourg" pattern made by Reed & Barton, and has been gilded. In the center of each of the twelve blossoms in the engraved floral design is a brilliant diamond. Each stone was cut in one of the twelve factories that were supplied by the Arthur Company (Fig. 344).

Comic Strip Characters

Souvenir spoons featuring comic strip characters (Figs. 345-349), whose appeal is directed to children, are used as premiums, making it fun to eat breakfast cereal.

Chapter Ten
Once Upon a Time

Leatherstocking

Natty Bumpo, the Pathfinder, was the fictional hero of James Fenimore Cooper's *The Pioneers*, written in 1823. Cooper's hero was endowed with the qualities he himself admired: love of justice and truth, reverence, integrity, frankness, and courage. Five novels drawn in later years around this central figure became known as "The Leatherstocking Tales" (Fig. 350).

Cooper was born in 1789, a son of Judge William Cooper who founded Cooperstown, New York, in 1786. His early life was spent on his father's vast estate. He entered Yale at thirteen, spent three years in the navy, and married in 1811.

Cooper was the first writer to make use of the materials of American life and the details of American landscape. His novels of Indian and pioneer romances laid the cornerstone for a native American art. Some of his later novels used the sea as a background as did his nonfiction works, such as *A History of the Navy of the United States of America*, published in 1839.

His life spanned a period of immense social change which is reflected in his novels. His concern with the struggle of Indians and frontier white men against the encroachments of civilization places his novels among the great chronicles of American life and manners.

Hiawatha

It is difficult to separate the Indian hero of Henry Wadsworth Longfellow's poem, *The Song of Hiawatha*, from the real Hiawatha about whom so many legends grew (Figs. 351 & 352).

The true Hiawatha, a Mohawk Indian chief who founded the Iroquois Confederacy, lived about the middle of the sixteenth century in what is now central New York. He was a social reformer, interested in ending war and promoting universal peace among the Indian tribes.

Five of the Iroquois tribes formed the League of the Five Nations—the Senecas, Onondagas, Cayugas, Mohawks, and Oneidas—to which, later, the Tuscaroras were added. The league remained united and powerful until after the American Revolution. It still exists in a somewhat shadowy form.

Hiawatha's name and title were hereditary in the Tortoise clan of the Mohawk tribe. Longfellow collected stories about various Chippewa Indian heroes and incorporated them into his well-known poem.

Evangeline

Evangeline (Fig. 353) was the heroine of Longfellow's first long narrative poem which related the tragic history of two lovers, Evangeline and Gabriel.

The Evangeline Oak, on the bayou at the end of Port Street, in St. Martinville, Louisiana, marks the legendary spot where some of the Acadians landed after leaving eastern Canada. According to tradition, it was here that Emmeline Labiche and Louis Arceneaux, the Evangeline and Gabriel of the poem, met.

At the rear of St. Martin's Catholic Church is the grave of Emmeline Labiche, while nearby in the churchyard is the statue of Evangeline.

Diedrich Knickerbocker

Washington Irving's lighthearted *History of New York from the Beginning of the World to the End of the Dutch Dynasty* was the first outstanding American comic chronicle, a brilliant satire on history, politics, government, and manners. It was published in 1809, though Irving had begun it much earlier, with his brother Peter. Written under the pseudonym, Diedrich Knickerbocker, it preserves the rich flavor of Dutch life on the Hudson. The name is derived from Knicker, "to nod," and *Bocken*, "books"—in short, "nodders over books" (Figs. 354-356).

The authenticity of the *History* is the result of Irving's thorough knowledge of the city gained from boyhood rambles about the streets and docks, as well as his researches into old Dutch documents.

Rip Van Winkle and The Legend of Sleepy Hollow

In 1819 Washington Irving sent to the publishers the first number of *The Sketch Book of Geoffrey*

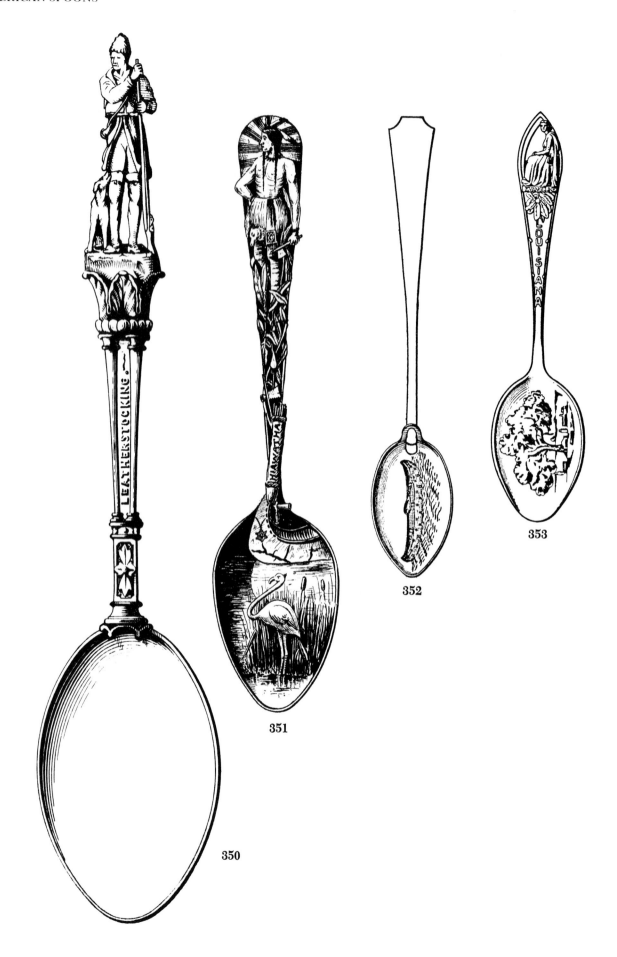

350

351

352

353

Crayon (pun intended) which, with the others that followed, eventually included *Rip Van Winkle* (Figs. 357 & 358) and *The Legend of Sleepy Hollow* (Fig. 359).

Irving did not invent the central incidences of either of these sketches—one was from a German, and one from an American source—but he so firmly localized the two stories in the Hudson Valley they seem to have been founded on folk legends. Irving's extraordinary ability to paint pictures with words inspired talented illustrators to give generations of readers their image of early New York state. Irving's characterizations of pompous Dutch burghers are filled with a kindly, chuckling humor, and his descriptions of landscapes have the golden look of perpetual autumns.

The White Canoe

The legend told in William Trumbull's poem, *The White Canoe*, has inspired painters and musicians. J. F. Brown's painting, *The Legend of the White Canoe*, in the Buffalo and Erie County Historical Society, was the direct source of the scene portrayed here (Figs. 360-362).

Wenolah, beautiful daughter of Kwasind, the proud and courageous chief of the Senecas, was demanded as a sacrifice by Meda, the medicine man, whose attentions she had spurned. As tribal medicine man, he sought his revenge in demanding the sacrifice of her life to restore prosperity to the tribe.

350. LEATHERSTOCKING, Charles R. Burch, Cooperstown, N.Y. June 2, 1891 (U.S. Pat. No. 20,793). Manufactured by the Gorham Corporation, exclusive to C. R. Burch & Brother. The figure of Leatherstocking, his dog and his gun, Killdeer, is a miniature of the statue erected to Cooper's memory on the shore of Lake Otsego, N.Y.—the "Glimmerglass" of his novels.

351. HIAWATHA, William B. Durgin, Concord, N.H. Apr. 14, 1891 (U.S. Pat. No. 20,673). Wm. B. Durgin Co. trademark.

352. BIRCH BARK CANOE, Edward Todd, Jr., N.Y.C. May 31, 1898 (U.S. Pat. No. 28,719). Assigned to Edward Todd & Co.

353. EVANGELINE, Edmund A. Davis, Attleboro, Mass. Jan. 24, 1950 (U.S. Pat. No. 156,943). Assigned to Edith E. Stickler, St. Martinville, La. Robbins Co.

354. DIEDRICH KNICKERBOCKER, John H. Johnston, N.Y.C. Feb. 3, 1891 (U.S. Pat. No. 20,495). Manufactured by the Wm. B. Durgin Co.

355. KNICKERBOCKER, Benjamin Marsh & Frederick Hoffman, Albany, N.Y. July 7, 1891 (U.S. Pat. No. 20,923). Manufactured by the Wm. B. Durgin Co.

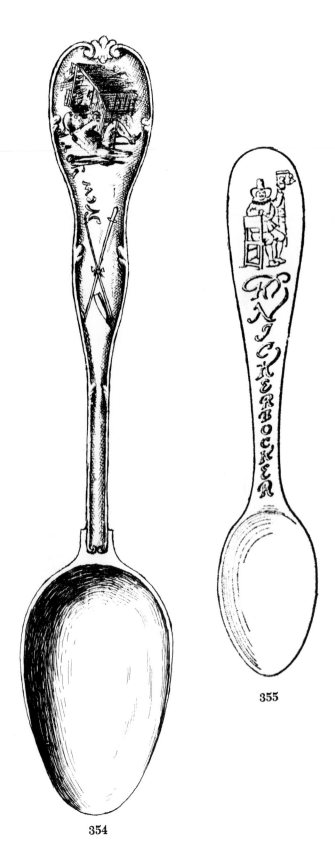

354

355

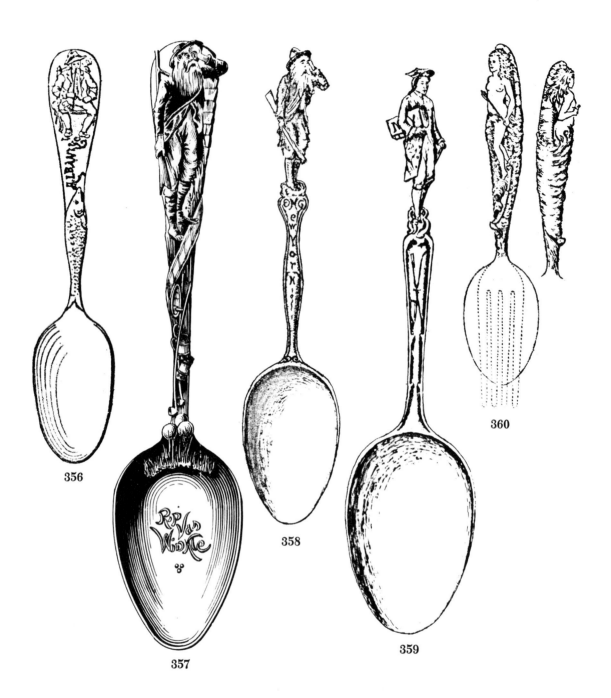

356. "KNICKERBOCKER" ALBANY, Benjamin Marsh, Albany, N.Y. July 21, 1891 (U.S. Pat. No. 20,948). Assigned to Marsh & Hoffman. Wm. B. Durgin Co. trademark. Marked: "Marsh & Hoffman Pat. Appl'd for."

357. RIP VAN WINKLE, William B. Durgin, Concord, N.H. Mar. 31, 1891 (U.S. Pat. No. 20,644). Wm. B. Durgin Co. trademark. Marked: "Pat. Mar. 31 '91."

358. RIP VAN WINKLE, John H. Johnston, N.Y.C. Feb. 3, 1891 (U.S. Pat. No. 20,493). Manufactured by the Wm. B. Durgin Co.

359. ICHABOD CRANE, John H. Johnston, N.Y.C. Feb. 3, 1891 (U.S. Pat. No. 20,496). Ichabod Crane, superstitious schoolmaster, was one of the many fictional characters in the *Legend of Sleepy Hollow*. His costume includes the knee britches, later more familiarly called "knickers."

360. THE WHITE CANOE, Chester B. Shepard, Melrose, Mass. Dec. 5, 1905 (U.S. Pat. No. 37,711).

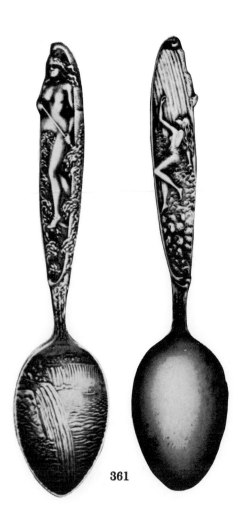

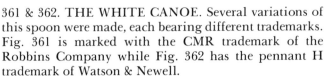

361 & 362. THE WHITE CANOE. Several variations of this spoon were made, each bearing different trademarks. Fig. 361 is marked with the CMR trademark of the Robbins Company while Fig. 362 has the pennant H trademark of Watson & Newell.

An only child, Wenolah was dear to her widowed father's heart. He was angry and bitter against the medicine man, but pride forced him to make the decision of sacrifice.

When the harvest moon rose on the scene of Niagara Falls and Wenolah in her white birch canoe was poised above the falls, about to perish, a second canoe burst into the onrushing cascade of waters. Kwasind, the heroic father, could not endure the thought that his daughter must go to her death alone.

Trilby

Trilby was the heroine in a novel written by George du Maurier in 1894. It is the story of a young artists' model, Trilby O'Farrell. She fell into the hands of Svengali, a Hungarian musician, who taught her singing under mesmeric influence. Under his spell, her singing was the most beautiful ever heard. When she sang in public, it was customary for her to put one of her dainty feet on a cushion in front of her (Fig. 363). She was appearing before the British public when Svengali, sitting in the stage-box, was fatally stricken. Trilby lost her voice entirely, and never regained it. She languished and died, beloved by everyone.

The name Trilby was given to all sorts of merchandise. A shoe manufacturer advertised ladies' shoes called "Trilby"—the first choice of milady who thought she had, or desired to have, a beautiful foot like Trilby O'Farrell's.

Brownies

Stories and drawings of Brownies (Fig. 364) first appeared in the *St. Nicholas Magazine* in 1883, brain children of bachelor Palmer Cox (Fig. 365).

The Brownies, a lovable and comical combination of gnomes and good fairies, roamed the world, filling many books with their adventures, and delighting the hearts of children and grownups alike.

Brownies were found on souvenir cups, paper cutouts, framed pictures, and figurines. Designs of twelve of the Brownie characters were patented by Cox, January 15, 1892, and sold to the Arnold Print Works to be printed on muslin for making stuffed dolls.

The Brownies attended the World's Columbian Exposition where they are portrayed riding the Ferris wheel (Fig 366). This, the first Ferris wheel, was built by G. W. Gale Ferris, mechanical engineer of Galesburg, Illinois. It was 250 feet in diameter and had thirty-six cars, each of which held sixty passengers. It was first used at the Columbian Exposition in 1893, then in St. Louis at the Louisiana Purchase Exposition in 1904. It was afterward dismantled and sold for scrap metal.

Ben Hur

Ben Hur, A Tale of the Christ, a popular novel by General Lewis Wallace, was published in 1880. The story begins with the journey of the three wise men to worship the Babe born in a manger in Bethlehem. The hero, Ben Hur, is involved in many exciting adventures and is eventually converted to the Christian faith.

Spectacular features of the story, such as the chariot race (Fig. 367), lent themselves to successful dramatization. The tremendous success of *Ben Hur* did a great deal to popularize historical novels.

Luna via Tampa

In 1865, when Jules Verne wrote *From the Earth to the Moon* and its sequel, *A Trip Around It*, he anticipated by ninety-three years man's first space travel. He selected Tampa, Florida (Fig. 368), as the launching site for American efforts—less than 100 air miles from Cape Canaveral (now Cape Kennedy), the actual launching site.

Verne's three intrepid explorers and two dogs circled the moon; when they were picked up after their splashdown in the Pacific, the men were nonchalantly playing dominoes!

His work, appearing at a time when even the first transcontinental railroad had not been completed, was dismissed as all-too-impossible science fiction.

Mary Poppins

The delightful story of the English nanny, Mary Poppins, was written by P. L. Travers and made into a movie by Walt Disney. For the musical movie, Richard M. and Robert B. Sherman composed

363

364

365

363. TRILBY, John W. Maillot, North Attleboro, Mass. June 25, 1895 (U.S. Pat. No. 24,417). Assigned to F. M. Whiting Co. Manufactured by F. M. Whiting Co.

364. BROWNIES, Henry J. Robinson, Washington, D.C. Oct. 30, 1894 (U.S. Pat. No. 23,747). Assigned to Rieman & Dawson. Manufactured by the Gorham Corporation exclusive to William Kendricks Sons.

365. COX'S BROWNIES, *Jewelers' Weekly*, Feb. 21, 1894.

366

367

368

369

370

366. COX'S BROWNIES, Ulysses Racine, Providence, R.I. Aug. 15, 1893 (U.S. Pat. No. 22,699). Assigned to Watson & Newell Co. Manufactured by Watson & Newell Co.

367. BEN HUR, Julius A. Oswald, Crawfordsville, Ind. Jan. 14, 1902 (U.S. Pat. No. 35,573). Portrait of General Wallace on handle. Shepard Mfg. Co.

368. LUNA VIA TAMPA, Sidney B. Leonardi, Tampa, Fla. Feb. 16, 1892 (U.S. Pat. No. 21,348). Marked: "STERLING S. B. LEONARDI & Co." Whiting trademark. As manufactured.

369. MARY POPPINS. Marked "© 1964 WALT DISNEY PRODUCTIONS IS."

370. MARY POPPINS. Marked: "WM. A. ROGERS ONEIDA LTD. © 1964 WALT DISNEY PRODUCTIONS"

fourteen new songs, the most popular of which was "A Spoonful of Sugar." When her little charges were faced with unwelcome chores, Mary Poppins (Figs. 369 & 370) sang "A spoonful of sugar helps the medicine go down."

371

372

373

374

371. HAPPY NEW YEAR, F. M. Van Etten N.Y.C.
Jewelers' Weekly, Nov. 27, 1895.

372. 1900, Carl G. Schmidt, St. John, Canada. Jan. 9, 1900
(U.S. Pat. No. 32,082).

373. 1903, Solomon Ruby, St Louis, Mo. Sept 17, 1901
(U.S. Pat. No. 35,091).

374. 1914, Charles F. Simms, Attleboro, Mass. Jan. 13,
1914 (U.S. Pat. No. 45,159).

Chapter Eleven
Every Day's a Holiday

Every day is a holiday somewhere, or at least a festival or special day for someone. Every country, city, and state has its holidays, many of religious significance. From these church festivals, the word "holiday," or "holy day," is derived.

New Year's Day

New Year's Day is the most universally celebrated of all holidays (Fig. 371). In ancient times the beginning of the year depended on seasonal and religious observances within individuseasons marked beginnings and endings for primitive man.

By 1700, most European countries had adopted the Gregorian calendar which established New Year's Day as January 1, but England and the British colonies did not change until 1752.

The Jewish New Year may vary from September 6 to October 5. The Chinese New Year may occur at any time between January 21 and February 19, and ends with the Feast of Lanterns. In Japan, the New Year is the beginning of a new life. All debts must be paid before the last day of the old year and the home thoroughly cleaned. New Year's Day itself is the occasion for gifts, new clothing, new household articles, and special foods.

In many countries, New Year's Day is the occasion for gift-giving. These silver spoons (Figs. 372-374) would be appropriate. The one dated "1914" could easily be adapted to a particular location by the addition of a city or college seal.

Valentine's Day

Since the fourteenth century, Valentine's Day has been dedicated to lovers and is traditionally observed by sending messages and gifts (Fig. 375), usually employing the motif of a red heart.

At the old Roman February feast called the Lupercalia, young people drew partners by lot. This ancient festival custom was later associated with the name of a Christian bishop, Saint Valentine, who was martyred on February 14, 271.

In Roman mythology, Cupid (Fig. 376) (Eros, in Greek mythology), was the son of Venus, the goddess of love. A wound from one of his arrows (Figs. 377 & 378) made a person fall in love. When Cupid was wounded by one of his own arrows and fell in love

375. PHILOPENA, literally, "much loved." Later, the name given a game of forfeit on the order of "Post Office." (*Jewelers' Weekly*, Sept. 28, 1892)

The Philopena Spoon

DAINTILY CONVEYS AN EXPRESSION OF SENTIMENT.

PATENT PENDING

Made only by HOWARD STERLING COMPANY 7 EDDY ST, Providence R I

Bowls decorated with special scene or motto without extra charge if twelve dozen are ordered.

376

377

378

379

380

381

with a mortal princess named Psyche, the gods made her immortal so that they could be together forever.

To tell if one's love be true, take an evening primrose (Fig. 379), cut off the stamens and lay the flower in a secret place where no human eye can see. Throughout the day and night, dream of one's love and if, by morn, the stamens have regrown to their former length, success will attend in love; if not, only disappointment follows.

The choosing of a valentine means eventually a wedding (Fig. 380) and hopefully, many happy anniversaries (Figs. 381 & 382) to follow.

Easter

Three traditions converge in the celebration of Easter: the *pagan* festival of spring at the vernal equinox when nature arises from winter sleep; the *Hebrew* Passover—in the twelfth chapter of Exodus the story is told of the angel of death who "passed over" the dwellings of the Israelites, sparing their first-born; and the *Christian* celebration of the resurrection (Fig. 383) of Christ after the crucifixion.

The word Easter, derived from "Ostera" or "Ostre," indicates the original relationship between this most joyous of Christian festivals and pagan celebrations in honor of the Anglo-Saxon goddess of spring.

The egg (Figs. 384-386), a symbol of continuing life, is mentioned in the folklore of Europe, Asia, and ancient Egypt. Roasted eggs are served at the Seder Feast of great family reunion in celebration of the Jewish Passover.

Flowers, representative of the renewal of life, have been a part of the rites and observances of the vernal equinox longer than written history.

Anemone coronaria (Fig. 387), the poppy anemone or windflower, is the "lily of the field" in the Bible. The use of *Lilium longiflorum var. eximium,* the

Easter Lily (Fig. 388) (often called "Bermuda lily," although not native there), is of recent use.

Derby Day

Each year, on the first Saturday in May, the eyes of the nation are focused on Louisville, Kentucky, when, at Churchill Downs, horses of the famed Bluegrass are led to the starting gate to the strains of "My Old Kentucky Home." This is Derby Day (Fig. 389) and a wreath of roses awaits the winner. Copied after the Epsom Downs Derby of England, this U.S. racing classic began in 1875.

Kentucky produces two-thirds of the nation's burley tobacco, which forms the design of the spoon lady's gown.

Independence Day

The Fourth of July, often called Independence Day, is the most important secular holiday in the United States. It celebrates the anniversary of the adoption, by the Continental Congress, of the Declaration of Independence, which broke the ties between the American colonies and England.

The historic bell (Fig. 390) in Independence Hall, Philadelphia, was first cast in England in 1751. It arrived safely in Philadelphia but cracked while it was being tested. It was recast with additional copper to make it less brittle. The second bell proved defective, and again it was recast. The third bell was hung in the State House tower and rung for the first time on August 27, 1753, to convene the Assembly. The most famous occasion for ringing the bell was July 8, 1776, when the Declaration of Independence, adopted four days earlier by the Continental Congress, was proclaimed. After it was rung for the proclamation of peace, April 16, 1783, it was known as the Independence Bell. It rang for every festival and anniversary until July 8, 1835. On that day it cracked while being tolled during the funeral of Chief Justice John Marshall. Once again it was repaired. It received its present name, the Liberty Bell, during the anti-slavery movement of 1839. After ringing in 1846, on Washington's Birthday, it suddenly cracked beyond repair. Now it hangs in a frame above a small platform in Independence Hall.

The name, Uncle Sam (Figs. 391 & 392), symbol of our independent nation, was derived from a real person. Samuel Wilson, always called Uncle Sam by family and friends, was a government inspector appointed to receive large shipments of supplies for the army in 1812. These stores were marked with the initials of the contractor, Elbert Anderson (E.A.) above, and those of the country, United States (U.S.), below. A facetious workman said that the initials stood for Elbert Anderson and Uncle Sam. This was repeated until it became widespread. So, Uncle Sam became the symbol of the United States government.

376. CUPID, Mary E. Gilbreth, Boston, Mass. Dec. 8, 1891 (U.S. Pat. No. 21,225).

377. LOVE, Edgar L. Everett, Troy, N.Y. Sept. 15, 1891 (U.S. Pat. No. 21,034). Shiebler Mfg. Co.

378. ARROW AND HEART, Chauncey Cassidy, Great Falls, Mont. May 22, 1928 (U.S. Pat. No. 75,211).

379. EVENING PRIMROSE AND HEART, Edwin N. Denison, Westerly, R.I. Mar. 22, 1892 (U.S. Pat. No. 21,422).

380. BRIDAL COUPLE, Robert L. Carnes, Winchester, Va. Oct. 30, 1962 (U.S. Pat. No. 193,948).

381. TWENTY-FIFTH ANNIVERSARY, Russell G. Schmitz & Vincent M. Vesely, Silver City, N.M. May 24, 1960 (U.S. Pat. No. 188,022). According to the designers, this spoon has not yet been made.

382

383

384

385

386

387

The Veiled Prophet

The theme of the Veiled Prophet (Figs. 393 & 394), a gay autumnal holiday pageant held each year in St. Louis, Missouri, is based loosely on *Lalla Rookh*, by Thomas Moore, published in 1817. The story tells of the journey of Lalla Rookh, an Indian princess, on her way to Cashmere to marry the young king. A Cashmerian poet, Feramorz, accompanies her party and entertains the princess with four narrative poems dealing with romantic themes of love and liberty. Lalla Rookh finds herself falling in love with the poet and is delighted to find that he is actually her future bridegroom. *The Veiled Prophet of Khorassan* is the first of the four poems. Pretending to be a god, the prophet wears a mask, presumably to hide the brilliance of his face, but more probably to conceal disfigurements incurred in battle.

The Veiled Prophet celebration in St. Louis, which began in 1878, was originally part of the Fall Festival of Fair Week. At first, a street parade and a ball were held on the same night. As the city grew and the parade became longer, it became necessary to hold the parade and the ball on successive nights.

The Veiled Prophet ball is the greatest of social events. Invitations come from no one knows where; only the elect of the social world are invited. The custom of sending a souvenir with each invitation persists, and even the invitations, which are works of art, are treasured. The parade is open to the public and draws a huge crowd no matter what the weather.

A mysterious prophet, with his queen, court, and order of knights, rules over the two-day carnival, parade, and ball. The secrecy which surrounds the pageant makes it doubly attractive and has never been violated.

382. ANNIVERSARY, Axel Stokby, N.Y.C. July 30, 1946 (U.S. Pat. No. 145,339). Assigned to the Danish Trading Company, Inc.

383. EASTER—THE RESURRECTION, Creasey J. Whellams & Alfred G. Pinkham, St. Paul, Minn. Aug. 11, 1908 (U.S. Pat. No. 39,440).

384. EASTER CHICK-IN-EGG, George E. Homer, Boston, Mass. June 19, 1894 (U.S. Pat. No. 23,379).

385. Coffee spoon size "chick-in-egg" with design identical to U.S. Pat. No. 23,379. Marked "Sterling."

386. Slightly larger coffee spoon than shown in Fig. 385, differing slightly from U.S. Pat. No. 23,379. Marked "PAT. 94" and "STERLING PLATE."

387. EASTER CROSS, William C. Codman, Providence, R.I. Feb. 18, 1913 (U.S. Pat. No. 43,565). Assigned to the Gorham Manufacturing Company.

Thanksgiving

Thanksgiving Day (Fig. 395) was first observed by the Pilgrims in the fall of 1621, when Governor William Bradford of Plymouth Colony appointed a day for feasting and thanksgiving. It was frequently repeated, especially in New England, during the colonial period.

Thanksgiving was set by Presidential proclamation until 1941, when Congress passed a resolution making it the fourth Thursday of November.

388. EASTER LILY, George E. Nerney, Attleboro, Mass. Feb. 11, 1913 (U.S. Pat. No. 43,550). Charles M. Robbins Company trademark.

389. DERBY DAY, Alma F. Koch, Louisville, Ky. June 13, 1893 (U.S. Pat. No. 22,526). The back of the bowl is decorated with the Kentucky coat of arms. Probably issued in commemoration of the Kentucky Statehood Centennial in 1892.

388

389

390

391

392

393

394

390. LIBERTY BELL, William H. Jamouneau, Newark, N.J. July 28, 1891 (U.S. Pat. No. 20,967). Simons, Bros. & Co. trademark.

391. UNCLE SAM, Henry C. Karr, Washington, D.C. May 26, 1891 (U.S. Pat. No. 20,781). Marked: "J. Karr, Washington, D.C." Also made with the United States Capitol Building in the bowl.

392. UNCLE SAM. Marked: "PAT. APD FOR." Others of the same style have the mark of Alvin Manufacturing Company. Made with plain bowl or with United States Capitol or with the United States flag with a Liberty Cap atop the staff in bowl.

393 & 394. VEILED PROPHET, Rolla W. Hess, St. Louis, Mo. Apr. 21, 1891 (U.S. Pat. Nos. 20,682 & 20,683). Manufactured by the Gorham Corporation, exclusive to Hess & Culbertson, St. Louis.

395. THANKSGIVING, F. A. Dowling, Cleveland, Ohio. Sept. 12, 1893 (U.S. Pat. No. 22,778).

396. MERRY CHRISTMAS, Francis Van Etten, Buffalo, N.Y. Aug. 21, 1912 (U.S. Pat. No. 42,935). Back and front views. R. Wallace Mfg. Co.

397. MADONNA, Caroline Bunker, Providence, R.I. Dec. 15, 1891 (U.S. Pat. No. 21,240). Howard Co.

398. MERRY CHRISTMAS, George U. Roulet, Toledo, Ohio. Dec. 20, 1892 (U.S. Pat. No. 22,059). Howard Sterling Company trademark.

Christmas

Christmas, the festival celebrating the birth of Christ (Figs. 396-399), is one of the most cherished holidays throughout the Christian world.

The name is derived from "Mass of Christ," and was originally a church holy day. It has now become also a day of secular festivity, marked by the exchange of gifts, feasting, and other manifestations of joy and good will.

The shift in emphasis from the holy aspect to one concerned more with merriment is illustrated in the popular greeting, "Merry Christmas." Originally, the word "merry" did not mean joyful as it does today. It meant "peaceful," an expression of spiritual joys rather than earthly ones. The carol, "God rest you merry, gentlemen," illustrates the original meaning. The position of the comma shows that the word is not an adjective modifying "gentlemen." The true meaning is then "God rest you peacefully, gentlemen," and not, "God rest you, joyful gentlemen."

With the Reformation in the sixteenth century there was a sharp reduction in Christmas celebrations; in many countries all that remained was a sermon and a prayer service. Some, including the German Lutherans, continued to celebrate Christmas in a deeply spiritual way. In England, the Puritans were determined to abolish Christmas altogether as it was their contention that no feast of human institution should outrank the "sabbath" (Sunday). Strict ordinances were issued against celebrating Christmas, and punishment for doing so was severe. With the restoration of the Monarchy (1600), old Christmas returned. Actually it was a "new" Christmas because the old traditions of religious observances had disappeared from English homes; all that was left was boisterous revelry and bouts of gluttony.

Misdirected zeal against Christmas persisted in America, where its celebration was outlawed in New England until the middle of the nineteenth century. Governor Bradford recorded that "no man rested all day" on December 25, 1620, though our Pilgrim Fathers had observed the most rigid Sabbath-rest on the preceding day, which was Sunday. As late as 1870, public schools held classes on Christmas Day.

With the arrival in America of large numbers of Irish and German people, about 1850, Christmas as we know it today began to flourish. The Germans brought their beloved Christmas tree (Fig. 400), and the Irish contributed the ancient Gaelic custom of lighted windows. Both groups brought the crèche, carols and hymns, three Masses on Christmas Day with obligatory attendance and abstention from regular work on Christmas Day. Despite dire warnings of clergymen, people of all faiths turned to the revival of a deeper and richer observance of Christmas. Old traditions from many countries have been blended with modern ones (Figs. 401-403).

The Christmas tree came to this country with the first wave of German Protestants from the Palatinate who settled in western Pennsylvania. The second large German group, both Catholic and Protestant, came about 1830 and settled in New York, New England, Ohio, Wisconsin, and other parts of the country. Their custom of the Christmas tree spread so rapidly that what was called a "new German toy" by Charles Dickens in 1850, was termed "old-fashioned" by President Harrison in 1891, when he spoke to reporters about the Christmas celebration at the White House.

The present concept of Santa Claus is American (Figs. 404-408), having been first illustrated by Thomas Nast, political cartoonist, in *Harper's Weekly* in 1863 (Fig. 409). Here Santa Claus is represented as a combination of Father Christmas and St. Nicholas, special guardian of maidens, children, merchants, sailors, and scholars. No doubt Nast was influenced by the poem by Dr. Clement Clarke Moore, "The Visit of Saint Nicholas," in which Saint Nicholas resembled a jolly elf.

Happy Birthday

Everyone has a birthday—a day each of us may consider his own "special day." Recent probability studies of what mathematicians call the birthday paradox show that, in a random group of 23 persons, the chances are about even that two of these persons were born on the same day of the same month! The probability increases with a larger group so that in a group of 50, the chances are more than 97 out of 100.

399. MADONNA. Marked: "Mayer Bros." with 'crossed-tools' trademark.

400. SANTA CLAUS AND CHRISTMAS TREE, Justus Verschuur, Jersey City, N.J. Feb. 7, 1893 (U.S. Pat. No. 22,196). Assigned to J. H. Johnston, N.Y.C. Manufactured by the Alvin Manufacturing Company.

401. CHRISTMAS, manufactured by the Gorham Manufacturing Company. The holly and mistletoe are enameled in natural colors. *Jewelers' Weekly*, Nov. 27, 1895.

402. MERRY CHRISTMAS, manufactured by R. Wallace & Sons Manufacturing Company. *Jewelers' Weekly*, Nov. 27, 1895.

403. CHRISTMAS, F. M. Van Etten, N.Y.C. *Jewelers' Weekly*, Nov. 27, 1895.

404. THE NIGHT BEFORE CHRISTMAS, Francis M. Van Etten, N.Y.C. July 4, 1899 (U.S. Pat. No. 31,117). No trademark. The reverse shows many of the symbols associated with the New Year. Marked: "PAT. APPLIED FOR." Silverplate.

399

400

401

402

403

404

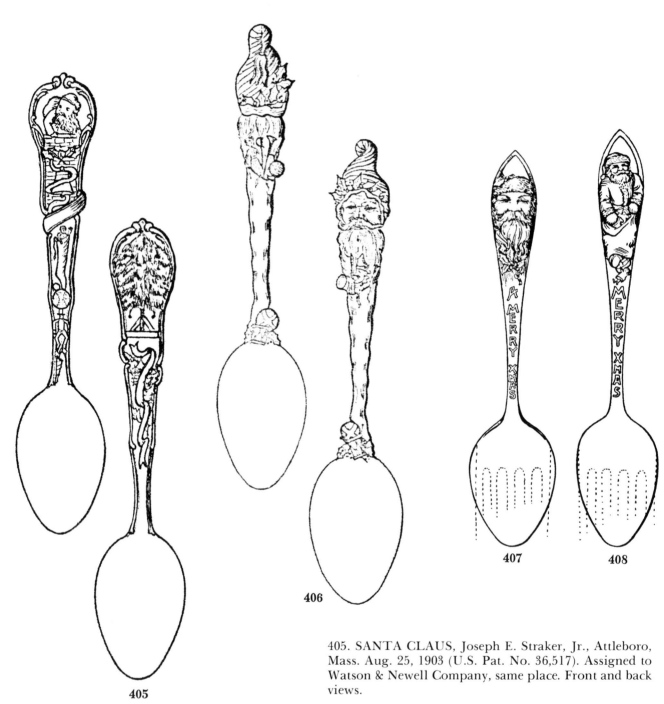

405

406

407

408

405. SANTA CLAUS, Joseph E. Straker, Jr., Attleboro, Mass. Aug. 25, 1903 (U.S. Pat. No. 36,517). Assigned to Watson & Newell Company, same place. Front and back views.

406. SANTA CLAUS, Eustace Crees & Charles S. Court, Providence, R.I. Aug. 7, 1903 (U.S. Pat. No. 36,471). Assigned to Watson & Newell Company, same place. Watson & Newell banner trademark. Front and back views.

407. SANTA CLAUS, George E. Nerney, Attleboro, Mass. Feb. 11, 1913 (U.S. Pat. No. 43,545). Robbins Company trademark.

408. SANTA CLAUS, George E. Nerney, Attleboro, Mass. Feb. 11, 1913 (U.S. Pat. No. 43,546). Robbins Company trademark.

409. First illustration of Santa Claus, by Thomas Nast, *Harper's Weekly*, Jan. 3, 1863.

Each of us, then, shares his special day with people all over the world.

The custom of giving spoons for birthdays and christenings is an ancient one. Gift spoons with the sign of the zodiac or the birthstone of the recipient are undoubtedly derived from Apostle spoons which were popular as christening gifts from the latter part of the fifteenth century till the middle of the seventeenth century. If only one spoon were given, it usually had the figure of the Apostle or saint whose anniversary came nearest in the calendar to the birth or christening. Apostle spoons (Fig. 410) as christening gifts are out of fashion, but the custom of giving zodiac (Fig. 411-423) or birthstone spoons continues.

Ancient peoples believed that the motions of the planets and the moon controlled the fates of men. They identified twelve constellations in the celestial band through which the sun passes through the stars. This band is called the zodiac, from the Greek terms meaning a "circle of animals." The division of the zodiac into twelve parts was suggested by the twelve reappearances of the moon in a year and seems to have originated with Chaldean astronomers about 2100 B.C.

The constellations bear the names of the animals assigned to each and are usually known by their Latin names. The spring signs, Aries, the Ram; Taurus, the Bull; and Gemini, the Twins, coincide with the birth of young animals. Cancer, the Crab, denotes that time when the sun appears to move backward in the sky. Leo, the Lion, marks the fierce heat of summer, and Virgo, the Virgin, gleaning corn, symbolizes the harvest. When the sun is in Libra, the Balance, the day and night are about the same length and balance each other. Scorpio, the Scorpion, marks the presence of venomous reptiles in October. Sagittarius, the Archer, symbolizes the hunting season. Capricornus, the Goat, marks the return of the sun to the North; Aquarius, the Water Bearer, symbolizes winter rains, and Pisces, the Fishes, the season of fishes.

Each zodiacal month has its own gemstone (Figs. 424 & 425), and those born in that period were

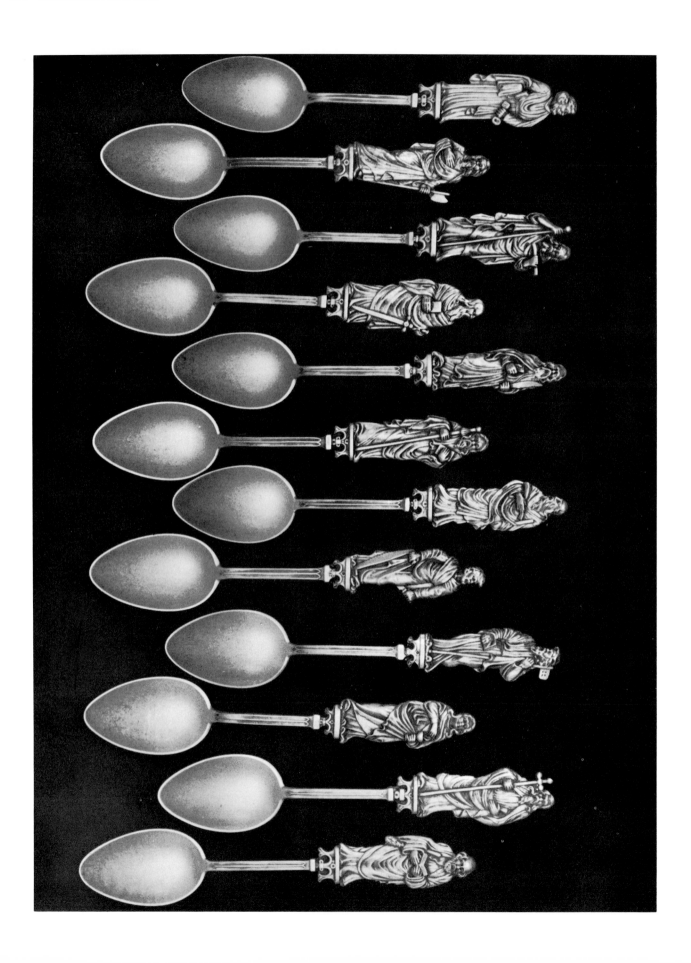

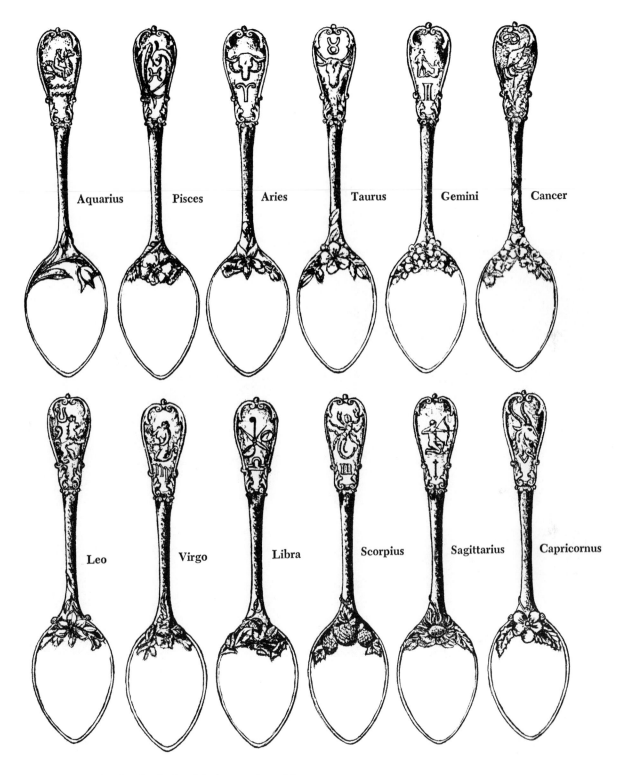

410. APOSTLE SPOONS. Marked with 'crossed-tools' trademark of Joseph Mayer & Bros., Seattle, Wash. (now E. J. Towle Co.). From left to right: St. Peter, St. Matthew, St. Thomas, St. Paul, St. Bartholomew, St. James the Greater, St. Andrews, St. Simon Zelotes, St. James the Minor, St. John, St. Philip, and St. Jude.

411-422. ZODIAC SPOONS, Wallace Durand, Newark, N.J. Mar. 20, 1894 (U.S. Pat. Nos. 23,119-23,130). Manufactured by the Gorham Corporation.

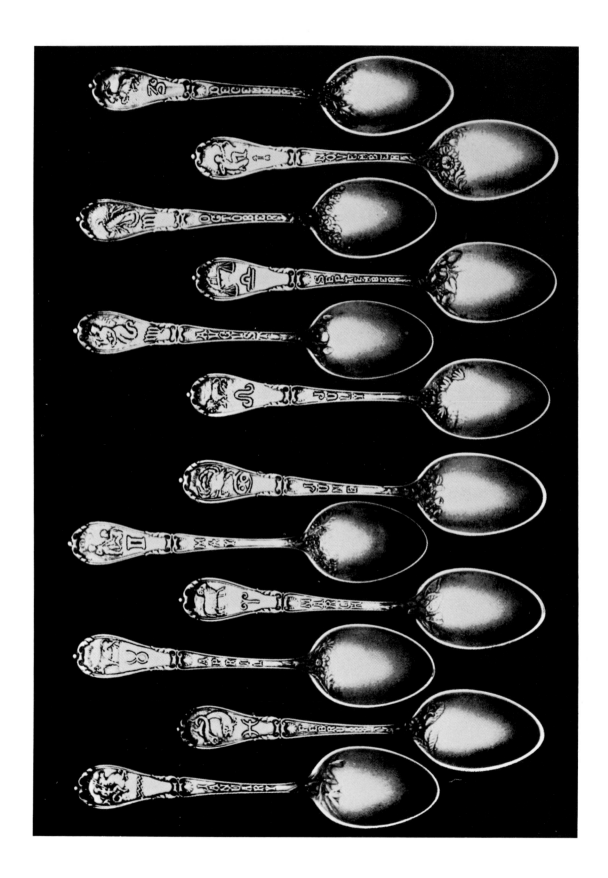

423

MONTH	BIRTHSTONE	MEANING	FLOWER
January	Garnet	Constancy and fidelity	Snowdrop
February	Amethyst	Sincerity	Primrose
March	Aquamarine or bloodstone	Courage and presence of mind	Violet
April	Diamond	Innocence	Daisy
May	Emerald	Success in Love	Hawthorne
June	Moonstone, agate, or pearl	Health and long life	Honeysuckle
July	Cornelian or ruby	Peace of mind	Water lily
August	Sardonyx, onyx, or peridot	Conjugal felicity	Poppy
September	Chrysolite, lapis lazuli, or sapphire	Preservation from folly	Morning-glory
October	Opal, beryl, or aquamarine	Hope	Chrysanthemum
November	Topaz	Fidelity	Holly
December	Turquoise	Prosperity	

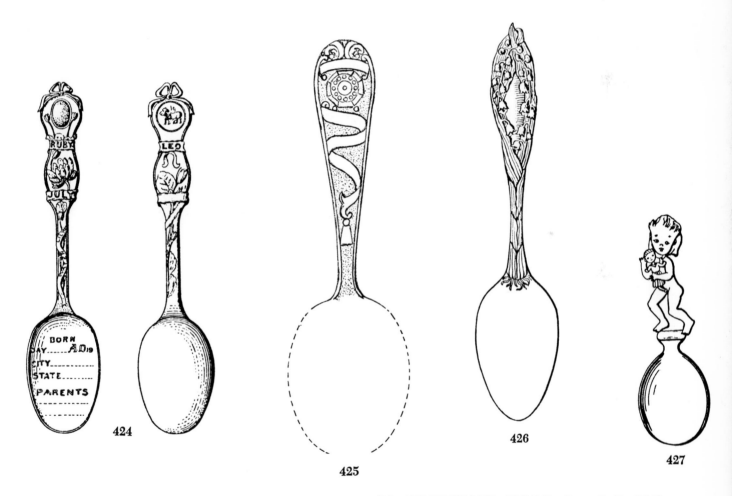

424

425

426

427

423. ZODIAC SPOONS. Gorham Mfg. Co. In same order of appearance as in Figs. 411-422. Manufacture of both tea and coffee spoons from nineteenth-century dies was resumed in the fall of 1968.

424. BIRTHSTONE ZODIAC SPOONS, Gustave F. Kolb, Mt. Vernon, N.Y. June 18, 1912 (U.S. Pat. No. 42,630). The front of the handle is decorated with the birthstone of the month. Front and back views.

425. BIRTHSTONE SPOON, Russell E. McKenna, Warwick, R.I. Aug. 23, 1949 (U.S. Pat. No. 154,942). Assigned to Walter H. McKenna & Company, Inc.

426. FLOWER-OF-THE-MONTH, Eustace Crees and Charles S. Court, Providence, R.I., June 30, 1903 (U.S. Pat. No. 36,385). Assignor to Watson & Newell. One of several series of flower-of-the-month spoons.

427. DAY-OF-THE-WEEK, William Ruser, Beverly Hills, Cal. Dec. 30, 1952 (U.S. Pat. No. 168,522). Exclusive to William E. Ruser, Jewels, Beverly Hills, Cal.

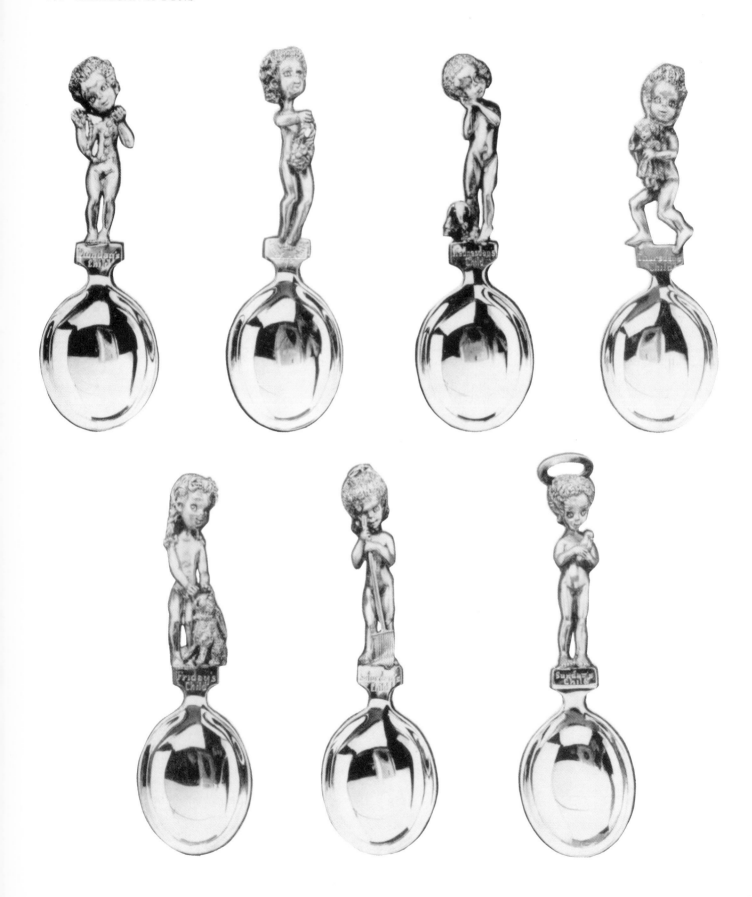

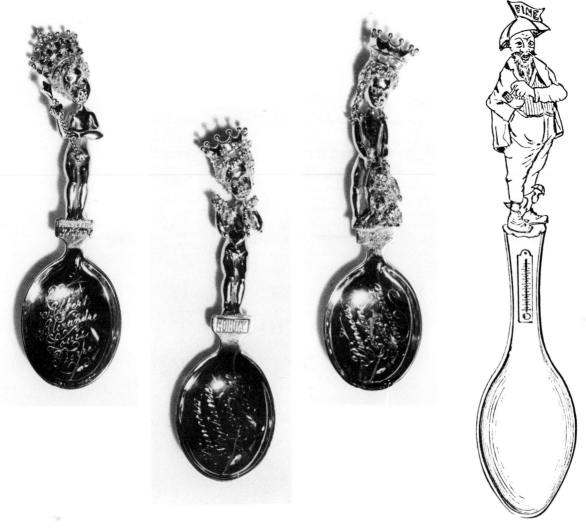

428. DAY-OF-THE-WEEK spoons. They are made in sterling silver or 14 kt. gold. The figures are full dimensional and may be set with jewels. Inspired by the anonymously written nursery rhyme:

Monday's child is fair of face,

Tuesday's child is full of grace,

Wednesday's child is full of woe,

Thursday's child has far to go,

Friday's child is loving and giving,

Saturday's child works for its living,

And a child that's born on the Sabbath day

Is fair and wise and good and gay.

429. *Left:* FRIDAY'S CHILD, jeweled. Made for Prince Albert born in 1958. *Center:* MONDAY'S CHILD, jeweled. Made for Princess Stephanie, born Feb. 1, 1965. *Right:* WEDNESDAY'S CHILD, jeweled. Made for Princess Caroline, born Jan. 23, 1957. (Courtesy of S.A.S. the late Princess Grace of Monaco and Louisette Levy-Soussan, Private Secretary to Princess Grace.)

430. FINE WEATHER MAN, Joseph Mayer, Seattle, Wash. Nov. 26, 1912 (U.S. Pat. No. 43,286). Joseph Mayer & Bros. Company trademark. The Umbrella Man, Robert W. Patten, was a picturesque Seattle character whose odd headgear inspired "Kok" Hager, cartoonist for the *Seattle Times.* Hager added the small flag with the one-word weather forecast creating a feature that ran in the paper for many years. Sometimes enameled.

thought to acquire the special benefits of the gem if they wore it. Each month has its flower (Fig. 426; and see chart) and each day of the week has its special meaning (Figs. 427-429).

Happy Holidays

All holidays are happy ones if the weather man is smiling (Fig. 430).

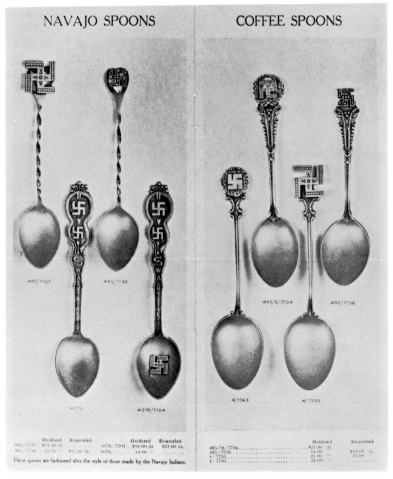

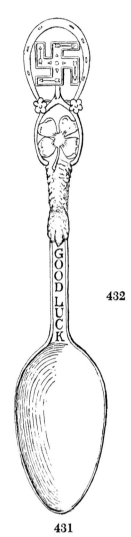

431

432

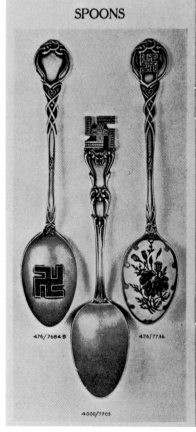

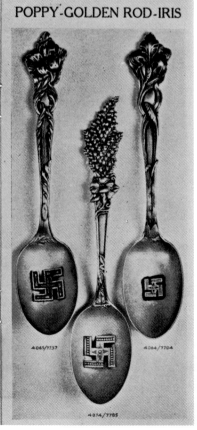

433

Chapter Twelve
A Little Bit O' Luck

All people have some beliefs about luck, ranging from "luck is all" to "the harder I work, the more luck I have" schools of thought. The symbols and amulets of luck are equally varied.

The oldest known and most widespread symbol of luck is the swastika (Figs. 431-434), believed to represent the sun. It consists of a Greek cross, either enclosed in a circle, the circumference of which passes through its extremities ⊕, or with its arms bent back 卍 or 卐.

In English heraldry it is familiar as the arms of the Isle of Man in a three-legged form, or fylfot.

The swastika was adopted by the Nazis as the German national symbol. Despite this unfortunate recent association, it is still considered a good luck sign.

Representations of scarabs (Fig. 435), the sacred beetles of ancient Egypt, have long been considered good luck pieces, believed to perpetuate life, happiness, and love.

The appearance and rapid multiplication of beetles in the mud, following the subsidence of the Nile, gave rise to the belief in their spontaneous generation. They came to be regarded as a symbol of creation and creative power. Because their almost circular shape and the bright, golden tints of their wing-cases suggested the shape and luster of the sun, they were thought to be one of the forms in which the sun-god appeared.

The Egyptian words for "become" and "come into existence" and one of the names of the sun-god are from the same stem word (*kepher*) as the word for scarab beetle, and are written with the sign 🪲.

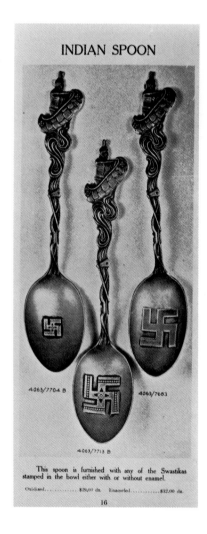

INDIAN SPOON

4063/7704 B 4063/7663

4063/7713 B

This spoon is furnished with any of the Swastikas stamped in the bowl either with or without enamel.

Oxidized............$29.00 da. Enameled............$32.00 da.

16

431. GOOD LUCK, George B. Ludy, Cedar Rapids, Ia. July 16, 1907 (U.S. Pat. No. 38,678). Note that this design incorporates the swastika, the horseshoe, the myrtle, the wishbone, the four-leaf clover, and the rabbit's foot. Marked: "G. L. STERLING Pat. Applied For."

432. These SWASTIKA spoons are from Charles M. Robbins Co. circular, no date. Inside front cover states, "Highest awards at the St. Louis Exposition, 1904."

433. Charles M. Robbins Co. circular, no date.

434. Charles M. Robbins Co. circular, no date.

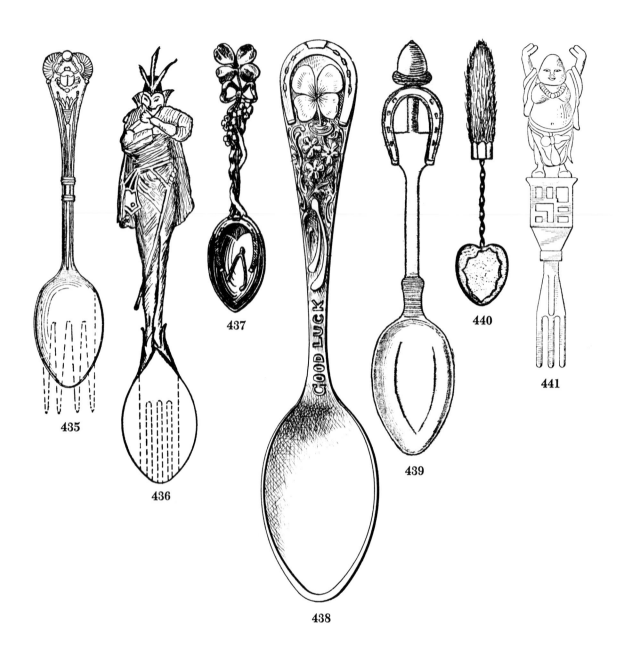

435. EGYPTIAN SCARAB, George P. Ittig Bridgeport, Conn., Sept. 14, 1909 (U.S. Pat. No. 40,257). Assigned to E. H. H. Smith Silver Company. No trademark on plated silver spoons. Gold washed spoons marked: "WM. A. ROGERS ONEIDA, LTD."

436. DEVIL, Artemas E. Colburn, Bellingham, Wash. Aug. 6, 1907 (U.S. Pat. No. 38,715).

437. GOOD LUCK, Adolph Ludwig, Brooklyn, N.Y. Oct. 4, 1892 (U.S. Pat. No. 21,879). Advertised by Ludwig, Redlich & Co., Silversmiths. Note that this design incorporates several good-luck symbols.

438. GOOD LUCK, Charles E. Barker, Brooklyn, N.Y. July 18, 1893 (U.S. Pat. No. 22,639). Marked: "G. L. STERLING PAT APP'D FOR." Four good-luck symbols in this design.

439. ACORN AND HORSESHOE, John Wood, Washington, D.C. Jan. 3, 1893 (U.S. Pat. No. 22,092).

440. RABBIT'S FOOT, William N. Capurro, Hot Springs, Ark. Sept. 25, 1894 (U.S. Pat. No. 23,651).

441. HOTAI, Jerome Ross, Kew Gardens, N.Y. Jan. 26, 1965 (U.S. Pat. No. 200,175).

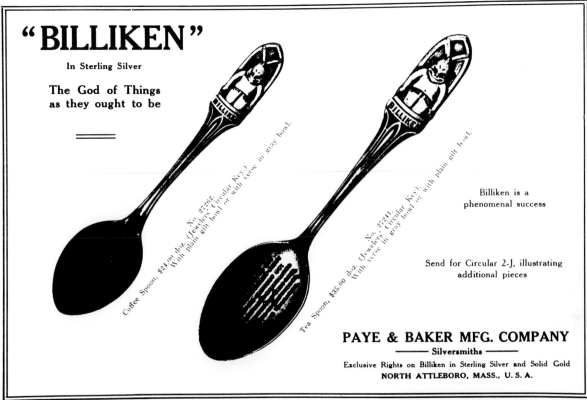

"BILLIKEN"

In Sterling Silver

The God of Things as they ought to be

Coffee Spoon, $24.00 doz. (Jewelers' Circular Key). With plain gilt bowl or with verse in gray bowl.

Tea Spoon, $35.00 doz. (Jewelers' Circular Key). With verse in gray bowl or with plain gilt bowl.

Billiken is a phenomenal success

Send for Circular 2-J, illustrating additional pieces

PAYE & BAKER MFG. COMPANY
—————— Silversmiths ——————
Exclusive Rights on Billiken in Sterling Silver and Solid Gold
NORTH ATTLEBORO, MASS., U. S. A.

442. BILLIKEN. Advertisement *Jewelers' Circular Weekly*, Apr. 28, 1909. "The God of Things as They OUGHT to Be!" on back of handle. Verse in the bowl reads:

I'm the God of Luckiness,
Observe my Twinkling Eye—
Success is sure to follow those
Who keep me closely by;
I prove that life's worth living
And make the Sad Ones grin,
I am the God of Happiness—
My name is Billiken!

443. BILLIKEN and Paye & Baker trademarks.

Kephera was the god of the transformations which life, forever renewing itself, manifests. He represented the rising sun, which like the scarab, emerges from its own substance and is reborn of itself.

Lucky pieces and ornaments in the form of scarabs are still popular in Egypt as symbols of resurrection and immortality. Many are made for export, usually of stone or painted pottery. They are inscribed on the under side with appropriate inscriptions. Precious stones are used for more elaborate ones.

Another widespread belief is that a horseshoe nailed over the door lintel of a house will bring good luck to all inside (Figs. 431, 437, 438, 439). It must be nailed with the points upwards—lest all good luck run out.

One origin of this belief is ascribed to the legend of St. Dunstan and the Devil. St. Dunstan was the patron saint of goldsmiths and silversmiths and a noted blacksmith himself. The Devil approached him one day and asked to have his hoof shod (Fig. 436). St. Dunstan recognized him. After fastening the Devil to the wall, he went to work on the hoof with such vigor that the Devil begged for mercy. Before releasing him, St. Dunstan made him promise never to enter a place where a horseshoe was displayed.

Belief in the magical powers of a four-leaf clover (Figs. 431, 437, & 438) can be traced to the sun-worshiping Druids of England. They thought that whoever found a four-leaf clover was blessed with super powers of sight and was therefore able to see evil beings and avoid them.

Others believe that the origin of the four-leaf clover as a lucky symbol is based on the four leaves forming a solar or sun cross which primitive man used as a crude system of finding direction.

According to an old superstition, if two people make a wish and pull on the ends of a wishbone, the one holding the longer end is granted his wish (Figs. 431, 437 & 438). An extension of this belief is that the wishbone of any fowl will bring good luck. Many such amulets are created in gold and silver to be worn as pins, bracelet charms, or other jewelry.

According to an old Sussex belief, if a lady carries an acorn in her pocket (Fig. 439), she will be blessed with perpetual youth. In many parts of the world people carry an acorn for general good luck or to insure a long life. The acorn may be a real one, or may be made of precious metal.

The acorn, and the oak tree from which it comes, was sacred to gods or goddesses of Nature of many lands. The Scandinavians regarded the oak as sacred to Thor, god of thunder and lightning. The Druids, or holy men of the Celts, held no ceremonies without the aid of the oak and mistletoe.

The left hind foot of a rabbit (Figs. 431 & 440), killed at the full of the moon by a cross-eyed person, and carried in the left-hand pocket, is considered by some to be the most potent amulet one can own. The origin of this superstition lies in the belief that young rabbits are born with their eyes open and are therefore blessed with the power of the Evil Eye.

The Chinese believe rubbing the tummy of Hotai, the God of Happiness, ensures good fortune the whole day through (Fig. 441).

Billiken, the "God of Things as They Ought to Be," was used not only on children's mugs, plates, and many other pieces, but was also used on the back of the Billiken spoons as a trademark (Figs. 442 & 443).

Chapter Thirteen
Bibs and Bubbles

444. MOTHER, Emil Fuchs, N.Y.C. July 24, 1923 (U.S. Pat. No. 62,718). Assigned to Cartier, Inc., N.Y. In bowl: embossed portrait of H.J. Heinz (of 57 varieties) with his name. Given by Heinz to VIP employees on birth of each child.

445. FEEDING SPOON, Frank Adler, Brooklyn, N.Y. Oct. 23, 1934 (U.S. Pat. No. 93,644).

446. SAFETY FEEDING SPOON, Albert Bloom, Hicksville, N.Y. Nov. 18, 1958 (U.S. Pat. No. 183, 912).

447. BABY SPOON, William Albert Rayment, Taunton, Mass. Aug. 29, 1899 (U.S. Pat. No. 31,460). Assigned to Reed & Barton.

448. BABY SPOON, William McAusland, Taunton, Mass. Aug. 29, 1899 (U.S. Pat. No. 31,461). Assigned to Reed & Barton.

One of the most universally talked-about and illustrated subjects for centuries has been babies. Rich and poor, young and old, everyone loves the innocence and helplessness of infants.

The feeding of infants (Fig. 444) is of widespread interest and countless baby foods and devices for feeding are continually being developed (Figs. 445 & 446). When baby begins to feed himself, the new learning process should be made as pleasant as possible. His first experimental implement (Figs. 447-449) is the spoon. Some are designed to make the task easier.

Recording the birth of a child on a spoon has long been a popular custom in the United States and is still practiced today (Figs. 450-453). Often such a spoon is given as a birth gift.

Featured on many baby spoons are subjects familiar and appealing to the infant. World-around, children love Mother Goose (Fig. 454). The origin of Mother Goose rhymes (Fig. 455) has never been confirmed. Some believe the versifier was Elizabeth Vergoose, a widow in Boston who sang these ditties to her grandchildren. Reputedly, her son-in-law, Thomas Fleet, published the songs and rhymes in 1719. However, no copy of this book has ever been found. Mother Goose is the direct translation from the French *Mere 'Oye*. Charles Perrault, a Frenchman, published the first book in which this name was used in 1697; it was called *Stories of Long Ago* or *Tales of Mother Goose*.

Pets, being lovable companions, always attract attention and are frequent motifs on articles made for children (Figs. 456-461).

captions

449. BABY SPOON, Simeon H. Ashton, Rhinelander, Wis. Apr. 8, 1913 (U.S. Pat No 43,812). The hood on this spoon facilitates feeding without spilling.

450. BIRTH RECORD, Nelson Goodsell, Philadelphia, Pa. Mar. 9, 1897 (U.S. Pat. No. 26,724).

451. STORK, Gustave F. Kolb, Mount Vernon, N.Y. July 9, 1907 (U.S. Pat. No. 38,655). Assigned to the Mauser Mfg. Co. Marked: "Pat'd. '07." Mauser Mfg. Co. trademark.

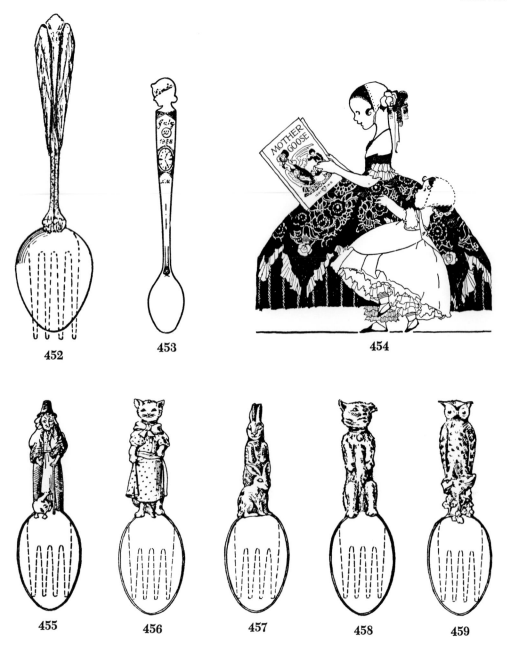

452. STORK, Julia Bracken Wendt, Chicago, Ill. Dec. 15, 1908 (U.S. Pat. No. 39,687).

453. BIRTH RECORD GIRL, Louis Zuckerman, Wooster, Ohio. May 16, 1961 (U.S. Pat. No. 190,343). According to the designer, this spoon had not yet been made.

454. Mother Goose.

455. MOTHER GOOSE, Samuel G. Wilkes, Wallingford, Conn. July 4, 1916 (U.S. Pat. No. 49,332). Assigned to R. Wallace & Sons Mfg. Co.

456. MOTHER PUSSYCAT, Samuel G. Wilkes, Wallingford, Conn. June 20, 1916 (U.S. Pat. No. 49,244). Assigned to R. Wallace & Sons Mfg. Co.

457. BUNNIES, Samuel G. Wilkes, Wallingford, Conn. June 20, 1916 (U.S. Pat. No. 49,245). Assigned to R. Wallace & Sons Mfg. Co.

458. BEGGING DOG, Samuel G. Wilkes, Wallingford, Conn. July 4, 1916 (U.S. Pat. No. 49,321). Assigned to R. Wallace & Sons Mfg. Co.

459. WISE OLD OWL, Samuel G. Wilkes, Wallingford, Conn. July 4, 1916 (U.S. Pat. No. 49,323). Assigned to R. Wallace & Sons Mfg. Co.

460. BUNNY RABBIT, Josephine Kern, Chicago, Ill. Nov. 29, 1932 (U.S. Pat. No. 88,420). Assigned to the Imperial Brass Co., Chicago, Ill.

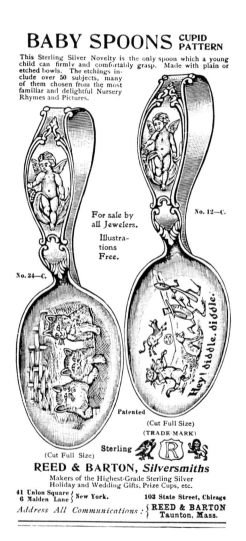

461. Lovable pets, Reed & Barton, Tauton, Mass.

Chapter Fourteen
Mother's Little Helpers

The never-ending desire to invent helpful kitchen implements is illustrated by some ingenious, although not always practical, examples.

Spoon-fork combinations are no doubt intended to be handy gadgets, hopefully saving Mother time and dishwashing (Figs. 462-465). Such a combination is also useful for out-of-doors cooking and eating.

Many variations have been designed (Figs. 466-468) by adding a cutting edge, or combining just a fork and knife (Fig. 469).

Every kitchen is equipped with measuring devices in assorted sizes. Those designed to avoid spilling (Fig. 470) are the most desirable.

462. SPOON-FORK, Grace E. Whitcomb, Andover, N.H. & James E. Barnard, Franklin, N.H. Feb. 7, 1899 (U.S. Pat. No. 30,129).

463. SPOON-FORK, Jacob Wolsten, Newark, N.J. Apr. 1, 1919 (U.S. Pat. No. 53,170).

464. SPOON-FORK, Jacob Wolsten, Newark, N.J. Apr. 1, 1919 (U.S. Pat. No. 53,171).

465. SPOON-FORK, Joseph Domingo y Canellas, Nice, France. Sept. 6, 1921 (U.S. Pat. No. 58,881). An example of this spoon-fork is embossed "AT LAST" on the handle tip, serving spoon size. Marked "Pat. Appd. For." "Made in Germany."

462

463

464

465

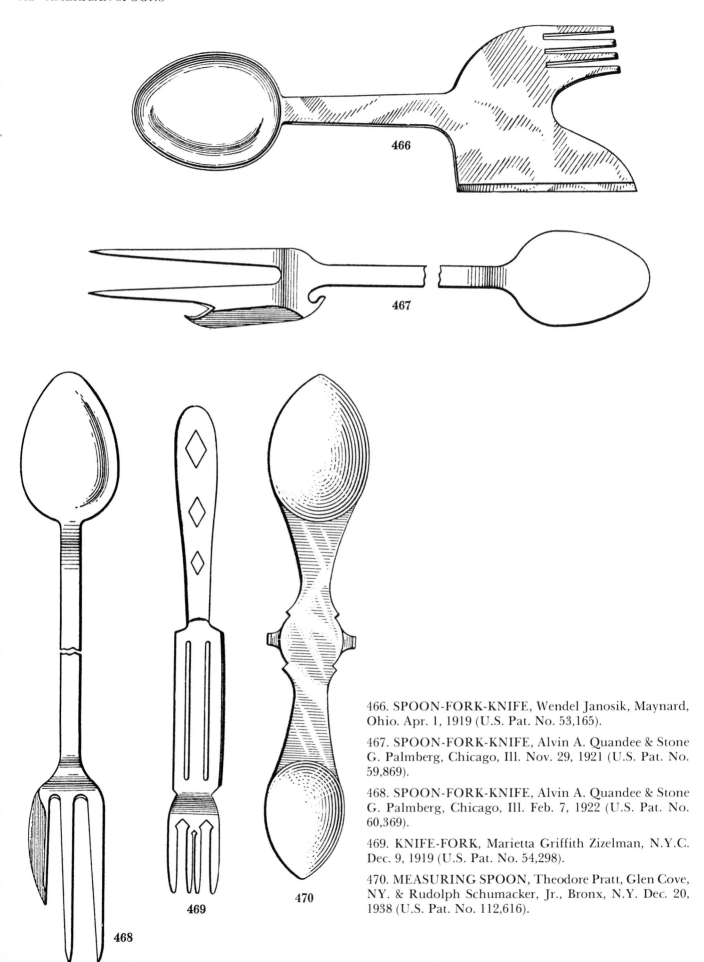

466. SPOON-FORK-KNIFE, Wendel Janosik, Maynard, Ohio. Apr. 1, 1919 (U.S. Pat. No. 53,165).

467. SPOON-FORK-KNIFE, Alvin A. Quandee & Stone G. Palmberg, Chicago, Ill. Nov. 29, 1921 (U.S. Pat. No. 59,869).

468. SPOON-FORK-KNIFE, Alvin A. Quandee & Stone G. Palmberg, Chicago, Ill. Feb. 7, 1922 (U.S. Pat. No. 60,369).

469. KNIFE-FORK, Marietta Griffith Zizelman, N.Y.C. Dec. 9, 1919 (U.S. Pat. No. 54,298).

470. MEASURING SPOON, Theodore Pratt, Glen Cove, NY. & Rudolph Schumacker, Jr., Bronx, N.Y. Dec. 20, 1938 (U.S. Pat. No. 112,616).

Chapter Fifteen
School Days

When the colonists came to America they established the type of schools they had known in Europe. As time passed, these had to be adapted to their new and strange environment. Their local governments were relied upon heavily to provide education, much more so than had been the case in the mother country during the 1600s. The Massachusetts law of 1642 became the first to order that children should be taught to read; by 1647, every town with a population exceeding fifty families was required to have an elementary school. Every town with more than one hundred families had to have a Latin Grammar School. The famous textbook, *The New England Primer,* was first published in 1690.

Following the Revolutionary War people realized that private schools could not provide the equality, unity, and freedom necessary for the new democratic nation. The state system of public schools was introduced in the 1830s.

Harvard

By 1636 it became apparent that the sons of gentlemen who ruled Massachusetts would, if left to themselves, show a decided preference for buckskin rather than books. The General Court of Massachusetts voted to give "400 [pounds] toward a schoale or colledge" on October 28th. However, it did not order that the new institution was "to bee at Newetowne," renamed Cambridge, until November 15, 1637.

Two years later, John Harvard gave his library of 400 volumes and half his estate for the erection of this institution, a generous endowment for that time. On March 13, 1639, the General Court "ordered, that the colledge agreed upon formerly to bee built at Cambidg shalbee called Harvard Colledge."

In front of Memorial Hall on the grounds at Harvard University, the oldest university in the United States, stands a statue by Daniel Chester Frank (Figs. 471 & 472), erected to John Harvard's memory.

Samuel Gilman, an American Unitarian clergyman and poet was author of *Fair Harvard* (Fig. 473). A graduate of this university in 1811, Gilman wrote this poem at a few hours' notice for the 200th anniversary of the college, held September 8, 1836.

University of Missouri

The oldest state university in the West, the University of Missouri, was founded in 1839. Their School of Journalism was the first in the world and still is one of the finest. The six Ionic columns (Fig. 474), standing in Francis Quadrangle, are the remains of the university's original administration building erected in 1842 and destroyed by fire in 1892.

Graduates

Institutions of learning usually give a diploma or certificate in recognition of achievement to students who complete a course satisfactorily. Graduation exercises were first held by European universities in the Middle Ages. American educational institutions observe many of the European graduation customs. By tradition, graduates wear academic gowns and caps (Figs. 475-478), both patterned after European academic dress. The color of the tassle designates the degree the graduate is receiving. Graduates may wear colored hoods denoting the highest degree they have already earned and the institution which conferred it. Caps and gowns have become symbolic of educational achievement.

School Symbols

Familiar symbols of learning appear on many spoons. The owl, by tradition, is the symbol of wisdom (Fig. 479). Owls abounded in Athens, Greece, where the owl was given to Minerva (Goddess of Wisdom) as her symbol. Different branches of study have their own symbols, such as the algebraic equation for mathematics, the palette and brush for art, and the pen representing all disciplines (Fig. 480).

Friedrich Froebel

Friedrich Wilhelm Froebel, author, German educator, and founder of the kindergarten system

471

472

473

474

475

476

471. JOHN HARVARD, Benjamin B. Freeman, Cambridge, Mass. May 26, 1891 (U.S. Pat. No. 20,774). Frank M. Whiting trademark.

472. HARVARD, Maude Blanche Frye, Boston, Mass. June 20, 1893 (U.S. Pat. No. 22,546).

473. FAIR HARVARD, Horace M. Wilson, Cambridge, Mass. Oct. 6, 1891 (U.S. Pat. No. 21,105).

474. UNIVERSITY OF MISSOURI, Frederick Schwinn, Attleboro, Mass. June 22, 1915 (U.S. Pat. No. 47,509).

475. GRADUATE, Theodore B. Combes, Philadelphia, Pa. Oct. 18, 1892 (U.S. Pat. No. 21,900). No trademark. Diamond at handle-drop enameled in school colors.

476. BOY GRADUATE, Albert H. Ullrich, Evanston, Ill. Oct. 25, 1892 (U.S. Pat. No. 21,919).

(Fig. 481), devoted his life to the education of preschool-age children, a field which had been previously neglected. Froebel believed that children must not be taught by rule, but according to their natural instincts and activities. His first kindergarten was opened in 1837 in an old mill in Blankenburg, Germany.

477

478

479

480

481

477. GIRL GRADUATE, Henry H. Burdick, Syracuse, N.Y. Apr. 8, 1902 (U.S. Pat. No. 35,850). Jos. Seymour Mfg. Co. trademark.

478. VALEDICTORIAN, George W. Shiebler, Brooklyn, N.Y. Apr. 25, 1893 (U.S. Pat. No. 22,363). The Valedictorian of a class is usually the student with the highest scholastic standing.

479. WISE OLD OWL, Joseph E. Straker, Jr., Attleboro, Mass. July 14, 1903 (U.S. Pat. No. 36,419). Assigned to Watson & Newell.

480. SCHOOL SYMBOLS Della Graeme Smallwood, Washington, D.C. June 27, 1893 (U.S. Pat. No. 22,559).

481. FRIEDRICH FROEBEL, Eliza Ann Blaker, Indianapolis, Ind. May 2, 1893 (U.S. Pat. No. 22,375). Made by Dominick & Haff for Julius C. Walk & Son.

One of our latest ✿ ✿ ✿ ✿ ✿ productions is

The **College Spoon**

An appropriate, useful and artistic School *and* College Souvenir

✿

SEND FOR DESCRIPTIVE
CIRCULAR & PRICE LIST

✿

Jos. Seymour Mfg. Co.

SILVERSMITHS

Trade ★ S ★ Mark
STERLING SYRACUSE, NEW YORK

482. Advertisement Jos. Seymour Mfg. Co. (Courtesy Noel D. Turner)

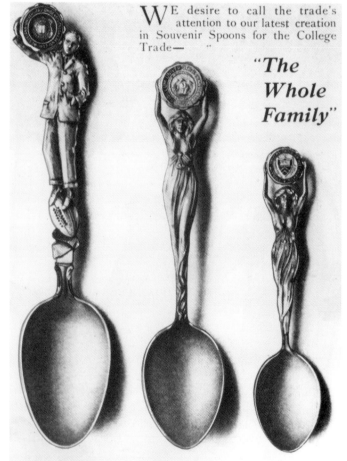

WE desire to call the trade's attention to our latest creation in Souvenir Spoons for the College Trade—

"The Whole Family"

These articles have proven ready sellers, so that every jeweler who caters for college trade should not be without them. Write to us for samples, prices and terms.

THE KINNEY CO. Main Office and Factory, 14 Blount St. PROVIDENCE, R. I.

482b. Advertisement The Kinney Co. Providence, R.I.

Chapter Sixteen
Sports Round-up

From earliest times men have engaged in various forms of play activity, with athletic contests (Fig. 483) being a means of amusement and recreation, as well as a training for other pursuits in life. Sports are considered essential in the development of physical skill, bodily strength, mental activity, and as a means of relaxation. Friedrich Wilhelm Froebel said, "Play is not trivial; it is highly serious and with deep meaning." (Fig. 484)

Horse racing, fishing, and hunting (Fig. 485) were the chief sports of the American people before the middle of the nineteenth century. Between 1850 and 1900, many new forms of athletics were organized and adopted. The "golden age" of sport developed after World War II.

Hunting game was first a means of supplying food. Until farming and the raising of livestock supplied food for their families, the frontiersmen depended largely upon wild game. Today hunting is primarily a sport, with the number of licensed hunters increasing steadily each year. Much of the enjoyment a hunter derives from the sport comes from just being out-of-doors, enjoying nature, and from the company of his dog (Fig. 486).

Bison Hunt

The largest of the North American mammals ever hunted was the bison (Fig. 487), now commonly called the "American buffalo." Great herds, totaling an estimated 75 million, roamed the western plains from Montana southward through Texas and from Pennsylvania to west of the Rockies.

Until about 1870 the market for hides was limited largely to their use in making lap-robes. When English and American firms found that the leather could be used for many purposes, a whole army of hunters surged to the ranges. A decade of wholesale slaughter followed.

The opening of the Union Pacific and Kansas Pacific railroads was a contributing factor to the almost total disappearance of the bison. But probably the major cause was a military-political excuse put forth when Indians resisted encroachment on their lands; government officials encouraged the idea that the Indians could be civilized by exterminating the bison. As one authority (Karl F. Koopman) has expressed it, by 1900 this shameless killing "brought the native wild animal race to near extinction and the native human race to 'civilization.'"

In 1902 Congress appropriated money to assemble the surviving bison in Yellowstone National Park. The American Bison Society, formed in 1905, did much to build up the few herds and save the bison from utter annihilation.

Bison are now protected in federal game preserves, but the vast herds have vanished.

Moose Hunt

A member of the deer family, the moose differs from round-horned deer in having horns that are flattened in a manner known as "palmation." The American moose is a veritable giant compared to the moose of Asia and Europe, where they are called "elk." The North American moose is enormous in comparison with even the largest of the American elk. The largest moose specimens measured by naturalists stood from six and a half to more than eight feet in height at the shoulder. The most striking peculiarity of this animal is its antlers, the upper two thirds of the beam being flattened, sometimes exceeding a foot in width. The upper end of this great "shovel" of solid bone terminates in a row of from six to twelve short points.

The American moose range extends from Nova Scotia and New Brunswick to northern Alaska, with small numbers still existing along the western slope of the Rockies as far south as the head of Green River, Wyoming, and in northern Minnesota. The moose is protected by law, which allows a very short open season for hunting them (Fig. 488).

Yachting

The sailing yachtsman (Fig. 489) is the only survivor of the great tradition of the days of sail, for centuries the mainstay of commerce and exploration.

Pleasure barges of the Egyptians, Greeks, and Romans indicate that yachting goes back to the dawn of history. In England, races and pleasure

The Athletic Spoon.

A new spoon, symbolic of athletic sports, has been recently produced by the Alvin Manufacturing Company, of 860 Broadway, New York, for Hammersmith & Field, of San Francisco, Cal. The handle is surmounted by a laurel wreath and a winged foot. The flowing ends of a ribbon knot entwine the handle to the bowl, in which the emblem of the particular club using the spoon, or anything else that is desired, may be engraved or photographed. The

beauty, originality and thorough appropriateness of the design are apparent.

483

484

485

486

487

sailing on the Thames and other British waters became popular when King Charles II introduced yachting in the Restoration in 1660. He had become a devotee while in exile in the Channel Islands and Holland. The word itself comes from the Dutch *jaght* or *jaght schip*, with connotations of sport and speed (Figs. 490 & 491).

The first yacht club in Britain was the Water Club of Cork Harbor in 1720. In 1815 The Yacht Club, later the Royal Yacht Squadron, at Cowes, England, was formed in London.

In America, yachting began in colonial times and continued through the federal period with emphasis on pleasure craft.

The first permanent yacht club in America was the New York Yacht Club, founded in 1844. It held its first annual cruise that year and its first annual regatta the following year. Both events, except for interruptions by wars, have been held annually since that time.

International yacht racing began in 1851 when members of the New York Yacht Club built and sailed the 101-foot schooner, the *America*, to England. There she showed her stern to Britain's best and won the trophy of the Royal Yacht Squadron, called the Hundred-Guinea Cup (Figs. 492 & 493). The *America* herself, after a career as a blockade runner, naval dispatch, and training vessel, lives now only in the minds and hearts of yachtsmen.

483. ATHLETIC. Manufactured by Alvin Manufacturing Company for Hammersmith & Field, San Francisco, Cal. The flowing ends of the ribbon knot entwine the handle to the bowl, in which the emblem of the particular club using the spoon, or anything else that is desired, may be engraved or photographed. *Jewelers' Weekly*, June 21, 1893.

484. SPORTS, Eustace Crees & Charles S. Court, Providence, R.I. Oct. 27, 1903 (U.S. Pat. No. 36,604). Assigned to Watson & Newell.

485. FOREST & STREAM, W. S. Taylor & Son, Utica, N.Y. Manufactured by the Howard Sterling Company, Providence, R.I. The deer standing erect in his natural position when startled is said to have been copied from a photograph taken at the moment when the animal hesitated between curiosity and fear. Handle represents an oar or floating paddle employed by hunters in floating for deer along shores of lakes and rivers. *Jewelers' Weekly*, June 28, 1893.

486. BIRD DOG, Joseph E. Straker, Jr., Attleboro, Mass. Feb. 16, 1904 (U.S. Pat. No. 36,796). Assigned to Watson & Newell.

487. BISON HUNT, Eustace Crees & Charles S. Court, Providence, R.I. Mar. 1, 1904 (U.S. Pat. No. 36,826). Assigned to Watson & Newell.

In 1857 the Hundred-Guinea Cup was deeded to the New York Yacht Club as an international yacht-racing trophy and renamed the America's Cup in honor of the gallant schooner that won it (Fig. 494).

Bathing

In the mid-1800s, society's interest in out-of-door activities quickly increased. From Maine to Florida, beaches became crowded with heavily clothed bathers during appropriate seasons.

Atlantic City, then a village, attracted family groups less interested in fashionable society than in the benefits of the sea air (Figs. 495 & 496), while at Coney Island the Beau Brummells stared at the belles in their "daring" bathing costumes.

Bicycle

For centuries the idea of a self-propelled vehicle intrigued mankind, but not until 1679 did it take definite form.

The first two-wheeled contrivance made its appearance in Paris, its originator being M. de Sivrac.

Pierre Lallement, also of France, brought his patented high two-wheeler to the United States in 1866. It was constructed entirely of wood except for the tires, which were of iron. To this contraption was given the nickname, "Bone Shaker." The early bicycles were also called "dandyhorses" and "velocipedes." Cycling became so popular that great parades were held (Figs. 497 & 498). By the turn of the century, more than ten million bicycles were being peddled over the countryside and through the city streets. Some cyclists rode for exercise, some for pure pleasure, and some raced. The bicycle also became an important means of transportation. Clubs were formed and people rode from one town to another, or met for a "run" such as the one around the city of Boston in 1880 (Fig. 499). There some forty possessors of birotate chariots—members of bicycle clubs from Boston, Newark, Washington, Salem, Hartford, Worcester, and Massachusetts State—met for a two-day informal run, which earned the title, "Around the Hub" (Fig. 500). Each cyclist wore a uniform representing his club. This furnished a colorful spectacle for the crowds of spectators all along the route, who appeared at factory windows, on roof tops, or perched in tree-tops (Fig. 501).

Trap Shooting

Trap shooting in the United States became a popular sport only after the introduction, in 1866, of glass balls as targets in place of live pigeons.

The first national tournament was held at New Orleans, Louisiana, February 11-16, 1885, under the auspices of the National Gun Association.

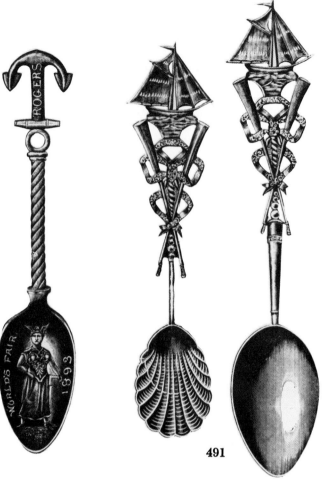

488. MOOSE HUNT, Eustace Crees & Charles S. Court, Providence, R.I. Mar. 1, 1904 (U.S. Pat. No. 36,828). Assigned to Watson & Newell.

489. NAUTICAL, Edward Todd, Jr., Brooklyn, N.Y. May 28, 1912 (U.S. Pat. No. 42,568).

490. ANCHOR ROGERS. Manufactured and distributed free of charge by The William Rogers Manufacturing Company, Hartford, Conn., to visitors to their pavilion in the Manufactures and Liberal Arts Building at the Columbian Exposition. Intended as a reminder of the merits of the "Anchor Rogers" brand of silver-plated ware. *Jewelers' Weekly*, July 5, 1893.

491. YACHTING, Stone Brothers, N.Y.C. *Jewelers' Weekly*, July 5, 1893.

492. AMERICA'S CUP, Harry H. Cabot, Bristol, R.I. Apr. 17, 1894 (U.S. Pat. No. 28,194). Assigned to Kent & Stanley Company. Manufactured by the Howard Sterling Co. Also made with American and British flags, enameled in bowl.

493. AMERICA'S CUP, Harry H. Cabot, Bristol, R.I. Apr. 17, 1894 (U.S. Pat. No. 23,195). Assigned to Kent & Stanley Company. Manufactured by the Howard Sterling Co. On May 1, 1894 the device of the America's Cup was registered as a trademark of the Kent & Stanley Company.

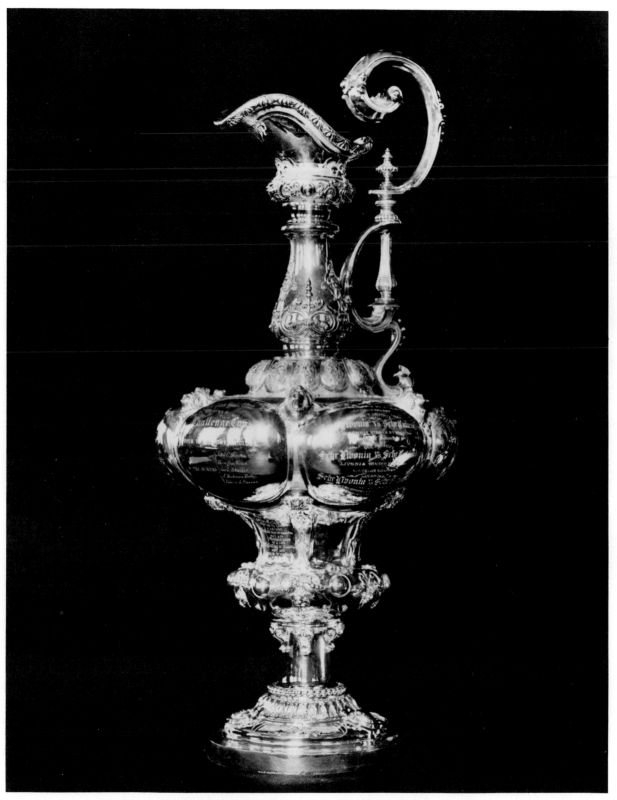

494. AMERICA'S CUP. Originally designated the Royal Yacht Squadron One Hundred Guinea Cup Won by the yacht *America* in 1851; deeded to the New York Yacht Club in 1857 and has since been known as the America's Cup. Made by R. & S. Garrard, Panton Street, London. It bears the maker's name and London hallmarks. (Photo by Morris Rosenfeld, N.Y.C.)

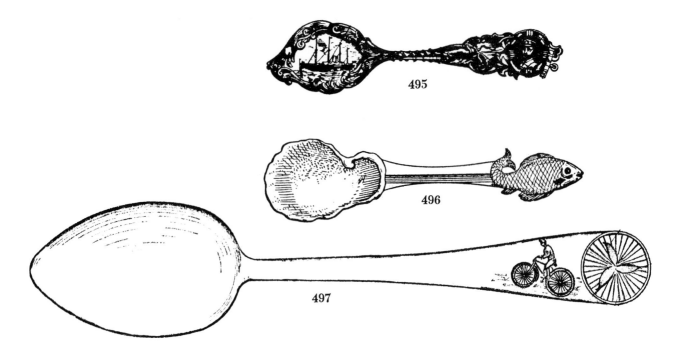

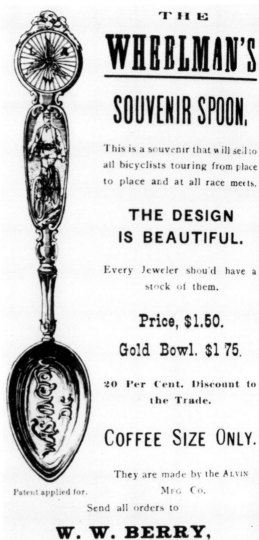

495. SEASIDE SOUVENIR, Emil H. Rosenblatt, N.Y.C. Dec. 6, 1892 (U.S. Pat. No. 22,032). Manufactured by the Alvin Manufacturing Company. Advertised as "Adapted for sale at any seaside resort or watering place...the date on the handle...the name of the place etched in the bowl...." Patent specifications mention a naval officer on the handle and steamship in the bowl. These features apparently were not used when the spoon was made.

496. FROM THE SEASIDE, Brereton, Glen Allen, Va. July 16, 1907 (U.S. Pat. No. 38,680).

497. WHEELMAN'S SOUVENIR, William W. Berry, Scranton, Pa. July 12, 1892 (U.S. Pat. No. 21,699). Manufactured by the Alvin Corporation.

498. WHEELMAN'S SOUVENIR. This advertisement illustrates the spoon as it was manufactured. *Jewelers' Weekl*, Oct. 5, 1892.

THE WHEELMAN'S SOUVENIR SPOON.

This is a souvenir that will sell to all bicyclists touring from place to place and at all race meets.

THE DESIGN IS BEAUTIFUL.

Every Jeweler should have a stock of them.

Price, $1.50.
Gold Bowl. $1 75.

20 Per Cent. Discount to the Trade.

COFFEE SIZE ONLY.

They are made by the ALVIN MFG Co.

Send all orders to

W. W. BERRY,

JEWELER. **SCRANTON, PA.**

Patent applied for.

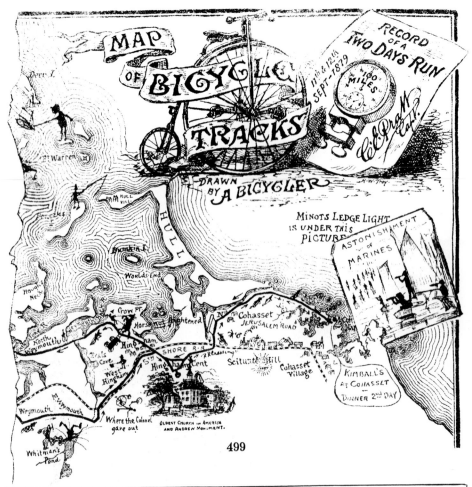

499

A WHEEL AROUND THE HUB.

500

501

499, 500 & 501. From *Scribner's Monthly*, Feb. 1880.

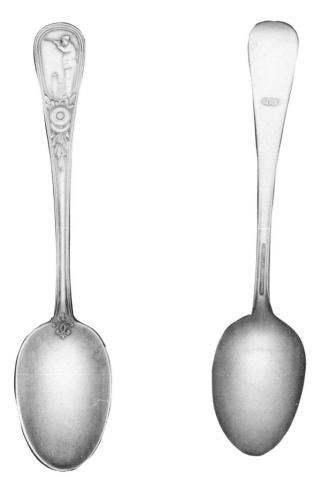

502. TRAPSHOOTER, E.I. Du Pont Company, Wilmington, Del., trademark on reverse side of handle. Marked: "Tiffany & Co. Sterling M."

Hundreds of gun clubs participated in state leagues which received recognition from the Interstate Association and leading gun and ammunitions manufacturers (Fig. 502). Men and women contestants were often awarded prizes by these companies for their marksmanship (Fig. 503).

In the last quarter of the nineteenth century, the now almost universal clay disk was introduced.

The sport was reorganized in 1918; all recognized contests have since that time been in the hands of the Interstate Trapshooting Association.

Football

Football, the "king" of the autumn sports in the United States, demands more teamwork, strength, and alertness perhaps than any other, and provides its spectators with a thrilling contest. An ancient sport, it resembles the game called "harpaston," played by the Spartans around 500 B.C.

The English colonists probably brought the game to America. They used an inflated pig bladder for a ball. By the beginning of the nineteenth century, Harvard and Yale played football to determine supremacy between the freshman and sophomore classes (Fig. 504). The first organized football club was the Oneida Football Club of Boston founded in 1862 by Gerrit Smith Miller. Intercollegiate football began when Princeton and Rutgers played in New Brunswick, New Jersey, in 1869.

For many years the game was brutal, and many of the players were critically injured. In 1905 President Roosevelt called in experts to a White House Conference to find ways to prevent death and injuries from the game. New safety rules were introduced. Since that time the game has been one of the major sports in this country.

Horse Racing

Horse racing in the United States began in New York State where the first recorded race took place in 1665.

The best-known horse races today are for three-year olds: the Kentucky Derby at Churchill Downs, the Preakness Stakes at Pimlico, Maryland, and the Belmont Stakes at Belmont Park, New York. Combined, these races are known as the "Triple Crown" of the American turf (Fig. 505).

Baseball

In common with many other bat and ball games, baseball has an ancient lineage. It was derived from stoolball, first played in England by milkmaids and farm hands who used a ball thrown at an upturned milking stool.

The game did not develop in the United States (Figs. 506 & 507) until the mid-1800s. During the Civil War it was one of the most popular means of entertainment for the troops.

Until the 1860s the game was strictly amateur. Then a few cities, eager to have outstanding teams, offered salary inducements to star players. The Cincinnati Red Stockings was the first completely professional team, with every player receiving a salary. Established in 1869, the team made an outstanding record in their first season.

By the 1890s, the game was established as one of the country's most popular sports and was nicknamed the "National Pastime."

Golf

Games similar to golf have been played in several countries since ancient times, but the modern sport was developed in Scotland in the fourteenth or fifteenth century. The story of golf in the United States began in the 1880s.

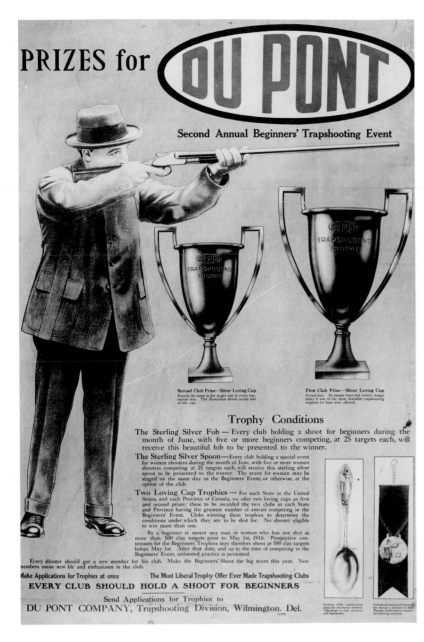

503. Du Pont Company poster *ca.* 1910-1915 boosting the organization of trapshooting clubs and showing the trophies that Du Pont awarded. The lady winners were awarded a teaspoon the men were given loving cups, and for any club sponsoring a shoot for beginners with at least five contestants participating, the winner in this beginning class won a watch fob featuring the likeness of Jack Fanning, world-famous trapshot and shooting instructor. (The Hagley Museum, Wilmington, Del.)

504. FOOTBALL HERO, Cora A. Gooding, Brookline, Mass. Sept. 10, 1895 (U.S. Pat. No. 24,659). The turtleneck sweater is enameled in school colors and adorned with school letter. Marked: "W. C. Finck 925 1000 STERLING."

505. JOCKEY CAP, Roberta H. Abel, Jeffersontown, Ky. Oct. 29, 1946 (U.S. Pat. No. 145,830). The cap forms the bowl of the spoon.

506

507

508

509

Authorities do not agree on the location or date of the first game, but the Foxburg Golf Club, founded in 1887 in Foxburg, Pennsylvania, is still in existence. Not until 1913 did golf become popular, when Francis Ouimet, formerly a caddie, won the U.S. Open tournament over some heavily favored British stars. Ouimet's victory gained nation-wide attention; ever since, interest in golf has increased (Figs. 508 & 509).

Almost three million people play golf in this country yearly on some five thousand courses. The game is taught in more than a thousand colleges and high schools as a part of the physical education curriculum.

As our leisure time has increased, more people devote time to athletic pursuits. Television has made spectator sports available to nearly everyone in the country with the number of enthusiasts growing by millions.

506. BASEBALL, Frederick E. Maynard, Berkeley, Cal. Nov. 12, 1918 (U.S. Pat. No. 52,667).

507. BASEBALL, Jess L. McCain, Venice, Cal. Nov. 12, 1963 (U.S. Pat. No. 196,878).

508 & 509. GOLF, George D. Merrill, East Orange, N.J. Oct. 23, 1900 (U.S. Pat. Nos. 33,413 & 33,414).

Chapter Seventeen
Meet Me at the Fair

World's Columbian Exposition

The World's Columbian Exposition (Fig. 510) opened in 1893 in Chicago, Illinois, in commemoration of the 400th anniversary of the discovery of America by Christopher Columbus. By his touch, President Cleveland set in motion the machinery that awakened the electrical fountains and glittering lights that were the life of the exposition. The Chicago Fair had a more lasting effect on its visitors than any other world's fair before or since. The memory of "The Great White City" with its classic columns influenced architecture, painting, sculpture, and industrial arts (Figs. 511-513).

More souvenir spoons were made to commemorate the World's Columbian Exposition than any other event in history (Figs. 514-516). This celebration of one of the world's most important landings inspired the manufacture of countless spoons, and almost overnight, souvenir spoon collecting became not merely a hobby, but a consuming rage.

Christopher Columbus (Figs. 517, 519) believed that he could reach India by a western route (Figs. 520 & 521). Obtaining no aid from King John II of Portugal, he went to Spain, where, in 1486, he presented his plan to King Ferdinand and Queen Isabella. Finally, in the fall of 1492, Ferdinand and Isabella (Figs. 522-524) agreed to finance his expedition. They furnished two ships, the *Nina* and the *Pinta* (Fig. 525). His third ship, the *Santa Maria* (Figs. 526-528), was chartered by friends; this he commanded as his flagship (Figs. 529-532).

The voyage began August 3, 1492, and after a difficult time because of unrest and disobedience among the crew, land was sighted (Fig. 533) by men on the *Pinta* on October 12th. Columbus, his officers, and crew went ashore, carrying the royal banners of Ferdinand and Isabella (Figs. 534-538). After kneeling on the sand and giving thanks to God for the successful journey (Fig. 539), Columbus took possession of the island of San Salvador in the name of the Spanish rulers (Fig. 540).

Columbus sailed on, stopping at various islands, and returned to Spain to be received at court at Barcelona (Figs. 541-543) by Ferdinand and Isabella.

Titles and high honors were bestowed on him.

Three more successful voyages followed, but on the fourth, Columbus lost two ships and ran the rest of his fleet aground. His return to Spain found him broken in spirit and health, and on May 20, 1506, he died in Valladolid, Spain.

The striking beauty of the Chicago fairgrounds and Exposition buildings (Figs. 544-548) were the work of Daniel H. Burnham and other noted architects.

Chicago had become a symbol of regeneration because only twenty-four years before, on October 8, 1871, the great fire had swept the city (Fig. 549). Rebuilding had begun immediately, and within two years, the burned-over ground alone was worth more than the land and buildings had been before the fire (Figs. 550 & 551).

Bertha Palmer, Chicago's social queen, was the wife of Potter Palmer, well-known Chicago merchant. In 1891 Mrs. Palmer was chosen President of the Board of Lady Managers of the Fair (Fig. 552). She dedicated the Woman's Building (Figs. 553 & 554), the plainest of the buildings on the fairgrounds, despite the notion that women love the ornate. The last nail used in completing the building was a golden one, presented to Mrs. Palmer by the ladies of Montana, and was driven in with a silver hammer, presented by the ladies of Nebraska. The golden nail, when drawn, served as the principal piece of a brooch which was given to Mrs. Palmer (Figs. 555-557).

The Columbian Exposition had an extensive exhibit of totem poles (Fig. 558) and other Northwest Coast Indian arts. Many of these exhibits were later placed in the Field Columbian Museum in Chicago. Totem poles are symbols of family crests and their associated myths erected to inspire respect rather than reverence, their purpose comparable to crests of European heraldry.

Columbus Memorial Arch

A temporary structure erected in New York City, the Columbus Memorial Arch was part of their Columbian celebration. This 160 foot high arch

COLUMBIAN EXPOSITION—HOW THE CROWDS LUNCH.—Drawn by T. de Thulstrup.

510. From *Harper's Weekly*, July 15, 1893.

511. COLUMBIAN EXPOSITION, William A. Bigler, Chicago, Ill. Dec. 6, 1892 (U.S. Pat. No. 22,035). No trademark.

designed by Henry Hert was erected at Fifth Avenue and 59th Street.

Columbian Naval Review

For the Columbian Exposition in Chicago in 1893, the Spanish government built three caravels in exact imitation, as far as could be determined from old prints and descriptions, of the fleet in which Columbus began his voyage. The United States provided funds for the *Nina* and *Pinta,* while the *Santa Maria* was a gift from the Spanish government (Figs. 562 & 563).

These vessels left the Convent of Rabida, at Palos, Spain, on August 6, 1892, exactly 400 years from the day the great navigator weighed anchor and "sailed into the ocean sea" (Figs. 564-566). They sailed first to Cuba then rendezvoused at Hampton Roads, Virginia, with ships from Argentina, Brazil, France, Germany, Great Britain, Italy, the Netherlands, Russia, and twelve vessels belonging to the United States. From Hampton Roads they sailed north to New York harbor for the grand Columbian Naval Review held April 27, 1893 (Figs. 567 & 568).

Following the Review, a municipal ball was held at Madison Square Garden. Three thousand, eight hundred naval personnel, led by Rear Admiral Bancroft Gherardi, took part in the Review and added to the gala atmosphere of the grand ball.

The three caravels then sailed for the St. Lawrence River, made the tour of the Great Lakes and entered the harbor of the World's Fair, where they cast anchor at the walls of the New Rabida, replica of the convent where Columbus had laid his plans for his voyage of exploration.

On September 12, 1893, the vessels were formally presented to the United States government and accepted by the Navy Department.

California Mid-Winter International Exposition

The California Mid-Winter International Exposition (Fig. 569) held in San Francisco, January 27 to June 30, 1894, was the inspiration of M. H. de Young owner and editor of the San Francisco *Chronicle.* He had been vice-president of the Columbian Exposition. The primary purpose of the fair was to portray the wealth and beauty of California (Figs. 570-575). At the close of the Mid-Winter Exposition, some of the exhibits were used in the establishment of the M. H. de Young Memorial Museum.

California's mineral products include petroleum, natural gas, stone, gravel, and sand. Mother Lode, the major gold region, has mines reaching depths of 6,000 feet which have yielded gold since the mid-1880s. San Joaquin Valley's cotton crops (Fig. 576) are called "white gold" and are one of California's most important field crops.

Cotton States and International Exposition

King Cotton was the "white gold" of Georgia when the Cotton States and International Exposition was held in Atlanta, Georgia (Figs. 577 & 578), from September 12 to December 5, 1895.

Pan-American Exposition

In 1901 the Pan-American Exposition was held in Buffalo, New York (Fig. 579). The nation's progress in the nineteenth century was the theme of the fair. Buffalo earned the nickname of "The Rainbow City" from the extraordinary color schemes (Fig. 580) exhibited at the 350-acre fairgrounds (Figs. 581-586).

Louisiana Purchase Exposition

The Louisiana Purchase Exposition held in St. Louis, Missouri, April 30 to December 1, 1904, received world-wide acclaim. This international fair commemorated the 100th anniversary of the purchase of Louisiana from France (Figs. 587-592). Fifteen

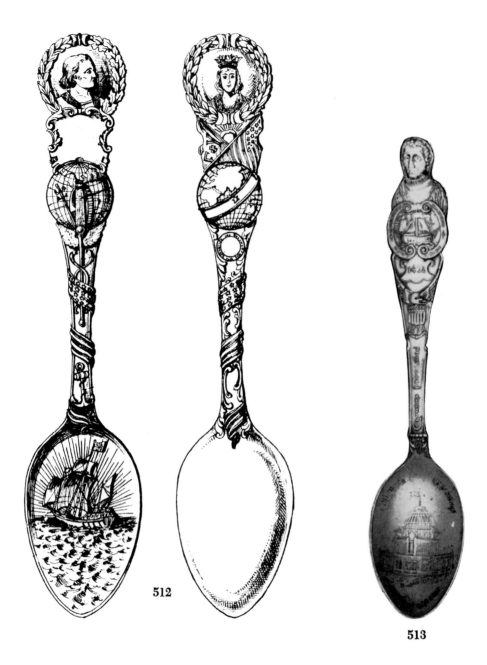

512

513

512. OFFICIAL WORLD'S FAIR, William H. Jamouneau, Newark, N.J. June 6, 1893 (U.S. Pat. No. 22,499). Assigned to B.F. Norris, Alister & Co., Chicago, Ill. Marked: "PAT. APP'D FOR." Alvin-Beiderhase Co. manufacturer.

513. COLUMBUS, Charles E. Barker, N.Y.C. Made in sterling silver, triple plate, and aluminum. Charles E. Barker trademark.

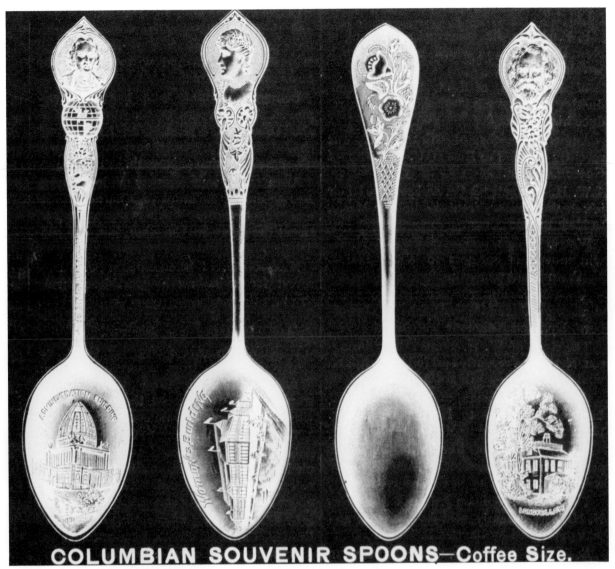

514. *Jewelers' Weekly*, Mar. 1, 1893. Manufactured by Watson, Newell & Co.

515. CHICAGO, Wendell Manufacturing Company, Chicago, Ill. Reverse of handle features a winged wheel, symbolizing commerce. *Jewelers' Weekly*, Oct. 1892 Souvenir Issue.

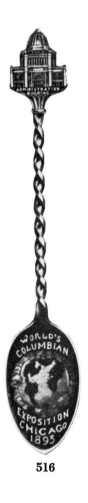

516

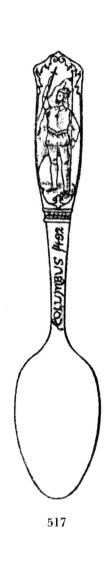

517

519

516. ADMINISTRATION BUILDING—COLUMBIAN EXPOSITION, Wendell Manufacturing Company, Chicago Ill. *Jewelers' Weekly*, Oct. 1892 Souvenir Issue.

517. COLUMBUS 1492, Austin F. Jackson, Taunton, Mass. June 16, 1891 (U.S. Pat. No. 20,838). Assigned to Reed & Barton.

519. COLUMBIAN EXPOSITION, William H. Jamouneau, Newark, N.J. & Justus Verschuur, Jersey City, N.J. June 6, 1893 (U.S Pat. No. 22,500). Assigned to B. F. Norris, Alister & Co., Chicago, Ill. Marked: "Quadruple Plate." Alvin Mfg. Co.

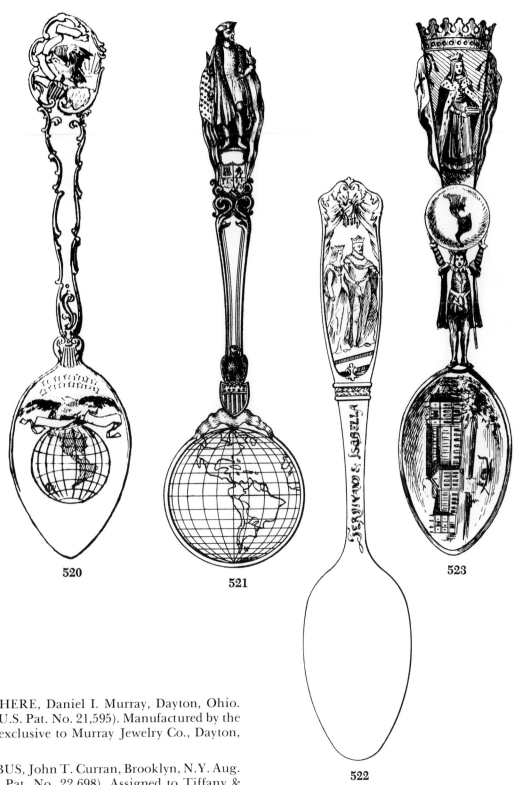

520. HEMISPHERE, Daniel I. Murray, Dayton, Ohio. May 31, 1892 (U.S. Pat. No. 21,595). Manufactured by the Gorham Co., exclusive to Murray Jewelry Co., Dayton, Ohio.

521. COLUMBUS, John T. Curran, Brooklyn, N.Y. Aug. 15, 1893 (U.S. Pat. No. 22,698). Assigned to Tiffany & Company, N.Y.C.

522. FERDINAND AND ISABELLA, Austin F. Jackson, Taunton, Mass. June 2, 1891 (U.S. Pat. No. 20,813). Assigned to Reed & Barton.

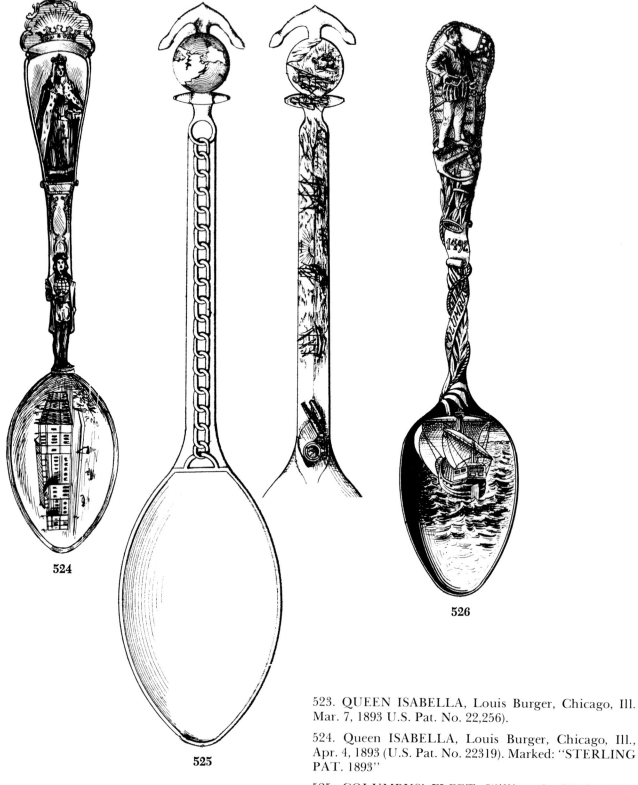

524

525

526

523. QUEEN ISABELLA, Louis Burger, Chicago, Ill. Mar. 7, 1893 U.S. Pat. No. 22,256).

524. Queen ISABELLA, Louis Burger, Chicago, Ill., Apr. 4, 1893 (U.S. Pat. No. 22319). Marked: "STERLING PAT. 1893"

525. COLUMBUS' FLEET, William S. O'Brien, San Francisco, Cal. Mar. 28, 1893 (U.S. Pat. No. 22,308).

526. COLUMBUS, William B. Durgin, Concord, N.H. Apr. 21, 1891 (U.S. Pat. No. 20,685). Manufactured by the Wm. B. Durgin Co.

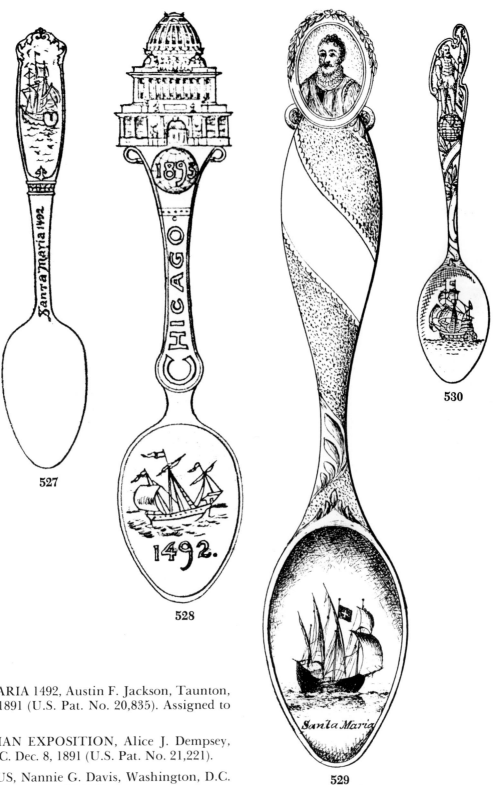

527

528

529

530

527. SANTA MARIA 1492, Austin F. Jackson, Taunton, Mass. June 16, 1891 (U.S. Pat. No. 20,835). Assigned to Reed & Barton.

528. COLUMBIAN EXPOSITION, Alice J. Dempsey, Washington, D.C. Dec. 8, 1891 (U.S. Pat. No. 21,221).

529. COLUMBUS, Nannie G. Davis, Washington, D.C. June 9, 1891 (U.S. Pat. No. 20,828).

530. COLUMBUS, Joseph E. Birmingham & Charles Grandjean, San Francisco, Cal. Feb. 14, 1893 (U.S. Pat. No. 22,223). Wood & Hughes trademark. ometimes unmarked.

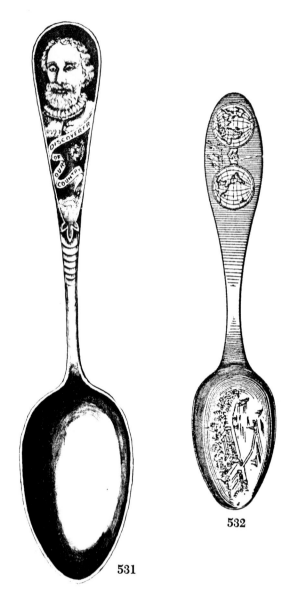

531

532

531. COLUMBUS, Charles M. MacFarland, Worcester, Mass. Nov. 10, 1891 (U.S. Pat. No. 21,165).

532. FRIENDSHIP, Thomas H. Bates & Albert O. Quimby, Fresno, Cal. Nov. 1, 1892 (U.S. Pat. No. 21,952).

large exhibition halls and more than five hundred other structures were erected on the 1,400 acres of Forest Park, the chosen site of the fair.

Alaska-Yukon-Pacific Exposition

A notable achievement of the Pacific Northwest was the Alaska-Yukon-Pacific Exposition (Fig. 593), held in Seattle, Washington, June 1 to October 16, 1909. The federal government spent $600,000 for exhibits to reveal to the American people the arts and industries of America's possessions—Alaska, Hawaii, and the Philippine Islands. It was estimated

that more than $20 million was spent on this successful, although minor, exposition.

Panama-California Exposition

The Panama-California Exposition held in San Diego in 1915 was strongly local in character; the locality was the Spanish Southwest of the United States, nearly a nation in itself (Fig. 598).

Panama-Pacific International Exposition

To celebrate the opening of the Panama Canal, the Panama-Pacific International Exposition was held at San Francisco, California, February 20 to December 4, 1915. Thirty-six nations participated. The Panama Canal and the Exposition (Figs. 594-601) were linked together, the former a tangible and useful monument to man's accomplishment; the latter, a concourse for the different countries to exchange thought, compete in friendly rivalry for honors in various achievements, and form connections for trade between nations.

Sesquicentennial International Exposition

The Sesquicentennial International Exposition (Figs. 602 & 603), a celebration held in Philadelphia, Pennsylvania, June 1 to November 30, 1926, commemorated the 150th anniversary of the signing of the Declaration of Independence. The great advances made in the machine industry attracted more than eight million visitors to the fair.

533. CHRISTOPHER COLUMBUS, William H. Thurber, Providence, R.I. July 28, 1891 (U.S. Pat. No. 20,971). The portrait of Columbus is a reproduction from the mosaic portrait of him presented to the city of Genoa by the city of Venice. Howard Sterling Co. Tilden-Thurber retailer.

534. COLUMBIAN EXPOSITION, George Wilkinson, Providence, R.I. June 7, 1892 (U.S. Pat. No. 21,603). Assigned to the Gorham Corporation. Manufactured by the Gorham Corporation exclusive to Spaulding & Co., Chicago. Machinery Hall is featured in the bowl.

535. LANDING OF COLUMBUS, George Wilkinson, Providence, R.I. June 7, 1892 (U.S. Pat. No. 21,605). Assigned to the Gorham Corporation. Manufactured by the Gorham Corporation exclusive to Spaulding & Co., Chicago. Made with five different bowls: Woman's Building, Fine Art Gallery, Mines and Mining Building, Fishery and Aquarium, and the Transportation Building.

536. QUEEN ISABELLA. Woman's Building embossed in bowl. Marked: "STERLING PAT. 1893." Marked: "CS" (Columbian Souvenir Manufacturing Co.). Manufactured by Wendell Mfg. Co.

537. DISCOVERY. Controlled by C. D. Peacock, Chicago, Ill. *Jewelers' Weekly,* Oct. 1892 Souvenir Issue.

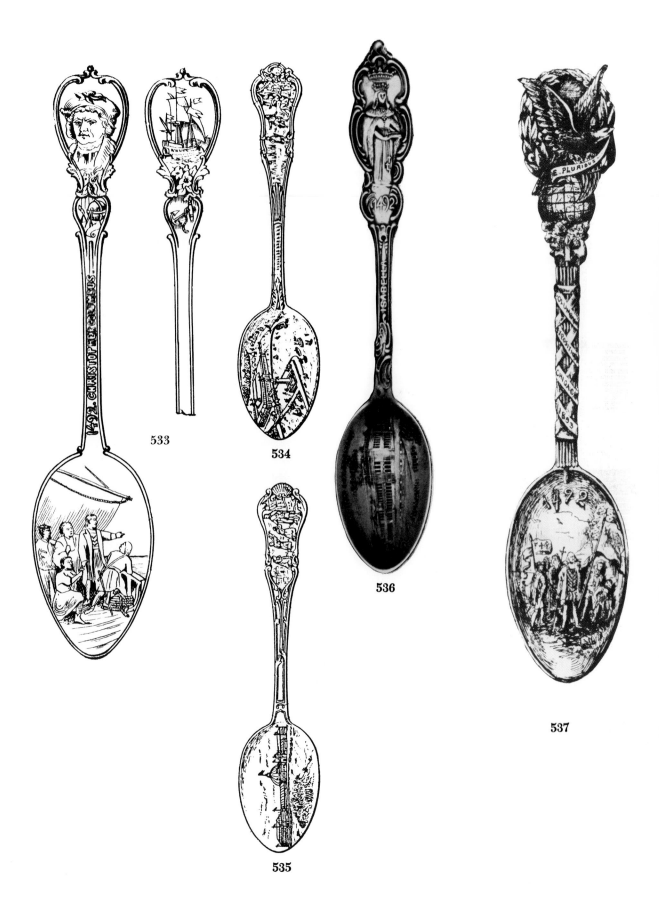

533

534

535

536

537

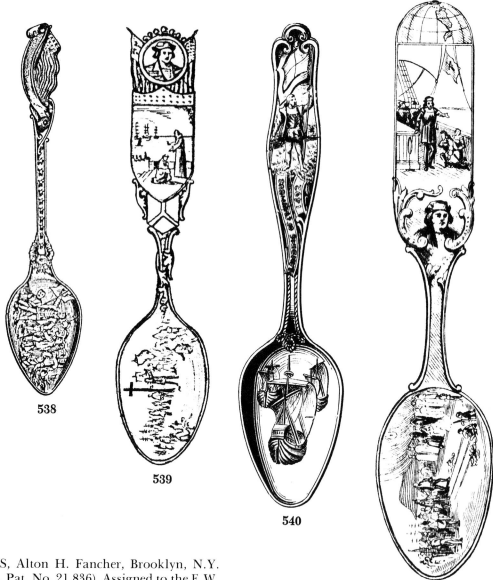

538

539

540

541

538. COLUMBUS, Alton H. Fancher, Brooklyn, N.Y. Sept. 6, 1892 (U.S. Pat. No. 21,836). Assigned to the E.W. Bliss Company, Ltd., London, England.

539. COLUMBUS, Louis Burger, Chicago, Ill. Mar. 7, 1893 (U.S. Pat. No. 22,255). Wm. Rogers Mfg. Co. Silverplate.

540. LANDING OF COLUMBUS, George P. Tilton, Newburyport, Mass. May 19, 1891 (U.S. Pat. No. 20,734). Assigned to the Towle Manufacturing Company. The ribbons contain the words, "Landing of Columbus," and "1492." On the reverse of the handle is a longitudinal view of the old convent, La Rabida at Palos.

541. COLUMBUS, Louis Burger, Chicago, Ill. Mar. 7, 1893 (U.S. Pat. No. 22,257). Wm. Rogers Mfg. Co. Silverplate.

542. COLUMBUS AT BARCELONA. Manufactured by R. Wallace & Sons, Wallingford, Conn. Reverse of handle bears a picture of the *Santa Maria* under sail, a scroll, an orrery, a rosary and crucifix, and two closed volumes. *Jewelers' Weekly*, Oct. 1892 Souvenir Issue.

543. THE DISCOVERER, William H. Tomey, Wallingford, Conn. June 16, 1893 (U.S. Pat. No. 22,498). Assigned to R. Wallace & Sons Mfg. Co.

544. ARMS OF THE UNITED STATES, David T. Foley, Chicago, Ill. Dec. 29, 1891 (U.S. Pat. No. 21,266).

200. AMERICA 1492. Indians watching arrival of three ships. "America 1492 on handle. Marked: "Pat'd. apl'd. For." Pewter.

545. THOMAS W. PALMER, George Wilkinson, Providence, R.I. June 7, 1892 (U.S. Pat No. 21,604). Assigned to the Gorham Corporation. Manufactured exclusive for Spaulding & Co., Chicago, by Gorham. Marked: "Spaulding & Co." Thomas W. Palmer was President of the World's Columbian Commission.

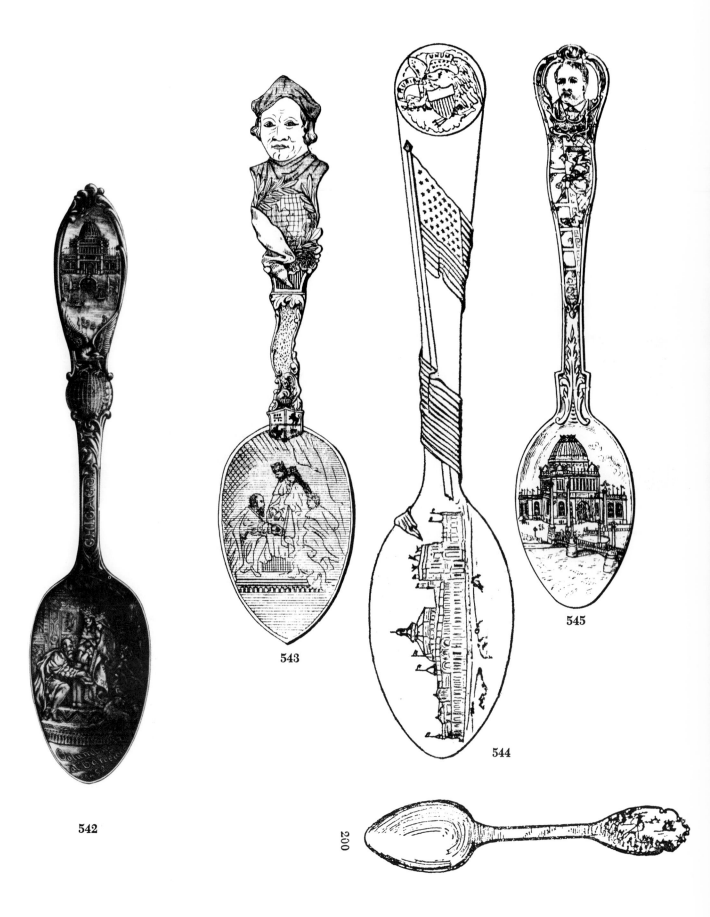

542

543

544

545

200

546

547

548

549

550

546. ELECTRICAL BUILDING, Samuel F. Myers, N.Y.C. Apr. 12, 1892 (U.S. Pat. No. 21,462).

547. COLUMBIAN EXPOSITION, Louis Burger, Chicago, Ill. Mar. 7, 1893 (U.S. Pat. No. 22,253).

548. COLUMBUS, Louis Burger, Chicago, Ill. Mar. 7, 1893 (U.S. Pat. No. 22,254).

549. CHICAGO FIRE. Marked: "C. D. PEACOCK. Pat'd. 1891." Dominick & Haff trademark. Masonic Temple etched in the bowl.

550. CHICAGO, Charles Osborne, N.Y.C. Sept 1, 1891 (U.S. Pat. No. 21,027). Manufactured by the Whiting Mfg. Co.

551

552

553

554

551. CHICAGO PHOENIX, William H. Jamouneau, Newark, N.J. Dec. 22, 1891 (U.S, Pat. No. 21,252). Manufactured by the Alvin Corporation. Marked: "Hyman Berg & Co." No manufacturer's mark.

552. MRS. POTTER PALMER, Louis Burger, Chicago, Ill. Feb. 28, 1893 (U.S. Pat. No. 22,242). Marked: "Pat. 1893." Dominick & Haff trademark.

553. WOMAN'S BUILDING, Alice J. Dempsey, Washington, D.C. Dec. 8, 1891 (U.S. Pat. No. 21,222).

554. WOMAN'S BUILDING, William H. Jamouneau, Newark, N.J. Aug. 8, 1893 (U.S. Pat. No. 22,678). Assigned to B. F. Norris, Alister & Co., Chicago, Ill. Marked: "Alvin, PAT. APPL'D FOR."

555. WOMAN'S BUILDING, Austin F. Jackson, Taunton, Mass. June 30, 1891 (U.S. Pat. No. 20,863). Assigned to Reed & Barton.

556. NEBRASKA HAMMER, Charles Otero, Pueblo, Colo. June 27, 1893 (U.S. Pat. No. 22,557). Manufactured by the Howard Sterling Co.

557. CHILDREN'S HOME, Justus Verschuur, Jersey City, N.J. Aug. 8, 1893 (U.S. Pat. No. 22,679). Manufactured by the Alvin Corporation.

558. TOTEM POLE, Frederick Schwatka, Rock Island, Ill. June 16, 1891 (U.S. Pat. No. 20,832).

559. COLUMBUS MEMORIAL ARCH, John W. Maillot, North Attleboro, Mass. Mar. 21, 1893 (U.S. Pat. No. 22,302). Assigned to F. M. Whiting & Co. F. M. Whiting & Co. trademark.

THE VICTORY DESIGN.

WORLD'S COLUMBIAN EXPOSITION SOUVENIR SPOON.

The striking feature of this attractive spoon is the allegorical design at the top of the handle representing Victory, trumpet and laurel in hand, seated on the globe—a very poetical treatment of the event to be commemorated.

The handle shows also an architectural column, festooned with floral garlands, typical of the festive character of the occasion.

The bowl can be ordered either with the bird's eye view of the Exposition buildings and grounds as shown, or plain.

PRICES PER DOZEN:

	TEAS.	COFFEES.
OXIDIZED,	$24.00	$12.00
GOLD BOWL,	27.00	14.00

Other designs of World's Fair Spoons furnished on application.

ALVIN MFG. CO.,

860 BROADWAY, NEW YORK.

Also Manufacturers of the following Spoons:

UNCLE SAM, OLD OAKEN BUCKET,
WASHINGTON, ALLIGATOR,
SHERMAN, ECCLESIASTICAL,
CLEOPATRA, MARGUERITE
AND THE
HARRISON-REID AND
CLEVELAND-STEVENSON
CAMPAIGN SPOONS.

560. VICTORY. *Jewelers' Weekly,* Oct. 5, 1892.

THE GREATEST
— OF THE —
WORLD'S SPOONS.

As Handsome a Spoon as any in the Market.
As a Unique Souvenir surpasses
all others.

The globe at the top of the handle contains a cylinder in which are five microscopic views of World's Fair Buildings. These are shown through the aperture in the globe by revolving the cylinder.

Also with photos of the President and Vice-President elect, Mrs Cleveland, the Capitol and the White House, as an Inaugural Spoon.

May be supplied with other views to accommodate it to any locality or occasion.

War Ships can be inserted for great Naval Parade in April.

Sterling Silver, $3.00 ; Gilt, $3.50, list.
33⅓ off to the Trade.

GEO. W. BROWN,
CHEYENNE, WYOMING.

561. REVOLVING WORLD. *Jewelers' Weekly,* Mar. 1, 1893. Howard Sterling Co.

562. *SANTA MARIA*, William S. O'Brien, San Francisco, Cal. Mar. 21, 1893 (U.S. Pat. No. 22,301).

567. THE FLEET, William S. O'Brien, San Francisco, Cal. May 9, 1893 (U.S. Pat. No. 22,408).

568. COLUMBIAN NAVAL REVIEW, Robert Leding, Washington, D.C. Jan. 23 1894 (U.S. Pat. No. 23,010). Howard Sterling Co.

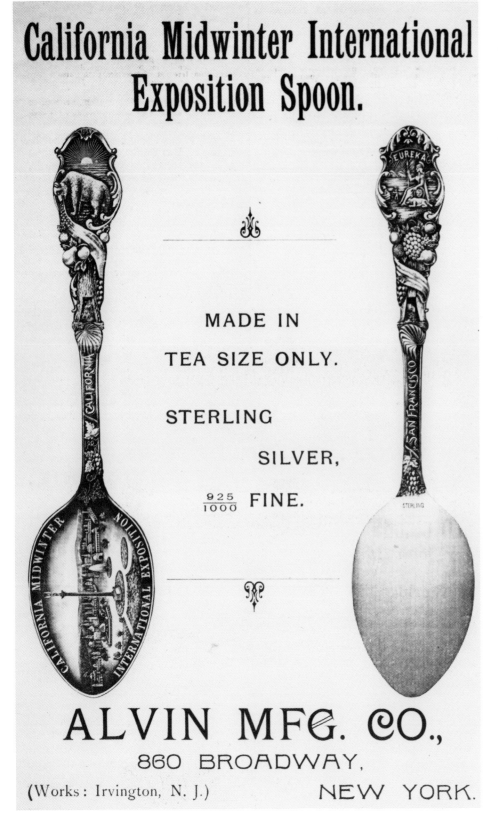

569. *Jewelers' Weekly*, Jan. 17, 1894.

570. CALIFORNIA MID—
WINTER INTERNATIONAL
EXPOSITION, Ernest W. Camp-
bell, Providence, R.I. Mar. 6,
1894 (U.S. Pat. No. 23,097).
Assigned to the Campbell-Metcalf
Co. Campbell-Metcalf Co. trade-
mark.

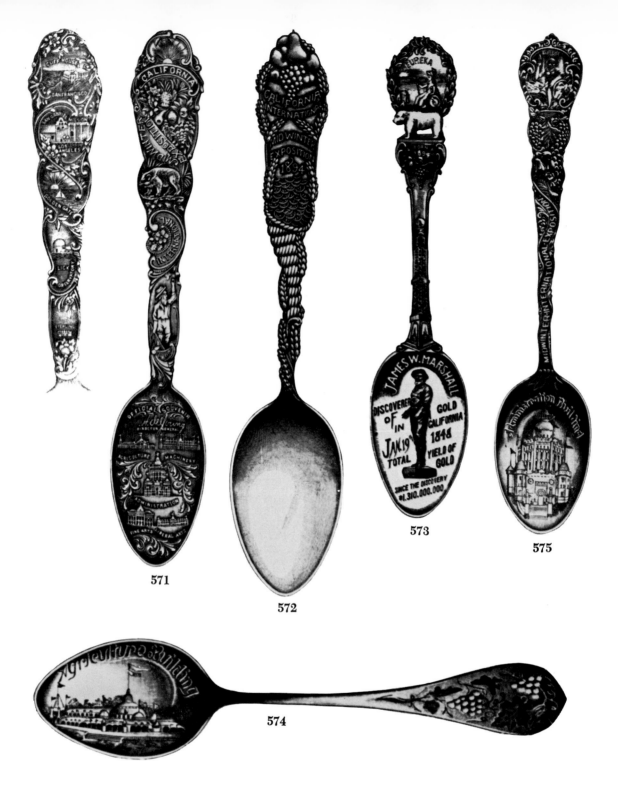

571. CALIFORNIA MID-WINTER INTERNATIONAL EXPOSITION, Campbell-Metcalf Silver Company, Providence, R.I. *Jewelers' Weekly*, Jan. 10, 1894. Spoon as manufactured.

572. CALIFORNIA MID-WINTER INTERNATIONAL EXPOSITION, *Jewelers' Weekly*, Jan. 17, 1894.

573. CALIFORNIA MID-WINTER INTERNATIONAL EXPOSITION, F. M. Van Etten, N.Y.C. Manufactured by the Alvin Manufacturing Company. *Jewelers' Weekly*, Jan. 31, 1894.

574. CALIFORNIA MID-WINTER INTERNATIONAL

EXPOSITION, Julius Eichenberg, Providence, R.I. Manufactured with the handle bearing engraved and hand painted cluster of grapes or hand painted enamel orange sprig. Midwinter Exposition featured in bowl or engraved as desired. *Jewelers' Weekly*, Mar. 14, 1894. Watson, Newell & Co.

575. CALIFORNIA MID-WINTER INTERNATIONAL EXPOSITION, Julius Eichenberg, Providence. R.I. This spoon was manufactured with different bowls, each featuring one of the Fair buildings and was made in both teaspoon and coffee size *Jewelers' Weekly*, Mar. 7, 1894. Watson, Newell & Co.

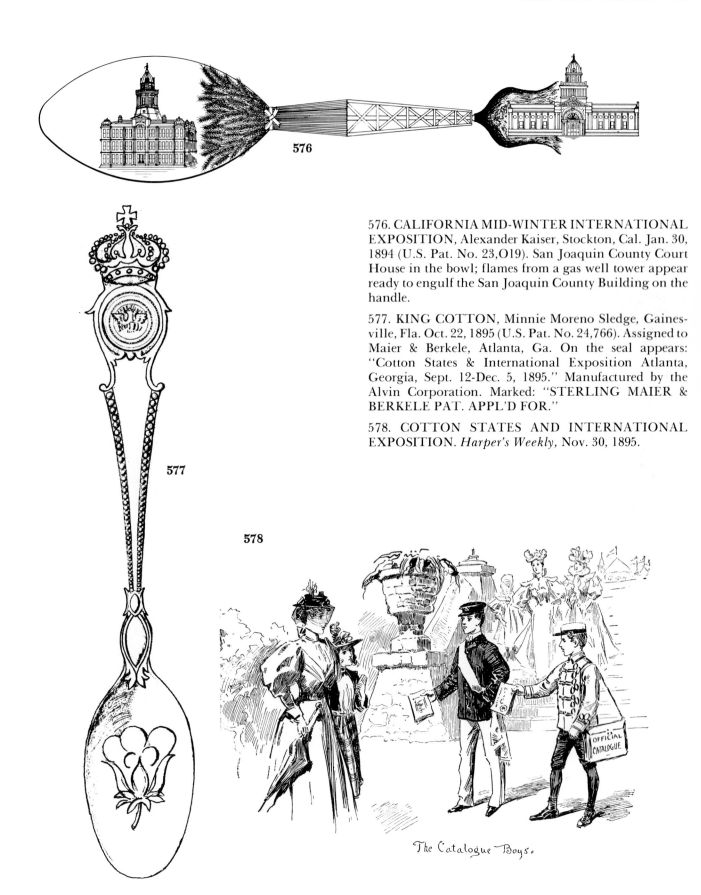

576. CALIFORNIA MID-WINTER INTERNATIONAL EXPOSITION, Alexander Kaiser, Stockton, Cal. Jan. 30, 1894 (U.S. Pat. No. 23,019). San Joaquin County Court House in the bowl; flames from a gas well tower appear ready to engulf the San Joaquin County Building on the handle.

577. KING COTTON, Minnie Moreno Sledge, Gainesville, Fla. Oct. 22, 1895 (U.S. Pat. No. 24,766). Assigned to Maier & Berkele, Atlanta, Ga. On the seal appears: "Cotton States & International Exposition Atlanta, Georgia, Sept. 12-Dec. 5, 1895." Manufactured by the Alvin Corporation. Marked: "STERLING MAIER & BERKELE PAT. APPL'D FOR."

578. COTTON STATES AND INTERNATIONAL EXPOSITION. *Harper's Weekly*, Nov. 30, 1895.

The Catalogue Boys.

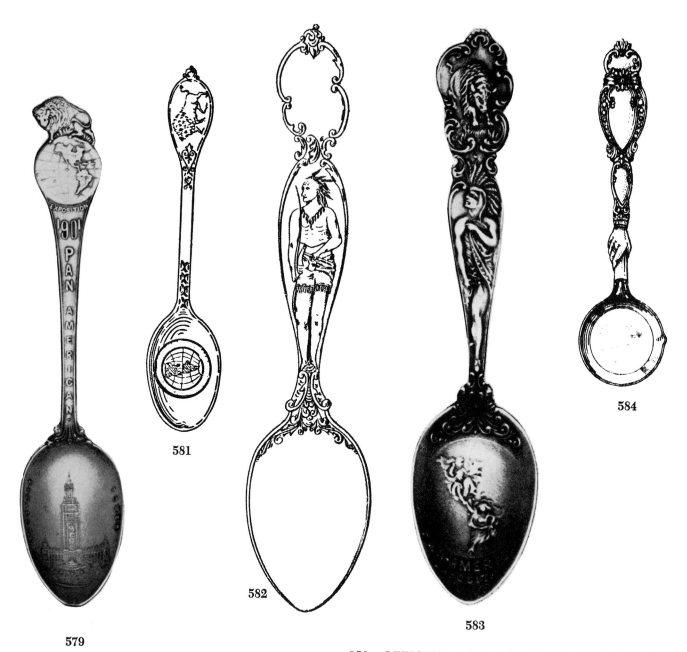

579

581

582

583

584

579. OFFICIAL PAN-AMERICAN EXPOSITION. Marked: "AMERICAN SOUVENIR CO. PAT." "OFFICIAL" on back side of stem. Plated silver.

581. PAN-AMERICAN EXPOSITION, Edward A. Muth, Buffalo, N.Y. May 2, 1899 (U.S Pat. No. 30,650). Jos. Seymour Mfg. Co. trademark.

582. PAN-AMERICAN EXPOSITION INDIAN, Edward A. Muth, Buffalo, N.Y. May 1, 1900 (U.S. Pat. No. 32,609). Jos. Seymour Mfg. Co. trademark.

583. PAN-AMERICAN EXPOSITION INDIAN, as manufactured.

584. PAN-AMERICAN EXPOSITION Charles J. Buchheit, Buffalo, N.Y. Mar. 12, 1901 (U.S. Pat. No. 34,199). No trademark.

587

586

585

588

585. PAN-AMERICAN EXPOSITION spoon as manufactured. Marked: "PAN-AMERICAN EXPOSITION 1901." (Collection of Pearl Gunnerson, Winter Park, Fla.)

586. PAN-AMERICAN EXPOSITION, William F. Ehmann, Buffalo, N.Y. May 7, 1901 (U.S. Pat. No. 34,469).

587. PROGRESS OF LOUISIANA PURCHASE, Bert Ball, St. Louis, Mo. Apr. 29, 1902 (U.S. Pat. No. 35,882). Made with several different trademarks including that of the M. Eisenstadt Jewelry Co. and marked: "Copyright 1902 by Bert Ball."

588. LOUISIANA PURCHASE EXPOSITION, John T. Donnell, St. Louis, Mo. May 27, 1902 (U.S. Pat. No. 35,923).

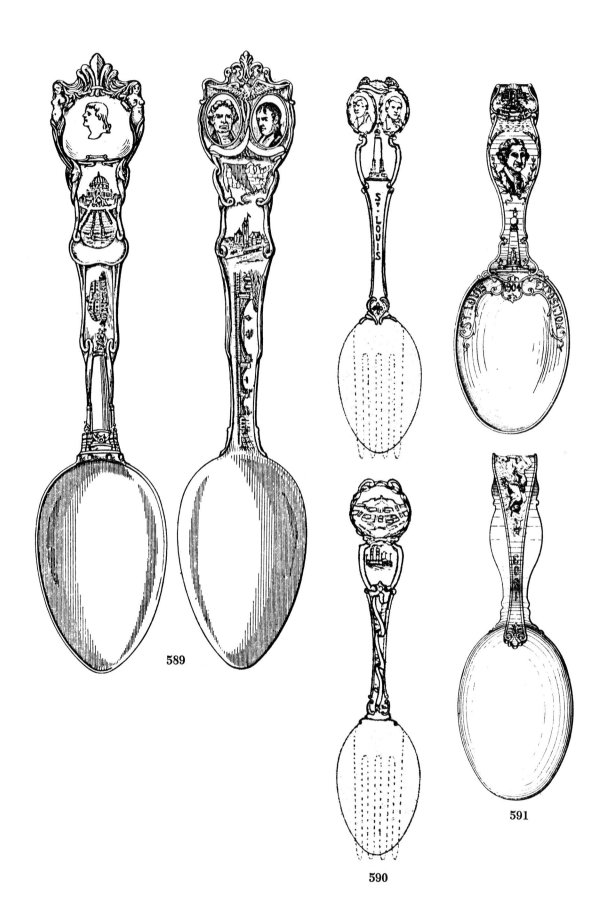

589

590

591

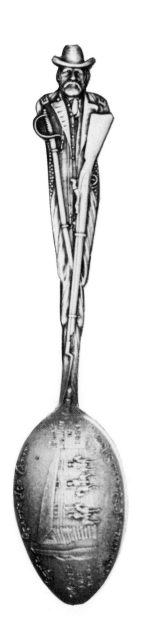

592

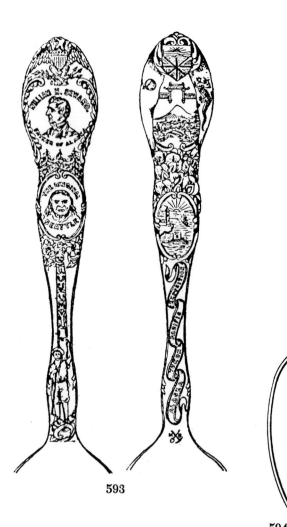

593

594

589. LOUISIANA PURCHASE EXPOSITION, Chester B. Shepard, Melrose, Mass. Sept. 22, 1903 (U.S. Pat. No. 36,567). Marked: "STERLING PAT. 1903."

590. LEWIS & CLARK MONUMENT, Joseph E. Straker, Jr., Attleboro, Mass. Jan. 5, 1904 (U.S. Pat. No. 36,726). Assigned to Watson & Newell. Watson & Newell banner H trademark.

591. LOUISIANA PURCHASE EXPOSITION BABY SPOON, Charles A. Bennett, Taunton, Mass. Dec. 5, 1905 (U.S. Pat. No. 37,707)

592. GENERAL GRANT'S LOG CABIN. Marked: "Copyrighted, C. F. Blanke. Watson & Newell pennant H

trademark. J. L. Post." General Grant's Log Cabin was built by him in 1854 and is now on Grant's Farm near St. Louis, a 281-acre tract once farmed by him. The spoon was made for the Louisiana Purchase Exposition held in St. Louis in 1904.

593. ALASKA-YUKON-PACIFIC EXPOSITION, Joseph Mayer, Seattle, Wash. July 23, 1907 (U.S. Pat. No. 38,695). Joseph Mayer & Bros. 'crossed-tools' trademark.

594. PANAMA-PACIFIC INTERNATIONAL EXPOSITION, Gilbert L. Crowell, Jr., Arlington, N.J., June 4, 1907 (U.S. Pat. No. 38,601). Assigned to Dominick & Haff. Marked: " ◄BARTH► ."

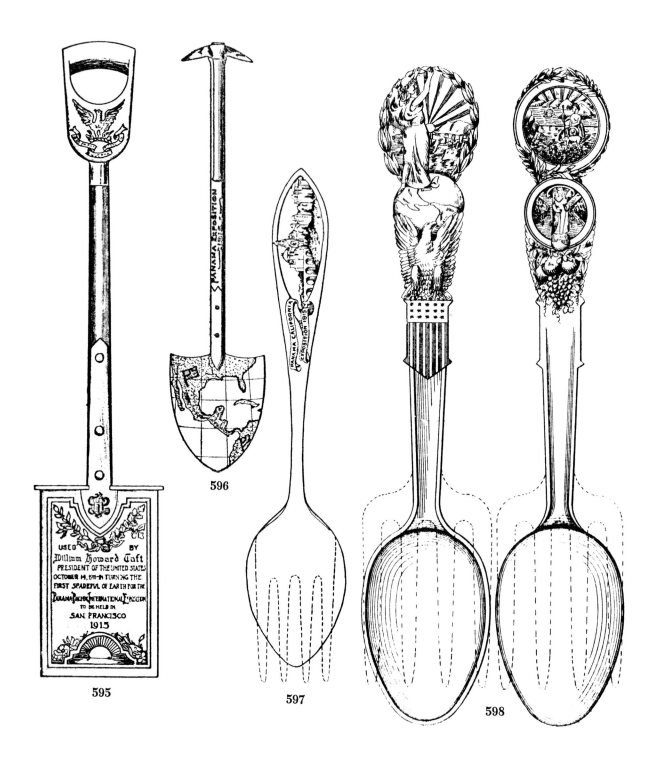

595

596

597

598

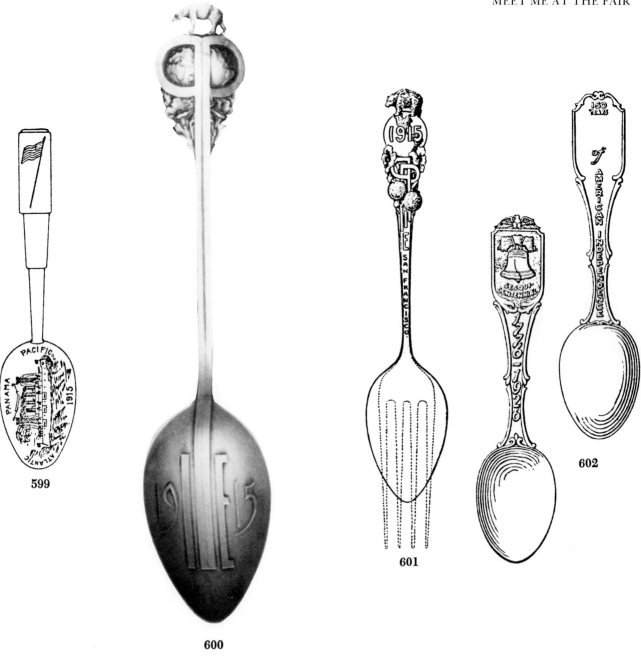

599

600

601

602

595. PANAMA PACIFIC INTERNATIONAL EXPOSITION, George B. Lewis, San Francisco, Cal. Nov. 26, 1912 (U.S. Pat. No. 43,285). Assigned to Panama-Pacific International Exposition Co., San Francisco, Cal. Marked: "STERLING PAT. APP'D. FOR." Shreve & Co. trademark.

596. PANAMA PACIFIC INTERNATIONAL EXPOSITION, Margaret Avera & Hardy A. Avera, Los Angeles, Cal. Feb. 4, 1913 (U.S. Pat. No 43,494).

597. PANAMA-CALIFORNIA EXPOSITION, Ralph C. Thompson, Attleboro, Mass. Mar. 24, 1914 (U.S. Pat. No. 45,512).

598. PANAMA-PACIFIC INTERNATIONAL EXPOSITION, Howard A. Baxter, Melrose Highlands, Mass. Oct. 20, 1914 (U.S. Pat. No. 46,556). Assigned to Panama-Pacific International Exposition Co., San

Francisco. Joseph Mayer & Bros. 'crossed-tools' trademark. Also found with "SMCO in a diamond" trademark of the Shepard Mfg. Co.

599. PANAMA PACIFIC INTERNATIONAL EXPOSITION, Theodore J. Lowery, Washington, D.C. May 4, 1915 (U.S. Pat. No. 47,305).

600. PANAMA-PACIFIC INTERNATIONAL EXPOSITION. Marked: "STERLING. PAT. 1914."

601. PANAMA-PACIFIC INTERNATIONAL EXPOSITION, Frederick Schwinn, Attleboro, Mass. Aug. 17, 1915 (U.S. Pat. No. 47,740). Marked: "OFFICIAL SOUVENIR P.P.I.E." Robbins Co. mark.

602. SESQUICENTENNIAL INTERNATIONAL EXPOSITION 1776-1926, Max L. Wolper, Bronx, N.Y. Oct. 5, 1926 (U.S. Pat. No. 71,234).

603. SESQUICENTENNIAL INTERNATIONAL EXPOSITION, Charles H. Weisgerber, Philadelphia, Pa. May 18, 1926 (U.S. Pat. No. 70,201).

A Century of Progress

A Century of Progress exposition was held in Chicago, Illinois, in 1933 and 1934, on land reclaimed from Lake Michigan. The exposition commemorated Chicago's 100th anniversary. From a huddle of huts and log cabins clinging to the shadows of Fort Dearborn for safety from the Indians, Chicago had grown, in a single century, to become the second largest city in America and fourth largest in the world. The growth of science and the dependence of industry on scientific research was the theme of A Century of Progress (Fig. 604).

The New York World's Fair (1939)

In 1939-40 the New York World's Fair was planned around "The World of Tomorrow" (Figs. 605-607). Long Island marshes were filled to make a site for the Fair. At its heart stood its symbol, the trylon and perisphere.

Century 21 Exposition

The Century 21 Exposition held in Seattle, Washington, in 1962, covered seventy-four acres and was visited by nearly ten million people. The five themes, The World of Century 21, The World of Art, The World of Commerce and Industry, The World of Science, and The World of Entertainment, were virtually a "World of Space Travel."

The 600-foot-high Space Needle (Fig. 608) towered over the fairgrounds. Most of the exposition remains, providing Seattle with a combined civic and cultural center.

The New York World's Fair (1964)

The International World's Fair, held on New York City's 646-acre marshland in 1964-65, displayed the world's past, present, and future, with forty-five countries displaying their products and heritages. The Fair was dedicated to "Peace Through Understanding" (Fig. 609) with the Unisphere—symbol of a shrinking world in an expanding universe—dominating the scene.

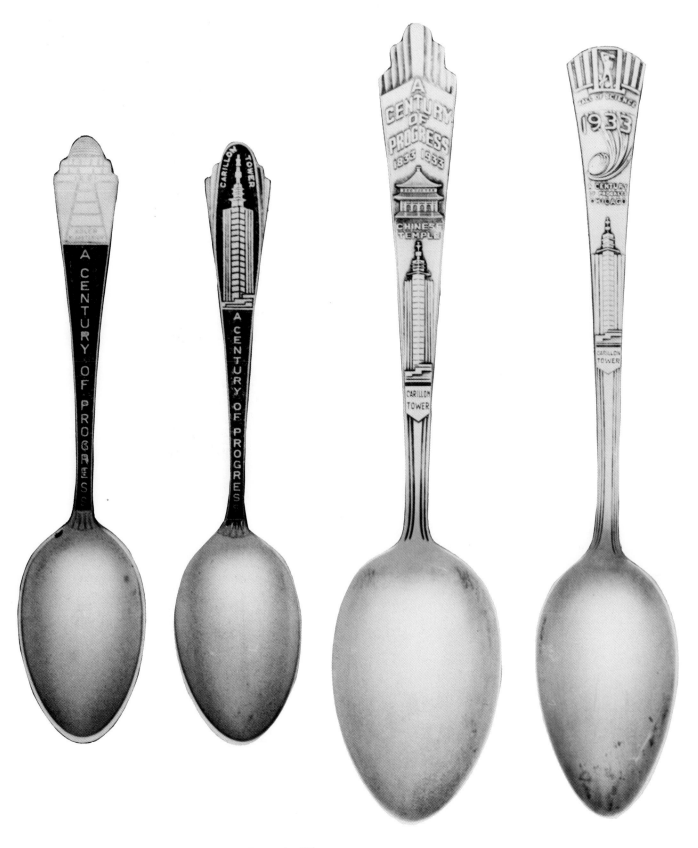

604. A CENTURY OF PROGRESS. *Left:* The two smaller spoons are enameled DIRIGOLD (DIRILYTE). *Right:* Sterling silver. All spoons manufactured by a division of the Watson Company.

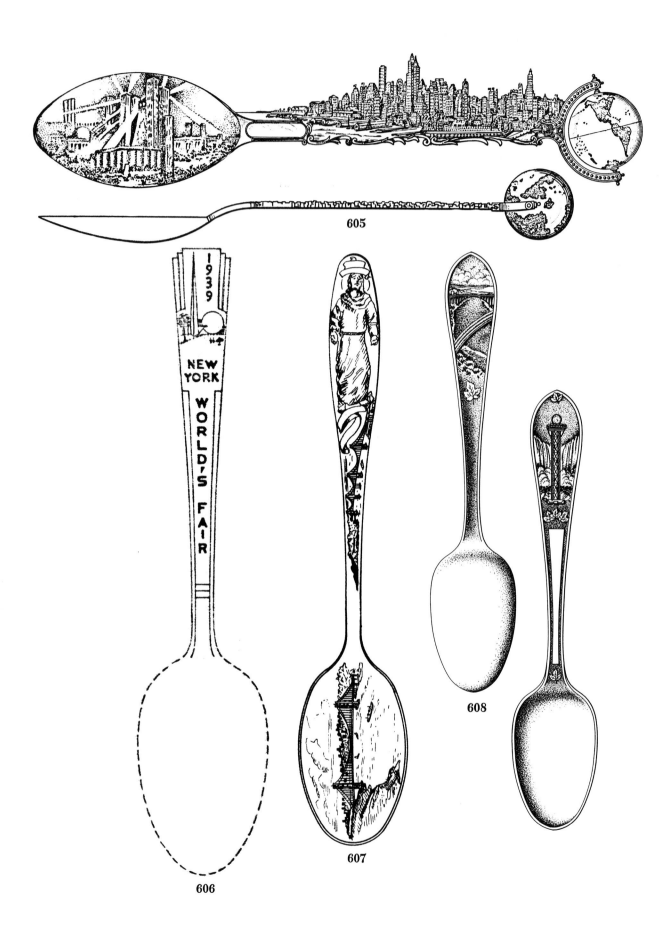

605

606

607

608

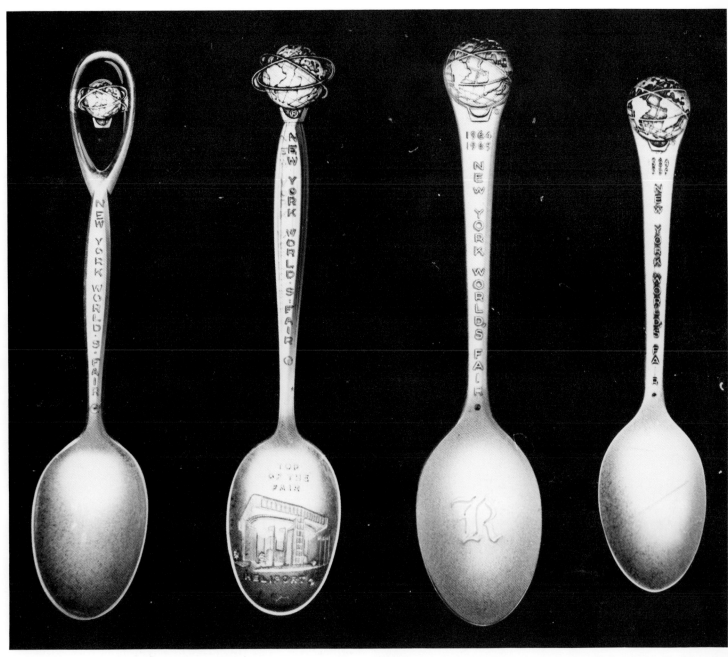

609. *a & b:* Marked: © 1961 N.Y.W.F. 1964-65 Th. Marthinson Sterling Norway." *c & d:* Marked: "Oneida Sterling © 1961 N.Y.W.F."

605. NEW YORK WORLD'S FAIR, Peter F. Meyer, Brooklyn, N.Y. Mar. 22, 1938 (U.S. Pat. No. 108,878).

606. NEW YORK WORLD'S FAIR (1939), Lillian V. M. Helander, Meriden, Conn. Mar. 21, 1938 (U.S. Pat. No. 113,866). Assigned to The International Silver Company. Marked: "Century Silverplate—INSILCO."

607. NEW YORK WORLD'S FAIR (1939), Lillie A. Birmingham, San Francisco, Cal. July 11, 1939 (U.S. Pat. No. 115,609).

608. CENTURY 21 EXPOSITION, Ellen B. Manderfield, Syracuse, N.Y. Jan. 11, 1966 (U.S. Pat. No. 203,479). Assigned to Oneida, Ltd.

610

611

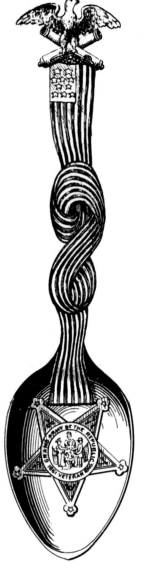

612

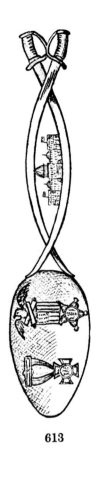

613

610. G.A.R. UNION SOLDIER, John C. Eberhardt, Dayton, Ohio. July 7, 1891 (U.S. Pat. No. 20,907). Assigned to Anderton Eberhardt & Co., Dayton, Ohio. This spoon was originally designed for the Soldiers' Home, Dayton. Later it was produced as a general souvenir for the veteran soldier. Manufactured by the Gorham Corporation. Seen also with the Howard Co. clover mark.

611. G.A.R. ENCAMPMENT, Charles S. Champion, Washington, D.C. July 19, 1892 (U.S. Pat. No. 21,714). Manufactured by the Alvin Corporation.

612. G.A.R., John L. Shepard, Brooklyn, N.Y. June 2, 1891 (U.S. Pat. No. 20,798).

613. G.A.R., George T. Jacobs, Washington, D.C. Aug. 22, 1893 (U.S. Pat. No. 22,718). Assigned one-half to Daniel Williams, Washington, D.C.

Chapter Eighteen
Meeting Time

Grand Army of the Republic

Many patriotic societies have been formed to keep American tradition alive and to honor the memory of ancestors who fought to defend our country's freedom. The Grand Army of the Republic was established April 6, 1866, through the efforts of Major B. F. Stephenson of Springfield, Illinois Members were Union veterans of the American Civil War (Fig 610). The first National Encampment was held November 20, 1866; the last—the 83rd, with the surviving members attending—took place in 1949; both in Indianapolis, Indiana. At the 83rd Encampment, it was voted to disband at the death of the last member. Albert Woolson of Duluth, Minnesota, the last Union veteran, died August 2, 1956.

The badge of the order consists of the G.A.R. emblem, a spread eagle over cannons (Figs. 611-613), with pendant thirteen-star flag and the G.A.R. seal. Establishment of Memorial Day in recognition of veterans, and the founding of many soldiers' homes are credited to the G.A.R. Their work is being continued by affiliated organizations.

Sons of the American Revolution

The Sons of the American Revolution is a patriotic society organized in New York, in April 1889, for the purpose of perpetuating the memory and spirit of the men who helped achieve the independence of the United States. Their activities include the encouragement of historical research in relation to the Revolution; preservation of documents, records, and relics; and to inspire true American patriotism (Fig. 614).

The national headquarters is in Washington, D.C.

Sons of the Revolution

This patriotic society was organized in New York in 1875 by John Austin Stevens, American author who was also founder and editor of *The Magazine of American History*. The Sons of the Revolution was organized to perpetuate the memory of the men who won the independence of the United States; to further proper celebration of Washington's birthday; to collect and preserve records relating to the

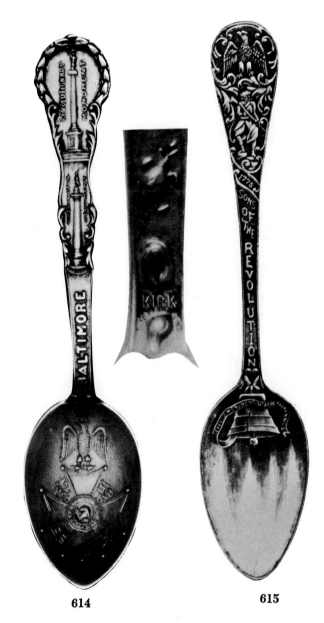

614 **615**

614. *Left:* SONS OF THE AMERICAN REVOLUTION. Manufactured by Samuel Kirk & Son, Baltimore, Md. *Right:* Kirk mark on back.

615. SONS OF THE REVOLUTION, Wood & Hughes, N.Y.C. The Revolutionary Soldier on handle is a likeness of the one on the badge of the society. Reverse of stem features 13 stars. *Jewelers' Weekly*, Dec. 7, 1892.

American Revolution; to inspire members with patriotic spirit; and to promote friendship among them. (Fig. 615)

Daughters of the American Revolution

Organized in 1890, in Washington, D.C., the National Society of the Daughters of the American Revolution perpetuates the memory of its members' ancestors, citizens who have helped to achieve and maintain American Independence. The flag, lady spinning (Figs. 616, 616a, 616b, 616c), and the words, "Home and Country," are featured on the official D.A.R. spoon.

Promoting education, patriotism, and preserving America's history are the objectives of the D.A.R. The National Society presented official D.A.R. spoons of 14k gold to "Real Daughters," with their society number and initials engraved on the back of the handle.

Daughters of the Revolution

In August 1891 several members of the National Society of the Daughters of the American Revolution withdrew from that society and formed their own society. They were dissatisfied because the DAR then admitted as members descendants of the "mother of a patriot" even though the descendant's direct ancestor, brother of the patriot ancestor, might himself be a Tory. The DAR soon changed this policy.

Children of the American Revolution

In 1895 Harriett Lothrop (pseudonym Margaret Sidney, author of the *Five Little Peppers* books) organized the National Society of the Children of the American Revolution (Fig. 617) which has its national headquarters in Washington, D.C.

American Legion

On February 16, 1919, some twenty men of the American Expeditionary Forces met for dinner in Paris and at this dinner the American Legion was born. Originally its membership was limited to veterans of World War I, but in 1942, the organization opened its ranks to veterans of World War II and those who served later in defense of our country. The words, "For God and Country," found in the Preamble to the Constitution of the American Legion (Fig. 618), comprise the organization's motto.

The American Legion is active in helping with the rehabilitation of veterans, in promoting education and good citizenship, and in sponsoring many children's organizations, such as the Boy Scouts.

Order of Masons

The Ancient Free and Accepted Order of Masons is a worldwide secret fraternal society which emphasizes duty to family, country, and God and the pledge to aid fellow members.

Masonry was introduced in the United States around 1730. In 1776 a General Grand Lodge for the United States was proposed with George Washington at its head (Figs. 619 & 620). However, it was later agreed that one independent Grand Lodge in each state should become the accepted pattern.

George Washington was a Master of a Lodge in Alexandria, Virginia. The George Washington Masonic National Memorial at Alexandria was erected in his memory.

Of the six million Masons in the world today, nearly four million reside in the United States. Fifteen of our country's presidents have belonged to this fraternity.

Nobles of the Mystic Shrine

An auxiliary of the Masonic order is the Ancient Arabic Order of Nobles of the Mystic Shrine whose members are thirty-second degree Masons or Knights Templars. The first official session with the thirteen charter members in attendance was held September 26, 1872, at the Masonic Hall on East 23rd Street in New York City. The Shrine of North America has grown to a membership of more than 800,000. The official headgear of this order is the Red Fez (Figs. 621-623); the insigne consists of the scimitar and crescent.

Although the Shrine believes in wholesome companionship within the order, it also believes no man has the right to play unless he also contributes to the happiness of others. Out of this belief grew the

616. D.A.R. Official DAR spoon. Hugh B. Houston, Philadelphia, Pa. July 19, 1892 (U.S. Pat. No. 21,715). Assigned to J. E. Caldwell & Co. Manufactured by the Gorham Corporation exclusive for J. E. Caldwell & Co. Durgin trademark.

616a. D.A.R. MEMORIAL CONTINENTAL HALL. Bust of Cornelia Cole Fairbanks, President General at the time (1905) the hall was completed. Marked Sterling J. E. Caldwell & Co. Phila.

616b. D.A.R. MEMORIAL CONTINENTAL HALL. NSDAR (National Society, Daughters of the American Revolution) and an eagle on the top of the handle. The names of the original thirteen states, in the order in which they joined the Union, are on the Ionic column. Memorial Continental Hall in the bowl. Marked: J. E. Caldwell, Philadelphia.

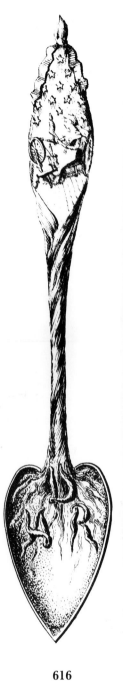

616

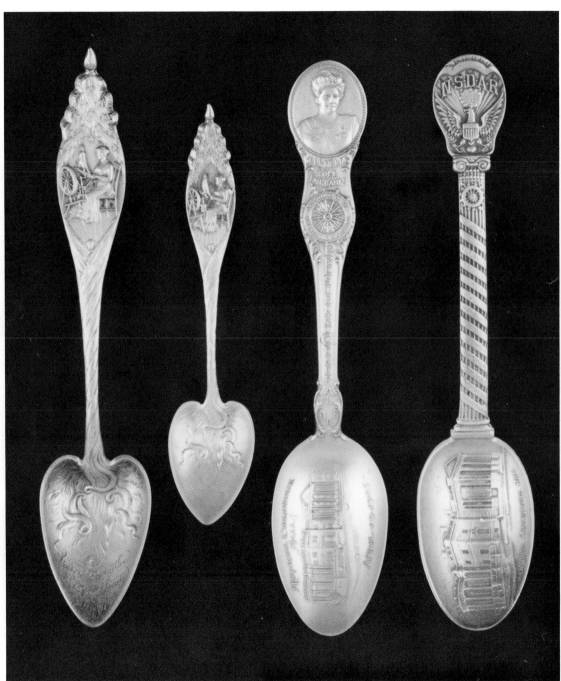

616a 616b

616c

616d

616c. D.A.R. The official insignia of the DAR was unanimously adopted by the Board of Management May 26, 1891 and patented September 22, 1891. The golden wheel of the insignia represents a spinning wheel, the platinum or white gold distaff represents flax, the blue rim and the distaff carry the colors of the society, and the stars represent the origimal thirteen colonies. Marked: Sterling. Though not so marked, a brochure from J. E. Caldwell, says, "Made and sold only by J. E. Caldwell."

616d. DAUGHTERS OF THE REVOLUTION. DAR seal/VF (Valley Forge)/Washington Monument on front. Reverse: Valley Forge 1777-1778. Marked: "Sterling" J. E. Caldwell & Co.

Shriners' Hospitals for Crippled Children of which there are now nineteen. Since 1922, thousands of underprivileged crippled children of all races and creeds have been given free treatment in these hospitals.

Knights Templars

The Commandery of Knights Templars is a fraternal Masonic organization which shares in the charitable and fraternal ideals common to all Masonic organizations (Figs. 624-626). In addition, the Knights Templars are devoted to the Christian faith and works. Since the 1922 Grand Encampment, they have continued a program of financial assistance to deserving and needy college students.

Eastern Star

Another fraternal and charitable organization is the Order of the Eastern Star (Fig. 627), its members being Master Masons or their immediate women relatives. French in origin, it was introduced into the American Colonies by General La Fayette during the Revolutionary War. In 1876 the General Grand Chapter was organized and the order has a current membership of more than three million.

Rebekah Degree

In Baltimore, Maryland, in 1819, the Independent Order of Odd Fellows, an international, secret

617. C.A.R., John H. Kimbell, Jr., Shreveport, La. May 20, 1913 (U.S. Pat. No. 44,065). Assigned to the National Society of the Children of the American Revolution Washington, D.C. Marked: "STERLING PAT. APL'D FOR GALT & BRO. WASHINGTON, D.C."

618. AMERICAN LEGION, F. Russell Woodward, Attleboro, Mass. Apr. 27, 1920 (U.S. Pat. No. 55,002). Assigned to the Watson Company.

619. MASONIC, Harry I. Clulee, Wallingford, Conn. July 5, 1892 (U.S. Pat. No. 21,692). Assigned to R. Wallace & Sons Manufacturing Co. Sterling spoon has R. Wallace & Sons Manufacturing Co. trademark. Spoon of silver plate marked "U. S. Silver Co." The handle features the emblems of (beginning at the top) the Shrine, Commandery, Royal Arch Chapter, Council of Royal and Select Masters, and the Blue Lodge. The bowl was made with various designs.

620. MASONIC, Edward H. Burdick, Syracuse, N.Y. Nov. 28, 1901 (U.S. Pat. No. 35,321). The handle features the emblems of (beginning at the top) the first three degrees of the Masonic Lodge, the G, square and compass, and the plumb line (view one), the level, rule, gavel and trowel (view two). Marked "STERLING PAT." Trademark of Joseph Seymour Mfg. Co.

621. SHRINE, Benage S. Josselyn, Denver, Colo. May 10, 1892 (U.S. Pat. No. 21,519).

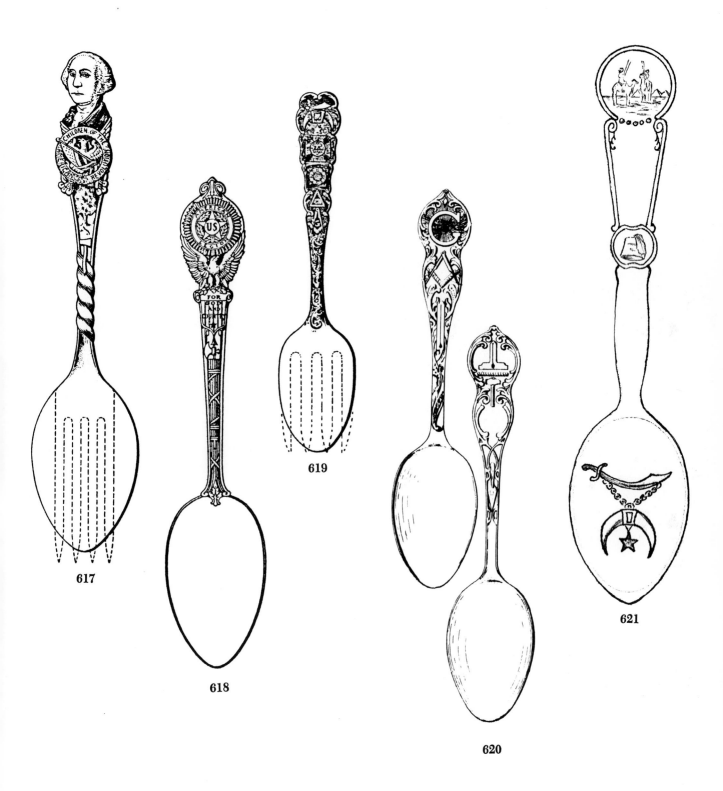

617

618

619

620

621

622

623

fraternal organization has subordinate lodges with membership of more than one million. The primary objective of the Elks is to practice charity and to promote educational opportunities. They spend large amounts annually on charitable and welfare work, and also sponsor other national projects, such as the Elks National Home for aged Elks (Fig. 630).

Jewelers' Crown Guild

The Jewelers' Crown Guild (Fig. 631) was incorporated in Rockford, Illinois, by Joseph C. Peers, Joseph C. Beale, and Joseph B. Kelley (manager, Rockford Silverplate Co.).

Woman's Benefit Association

During the nineteenth century a great increase in the number and variety of associations developed, and by the middle of the twentieth century they had become a prominent feature of the American scene. Many of these organizations worked solely for one philanthropy, and the Woman's Benefit Association (Fig. 632) was one of these.

622. MYSTIC SHRINE, Jacob C. Schmidt, Reading, Pa. May 17, 1892 (U.S. Pat. No. 21,540). Marked: "STERLING." Geo. E. Homer trademark.

623. SHRINE, Robert Castelberg, Washington, D.C. May 29, 1900 (U.S. Pat. No. 32,725). Souvenir of the Imperial Council Session of 1900 held at the Columbia Theater, Washington, D.C. on May 22nd.

fraternal society was founded. Its origin dated around 1750 in England. A beneficiary society, one of its chief concerns is the care of the sick and distressed. The Rebekah Degree (Fig. 628) is a subordinate lodge of the Order of Odd Fellows.

Pythian Sisters

On February 19, 1864, Justus H. Rathbone founded the international fraternity, the Knights of Pythias, in Washington, D.C. Subordinate lodges are located in the United States and Canada with a total membership of approximately 250,000. Friendship, charity, and benevolence are the principles of the fraternity which provides homes for the aged, encourages education, and contributes to emergency funds for use in case of disaster.

The Pythian Sisters (Fig. 629) is an auxiliary organization of the Knights of Pythias.

Order of the Elks

The Benevolent and Protective Order of the Elks was founded in New York City in 1868. This

624. SILVER TRIENNIAL, Benage S. Josselyn, Denver, Colo. Feb. 16, 1892 (U.S Pat. No. 21,347). *Harper's Magazine*, July, 1892, advertisement read, "A Souvenir Commemorative of the Silver Triennial Conclave at Denver, Colorado, August, 1892. Made of Colorado Silver from the Mines of Creede and Cripple Creek. Artistically Engraved with Emblems of the Order and Colorado Scenery." Wendell Mfg. Co.

625. KNIGHTS TEMPLAR, Benage S. Josselyn, Denver, Colo. Apr. 19, 1892 (U.S. Pat. No. 21,469). Howard Sterling Co. trademark.

626. COMMANDERY OF KNIGHTS TEMPLARS, Franklin A. Whelan, Mt. Vernon, Va. Oct. 3, 1911 (U.S. Pat. No. 41,815). Reverse features George Washington over emblem and the dates, "1732-1799," embossed. Marked: "Sterling, Pat. F. A. Whelan." No trademark.

627. EASTERN STAR, Hans Reichl, Seattle, Wash. Aug. 19, 1952 (U.S. Pat. No. 167,541). Assigned to E. Kenneth Rogers, Oakland, Cal. Manufactured by the E. J. Towle Mfg. Co. A set of five spoons was made, each featuring a different figure and name (those incidental to the Order) under the Eastern Star emblem. The points of the star enameled red, blue, yellow, white, and green. Reverse of all spoons identical to view two.

628. REBEKAH DEGREE, Lulu Grimm Blaiser, Williamsburg, Ia. June 18, 1907 (U.S. Pat. No. 38,625). Marked: "Alvin (trademark) STERLING."

629. PYTHIAN SISTERS, Lulu Grimm Blaiser, Williamsburg, Ia. June 18, 1907 (U.S. Pat. No. 38,625).

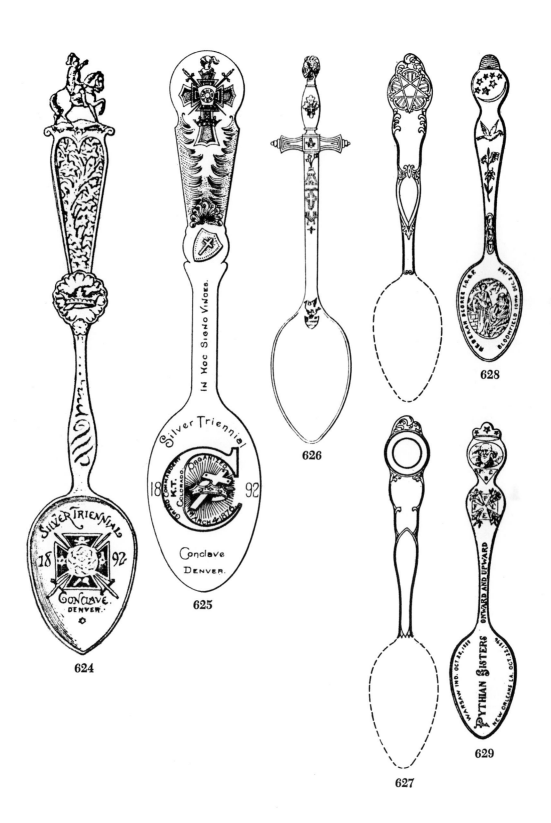

624

625

626

627

628

629

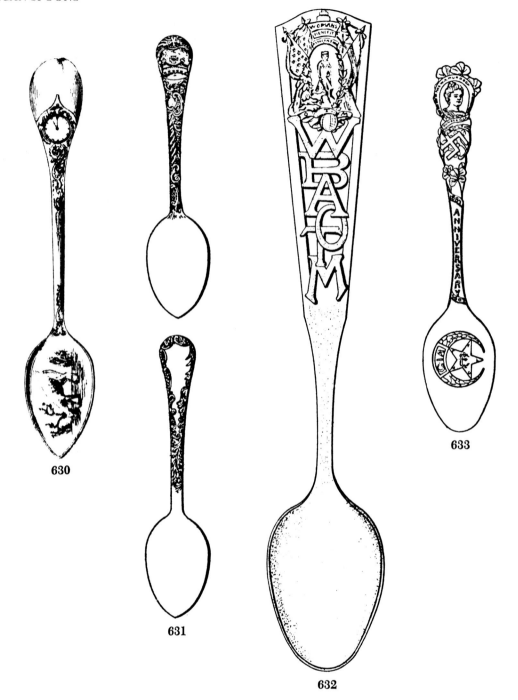

630

631

632

633

630. ELK, Celestin Gustave Tingry, Portland, Ore. May 25, 1897 (U.S. Pat. No. 27,089).

631. JEWELERS' CROWN GUILD, George B. Kelley, Rockford, Ill. Feb. 21, 1893 (U.S. Pat. No. 22,228). Assigned to Jewelers' Crown Guild.

632. WOMAN'S BENEFIT ASSOCIATION, Anton W. Johanson, Chicago, Ill. July 11, 1916 (U.S Pat. No. 49,355).

633. AUXILIARY TO BROTHERHOOD OF LOCO-MOTIVE ENGINEERS, Eustace Crees & Charles S. Court, Providence, R.I. Nov. 26, 1907 (U.S. Pat. No. 38,897). Assigned to J.S. Townsend, Chicago, Ill. Marked: "STERLING J.S.T. Pat. Applied For."

634. W.C.T.U. *Jewelers' Weekly*, Dec. 9, 1891. Peter Krider Co. Mfg.

Auxiliary to Brotherhood of Locomotive Engineers

Mrs. W. A. Murdock was the founder of the Grand International Auxiliary to Brotherhood of Locomotive Engineers (Fig. 633) in 1887.

Woman's Christian Temperance Union

Organized in Cleveland, Ohio, in 1874, the Woman's Christian Temperance Union promotes total abstinence and the abolition of liquor manufacture and sale. The World's W.C.T.U. was the first international organization for women. It was founded by Frances E. Willard of Chicago in 1883 (Fig. 634).

Emblem

Innumerable spoons have been made (Figs. 635-638) which could be adapted by any association or organization by the addition of a medallion or symbol.

635. EMBLEM, Gustave A. Schlechter, Reading, Pa. Dec. 6, 1892 (U.S. Pat. No. 22,033). Manufactured by the Gorham Corporation exclusive to G. A. Schlechter.

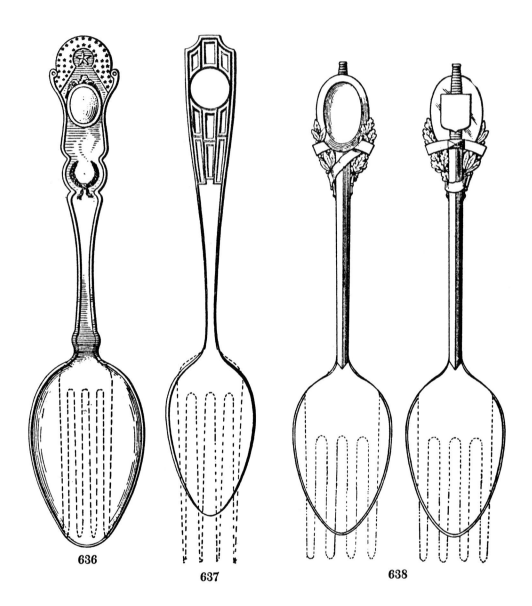

636

637

638

636. EMBLEM, Moses A. Anzelwitz, N.Y.C. Aug. 9, 1910 (U.S. Pat. No. 40,814).

637. EMBLEM, Frederick Schwinn, Attleboro, Mass. July 20, 1915 (U.S. Pat. No. 47,629)

638. EMBLEM, Frederick Schwinn, Attleboro, Mass. May 6, 1919 (U.S. Pat. No. 53,277).

Chapter Nineteen
Bells and Steeples

Because of the religious freedom on which our country was founded, many denominations are represented on souvenir spoons.

Mission San Diego de Alcala

Two centuries ago, from San Diego northward to San Francisco and beyond, twenty-one old Missions of California stood as sentinels along El Camino Real, "the King's Highway" (Fig. 639). These missions were outposts of religion and civilization during the Revolutionary War. A number of them are now in ruins, but each has a rich heritage of history for every Californian. Nine of the California Missions were founded under the direction of Padre Junipero Serra, who came to America in 1749. Twenty years later, he accompanied the Portola expedition to locate the ports of San Diego and Monterey and to colonize the then pagan land of California. San Diego de Alcala (Figs. 640-642), the first of the California missions to be founded—July 16, 1769—was known as "The Mother of All Missions." In 1774 this Mission was moved six miles inland to its present site. Destroyed by an Indian uprising in 1775, it was rebuilt in 1780 and restored by 1941.

Mission Santa Barbara

The military presidio chapel, dating from 1782, at which Padre Junipero Serra officiated, was the original church of Santa Barbara, California. The formal founding took place on December 16, 1786. The following year the first mission church and Franciscan friary were erected. A new church of adobe was built in 1789. A third building, erected in 1793, served the needs of the Indian community until 1812 when it was destroyed by an earthquake. In 1820, the new building (Fig. 643), was completed and dedicated. In 1925, the building was again destroyed by earthquake, but was restored during 1926-27.

Today Santa Barbara is a major theological seminary where students receive their final years of training and ordination for the Franciscan priesthood.

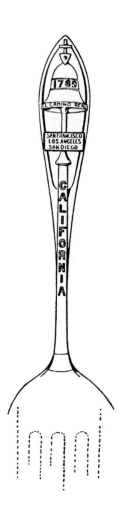

639. EL CAMINO REAL, Frederick Schwinn, Attleboro, Mass. Apr. 18, 1916 (U.S. Pat. No. 48,916).

MISSION BELL

Outstanding features of the California Missions, which never cease to win the admiration of visitors, are the thick adobe walls, the hand-hewn redwood beams, the Mission Bells (Fig. 644), and the priceless Indian and Spanish paintings.

St. Paul's Episcopal Church

St. Paul's Episcopal Church, Norfolk, Virginia

640

641

642

(Fig. 645), was built on the site of an earlier church known as "The Chapel of Ease." The first church was constructed in 1641; the second, in 1739. After the burning of Norfolk in 1776, the present structure was the only building of note left standing.

The Cathedral of St. John the Divine, Episcopal

Located on Amsterdam Avenue between West 110 and West 113 Streets in New York City is the Cathedral of St. John the Divine (Fig. 646), the world's largest Gothic cathedral. The cornerstone was laid December 17, 1892. Construction of this Episcopal Cathedral was partially finished in a combination of Byzantine, Romanesque, and Gothic styles when, in 1911, plans were changed to copy late Gothic styles. Work continues on the unfinished cathedral.

First Church of Christ, Congregational

The First Church of Christ, Congregational, in Pittsfield, Massachusetts, was organized February 7, 1764. The parish met in a modest frame building until 1793 when a new church building, designed by Charles Bulfinch, was completed. The parish became known as "The Bulfinch Church." In 1842, the church was totally destroyed by fire. Rebuilding began at once, but in the process of construction, the building was again destroyed by fire. A new church was finally completed in 1852. It remained intact until 1951, when it underwent a complete modernization (Fig. 647).

On February 9, 1964, The First Church of Christ celebrated its bicentennial. The festivities included an historical exhibit of memorabilia pertaining to the Bulfinch Church and the Old Elm.

The Old Elm, nearly 150 feet high, stood in the center of a small Pittsfield park until struck by lightning in 1863.

640. MISSION SAN DIEGO DE ALCALA, Charles T. Paye, North Attleboro, Mass. May 8, 1906 (U.S. Pat. No. 37,991). Assigned to mesne assignments, to Chris W. Ernsting, San Diego, Cal. Marked: "ERNSTING STERLING." Ribbon in view one reads: "OLD MISSION 1769." On stem "Ramona's Wedding Place," originally known as Casa de Estudillo. Presently it houses a large collection of Spanish, Indian, and American antiques. Received the name, "Ramona's Wedding Place" because it was used by Helen Hunt Jackson as the background for her novel, *Ramona*. Reverse features Hotel Del Coronado, Point Loma, boat house, and old Spanish lighthouse erected in 1855 and used until 1891.

641. MISSION SAN DIEGO DE ALCALA, Paye & Baker trademark. One of a series of California Mission spoons.

642. MISSION SAN DIEGO DE ALCALA, Charles C. Thompson, San Diego, Cal. May 29, 1894 (U.S. Pat. No. 23,310).

Mormon Tabernacle and Temple

The chief buildings of the Mormon Church (The Church of the Latter Day Saints) are situated in the center of Salt Lake City, Utah's capital. The Tabernacle, famous for its huge pipe organ, is an oval structure which seats 8,000 and is noted for its remarkable acoustical properties. The Tabernacle and Assembly Hall are open to the public; only Mormons are admitted to the many-spired Temple (Fig. 648), used for marriages, prayer, and baptisms.

643. MISSION SANTA BARBARA, Edward Mehesey, Jr., Salt Lake City, Utah. Mar. 6, 1906 (U.S. Pat. No. 37,867). Handle comprises the figure of Father Raynerius Dickneite, O.F.M., with the Mission Santa Barbara. The fish on the reverse side symbolize the Indians' conversion to Christianity by the Franciscan missionaries. The anchor signifies hope. The hibiscus, above the bunch of grapes, represents the hibiscus flowers grown for many years in the cloister garden of the mission.

644

645

646

644. MISSION BELL, George E. Nerney, Attleboro, Mass. Feb. 11, 1913 (U.S. Pat. No. 43,551). Manufactured by the Robbins Company.

645. ST. PAUL'S CHURCH, Charles F. Greenwood & Frederick Greenwood, Norfolk, Va. July 7, 1891 (U.S. Pat. No. 20,916). Manufactured by the Gorham Corporation.

646. CATHEDRAL OF ST. JOHN THE DIVINE, George W. Shiebler, Brooklyn, N.Y. June 21, 1892 (U.S. Pat. No. 21,633). Geo. W. Shiebler & Co. trademark. In bowl, Cathedral of St. John. On back of bowl, in the original Greek, is "God is Love." Above the motto is the cross of the King's Daughters.

Christian Endeavor Society

The Christian Endeavor Society was formed by Francis E. Clark in the parsonage of the Williston Congregational Church (Figs. 649 & 650) in Portland, Maine, February 2, 1881. The society provides an avenue of expression for the religious life of young people, giving them worthwhile tasks to do and emphasizing service and loyalty to Christianity. The first Christian Endeavor convention was held at Williston Church in 1882. In 1892 the Junior Endeavorers held their first convention in New York City (Figs. 651 & 652).

647

648

647. FIRST CHURCH OF CHRIST, CONGRE-GATIONAL—THE OLD ELM, Frank A. Robbins, Pittsfield, Mass. June 30, 1891 (U.S. Pat. No. 20,893). Dominick & Haff trademark. Marked: "F. A. Robbins." The Old Elm was an ancient Indian landmark and guide.

648. MORMON TABERNACLE AND TEMPLE, Ralph C. Thompson, Attleboro, Mass. Dec. 21, 1913 (U.S. Pat. No. 45,078).

649

650

651

649. CHRISTIAN ENDEAVOR, Edward T. Fenwick, Washington, D.C. May 24, 1892 (U.S. Pat. No. 21,554).

650. WILLISTON CHURCH, Edward T. Fenwick, Washington, D.C. May 24, 1892 (U.S. Pat. No. 21,565).

651. CHRISTIAN ENDEAVOR, William Shaw, Ballard Vale, Mass. June 28, 1892 (U.S. Pat. No. 21,657). Manufactured by the Gorham Corporation exclusive to William Shaw.

652. CHRISTIAN ENDEAVOR, Edmund Ira Richards, Brooklyn, N.Y. Sept. 27, 1892 (U.S. Pat. No. 21,868).

653. EPWORTH LEAGUE, Carrie Patton Truesdell, Cleveland, Ohio. Apr. 25, 1893 (U.S. Pat. No. 22,364). Manufactured by the Gorham Co., exclusive to A. I. Truesdell.

654. EPWORTH METHODIST EPISCOPAL CHURCH, Carrie Patton Truesdell Cleveland, Ohio. July 25, 1893 (U.S. Pat. No. 22,643). Gorham Co. trademark.

655. KING'S DAUGHTERS, Mae Wallace McCastline, Syracuse, N.Y. June 18, 1895 (U.S. Pat. No. 24,397). Manufactured by the Gorham Corporation.

656. MARY BAKER EDDY, Frederick R. Roberts, Concord, N.H. Jan. 24, 1899 (U.S. Pat. No. 30,043). Assigned to George F. Durgin, Allan H. Robinson, and George H. Moses. Marked: "STERLING PATENT." Durgin trademark. A gold spoon, in this design, was once presented to Calvin C. Hill, executive of the Church, and is now in the Archives of the Mother Church.

657

658

659

657. FIRST CHURCH OF CHRIST, SCIENTIST, George H. Barrett Jr., N.Y.C. Nov. 15, 1904 (U.S. Pat. No. 37,220). Assigned to Wm. R. Phelps & Co. The grapes and vines have reference to the Mother Church, which is the vine, and its branches. The spoon was made to commemorate the dedication of the New York Church, Thanksgiving Day in 1903. The designer was a member of the N.Y. Church.

658. KNIGHTS OF COLUMBUS, James J. Condon, Atlanta, Ga. Apr. 11, 1905 (U.S. Pat. No. 37,392).

659. STAR OF DAVID, Michael C. Fina, Forest Hills, N.Y. Oct. 19, 1954 (U.S. Pat. No. 173,262). Symbols on the handle, from the top: Star of David, seven-branched candlestick between two olive branches, Torah Scroll, Tallith or prayer-shawl, Shofar, the Two Tablets of the Law, two wine cups with grapes, American flag and flag of Israel. On the reverse is the United States coat-of-arms. Made in plated silver.

The Epworth League

The Epworth League was founded in Cleveland, Ohio, in 1889. It is a Methodist youth organization with a membership of some 1,400,000 people between the ages of twelve and twenty-three (Figs. 653 & 654). Until 1941 it was called the "Epworth League," in honor of John Wesley's English birthplace. It is now known as "Methodist Youth Fellowship." The seal of the organization is a Maltese Cross with the motto, "Look up; lift up."

King's Daughters

King's Daughters (Fig. 655), a religious organization, was founded in 1886 by Margaret McDonald Bottome, wife of the Rev. Frank Bottome, a Methodist clergyman.

Church of Christ, Scientist

Mary Baker Eddy (Fig. 656), founder of Christian Science and the Church of Christ, Scientist (Fig. 36), was a native of Concord, New Hampshire. Misfortune caused her to turn to the Bible for guidance. Her convictions were strengthened when she was healed of a severe injury while reading the Bible. *Science and Health with Key to the Scriptures*, her chief work, was published in 1875. Four years later, with the help of Asa G. Eddy, her husband, Mrs. Eddy organized the Church of Christ, Scientist (Fig. 657), and directed it until her death. *The Christian Science Monitor* was founded in 1908.

Knights of Columbus

The Knights of Columbus, a Catholic laymen's organization, was chartered March 29, 1882, by the State of Connecticut as a mutual benefit society (Fig. 658). Its charter states its purposes; aiding fellow members, promoting education, charity, religion, public relief and welfare, and social welfare. Through its organ, *Columbia*, it campaigns for the American form of government.

Star of David

The Bible tells us that God created the heavens, and earth and sea, and all living things in six days, and on the seventh He rested. One day out of every seven is observed as a holy day, called the Sabbath.

The Jewish people observe their Sabbath (Fig. 659) from sundown Friday until sundown Saturday, because Saturday is the seventh day of the week.

36

36. MOTHER CHURCH, First Church of Christ Scientist, Geo. E Homer, Boston, July 31, 1906 (U.S. Pat. No. 38,138).

Chapter Twenty
American Wonderlands

Portland Observatory

Maine's Portland Observatory (Fig. 660) was built in 1807 by Lemuel Moody, who had been a water boy in the Revolution. Commissioned by George Washington, the red-shingled tower was a lookout and signalling station for vessels approaching Portland Harbor.

The poet, Longfellow, when he lived in Portland, composed many of his verses perched in the shade of the lighthouse where heavy seas crashed on the rocky shore.

An 1858 traveler exclaimed that the view was "...one of the most magnificent...I have ever beheld.... Land, forest, and mountain, gradually rose from Portland harbor in full perspective before me, terminating only in the lofty White Mountains in New Hampshire..." Today's visitor can behold this same view from this unique monument to a bygone era.

Old Man of the Mountains

The Old Man of the Mountains, the Great Stone Face, and The Profile (Figs. 661-664) are various names given to the optical illusion created by a chance alignment of five separate granite ledges and boulders in New Hampshire's White Mountains. The head measures about 40 feet from chin to forehead and juts from a sheer cliff 1,200 feet above Profile Lake.

This most famous of all natural profiles, first seen by white men in 1805, has become New Hampshire's trademark. Its size and shape were determined some 200 million years ago when the Conway granite crystallized, forming vertical cracks, and frost action, after the great ice sheet melted, forced granite blocks to fall, leaving the Profile.

Once threatened by the building of Interstate Highway No. 93, The Great Stone Face, immortalized by Nathaniel Hawthorne in his short story, still glowers in Franconia Notch. Only two generations ago, the intervention of the Society for the Protection of New Hampshire Forests and the Franconia Notch Reservation, which was created through private contributions, rescued the site from fast-buck operations. Formation of the Franconia Notch State Park enables throngs of visitors to enjoy the scenic and recreational aspects of the area. The Profile itself is best viewed from the eastern shore of Profile Lake between 10:00 a.m. and sunset.

Boston Lighthouse

The first lighthouse built in the United States was Boston Light, erected by the Massachusetts Bay Colony in 1716.

Before the nineteenth century there were only twenty-five lighthouses in the United States; that number had increased to 10,000 by 1957, and was augmented by lightships and some 39,000 warning lights and signals.

Lighthouses were first erected by the colonies and were taken over by the federal government when it was established in 1789. Lighthouses are now a function of the United States Coast Guard (Fig. 665).

The earliest lighthouses in America burned oil in wick lamps. The first nuclear lighthouse, an unmanned station off Gibson Island, Maryland, near the entrance to Baltimore Harbor, was put into operation in 1963. It is powered by a 250,000-curie source of strontium-90 producing 60 watts of electricity.

One of the most outstanding developments in lighthouse engineering is the marine radiobeacon. Radio signals, sent from a number of important lighthouses and lightships, enable mariners to determine their position with accuracy by cross-bearing from two or more stations.

Early in the nineteenth century the Atlantic seaboard was one of the most poorly lighted coasts in the world; now it is one of the best.

Inclined Railroad—Mt. Tom

From the Mountain Park, at the summit of Mount Tom, 1,214 feet above the Connecticut Valley near Holyoke, Massachusetts, there is a magnificent view overlooking pine, hemlock, spruce, and hardwood forests. Once accessible mainly by inclined railroad (Figs. 666 & 667), it may now be reached by a mountain road, on foot, or by ski lifts.

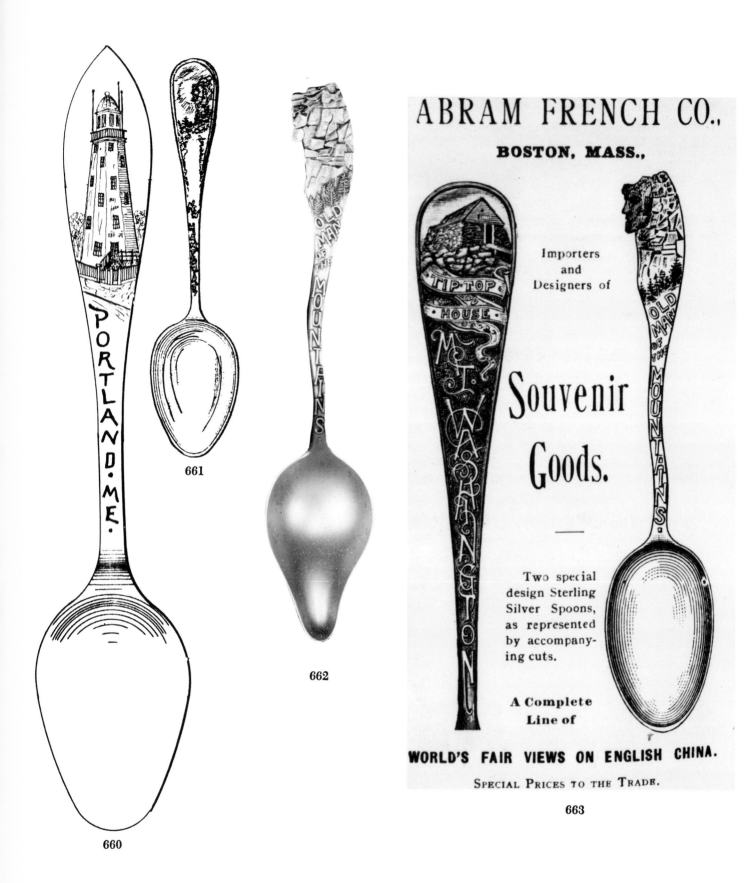

660

661

662

ABRAM FRENCH CO.,

BOSTON, MASS.,

Importers
and
Designers of

Souvenir
Goods.

Two special
design Sterling
Silver Spoons,
as represented
by accompany-
ing cuts.

**A Complete
Line of**

WORLD'S FAIR VIEWS ON ENGLISH CHINA.

SPECIAL PRICES TO THE TRADE.

663

664

665

666

667

660. PORTLAND OBSERVATORY, William Senter, Portland, Me. Nov. 10, 1891 (U.S. Pat. No. 21,167). Marked: "W. Senter & Co." Manufactured by the Wm. B. Durgin Co.

661. OLD MAN OF THE MOUNTAINS, Wm. B. Durgin, Concord, N.H. Mar. 3, 1891 (U.S. Pat. No. 20,542). Manufactured by the Wm. B. Durgin Co.

662. OLD MAN OF THE MOUNTAINS. Marked: "PAT. MCH. 3. 91 (Durgin trademark) STERLING PROFILE HOUSE."

663. MOUNT WASHINGTON and OLD MAN OF THE MOUNTAINS. Jewelers' Weekly, July 12, 1893.

664. OLD MAN OF THE MOUNTAINS, George E. Nerney, Attleboro, Mass. Feb. 11, 1913 (U.S. Pat. No. 43,548). The Robbins Company trademark.

665. BOSTON LIGHTHOUSE, George E. Nerney, Attleboro, Mass. Feb. 11, 1913 (U.S. Pat. No. 43,549). The Robbins Company trademark.

666. MT. TOM—INCLINED RAILROAD, Frank E. Ladd, Springfield, Mass. Dec. 28, 1897 (U.S. Pat. No. 28,091). Marked: "F. E. Ladd." Towle Manufacturing Co. trademark,

667. INCLINED RAILROAD—MT. TOM.

Marked: "$\frac{925}{1000}$ STERLING F. E. LADD."

Towle Manufacturing Co. trademark.

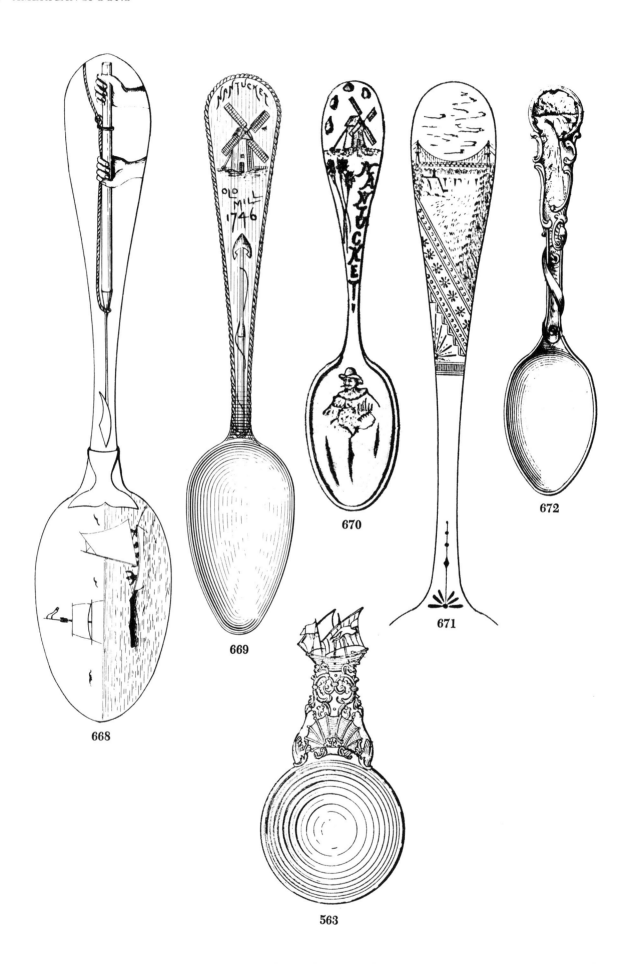

668

669

670

671

672

563

New Bedford Whale

New Bedford, on Buzzard's Bay, Massachusetts, was once the largest whaling port in the world (Fig. 668). Its fishing fleet and related industries are still an important factor in the economic life of the city.

There are obscure references to whaling in the North Atlantic Ocean as early as the beginning of the tenth century. American colonists established a boat shore-fishery for the Atlantic right whale about 1670. Around 1712, the first sperm whale was captured at sea by a Nantucket whaler. Whaling rapidly rose in importance; the size of the American whaling fleet reached its peak in 1846 with 729 vessels.

The introduction of mineral oils and the decline in the number of whales has reduced the whaling fleet to a negligible figure.

Nantucket Old Mill

Nantucket Island, thirty miles off the mainland of Cape Cod, Massachusetts, was not always dependent on tourist trade for much of its income.

Thomas Macy purchased the island for 30 pounds and two beaver hats in 1659, and established his first settlement there. Fishing was important from the earliest days and Nantucket became one of the greatest whaling ports in the world.

The Old Mill (Figs. 669 & 670), built in 1746, of wood from shipwrecks, still does business at the same old stand. At one time there were twelve grist mills on the island, some worked by wind and some by water. Now, there is only the one where Peter Folger, the island's first miller, got "two quarts, for his trouble" from every bushel of corn he ground.

The Old Mill is one of the principal landmarks on Nantucket. Situated on a high promontory, it

563. SALEM, Ross Turner, Salem, Mass., Jan. 2, 1894 (U.S. Pat. No. 22,994). Marked: "ABW" in a shield. Towle Mfg.

668. NEW BEDFORD WHALE, Jesse T. Sherman, New Bedford, Mass. Apr. 28, 1891 (U.S. Pat. No. 20,795).

669. NANTUCKET OLD MILL, Albert N. Wood & Frederic M. Wood, Boston, Mass. Apr. 14, 1891 (U.S. Pat. No. 20,672). Marked: "N. G. Wood, Boston, Mass."

670. NANTUCKET WINDMILL, Emma V. Hallett, Hartford, Conn. Apr. 21, 1891 (U.S. Pat. No. 20,687). Marked: "E. V. Hallett exclusive." Wm. B. Durgin Co. trademark.

671. NIAGARA FALLS SUSPENSION BRIDGE, Myron H. Kinsley, Wallingford, Conn. Aug. 23, 1881 (U.S. Pat. No. 12,428). The earliest spoon in U. S Patent Office records representing a person or place.

672. NIAGARA FALLS, William A. Jameson, Niagara Falls, N.Y. May 24, 1892 (U.S. Pat. No. 21,555). Durgin trademark.

provides a splendid view for summer visitors to whom it is open from June to September. Corn is ground and sold in season.

Niagara Falls Suspension Bridge

The Niagara Falls Suspension Bridge (Fig. 671) was designed and built by John Augustus Roebling in 1851-55. Roebling, a refugee from Prussian oppression, settled in western Pennsylvania in 1831. He had graduated at the Royal Polytechnic School in Berlin, his thesis being on suspension bridges. In 1868 Roebling was chief engineer for the construction of the Brooklyn Bridge, but he died before its completion. His son carried out the Brooklyn project.

The great Niagara Falls Suspension Bridge, 821 feet long and 240 feet above the water, bearing the tracks of the New York Central and the Great Western railroads, was an attraction second only to the waterfall itself (Figs. 672 & 673). It carried the ever-increasing weight of trains and locomotives for forty-two years, until it was replaced by an arch bridge in 1897.

The Bridge was the subject of many paintings and sketches; a Currier and Ives lithograph published in 1856 was widely distributed.

Catskill Mountains

The Catskill Mountains in New York State (Figs. 674 & 675), immortalized by Cooper, Irving, and Bryant, have also been the subject of paintings by such American artists as Thomas Cole, Asher B. Durand, J. F. Kensett, and S. R. Gifford. For these early nineteenth-century artists the Catskills were a favorite field of study. Cole and Durand, who founded the Hudson River Valley school of painting, were especially influenced by the magnificent views of these mountains.

About the middle of the nineteenth century, the Mountain House was a resort of wealth and fashion, its view being one of its main attractions. Luxurious hotels, camp sites, and picnic areas now abound where the ghosts of Rip Van Winkle and Ichabod Crane still linger.

Saratoga

Saratoga Springs, New York (Fig. 676), the "place of swift water," is a famous health resort at the foot of the southernmost spur of the Adirondack Mountains. The Indians called one of the springs "Medicine Spring of the Great Spirit."

French Catholic missionaries were the first white men known to have visited the region, and the first white man to test the efficacy of the waters was Sir William Johnson who was taken there by Mohawk Indians to bathe.

673. NIAGARA FALLS. Marked: "W. H. GLENNY SONS & CO. STERLING." Durgin trademark. In *Souvenir Spoons of America,* p. 30, this spoon is said to "have been done by W. H. Glenny, Sons & Co.... who have been granted a patent on the design...." No record of this patent in Patent Office.

674

674. CATSKILL MOUNTAINS, John T. Henderson, Catskill, N.Y. Jan. 5, 1892 (U.S. Pat. No. 21,283).

675

676

677. BEACON MOUNTAIN, Frank W. Colwell, Matteawan, N.Y. Nov. 25, 1902 (U.S. Pat. No. 86,147). Manufactured by the Gorham Corporation exclusive to Allward & Pearson.

675. CATSKILL MOUNTAINS, John T. Henderson, Catskill, N.Y. Dec. 8, 1891 (U.S. Pat. No. 21,226).

676. SARATOGA, Charles Selkirk, Albany, N.Y. July 7, 1891 (U.S. Pat. No. 20,929). Assigned to Benj. Marsh & Frederick W. Hoffman. Wm. B. Durgin Co. trademark. Featured—UNCAS, the last of the Mohicans, drinking from High Rock Spring.

Beacon Mountain

Fires burning on the summit of Mount Beacon (Fig. 677) to warn Washington, at Newburgh, New York, of British movements up the Hudson gave the city and mountain their name. The city of Beacon was formed through the merging of the villages of Matteawan and Fishkill Landing.

The Mount Beacon Inclined Railway carries passengers 1,500 feet above the Hudson River for a magnificent view of the surrounding country.

Atlantic City

Atlantic City, New Jersey (Fig. 678), is one of the most popular seaside resorts in this country. The famous Boardwalk is eight miles long and sixty feet wide. The familiar rolling chairs have operated on the Boardwalk, twenty-four hours a day, all year long, since the latter part of the nineteenth century. The new ones sport motors for modern tastes.

The city is built on an island, called by the Indians, Absecon, or "place of swans"; it was laid out and named by an engineer of the Camden and Atlantic Railroad. The city was begun in 1824 as a seaside resort and terminus of the railroad. An unusual feature of the city streets is in their names; those running from the beach to the marshes have the names of states; those paralleling the beach, the names of the seven seas.

Picture postcards were introduced here from Europe in 1895 as an advertising idea for hotels and became a national fad.

Reading, Pennsylvania—Klapperthal Pavilion

Reading, Pennsylvania, beautifully situated on a plain which rises gradually from the Schuylkill River, was laid out in 1748 by Thomas and Richard Penn, sons of William Penn. It was named for the town of Reading in England. Immediately east of the city is Mount Penn at whose summit was the Klapperthal Pavilion (Figs. 679-681), terminal of a gravity railroad, where music and dancing entertained the younger generations of the late nineteenth and early twentieth centuries. Klapperthal Pavilion no longer stands but a winding skyline drive to the Pagoda at the summit affords a fine view.

Maryland Mallards

Early explorers and pioneers left glowing accounts of Maryland. Though small in size, Maryland has a scenic variety and a choice of outdoor pleasures that are unsurpassed anywhere. High mountains, rolling valleys, level plains, fresh water lakes and streams, and salt water of the largest bay on the Atlantic Coast are within its boundaries. The marshes of the bay region are home to wild ducks, geese, turkeys, and ruffed grouse.

The sky above the headwaters of Chesapeake Bay tributaries at break of dawn may be dotted with black specks with beating wings. Silhouetted against a gray and crimson sky, hundreds of ducks may be seen in their breeding plumage (Fig. 682).

The Manitou—Balanced Rock

Some of the most striking effects of erosion ever found on earth are among the grotesque masses of vivid red sandstone in the Garden of the Gods just west of Colorado Springs, Colorado. These remarkable formations are particularly beautiful in the early morning or late afternoon. Many have been given names suggested by their various formations.

Balanced Rock (Fig. 683), on Rampart Range Road, near the entrance to the Garden of the Gods, rests on so slight an axis it would seem about to topple.

Manitou, their word for "Great Spirit," was the name applied by the Indians to the medicinal springs, and they gave the name Manitou Springs to the town here. From here cog railway "vista top" cars run to the summit of Pikes Peak.

Yellowstone—Old Faithful

Yellowstone National Park in northwestern Wyoming was the first national park. It was established in 1872 and is the largest and best known of the National Park system. Some parts of its 3,472 square miles extend into Montana and Idaho.

Most spectacular of Yellowstone's natural phenomena are the thousands of thermal geysers which form the world's largest geyser basin. Old Faithful (Fig. 684), queen of the geysers, erupts on the average of every 64.5 minutes. The height of the eruption, which casts a shadow over Old Faithful Inn, varies from 115 to 180 feet.

Mists swirl at the foot of the Lower Falls of the Yellowstone as 60,000 gallons of water a second thunder through the channel carved in volcanic rock.

California

Since the days of the Gold Rush, people by the thousands have flocked to California to sightsee, and often to stay (Figs. 685-687).

678. ATLANTIC CITY, Victor Friesinger, Atlantic City, N.J. Oct. 2, 1906 (U.S. Pat. No. 38,258). Absecon Lighthouse on back of the spoon was built in 1854.

679. READING, PA., Charles G. Willson, Reading, Pa. June 30, 1891 (U.S. Pat. No. 20,900).

680. KLAPPERTHAL PAVILION, Charles G. Willson, Reading, Pa. Oct. 6, 1891 (U.S. Pat. No. 21,092).

681. KLAPPERTHAL PAVILION, Gustave A. Schlechter, Reading, Pa. Dec. 8, 1891 (U.S. Pat. No. 21,229). Manufactured by the Wm. B. Durgin Co.

682. MARYLAND MALLARDS, George M. Latshaw, Centerville, Md. Sept. 23, 1941 (U.S. Pat. No. 129,592).

683. THE MANITOU—BALANCED ROCK, Arthur West, Manitou Springs, Colo. July 21, 1891 (U.S. Pat. No. 20,960). Manufactured by the Gorham Corporation, exclusive to L. A. West. A miner's burro, carrying pick and shovel, stands on the Pikes Peak cog railway.

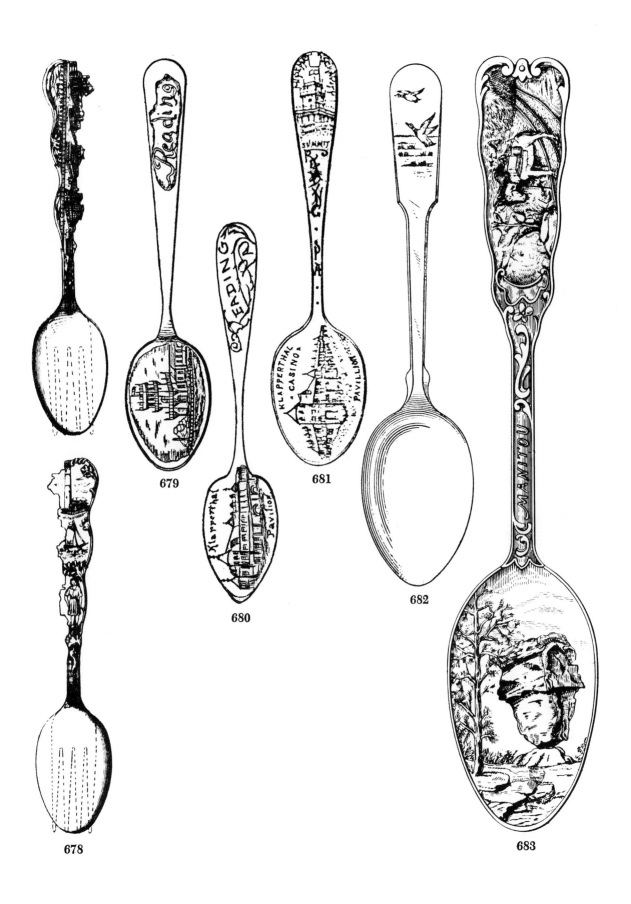

678

679

680

681

682

683

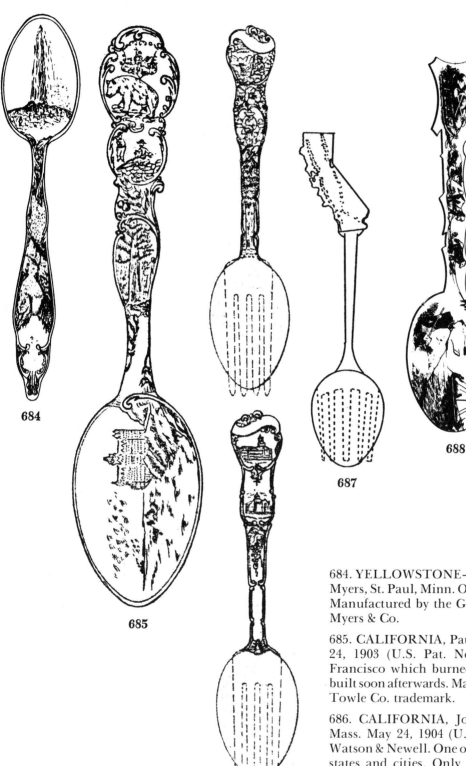

684

685

686

687

688

684. YELLOWSTONE—OLD FAITHFUL, Theodore B. Myers, St. Paul, Minn. Oct. 11, 1892 (U.S. Pat. No. 21,894). Manufactured by the Gorham Corporation exclusive to Myers & Co.

685. CALIFORNIA, Paul A. Haberl, Denver, Colo. Mar. 24, 1903 (U.S. Pat. No. 36,249). Cliff House in San Francisco which burned in 1907. The present one was built soon afterwards. Marked: "925/1OOO STERLING." Towle Co. trademark.

686. CALIFORNIA, Joseph E. Straker, Jr., Attleboro, Mass. May 24, 1904 (U.S. Pat. No. 36,928). Assigned to Watson & Newell. One of a large series representing many states and cities. Only the California State Seal spoon illustrated in Patent Office design.

687. CALIFORNIA, Saul Robert Jacobs, Alameda, Cal. Apr. 28, 1908 (U.S. Pat. No. 39,281).

688. MIDNIGHT SUN EXPRESS Aline Phillips, Seattle, Wash. May 21, l901 (U.S. Pat. No. 34,256). Marked: "Pat May 21, 1901." Mayer triangle mark.

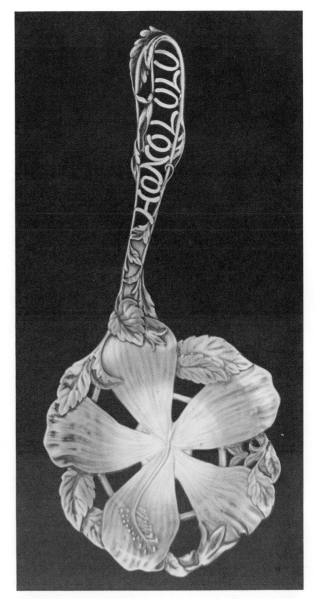

689. DATE PALMS, George E. Nerney, Attleboro, Mass. Feb. 11, 1913 (U.S. Pat. No. 43,553). Robbins Company trademark. "HONOLULU" on handle. The same design also used to represent other places.

690. HAWAIIAN HIBISCUS, Watson & Newell Company, 1905-29. Controlled by Wall & Dougherty, Honolulu, Hawaii.

California is a state of contrasts. Within its boundaries are one of the lowest points in the United States, and one of the highest; magnificent ski slopes, and beautiful bathing beaches; the San Joaquin Valley, and Yosemite National Park; Mono Lake, and Marineland; a chain of old Missions that are relics of Spanish occupation, and Palm Springs; Death Valley, and Muir Woods; sprawling Los Angeles, and bustling, sophisticated San Francisco.

Midnight Sun Express

"A souvenir spoon showing clearly the earlier methods of transporting freight through Alaska, over ice and snow, by means of the Dog Team and Sled. Even at this day this is the principal means of transportation to many of the interior points of this territory." So reads the description of the Alaska and Midnight Sun Express spoons (Fig. 688) illustrated in a catalog of the Joseph P. Mayer & Bros. Co., Manufacturing Jewelers, Seattle, Washington, published November 10, 1906. Many changes have taken place since then; even before Alaska became the forty-ninth state on January 3, 1959, "transportation to interior points' was most often by plane.

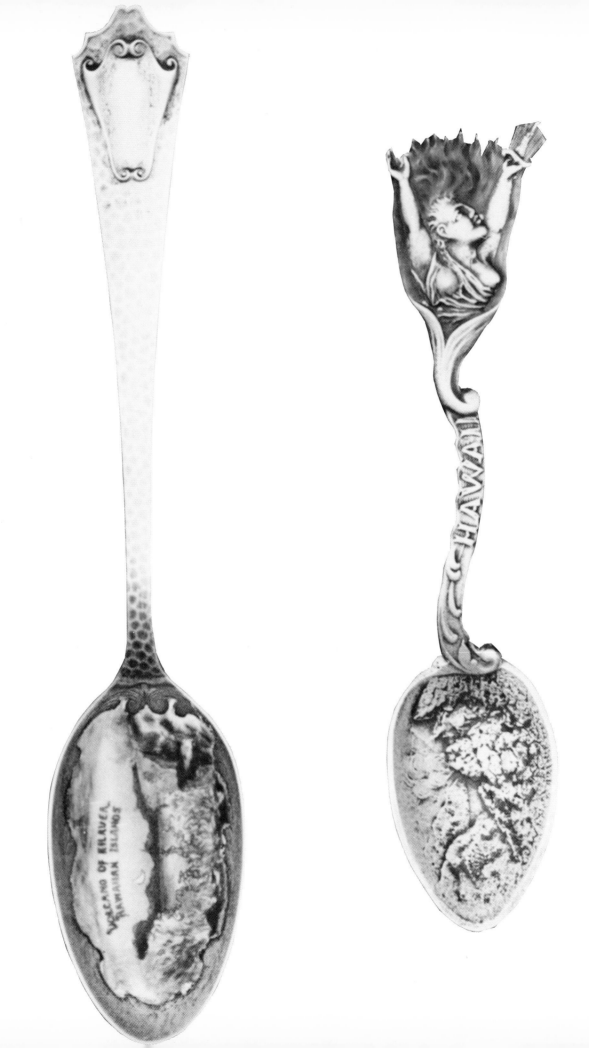

Honolulu—Hawaii

Hawaii was described by Mark Twain as "the loveliest fleet of islands that lies anchored in any ocean."

Captain James Cook, distinguished English navigator, may not have been the first white man to see the islands he named for his patron, the Earl of Sandwich, but he was the first to make them known to the rest of the world. He first visited the islands in 1778; returned in 1779 and anchored off Kealakekua Bay, where he was received as a reincarnation of the Hawaiian god, Lono. His ships with their high masts must have appeared to be the floating islands of Lono on which, according to ancient prophecy, he would return. Unhappily, Cook and his men did not act like gods, and through a series of tragic events, the explorer met his death.

The islands soon became an important port of call, first for explorers and later for whalers to replenish food and water supplies.

According to tradition, the large-fruited coconut palm was carried to Hawaii by early Polynesians. It provided ancient Hawaiians with nuts for food and drink, leaves for mats, thatching, and baskets, and coarse fiber for rope. A wild date palm (Fig. 689) was of less importance though it also provided building materials.

The red hibiscus (Fig. 690) is the official flower of Hawaii and was considered a sacred flower in Polynesia.

Kilauea Crater, on the island of Hawaii, is the traditional home of Pele (Fig. 691), Polynesian goddess of volcanoes. Ancient Hawaiians regarded volcanoes with fear and, when traveling threw offerings of food into the fiery depths to invoke Pele's pleasure before crossing her sacred land. Mauna Loa's eruptions have averaged every three years while Kilauea's are more sporadic. Both are now part of the Hawaii National Park, another section of which is thirty miles away on the Island of Maui.

Hawaiian Royalty

In 1778 Captain James Cook made the islands known to the rest of the world. A few years later Kamehameha I brought the islands under one rule. He is commemorated by a bronze statue (619a-d color plate) which shows him wearing his feather cloak.

Outsiders brought many changes; royal orders and seals were introduced. Hawaii's coat of arms (619a-h color plate) was based on a design suggested by the College of Heralds in London in 1850. The design itself has undergone changes. Unchanged is the motto which was uttered by Kamehameha I in 1843, *Una mau ke ea o ka aina i ka pono* (The life of the land is perpetuated in righteousness).

In 1883, the Hawaiian government minted its own coins. Following annexation, an Act of Congress provided for the redemption of Hawaiian coins in Unites states' coins at par value and recoinage of the redeemed coins into United States' silver coins. Only a small portion showed up for redemption. Hundreds, perhaps thousands, were made into souvenirs (see page 18 top).

691. Left: KILAUEA CRATER, Sterling Silver Manufacturing Company. Right: PELE, GODDESS OF FIRE, The Gorham Company, 1894.

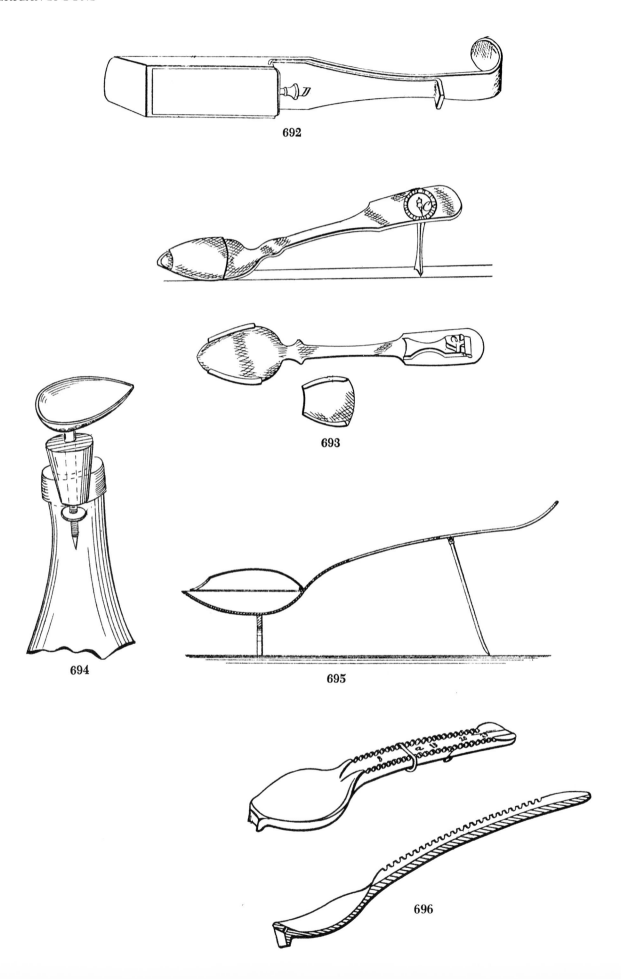

692

693

694

695

696

Chapter Twentyone
Open Wide

The first spoons of the ancient inhabitants of southern Europe were probably shells. The Greek word for spoon was *kochliarion (see page 295), and the Latin word was cochlea,* both having been derived from *cochlea* (see page 295), meaning snail-shell.

The English word "spoon" is derived from the Anglo-Saxon, *spon,* a chip or splinter of wood, which suggests that northern European spoons had as their origin chips of wood rather than shells. However, *cochlear* was retained in medieval wills and inventories.

The measurement of medicine "by the spoonful" began at least as early as Greek and Roman times when both shells and spoons were used as standard measures. The Greek *kochliarion* held a little more than a fluid dram, or about the same as a modern teaspoon.

692. I. C. Taylor, West Liberty, Ohio. Feb. 17, 1852 (U.S. Pat. No. 8,749). The earliest medicine spoon patent located in U. S. Patent Office records. Under the sliding top is a piston-action scraper that pushes the medicine into the patient's mouth.

693. David J. Pearson, Boston, Mass. Dec. 26, 1865 (U.S. Pat. No. 51,748). An adjustable cover to be slid over the bowl of a common teaspoon; a dial with an indicator denoting the hour of the next dosage and a hinged support were the features of this spoon.

694. Susan C. Currie, New York. July 6, 1869 (U.S. Pat. No. 92,278). "...serving both as a cork-screw...and for supporting the spoon in a conspicuous position, where it will be readily noticed when wanted...," according to the inventor.

695. James L. Colby & Le Roy B. Thomson, Saxonville, Mass. June 17, 1873 (U.S. Pat. No. 139,944).

696. Edward K. Walker, Exeter, N.H. Mar. 19, 1878 (U.S. Pat. No. 201,369). The handle is notched and numbered. The spoon is intended to hold a fluid dram; any number of drops can be poured through the hole in the bowl. A rubber ring around the handle marks the notch corresponding with the number of drops to be given.

Though the form of spoon bowls and handles changed through the centuries, the size remained relatively large until the introduction of tea.

Spoons of colonial days in America had large, rounded bowls. When tea was introduced about the middle of the seventeenth century, small teaspoons, about the size of our modern after-dinner coffee spoons, were made to accompany the tiny porcelain cups. As tea became less expensive, the size of teacups and teaspoons increased steadily, though not consistently, until about the middle of the nineteenth century when they reached their present size.

Teaspoons of varying sizes, as well as the proliferation of dessert spoons, tablespoons, and the five o'clock teaspoons, dear to the hearts of the Victorians, raised the question, "How much is a spoonful?" The problem became of great concern.

Wood and Bache, in the *United States Dispensatory* of 1834, set the teaspoon (*cochlear parvum*) at one fluid dram and the tablespoon (*cochlear magnum*) at half a fluid ounce (four fluid drams). As the teaspoon size increased, these measurements no longer applied and, in 1850, it was protested that the capacity of the teaspoon was rated too low.

In an effort to correct the problem of variations in spoons as measuring instruments, graduated medicine spoons were made in porcelain, glass, and various metals. These completely failed to solve the situation, as they were even less reliable than the household spoon.

A concurrent development was the medicine spoon, designed to facilitate administration of liquid medicines that tasted unpleasant. Various covers were devised to permit the spoonful of medicine to be placed far enough into the patient's mouth to prevent regurgitation.

When is a spoon full?" was another problem. With the legal acceptance of the metric system, in 1902 the American Pharmaceutical Association adopted a resolution that "a spoon is full when the liquid it contains comes up to but does not curve above the upper edge or rim of the bowl." Spoons with supports, to keep the bowls level while medicine was being poured into them, were designed to assure

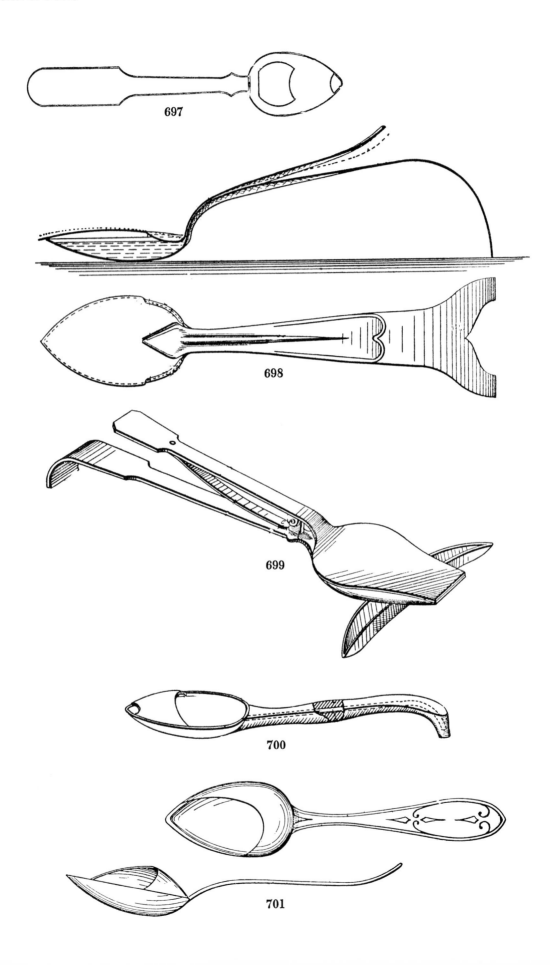

697

698

699

700

701

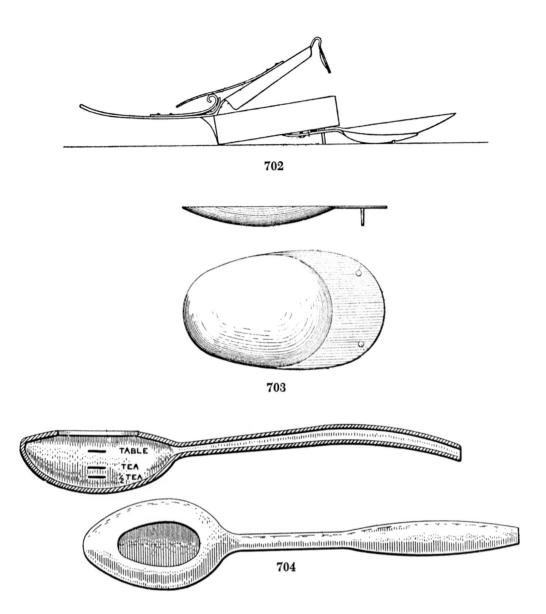

702

703

704

697. John W. Force, Springfield, Mass. Feb. 28, 1879 (U.S. Pat. No. 212,677). Unlike earlier medicine spoons with loose covers, this one is soldered in place to prevent leakage.

698. Barclay Tennyson Trueblood, Hadley, Ind. Dec. 9, 1879 (U.S. Pat. No. 222,549). Pressing the handle raises the cover to allow the medicine to run into the patient's mouth.

699. Thomas M. Baker, Washington, D.C. Oct. 12, 1880 (U.S. Pat. No. 223,185). Spring-operated cover to be raised when inserted into patient's mouth. The support also acts as a reservoir to collect medicine as "it is well known that children...will attempt to spit it out..."

700. Herbert Clayton, Cincinnati, Ohio. July 19, 1881 (U.S. Pat. No. 244,551). Porcelain medicine spoon with wire-strengthened handle. Identical in appearance to one advertised in McKesson & Robbins catalog as patented Feb. 25, 1879. (See Figs. 741 & 746.)

701. Amelia C. Felsburg, Newark, N.J. Apr. 25, 1882 (U.S. Pat. No. 256,989).

702. Sophia Pelkey, Eau Claire, Wis. May 22, 1883 (U.S. Pat. No. 277,924). "...Improved vial-holder with spoon attached for exact measure of medicine...."

703. Boise Sherwin, N.Y.C. Apr. 6, 1886 (U.S. Pat. No. 339,221). The wide handle has a transverse rib on the under side that acts as legs to keep the spoon level.

704. Conrod S. Dorr, Wheeling, W. Va. Nov. 23, 1886 (U.S. Pat. No. 353,055). The handle is hollow and open at both ends. Medicine is measured in the bowl and by means of the hollow handle is carried back into the mouth and does not come into contact with the teeth.

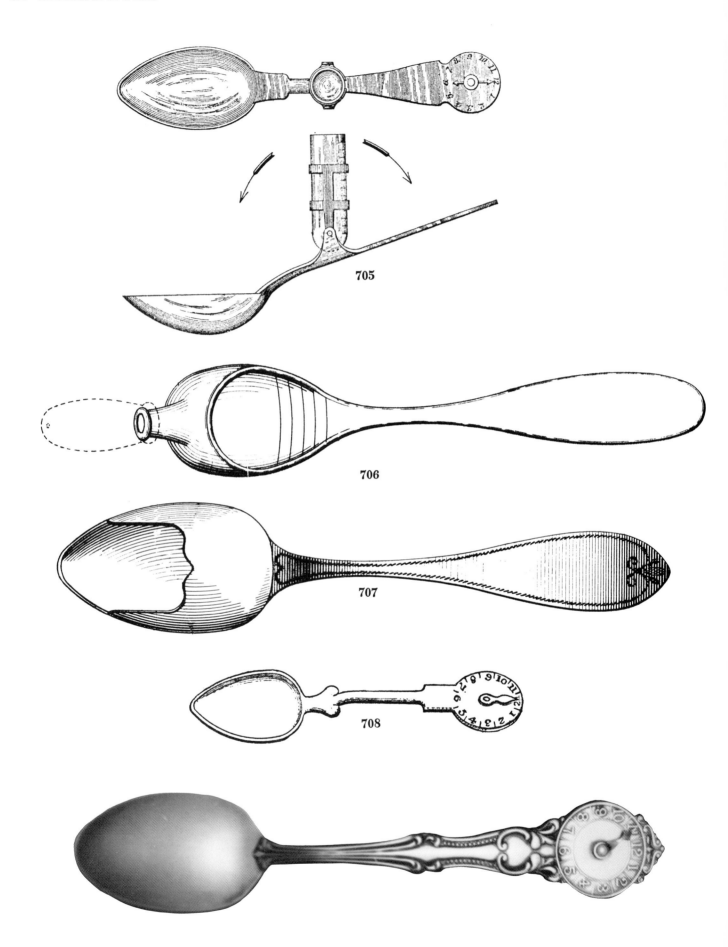

705

706

707

708

709

705. Carl Danielowsky, Breslau, Prussia, Germany. May 6, 1890 (U.S. Pat. No. 427,254). The measuring glass is to be filled with a determined quantity of medicine, tipped so that the contents will flow into the spoon, and the medicine given to the patient. An indicator on the handle shows when medicine is to be given.

706. George E. Nye, Providence, R.I. Apr. 16, 1895 (U.S. Pat. No. 24,197). The funnel-like opening at the end of the bowl is provided with a collar—presumably to accommodate a rubber bulb.

707. Amaziah Garner, Lynchburg, Ohio. Feb. 18, 1896 (U.S. Pat. No. 25,168).

708. James Barnard Wilson, Philadelphia. Mar. 9, 1897 (U.S. Pat. No. 26,725). Handle on dial indicates time of next dosage. Made as a plated silver teaspoon.

709. TIME MEDICINE SPOON. Made according to specifications of James Bernard Wilson, Philadelphia, Pa. Marked: "Pat. March 9, '97 Wilson Spoon Co."

THE HOLMES & EDWARDS SILVER CO.

TIME MEDICINE SPOON

WILSON'S PATENT, MARCH 9, 1897

PHYSICIANS

RECOMMEND

IT

To the point of the spear in the bowl measures an exact drachm.

The hand on the dial is moved to time desired for next dose, thus insuring regularity of time and size of dose, so essential to every patient.

List, $14.00 per dozen.

710. TIME MEDICINE SPOON. Illustrated in Holmes & Edwards catalog #21, dated 1899.

711

712

713

711. Joseph T. Homan, Cincinnati, Ohio. Apr. 27, 1897 (U.S. Pat. No. 26,972). A spoon-cup "...to be used by the Catholic clergy in visiting the sick...."

712. Hugh C. Middleton, Augusta, Ga. Mar. 7, 1899 (U.S. Pat. No. 620,792). Covered medicine spoon "...with hollow handle through which the nurse blows the medicine into a child's mouth."

713. Clarence L. Watson, Attleboro, Mass. Oct. 31, 1899 (U.S. Pat. No. 31,732). Assignor to Watson & Newell. The curved strip on the back of the handle keeps the bowl level.

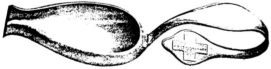

714

715

717

716

714. Tyler Calhoun, Ridgetop, Tenn. Mar. 26, 1901 (U.S. Pat. No. 34,267). The back-curved handle and hood are precautions against spilling medicine.

715. Matthew C. Day, Providence, R.I. Apr. 2, 1901 (U.S. Pat. No. 34,314). The object of this partial cover is to allow the contents to flow out only through the small opening at the end of the bowl.

716. Advertisement of RED CROSS medicine spoon. Protected by trademark No. 38,096 registered Apr. 15, 1902. The design of the spoon was also patented. Though the handle is not back-curved in the U.S. Patent Office drawing, the bowl closely resembles the one patented by Matthew C. Day, also of Providence, R.I. (*Jewelers' Circular Weekly,* Jan. 8, 1902)

717. Tyler Calhoun, Ridgetop, Tenn. Apr. 23, 1901 (U.S. Pat. No. 34,399).

718. Charles Langguth, Chicago, Ill. May 14, 1901 (U.S. Pat. No. 673,958). Assignor of one-half to John W. Adams. Glass medicine spoon with graduated bowl and hollow handle through which medicine may be administered to a recumbent patient.

719. Frances E. Boutelle, Fitchburg, Mass. Jan. 24, 1905 (U.S. Pat. No. 780,492). "The object...is a measure of liquids, medicines, and cooking materials, and, further, for use as a fruit-spoon.... Its capacity is exactly one-half of that of a spoon, and its peculiar form causes it to be conspicuous and easily found among other household utensils." Marked: "THE DEBOUTVILLE CO. Fitchburg, Mass. PAT. JAN. 24 '05"

720. George C. Hohein, Norfolk, Va. Mar. 7, 1905 (U.S. Pat. No. 784,399).

721. Martin L. Beistle, Ingram, Pa. Mar. 14, 1905 (U.S. Pat. No. 784,830). "Medicine may be placed in the spoon and when the glass is tilted for drinking, the medicine is swallowed with the water without causing...any disagreeable taste or nauseous sensation."

722. William L. Jerkins, Moulrie, Ga. Jan. 2, 1906 (U.S. Pat. No. 808,845).

723

accuracy. There is still much variation of capacity depending on the specific gravity of the liquid.

This same resolution called for the establishment of the teaspoon capacity at 5 cc., the dessert spoon at 10 cc., and the tablespoon at 15 cc. Several attempts were made to bring about national recognition of 5 cc. as the most nearly correct metric equivalent for the average teaspoon to conform to the figure recognized in other countries.

The National Bureau of Standards, in 1956, defined three teaspoons as the equivalent of one tablespoon or four fluid drams for household purposes, making the teaspoon capacity 4.93 cc.

No real agreement has been reached. *Blakiston's New Gould Medical Dictionary* (1956) says the teaspoon is "a spoon commonly assumed to hold about 4 cc. but usually holding 5 cc." The 1956 edition of *The Merck Manual* says the equivalent of a teaspoon is 4 cc.

The discovery of more potent drugs increases the need for more accurate measurement, but the problem is still unresolved. After nearly 300 years of discussion and controversy, it is ironical to find that the ancient Greek *kochliarion* was the equivalent of 4.5 cc., exactly halfway between the controversial 4 and 5 cc. measure.

724

725

723. Henry D. Ward, Worcester, Mass. Feb. 13, 1906 (U.S. Pat. No. 812,312). Assignor of one-half to Ira B. Hubbard. The hinged handle may be raised by finger loops. Specifications say it may also be used as a mustache spoon.

724. William E. Raney, Norfolk, Va. Dec. 4, 1906 (U.S. Pat. No. 837,506). Assignor of one-half to John F. Woodward. The cover of the bowl turns to the side for cleaning.

725. George C. Hohein, Norfolk, Va. Mar. 19, 1907 (U.S. Pat. No. 847,942). An attachment for an ordinary spoon consisting of a cover and combined dropper-blower. After the medicine is dropped into the spoon through the tube, it may be forced into the mouth of the patient by blowing into the tube.

726. William L. Jerkins, Moultrie, Ga. Apr. 14, 1908 (U.S. Pat. No. 884,390). The offset handle and flattened bottom of bowl are intended to keep the spoon level.

727. Epiphane Theriault, Taunton, Mass. Aug. 29, 1911 (U.S. Pat. No. 1,002,094). A spoon cover which may be fitted on any ordinary spoon, making it into a medicine spoon.

728. Christopher C. Beamer, Steubenville, Ohio. May 28, 1912 (U.S. Pat. No. 1,027,976). The purpose of the long "spout" is to administer medicine without it coming in contact with the mouth or teeth. "It will also enable the proper administration of medicine to a patient that should resist the dose."

729

730

731

732

733

734

735

729. Edward N. McNair, Newark, N.J. Aug. 12, 1913 (U.S. Pat. No. 44,485). Spoon holder with clock dial. For the forgetful patient who might misplace his medicine spoon and also forget when to take the medicine.

730. Dink Fitzgerald, El Dorado, Ark. Sept. 24, 1918 (U.S. Pat. No. 1,280,006). Medicine spoon with hinged cover.

731. Annie L. Westbrook, Lorena, Tex. Nov. 12, 1918 (U.S. Pat. No. 52,688).

732. Hubert Toler, Sweetwater, Tex. Sept. 13, 1921 (U.S. Pat. No. 1,390,475). Spoon with cover so that medicine may be carried to patient without spilling. May be taken apart for cleaning.

733. Adolph W. Buchbinder, Detroit, Mich. Dec. 5, 1922 (U.S. Pat. No. 1,438,018). Snap-on guard for retaining food or medicine.

734. Harry D. Morgan & Franklin P. Bushey, San Francisco, Cal. Mar. 8, 1927 (U.S. Pat. No. 1,619,878). "Dosage spoon" with graduations marked in bowl; timer on handle.

735. Robert E. Hodgmon, Denver, Colo. Nov. 8, 1927 (U.S. Pat. No. 1,648,123). Assignor to Babespune Co., Denver, Colo. The cover slips off for cleaning but is never lost as the loop keeps it attached.

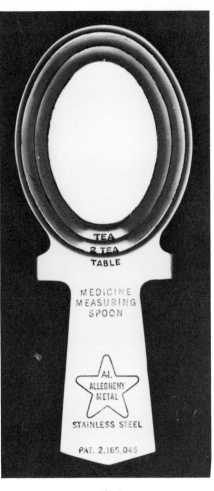

736. Elena May Garside, Spokane, Wash. July 4, 1939 (U.S. Pat. No. 2,165,045). "Calibrated self-supporting sanitary spoon." Made of stainless steel and calibrated for one teaspoon, two teaspoons, and tablespoon. Marked: "A-L ALLEGHENY METAL (within a star), PAT. 2,165,045."

737. CALIBRATED SELF-SUPPORTING SANITARY SPOON.

738. Leon Fuchs, St. Louis, Mo. Dec. 5, 1944 (U.S. Pat. No. 139,605). Chrome plated metal. Marked: "PAT. D 139,605."

739. John Orenstein, Minneapolis, Minn. Mar. 19, 1946 (U.S. Pat. No. 144,212). "Prescription" spoon.

740. Charles H. Sanford, N.Y.C. Apr. 8, 1952 (U.S. Pat. No. 2,592,192). Self-supporting medicine spoon. In the upright position it holds the same amount of liquid as when held horizontally. To be made of transparent material with graduations denoting volumetric measures. The tip-proof base provides that medicine may be held safely near a bed-ridden patient to be self-administered when needed.

741. Clayton porcelain medicine spoon, as shown in late nineteenth-century catalog of McKesson & Robbins, New York. (Courtesy George Griffenhagen, American Pharmaceutical Association)

GENERAL PRICES CURRENT.

BOX PATTERN, WITH LID AND DRAWERS UNDER:

No. 6—Containing 10..8 oz... 7..4 oz..13..2 oz.—30 bottles..................... 23 00
 7— " 10..4 oz...12..2 oz.. 7..1 oz.—29 " 15 00
 8— " 8..4 oz...12..2 oz. —20 " 13 00
 9— " 4..4 oz...12..2 oz.. —16 " 11 00
 10— " 3..4 oz...10..2 oz.. —13 " 8 50
 11—Large Brass Bound Chest, containing 12..8 oz. 16..4 oz. 8..1 oz.—36
 bottles; 4 jars.. 36 00

WALNUT AND POPLAR CHESTS, for Ships and Plantations, STAINED AND VARNISHED.

		Walnut.	Poplar.
No. 13—Containing 12..8 oz. 16..4 oz. 8..1 oz. 36 bottles; 4 jars		$22 00	$20 00
14— " 5..8 oz. 7..4 oz. 8..2 oz. 4..1 oz.—25 bottles; 4 jars		15 50	14 00
15— " 10..4 oz. 6..2 oz. 4..1 oz. —20 " 3 "		12 00	11 00
16— " 8..4 oz. 12..2 oz. —18 "		10 00	9 00
17— " no drawers—6..8 oz. 4..4 oz. and space—15 bottles		7 00	

A Medical Manual and Medical Chest Companion, with English Labels, Fifty Cents.

Clayton Long Handle.

Porcelain Tea, on foot.

Tweed's.

Metal.

Bulb.

Clayton Combination.

Earthen Ware.

Medicine Glasses (see page 302).
Medicine Spoons, Earthen, Tea..doz. 1 25
 " " Porcelain, " " 3 00
 " " " " on foot............................. " 3 00
 " " " Dessert............................... " 4 00
 " " " " on foot........................... " 4 00
 " " " Tea, covered.......................... " 2 50
 " " " Dessert, " " 3 50
 " " Maw's Combination............................ " 2 50
 " " Metal.................................... " 9 00
 " " Clayton Long Handle....................... " 1 50
 " " " Combination.... " 2 75
 " Droppers, Barnes'......................... " 80
 " " Bulb................................ " 50
 " " Tweed's................................... " 1 50
Meen Fun, "Hobbs"..................................... " 1 00

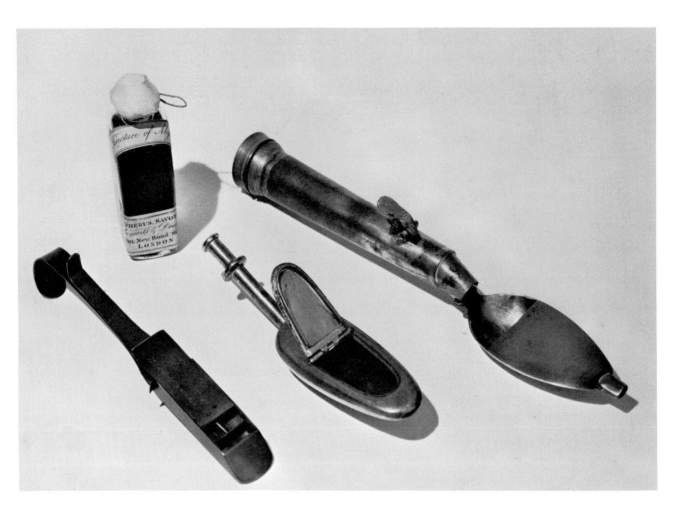

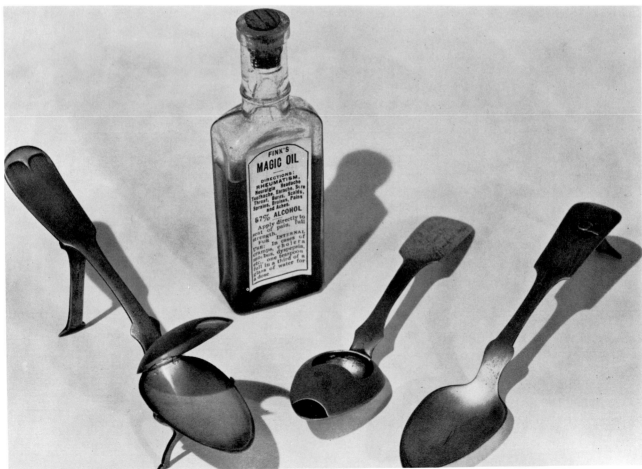

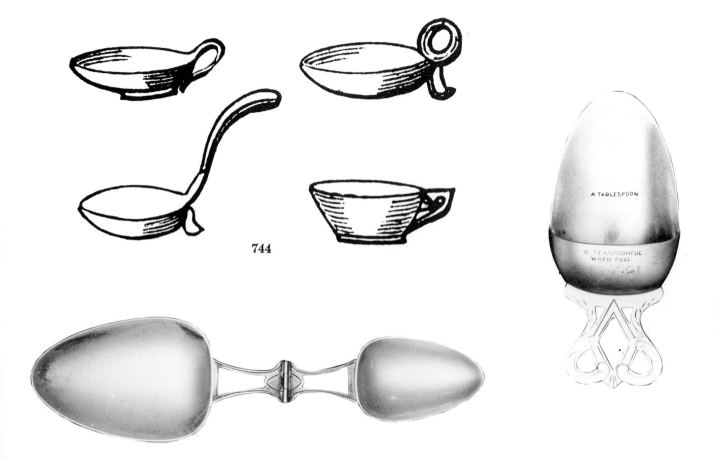

744

745

742. Nineteenth-century medicine spoons. *Left to right:* U.S. Patent Office model by Dr. I.C. Taylor, 1852; pewter by Maw of Aldersgate, London; U.S. patent model by George H. Spencer, 1870. (Dr. Lewis H. Wright collection and Smithsonian Institution. Photo, courtesy George Griffenhagen, American Pharmaceutical Association)

743. Original U.S. Patent Office models of medicine spoons, invented by, *left to right*, Colby & Thomson, 1873; J.U. Force, 1879; D.J. Pearson, 1865, all of Massachusetts. The Colby and Thomson spoon is stamped "1847 Rogers Bros. A1" on the support. (Smithsonian Institution. Photo, courtesy George Griffenhagen, American Pharmaceutical Association)

744. Porcelain medicine spoons, from the catalog of Van Schaack, Stevenson & Reid, 1875 Annual Prices Current. Chicago. (Courtesy George Griffenhagen, American Pharmaceutical Association)

745. *Left:* Medicine spoon. Marked: "STERLING R. Blackinton 2179 PAT Apd For." *Right:* Folding medicine spoon. Marked: "R. Blackinton STERLING 8290."

746. Porcelain medicine spoon of the type advertised in McKesson & Robbins catalog.

747. Ad by Sharon Manufacturing Co., Philadelphia.

746

Pages from Old Catalogs

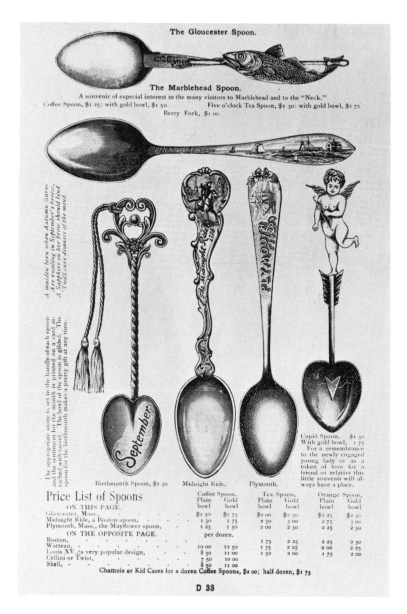

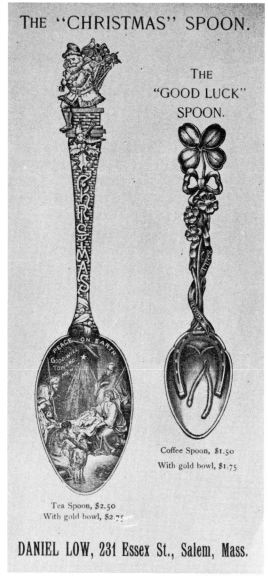

748-479. (pp. 315-316) Daniel Low catalog, Nov. 1, 1893.
(Courtesy Whittelsey Fund, Metropolitan Museum of Art)

750. R. Wallace & Sons catalog, 1895.

Confederate.

Seal of Confederate States.
Can be used on any of our
Standard Tea Spoon Bowls.

Fort Dearborn, Coffee. Large.

Fort Dearborn, Tea.

Easter Spoon.

Mount Vernon.

The Chicago.

A perfect representation of the U. S. War Ship Chicago. Can be used on any of our Standard Tea Spoon Bowls.

Souvenir Spoons.

Sterling Silver. Guaranteed $\frac{925}{1000}$ Fine.

Fort Dearborn, Coffee. Small.

Masonic. Design Patented.

Trade Mark.

Sterling.

AMERICAN NAVY WAR SOUVENIR SPOONS

**Representing Six Most Prominent Battleships Embossed in the Bowl of the Spoon.
On Each Handle the American Flag is Enameled in Proper Colors**

U. S.
Battleship
Massachu-
setts

U. S.
Battleship
Iowa

U. S.
Battleship
Texas

U. S.
Battleship
Maine

U. S.
Battleship
Indiana

U. S.
Battleship
Oregon

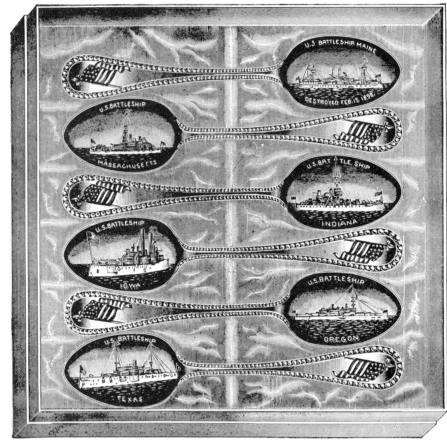

No. 218—American Navy War Souvenir Spoons. Price per dozen sets, **$5.00**

No. 219—Lady Elgin Button Hook, packed in satin-lined box. Price per dozen, **$1.25**

No. 220—Coral Letter Opener or Paper Knife, packed in satin-lined box. Price per dozen, **$1.25**

10

751-753. (pp. 318-320) Elgin-American Manufacturing
Company catalog, 1898.

ELGIN–AMERICAN MANUFACTURING COMPANY, ELGIN, ILLINOIS, U. S. A.

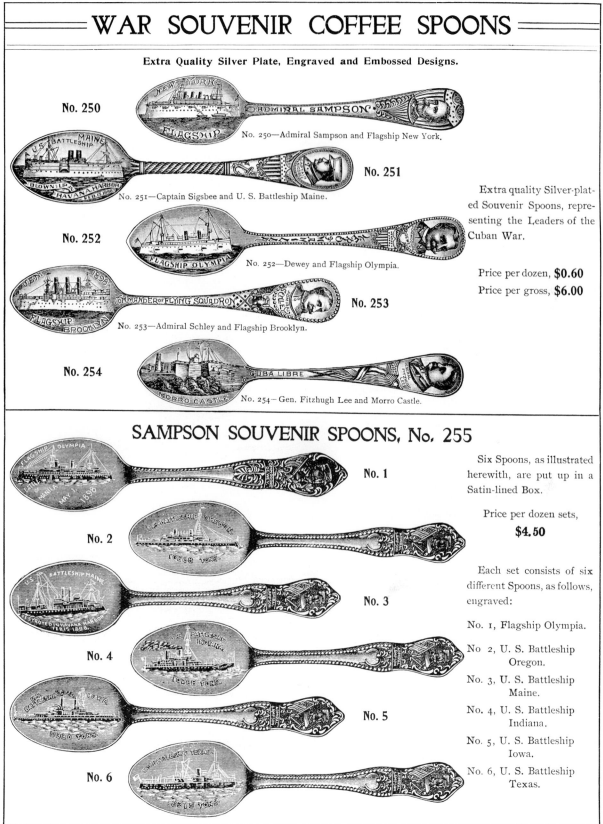

WAR SOUVENIR COFFEE SPOONS

Extra Quality Silver Plate, Engraved and Embossed Designs.

No. 250

No. 250—Admiral Sampson and Flagship New York.

No. 251

No. 251—Captain Sigsbee and U. S. Battleship Maine.

No. 252

No. 252—Dewey and Flagship Olympia.

No. 253

No. 253—Admiral Schley and Flagship Brooklyn.

No. 254

No. 254—Gen. Fitzhugh Lee and Morro Castle.

Extra quality Silver-plated Souvenir Spoons, representing the Leaders of the Cuban War.

Price per dozen, **$0.60**
Price per gross, **$6.00**

SAMPSON SOUVENIR SPOONS, No. 255

No. 1

No. 2

No. 3

No. 4

No. 5

No. 6

Six Spoons, as illustrated herewith, are put up in a Satin-lined Box.

Price per dozen sets,
$4.50

Each set consists of six different Spoons, as follows, engraved:

No. 1, Flagship Olympia.

No 2, U. S. Battleship Oregon.

No. 3, U. S. Battleship Maine.

No. 4, U. S. Battleship Indiana.

No. 5, U. S. Battleship Iowa.

No. 6, U. S. Battleship Texas.

ELGIN-AMERICAN MANUFACTURING COMPANY, ELGIN, ILLINOIS, U. S. A.

WAR SOUVENIR TEA SPOONS

Extra Quality Silver Plate. Engraved and Embossed Designs.

No. 256

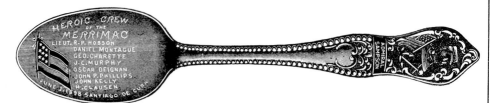

No. 256—Merrimac and Sampson. Price per dozen, **$0.60**

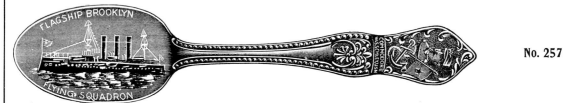

No. 257

No. 257—Commodore Schley and Flagship Brooklyn. Price per dozen, **$0.60**

No. 258

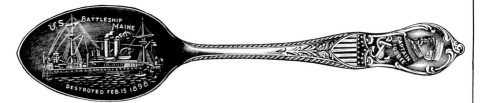

No. 258—Captain Sigsbee and U. S. Battleship Maine. Price per dozen, **$0.60**

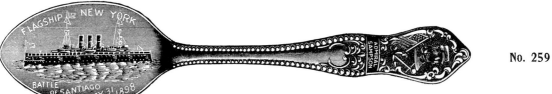

No. 259

No. 259—Admiral Sampson and Flagship New York. Price per dozen, **$0.60**

No. 260

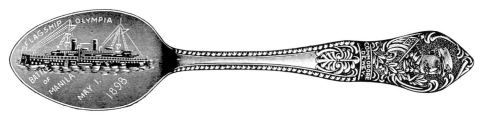

No. 260—Commodore Dewey and Flagship Olympia. Price per dozen, **$0.60**

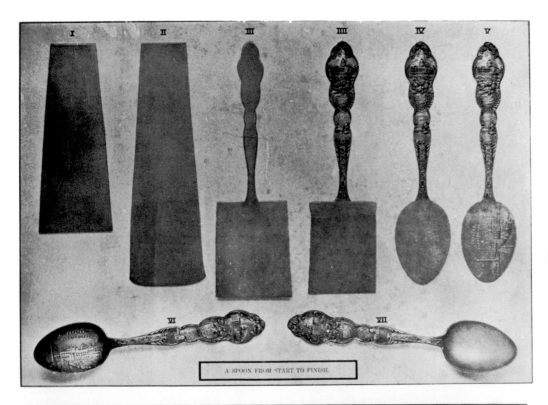

A SPOON FROM START TO FINISH.

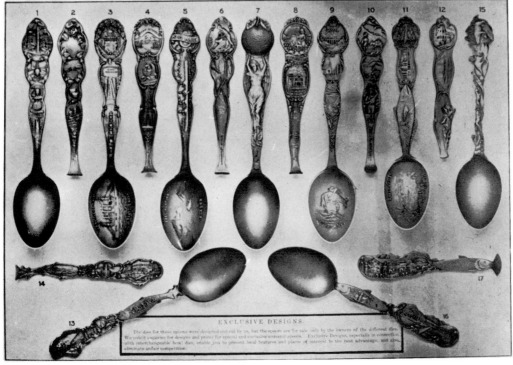

EXCLUSIVE DESIGNS.

754-769. (pp. 321-336) Jos. P. Mayer & Bros. catalog, No. 10, 1906.

WASHINGTON STATE SEAL, UTAH, LOS ANGELES, LEWIS & CLARK CENTENNIAL, AND EASTERN STAR SPOONS

Sterling Silver .925 fine

No. 270	Washington State Seal Spoon, gray finish, gold-lined bowl	per doz.	$20.00	
No. 269	Washington State Seal Spoon, small size, gray finish, gold-lined bowl	per doz.	16.00	
No. 271	Washington State Seal Coffee Spoon, gray finish, gold-lined bowl	per doz.	10.00	
No. 311	Utah State Spoon, gray finish, gold-lined bowl	per doz.	27.00	
No. 312	Los Angeles Spoon, gray finish, rose gold orange, gold-lined bowl	per doz.	$28.00	
No. 310	Lewis & Clark Centennial Spoon, gray finish, gold-lined bowl	per doz.	26.00	
No. 356	Eastern Star Spoon, gray finish, emblems enameled in appropriate colors, gold-lined bowl	per doz.	33.00	

Page fourteen

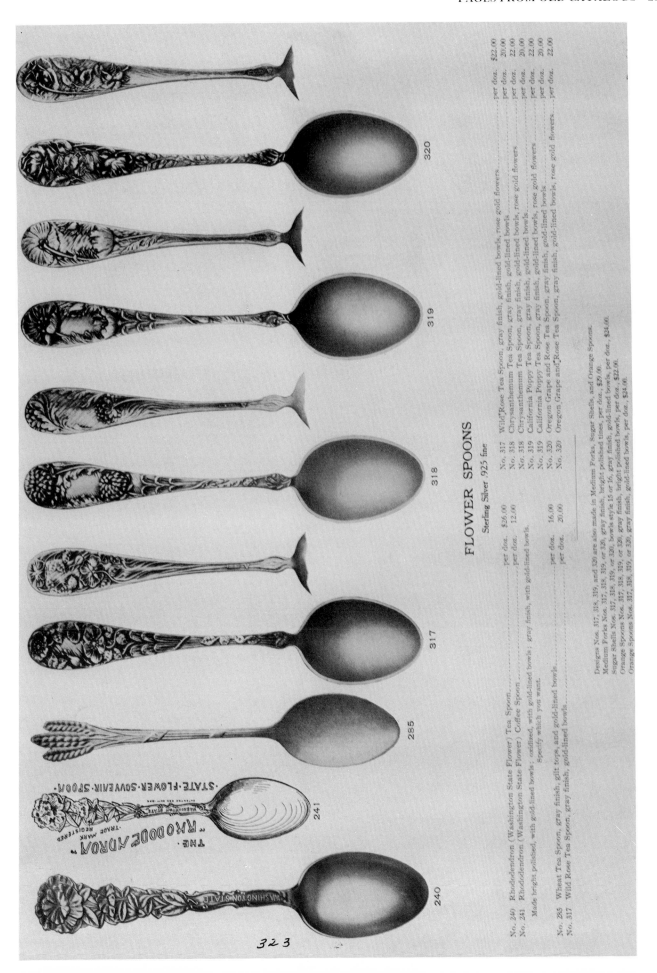

FLOWER SPOONS

Sterling Silver .925 fine

No. 317	Wild Rose Tea Spoon, gray finish, gold-lined bowls, rose gold flowers	per doz. $22.00
No. 318	Chrysanthemum Tea Spoon, gray finish, gold-lined bowls	per doz. 20.00
No. 318	Chrysanthemum Tea Spoon, gray finish, gold-lined bowls, rose gold flowers	per doz. 22.00
No. 319	California Poppy Tea Spoon, gray finish, gold-lined bowls	per doz. 20.00
No. 319	California Poppy Tea Spoon, gray finish, gold-lined bowls, rose gold flowers	per doz. 22.00
No. 320	Oregon Grape and Rose Tea Spoon, gray finish, gold-lined bowls	per doz. 20.00
No. 320	Oregon Grape and Rose Tea Spoon, gray finish, gold-lined bowls, rose gold flowers	per doz. 22.00

Designs Nos. 317, 318, 319, and 320 are also made in Medium Forks, Sugar Shells, and Orange Spoons.

Medium Forks Nos. 317, 318, 319, or 320, gray finish, bright polished tines, per doz., $25.00.
Medium Forks Nos. 317, 318, 319, or 320, bowls style 15 or 16, gray finish, gold-lined bowls, per doz., $24.00.
Sugar Shells Nos. 317, 318, 319, or 320, gray finish, bright-polished bowls, per doz., $22.00.
Orange Spoons Nos. 317, 318, 319, or 320, gray finish, bright-polished bowls, per doz., $22.00.
Orange Spoons Nos. 317, 318, 319, or 320, gray finish, gold-lined bowls, per doz. $24.00.

No. 240	Rhododendron (Washington State Flower) Tea Spoon	per doz. $26.00
No. 241	Rhododendron (Washington State Flower) Coffee Spoon	per doz. 12.00

Made bright polished, with gold-lined bowls; oxidized, with gold-lined bowls; gray finish, with gold-lined bowls. Specify which you want.

No. 285	Wheat Tea Spoon, gray finish, gilt tops, and gold-lined bowls	per doz. 16.00
No. 317	Wild Rose Tea Spoon, gray finish, gold-lined bowls	per doz. 20.00

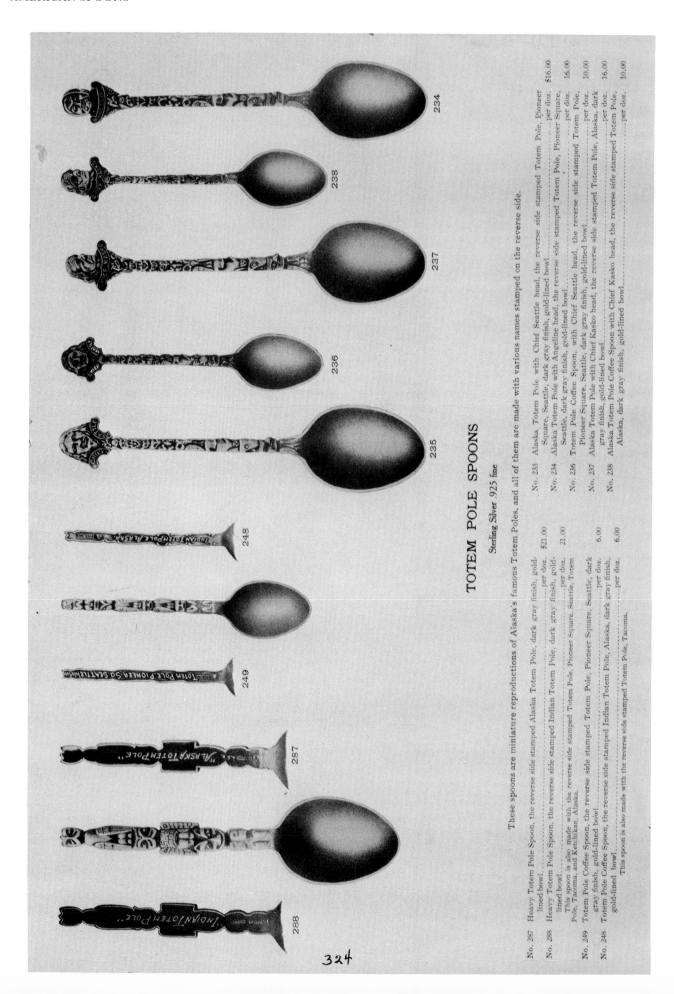

TOTEM POLE SPOONS

Sterling Silver .925 fine

These spoons are miniature reproductions of Alaska's famous Totem Poles, and all of them are made with various names stamped on the reverse side.

No. 235 Alaska Totem Pole with Chief Seattle head, the reverse side stamped Totem Pole, Pioneer Square, Seattle, dark gray finish, gold-lined bowl. per doz. $16.00

No. 234 Alaska Totem Pole with Angeline head, the reverse side stamped Totem Pole, Pioneer Square, Seattle, dark gray finish, gold-lined bowl. per doz. 16.00

No. 236 Totem Pole Coffee Spoon, with Chief Seattle head, the reverse side stamped Totem Pole, Pioneer Square, Seattle, dark gray finish, gold-lined bowl. ... per doz. 10.00

No. 237 Alaska Totem Pole with Chief Kasko head, the reverse side stamped Totem Pole, Alaska, dark gray finish, gold-lined bowl. per doz. 16.00

No. 238 Alaska Totem Pole Coffee Spoon with Chief Kasko head, the reverse side stamped Totem Pole, Alaska, dark gray finish, gold-lined bowl. per doz. 10.00

No. 287 Heavy Totem Pole Spoon, the reverse side stamped Alaska Totem Pole, dark gray finish, gold-lined bowl. per doz. $21.00

No. 288 Heavy Totem Pole Spoon, the reverse side stamped Indian Totem Pole, dark gray finish, gold-lined bowl. per doz. 21.00

This spoon is also made with the reverse side stamped Totem Pole. Pioneer Square, Seattle, Totem Pole, Tacoma, and Ketchikan, Alaska.

No. 249 Totem Pole Coffee Spoon, the reverse side stamped Totem Pole, Pioneer Square, Seattle, dark gray finish, gold-lined bowl. per doz. 6.00

No. 248 Totem Pole Coffee Spoon, the reverse side stamped Indian Totem Pole, Alaska, dark gray finish, gold-lined bowl. per doz. 6.00

This spoon is also made with the reverse side stamped Totem Pole, Tacoma.

ALASKA AND MIDNIGHT SUN EXPRESS SPOONS

Sterling Silver .925 fine

A Souvenir Spoon showing clearly the earlier methods of transporting freight through Alaska, over ice and snow, by means of the Dog Team and Sled. Even at this day this is the principal means of transportation to many of the interior points of this territory.

No. 203 Front die with Dog Team and Sled ; reverse side the letters NOME.

No. 204 Front die with Dog Team and Sled ; the reverse side a common Klondyke scene showing the method of hoisting pay dirt from the drift.

No. 205 Front die with Dog Team and Sled ; reverse represents the present method of travel via Ocean Steamer to Skagway, over the White Pass and Yukon Railroad to White Horse, and by River Steamer to Dawson.

This is a particularly appropriate souvenir spoon of Dawson.

No. 206 The same as No. 205, excepting the front and back dies are reversed.

No. 221 Alaska Salmon Spoon, gold pan, pick, and shovel, and real nuggets : gray finish, gilt fins, and gold-lined bowl .. per doz. $27.00

No. 231 Alaska Salmon Spoon, gold pan, pick and shovel, and real nuggets per doz. 21.00

PRICES : Nos. 203, 204, 205, 206, gray finish, gold-lined bowls per doz. 27.00

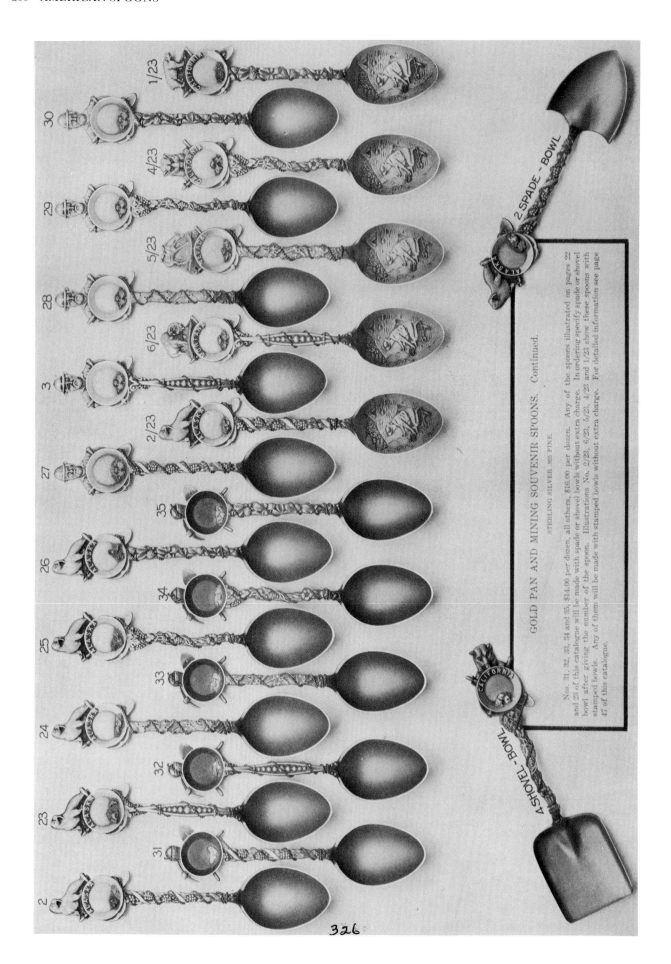

GOLD PAN AND MINING SOUVENIR SPOONS. Continued.

STERLING SILVER 925 FINE.

Nos. 31, 32, 33, 34 and 35, $14.00 per dozen, all others, $16.00 per dozen. Any of the spoons illustrated on pages 22 and 23 of this catalogue will be made with spade or shovel bowls without extra charge. In ordering specify spade or shovel bowl after giving the number of the spoon. Illustrations No. 2/23, 6/23, 5/23, 4/23 and 1/23 show these spoons with stamped bowls. Any of them will be made with stamped bowls without extra charge. For detailed information see page 47 of this catalogue.

326

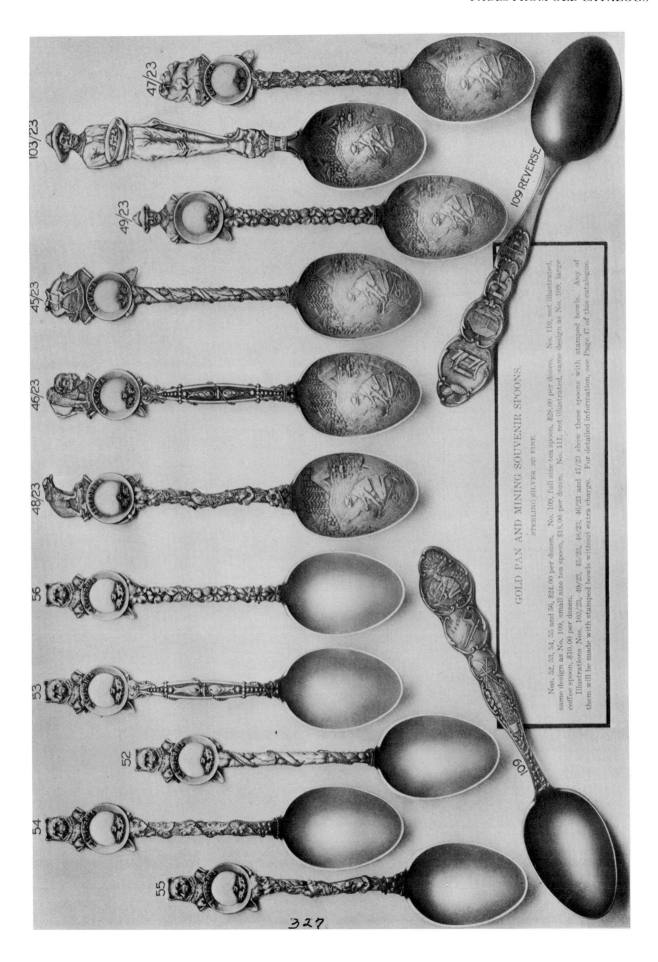

GOLD PAN AND MINING SOUVENIR SPOONS.

STERLING SILVER .925 FINE.

Nos. 52, 53, 54, 55 and 56, $24.00 per dozen. No. 109, full size tea spoon, $28.00 per dozen. No. 110, not illustrated, same design as No. 109, large coffee spoon, $10.00 per dozen. No. 109, small size tea spoon, $18.00 per dozen. No. 111, not illustrated, same design as No. 109, large coffee spoon, $10.00 per dozen. Illustrations Nos. 103/23, 49/23, 45/23, 48/23, 46/23 and 47/23 show these spoons with stamped bowls. Any of them will be made with stamped bowls without extra charge. For detailed information, see Page 47 of this catalogue.

327

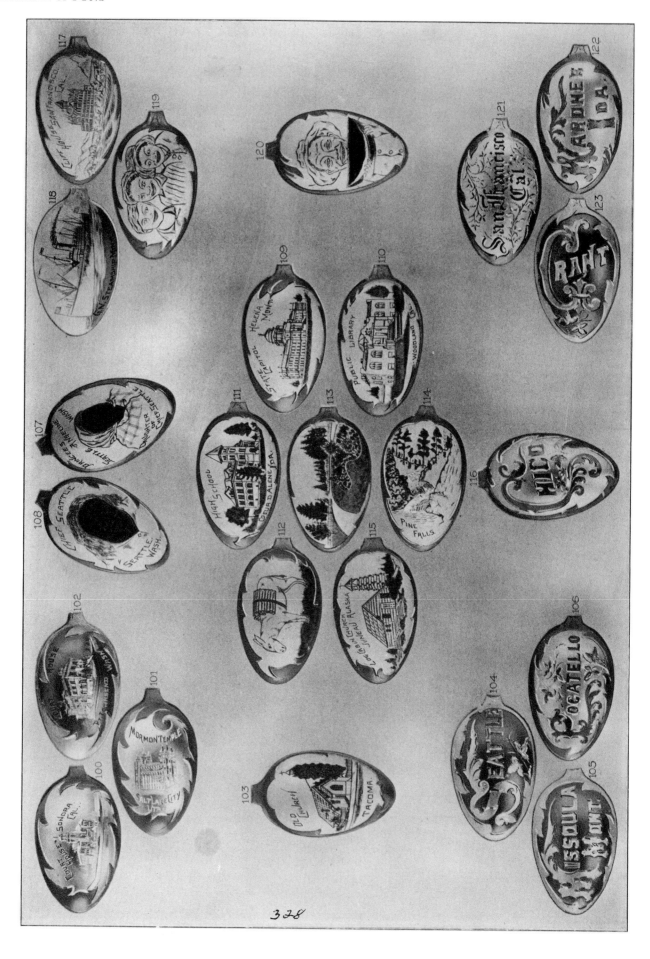

328

ALL DESIGNS ON THIS PAGE ARE SHOWN IN ACTUAL SIZE
SMALL TEA SPOONS AND COFFEES ARE NOT ILLUSTRATED

FULL SIZE TEA SPOONS		SMALL TEA SPOONS		COFFEE SPOONS	
461—Santa Claus	Per doz. $30.00	442—Santa Claus	Per doz. $20.00	462—Santa Claus	Per doz. $15.00
430—Madonna	" 30.00	449—Madonna	" 24.00	450—Madonna	" 15.00
439—Girl of the West	" 30.00	457—Girl of the West	" 24.00	458—Girl of the West	" 15.00
431—Roping the Steer	" 36.00	494—Roping the Steer	" 26.00	495—Roping the Steer	" 15.00
451—Broncho Buster	" 30.00	452—Broncho Buster	" 24.00	453—Broncho Buster	" 15.00
454—Golf Girl	" 30.00	455—Golf Girl	" 24.00	456—Golf Girl	" 15.00
443—College Girl, with one or two-color enamel Pennants. Full size Teaspoon					30.00
496—College Girl, with one or two-color enamel Pennants. Small Tea Spoon					27.00
497—College Girl, with one or two-color enamel Pennants. Coffee Spoons					18.00

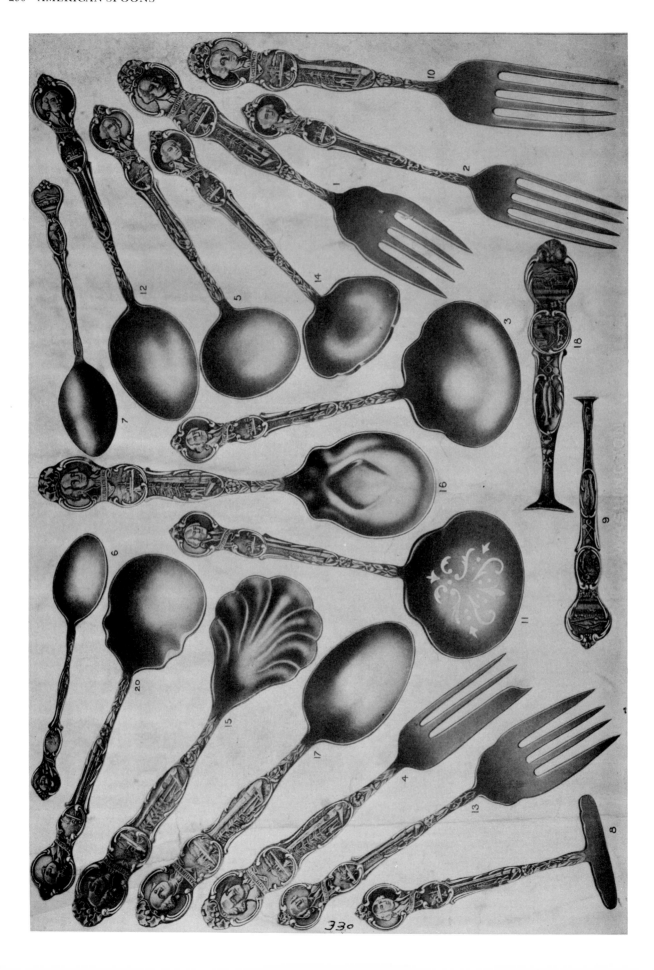

330

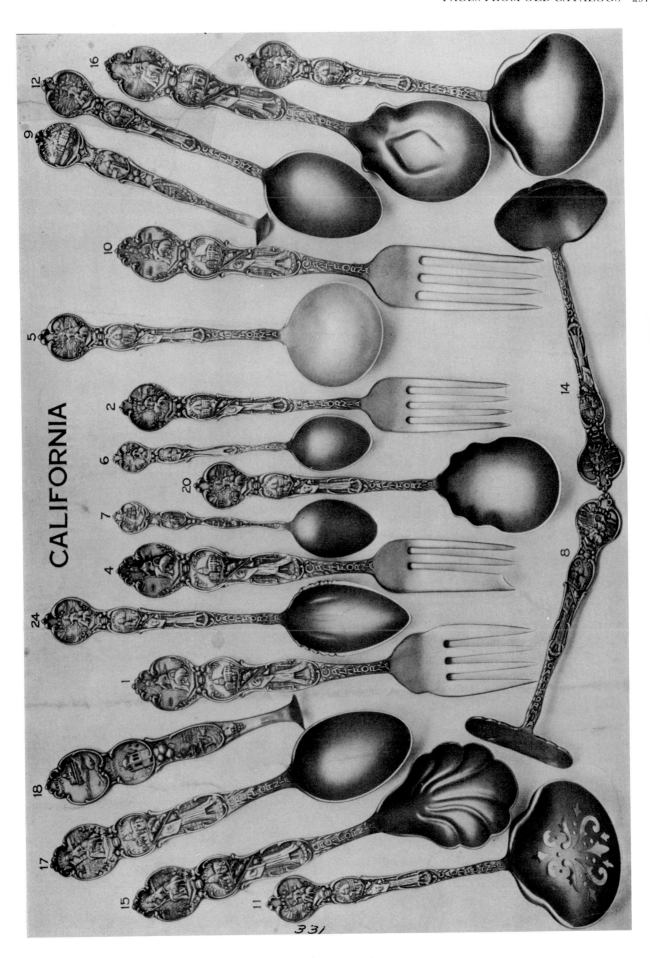

CALIFORNIA

331

THE ORIGINAL AMERICAN SOUVENIR SPOONS

Sterling Silver .925 fine

No. 315	Indian Tea Spoon, full size	per doz. $27.00
No. 360	(Not Illustrated), Indian Tea Spoon, same design as No. 315, small size	per doz. 18.00
No. 313	Indian Tea Spoon, full size	per doz. 27.00
No. 361	(Not Illustrated), Indian Tea Spoon, same design as No. 313, small size	per doz. 18.00
No. 316	Indian Coffee Spoon	per doz. 10.00
No. 314	Indian Coffee Spoon	per doz. 10.00
No. 115	Indian Tea Spoon, full size	per doz. $28.00
No. 116	(Not illustrated), same design as No. 115, small size Tea Spoon	per doz. 20.00
No. 117	(Not illustrated), same design as No. 115, large Coffee Spoon	per doz. 15.00
No. 118	Indian Tea Spoon, full size	per doz. 28.00
No. 119	(Not illustrated), same design as No. 118, small size Tea Spoon	per doz. 20.00
No. 120	(Not illustrated), same design as No. 118, large size Coffee Spoon	per doz. 15.00

The above spoons are gray finish with gilt bowls.

332

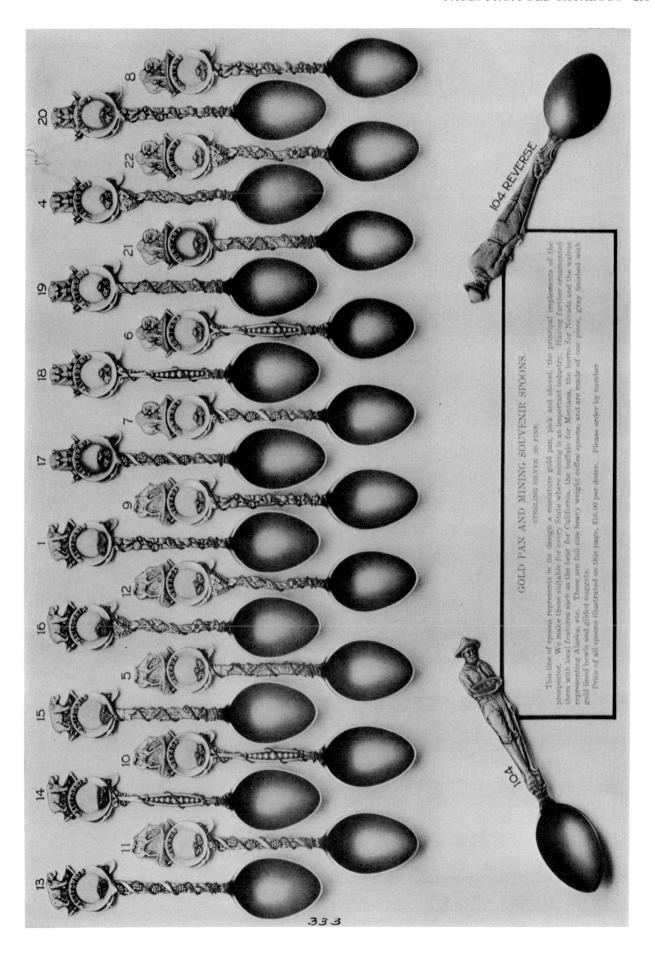

GOLD PAN AND MINING SOUVENIR SPOONS.

STERLING SILVER .925 FINE.

This line of spoons represents in its design a miniature gold pan, pick and shovel; the principal implements of the prospector. We make these suitable for every State where mining is an important industry. Having further ornamented them with local features such as the bear for California, the buffalo for Montana, the burro for Nevada and the walrus representing Alaska, etc. These are full size heavy weight coffee spoons, and are made of one piece, gray finished with gold lined bowls and gilded nuggets.

Price of all spoons illustrated on this page, $16.00 per dozen. Please order by number

104 REVERSE

104

333

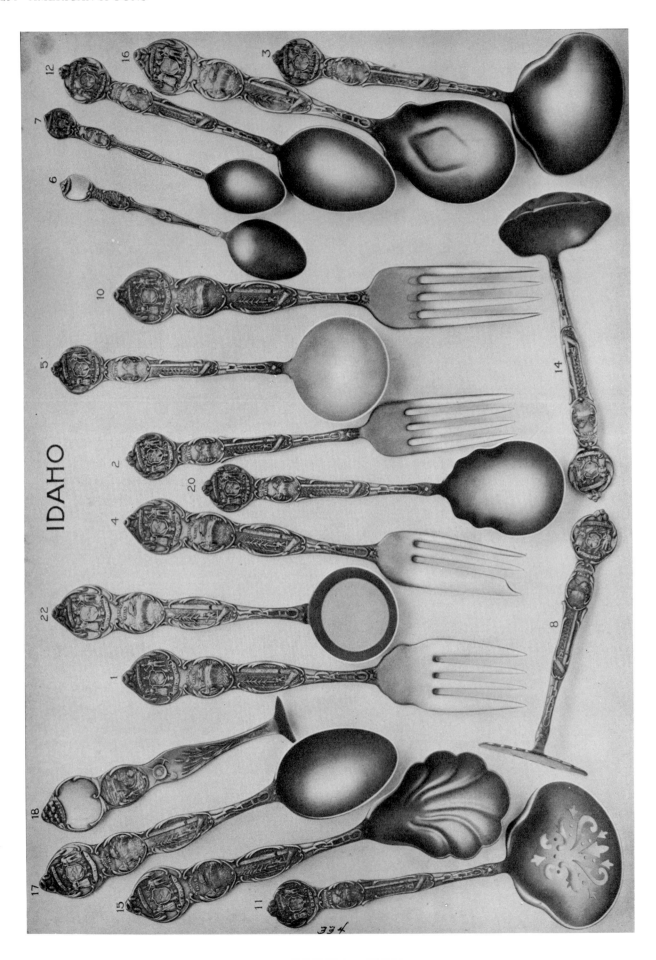

IDAHO

334

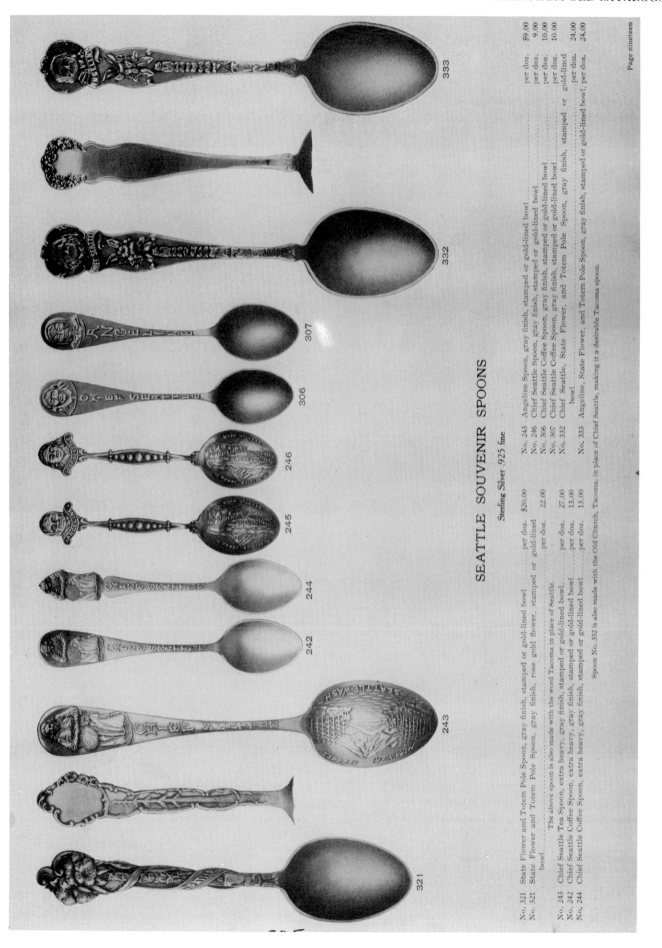

SEATTLE SOUVENIR SPOONS

Sterling Silver .925 fine

No. 321 State Flower and Totem Pole Spoon, gray finish, stamped or gold-lined bowl per doz. $20.00
No. 321 State Flower and Totem Pole Spoon, gray finish, rose gold flower, stamped or gold-lined
 bowl .. per doz. 22.00

 The above spoon is also made with the word Tacoma in place of Seattle.

No. 243 Chief Seattle Tea Spoon, extra heavy, stamped or gold-lined bowl per doz. 27.00
No. 242 Chief Seattle Coffee Spoon, extra heavy, gray finish, stamped or gold-lined bowl per doz. 13.00
No. 244 Chief Seattle Coffee Spoon, extra heavy, gray finish, stamped or gold-lined bowl per doz. 13.00

No. 245 Angeline Spoon, gray finish, stamped or gold-lined bowl per doz. $9.00
No. 246 Chief Seattle Spoon, gray finish, stamped or gold-lined bowl per doz. 9.00
No. 306 Chief Seattle Coffee Spoon, gray finish, stamped or gold-lined bowl per doz. 10.00
No. 307 Chief Seattle Coffee Spoon, gray finish, stamped or gold-lined bowl per doz. 10.00
No. 332 Chief Seattle, State Flower, and Totem Pole Spoon, gray finish, stamped or gold-lined
 bowl .. per doz. 24.00
No. 333 Angeline, State Flower, and Totem Pole Spoon, gray finish, stamped or gold-lined bowl, per doz. 24.00

Spoon No. 332 is also made with the Old Church, Tacoma, in place of Chief Seattle, making it a desirable Tacoma spoon.

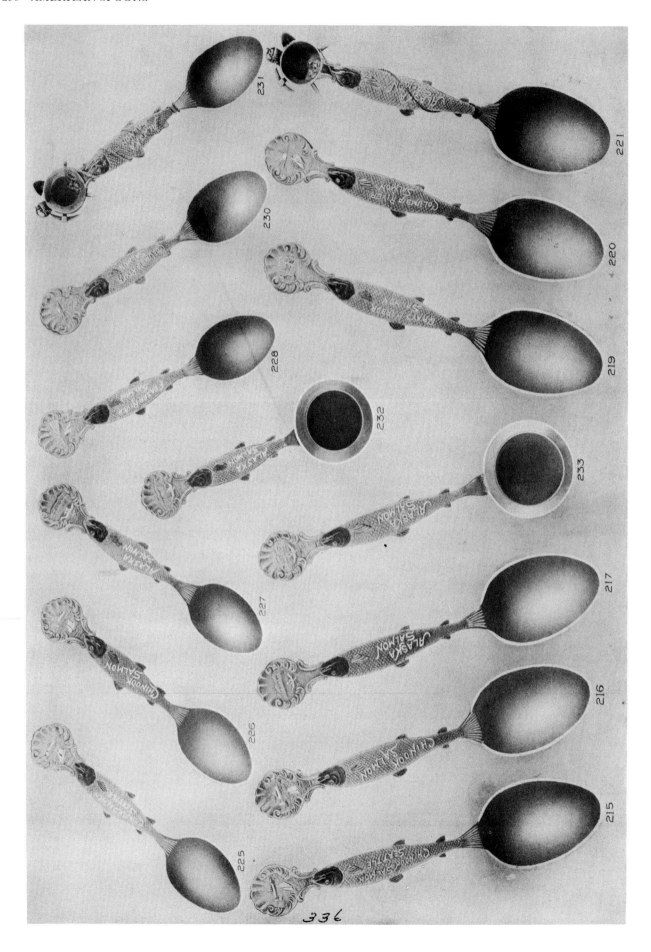

THE WARREN MANSFIELD CO., GOLD AND SILVER SMITHS, PORTLAND, ME. 83

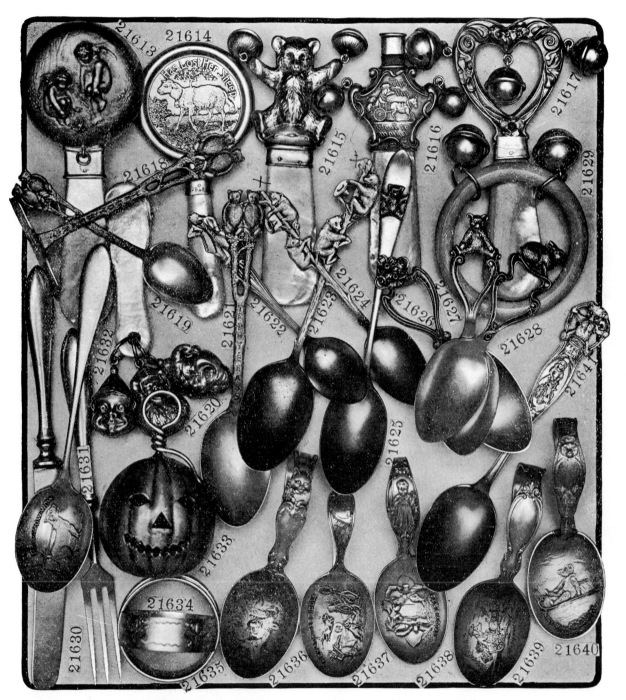

Sterling Articles for Children. Illustrations are two-thirds of actual size.

21613 Rattle, Sterling, Gray finish, Pearl handle....................	$3.50	
21614 Rattle, Sterling, Gray finish, Pearl handle, "Little Bo Peep"..........	3.75	
21615 Rattle, Sterling, Gray finish, Pearl handle, Teddy Bear.................	1.50	
21616 Rattle, Ster., Gray fin., Prl. handle, Whistle, "Little Pig went to Market"	2.00	
21617 Rattle, Sterling, Gray finish, Pearl handle......................	3.50	
21618 Food Pusher, Sterling, Gray finish, 2 Teddy Bears....................	1.50	
21619 Coffee Spoon, Sterling, Gray finish, 2 Teddy Bears....................	.65	
21620 Rattle, Sterling, Grey finish, Pearl handle.......................	1.75	
21621 Teaspoon, Sterling, Gray finish, 2 Teddy Bears....................	1.25	
21622 Coffee Spoon, Sterling, Gray finish, Gold bowl, Teddy Bear..............	.65	
21623 Teaspoon, Sterling, Gray finish, Gold bowl, 2 Teddy Bears...........	1.50	
21624 Coffee Spoon, Sterling, Gray finish, Gold bowl, 2 Teddy Bears...........	1.00	
21625 Teaspoon, Sterling, Polished, Gold bowl, Teddy Bear.................	1.50	
21626 Baby Spoon, Sterling, Gray finish, Flower......................	1.25	
21627 Baby Spoon, Sterling, Gray finish, Teddy Bear..................	1.25	

21628 Baby Spoon, Sterling, Gray finish, Rabbit....................	$1.35	
21629 Rattle, Sterling, Polished, Ivory Ring	1.75	
21630 Child's Knife, Sterling.... $.75 Set complete.................	2.50	
21631 Child's Fork, Sterling..... .85 Set complete.................	2.50	
21632 Child's Spoon, Sterling..... .90 "Bow Wow," set complete...........	2.50	
21633 Rattle, Sterling, Gray finish, "Jack o' Lantern"..................	3.50	
21634 Napkin Ring, Sterling, Satin finish, Engraved..................	.75	
21635 Napkin Ring, Sterling, Polished, Plain, good weight.................	1.00	
21636 Baby Spoon, Sterling, Gray finish, 3 Kittens..................	2.00	
21637 Baby Spoon, Sterling, Gray finish, "Hey Diddle Diddle".............	1.00	
21638 Baby Spoon, Sterling, Gray finish, Teddy Bear..................	1.25	
21639 Baby Spoon, Sterling, Gray fin., Louis XV, "Little Pig went to Market"	2.00	
Plain bowl..................................	1.50	
21640 Baby Spoon, Sterling, Gray finish, Teddy Bear.......	1.50	
21641 Teaspoon, Sterling, Gray finish, Gold bowl, Teddy Bear..............	1.75	

770-780. (pp. 337-347) The Warren Mansfield Co., Portland, Me., 1907-8.

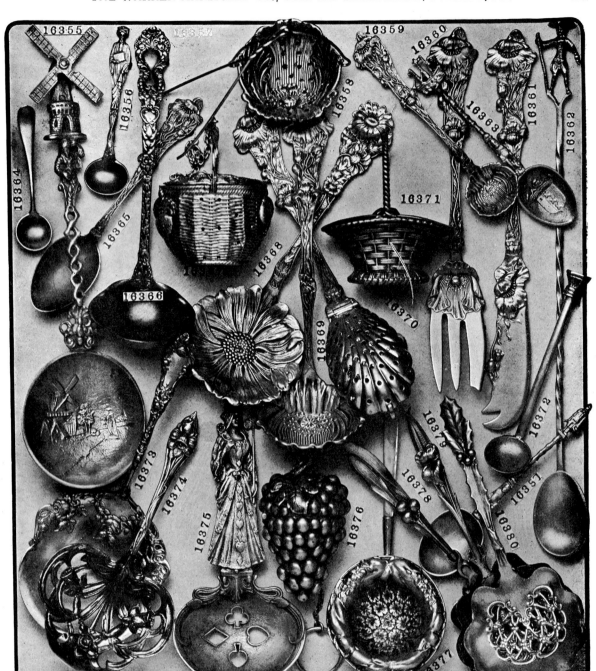

Odd Sterling Silver Spoons, Tea Balls, Bonbon Scoops, Etc. Illustrations are two-thirds actual size.

16355	Dutch Spoon, Sterling, Gray finish................	$6.00
16356	Salt Spoon, Sterling, Gray finish, Gold bowl, College Girl...	.40
16357	Dutch Coffee Spoon, Sterling, Gray finish...........	.75
16358	Tea Strainer, Sterling, Gray finish, Poppy..........	1.20
16359	Salt Spoon, Sterling, Gray finish, Poppy...........	.65
16360	Pickle Fork, Sterling, Gray finish, Poppy..........	1.65
16361	Cheese Knife, Sterling, Gray finish. Poppy.........	1.65
16362	Dutch Olive Spoon, Sterling, Gray finish...........	2.25
16363	Dutch Coffee Spoon, Sterling, Gray finish..........	1.50
16364	Salt Spoon, Sterling, Polished....................	.40
16365	Coffee Spoon, Sterling, Gray finish. Gold bowl, Poppy	.75
16366	Cream Ladle, Sterling, Gray finish, Gold bowl......	2.00
16367	Tea Ball, Sterling, Gray finish, Basket............	4 00

16368	Bonbon Spoon, Sterling, Gray finish, Daisy..........	$1.75
16369	Cream Ladle, Sterling, Gray finish, Poppy..........	1 85
16370	Teaette, Sterling, Gray finish, Poppy..............	3 00
16371	Individual Salt, Ster., Gray fin., Gold lined, Basket..	2.75
16372	Salt Spoon, Sterling, Gray finish, Pudsey..........	1.00
16373	Bonbon Scoop, Sterling, Gray finish, Marechal Niel	2.50
16374	Bonbon Scoop, Sterling, Gray finish, Gold bowl, Trumpet Flower..................................	1.15
16375	Bonbon Scoop, Sterling, Gray finish, Queen of Clubs	2.75
16376	Tea Ball, Sterling, Gray finish, Bunch of Grapes.....	3 50
16377	Tea Strainer, Sterling, Gray finish. Pearl handle....	.85
16378	Bonbon Scoop, Sterling, Gray finish, Mistletoe......	.90
16379	Bonbon Scoop, Sterling, Gray finish, Violet........	.90
16380	Bonbon Scoop. Sterling, Gray finish, Holly..........	.90

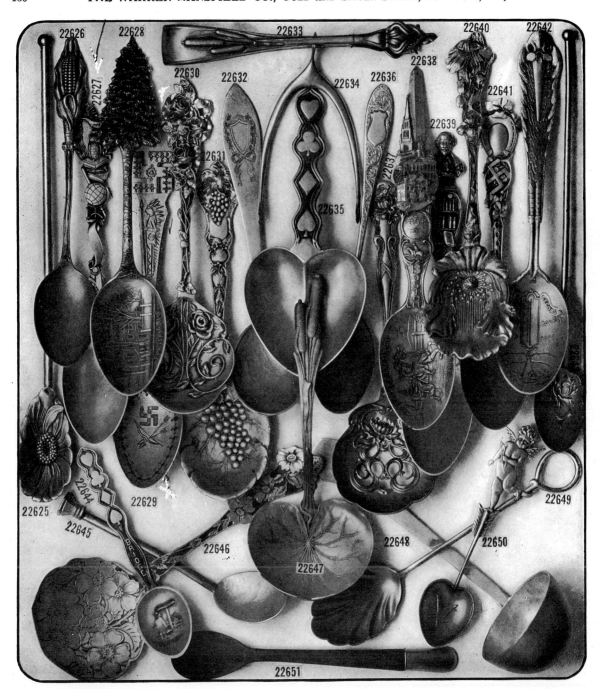

Souvenir Spoons, Fancy Sugar Spoons and Ladles. All Sterling Silver. Shown about two-thirds of the length and width of the articles.

22625 Lemonade Spoon, Gray finish, Daisy........................ $1.00	22638 Boston Souvenir Spoon, Gray finish, Bunker Hill Monument,
22626 Teaspoon, Gray finish, Gold bowl, Corn.................... 1.25	Paul Revere, North Church, Faneuil Hall, Old State House.. $2.00
22627 Teaspoon, Gray finish, Alma Mater........................ 1.25	22639 Teaspoon, Gray finish, Shakespeare....................... 1.50
22628 Souvenir Spoon, Gray finish, Longfellow Home in bowl, Pine	22640 Sugar Spoon, Gray finish, Poppy.......................... 1.75
Tree handle........................ 2.00	22641 Teaspoon, Gray finish, Gold bowl, Good Luck, Swastika..... 1.50
22629 Souvenir Spoon, Gray finish, Etched, Swastika, Bow and	22642 Baby Spoon, Gray finish, Stork, Birth Record, etc.......... 2.00
Arrow......................... 1.15	22643 Lemonade Spoon, Polished, Gold bowl...................... .75
22630 Sugar Spoon, Gray finish, Bridal Rose.................... 2.00	22644 Bridge Whist Spoon, Gray finish.......................... .75
22631 Sugar Spoon, Gray finish, Grapes......................... 1.50	22645 Coffee Spoon, Hammered Silver, Pudsey.................... 1.25
22632 Teaspoon, heavy weight, Wreath.......................... 2.00	22646 Bonbon Scoop, Gray finish, Etched........................ 1.65
22633 Sugar Tongs, Gray finish, Cat-o'-nine-tails................. 2.50	22647 Cream Ladle, Gray finish, Cat-o'-nine-tails................. 3.00
22634 Bonbon Tongs, Wishbone................................ 2.50	22648 Cream Ladle, Hammered Silver, Colonial................... 3.50
22635 Bonbon Spoon, Gray finish, Whist Prize................... 2.75	22649 Marmalade Spoon, Polished, Gold bowl.................... .90
22636 Teaspoon, Polished, Engraved, Gold bowl................. 1.25	22650 Coffee Spoon, Gray finish, Cupid......................... .90
22637 Bonbon Spoon, Gray finish, Gold bowl, Water Lily.......... 1.25	22651 Mustard Spoon, Olive Wood, Sterling mounted.............. .85

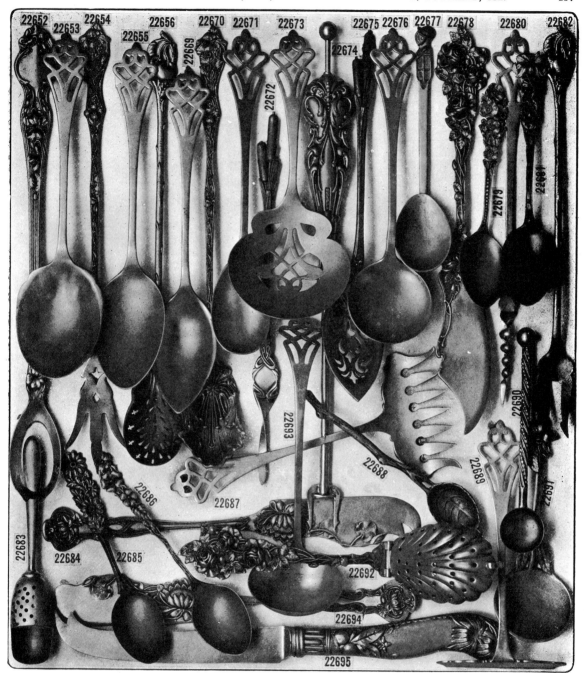

Some Interesting Sterling Pieces for the Table. Shown two-thirds actual length and width.

22652	Olive Spoon and Fork, Gray finish, Violet	$2.25
22653	Sugar Spoon, Polished, Pynchon	1.50
22654	Lettuce Fork, Gray finish, Poppy	1.00
22655	Teaspoon, Polished, Pynchon	1.20
22656	Olive Spoon, Gray finish, Gold bowl, Cherries	1.50
22669	Orange Spoon, Polished, Pynchon	1.20
22670	Horseradish Spoon, Gray finish, Poppy	1.00
22671	Sherbet Spoon, Polished, Pynchon	1.20
22672	Butter Pick, Gray finish, Cat-o'-nine-tails	1.85
22673	Bonbon Spoon, Polished, Pynchon	1.20
22674	Olive or Pickle Fork, Gray finish, Patent Remover	1.75
22675	Olive Spoon, Gray finish, Cat-o'-nine-tails	2.00
22676	Bouillon Spoon, Polished, Pynchon	1.20
22677	Coffee Spoon, Hammered Silver, Heraldic	1.25
22678	Butter Knife, Gray finish, Bridal Rose	1.75
22679	Coffee Spoon, Gray finish, Gold bowl, Wild Rose	.65
22680	Butter Pick, Polished, Pynchon	1.20
22681	Coffee Spoon, Gray finish, Gold bowl, Lily	$.90
22682	Olive Fork, Gray finish, Gold tines, Cherries	1.50
22683	Salt Sifter, Polished, Gold lined	.85
22684	Cheese Knife, Gray finish, Water Lily	1.35
22685	Coffee Spoon, Gray finish, Gold bowl, Daisies	.65
22686	Coffee Spoon, Gray finish, Gold bowl, Wild Rose	.50
22687	Sardine Fork, Polished, Pynchon	1.20
22688	Mustard Spoon, Gray finish, Gold bowl	1.35
22689	Food Pusher, Polished, Pynchon	1.20
22690	Mustard Spoon, Polished, Gold bowl	.75
22691	Bonbon Spoon, Gray finish, Orange bowl and Flower	1.25
	The same with Orange Gold bowl	1.50
22692	Teaette, Gray finish, Bridal Rose	3.25
22693	Cream Ladle, Polished, Pynchon	1.20
22694	Butter Spreader, Gray finish, Water Lily	1.35
22695	Orange Knife, Gray finish, saw back	1.65
	Same without saw back	1.50

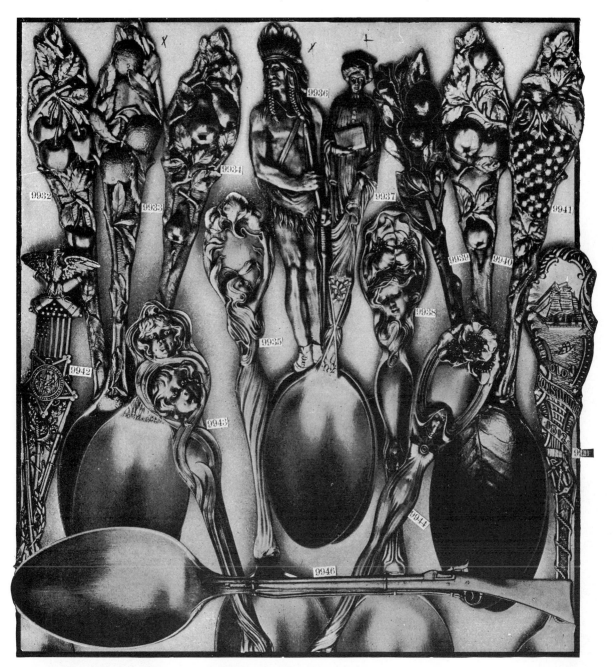

Heavy Sterling Silver Spoons. Some odd and beautiful designs.

9932	Teaspoon, Sterling, Gray, Cherry.	$2.25
9933	Teaspoon, Sterling, Gray, Orange	2.25
9934	Teaspoon, Sterling, Gray, Pear	2.25
9935	Teaspoon, Sterling, Gray, "Secret of the Flowers"	1.50
9936	Teaspoon, Sterling, Gray, Indian	2.25
9937	Teaspoon, Sterling, Gray, College Girl	1.50
9938	Teaspoon, Sterling, Gray, "Evangeline"	1.50
9939	Orange, Sterling, Gray, Gold bowl and Oranges	3.00
9940	Teaspoon, Sterling, Gray, Apple	2.25
9941	Teaspoon, Sterling, Gray, Grape	2.25
9942	Souvenir Spoon, Grand Army, Sterling, Gray	1.65
9943	Teaspoon, Sterling, Gray, Cupid Sunbeam	1.50
9944	Teaspoon, Sterling, Gray, "La Fantasie"	1.75
9945	Discontinued	
9946	Teaspoon, Sterling, Gray, Rifle.	1.65

Illustrations are full size.

12858 Six Coffee Spoons, Sterling, Assorted Floral handles, Enameled, Silk case 6¾ inches..............................$6.50

THE WARREN MANSFIELD CO., GOLD AND SILVER SMITHS, PORTLAND, ME.

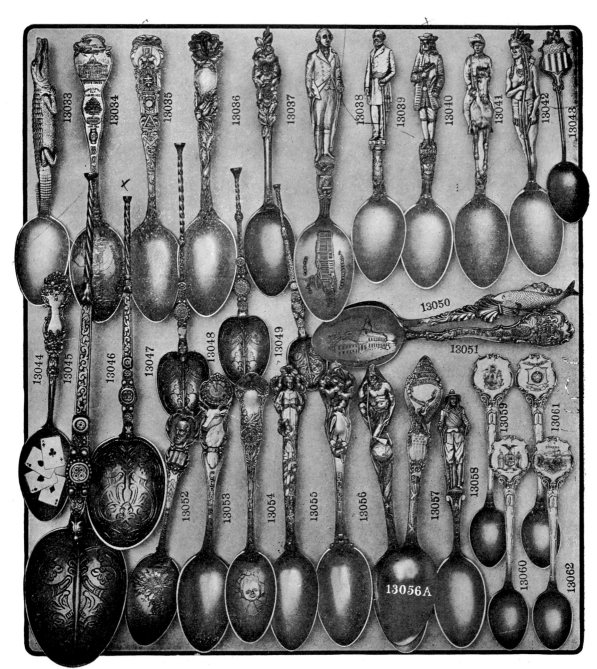

Odd Spoons in Sterling Silver. Illustrations are one-half actual size.

13033	Alligator, Gray, Gold bowl............................	$1.75
13034	Boston Souvenir, Gray, Codfish, State House, Washington Elm, Hub, Subway, Public Library, Faneuil Hall, Old South Church, Old State House...............	2.50
13035	Masonic, Gray ..	1.15
13036	Bridal Rose, Gray	1.35
13037	Birthmonth, Gray, Gold bowl, January, Wild Rose..........	1.50
13038	George Washington, Gray, Capitol in bowl................	3.00
13039	General Lee, Gray......................................	1.75
13040	William Penn, Gray	1.75
13041	Theodore Roosevelt, Gray................................	1.75
13042	Indian, Gray ...	1.75
13043	Discontinued.	
13044	Small Tea, Gray handle, Gilt bowl, Enameled cards	1.75
13045	Coronation Spoon, large, heavy, Gold finish, 3½ ounces, 10 inches long.......................................	12.00
13046	Coronation Spoon, heavy, Gold finish, 7 inches.............	6.50

13047	Coronation Spoon, heavy, Gold finish, 5½ inches...........	$3.50
13048	Coronation Spoon, heavy, Gold finish, 4½ inches...........	2.50
13049	Coronation Spoon, heavy, Gold finish, 4½ inches...........	1.50
13050	Fish, heavy, Gray.......................................	1.50
13051	Pennsylvania Souvenir, Gray, Seal on handle, Independence Hall in bowl.......................................	2.25
13052	Whittier, Gray, Birthplace in bowl........................	1.50
13053	Elk, B. P. O. E., Gray..................................	1.50
13054	Baby Teaspoon, Gray....................................	1.75
13055	Choir Boy, Gray..	1.50
13056	Easter Spoon, Gray......................................	1.75
13057	United States Souvenir, showing front and back of spoon....	1.50
13058	Stuyvesant, Gray..	1.85
13059	Large Coffee, Gold bowl, Enameled Maine State Seal.........	1.50
13060	Large Coffee, Gold bowl, Enameled New York State Seal.....	1.35
13061	Large Coffee, Gold bowl, Enameled Texas State Seal........	1.35
13062	Large Coffee, Gold bowl, Enameled California State Seal....	1.35

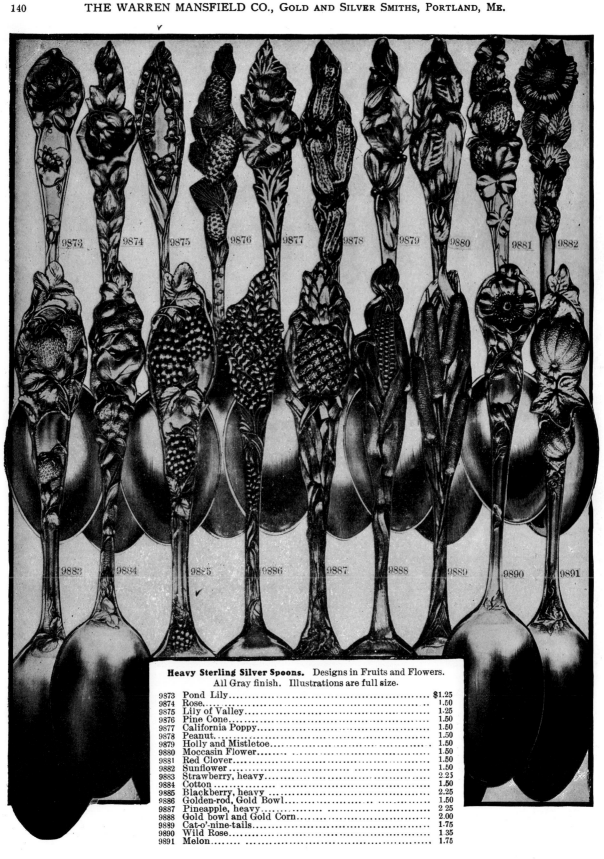

Heavy Sterling Silver Spoons. Designs in Fruits and Flowers.
All Gray finish. Illustrations are full size.

9873	Pond Lily	$1.25
9874	Rose	1.50
9875	Lily of Valley	1.25
9876	Pine Cone	1.50
9877	California Poppy	1.50
9878	Peanut	1.50
9879	Holly and Mistletoe	1.50
9880	Moccasin Flower	1.50
9881	Red Clover	1.50
9882	Sunflower	1.50
9883	Strawberry, heavy	2.25
9884	Cotton	1.50
9885	Blackberry, heavy	2.25
9886	Golden-rod, Gold Bowl	1.50
9887	Pineapple, heavy	2.25
9888	Gold bowl and Gold Corn	2.00
9889	Cat-o'-nine-tails	1.75
9890	Wild Rose	1.35
9891	Melon	1.75

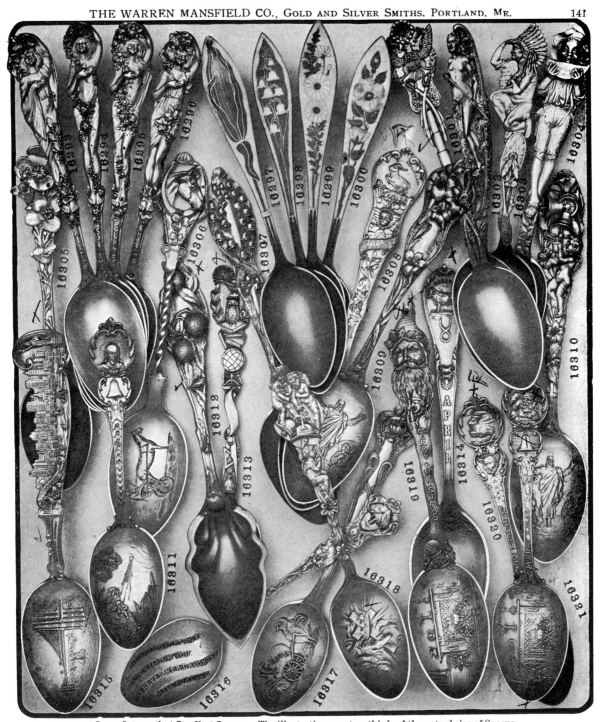

Some Interesting Sterling Spoons. The illustrations are two-thirds of the actual size of Spoons.

16293	Winter, heavy	$1.65	16303	Indian, Setting Sun	$1.85	16313	Alma Mater	$1 35
16294	Spring, heavy	1.65	16304	Negro Boy	2.25	16314*	Birth, Tea, Zodiacal, April	1.50
16295	Summer, heavy	1.65	16305	Poppy	1.50	16315**	Brooklyn Bridge and Lower	
16296	Autumn, heavy	1.65	16306	Racer	2.75		New York	1.75
16297	Gold finish, Enameled, Corn	2.00	16307	Valley Lily	1.75	16316†	Toast Spoon, "Dame Fortune"	1.00
16298	Gold fin., Enam., Valley Lily	2.25	16308*	Birthmonth Zodiacal, Dec	1.75	16317	Easter, Chick in bowl	1 25
16299	Gold finish, Enam,, Daisies	2.25	16309	Easter Lily, Ascension	2.00	16318	Easter Spoon	2.00
16300	Gold fin., Enam., Wild Rose	2.25	16310	Easter, Ascension	2.00	16319	Christmas Spoon, Santa Claus	2.00
16301	U. S. Army	1.85	16311	Christmas	1.25	16320*	Birthmonth Zodiacal, Dec	1.15
16302	The Sacrifice	1.75	16312	Orange Spoon, heavy	3.00	16321	Christmas Spoon	1.25

*Can be furnished with appropriate zodiacal sign and flower for any month in the year. **Also same style for Chicago, Boston and New Orleans. †Can be furnished with the following toasts: A "May Dame Fortune ever smile on you, but never her daughter Misfortune." B "Here's champagne to our real friends and real pain to our sham friends." C "Here's to our wives and sweethearts; may they never meet." D "Here's to love, the only fire against which there is no insurance." E "May you always be good, but not too good; the good die young.

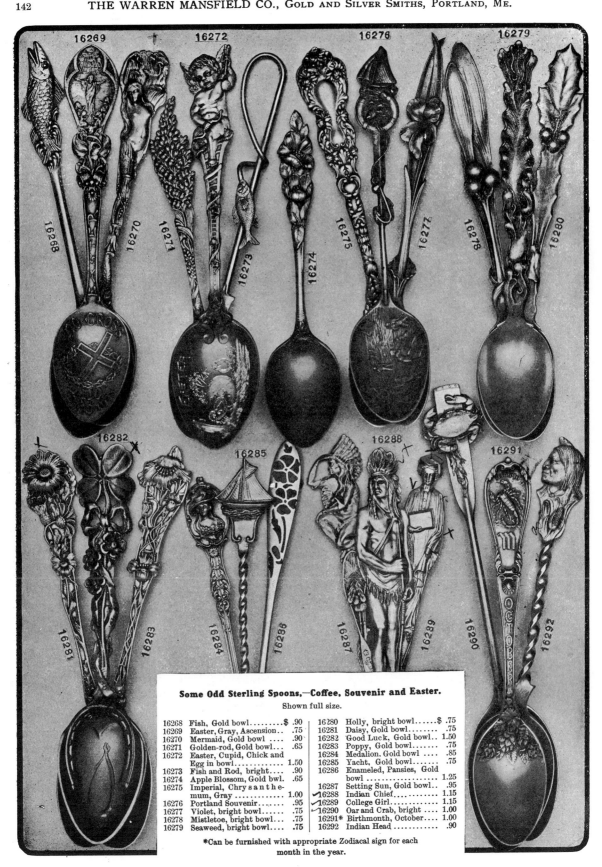

Some Odd Sterling Spoons.—Coffee, Souvenir and Easter.

Shown full size.

16268	Fish, Gold bowl.........$.90		16280	Holly, bright bowl......$.75
16269	Easter, Gray, Ascension.. .75		16281	Daisy, Gold bowl......... .75
16270	Mermaid, Gold bowl90		16282	Good Luck, Gold bowl.. 1.50
16271	Golden-rod, Gold bowl... .65		16283	Poppy, Gold bowl........ .75
16272	Easter, Cupid, Chick and		16284	Medalion, Gold bowl85
	Egg in bowl............. 1.50		16285	Yacht, Gold bowl........ .75
16273	Fish and Rod, bright.... .90		16286	Enameled, Pansies, Gold
16274	Apple Blossom, Gold bwl. .65			bowl 1.25
16275	Imperial, Chrysanthe-		16287	Setting Sun, Gold bowl.. .95
	mum, Gray 1.00		16288	Indian Chief............ 1.15
16276	Portland Souvenir....... .95		16289	College Girl............. 1.15
16277	Violet, bright bowl...... .75		16290	Oar and Crab, bright 1.00
16278	Mistletoe, bright bowl... .75		16291*	Birthmonth, October.... 1.00
16279	Seaweed, bright bowl.... .75		16292	Indian Head90

*Can be furnished with appropriate Zodiacal sign for each
month in the year.

The Warren Mansfield Co., Gold and Silversmiths, Portland, Maine.

No. 11517

No. 5194

No. 11518

No. 10930

No. 11517. The Double Up. An Ideal Parasol for the summer vacation. Full size but folds to fit 22 in. dress suit case. Good quality Taffeta in black, white, gray, brown, tan, navy, royal, green, red, pink, old rose, light blue, lavender, and blue and green changeable. Sticks to match. Price $4.50 prepaid.

No. 5194. Handy Pin 14k. We have these with flowers for each month in the year, ea. $1.50, pr. $3.00. The pins shown are the rose for June.

No. 10930. New Birthday Spoons. Sterling silver, gold bowls, with appropriate flower and name of each month in the year, beautifully enameled in appropriate colors on the end of the handle—Jan., wild rose; Feb., pink; March, violet; April, lily; May, lily of valley; June, rose; July, daisy; August, water lily; Sep., poppy; Oct., cosmos; Nov., chrysanthemum; Dec., holly. Price $1.65 each. Order by month.

No. 11518. Sterling Silver Postal Scale for desk, 3 in. high, 2 in. wide, 3 in. deep, very attractive and warranted accurate. Price prepaid, $4.50. In genuine black seal leather, sterling trimmed, $3.50.

THE WARREN MANSFIELD CO., GOLD AND SILVER SMITHS, PORTLAND, ME. **143**

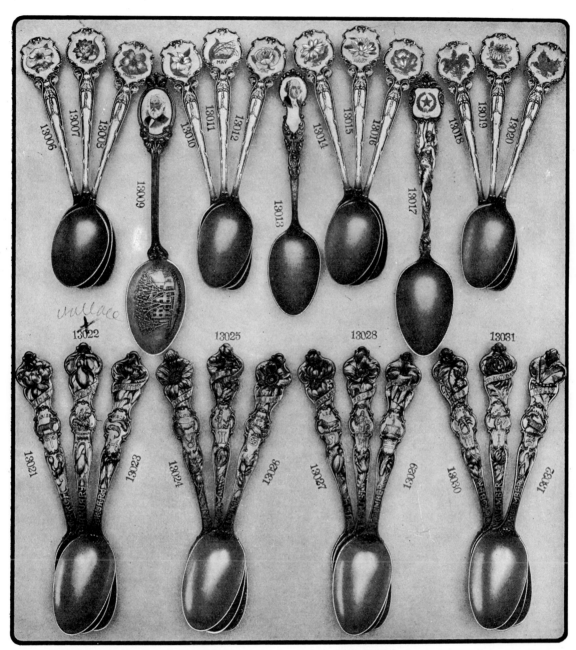

Sterling Silver Floral Birthmonth Spoons. Illustrations are one-half size.

13006	Birthmonth, Enameled flower, Gold bowl, January, Wild Rose........	$1.65
13007	Birthmonth, Enameled flower, Gold bowl, February, Carnation.........	1.65
13008	Birthmonth, Enam. flower, Gold bowl, March, Violet	1.65
13009	Longfellow, Gilt handle, Enameled, Gray bowl......	2.50
13010	Birthmonth, Enameled flower, Gold bowl, April, Easter Lily..........	1.65
13011	Birthmonth, Enameled flower, Gold bowl, May, Lily of Valley.........	1.65
13012	Birthmonth, Enam. flower, Gold bowl, June, Rose...	1.65
13013	Washington, Gold finish, Enameled...............	1.75
13014	Birthmonth, Enam. flower, Gold bowl, July, Daisy..	1.65
13015	Birthmonth, Enameled flower, Gold bowl, August, Water Lily...........	1.65
13016	Birthmonth, Enam. flower, Gold bowl, Sept., Poppy	1.65
13017	Discontinued.	
13018	Birthmonth, Enameled flower, Gold bowl, October, Golden-rod..........	1 65
13019	Birthmonth, Enameled flower, Gold bowl, November, Chrysanthemum	$1.65
13020	Birthmonth, Enam. flower, Gold bowl, Dec., Holly..	1.65
13021	Zodiacal, Birthmonth, Gray, heavy, March, Violet..	1.25
13022	Zodiacal, Birthmonth, Gray, heavy, Jan., Snowdrop	1.25
13023	Zodiacal, Birthmonth, Gray, heavy, February, Carnation..	1.25
13024	Zodiacal, Birthmonth, Gray, heavy, April, Daisy....	1.25
13025	Zodiacal, Birthmonth, Gray, heavy, May, Apple Blossom	1.25
13026	Zodiacal, Birthmonth, Gray, heavy, June, Wild Rose	1.25
13027	Zodiacal, Birthmonth, Gray, heavy, July, Water Lily	1.25
13028	Zodiacal, Birthmonth, Gray, heavy, August, Poppy..	1.25
13029	Zodiacal, Birthmonth, Gray, heavy, September, Morning Glory	1.25
13030	Zodiacal, Birthmonth, Gray, heavy, October, Hops..	1.25
13031	Zodiacal, Birthmonth, Gray, heavy, November, Chrysanthemum.	1.25
13032	Zodiacal, Birthmonth, Gray, heavy, December, Holly	1.25

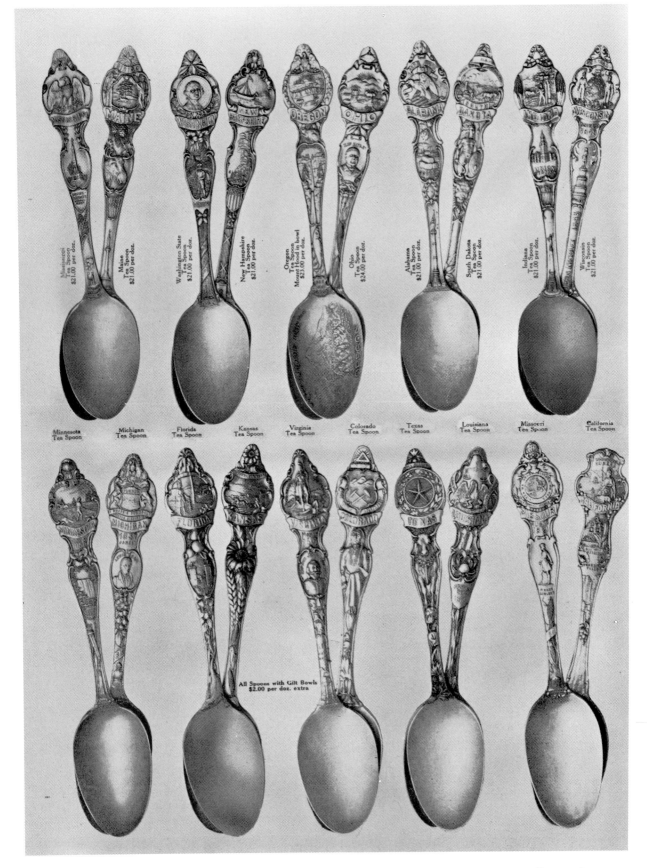

781-784. (pp. 348-351) R. Wallace & Sons Mfg. Co. catalog, circa 1909-1910. (Courtesy of Mary Anderson, Kingsport, Tenn.)

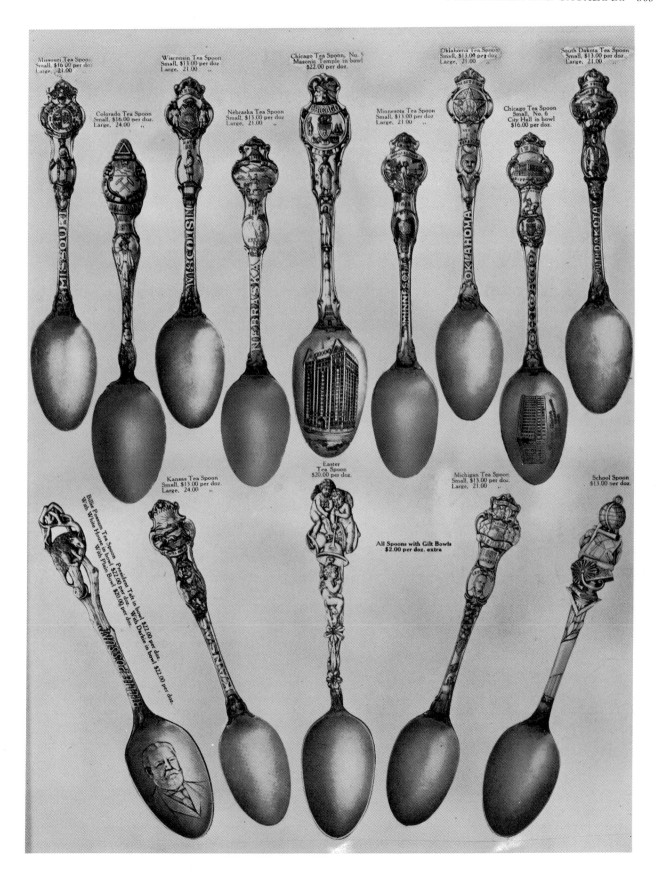

Missouri Tea Spoon.
Small, $16.00 per doz.
Large, 21.00 "

Wisconsin Tea Spoon
Small, $13.00 per doz.
Large, 21.00 "

Chicago Tea Spoon, No. 5
Masonic Temple in bowl
$22.00 per doz.

Oklahoma Tea Spoon
Small, $13.00 per doz.
Large, 21.00 "

South Dakota Tea Spoon
Small, $13.00 per doz.
Large, 21.00 "

Colorado Tea Spoon
Small, $16.00 per doz.
Large, 24.00 "

Nebraska Tea Spoon
Small, $13.00 per doz.
Large, 21.00 "

Minnesota Tea Spoon
Small, $13.00 per doz.
Large, 21.00 "

Chicago Tea Spoon
Small, No. 6
City Hall in bowl
$16.00 per doz.

Kansas Tea Spoon
Small, $13.00 per doz.
Large, 24.00 "

Easter
Tea Spoon
$20.00 per doz.

Michigan Tea Spoon
Small, $13.00 per doz.
Large, 21.00 "

School Spoon
$13.00 per doz.

Billie Possum Tea Spoon
With White House in bowl

President Taft in bowl $22.00 per doz.
With Darkie in bowl $22.00 per doz.
With Plain Bowl $20.00 per doz.

All Spoons with Gilt Bowls
$2.00 per doz. extra

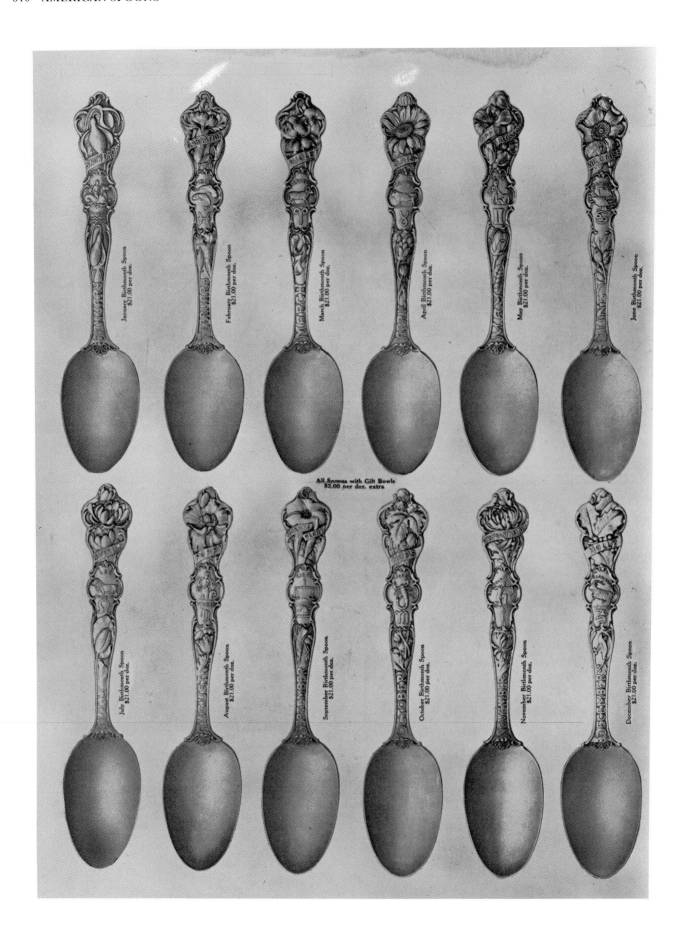

January Birthmonth Spoon
$21.00 per doz.

February Birthmonth Spoon
$21.00 per doz.

March Birthmonth Spoon
$21.00 per doz.

April Birthmonth Spoon
$21.00 per doz.

May Birthmonth Spoon
$21.00 per doz.

June Birthmonth Spoon
$21.00 per doz.

All Spoons with Gilt Bowls
$2.00 per doz. extra

July Birthmonth Spoon
$21.00 per doz.

August Birthmonth Spoon
$21.00 per doz.

September Birthmonth Spoon
$21.00 per doz.

October Birthmonth Spoon
$21.00 per doz.

November Birthmonth Spoon
$21.00 per doz.

December Birthmonth Spoon
$21.00 per doz.

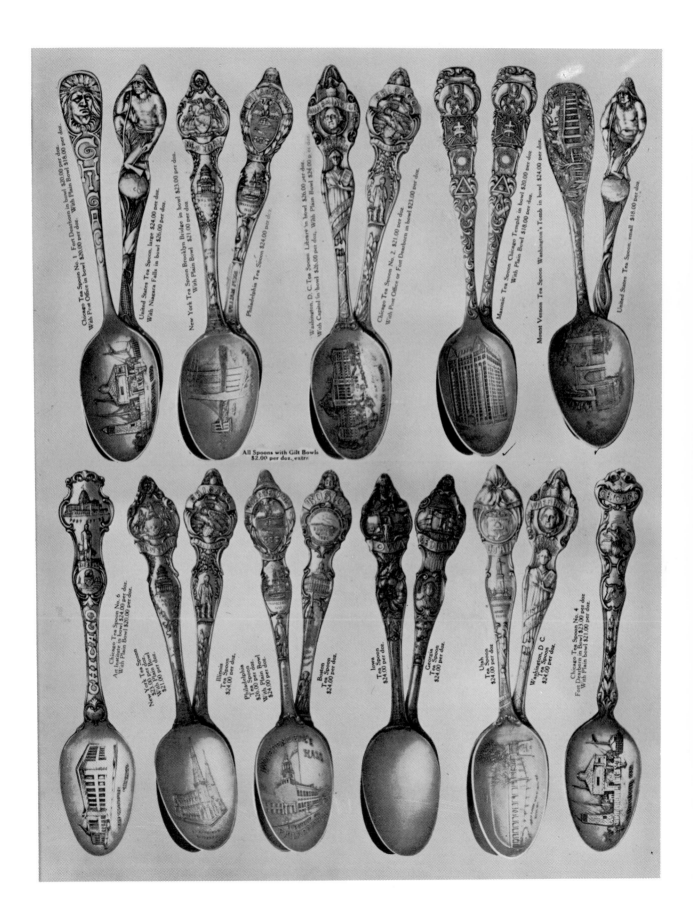

SOUVENIR SPOONS — French Gray

SOUVENIR SPOONS — French Gray

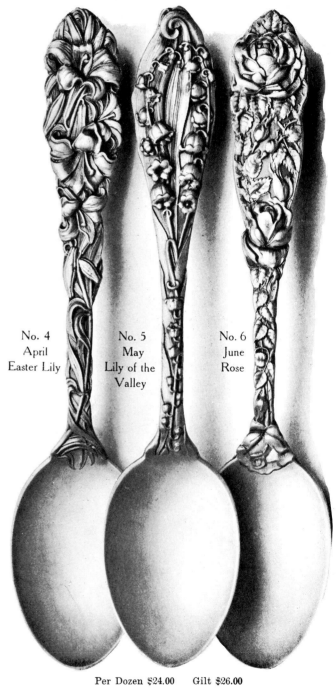

No. 1
January
Wild Rose

No. 2
February
Carnation

No. 3
March
Violet

No. 4
April
Easter Lily

No. 5
May
Lily of the
Valley

No. 6
June
Rose

Per Dozen $24.00 Gilt $26.00
30

Per Dozen $24.00 Gilt $26.00
31

785-792. (pp. 352-359) Simpson, Hall, Miller & Co.
Catalog No. 47, Wallingford, Conn. (Courtesy E.P.
Hogan, Historical Library, International Silver Co.)

SOUVENIR SPOONS — French Gray

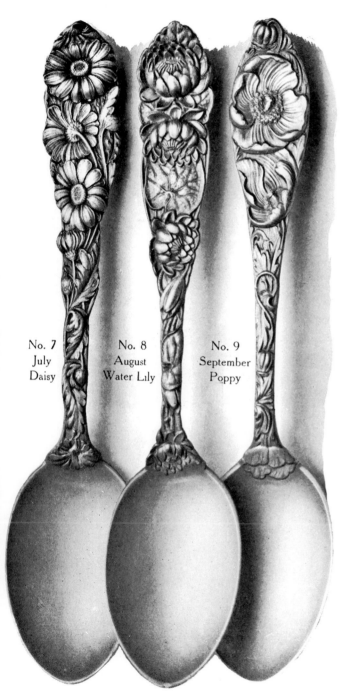

No. 7
July
Daisy

No. 8
August
Water Lily

No. 9
September
Poppy

Per Dozen $24.00 Gilt $26.00

SOUVENIR SPOONS — French Gray

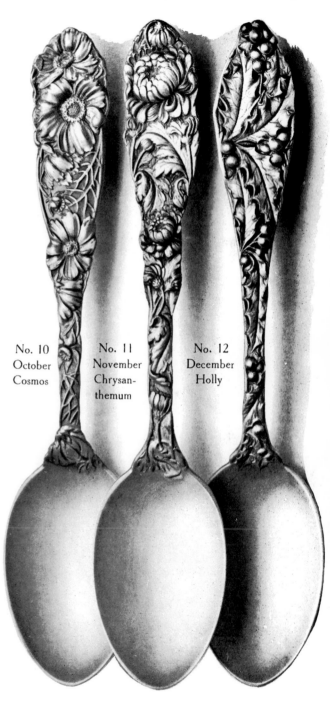

No. 10
October
Cosmos

No. 11
November
Chrysan-
themum

No. 12
December
Holly

Per Dozen $24.00 Gilt $26.00

ZODIAC SOUVENIR SPOONS—French Gray
IN COFFEE SPOON SIZE

ZODIAC SOUVENIR SPOONS—French Gray
IN COFFEE SPOON SIZE

No. 2　February
Carnation

Pisces
"Fishes"

No. 1　January
Wild Rose

Aquarius
"Waterman"

No. 3　March
Violet

Aries
"Ram"

No. 5　May
Lily of the Valley

Gemini
"Twins"

No. 4　April
Easter Lily

Taurus
"Bull"

No. 6　June
Rose

Cancer
"Crab"

Per Dozen $12.00　　Gilt $14.00
34

Per Dozen $12.00　　Gilt $14.00
35

No. 12 December
Holly
Capricornus
"Goat"

No. 11 November
Chrysanthemum
Sagittarius
"Archer"

No. 10 October
Cosmos
Scorpio
"Scorpion"

No. 9 September
Poppy
Libra
"Balance"

No. 8 August
Water Lily
Virgo
"Virgin"

No. 7 July
Daisy
Leo
"Lion"

"UNITED STATES" SOUVENIR SPOON
French Gray

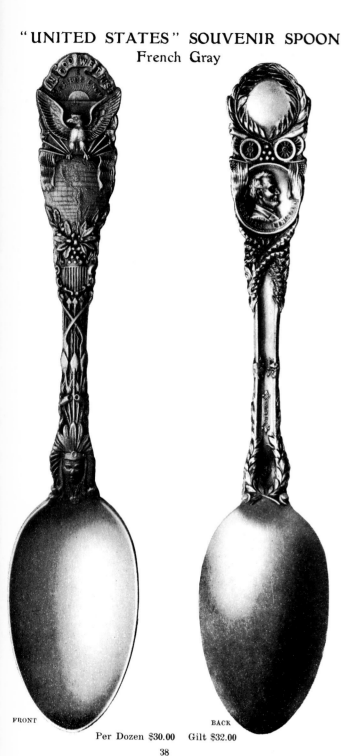

FRONT

BACK

Per Dozen $30.00 Gilt $32.00

38

BABY'S AND CHILD'S SETS.

"Hobby Horse" Etching "Humpty Dumpty" Etching

Illustrations
Actual Size.

TRADE MARK

STERLING $\frac{925}{1000}$ FINE

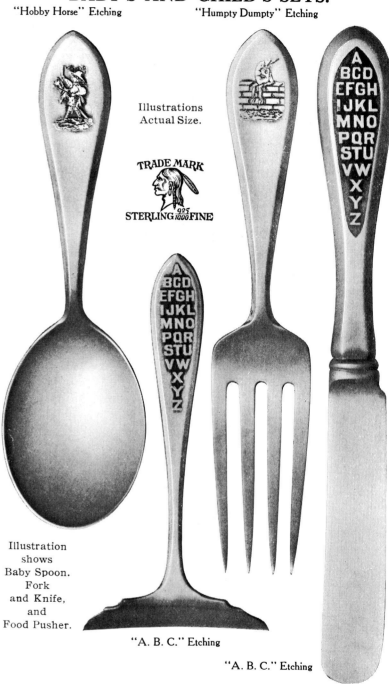

Illustration
shows
Baby Spoon.
Fork
and Knife,
and
Food Pusher.

"A. B. C." Etching

"A. B. C." Etching

Baby Spoon, short handle, each, $2.60; Child's Spoon, each, $2.60
Baby Fork, " 2.60; Child's Fork, " 3.40
Baby Knife, " 3.40; Child's Knife, " 3.40
Food Pusher, " 3.00;
(For prices of Sets see opposite page.)
20

793-794. (pp. 360-361) Wilcox & Evertsen Catalog No. 135, Meriden, Conn. (Courtesy E.P. Hogan, Historical Library, International Silver Co.)

BABY SPOONS AND FOOD PUSHERS

Birth Month Designs — Signs of the Zodiac

Different Design for Each Month

Illustration
Actual Size.

Each Spoon and Food Pusher has as part of its design the sign of the Zodiac and the Flower peculiar to the month it represents. A dozen includes one of each of the designs.

Birth Month Baby Spoons, $22.90 per doz.
Twelve different designs.

Birth Month Food Pushers, $22.90 per doz.
Twelve different designs.

One each in silk lined box.

BABY'S AND CHILD'S SETS

With "Hobby Horse," "Humpty Dumpty" or "A. B. C." Etching.

(Illustrated on opposite page.)

Baby Set (Spoon, Fork, Food Pusher), . $8.00
Baby Set (Spoon, Fork, Knife), . . . 8.40
Child's Set (Spoon, Fork, Knife) not illustrated, 9.00
Baby Sets in Blue Flannel Rolls.

21

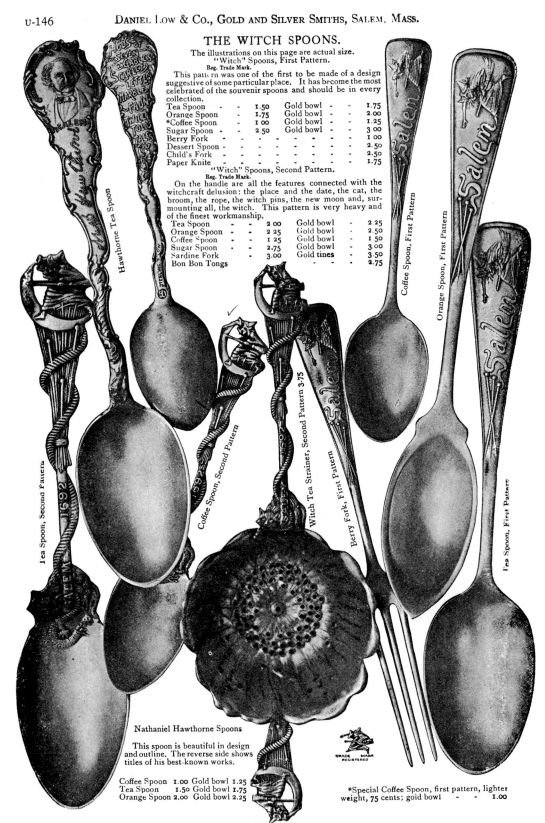

U-146 DANIEL LOW & CO., GOLD AND SILVER SMITHS, SALEM, MASS.

THE WITCH SPOONS.

The illustrations on this page are actual size.
"Witch" Spoons, First Pattern.
Reg. Trade Mark.

This pattern was one of the first to be made of a design suggestive of some particular place. It has become the most celebrated of the souvenir spoons and should be in every collection.

Tea Spoon	-	1.50	Gold bowl -	1.75
Orange Spoon	-	1.75	Gold bowl -	2.00
*Coffee Spoon	-	1 00	Gold bowl -	1.25
Sugar Spoon	-	2.50	Gold bowl -	3 00
Berry Fork	-	-	-	1 00
Dessert Spoon	-	-	-	2.50
Child's Fork	-	-	-	2.50
Paper Knife	-	-	-	1.75

"Witch" Spoons, Second Pattern.
Reg. Trade Mark.

On the handle are all the features connected with the witchcraft delusion: the place and the date, the cat, the broom, the rope, the witch pins, the new moon and, surmounting all, the witch. This pattern is very heavy and of the finest workmanship.

Tea Spoon	-	2 00	Gold bowl	2.25
Orange Spoon	-	2 25	Gold bowl	2.50
Coffee Spoon	-	1 25	Gold bowl	1.50
Sugar Spoon	-	2.75	Gold bowl	3.00
Sardine Fork	-	3.00	Gold tines	3.50
Bon Bon Tongs	-	-	-	2.75

Hawthorne Tea Spoon

Tea Spoon, Second Pattern

Coffee Spoon, Second Pattern

Witch Tea Strainer, Second Pattern 3.75

Berry Fork, First Pattern

Coffee Spoon, First Pattern

Orange Spoon, First Pattern

Tea Spoon, First Pattern

Nathaniel Hawthorne Spoons

This spoon is beautiful in design and outline. The reverse side shows titles of his best-known works.

Coffee Spoon	1.00	Gold bowl	1.25
Tea Spoon	1.50	Gold bowl	1.75
Orange Spoon	2.00	Gold bowl	2.25

*Special Coffee Spoon, first pattern, lighter weight, 75 cents; gold bowl - - 1.00

TRADE MARK REGISTERED

Wherever we say silver we mean the sterling standard—925 thousandths fine. All gold articles mentioned herein are solid 14-karat or 18-karat unless otherwise stated.

795-797. (pp. 362-364) Daniel Low catalog, 1908. (Courtesy Mrs. Arthur Schuster, El Paso, Texas)

U-186 DANIEL LOW & CO., GOLD AND SILVER SMITHS, SALEM, MASS.

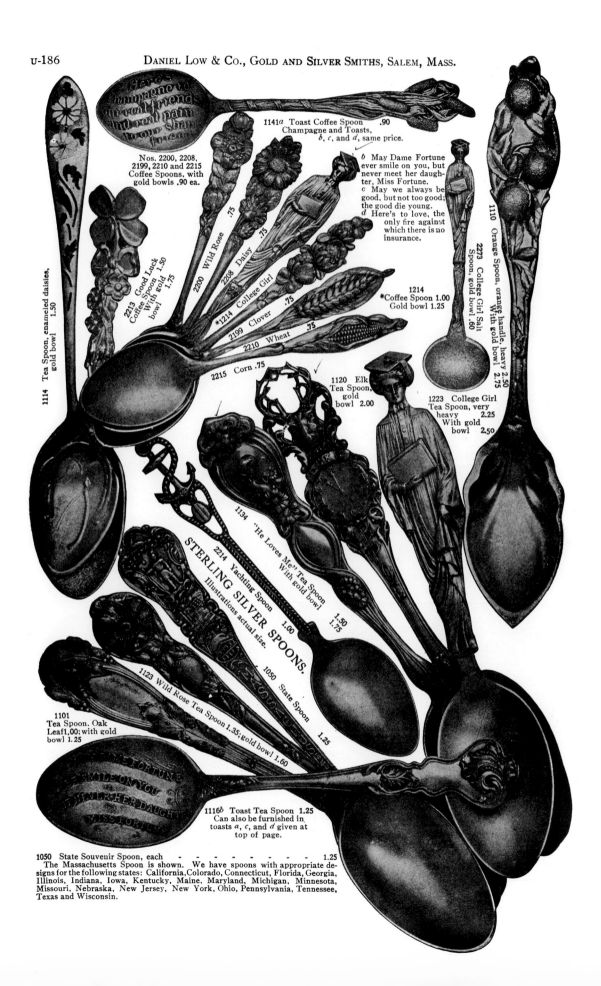

1141a Toast Coffee Spoon .90
Champagne and Toasts,
b, c, and d, same price.

b May Dame Fortune
ever smile on you, but
never meet her daugh-
ter, Miss Fortune.
c May we always be
good, but not too good;
the good die young.
d Here's to love, the
only fire against
which there is no
insurance.

Nos. 2200, 2208,
2199, 2210 and 2215
Coffee Spoons, with
gold bowls .90 ea.

2273 College Girl Salt
Spoon, gold bowl .60

1110 Orange Spoon, orange handle, heavy 2.50
With gold bowl 2.75

2213 Good Luck
Coffee Spoon 1.50
With gold
bowl 1.75

2200 Wild Rose .75
2208 Daisy .75
*1214 College Girl .75
2199 Clover .75
2210 Wheat .75

1214
*Coffee Spoon 1.00
Gold bowl 1.25

2215 Corn .75

1114 Tea Spoon, enameled daisies,
gold bowl 1.50

1120 Elk
Tea Spoon,
gold
bowl 2.00

1223 College Girl
Tea Spoon, very
heavy 2.25
With gold
bowl 2.50

1134 "He Loves Me" Tea Spoon
With gold bowl]
1.50
1.75

2214 Yachting Spoon 1.00

STERLING SILVER SPOONS.
Illustrations actual size.

1050 State Spoon
1.25

1101
Tea Spoon, Oak
Leaf 1.00; with gold
bowl 1.25

1123 Wild Rose Tea Spoon 1.35; gold bowl 1.60

1116b Toast Tea Spoon 1.25
Can also be furnished in
toasts a, c, and d given at
top of page.

1050 State Souvenir Spoon, each - - - - - - - - - 1.25
The Massachusetts Spoon is shown. We have spoons with appropriate de-
signs for the following states: California, Colorado, Connecticut, Florida, Georgia,
Illinois, Indiana, Iowa, Kentucky, Maine, Maryland, Michigan, Minnesota,
Missouri, Nebraska, New Jersey, New York, Ohio, Pennsylvania, Tennessee,
Texas and Wisconsin.

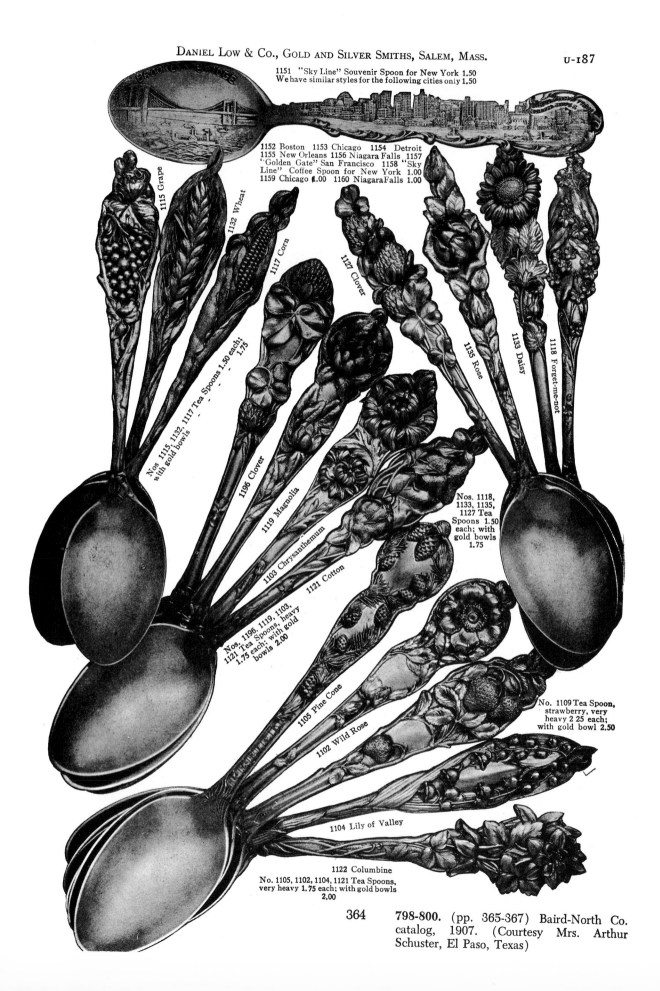

DANIEL LOW & CO., GOLD AND SILVER SMITHS, SALEM, MASS.

U-187

1151 "Sky Line" Souvenir Spoon for New York 1.50
We have similar styles for the following cities only 1.50

1152 Boston 1153 Chicago 1154 Detroit
1155 New Orleans 1156 Niagara Falls 1157
"Golden Gate" San Francisco 1158 "Sky
Line" Coffee Spoon for New York 1.00
1159 Chicago 1.00 1160 Niagara Falls 1.00

1115 Grape

1132 Wheat

1117 Corn

1127 Clover

1135 Rose

1133 Daisy

1118 Forget-me-not

Nos. 1115, 1132, 1117 Tea Spoons 1.50 each;
with gold bowls - - - - 1.75

1196 Clover

1119 Magnolia

1103 Chrysanthemum

1121 Cotton

Nos. 1196, 1119, 1103,
1121 Tea Spoons, heavy
1.75 each; with gold
bowls 2.00

Nos. 1118,
1133, 1135,
1127 Tea
Spoons 1.50
each; with
gold bowls
1.75

1105 Pine Cone

1102 Wild Rose

No. 1109 Tea Spoon,
strawberry, very
heavy 2 25 each;
with gold bowl 2.50

1104 Lily of Valley

1122 Columbine

No. 1105, 1102, 1104, 1121 Tea Spoons,
very heavy 1.75 each; with gold bowls
2.00

364 **798-800.** (pp. 365-367) Baird-North Co.
catalog, 1907. (Courtesy Mrs. Arthur
Schuster, El Paso, Texas)

X-132 BAIRD NORTH CO., GOLD AND SILVER SMITHS, SALEM, MASS.

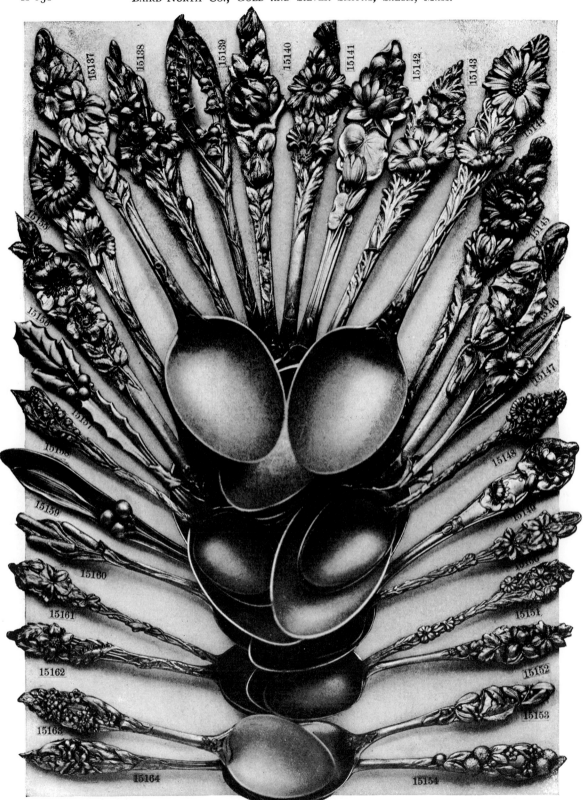

STERLING SILVER BIRTH MONTH TEA SPOONS AND FLORAL COFFEE SPOONS.

These are superior spoons in weight and die work. All are in the gray finish. The illustrations show the actual size. There is no place on handles for engraving — for engraving in bowls, see last page of this catalog.

Tea Spoons							
15156	Jan., Wild rose	$1.25	15144	Oct., Cosmos	$1.25	15151	Forget-me-not, gilt
15155	Feb., Carnation	1.25	15145	Nov. Chrysanthe-			bowl . . $.50
15137	Mar., Violet	1.25		mum	1.25	15152	Columbine, gilt bowl .60
15138	Apr., Easter lily	1.25	15146	Dec., Holly and mis-		15153	Holly and mistletoe,
15139	May, Lily of the			tletoe	1.25		gilt bowl . . .60
	valley .	1.25		Coffee Spoons.		15154	Oranges and blossoms,
15140	June, Rose .	1.25	15147	Violet .	.75		gilt bowl . .60
15141	July, Daisy	1.25	15148	Daisy, gilt bowl	.50	15157	Holly . . .75
15142	Aug., Pond lily .	1.25	15149	Water lily	1.00	15165	Same as 15157, gilt bowl 1.90
15143	Sept., Poppy .	1.25	15150	Lily, gilt bowl .	.50		

15158	Lily of the valley, gilt		
	bowl . .	$.50	
15159	Mistletoe .	.75	
15160	Cat tails, gilt bowl	.60	
15161	Violet, gilt bowl	.50	
15162	Columbine, gilt bowl	.60	
15163	Peach blossom, gilt		
	bowl . .	.60	
15164	Tobacco blossom, gilt		
	bowl . .	.60	

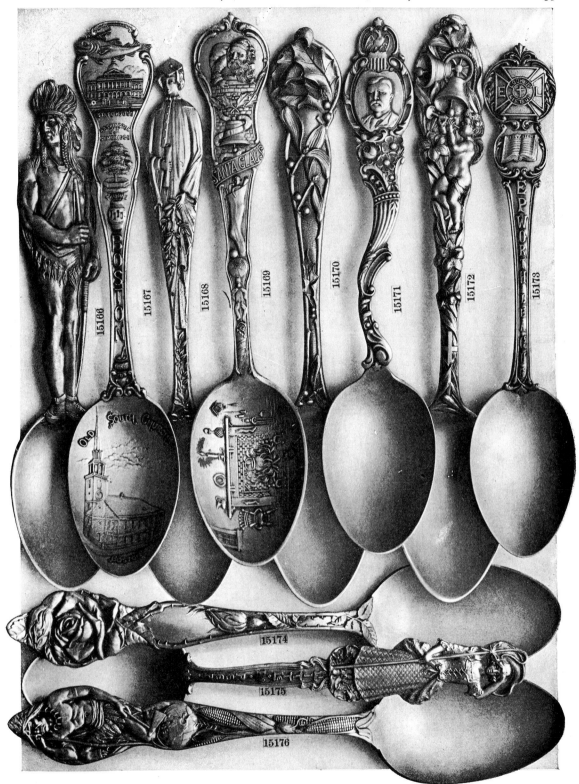

STERLING SILVER SOUVENIR AND FANCY TEA SPOONS.

These spoons are all of heavy weight. The pictures show the actual size.

15166	North American	$2.00	15168	College girl, gold bowl		$1.25
15167	Boston spoon, showing State		15169	Christmas spoon		1.50
	House, Washington Elm at		15170	Holly		1.50
	Cambridge, "The Hub,"		15171	Roosevelt spoon		1.00
	Old South Church on front;		15172	Easter spoon		1.50
	PublicLibrary, Fanueil Hall,					
	Old State House—on back	1.75				

15173	Epworth League	$1.25
15174	Bridal rose	1.50
15175	Little Bo Peep	1.50
15176	United States spoon	1.50

If you're in doubt about anything, or wish any information pertinent to our line of business, we want you to feel free to write us. We are glad to answer your questions and to quote prices on things not pictured in our catalog.

X-134 BAIRD-NORTH CO., GOLD AND SILVER SMITHS, SALEM, MASS.

STERLING SILVER BIRTH MONTH AND FANCY TEA SPOONS.

These spoons are shown one half scale. They are heavy spoons and the die work is exceptionally fine. Each spoon has an appropriate flower, sign of the zodiac, and the name of the month, all included in the die work. The finish is the popular French gray.

11662	January, Snowdrop	$1.25	11668	July, Water Lily	$1.25	11674	Christmas spoon	$1.25
11663	February, Carnation	1.25	11669	August, Poppy	1.25	11675	American spoon, gilt	1.50
11664	March, Violet	1.25	11670	September, Morning Glory	1.25	11676	Christmas spoon, holly gilt,	1.25
11665	April, Daisy	1.25	11671	October, Hops	1.25	11677	Easter spoon, gilt	1.25
11666	May, Apple blossoms	1.25	11672	November, Chrysanthemum	1.25	11678	Golden rod, gilt flower	1.25
11667	June, Wild Rose	1.25	11673	December, Holly	1.25			

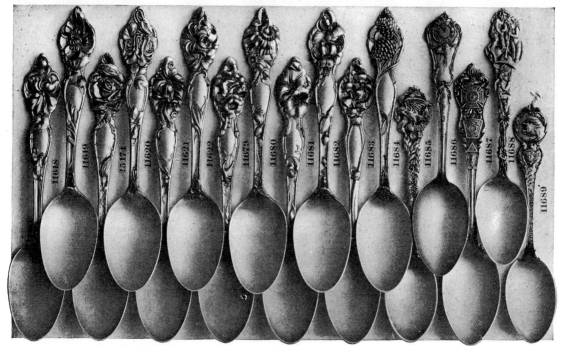

STERLING SILVER FLORAL AND FANCY TEA SPOONS.

These spoons are heavy weight and are finished in the popular gray. These spoons are twice as wide and twice as long as the pictures. Each of the first twelve spoons has a popular flower struck on the handle in fine die work.

11618	Violet	$1.50	11680	Passion Flower	$1.50	11686	B. P. O. E. spoon, gilt bowl	$1.25
11619	Butter Cup	1.50	11681	Morning Glory	1.50	11687	Masonic spoon	1.50
11620	Columbine	1.50	11682	Fuchsia	1.50	11688	Easter Spoon	1.25
11621	Orchid	1.50	11683	Lily of the Valley	1.50	11689	December spoon	.90
11622	Lily	1.50	11684	Pine Cone	1.50	15174	Rose	1.50
11679	Yellow Jessamine	1.50	11685	United States spoon, gilt bowl	1.35			

DANIEL LOW & CO., GOLD AND SILVER SMITHS, SALEM, MASS. P-161

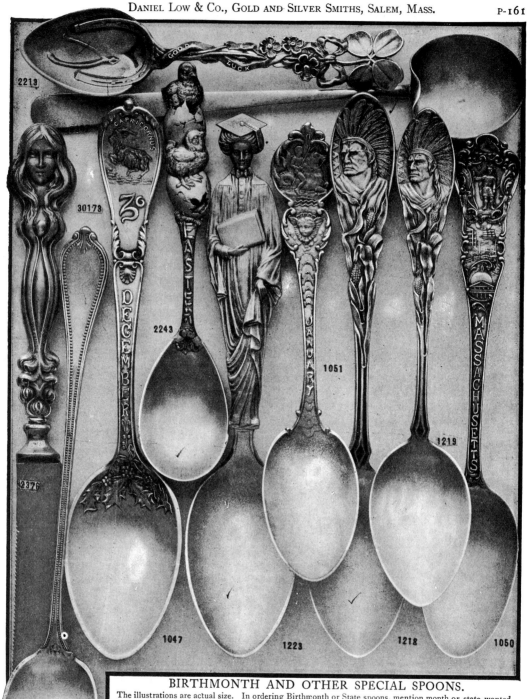

BIRTHMONTH AND OTHER SPECIAL SPOONS.

The illustrations are actual size. In ordering Birthmonth or State spoons, mention month or state wanted.

†1047 Birthmonth Tea Spoon, very heavy - 2.25
 1048 Coffee Spoon 1.00 1049 Gilded 1.25

A Birthmonth Spoon is a suitable token of remembrance for a child or an adult. The characteristic features are the signs of the Zodiac and the flower for each month.

1050 State Souvenir Spoon, each - - - 1.25

The Massachusetts Spoon is shown. We have spoons with appropriate designs for the following states: California, Colorado, Connecticut, Florida, Georgia, Illinois, Indiana, Iowa, Kentucky, Maine, Maryland, Michigan, Minnesota, Missouri, Nebraska, New Jersey, New York, Ohio, Pennsylvania, Tennessee, Texas and Wisconsin.

1051 Birthmonth Five O'clock Tea Spoon, gilded, 1.25
1218 Tea Spoon, Indian head - - - - 1.25
1219 Five O'clock Tea Spoon, Indian head - .90
1223 College Girl Spoon, very heavy 2.00 gilded 2.25
2213 Coffee Spoon, Good Luck - 1.50 gilded 1.75
2243 Egg Spoon, each - - - 1.25 a dozen 13.00
 Egg Spoon, gilded, each 1.50 a dozen 16.50
2376 Orange Knife, Art Nouveau, ea. 1.00 doz. 11.00
 The blade is of Wessel steel and will not stain.
*19907 Chocolate Spoon, gilded, ea. 1.10 doz. 12.00
 Copied from an English hand made spoon.
*30173 Iced Tea Spoon, Newbury, ea. 1.10 doz. 12.00

*Leatherette case for 12 spoons 1.90; for 6 spoons 1.25

†Birthmonth Knife and Fork, with handles to match 1047, furnished to special order, each 2.50

Should your catalogue be lost we will gladly send another on application.

Read your order carefully before mailing.

801. Daniel Low catalog, 1903. (Courtesy Mrs. Arthur Schuster, El Paso, Texas)

Souvenir Spoons

A List of Those Produced in the United States

In response to numerous inquiries for such information, *The Weekly* prints

* Reprinted from Jewelers' Weekly, October 11, 1893.

below a list of the souvenir spoons produced in the United States. The effort to render the list complete is believed to be successful, although a few manufacturers have neglected to respond to repeated requests for information.

This list should be carefully preserved, as it is certainly the most complete ever published, and possibly the last which will appear in many years. Heavy expenditures of both time and money have been required in compiling this remarkable directory, and *The Weekly* trusts that retailers will appreciate its value.

Actress (15 styles, Gorham Mfg. Co., New York.
Agate (agate and silver), Rud. C. Hahn, New York.
Akron, O., Frank Lauback & Nutt Co.
Alamo, The, built 1720, San Antonio, Tex., R. Wallace & Sons Mfg. Co. Wallingford, Conn.
Alaska (see Totem Pole), J. H. Johnston & Co., New York.
Albany, N. Y., James Mix.
Alger, Gen. F. G. Smith, Sons & Co., Detroit, Mich.
All America, Howard Sterling Co., Providence, R. I.
All America, Orange, the Williams Bros. Mfg. Co., Naubuc, Conn.
Alligator (Florida), Alvin Mfg. Co., New York.
Alligator, Greenleaf & Crosby, Jacksonville, Fla.
Alton, Ill., J. H. Booth.
America (World's Fair), Alvin Mfg. Co., New York.
American, The (Landing of C.), R. Wallace & Sons' Mfg. Co., Wallingford, Conn.
Anderson, Bene, Lindenberg & Co., Cincinnati, O.
Anderson, Mary, Geo. Wolf & Co., Louisville, Ky.
Angel, Our, Montgomery Bros., Los Angeles, Cal.
Anneke Jans, J. H. Johnston & Co., New York.
Arch, The, F. M. Whiting & Co., North Attleboro, Mass.
Asheville, N. C., Arthur M. Field.
Athletic, Hammersmith & Field, San Francisco, Cal.
Atlanta, Ga., Freeman Jewelry Co.
Atlanta, Ga., J. P. Stevens & Bro.
Augusta, Ga., Wm. Schweigert.
Aurora, Ill., Trask & Plain.
Austin, Tex., Cary Maver.
Baby, The Shepard Mfg. Co., Melrose, Mass.
Baby Roger, Codding Bros. & Heilborn, North Attleboro, Mass.
Baltimore, Md., Gorham Mfg. Co., New York
Baltimore, Md., Hennegen, Bates & Co.
Baltimore, Md., Justis & Armiger.
Bangor, Me., (Pine cone in bowl), John Tebbets & Co.
Bar Harbor, Me., Carter Bros., Portland, Me.
Bar Harbor, Me., Ovington Bros., Brooklyn, N. Y.
Bather, The, or Seashore, Ovington Bros., Brooklyn, N. Y.
Battleship, Tilden-Thurber Co., Providence, R. I.
Beaver Dam, Wis., A. F. Mirlach & Bro.
Beaver Dam, Wis., W. H. Thorp.
Bechtler Dollar, A. M. Field, Asheville, N. C.
Beecher, Henry Ward, Wm. Wise & Son, Brooklyn, N. Y.
Bennington, Vt., Squire & Rawson.
Bethlehem, Pa., E. Keller.
Beverwyck, W. H. Williams & Son, Albany, N. Y.
Birmingham, Ala., Harry Mercer.
Birthday, Alvin Manufacturing Co., New York.
Birthday, Codding Brothers & Heilborn, North Attleboro, Mass.
Birthday, the Shepard Manufacturing Co., Melrose, Mass.
Black Hawk, T. Kircher, Davenport, Ia.
Blaine, E. Kaiser, Jamestown, N. Y.
Blair Hall, E. H. Freeman, Blairstown, N. J.
Block House S. Loeb, Erie, Pa.
Boone, Dan'l, Wm. Kendrick's Sons, Louisville, Ky.
Boston, Geo. W. Shiebler Co., New York.
Boston Bean, Codding Brothers & Heilborn, North Attleboro, Mass.
Boston Beans, Geo. E. Homer, Boston, Mass.
Boston, No. 4, F. M. Whiting & Co., North Attleboro, Mass.
Boston Tea Party, Geo. E. Homer, Boston, Mass.
Boston Tea Party, Towle Mfg. Co., Newburyport, Mass.
Bradley, A. R. Justice & Co., Philadelphia, Pa.
Brick & Herring, E. D. Tisdale & Son, Taunton, Mass.
Brigham Young, J. H. Leyson Co., Salt Lake City, Utah.
Brooklyn, N. Y., see City of Churches, C. C. Adams & Co.
Brooklyn, N. Y., see City of Churches, William Wise & Son.
Brooklyn Heights, N. Y., James H. Hart.
Brooklyn, Historical, C. C. Adams & Co.
Brooks, Phillips, Geo. E. Homer, Boston, Mass.
Brown, John, (Scaffold), Charles W. Brown, Charlestown, W. Va. "Brownies," Wm. Kendrick's Sons, Louisville, Ky.
Brown University, Tilden-Thurber Co., Providence, R. I.
Buffalo, N. Y., T. & E. Dickinson.
Buffalo, N. Y., W. H. Glenny, Sons & Co.

Buffalo, N.Y.C. T. C. Tanke.
Bunker Hill, Geo. E. Homer, Boston, Mass.
Burro, Wendell Mfg. Co., Chicago, Ill.Cadillac, Wright, Kay & Co., Detroit, Mich.
Canteen, R. Harris & Co., Washington, D. C.
Cape Cod, A. W. Flye, Gloucester, Mass.
Capital, Moore & Leding, Washington, D. C.
Capitol, J. A. Goldstein, Washington, D. C.
Capitol, R. Harris & Co., Washington, D. C.
Capitol, F. M. Whiting & Co., North Attleboro, Mass.
Caravels, Moore & Leding, Washington, D. C.
Casa Grande Ruins, Geo. H. Curry, Prescott, Ariz.
Castine (U. S. Gunboat), A. G. Page, Jr., Bath, Me.
Cathedral (Canterbury, Westminster, Milan, St. Paul's, Durham, Lincoln), Bachrach & Freedman, New York.
Catskill Mountain House, J. T. Henderson, Catskill, N. Y.
Catskill Mountains (2 styles), Gorham Mfg. Co., New York.
Charleston, S. C., James Allan & Co.
Charleston, S. C. (2 styles), Carrington, Thomas & Co.
Charleston, W. Va., R. J. Satterthwait.
Charlestown, W. Va., St. George's Chapel, Charles W. Brown.
Charlotte, N. C., Boyne & Badger.
Charter Oak, Hansel, Sloan & Co., Hartford, Conn.
Chautauqua, W. H. Glenny, Sons & Co., Buffalo, N. Y.
Chautauqua, Phillips & Armitage, Jamestown, N.Y.
Chautauqua, The Shepard Mfg. Co., Melrose, Mass.
Chicago, Alvin Mfg. Co., New York.
Chicago (18 patterns), Bachrach & Freedman, New York.
Chicago, Reilly, Curtis & Co., Chicago, Ill.
Chicago, Simons, Bro. & Co., Philadelphia, Pa.
Chicago (two designs), Spaulding & Co.
Chicago, Whiting Mfg. Co., New York.
Chicago, Columbian Exposition, Murray Jewelry Co.
Chicago Fire, 1871, C. D. Peacock.
Chicago Fire, G. A. Schlechter, Reading, Pa.
Chicago Herald, Chicago Herald.
Chicago, New (see New Chicago), John Larson & Co., Madison, Wis.
Chicago, The (man-of-war), R. Wallace & Sons Mfg. Co., Wallingford, Conn.
Chicago, Typical (see Typical Chicago). Wendell Mfg. Co.
Chickasaw, C. L. Byrd & Co., Memphis, Tenn.
Christian Endeavor, Charles E. Barker, New York.
Christian Endeavor (C. E.), W. C. Finck, Elizabeth, N. J.
Christian Endeavor (see Y. P. S. C. E.).
Christmas (Merry Xmas), Alvin Mfg. Co., New York.
Christmas, W. H. Glenny, Sons & Co., Buffalo, N. Y.
Cincinnati, Ohio (three styles), Duhme & Co.
Cincinnati, Ohio, A. & J. Plant.
City of Churches, C. C. Adams & Co. Brooklyn, N. Y.
City of Churches, Wm. Wise & Son, Brooklyn, N. Y.
Cleft Rock, A. G. Page, Jr., Bath, Me.
Cleopatra, Alvin Mfg. Co., New York
Cleveland, J. H. Flanagan, Washington, D. C.
Cleveland Campaign Record, Carl Petersen, Washington, D. C.
Cleveland Family, M. W. Beveridge, Washington, D. C.
Cleveland, Grover, J. H. Flanagan, Washington, D. C.
Cleveland, Grover, John Larson & Co., Madison Wis.

Cleveland and Family, Chas. E. Barker, New York.
Cleveland & Stevenson, Alvin Mfg. Co., New York.
Cleveland, Ohio, Bowler & Burdick Co.
Cleveland, Ohio, Cowell & Hubbard Co.
Coal Breaker, W. H. Mortimer, Pottsville, Pa.
College, Peter L. Krider Co., Philadelphia, Pa.
Columbia (World's Fair), Kelley & Woolworth, Niagara Falls, N. Y.
Columbian (two patterns), Bachrach & Freedman, New York.
Columbian, the Shepard Mfg. Co., Melrose, Mass.
Columbian (three patterns), Watson, Newell & Co., Attleboro, Mass.
Columbian Seal, Duhme & Co., Cincinnati, Ohio.
Columbus (World's Fair), Alvin Mfg. Co., New York.
Columbus, 1492, Gorham Mfg. Co., New York.
Columbus (Landing of), Stone Bros., New York.
Columbus (Santa Maria, Administration Building, before Ferdinand and Isabella, name Chicago), R. Wallace & Sons Mfg. Co., Wallingford, Conn.
Columbus (at Barcelona), R. Wallace & Sons Mfg. Co., Wallingford, Conn.
Columbus (see Discovery).
Columbus, Christopher, Codding Bros. & Heilborn, North Attleboro, Mass.
Columbus, Christopher, Columbian Souvenir Mfg. Co., Chicago.
Columbus, Christopher, Geo. E. Homer, Boston, Mass.
Columbus, Christopher, Hyman, Berg & Co., Chicago.
Columbus, Christopher, Reilly, Curtis & Co., Chicago, Ill.
Columbus, Christopher, Tilden-Thurber Co., Providence, R. I.
Columbus, Christopher, Wendell Mfg. Co., Chicago.
Columbus, Christopher, Williams Bros. Mfg. Co., Naubuc, Conn.
Columbus-American, Geo. W. Shiebler Co., New York.
Columbus, Ohio, Harrington & Co.
Columbus, Ohio, F. F. Bonnet.
Concord, Mass., Daniel Low, Salem, Mass.
Confederate, R. Wallace & Sons Mfg. Co. Wallingford, Conn.
Cooper, Jas. Fenimore, G. M. Grant & Co.
Cowboy, Wendell Mfg. Co., Chicago.
Crab, W. C. Finck, Elizabeth, N. J.
Crockett, Davy, W. D. Dreher, Knoxville, Tenn.
Cupid, J. R. Tennant, New York.
Dayton, Ohio, A. Newsalt.
Depew, Chauncey M., Arthur J. Birdsey, Peekskill, N. Y.
Detroit, Mich., Roehm & Son.
Detroit, Mich. (two styles), F. G. Smith & Sons.
Detroit, Mich., Wright, Kay & Co.
Dexter, Lord Timothy, Wm. P. Jones, Newburyport, Mass.
Discoverer (Columbus, see Columbus), Alvin Mfg. Co., New York.
Diver, The, Ovington Bros., Brooklyn, N. Y.
Dixie, Wendell Mfg. Co., Chicago.
Dow, Neal, Carter Bros., Portland, Me.
Drake Historical, G. S. Stewart, Bradford, Pa.
Dumplings, H. A. Heath, Newport, R. I.
Dungeon Rock, H. M. Hill & Co., Lynn, Mass.Eagle Lake, Carter Bros., Portland, Me.

Easter, Alvin Mfg. Co., New York.

Easter, Geo. E. Homer, Boston, Mass.

Easter, E. B. McClelland, Syracuse, N. Y.

Easter Coffee Spoon, Gorham Mfg. Co., New York.

Easter Lily, Stone Bros., New York.

Easter Wreath, Stone Bros., New York.

Ecclesiastical, Alvin Mfg. Co., New York.

Elk, Tooth, Zehner, Buechner & Co., Cheyenne, Wyo.

Elks, G. A. Schlechter, Reading, Pa.

Elks, B. P. O., G. A. Schlechter, Reading, Pa.

Elks, New, G. A. Schlechter, Reading, Pa.

Engagement, the Shepard Mfg. Co., Melrose, Mass.

Epworth League, Charles E. Barker, New York.

Epworth League, Geo. E. Shaw, Putnam, Conn.

Ericson, Leif, Daniel Low, Salem, Mass.

Ericson, Leif, Towle Mfg. Co., Newburyport, Mass.

Erie (Garfield on handle, Battle Lake Erie in bowl), Brunner Bros., Cleveland, Ohio.

Erie, Pa., S. Loeb.

Erudition, 1794, A. G. Page, Jr., Bath, Me.

Ethan Allen, F. W. Sim & Co., Troy, N. Y.

Euchre, Peter L., Krider Co., Philadelphia, Pa.

Faith, Hope and Charity, Stone Bros., New York.

Fall River, Mass., C. E. Gifford & Co.

Falls of St. Anthony, Eustis Bros., Minneapolis, Minn.

Faneuil Hall, Bigelow, Kennard & Co., Boston, Mass.

Faneuil Hall, Geo. E. Homer, Boston, Mass.

Female College, Sherman, Tex., R. Wallace & Sons Mfg. Co., Wallingford, Conn.

Ferris Wheel, Watson, Newell & Co., Attleboro, Mass.

Fish, Codding Bros. & Heilborn, North Attleboro, Mass.

Flag, Codding Bros. & Heilborn, North Attleboro, Mass.

Flora, Geo. W. Shiebler Co., New York.

Floral (Violet, Rose, Shamrock, Thistle, Mayflower, Lily, Golden Rod), Bachrach & Freedman, New York.

Floralia (Daisy, Clover, Forget-me-not, Pansy, Lily and Rose), Alvin Mfg. Co., New York.

Florida, Codding Bros. & Heilborn, North Attleboro, Mass.

Forest and Stream, W. S. Taylor & Son, Utica, N. Y.

Fort Dearborn, Hyman, Berg & Co., Chicago.

Fort Dearborn (2 designs), Spaulding & Co., Chicago.

Fort Dearborn, R. Wallace & Sons Mfg. Co., Wallingford, Conn.

Fort Dumplings, H. A. Heath & Co., Newport, R. I.

Fort Pitt, E. P. Roberts & Sons, Pittsburg, Pa.

Fort Sumter, Carrington, Thomas & Co., Charleston, S. C.

Fort Washington, Duhme & Co., Cincinnati, Ohio.

Franklin, Benj., Bailey, Banks & Biddle, Philadelphia, Pa.

Friendship, The Shepard Mfg. Co., Melrose, Mass.

Galveston, Tex., Gorham Mfg. Co., New York.

Galveston, Tex., M. W. Shaw.

Garfield, The Bowler & Burdick Co., Cleveland, Ohio.

Garfield, Cowell & Hubbard Co., Cleveland, Ohio.

Garfield, Webb C. Ball Co., Cleveland, Ohio.

Gaspée, Burning of the, Tilden, Thurber Co., Providence, R. I.

Gettysburg, Pa. (2 styles), Gorham Mfg. Co., New York.

Gettysburg, Pa., H. T. Spear & Son, Boston, Mass.

Gettysburg Battlefield, G. A. Schlechter, Reading, Pa.

Glens Falls, N. Y., L. P. Juvet.

Glenwood Springs, Col., Beans & Keck.

Gloucester, Mass., F. S. Thompson.

Gloucester, Mass., C. E. Wright.

Golden Rod, Geo. E. Homer, Boston, Mass.

Golden Rod, Shepard Mfg. Co., Melrose, Mass.

Good Luck, Codding Bros. & Heilborn, North Attleboro, Mass.

Good Luck (Clover Leaf and Horseshoe), Ludwig, Redlich & Co., New York.

Good Luck, R. Wallace & Sons Mfg. Co., Wallingford, Conn.

G. A. R., Alvin Mfg. Co., New York.

G. A. R., Mermod & Jaccard Jewelry Co., St. Louis, Mo.

Grant, U.S. Chas. Casper & Co., New York.

Greene, Gen., Gilbreath-Durham Co., Greenville, S.C.

Greenville, S.C. Gilbreath & Patton.

Habana, Gorham Mfg. Co., New York.

Hampton Roads, Fortress Monroe, C.S. Sherwood.

Harrison, Benj., John Larson & Co., Madison, Wis.

Harrison & Reid, Alvin Mfg Co., New York.

Hartford, Conn., David Mayer.

Harvard, Codding Bros. & Heilborn, North Attleboro, Mass.

Harvard, John, Freeman & Taylor, Boston, Mass.

Havana, Cuba (Columbus in bowl), E.W. Wilson.

Hawthorne, Nath., Daniel Low, Salem, Mass.

Hesperus, F.S. Thompson, Gloucester, Mass.

Hiawatha, Jos. Seymour, Sons & Co., Syracuse, N. Y.

Historical Cannon, Jacobs Brothers, Washington, D.C.

Holiday, Shepard Mfg. Co., Melrose, Mass.

Holland, J.G., Chas S. Saxton Co., Springfield, Mass.

Holmes, Oliver Wendell, Rand & Crane, Boston, Mass.

Hudson, Hendrick, James W. Cusack, Troy, N. Y.

Hutchinson, Kan., J.S. Dunn. "I will," or Typical Chicago, Codding Bros. & Heilborn, North Attleboro, Mass.

Inaugural, S. Desio, Washington, D.C.

Independence, Ia., D.G. Jones.

Indian, Peter L. Krider & Co., Philadelphia, Pa.

Indianapolis, Ind., Bingham & Walk.

International, Barrett & Goulding, Port Huron, Mich.

Isabella, Columbian Souvenir Mfg. Co., Chicago, Ill.

Jackson, Gen., B.H. Stief Jewelry Co., Nashville, Tenn.

Jackson, Birthplace of, B.H. Stief Jewelry Co., Nashville, Tenn.

Jackson, Miss., T.A. Iler.

Jackson Monument, A.B. Griswold & Co., Nashville, Tenn.

Jefferson, Joe, W.H. Williams & Son, Albany, N.Y.

Johnstown, (Pa.), Flood, J.A. Larkin & Co.

Juneau, Solomon, Stanley & Camp Co., Milwaukee, Wis.

Kaaterskill Falls, J.T. Henderson, Catskill, N. Y.

Kansas (Agricultural College), J.Q.A. Sheldon, Topeka, Kan.

Kansas City, Mo., Jaccard Watch and Jewelry Co.

Katahdin (Ammen Ram), A.G. Page, Jr., Bath, Me.

Keokuk, Ia., Calvin Hornady.

King's Daughter, Chas. E. Barker, New York.

King's Daughters, Geo. E. Shaw, Putnam, Conn.

Knickerbocker, J.H. Johnston & Co., New York.

Knickerbocker, Marsh & Hoffman, Albany, N. Y.

Knight Templar, Green-Smith Watch and Diamond Co., Denver, Col.

Lafayette, General, Duhme & Co., Cincinnati, Ohio.

Lake George, L.P. Juvet, Glen Falls, N. Y.

Lake George, F.W. Sim & Co., Troy, N. Y.
League of American Wheelmen, W.A. Berry, Scranton, Pa.
Leather-Stocking, C.R. Burch, Cooperstown, N. Y.
Lee, Gen., (Southern), L. G. Jahnke & Co., Lexington, Va.
Lehigh University, Emil Zothe, Philadelphia, Pa.
Lenape, Simons, Bro. & Co., Philadelphia, Pa.
Lexington, Mass., Dan'l Low, Salem, Mass.
Lexington, Va., L. G Jahnke.
Liberty Bell, Simons, Bro. & Co., Philadelphia, Pa.
Liberty Bell, R. Wallace & Sons Mfg. Co., Wallingford, Conn.
Liberty Coffee Spoon, Gorham Mfg. Co., New York.
Lime Rocks, H.A. Heath & Co., Newport, R.I.
Lincoln, Neb., J.B. Rickey & Co.
Lincoln Monument, Sommer & Pierik, Springfield, Ill.
Lockport, N. Y., C. G. Brown.
Longfellow, Carter Bros., Portland, Me.
Longfellow's Home, Geo. H. Griffen [Griffin?] Portland, Me.
Longfellow's Home, A.J. Applegate, Cambridgeport, Mass.
Longfellow's Home, Geo. H. Griffen, Portland, Me.
Louisville, Ky., Rogers & Pottinger.
Love, Codding Bros. & Heilborn, North Attleboro, Mass.
Love, Edgar L. Everett, Washington, D. C.
Love, Shepard Mfg. Co., Melrose, Mass.
Lynchburg, Va., H. Silverthorn.Machias (U. S. Gunboat), A.G. Page, Jr., Bath, Me.
Mackinac Island, Mich., Foley Bros.
Macon, Ga., Jos. E. Wells.
Madonna, J. R. Tennant, New York.
Manhattan, Chas. Casper & Co., New York.
Manhattan (Early Days), Chas. Casper & Co., New York.
Manhattan (Statue of Liberty), Chas. Casper & Co., New York.
Manitou, Col., L. A. West.
Marblehead, Daniel Low, Salem, Mass.
Mardi Gras, A. B. Griswold & Co., New Orleans, La.
Marguerite, Alvin Mfg. Co., New York.
Marquette, Mich., Geo. N. Conklin.
Masonic, Geo. E. Homer, Boston, Mass.
Masonic (Temple Chicago), R. Wallace & Sons Mfg. Co., Wallingford, Conn.
Masonic Home (two styles), W. S. Taylor & Son, Utica, N. Y.
Masonic Home, Utica, N. Y., R. Wallace & Sons Mfg. Co., Wallingford, Conn.
Masonic Temple, Town of Union, N. J., Gorham Mfg. Co., New York.
Massena Springs, A. J. Nelson, Massena, N. Y.
Mechanics' Bldg., Geo. E. Homer, Boston, Mass.
Mechanicsville, N. Y., Robt. Baxter.
Mecklenburg, Boyne & Badger, Charlotte, N. C.
Memorial Arch, James H. Hart, Brooklyn, N. Y.
Memorial Arch, P. W. Taylor, Brooklyn, N. Y.
Memorial Hall, Geo. E. Homer, Boston, Mass.
Memphis, Tenn. (2 styles), C. L. Byrd & Co.
Messiah Home for Children (New York), unidentified.
Mexican Filigree, W. G. Waltz Co., El Paso, Tex.
Miles City, Mon., Julius Basinski & Bros.
Milford, Conn., G. H. Ford Co., New Haven.
Minneapolis, Minn., John S. Allen & Co.

Minneapolis, Minn. (Flour Barrel in Bowl), Eustis Bros.
Minneapolis & St. Paul, Minn., H. F. Legg.
Minneapolis & St. Paul, Minn. (see Twin Cities), E. A. Brown, St. Paul.
Minnehaha, Eustis Bros., Minneapolis, Minn.
Minnehaha Falls, H. F. Legg, Minneapolis, Minn.
Monument, Carter Bros., Portland, Me.
Mt. Hood, A. Feldenheimer, Portland, Ore.
Mt. Pisgah, A. M. Field, Asheville, N. C.
Mt. Vernon, J. A. Goldstein, Washington, D. C.
Mt. Vernon, Harris & Shafer, Washington, D. C.
Mt. Vernon, Moore & Leding, Washington, D. C.
Mt. Vernon, R. Wallace & Sons Mfg. Co., Wallingford, Conn.
Mt. Washington, Abram French Co., Boston, Mass.
Mt. Washington, Geo. H. Griffen, Portland, Me.
Muscatine, Ia., G. W. Dilloway.
Muscatine, Ia., F. W. Swan.
Mystic Shrine, J. J. Cohn, New York.
Name, Codding Bros. & Heilborn, North Attleboro, Mass.
Narragansett Pier, H. A. Heath & Co., Newport, R. I.
National, St. Clair Fechner, Washington, D. C.
National, R. Harris & Co., Washington, D. C.
National, Harris & Shafer, Washington, D. C.
National (Washington, Lincoln, Grant) Shepard Mfg. Co., Melrose, Mass.
National (six patterns), the Williams Bros. Mfg. Co., Naubuc, Conn.
Naval Review, Moore & Leding, Washington, D. C.
New Amsterdam, Whiting Mfg. Co., New York City.
Newark, N. J., Benj. J. Mayo.
Newark, Ohio, L. D. Sturdevant.
New Bedford, Mass. (or Whale), Wood, Bicknall & Potter, Providence, R. I.
Newburyport, Mass. (Chain Bridge), Safford & Lunt.
"New Chicago," John Larson & Co., Madison, Wis.
New Haven, Conn., Geo. H. Ford Co.
New Jersey, W. C. Finck, Elizabeth, N. J.
Newman, Bishop, C. S. Raymond, Omaha, Neb.
New Year's, or Tennyson, J. H. Johnston & Co., New York.
New York, Alvin Mfg. Co., New York.
New York, Geo. W. Shiebler Co.
New York, Towle Mfg. Co., Newburyport, Mass.
N. Y. Press Club, Alvin Mfg. Co., New York.
New York State (two styles), Gorham Mfg. Co., New York.
New York and Brooklyn, E. G. Johnson, New York.
New Orleans, La. (two styles), A. M. Hill.
Niagara (Falls Handle), W. H. Glenny, Sons & Co., Buffalo, N. Y.
Niagara (Indian Handle), W. H. Glenny, Sons & Co., Buffalo, N. Y.
Niagara, J. G. Rosengarten & Co., Philadelphia, Pa.
Niagara Falls (two patterns), Thomas Trigby, Niagara Falls, N. Y.
Niagara Falls, F. M. Van Etten, New York.
Norfolk, Va., C. F. Greenwood & Brother.
North American, Wendell Mfg. Co., Chicago.
North Dakota, E. P. Sundberg, Fargo.
No. 1 Hard (North Dakota), E. P. Sundberg, Fargo.
Nutmeg, G. H. Ford Co., New Haven, Conn.
Nutmeg, Hansel, Sloan & Co., Hartford, Conn.
Observatory, Wm. Senter & Co., Portland, Me.

Official World's Fair Columbian souvenir spoons (three patterns), B. F. Norris, Alister & Co., Chicago, Ill.

Ogontz, Bailey, Banks & Biddle, Philadelphia, Pa.

"Old Abe" (Eagle), John Larson & Co., Madison, Wis.

Old City Gate, Greenleaf & Crosby, Jacksonville, Fla.

Old City Hall, Carter Bros., Portland, Me.

Old Elm, F. A. Robbins, Pittsfield, Mass.

Old Man of the Mountain (Landscape Profile), Abram French Co., Boston, Mass.

Old Oaken Bucket, Alvin Mfg. Co., New York

Old Orchard Beach, Carter Bros., Portland, Me.

Old Orchard Beach, Geo. E. Twambley Saco, Me.

Old State House, Bigelow, Kennard & Co., Boston, Mass.

Old Stone Mill, H. A. Heath & Co., Newport, R. I.

Old South Church, Bigelow, Kennard & Co., Boston, Mass.

Omaha, Neb., Max Meyer & Bro. Co.

Omaha, Neb., C. S. Raymond.

Oneida, Wendell Mfg. Co., Chicago.

Orange, A. R. Justice & Co., Philadelphia, Pa.

Orange, Wendell Mfg. Co., Chicago.

Oregon Salmon, A. Feldenheimer, Portland, Ore.

Osborn Hall, Yale College, R. Wallace & Sons Mfg. Co., Wallingford, Conn.

Otterbein, G. A. Schlechter, Reading, Pa.

Ouray, Col., C. E. Rose.Paducah, Ky., Wm. Nagel.

Palatka, Fla., G. A. Schlechter, Reading, Pa.

Palmer, Mrs., Columbian Souvenir Mfg. Co., Chicago, Ill.

Palmer, Mrs. Potter, Chas. Otero, Pueblo, Col.

Penn, William, J. E. Caldwell & Co., Philadelphia, Pa.

Penn, William, C. R. Smith & Son, Philadelphia, Pa.

Père Marquette, Geo. N. Conklin, Marquette, Mich.

Perry, Commodore, S. Loeb, Erie, Pa.

Philadelphia, Pa., J. E. Caldwell & Co.

Philadelphia, Pa., C. R. Smith & Sons.

Phoenix, 1871, C. D. Peacock, Chicago, Ill.

Pike's Peak, Col., R. D. Weir.

Pike's Peak, Col., L. A. West.

Pilgrim, F. M. Whiting & Co., North Attleboro, Mass.

Pine Tree, Geo. H. Griffin, Portland, Me.

Pittsburg, Pa. (two styles), J. C. Grogan.

Pittsburg, Pa., Presbyterian Church, Goddard, Hill & Co.

Plymouth, Mass., M. F. Campbell.

Plymouth Rock, Geo. E. Homer, Boston, Mass.

Point Loma, Fla., A. B. Conley.

Ponce de Leon, Greenleaf & Crosby, Jacksonville, Fla.

Ponce de Leon Hotel, Greenleaf & Crosby, Jacksonville, Fla.

Pope Leo XIII., Tilden-Thurber Co., Providence, R. I.

Portland, Me. (two styles), Carter Bros.

Portland, Me., Geo. H. Griffin.

Post Office, Newark, N. J., Frank Holt.

Pottsville, Pa., W. H. Mortimer.

Public Library, A. G. Page, Jr., Bath, Me.

Puck, Wendell Mfg. Co., Chicago.

Putnam, Gen., Geo. E. Shaw, Putnam, Conn.

Quincy, Mass., John O. Holden.

Rat, A. M. Field, Asheville, N. C.

Reading, Pa. (two styles), G. A. Schlechter.

Red Jacket, Geo. E. Sherwood Waterloo, N. Y.

Revere, Paul, Freeman & Taylor, Boston, Mass.

Revere, Paul (Signal Lights in bowl), Gorham Mfg. Co., New York.

Revere, Paul, Geo. E. Homer, Boston, Mass.

Rhode Island Tilden-Thurber Co., Providence, R. I.

Rice, Harvey, Bowler & Burdick Co., Cleveland, Ohio.

Richfield Springs, N. Y., Hy. Greenman.

Richfield Springs, N. Y., H. C. Walter.

Rip Van Winkle, W. B. Durgin, Concord, N. H.

Rip Van Winkle, J. T. Henderson, Catskill, N. Y.

Rip Van Winkle, J. H. Johnston & Co., New York.

Roanoke, Gunboat, A. G. Page, Jr., Bath, Me.

Rochelle, Ill., Otto Wettstein.

Rochester, Minn., J. B. Blickle.

Rochester, Minn., Stebbins & Co.

Rochester, N. Y., W. H. Glenny, Sons & Co., Buffalo, N. Y.

Rock Island, Ill., H. D. Folsom.

Russell, Governor, Geo. E. Homer, Boston, Mass.

Saginaw, Mich., Brown & Grant.

St. Augustine, Fla., Thomas Tugby.

St. Clair Tunnel, Barrett & Goulding, Port Huron, Mich.

St. John, Geo. W. Shiebler Co., New York.

St. Louis, Mo., Alvin Mfg. Co., New York.

St. Louis, Mo., Hess & Culbertson.

St. Louis, Mo. (three styles), Mermod & Jaccard Jewelry Co.

St Louis, Mo., Merrick, Walsh & Phelps.

St. Paul, Minn., Bullard Bros.

St. Paul, Minn., A. H. Simon.

St. Paul, Minn. (see Minneapolis and St. Paul and Twin Cities).

Salem, N. C., Female Academy, W. T. Vogler, Winston, N. C.

Salt Lake City, Utah, J. H. Leyson Co.

Salt Lake City, Utah, A. I. Wyatt.

San Francisco, Cal., Hammersmith & Field.

Santa Claus, Gorham Mfg. Co., New York.

Santa Claus, Roulet & Armstrong, Toledo, Ohio.

Santa Fe, N. M., G. W. Hickox & Co.

Saratoga, N. Y., Camerden & Forster, New York.

Saratoga, N. Y., Edgar L. Everett, Washington, D. C.

Saratoga, N. Y., D. A. Smith.

Saratoga, N. Y. (three patterns), E. R. Waterbury.

Saratoga Springs, N. Y., Jacob Dreiser.

Savannah, Ga., Theus Bros.

Schoharie, N. Y., Chas. M. Throop.

Sea Shore, Codding Bros. & Heilborn, North Attleboro, Mass.

Sea Shore, G. A. Schlechter, Reading, Pa.

Shakespeare, J. A. Merrill & Co.

Shell, Stone Bros., New York.

Shenandoah, A. G. Page, Jr., Bath, Me.

Sherman, Gen., Alvin Mfg. Co., New York.

Sherman, General, J. H. Johnston & Co., New York.

Silver Wedding, Shepard Mfg. Co., Melrose, Mass.

Sioux City, Ia., W. H. Beck.

Sioux Falls, S. Dak., H. W. Booth.

Sleepy Hollow, J. H. Johnston & Co., New York.

Soldiers' Home, M. Goldsmith & Son, Washington, D. C.

Soldiers' Monument, T. C. Tanke, Buffalo, N. Y.

Soo Lock, Otto Supe & Co., Sault Ste. Marie, Mich.

Southern or Lee, L. G. Jahnke & Co., Lexington, Va.

Spanish Coat of Arms, Greenleaf & Crosby, Jacksonville, Fla.

Spartanburg, S. C., Henneman Monumental Jewelry Co.

Sports and Pleasures of the Mountains, F. W. Sim & Co., Troy, N. Y.

Springfield, Mass., F. E. Ladd.

Squirrel Island, A. G. Page, Jr., Bath, Me.

State (All States of the U. S., except Miss. and La.), Wendell Mfg. Co., Chicago.

State House, Geo. E. Homer, Boston, Mass.

Steuben, Baron, H. B. Helm, Steubenville, O.

Stockbridge, F. A. Robbins, Pittsfield, Mass.

Stourbridge Lion, Chas. Petersen, Honesdale, Pa.

Stuyvesant, Peter, J. H. Johnston & Co., New York.

Sunny South, Greenleaf & Crosby, Jacksonville, Fla.

Syracuse, N. Y., E. B. McClelland.

Talmage, T. De Witt, P. W. Taylor, Brooklyn, N. Y.

Tammany, E. A. Whitney, Boston, Mass.

Texas (Coat of Arms), R. Wallace & Sons Mfg. Co., Wallingford, Conn.

Thousand Islands, E. W. Estes, Clayton, N. Y.

Toledo, Ohio, J. J. Freeman.

Topeka, Kan., W. Edmonds.

Totem Pole, J. H. Johnston & Co., New York.

Trinity College, David Mayer, Hartford, Conn.

Troy (see Hendrick Hudson), James W. Cusack, Troy, N. Y.

Twin Cities, E. A. Brown (see Minneapolis and St. Paul), St. Paul, Minn.

Typical Chicago, Wendell Mfg. Co. (see Chicago, Typical), Chicago.

United States, Bachrach & Freedman, New York.

U. S. Arsenal, Springfield, R. Wallace & Sons Mfg. Co., Wallingford, Conn.

Uncle Sam, Alvin Mfg. Co., New York.

Uncle Sam, J. Karr, Washington, D. C.Veiled Prophet, Hess & Culbertson, St. Louis, Mo.

Veteran or G. A. R., Anderton, Eberhardt & Co., Dayton, Ohio.

Victory (World's Fair), Alvin Mfg. Co., New York.

Warsaw, N. Y., James A. Main.

Washington, Alvin Mfg. Co., New York.

Washington (Equestrian), E. N. Denison & Co., Westerly, R. I.

Washington, M. W. Galt, Bro. & Co.

Washington (Equestrian), Harris & Shafer, Washington, D. C.

Washington City (two styles), Moore & Leding.

Washington, D. C., Harris & Shafer.

Washington, D. C. (handle in shape of cannon), Jacobs Bros.

Washington Elm, A. J. Applegate, Cambridgeport, Mass.

Washington Fir, Ovaitt & Warner, Portland, Ore.

Washington, Geo., Florence Silver Plate Co., Baltimore, Md.

Washington, Geo., J. Karr, Washington, D. C.

Washington, Geo., G. A. Schlechter, Reading, Pa.

Washington Headquarters, Hamilton & Diesinger, Philadelphia, Pa.

Washington Monument, E. L. Everett, Washington, D. C.

Waupaca, Wis., C. R. Hoffman.

Web Foot, Ovaitt & Warner, Portland, Ore.

Wedding, Shepard Mfg. Co., Mekose, Mass.

"Westward Ho," Reilly, Curtis & Co., Chicago.

Whale (or New Bedford), Wood, Bicknall & Potter, Providence, R. I.

What Cheer, H. C. Whittier & Co., Providence, R. I.

Wheelman, Chas. E. Barker, New York.

Wheelman, W. W. Berry, Scranton, Pa.

Whist, Codding Bros. & Heilborn, North Attleboro, Mass.

Whist, Stone Brothers, New York.

White Head, Carter Brothers, Portland, Me.

White House, Harris & Shafer, Washington, D. C.

Whittier (four designs), H. G. Hudson, Amesbury, Mass.

Wild West, Giles, Brother & Co., Chicago.

Wilkes-Barre, Pa., H. G. Shupp.

Willard, Emma, Moores & Winder, Troy, N. Y.

Williams, Roger, Tilden-Thurber Co., Providence, R. I.

Williams, Roger, Henry C. Whittier, Providence, R. I.

Windham (Frogs in bowl), Gorham Mfg. Co., New York.

Wisconsin, J. Larson & Co., Madison.

Witch (two patterns), Daniel Low, Salem, Mass.

Wolf, The Pomfret, Geo. E. Shaw, Putnam, Conn.

Woman's, Shepard Mfg. Co., Melrose, Mass.

W. C. T. U., W. F. Barden, North Attleboro, Mass.

W. C. T. U., Giles, Bro. & Co., Chicago.

Woman's Ideal, Charles Otero, Pueblo, Col.

Woman's Ideal, Charles Otero, Pueblo, Col.

Woman's Press Club, Alvin Mfg. Co., New York.

Wooster, F. L. Wilson, Danbury, Conn.

World, Geo. W. Brown, Cheyenne, Wyo.

World's Columbian Exposition, Wm. A. Bigler, Chicago.

World's Fair, Geo. E. Homer, Boston, Mass.

World's Fair, J. H. Johnston & Co., N. Y.

World's Fair, William Rogers Mfg. Co., Hartford, Conn.

World's Fair (twelve designs), Spaulding, & Co., Chicago.

World's Fair (two styles), Tilden-Thurber Co., Providence, R. I.

World's Fair, R. Wallace & Sons Mfg. Co., Wallingford, Conn.

World's Fair, Wendell Mfg. Co., Chicago.

World's Fair, No. 1, F. M. Whiting & Co., North Attleboro, Mass.

World's Fair, No. 2, F. M. Whiting & Co., North Attleboro, Mass.

World's Fair (Buildings of the), Spaulding & Co., Chicago.

World's Fair Children's Official Spoon, B. F. Norris, Alister & Co., Chicago.

World's Fair Official, B. F. Norris, Alister & Co., Chicago.

World's Fair Woman's Official, B. F. Norris, Alister & Co., Chicago.

Worcester, Mass., F. A. Knowlton.

Yacht, Codding Bros. & Heilborn, North Attleboro, Mass.

Yacht, Stone Brothers, New York.

Yale, Codding Bros. & Heilborn, North Attleboro, Mass.

Yale, Geo. H. Ford Co., New Haven, Conn.

Yale, Stone Bros., New York.

Yellowstone National Park, Myers & Co., Livingston, Mon.

Y. P. S. C. E. (Christian Endeavor), Gorham Mfg. Co., New York.

Y. P. S. C. E. (Christian Endeavor), Shepard Mfg. Co., Melrose, Mass.

Zeb Bance, Warren Prior & Son, Fayetteville, N. C.

Biographical Notes

Not all spoons included in this volume were designed by professional designers or silversmiths. A surprising number were based on ideas suggested by people in other professions—people who had a particular interest in honoring special persons, places, or events. The brief biographical notes will give some idea of the scope of their regular activities.

The following abbreviations have been used:
adv. advertised

b.	born	mgr.	manager
c.	circa	op.	optician
d.	died	ss.	silversmith
D.	directory (city)	w.	working
imp.	importer	w.c.	working circa
j.	jeweler(s)	wh.	wholesale
mfr.	manufacturer		

ACTON, RICHARD E., Alexandria Va.
(d. Oct. 8, 1893, Alexandria, Va.)
D 1888-9 Firm: R. C. Acton, j.
D 1905 Firm: R. C. Acton & Sons, R. E. & C., j. & ss.
ADAMS, CALEB CUSHING, Brooklyn, N.Y.
(b. Newburyport, Mass., March 25, 1883; d. Brooklyn, N.Y., Dec. 13, 1893)
Adams received his education at the famous colonial institution, Dummer Academy (founded by a son of Jeremiah Dummer, America's first native-born and native-trained goldsmith).
He began his business life in the employ of Joseph Moulton (1814-1903), silversmith and jeweler of the noted Moulton family. When about seventeen years of age he became a salesman for Ball, Black & Co., New York, with whom he remained three years. He established a jewelry store in Columbus, Georgia, but sold his interest in a little more than a year when he returned to New York, taking a position with Rogers & Bro. In 1858 he joined the Gorham Company as a traveler and remained with that company as a salesman and New York agent until the incorporation of the Gorham Mfg. Co. in 1865, at which time he became an officer in the company. He remained in charge of the New York business until his retirement in 1875.
After leaving the Gorham Mfg. Co., he was for about four years a partner in the Adams & Shaw Co., manufacturing silversmiths, which sold their silverware plant to Dominick & Haff. The following two years he was connected with Leroy W. Fairchild & Co. as salesman and superintendent of their factory. For about a year he was a

buyer for N(ewell) Matson & Co., Chicago, Illinois. Afterwards, he was a partner in the Eugene Jaccard Jewelry Co., St. Louis, Missouri for four years.
In 1886 he returned to New York and settled in Brooklyn where the following year he formed the firm of C. C. Adams & Co., retail jewelers. After his death the eldest son, Cushing Adams, continued the business.
ADDISON, CHARLES J. W., Chelsea, Mass.
D 1891 Firm: Addison Bros., j.
ALLEN, GROSVENOR, Oneida, N.Y.
Firm: Oneida Community, w. c. 1897-8 to 1915+. Allen was one of Oneida Community's top executives and a gifted designer of silverware. He and Julia Bracken (later Julia Bracken Wendt) worked out the *Fleur de Luce* pattern used to launch the sale of Community Plate in 1904. His eldest son, Hamilton Allen, was later Vice President and Director of Personnel of Oneida Silversmiths.
ALLEN, JAMES & CO., Charleston, S.C. j. w. c. 1888-1904+.
(See Eberhardt)
ALVIN MANUFACTURING COMPANY, Newark, N.J.
Originated as Alvin Manufacturing Company in 1886; incorporated August 17, 1887, for manufacturing sterling silver ware and novelties. Also produced plated silver wares and silver deposit wares.
Among the first to foresee the demand for souvenir spoons and set their most skilled designers to work on patterns especially adapted to be sold in various cities. Noted for originality of design and excellence of die cutting and finish. During the great souvenir spoon craze of the 1890s, the demand for Alvin company spoons often taxed the facilities of their manufacturing plant. This demand finally led to the building of new and larger facilities at Irvington, N.J. Among their most successful souvenir spoons were the Washington, Cleopatra, Miner, Uncle Sam, Phoenix, Columbus World's Fair, Buffalo, Historical Cannon, Wheelman, Washington Monument, New York Liberty, Marguerite, and Campaign spoons (Fig. 802). The two latter were in commemoration of the 1892 Presidential campaign.
The Alvin company was purchased by the Gorham Corporation in 1928 and the title changed to the Alvin Corporation. The Alvin trademark is still used.
ASHTON, SIMEON HARRY, Rhinelander, Wis.
(b. Jan. 18, 1861, Winchester, Ind.; d. Oct 8, 1948, Rhinelander, Wis.)
Served an apprenticeship with Western Union and entered

The Encampment Spoon.

(STERLING SILVER.)

Designed and manufactured expressly for the Twenty-sixth Annual Encampment of the G. A. R. to be held in Washington, D. C., September 19-26, 1892.

OXIDIZED
OR
BRIGHT,

$8.50

PER DOZ.

GILT

BOWL,

$10.50

PER DOZ.

ALVIN MFG. CO.,

860 Broadway, NEW YORK.

802. From *Jewelers' Weekly*, Sept. 14, 1892.

their employ at an early age, continuing until retirement c. 1931. Father of eight, perhaps he designed the baby spoon because of his interest in children.

ATWOOD, ALBERT, Seattle, Wash.
(b. Oct. 27, 1832, near Tuckerton, Burlington County, N.J.; d. Oct. 7, 1926, Seattle, Wash.)
Entered Methodist ministerial service, New Jersey Conference, 1858. Transferred to Oregon Conference, 1874. Ordained Deacon 1860; Elder 1862. Supervised work of Puget Sound District 1878-82. Wrote *History of Methodism in Cape Island, N.J., Glimpses in Pioneer Life on Puget Sound,* and *The Conquerors.* A pioneer Methodist minister himself, it is appropriate that he should have designed the spoon honoring Jason Lee, an earlier pioneer Methodist minister and founder of Salem, Oregon, and Willamette University.

BADGER, JAMES C., Concord, N.H.
j., w. c. 1892.

BAILEY, BANKS & BIDDLE CO., Philadelphia, Pa.
j. & ss. Founded 1833 by Joseph T. Bailey. Became Bailey,

Banks & Biddle Co. before 1904. Still in business.

BALL, BERT, St. Louis, Mo. j., adv. 1902.

BALL, WEBB C., Cleveland Ohio
Firm: **Webb C. Ball Co., j., adv. 1891.**

BARKER, CHARLES B. (same as Charles E.?), Brooklyn, N.Y.
j., adv. 1893.

BARKER, CHARLES E., New York, N.Y.
mfr.. imp., wh., adv. 1893.

BARRETT, GEORGE H., JR., New York, N.Y.
Member of First Church of Christ, Scientist, New York, when he designed spoon (assigned to William R. Phelps & Co., New York) commemorating dedication of the Church, Thanksgiving Day, 1903.

BAUMGRAS, ERWIN C., Washington, D.C.
Firm: Jacobs Bros., j., cashier, 1891.

BEAR, THEOPHILUS, Camden, N.J.
D 1927-31, j.

BERNHEIM, EUGENE CLAYTON, Washington, D.C.
Firm: John H. Flanagan, j., clerk, 1892.
Carl Petersen, j., 1893.

BERRY, WILLIAM W., Scranton, Pa.
D 1890-1904 j. and watchmaker.

BIGLER, W. A., Chicago, Ill.
j. c. 1892-3.

BINGHAM & WALK, Indianapolis, Ind.
j. c. 1891 (Julius C. Walk).

BIRELY, HARRY I., Oshkosh, Wis.
(d. c. Oct. 11,1906.)
D 1884 K. M. Birely & Henry R. Birely, j. and diamond merchants.
D 1905 Birely & Son.

BIRMINGHAM, JOSEPH EDWARD, San Francisco, Cal.
(b. c. 1867, Ill.)
D 1887-1893 salesman.
D 1894-1910 salesman and designer, Shreve & Co.
D 1911 Salesman, Radke & Co., j.
D 1913 department mgr.. Radke & Co., j.

BOAS, CHARLES ROSS, Harrisburg, Pa.
(b. Jan. 22, 1861. Harrisburg, Pa.)
Only son of Charles Augustus and Mary A. Reel Boas. High school graduate at 16 and a year later associated with his father in jewelry business to which he succeeded at his father's death. Married Myrta A. Knisely, June 12, 1888. Children: Charles K. (who succeeded his father in jewelry business until retirement), Ross H., Robert R., and Mary.

BOGAERT, VICTOR, Lexington, Ky.
(b. Mar. 7, 1859, Brussels, Belgium; d. Lexington, Ky., Mar. 7, 1950.)
Established the Victor Bogaert Co., Lexington, in 1883. Became a U.S. citizen in 1891. Conducted a successful jewelry and import business, specializing in fine stones and jewelry from foreign markets. Childhood accident prevented him from attending school, but he became an accomplished linguist. His command of 6 languages aided in successful purchasing during his 65 trips abroad. Received letters of commendation from Herbert Hoover, then Food Administrator of European relief, for his activities in behalf of Belgian children during World War I. From King Leopold he received several awards including La Croix de Chevalier de l'Order de Leopold. Bogaert firm is still in business and is noted for custom-

803. Great Seal of the State of Wyoming, designed by Hugo E. Buechner.

made jewelry and antique reproductions.

BOOKWALTER, JOHN R., Oklahoma, Okla. Terr.
D 1904-08: Bookwalter, John R., (Alice N.), watches, clocks, jewelry.

BOUTELLE, FRANCES E., Fitchburg, Mass.
"Mrs. Frances E. (Upton), widow of Frank L. Boutelle, died Tuesday afternoon...in her 81st year...born in this city Sept. 16, 1846, daughter of Warren C. and Ellen (McIntire) Upton..." (*Fitchburg Sentinel,* June 29, 1927).

Mrs. Boutelle invented a "true and accurate measure of one-half teaspoon" which was sold by the De Boutville Co. formed by her and her son, Ralph, and son-in-law, Kendall F. Crocker. The spoons were made in Wallingford, Conn. Most were plated silver and sold for 50 cents; some of white metal sold for 35 cents and a few were made of sterling for special gifts for friends. The sterling spoons were made by Frank W. Smith Co., Gardner, Mass. More than 40,000 were sold.

BOWLEN, WILLIAM C., Providence, R.I.; Greenfield, Mass.
With George E. Rogers and George C. Lunt, Bowlen; formed Rogers, Lunt & Bowlen Co. in 1902. Bowlen became president after the death of Rogers in 1915. Predecessors of the company had made both sterling and plated silver. Since 1923 only sterling silver has been made. The company now uses the tradename Lunt Silversmiths, but the corporation name remains Rogers, Lunt & Bowlen.

BRACKEN, JULIA
(*See* Julia Bracken Wendt)

BROWN, WILLIAM A., New York, N.Y.
Son of Thomas G. Brown, mfg. j., Newark, N.J., w.c. 1869-89. Firm established in 1834 as Baldwin & Co., which they purchased c. 1869-71. Became Thomas G. Brown & Sons, 1881. Sons were Thomas B. and William A. Sold products throughout the country. Made some goods for Gorham Mfg. Co. which were so marked (Gorham has no record). Out of business before 1922.

BUCHBINDER, ADOLPH W., Detroit, Mich.
(b. c. 1861; d. Sept. 22, 1931, Detroit, Mich.)
j. Firm: Wright, Kay & Co. c. 1881 until death.

BUECHNER, HUGO E., Cheyenne, Wyo. Adv. c. 1890-95. Firm: Zehner, Buechner & Co., j. & ss. Designer of the Great Seal of the State of Wyoming (Figs. 803 & 804).

BULLARD, JOHN H. & WILLIAM H., St. Paul, Minn.
(John: b. c. 1848; d. December 29, 1916; William: b. c. 1853; d. July 3, 1920)
Brothers, John and William, founded firm, Bullard Brothers, 1884. One of St. Paul's most distinguished jewelers, the firm continues under E. W. Kohlsatt, whose mother was a Bullard.

BURCH, CHARLES R., Cooperstown, N.Y. (b. c. 1835, New Berlin, Otsego County, N.Y.; d. Nov. 26, 1899.)
Moved to Cooperstown c. 1850; learned jeweler's trade from P. C. Tanner. Retired Dec. 1898 when he sold business (Burch & Brother) to Lippitt's Jewelers (M. Ernest Lippitt), still in business.

BURGER, LOUIS, Chicago, Ill.
President of Columbian Souvenir Mfg. Co., mfrs. of souvenir novelties, Chicago. Designed and patented numerous spoons and other souvenirs for Columbian Exposition. *Jewelers' Weekly* ad, May 31 1893, states spoons made for Columbian Souvenir Mfg. Co. by Dominick & Haff.

CALDWELL, JAMES E. & CO., Philadelphia, Pa.
j., ss. and antiquarians since 1839.

CAMP, ARTHUR K., Milwaukee, Wis.
(b. c. 1853; d. Feb. 27, 1916.)
D 1878 Firm: Stanley & Co. (William S. Stanley & Arthur K. Camp);
D 1881 Stanley & Camp. In 1891 Camp was president of the company. From 1894 until his death, he was in real estate business.

176 Broadway, N. Y., Room 14. 66 Stewart St., Prov., R. I.
Mills Building, San Francisco, 8th Floor, Room 1.

805. From *Jewelers' Weekly,* June 21, 1893.

804. From *Jewelers' Weekly,*
Oct. 25, 1893.

CAMPBELL, ERNEST W., Providence, R.I.
Well-known designer for the silver trade. He, Joseph W. Metcalf, Providence, and Charles M. Harris, West Boylston, Mass., founded Campbell-Metcalf Co., mfrs., ss. (Fig. 805.) In 1900 Campbell designed silver for W. H. Manchester, Providence.

CAPURRO. W. N., Hot Springs, Ark.
Listed in 1931 *Keystone Jewelers' Index* in San Antonio, Texas, as mfg. of gold and plated silver mountings, watch and clock repairing, engraving and special order work.

CASSIDY, CHAUNCEY, Great Falls, Mont.
The 1929 stock market crash and depression which followed prevented manufacture of "sweetheart" spoon. Cassidy kept the original spoon which he filed from aluminum stock.

CASTELBERG, ROBERT, Washington, D.C.
D 1900 Firm: Castelberg's National Jewelry Co., mgr.

CHAMBERS, GEORGE & STEWART, ROBERT J., Mt. Clemens, Mich.
(Chambers: b. 1858, New Albany, Ind.; d. 1940, Mt. Clemens, Mich.; Stewart: b. Guelph, Ont., Canada; d. 1944, Mt. Clemens, Mich.)
Firm: "Chambers & Stewart Company, jewelers, opticians, books and stationery." Chambers spent boyhood in Rochester, Mich. Went to work in Detroit, 1878. Bought small business in Mt. Clemens 4 or 5 years later. In 1900 Stewart, who had previously worked for him, became a partner. In 1923 Chambers sold his interest to Omar P. Stelle and retired.

Stewart had many business interests. Operating the Mt. Clemens Garage & Motor Sales at the time of his death.

CLULEE, JOHN & HARRY, Wallingford, Conn.
Two of five brothers, all associated with silver industry. Samuel, one of the five, die cutter for R. Wallace & Sons. Their father, Henry, active in silver industry. He and his family lived in King's Norton, Worcestershire, England, before moving to Providence, R.I. Three brothers moved to Wallingford later. John (b. London, England, 1865) and his father first listed Wallingford:
D 1885 employed R. Wallace & Sons.
D 1891-92 die sinker mold-maker, art metal worker (probably in business for himself).
D 1893-98 die sinker, Simpson Nickel Silver Co.
D 1899-1900 die sinker, Factory M (The International Silver Co.).
D 1906-16 foreman, Factory M.
D 1920 home address.
D 1922 moved to Florida.

CODMAN, WILLIAM CHRISTMAS, Providence, R.I.
(b. Christmas Day, 1839, Norfolk, England; d. Dec. 7, 1921, England.)
At an early age evinced a special aptitude for drawing and painting...placed with Heaviside, Norwich, for tuition. Turned attention to church mural painting. Engaged for three seasons with L'Estrange in decorating nave of Ely Cathedral, Cambridgeshire, which was begun by the Normans in 1081. Designed communion plate for See of Liverpool; corporation plate at Manchester Town Hall; awarded gold medal at International Exhibition in 1861.

Brought to the U.S. (1891) as art director, Gorham Mfg. Co., where he remained until retirement, 1914. Some of the most notable productions were wrought from his designs. Included were the massive bronze Ann Mar

Memorial gates to Roger Williams Park (Providence, R.I.); two well-known yachting trophies, the immense Dewey cup of sterling silver and the Sir Thomas Lipton gold cup, and the silver service for the *U.S.S. Delaware.* The Gorham exhibit at the St. Louis Exposition (1904) was directed and set up by Codman. Among the foremost interpreters of l'Art Nouveau. After retirement, he returned to England, where he remained until his death.

Before coming to this country, Codman married Emma Rolle of Norfolk, England. They had two daughters and three sons. Edwin E. became a well-known sculptor; William followed his father as art director of Gorham Mfg. Co.; Frank returned to England.

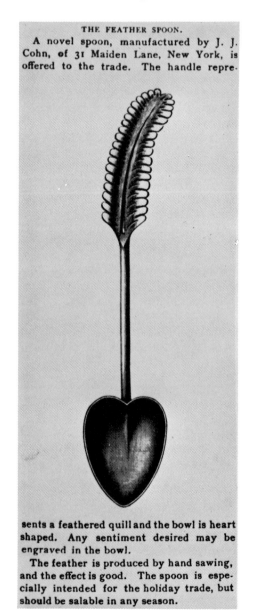

THE FEATHER SPOON.
A novel spoon, manufactured by J. J. Cohn, of 31 Maiden Lane, New York, is offered to the trade. The handle represents a feathered quill and the bowl is heart shaped. Any sentiment desired may be engraved in the bowl.

The feather is produced by hand sawing, and the effect is good. The spoon is especially intended for the holiday trade, but should be salable in any season.

806. From *Jewelers' Weekly*, Nov. 16, 1892.

COHN, J. J., New York, N.Y.
j., adv. c. 1890-96.

COLBURN, ARTEMUS E., Bellingham, Wash.
D 1904-07, mfr., j. & lapidarist.

CREES, EUSTACE & COURT, CHARLES S.,

Providence, R.I.
Designers for Watson, Newell & Co., c. 1903-07. Listed in 1931 *Keystone Jewelers' Index* under die sinking and designing.

CROSBY, JOSEPH H. (*See* Greenleaf & Crosby)

CROWELL, GILBERT L., JR., Arlington, N.J.; Newark, N.J.; Meriden, Conn.
(b. Apr. 4, 1869; d. Dec. 24, 1932.)
First with Dominick & Haff. Joined The International Silver Company when Dominick & Haff was sold to Reed & Barton in 1928. Entered International as designer, May 14, 1928. Among his designs were those for the silver service for the cruiser, *U.S.S. Houston.*

CURRAN, JOHN T., Brooklyn & New York, N.Y.
D 1891-1903 designer for Tiffany & Co.

DALE, CHARLES J., Chicago, Ill., & Plattsburgh, N.Y.
Moved from Chicago in late 1890s or early 1900s to Plattsburgh, where he opened a jewelry store.

DAVIS, NANNIE G., Washington, D.C.
D 1879 listed by name only.
D 1880 servant.
D 1881-99 clerk.
D 1900 clerk in war office.

DAVIS & GALT, Philadelphia, Pa.
Patent Office records show Davis & Galt in business by July 21, 1888-c. 1900. Successors to Hamilton & Davis (Matthew F. Hamilton & Junius H. Davis), ss., 1880 and Junius H. Davis ss. 1887-88. Philadelphia D 1889 Davis & Galt (Junius H. Davis & Charles E. Galt), ss. Charles E. Galt related to Galt family, Washington, D.C. Mentioned in Dec. 19, 1902, newspaper clipping as deceased.
(*Also see* Galt, M. W.)

DEACON, EUGENE L., Denver, Colo.
Firm: E. L. Deacon Jewelry Co. c. 1902-10 or 1915, when it was removed to Los Angeles.

DENISON, EDWIN N., Westerly, R.I.
(b. Nov. 23, 1832, Groton, Conn.; d. July 30, 1893, Westerly, R.I.)
Youthful days spent in common schools and on board a fishing smack. At 14, he was apprenticed to a Mr. Maxson, on Meetingstreet, Providence, to learn the manufacturing jeweler's trade. After two years he purchased the balance of his time and hired out as a journeyman in Worcester, Mass. Returned later to Providence and was employed by John Moran, manufacturing j., for many years. During the business recession of 1857 learned watchmaker's trade. With revival of business, resumed his old trade until, in 1872, he moved to Westerly and purchased an interest in a jewelry, watchmaker's, and silversmith's business, at the old stand of Thomas Perry. New firm name was Denison & Fifield. A few months later he purchased Fifield's interest and firm name became E. N. Denison & Co., which continued until his death.

DEUBLE, WALTER H., Canton, Ohio.
Firm: Deuble's. Celebrated its centennial in 1933 at which time Holmes & Edwards, Meriden, Conn., subdivision of The International Silver Co., made an extensive research and reported in *The Jewelers' Circular-Keystone* that Deuble's was the oldest jewelry store in the United States under one name and one continuous family ownership.

The founder, Michael George Deuble, settled in Canton in 1831. Born in 1798 in Baden, Germany, ancestral home of the family for several generations. Learned weaver's,

watchmaking, and clockmaking trades in Germany. Married Susannah Schmitt and in 1825 came to this country, settling first in Philadelphia and later at Mahanoy City, Pa., where he practiced clockmaking. When he learned Canton had no clockmakers, repair men or jewelers, he loaded his wife and son Martin (b. Germany, 1827), into a onehorse wagon and moved to Canton. By 1833 he had fitted up a shop in his home and became first permanent clockmaker and watch repair man in Canton. Deuble's second son, George, was b. in Canton in 1832. Both boys were apprenticed in jewelry business into which *their* sons followed. At one time there were 3 Deuble stores, run by 3 pairs of brothers, 2 pairs being sons of George and the other, sons of Martin. Some of the sons branched out into other interests and by 1910, the oldest of the Deuble stores became the sole survivor.

William McKinley was a regular customer of Deuble's and during the 1896 presidential campaign Deuble stores featured the McKinley spoon designed by Walter H., grandson of founder.

By 1950, the Deuble family had grown to the seventh generation in Canton and still owns and operates the Deuble store.

DIMMICK, GEORGE W., Brooklyn, N.Y.
Firm: James H. Hart, Ltd., j., c. 1891.

DISQUE, GEORGE, Erie, Pa.
(b. c. 1855, Powhatan, Ohio; d. Oct. 14, 1935, Erie, Pa.)
Firm: George Disque, j. Resided in Erie c. 1875-1935. Associated with Herman Jarecki, j.. until c. 1885.

DOLE, HENRY L., Haverhill, Mass.
(b. c. 1836, Hallowell, Me.; d. Feb. 10, 1914.)
Firm: Henry L. Dole, retail j. c. 1865-1907. Moved to Haverhill in 1864.

DOMINICK, H. BLANCHARD, New York, N.Y.
President of Dominick & Haff from 1873, when the company succeeded Gale, North & Dominick, until c. 1920. Descendant of George Dominique, French Huguenot, who came to this country in 1740.

DOMINICK & HAFF, New York, N.Y., & Newark, N.J.
Founded in 1870 but traced their beginnings to William Gale & Son, ss. in New York in 1821. Underwent several changes in name. Became Dominick & Haff in 1873. Purchased by Reed & Barton Company in 1928.

Manufacturers of fine quality sterling wares. Noted for excellent workmanship and design of their souvenir spoons.

DORR (DORER), CONROD (CONRAD), Wheeling, W. Va.
(b. Jan. 1854, Baden, Germany.)
"Received early schooling Baden, Germany and at trade school at Freiburg. L. B. Came to America in 1882 and spent a year at Pittsburg. Moved to Bellaire, Ohio in 1883 where he was connected with Rodefer Brothers Glass Company for 22 years; also with T. A. Rodefer. Made superintendent Imperial Glass Works. Nov. 19, 1900, he engaged in the foundry business, establishing his own plant. Also founder and vice-president of Enterprise Enamel Company, Bellaire, Ohio" (*History of Greater Wheeling and Vicinity*, Wingerter). Dorr was with Rodefer when he designed the graduated glass medicine spoon.
D 1880-81 glasspresser.

DOWLING, FRANK A., Cleveland, Ohio

(b. 1846, Newark, N.J.)
D 1893-96 engraver.

DURAND, WALLACE, Newark, N.J.
Designer; son of James Madison Durand, watchcase-maker and j. Three brothers Henry, Wallace, and Wickliffe, all joined their father's business, Durand & Co., listed D 1845-1919.

The name of Durand is a very old one, dating back to 1100 A.D., in France and Italy; Durante being the Italian spelling, of which "Dante" is a corruption. At least seven generations of Durands have been identified as manufacturing jewelers, watchmakers, engravers and silver-smiths.

Dr. Jean Durand, the Huguenot progenitor of the Durand family in America, was born at La Rochelle, France, in 1667. He came to this country in 1685 and died in Derby, Conn., in 1727.

Asher Brown Durand, (1796-1886) American painter of the "Hudson River School," was one of the best known of the Durand family. He gave up a successful career as an engraver to become a painter c. 1835. He also engraved plates from which pictures were printed, one of the most famous being "The Signing of the Declaration of Independence."

James Madison Durand, in 1838, founded Durand & Co., having learned jewelry manufacturing with Taylor & Baldwin of Newark.

Wallace Durand was associated with his father and brothers in the company in 1869 and became president when it was incorporated in 1892.

DURGIN, WM. B., CO., Concord, N.H.
Founded by Wm. B. Durgin (b. 1833, Compton Village, N.H.; d. 1905, Concord, N.H.) At sixteen Durgin became an apprentice in the silverware manufactory of Newell Harding & Co., Boston. He served his apprenticeship and became a journeyman silversmith. In the early days he would make up a lot of spoons and would start out with a horse and wagon to sell them, sometimes taking old silver in barter. Before long, with $200 savings and a small sum advanced by his father, he opened his own shop in Concord. The quality of his work brought enough trade for him to expand his business. He first built a small wooden shop and later a three-story brick building, fitting the first floor and basement for manufacturing.

"Durgin's spoons," at first of plain design, became known throughout New England. When figured patterns were demanded Durgin supplied that demand. Space in his building which had been rented to others was soon needed for men and machinery to supply his own growing business. An additional story was added but this proved inadequate so that in 1903-04 an entirely new factory was built.

In 1880 George F. Durgin, his only son, who had acquired a practical knowledge of the business, became active in determining its policies. The making of holloware was begun and later a full line of novelties was added.

The company was incorporated as Wm. B. Durgin Co. in 1898.

Durgin's was considered one of the most progressive in the trade. Their alertness in anticipating public taste was demonstrated by their early entry into the manufacturing of souvenir spoons of good design and excellent workmanship.

The Durgins, father and son, died the same year, 1905, in which year the business was purchased by the Gorham Company. It was moved to Providence Rhode Island, in 1931.

DYSON, GEORGE H., New Britain, Conn.
(b. c. 1884, Sheffield, England; d. May 1935, New Britain, Conn.)
Entered employ of Churchill & Lewis Jewelry Store, New Britain, as a boy. Learned the jewelry trade. Established firm of Porter & Dyson (Frederick Porter & George H. Dyson) in 1893, in which he was active until his death. Served as president of Connecticut Retail Jewelers' Association and was an aggressive foe of fraud jewelry sales.

EBERHARDT, JOHN C., Dayton, Ohio
(b. May 11, 1857, Thuringia, Prussia; d. after 1909, Dayton, Ohio.)
Firm: Anderton, Eberhardt & Co.. j. 1888-1900. Son of Gottlieb W. Eberhardt, mechanical engineer. The elder Eberhardt was a classmate and close friend of John G. Roebling, renowned bridge builder. John C. came to America with his parents in 1866; established their home in Dayton, Ohio. At 15, he entered the manufacturing jewelry establishment of E. A. Mudge. After a 4-year apprenticeship, he studied civil engineering. After qualifying, he worked on government land and railway surveys in Colorado and New Mexico, from 1878-1881. Served as assistant city engineer of Pueblo, Colo., in 1882 and that fall returned to Dayton and entered employ of Best & Son, j., with whom he continued until 1888. In that year he became associated with J. W. Anderton, j. (Anderton, Eberhardt & Co.) until 1900 when he withdrew to devote his entire time to optical practice. In 1902, served as president of the scientific section of American Federation of Optical Societies and in 1903 was over-all president of the society. Always interested in everything pertaining to the welfare of his adopted land and made significant contributions toward advancing municipal interests.

EVERETT, EDGAR L., Troy & Syracuse, N.Y.; Washington, D.C.
Adv. *Jewelers' Weekly,* 1891.

EVERTSEN, HENRY H., Meriden, Conn.
Notes from *Jewelers' Weekly:* H. H. Evertsen with Whiting Mfg. Co. of N.Y. visiting friends in North Attleboro. (July 10, 1890, p. 9)

Rowan & Wilcox have been succeeded by Wilcox & Evertsen...Evertsen, formerly superintendent of Dominick & Haff. (May 11, 1892, p. 12)

Wilcox & Evertsen have refitted their factory with new machinery. (Aug. 17, 1892, p. 12)

Wilcox & Evertsen sterling silver marks shown. (Mar. 29, 1893, p. 22)

Wilcox & Evertsen have incorporated. (Jan. 15, 1896, p. 11)

"...as a result of a recent arrangement with Wilcox & Evertsen, silversmiths...the factory of that firm would be removed to this city (Meriden, Conn., where they were taken over by Meriden Britannia Co.) and Henry H. Evertsen will take charge of the factory...." (Aug. 26, 1896, p. 7)

"Henry H. Evertsen of the Wilcox & Evertsen branch of

the International Silver Co. has severed his connection with that company and after a brief rest will be associated with Dominick & Haff, silversmiths, N.Y., with whom he was formerly connected for twenty-two years.'' (Jan. 10, 1900, p. 18)

FEAGANS, GEORGE E., Joliet, Ill.
D 1884-1910 j., wh. and retail.

FENWICK, EDWARD T., Washington, D.C.
D 1892 listed under Patents.

FINA, MICHAEL C., New York, N.Y.
wh. j., c. 1950, to date.

FITZGERALD, D. H. (Dink), El Dorado, Ark.
(b. Oct. 10, 1888, Union Co., near El Dorado, Ark.; d. 1958, Cal.)
Employed by Rock Island Railroad. Designed medicine spoon to give medicine to his second daughter, Ella Rhea.

FREEMAN, BENJAMIN B., Cambridge, Mass.
D 1890-96 Firm: Freeman & Taylor, j.

FREEMAN, JACOB J., Toledo, Ohio
Firm: J. J. Freeman Company, j. One of Toledo's oldest jewelry firms. Merged with W. F. Broer Co. in 1932; currently the Broer-Freeman Co.

FREISINGER, VICTOR, Atlantic City, N.J.
(b. Austria; d. Philadelphia, Pa.)
D 1895-1913 dealer in jewelry and objets d'art. Well known in Atlantic City as founder of the Vienna Restaurant, still in existence on the Boardwalk, though not in original location.

FREUND, GEORGE C. & FRANK WILLIAM, Durango, Colo.
(George: b. c. 1841-42, Heidelberg, Germany; Frank: b. 1837, Heideiberg, Germany; d. July 27, 1910, Jersey City, N.J.)
Primarily gunsmiths and dealers, who did business in

Colorado Armory
1869 - - 1895
HEADQUARTERS FOR THE
"More Light" Patent Gun Sights.
The "Smelter City" Original
Souvenir Spoons of Durango.
The "Columbian" Patent Double Ink Eraser.
The "Miners" Patent Pocket Knife and Companion.
Illustrated Circulars on application.
FREUND & CO.,
Gunsmith, Jewelers and Sporting Goods
DURANGO, COLO.

807. From *Colorado State Business Directory*, Durango, p. 296.

early West under the name Freund & Brother. Especially well known for alterations on Sharps rifles and other guns. Freunds came to America in 1857. Ad in *Nebraska City News* (July 27, 1867) states Frank and George Freund were leaving for Julesburg, Colo., and a Mr. Picard would take care of their business during their absence. The *News* (Dec. 30, 1867) mentioned Frank's return from *Cheyenne* to settle their business, so evidently they did not stay long in Julesberg and had preceded the railroad into Cheyenne. *Cheyenne Daily Leader* (Sept. 19, 1867) carried ad for their shop on Eddy Street (later renamed Pioneer Avenue).

They had gunshops in several places along Union Pacific while it was under construction. Photograph taken in 1869 in Corinne, Utah Territory, where they shared a temporary shop in a tent with a board front shows the sign, "John Kupfer, Watchmaker and Jeweler." A wooden rifle with "Freund & Bro." is at the side. Also listed in Salt Lake City D 1869. Opened a gun shop on Blake Street, Denver, c. 1870-71 which was described in a lengthy article in *Rocky Mountain News* (Dec. 12, 1872). At the 1873 Colorado Industrial Exposition, Frank was awarded first place for the best Colorado-made gun. Between Oct. 1873 and Mar. 1875 he secured 7 patents for gun improvements. The *News* (May 20, 1875) announced Freund & Brother had sold their Denver store and moved to Cheyenne. Frank married in 1876; lived in Cheyenne nearly 10 years and in mid-1880s moved his family to Jersey City, N.J., where he was listed in D 1886-1908. George's name appeared in Freund Brothers' ads in D 1880 of several states including (Cheyenne) Wyoming. His ads in Durango section show he established his Colorado Armory in 1881. Listed in D 1882-1909 (Fig. 807). Did not appear in subsequent D, nor did any death notice appear; may have left state c. 1909-10.

FULCHER, FRANK F., Great Barrington, Mass.
(*See* Perry & Fulcher)

FULLER, JAMES WILLIAM, St. Paul, Minn.
Associate (c. 1896) of Patrick J. Towle, founder of Towle's Log Cabin Syrup Company. The two designed and fashioned first log-cabin-shaped syrup containers by hand.

FURNISS, ALBERT, Meriden, Conn.
D 1874-5 mechanic.
D 1876-7 mold-maker and die sinker,
Wilcox Silver Plate Co. adv. *Meriden Daily Republican*, Oct. 10, 1877 and later.

ALBERT FURNISS,
GENERAL DIE SINKER,
Steel Engraver and Mould Maker.
SPOON AND FORK DIES A SPECIALTY.
All kinds of Cutting Dies and Punches made to Pattern.
Office, 250 Cook Avenue, - Meriden, Conn.

808. From *Meriden* Conn. Directory, 1885.

D 1880 mold-maker.
D 1881 spoon-maker.
D 1882 removed to Niagara.
D 1884-91 adv. die sinker business (Fig. 808). Removed to Bridgeport (West Meriden, now part of Meriden).
D 1895 die sinker.
D 1900 employed at Burns, Silver & Co.
D 1914 die sinker, last listing.
D 1915 Furniss, Ellen wid Albert h(ome)....

GALT & BRO., INC.
(*See* Davis & Galt)

GALT, M. W., Washington, D.C.
Established in 1802 by James Galt to make watches and later, fine silver. M. W. Galt and William Galt, sons of James Galt, assumed ownership in 1847. Norman Galt, grandson of founder, was owner 1880-1908. Company incorporated in 1934 when Norman Galt's widow, Edith

809. Cora Adelaide (Haven) Gooding.

Bolling Galt Wilson (then widow of former President Woodrow Wilson), turned firm over to employees. Corporate name is still Galt & Bro., Inc., but is usually referred to simply as Galt's (*see* Introduction, pp. 14-15).

The George and Martha Washington spoons issued May 11, 1889, and Oct. 1, 1889, respectively, preceded Salem Witch spoons by more than a year.

GARFIELD, ELLERY I., Lexington, Mass.
(d. Jan. 1904, Okla.)
Pioneer in development of electric light companies. Resident of Detroit, Mich. c. 1879. Associated with Thompson-Houston Electric Co., Lynn, Mass.; district mgr. of Ft. Wayne Electric Co. for four years, mgr. of arc light department, Boston Electric Light Co. before it was merged into Edison Electric Illuminating Co. From 1884 until his death, a resident of Lexington, where he was president of Lexington Gas & Electric Light Co. Also treasurer and general mgr. of Guthrie (Oklahoma) Electric Light Company.

GOETTHEIM, CHARLES F., Cincinnati, Ohio
(b. c. 1853; d. Sept. 27, 1929.) Investment broker.

GOLDSMITH, CHARLES A., Washington, D.C.
Firm: M. Goldsmith & Son, j. adv. 1891-2.

GOODING, CORA A., Brookline, Mass. (Fig. 809)
(b. Mar. 22, 1863; d. May 26, 1931.)
Married Charles S. Gooding (1881), graduate of M.I.T. who was a mechanical engineer through 1928 and patent attorney, D 1929-32.

GORHAM CORPORATION, Providence, R.I.
Founded by Jabez Gorham and Henry Webster in 1831; became Gorham, Webster & Price, 1837-41; J. Gorham & Son 1841-50; Gorham & Thurber, 1850-52; Gorham & Company, 1852-65; Gorham Mfg. Company, 1865-1961 (Fig. 810) and Gorham Corporation, 1961 to present. In 1868 they dropped the coin silver standard and adopted the sterling silver standard, which other companies soon followed. At the same time they adopted their trademark—a lion, an anchor, and a capital G—for all sterling articles. Gorham Corporation considers this trademark the most valuable one in the United States.

The Gorham company has, at various times, acquired Whiting, Durgin, Kerr, Mt. Vernon Silversmiths, Alvin Silver Company, Quaker Silver Company, Graff, Washbourne & Dunn, and others. Through the facilities of these and their own plant, Gorham has designed and made a very large proportion of the souvenir spoons produced in this country (Fig. 811). Many of these have been made exclusively for particular retail outlets and in some instances do not bear any Gorham company marks or those of its various divisions. For some, they have designed and made spoon dies which are then used by the individual firm to produce the spoons. They are stamped with the individual firm's name or trademark.

GRANDJEAN, CHARLES, San Francisco Cal.
(b. c. 1855, Switzerland.)
D 1887-99 engraver, Firm: Geo. Shreve & Co. Naturalized Aug. 1, 1888, San Francisco.

GREENLEAF & CROSBY, Jacksonville, Fla.
(Damon Greenleaf b. Nov. 13, 1834 Brockport, N.Y.; d. Dec. 15, 1895. Jacksonville, Fla. & Joseph H. Crosby, Jr.) j., established 1867 by Damon Greenleaf, native of Rockford, Ill., who opened his first jewelry business in Brockport, N.Y. Firm became D. Greenleaf & Company in 1880 when joined by J. W. Pomeroy and Joseph H. Crosby, Jr. By 1885 the firm employed 18 persons in various departments.

Pomeroy, a native of Utica, N.Y., was in charge of their books and correspondence. Crosby, a native of North Adams Mass., was a practical j. by profession. Learned the trade with a prominent j. of St. Albans, Vt., where he was located for several years prior to moving to Jacksonville in 1872. After joining Greenleaf, was in sole charge of buying for the house and general mgr. of firm.

810. From *Jewelers' Weekly*, Oct. 30, 1895.

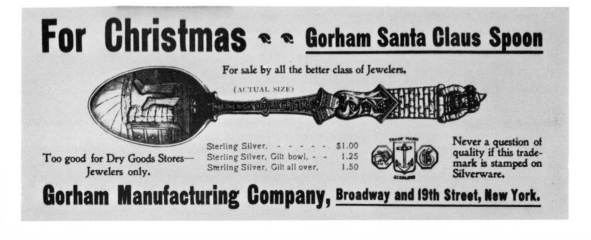

For Christmas ❧ ❧ **Gorham Santa Claus Spoon**

For sale by all the better class of Jewelers.

(ACTUAL SIZE)

Sterling Silver,	$1.00
Sterling Silver, Gilt bowl,	1.25
Sterling Silver, Gilt all over,	1.50

Too good for Dry Goods Stores— Jewelers only.

Never a question of quality if this trademark is stamped on Silverware.

Gorham Manufacturing Company, Broadway and 19th Street, New York.

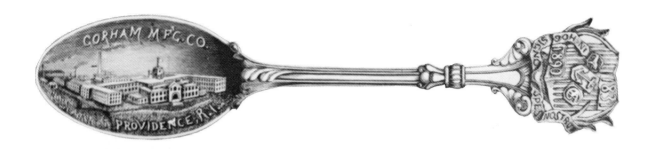

811. GORHAM MANUFACTURING COMPANY. From *Souvenir Spoons of America*, p. 77. (Courtesy Ray Schuster, El Paso, Tex.)

In the 1880s, Jacksonville was the mecca of Florida tourists. Its popularity declined with the Florida East Coast Railway extension southward. Greenleaf & Crosby catered to this tourist trade, carrying fine silver, magnificent diamonds, and other quality jewelry lines. Until World War I ended its manufacture, they carried an exclusive orange-blossom design fine china, made by Limoges. Greenleaf & Crosby followed the rich tourist circuit. They had a summer store in Hot Springs, Va.; winter stores in The Alcazar and Ponce de Leon hotels, St. Augustine, and in the Royal Poinciana and The Breakers hotels, Palm Beach—all of which were built by Henry M. Flagler, builder of the Florida East Coast Railway. The firm also had 2 year-round stores; one in Jacksonville and one in the Cordova, St. Augustine—another Flagler hotel. Later, a year-round store was opened in the part of Miami known as Bal Harbour, and is still in existence under the name Greenleaf & Crosby. It is the only establishment carrying that name today, the others having been bought out by William Scheer, Inc., during the Depression.

Greenleaf & Crosby are known to have manufactured many of the products sold in their stores and the second story of the main Jacksonville store was a "well-appointed and thoroughly equipped manufactory of Florida souvenirs."

They are said to have had a die press used in making some of their specialties. Described by one jeweler who had worked with it as "...an enormous affair working on ra₂tįchet principle with both male and female dies...and finally sold for scrap iron...."

A number of souvenir designs were theirs exclusively. Their souvenir spoons were especially popular. They are said to have sold as many as 500 a day in season. Two of their best sellers were the Alligator and Sunny South, the portrait head of the latter modeled from Johnnie Griffin, an *Evening Telegram* Negro newsboy.

GREENWOOD, FREDERIC & CHARLES F., Norfolk, Va.
Firm: C. F. Greenwood & Bro., j., c. 1891.

GROSJEAN, CHARLES T., New York, N.Y.
Designer for Tiffany c. 1885. Probably son of Charles Grosjean (firm: Grosjean & Woodward, ss., New York, 1852-62) who was a ss. in Wurtemberg, Germany, moved to New York in 1836; and d. there Jan. 30, 1865.

HABERL, PAUL A., Denver, Colo.

(b. Newark, N.J.; d. July 4, 1936.)
Pioneer j. in Denver. Parents moved to Denver by oxcart when Paul was 2 years of age. Ignatius Haberl, his father, established jewelry shop where young Paul served as apprentice after attending the old Arapahoe school. Continued father's jewelry business and was known throughout the state for the jewelry he made for Colorado pioneer women during the flourishing days of the Tabors and the Moffats. Sold jewelry store c. 1916 to manufacture patented fishing-rod tip.

HAMILTON, FRANCIS C., Syracuse, N.Y.
D 1894 listed name only.
D 1899 commercial traveler.
D 1900-02 salesman.
D 1903-14 author.
Last entry "removed to New York City." Commercial traveler, editor of Commercial Travellers Home Association Magazine, proprietor of an adv. company, proprietor of Prize Picture Puzzle Programme Company and secretary of Home Investment Association.

HARRIS, EDWIN, Washington, D.C.
Firm: Harris & Schafer, j., 1880-1938 (Edwin Harris & Charles A. Schafer).

HARRIS, REUBEN, Washington, D.C.
Firm: R. Harris & Co. (Reuben Harris & Abraham D. Prince), Established c. 1874, mfg. j. Still in business.

HART, JAMES, LTD., Brooklyn, N.Y.
j., c. 1891.

HEBBARD, HARRISON, East Orange, N.J.
(b. Aug. 28, 1874, New York; d. Sept. 1966, Short Hills, N.J.)
Attended New York University. An Army veteran (Co. I, Seventh Regiment of New York), his service may have inspired the design of the patriotic baby spoon.

Hebbard's father had worked for Dominick & Haff. At Mr. Dominick's suggestion, Hebbard joined the firm c. 1895, later becoming a partner and secretary. Retired in 1930.

His artistic talents were many. Concentrated mostly on oils and watercolor landscapes and seascapes of Nantucket, where he spent many summers.

HELANDER, LILLIAN V. M., Meriden, Conn.
Graduate of Rhode Island School of Design in Providence. Developed the asymmetric "Youth" pattern for Holmes & Edwards (div. of The International Silver Company) c.

1938-9. Also designed a World's Fair (1939) spoon for The International Silver Company which was distributed by the millions through a New York City newspaper.

HENDERSON, JOHN T., Catskill, N.Y.
j., adv. c. 1891.

HENNEGEN, BATES & COMPANY, Baltimore, Md.
Established 1857-60 in Wheeling, W. Va., by William H. Hennegen. Joined by James 0. Bates and John D. Reynolds prior to 1870. Moved to Baltimore, 1874. Agents for Gorham Mfg. Co. Baltimore
D 1874-c. 1930, j. & ss.

HESS, ROLLA W., St. Louis, Mo.
Firm: Hess & Culbertson. j., 1883 to present.
D 1891 Hess, Rolla, salesman.

HILBOM, HENRIK, Wallingford, Conn.
Of Swedish descent.
Designer with R. Wallace & Sons Mfg. Co., 1899-1942. Designed both flat and hollowware. Also noted for the excellence of his pen-and-ink sketches and watercolors.

HILL, ALVAN M., New Orleans, La.
Firm: A. M. Hill, j., adv. c. 1891.

HOFFMAN, FREDERICK W.
(*See* Marsh & Hoffman)

HOHEIN, GEORGE C., Norfolk, Va.
D 1902-10 insurance.

HOLLANDER, LEO, Salt Lake City, Utah
D 1892 watches, clocks, jewelry.

HOMAN, JOSEPH T., Cincinnati, Ohio
Son of Henry Homan, one of the founders of Homan Mfg. Co., established in 1847 to make pewter; later britannia and electroplated silverwares. The spoon-cup he designed in 1897 was part of Homan Mfg. Co.'s regular ecclesiastical line and intended for use by Catholic clergy in visiting sick.

HOMER, GEORGE E., Boston, Mass.
(b. c. 1858; d. Feb. 1, 1925, Belmont, Mass)
Established jewelry business with his brother, Joseph J., 1875. Business grew rapidly and additional stores were opened in Providence, R.I., Portland, Me., and Lowell, Taunton, and Ayer, Mass. These were discontinued after Joseph's death, before 1922. Same year George completed a new building for his store at 45 Winter Street, Boston. This firm still in business (Fig. 812).

HOOKER, ISABELLA BEECHER, Hartford, Conn.
(b. 1822; d. 1907.)
Half-sister of Harriet Beecher Stowe. "I have designed this Souvenir Spoon as a memento of my sister, and, should the sale of it bring some return to me, I shall delight to spend it largely in ways which she would have approved and for objects that always had her sympathy."

HORN, FREDERICK F., Colorado Springs, Colo.
(b. 1851, Watford. England; d. Mar. 1, 1925, Colorado Springs, Colo.)
Entered business Colorado Springs c. 1880 as a lapidary and native stone cutter.
D 1886-1925 lapidist and j.
D 1894 mining broker.
D 1895 lapidist.
D 1900 broker.
D 1902 real estate.
D 1904 mgr., Colorado Mineral Water Co.
D 1906-9 secretary, El Paso Co. Horticultural Society
D 1910 Electro-Metallurgical & Specialties Co., arts and

The Golden Rod Spoon.

George E. Homer, of 45 Winter street, Boston, Mass., is offering to the trade the

new "Golden Rod" spoon, illustrated in this paragraph. These goods are made in only sterling silver in coffee and tea sizes.

812. From *Jewelers' Weekly,* Dec. 6, 1893.

crafts novelties, mfrs. of Dodge-Camp adjustable chandelier.
D 1912 landscape gardener.
D 1913-16 gem cutter, Colorado Turquoise Co.
D 1917-20 rep., Toltec Oil Co.
D 1922 investments.
D 1925 Horn, Evalyn (widow of Fred F.)
One of the originators of annual regional flower show. Instrumental in reclamation of land near Fountain Creek and of formation of Dorchester Park, south of Colorado Springs. A semi-invalid from c. 1881, an adept and talented wood carver. Carved fanciful and grotesque figures from wood which were sold as souvenirs of Pikes Peak region.

HOWARD STERLING COMPANY, Providence, R.I.
Established in 1878 as H. Howard & Co.; later Howard & Scherrieble; Howard, Scherrieble & Co.; Howard & Son and by 1892, Howard Sterling Company. adv. *Jeweler's Weekly,* c. 1891 as The Sterling Company (Fig. 813). Between 1892 and 1901 became Roger Williams Silver Co.; merged with Mauser Mfg. Co. and Hayes & McFarland to form Mt. Vernon Silversmiths, Inc. Bought by Gorham Corporation in 1913.

The firm occupied part of Enterprise building owned by Kent & Stanley. A portion of the floor occupied by the

THIS

IS

THE

ALL AMERICA

COFFEE SPOON

REFERRED TO IN RECENT ISSUES AS

THE PAPPOOSE.

THE STERLING COMPANY,

HEAD OFFICE AND WORKS:

7 EDDY STREET,

PROVIDENCE, R. I.

THIS SIZE

NOW READY

FOR DELIVERY.

813. From *Jewelers' Weekly*, Sept. 30, 1891.

latter was also occupied by Parks Brothers & Rogers. The branch of the Howard business devoted to plating was sold c. 1892 to Parks Brothers and Rogers with Howard Company ceasing the mfr. of plated wares and devoting all their attention to sterling. The Parks Brothers and Rogers trademark (clover leaf within a horseshoe) is similar to Howard Co. mark H (Gothic letter), cloverleaf, symbol for the English pound sterling.

HOWE, DAVID (*See* Reed & Barton)

HUDSON, H. G., Amesbury, Mass.
j., adv. 1891-c. 1904.

HUGHES, JOSEPH A., Corpus Christi, Tex.
D 1908 partner in Craig-Hughes Land Company.
D 1915-19 real estate.
In September, 1919, a hurricane destroyed most of Corpus Christi and killed more than 300 people. Hughes was not listed after that date, nor on casualty lists, nor in any area cemetery records. He may have been one of the many unidentified victims.

THE INTERNATIONAL SILVER COMPANY, Meriden, Conn.
Incorporated in 1898 by a number of independent New England silver manufacturers, some of whom trace their beginnings back as far as 1808 when pewterer Ashbil Griswold set up his shop at Meriden.
Among the best known of the souvenir spoons (Fig. 814) produced by INSILCO are the State Seal series and the President spoons. Others, originally produced to appeal to children, are avidly collected by adults. Among these are Mary Poppins, Charlie McCarthy, Mickey Mouse, Howdy Doody, the Campbell Kids, Dennis the Menace, Woody Woodpecker, Tony the Tiger, Huckleberry Hound, Yogi Bear, and many others designed as premiums. International Silver Co. sold in 1988.

JACCARD, EUGENE G. E., Kansas City, Mo.
Member of the firm Jaccard Jewelry Company (c. 1891) founded in St. Louis as L. Jaccard, Watchmaking, c. 1829. The Jaccards, of French Huguenot stock, came from the Jacquard family who founded the Jacquard Looms, Lyons, France. Some of their early silver pieces were trinkets for the Indian trade.

JACKSON, AUSTIN F., Taunton, Mass.
(b. England)
Brought from England by Reed & Barton in 1889 as

successor to W. C. Beattie, designer. Began immediately to establish the name of Reed & Barton as a leader in the field of silver design. The increase in sterling sales by R & B c. 1890 was largely a result of Jackson's successful designing. Flatware sales were tremendous. In 1890 three patterns were introduced; two in 1891; two in 1892 and one each year thereafter for several years. In addition to these, Jackson designed, in 1891, numerous coffee spoons which were extremely popular.

JACOBS, GEORGE T., Washington, D.C.
D 1892 model-maker.

JACOBS, HENRY H., Washington, D.C.
Firm: Jacobs Bros., (Henry H. & Montague D. Jacobs) j., adv. c. 1891.

JACOBS, SAUL ROBERT, Alameda, Cal.
D 1907 real estate.
D 1914 jewelry.
D 1915-17 salesman.

JAMESON, WILLIAM ARTHUR, Niagara Falls, N.Y.
(b. near St. Stephen, N.B., Canada)
Son of Charles Jameson, shipbuilder and farmer of Scottish ancestry. Early acquaintance with mechanics influenced his later career. In 1870 he went to Hartford, Conn.; obtained situation with Weed Sewing Machine Company, general repairs; afterwards spent several years at carpentry and building. In 1877 removed to Wallingford, Conn., taking a position with the Oneida Company, which was just arranging to manufacture spoons, forks, etc. Remained there until 1881 when the company moved its works to Niagara Falls, N.Y., May 1, 1881. He removed to the latter place, superintended the construction of the factory buildings and installed the machinery for manufacturing plated ware. Served as superintendent there until Apr. 1, 1893, when he started a new enterprise, the Niagara Silver Company. As mgr., he obtained the land, supervised erection of buildings, purchased and installed machinery, and turned out the first finished spoon July 15, 1893.
Also a stockholder in Carter-Crume Company, of which Niagara Silver Company was a branch; also stockholder in the Oneida Company, in several building and loan associations, and in land companies. Listed in Niagara Falls D 1886 general foreman, Oneida Community, Ltd.

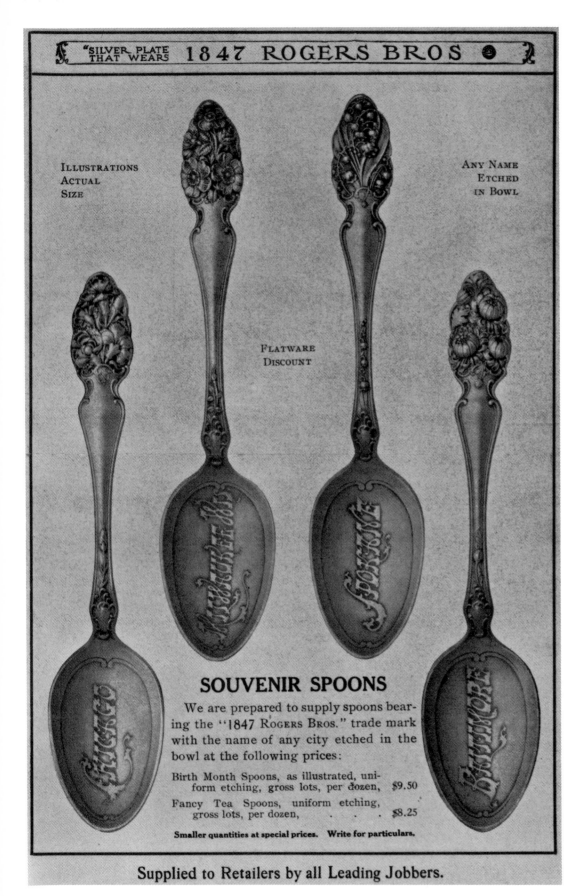

814. THE INTERNATIONAL SILVER COMPANY.
From *The Silver Standard*, Feb. 1910.

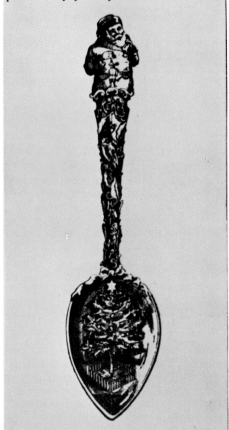

815. From *Jewelers' Weekly*, Nov. 16, 1892.

D 1893 foreman, Rodwell Mfg. Co.
D 1896-99 mgr. Niagara Silver Co.
D 1901-1918 general superintendent, William A. Rogers, Ltd. [successor to Niagara Silver Co. and purchased by Oneida Silversmiths in 1929.]
His sons, Walter R. and Howard D. listed in 1918 as assistant superintendent and die sinker, respectively, William A. Rogers, Ltd.

JAMOUNEAU, WILLIAM H., Newark, N.J.
President and secretary of Alvin Mfg. Co., founded in 1886 and incorporated August 17, 1887, for manufacturing sterling silverware and novelties. Designed many souvenir spoons produced by the Alvin company. Retired in 1898.

JARECKI, HERMAN T., Erie, Pa.
(b. June 1839, Germany, d. Oct. 7. 1909, Erie, Pa.)
Came to the United States with his parents as a boy. In jewelry business c. 1864-1909. Designed with George A. Disque.
JOHANNES, IRA H., Washington, D.C.
j. w. 1891.
JOHANSON, ANTON W., Chicago, Ill.
Firm: A. W. Johanson & Co., retail j. w. 1916.
JOHNSTON, JOHN H., New York, N.Y.
j. & distributor of sterling and plated silver novelties, established in 1844. Patented numerous souvenir articles (Figs. 815 & 816). Adv. widely in nationally circulated magazines. Out of business before 1915.
JONES, WILLIAM P. & WILLIAM B., Newburyport, Mass.
William P. was an apprentice of William Moulton IV and afterwards in partnership with Anthony F. Towle (Towle & Jones, 1857-73). They were brothers-in-law; Anthony F. Towle married William P. Jones' sister, Hannah 0. Jones, of Rings Island, Salisbury, Mass.

William Bartlett Jones was son of William P. Jones. For many years he was connected with the Raymond-Whit-

816. Undated "flyer."

817. From *Stockton and San Joachin County Illustrated*, 1895.

comb Travel Agency, Boston. He never married but lived with a spinster sister (Harriette) on Boardman Street, Newburyport, and commuted daily to Boston.

The Towle Silversmiths have no record of William B. having done any designing for them, nor any record of his connection with silversmithing in any way. The back of the Lord Timothy Dexter spoon is clearly embossed W. P. Jones along with the Towle trademark. On the patent papers, the drawing sheet gives the name as W. B. Jones, top and bottom, as inventor. The specification sheet lists William B. Jones at the top, in the body of the description and at the bottom. Witnesses are given as William P. Jones and Charles C. Dame.

JOSSELYN, BENAGE S., Denver, Colo.
Member of the Knights Templar of Colorado when his Knights Templar, Masonic, and Shriner spoons were designed and patented, 1892.

JUSTIS, JOHN C. C., Baltimore, Md.
John Christopher C. Justis, member of the firm founded by his great-grandfather, William S. Justis, in 1830. At first operated as a retail jewelry store on Pratt & Water Streets; later in larger quarters on East Baltimore Street, a wh. line was added. Two of William S. Justis' sons associated with their father. Baltimore fire (1904) destroyed the company's building but temporary quarters were used on Clay Street until rebuilding at 30 East Baltimore Street was completed.

William S. Justis, founder, outlived his sons and at his death, the business was taken over by William M. Justis, grandson. He, in turn, left it to his son, John C. C. Justis. The company continued to operate as a jewelers' supply house, specializing in watch and clock repairing. Continued to be listed in city D until 1956.

A related firm, Justis & Armiger, listed 1886-1961, mfrs. of silverware, solid and plated. John C. C. Justis listed as member of that firm which appears to have been succeeded by James R. Armiger. John C. C. Justis' independent listing continues through 1956; also listed with Armiger firm, apparently a retail outlet.

KAISER, ALEXANDER, Stockton, Cal.
(b. c. 1872, Cal.)
Son of Morris L. Kaiser, native of Prussia.
D 1893 dealer in jewelry, silverware & optical goods (Fig. 817). Practical watchmaker, j. & engraver.

"Mr. Kaiser grinding and fitting each [eye]glass especially to fit the eye per the doctor's directions ...he has become recognized as the optician in our city...."

KAISER, JOSEPH H., Brownville, Pa.
Son of Eramus Kaiser, j., who was born Freiburg, Baden, Germany. The father, Eramus Kaiser, learned the trade of watch and clockmaking in Germany and came to America in 1848. First located at Hollidaysburg, Pa., until 1850 when he went to Greensburg, Pa., from which he moved to Brownsville in April 1852, and established a jewelry store. Four children: Charles, Lizzie, Joseph and William F.

Joseph Henry Kaiser engaged in mining business near Goldfield, Nev., but considered Silver Creek, N.Y., his residence.

William Frederick, the youngest child, born in Brownsville, Pa., Oct. 10, 1871, became an expert j., continuing as his father's assistant until the death of the latter. He then became owner of the business. It is no longer in existence.

KARR, HENRY C., Washington, D.C.
Firm: J. Karr, j., watchmaker, w. c. 1891.

KARR, JACOB, Washington, D.C.
Firm: J. Karr, j., adv. c. 1890-91, "Exclusive sale of mementoes from Washington monument."

KEITH, ALBION
(*See* J. A. Merrill & Co.)

KELLEY, JOSEPH B., Rockford, Ill.
Mgr., secretary and treasurer of Rockford Silver Plate Co., established 1873; moved to Rockford, Ill. from Racine, Wis. in 1875; merged with Racine Silver Plate Co. in 1882 and forced to close in 1920 when it was succeeded by Sheets-Rockford Silver Plate Co. Raymond Sheets, who continued to operate company as a resilvering plant for some years, said that the stock of the company was purchased by S. L. & G. H. Rogers Co., which was, in turn, purchased by Oneida, in 1929. The Jeweler's Crown Guild, for which Kelley designed and patented a spoon, was incorporated in Rockford in 1892. No record of this organization in Rockford Public Library.

KENT & STANLEY, Providence, R.I.
Kent & Stanley (E. F. Kent & A. W. Stanley) were successors in 1888 to Wm. H. Robinson & Co., who began in 1873. They owned the Enterprise building, Providence, which was occupied by themselves and other silver and jewelry

mfrs. Kent & Stanley occupied top floor; the floor below was occupied by Hamilton & Hamilton, Jr.; beneath them was Howard Sterling Co., with a portion of that floor being occupied by Parks Brothers & Rogers. Kent & Stanley incorporated in 1891. Listed in Providence D 1889-97, mfrs. of silver souvenir articles. One of their trademarks was a drawing of the America's Cup, also subject of souvenir spoons made by Howard Sterling Co. (*See also* Howard Sterling Company)

KIMBELL, JOHN LAMAR, JR., Shreveport, La.
(b. Apr. 3, 1893, Homer, La.)
Son of Dr. & Mrs. John Lamar Kimbell. Mrs. Ada Kimbell was an active Colonial Dame, descended from William H. Prescott, historian. Her interest in the family's ancestry led John into joining John Hancock Society. He designed C.A.R. spoon during his teenaged years, at the request of the society. Studied art at Chicago Art Institute. After serving in France during World War I, practiced trade of photo engraving and color etching, until retirement in 1964.

KINSLEY, MYRON H., Wallingford, Conn., & Niagara Falls, N.Y.
Superintendent of an Oneida Community branch factory at Wallingford, where they began mfr. of tableware in 1877. Instrumental in moving silver business to Niagara Falls in 1880 where the water power was just beginning to be used. In 1882, mgr. of Oneida Community Ltd. for mfr. of plated silver.

Prominent in local affairs; active in real estate and in developing Niagara Falls hydroelectric power.

The Niagara Falls Suspension Bridge spoon he designed in 1881 was first spoon patented in United States commemorating a person or place and was probably inspired by his interest in Falls. Kinsley had visited Niagara Falls to determme the feasibility of moving the factory prior to actual move.

Some of his direct descendants were later prominently employed by Oneida Silversmiths.

KIRK, SAMUEL & SON, INC., Baltimore, Md.
Founded in 1815 and now the oldest surviving silversmithing firm in United States. Though the Kirk company has no record of its manufacture, the Sons of the American Revolution spoon bears their name and features Baltimore monuments. In September 1979 the Kirk Company and the Stieff Company jointly announced their merger. Known today as Kirk-Stieff.

KNORR, FRED J., Bloomington, Ill.
(b. 1868, Louisville, Ky.; d. 1947, Bloomington, Ill.)
Settled in Bloomington, July 4, 1888.
D 1889-1903 watchmaker.
D 1904-05 artist.
D 1942-44 first listing since 1905, name only.
Served 8 years in Illinois National Guard and in Spanish-American War. Considered finest engraver in Illinois. In early days was contacted by a gang in Kentucky, requesting him to cut counterfeit plates for $5 and $10 paper money—an honor he declined.

KNOWLTON, F. A., Worcester, Mass.
j., adv. c. 1891.

KOCH, ALMA, Louisville, Ky.
D 1892 clerk.

KOLB, GUSTAVE FREDERICK, Mt. Vernon, N.Y.
(b. c. 1865, New York, N.Y.; d. Aug. 28, 1945, Mt. Vernon, N.Y.)
Moved to Mt. Vernon in 1900. General superintendent and treasurer of Mauser Manufacturing Company which he later left to establish his own ss. business in New York City. Retired from this business in 1921 but continued as director of the George Borgfeldt Corporation, manufacturers' representatives and importers of glass and stemware.

Kolb supervised the building of the factory for the Mauser company. While with that company instrumental in persuading the New York, New Haven and Hartford Railroad to build the Columbus Avenue station, in Mt. Vernon, to accommodate commuters to New York City. Active in civic affairs and largely responsible for establishing a policeman's pension fund.

KRIDER, PETER L., CO., Philadelphia, Pa.
Founded by Peter L. Krider who was born 1821 in Philadelphia. At the age of ten he went to work on a farm where he remained until his fourteenth year. He was then apprenticed to John Curry, silversmith on Chestnut St., in Philadelphia, whom he served for six years. Curry retired because of failing health and transferred Kriders indentures to R. & W. Wilson, silversmiths also in Philadelphia. With this firm he worked as a journeyman for fifteen months at the end of which time he entered into a four-year contract with Obadiah Rich, silversmith in Boston. Two years before the conclusion of this contract, c. 1839, Rich sold out to Bracket, Crosby & Brown with Krider taking charge of the business.

Krider had become a highly skilled silversmith and after serving as foreman a short time in the factory of his old employers, he went into business for himself. In 1859 he took into partnership John W. Biddle. The firm name became Krider & Biddle in 1860.

During the Civil War, Krider served in the army while Biddle carried on the business. Five or six years after the war Biddle retired and Krider continued until c. 1889, when he sold out to August Weber who had served him in the capacity of a clerk. Weber later took a partner, W. E. Wood, and carried on the business for some years under the name P. L. Krider Company.

LADD, FRANK E., Springfield, Mass.
j., w. c. 1892. Firm: Frank E. Ladd.

LARSON, JOHN, & VAN SLYKE, JAMES M., Madison, Wis.
adv. as mfr. j. c. 1892.
D 1883-84 James Van Slyke, student.
D 1886 John Larson, watchmaker.
D 1890-91 John Larson, mgr., Belden Jewelry Store.
D 1892-93 John Larson & Co., James M. Van Slyke. mfr. j. (wh. & retail).
D 1896-97 James Van Slyke, employee Gorham Mfg. Co. (sterling silverware).
D 1898-99 Larson Jewelry Store, Van Slyke not listed.
D 1900 John Larson, mfr. Larson Pneumo-Electric Aural Masseur; James Van Slyke, j.
D 1902 John Larson not listed after this date.
D 1904-11 James Van Slyke, state agent for Southwestern Slate & Manufacturing Co.

LEDING, ROBERT, Washington, D.C.
Part owner, with Thomas S. Moore, of Moore & Leding, j., 1882-1900, when Robert Leding became successor.

LEONARDI, SIDNEY B., Tampa, Fla.

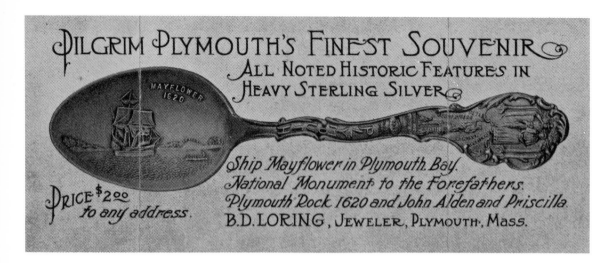

ALL NOTED HISTORIC FEATURES IN HEAVY STERLING SILVER

Ship Mayflower in Plymouth Bay.
National Monument to the Forefathers.
Plymouth Rock 1620 and John Alden and Priscilla.
B.D. LORING, JEWELER, PLYMOUTH, MASS.

PRICE $2.00 to any address.

818. Undated "flyer."

(b. Tampa 1862; d. New Rochelle, N.Y.)
Son of Bartholomew Leonardi who moved to Tampa in 1855 from St. Augustine with his brother Vincent. The Leonardi family is of Itaiian descent and is said to have moved to Florida with the Andrew Turnbull Minorcan Colony of 1768. Bartholomew and Vincent were architects. Sydney was a chemist; owned the leading drugstore in Tampa and later manufactured drugs. He held several drug patents which were financially successful. Married Alla Buff, of Indiana, who was an artist and taught painting. A Tampa resident who knew the family commented that, "If a Leonardi designed the [Luna Via Tampa] spoon, I rather think she would have been the one." The Leonardis moved to New York State in 1914 where the widow died in 1956.

LOGAN, MILLIE B., Rochester, N.Y.
Registered the Susan B. Anthony portrait as a trademark for gold and silver tableware, Nov. 17, 1891. Listed in 1896 *Jewelers' Circular Trademarks* among mfrs. of souvenir silverware. Rochester D 1871-1908 mfr. of ladies' fashionable hair work, hair jewelry, etc.

LORING, BENJAMIN D., Plymouth, Mass.
(b. Feb. 22, 1871, Charlestown, Mass.; d. 1940.)
Loring's, a prominent name in jewelry and watchmaking, has been operated continuously by the same family since 1894 (Fig. 818). Established by Benjamin D. Loring, father of the present owners, Charles & Bernard Loring.

LOW, SETH FREDERIC, Salem, Mass.
(b. July 17, 1867; d. in 1930s.)
Firm: Daniel Low & Co.
Son of the founder of Daniel Low & Co., Salem. In 1885 he entered his father's business which was founded the year Seth Low was born. In 1896, Seth Low became a partner, succeeding to the business in Feb. 1911 when Daniel died.

It is Daniel who is credited with the idea of the Salem Witch spoons which led to the widespread popularity of souvenir spoons. But the spoons were designed by Seth, who was also in charge of making up catalogs and directing the mail department. The Daniel Low Yearbook, now a national institution, was the first gift catalog of the jewelry trade. From the beginning it was successful, with many thousands of people in this country and throughout the world depending on it to solve their gift problems. The retail store expanded with the mail-order business so that several times it has been necessary to move to larger quarters. Their present showrooms are considered one of the tourist attractions of Salem.

LUDWIG, ADOLPH, Brooklyn, N.Y.
Firm: Ludwig-Rediich & Co., Iater Redlich & Co., Inc. Taken over by Elgin Silversmith Co., Inc. in 1946.

MACKEWICZ, ALEXANDRA A., Meriden, Conn.
w. c. 1930-40. Made the drawings for the President series of spoons made by The International Silver Company. Married c. 1940 to Edward T. Dabrowski, and for a short time continued working in the Design Department.

MCNAIR, EDWARD, Newark, N.J.
D 1890-1928 j. and op.
D 1900 jewelers' supplies.
D 1907-08 American Oil & Supply Co.
All other listings as j. and op.

MARSH, BENJAMIN
(*See* Marsh & Hoffman)

MARSH & HOFFMAN, Albany, N.Y.
j. & ss. w. 1891 (Benjamin Marsh & Frederick Hoffman).

MAUSER MANUFACTURING COMPANY, Mt. Vernon, N.Y.
Gold & ss. established in 1881 to manufacture sterling silver and silver-mounted cut glass, novelties, hollowware, and dresserware. The factory, the construction and fitting of which was supervised by Gustave S. Kolb (*see*), was considered most complete and modern. The plant was entirely operated by electricity furnished by a power plant on the premises. In 1903 they merged with Hayes & McFarlane Co., Mt. Vernon, and Roger Williams Co., Providence, R.I., to form the Mt. Vernon Company Silversmiths, Inc. Purchased by the Gorham Corporation in 1913.

MAYER, DAVID, Hartford, Conn.
Firm: David Mayer, j. w. 1891.

MAYER, JOSEPH
(*See* Joseph Mayer & Bros.)

MAYER, JOSEPH & BROS., Seattle, Wash.
Established c. 1895 as Joseph Mayer & Bros.; Joseph Mayer, Inc., c. 1920; later Northern Stamping and Mfg.

Co. (still used for some articles); purchased by E. J. Towle Mfg. Co. c. 1945. Mfr. of many souvenir spoons, especially for the western states. Noted for fine quality of die sinking. In 1980 the company was sold to Raoul Le Blanc.

MAYO, BENJAMIN J., Newark, N.J.
ss. w. c. 1860-1902. Began 1860 as Smith & Mayo.
D 1871 silver plater and mfr. of silver ware.

MEALY, JOHN W., Baltimore, Md.
D c. 1886-89 salesman.
D 1900 Tohn W. Mealy & Son Co., j.
D 1906 pres., John W. Mealy & Son Co., Edward H., treas. and Charles A. (who died in 1936), sec.
Company name listed through 1956.
D 1937 Judson S. Mealy.
D 1961 Helen F., widow of Judson S.

MERCER, HARRY, Birmingham, Ala.
(b. Sept. 1841, Philadelphia, Pa.; d. c. 1901.)
Son of Henry Mercer, shipbuilder of the celebrated Wm. Crump & Sons, Philadelphia. Attended mechanical college where he learned the rudiments of steam engineering. When 17, began to learn the trade of watchmaker and j. In 1865 served briefly in State militia. Served one year in city surveyor's office. Moved to Alabama in 1868 and engaged in watch and jewelry business for 2 years with Otto T. Stoelker; then to Opelika, Alabama, where he conducted his own business for 10 years. Established his business in Birmingham in 1880 and operated it successfully until his death.

MERRILL, GEORGE D., East Orange, N.J.
(d. c. 1918-20.)
w. c. 1882-c. 1918-20. Connected with Elizabeth T. Merrill who was in art metalwares business, 1908-?. Elizabeth T. Merrill last listed D 1957.

J.A. MERRILL & CO., Portland, Me. j., w. 1891 (Jonathan Ambrose Merrill & Albion Keith).

METZGER, HENRY, Kansas City, Mo.
j. associated with Paul Margolis, c. 1891-1904.

MIDDLETON, HUGH C., Augusta, Ga.
D 1896-1929 listed by name. Moved to Washington, D.C. and was employed at Library of Congress until c. 1948.

MOSES, HARRY M., Richmond, Va.
D 1879-80 clerk & agent, A. S. Barnes & Co.
D 1881-87 Goddard & Moses (Isaac Goddard & H. M. Moses), watchmakers and j.
D 1892-95 H. M. Moses Co., watches & jewelry.

MURRAY, DANIEL I., Dayton, Ohio
Firm: Murray Jewelry Co., W. 1892.

MUTH, EDWARD A., Buffalo, N.Y.
(d. c. 1934-35.)
D 1893 Edward A. Muth & Nicholas Kos, j. (Muth & Kos).
D 1894-1900 Edward A. Muth.
D 1901 American Souvenir Co.
D 1902 National Novelty Co.
D 1908 only home address listed.
D 1921 Union Souvenir Co., Inc., wh. and also listed as Edward A. Muth & Son, leather goods.

MYERS, S. F., New York, N.Y.
Notes from *Jewelers' Weekly:*
1882—Samuel F. Meyers of S. F. Myers Co. married to Miss Bertha Adler. S. F. Myers Co. will move May 1 from 304 to 179 Broadway.
1885—S. F. Myers & Co., after May 1, will occupy offlces at 50 Maiden Lane.

1886—S. F. Myers & Co. have added Simon Blumauer as a partner.
1889—The pioneer house in the jewelry trade to break loose from the ties binding them to public corporations in respect to furnishing of electric light is S. F. Myers & Co. They invested, at large expense, in an electric plant and installed it in one of their basements.

The spoon Myers designed, with Electrical Building at World's Columbian Exposition, Chicago may have been a manifestation of his interest in electricity.

Out of business before 1915.

NERNEY, GEORGE E., Attleboro, Mass.
Artist employed by The Robbins Company c. 1913.

NYE, GEORGE E., Providence, R.I.
D 1895 j.
D 1915 silver finisher.
D 1919 listed only by name.

OFFICER, JULIA, Council Bluffs, Iowa
(b. Dec. 17, 1858; d. Dec. 2, 1940.)
Concert pianist.

ONEIDA SILVERSMITHS, Sherrill, N.Y.
The Oneida Community, an experiment in communal living, began the manufacture of tableware in 1877 at Wallingford, Conn. where a branch of the Community had been started in 1852 on the farm of Henry Allen. Ungraded, tinned, iron spoons, in two patterns, *Lily* and *Oval*, were the direct ancestors of the whole Community Plate line.

819. Spoon made by Oneida Silversmiths. From Ainslee's Magazine, May, 1902.

Competition was keen and these first products could not compete with those of other companies. The decision was made to produce a better quality and better designed line. The first, called *Avalon*, was exhibited at Buffalo Exposition in 1901.

That same year an arrangement was made with American Cereal Company, makers of Quaker Oats, for production of a special cereal spoon. The resulting *Cereta* pattern, developed by Julia Bracken (Wendt), was used to promote Quaker Oats for years (Fig. 819). It was widely advertised and an important factor in acquainting the public with the quality of plated silverware produced by Oneida.

In addition to their regular full line of silver patterns, Oneida company still produces many commemorative and premium designs.

OSBORNE, CHARLES, New York, N.Y.
Designed for Whiting Mfg. Co. c. 1891. Possibly related to Frank N. Osborne, wh. j. and distributor, New York.
OSWALD, JULIUS A., Crawfordsville, Ind. Moved from Memphis, Tenn., c. 1900 and opened jewelry store in Crawfordsville; in business until 1911. Oswald and son, Chester, moved to Ft. Wayne, Ind., first as diamond salesman and later opened jewelry store. The son continued the jewelry business until retirement.
OTERO, CHARLES, Pueblo, Colo.
(b. c. 1854, Mexico; d. May 27, 1913, Long Beach, Cal.)
Of Spanish descent. Moved with parents to Santa Fe, N.M.; attended Christian Brothers University there, 1865-6. Afterwards, studied designing and manufacturing jewelry. In 1872, with W. C. Burdick, watch repairer, started small business in Pueblo, Colo., eventually taking over the whole business.

Active in various civic affairs, including old volunteer fire department; organized Volunteer Fireman's Association and was its first president.

Interested in music and other arts. Designed silver spurs and silver mounted revolvers. Practically every jewel and specially designed piece of work presented in lodge circles in Pueblo was the work of Charles Otero.
PARKER, EDWIN M., Bridgeport, Conn.
D 1871 j. with Blackman & Warner.
D 1876 Firm: Warner & Parker (partner with James P. Warner).
D 1890 Firm: Parker & Davis (partner with Charles D. Davis).
D 1898 retired.
D 1902 moved to New York. **PAYE & BAKER MFG. CO.,** North Attleboro, Mass.
Successors to Simmons & Paye before 1891. Large producers of souvenir spoons (Fig. 820). Out of business c. 1935.
PEACOCK, C. D., Chicago, Ill.
Established in 1837 by Elijah Peacock from London. Specialized in clock repairing and adjusting of chronometers for Great Lakes sailing vessels before Chicago was linked to the east by telegraph in 1848 or by railroad in 1852. Company became C. D. Peacock by 1838, incorporated in 1860. One of the first retail establishments to market flatware stamped with store name.
PEIFFER, A. H., Philadelphia, Pa.
Firm: Simons Bros. & Co., j., w. c. 1892.
PEIRSONS, HENRY C., Troy, N.Y.

820. From *Jewelers' Circular-Weekly*, July 10, 1907. (Courtesy of Noel D. Turner, Chicago, Ill.)

(b. Hudson Falls, N.Y.; d. July 22, 1920.)
Member of firm: F. W. Sim & Co., j. from 1888, until his death.
PERRY, ISAAC G., Great Barrington, Mass.
(*See* Perry & Fulcher)
PERRY & FULCHER, Great Barrington, Mass.
j. & ss. 1908 until 1911 or 1912. Isaac G. Perry, j.; Frank F. Fulcher, op.
PETERSEN, CHARLES, Honesdale, Pa.
Apprenticed as watchmaker with his father, Iven Petersen until his death in 1843. Charles completed his apprenticeship under Mr. Steinmetz, in Copenhagen. In 1848 he

821. From *City Directory, Bangor, Me., 1875-76.*

worked at his trade in Berlin, Prague, and Vienna. After participating in the 1849 Vienna Revolution, moved to Switzerland and studied under the celebrated Jules Jurgenson for 2 years. While there was granted a stipend by Danish government, enabling him to continue his study of the principles of watchmaking.

Came to New York City in 1851. Received offers of employment from several establishments. Chose to work for Moses Cummings of Honesdale, Pa. Within 6 months bought Mr. Cummings' establishment in partnership with his brother Herman Petersen, the firm being Petersen & Brother. Charles subsequently became sole owner.

In 1862, ran an experimental (the first) telegraph wire owned by the Delaware & Hudson Canal Co. which proved very successful. Became superintendent of the company's lines the same year.

PETTY, HORACE G., Fort Collins, Colo.
(b. Apr. 25, 1864, Fremont, Ohio; d. Mar. 16, 1944, Fort Collins, Colo.)
Apprenticed in watchmaking trade in Fairfield, Iowa. His interest in this field was aroused by the jewelry shop situated next door to his father's implement shop, where he spent many noon hours. Established the first jewelry store in Fort Collins. Associated with William Anderson in jewelry business for over 30 years.

PHILLIPS & ARMITAGE, Jamestown, N.Y.
j., c. 1891.

PINNEY (Phinney), GEORGE H., South Manchester, Conn.
Secretary of Williams Brothers' Manufacturing Company, Glastonbury, Conn. c. 1901.
(See Williams Brothers' Manufacturing Company)

POHL, GEORGE R., Washington, D.C.
Designed for Robert Leding, Washington, D.C. Listed in D as an architect.

POL, BERNHARD, Bangor, Me.
b. c. 1846, Gothenberg, Switzerland; d. Feb. 14, 1928, New York, N.Y.) j., watchmaker and op., established business in Bangor before 1876 (Fig. 821). Retired and moved to New York in 1926.

POTTER, ANTHONY U., Tampa, Fla.
(b. Ill. c. 1868; d. Tampa 1953.)
Moved to Tampa at age 22 on advice of physician following severe case of scarlet fever. Engraver; employed by H. Kistenmacher, j. Later owned a jewelry store with James H. Shirah. Afterwards engraver for Beckwith-Range Jewelers, a firm still in business.

RACINE, ULYSSES, Providence, R.I. Designed for Watson & Newell Company, Attleboro, Mass. c. 1893.

RAWSON
(See Squire & Rawson)

Trade Mark

Sterling

REED & BARTON,
—MANUFACTURERS OF—
Sterling Silver and Silver Plated Ware,

SALESROOMS: { 18 Maiden Lane, 37 Union Square, } NEW YORK.

925 Chestnut Street, PHILADELPHIA.
Venetian Building, CHICAGO.

Factories: Taunton, Mass.

822. From *Jewelers' Weekly.,* Jan. 17, 1894.

REED & BARTON, Taunton, Mass.
Founded in 1824 as Babbitt & Crossman. Underwent several changes in ownership, finally emerging as Reed & Barton c. 1840. Early products were britannia. By 1848 began mfg. plated silverwares. and sterling flatware in 1890 (Fig. 822). In late 1890s, David Howe of Reed & Barton invented a process of etching on metal so that souvenir spoons and a new type of patented baby spoon could be inscribed with appropriate scenes and verses.

REICHL, HANS, Seattle, Wash. (b. c. 1904, Germany.)
Accomplished die cutter and designer. Apprenticed in Germany in traditional manner. Was employed by the E. J. Towle Company, Seattle, and its predecessor, the Joseph Mayer Company, for about 35 years.

RICHARDSON, CHAUNCEY E., Duluth, Minn.
D 1887-88 stenographer, Richardson, Day & Co.
D 1888-90 bookkeeper, Richardson, Day & Co.
D 1890-91 real estate.
D 1891-92 secretary-treasurer, Cumulative Investment Co.
D 1893-97 clerk, City of Duluth.
D 1898-99 president, Richardson Printing Co.
D 1900-01 secretary, Mayor of Duluth and Board of Fire Commissioners.
D 1902 moved to Washington, D.C.

ROBBINS, FRANK A., Pittsfield, Mass.
(d. Feb. 10, 1926, Steelton, Pa.)
Firm: F. A. Robbins Company, j. before 1885 and succeeded by J. F. Kahl Company, j. & ss. before 1920.

ROBBINS COMPANY, THE, Attleboro, Mass.
Founded 1892 as Charles M. Robbins Co. for mfr. of campaign buttons. Ralph M. Thompson joined firm in 1904 and acquired ownership in 1910. Company name changed to Robbins Co. in 1912. Specialized in emblems, service and safety awards, badges, medallions, religious and organization jewelry, souvenirs, and costume jewelry. Still make numerous styles of souvenir spoons.

ROBERTS, MARSHALL O., Washington, D.C.
D 1893 clerk.

ROBERTS, STEELE F., Allegheny, Pa.
Firm: E. P. Roberts & Sons, j., ss., & art dealers, Pittsburgh, c. 1891.

ROBINSON, HENRY J., Washington, D.C.
Designed for Rieman & Dawson (John M. Rieman & Albert B. Dawson), j., in 1894. Draftsman with Munn & Co., Forest Glen, Md., in 1896.

ROCKFORD SILVER PLATE COMPANY, Racine, Wis., & Rockford, Ill.

Founded 1873 in Racine, Wis.; moved to Rockford, Ill., 1875; succeeded by Sheets-Rockford Silver Plate Company c. 1921 and operated as a re-silvering plant. The stock of the old company was purchased by Simeon L. & Geo. H. Rogers Company in the 1930s and all records destroyed or lost.

RUDISILL, WILLIAM W., Altoona, Pa.

j., out of business between 1905-10; d. shortly thereafter.

SCHALL, ERNST, Hartford, Conn.

Firm: Hansel (Hansell), Sloan & Co., j. adv. 1891.

SCHLECHTER, GUSTAVE A., Reading, Pa.

Designer and mfg. j. Specialized in novelties and fraternal jewelry, w. c. 1891-2.

SCHWATKA, FREDERICK, Rockford, Ill.

(b. Sept. 29, 1849, Galena, Ill.: d. Nov. 2, 1892, Portland, Ore.)

Arctic explorer. Graduated from West Point in 1871; as second lieutenant he studied both medicine and law while serving at army posts in the United States. From 1878-80 he and William Henry Gilder, of the *New York Herald*, led an expedition to King William Island through Hudson Bay and Chantrey Inlet in search of records and remains of Sir John Franklin's Arctic exploring party. During their search they made a sledge journey of 3,251 miles, the longest then on record. They were successful in finding some of the wreckage of the lost expedition and established that Franklin's records were irretrievably lost.

Schwatka next explored the course of the Yukon River in Alaska in 1883-84. In 1885 he resigned his army commission to devote himself to exploring, writing and lecturing. He led the *New York Times* Alaskan Expedition of 1886 and later made investigations of the Tarahumari Indians in Chihuahua in northern Mexico.

He was a member of the World's Columbian Exposition Commission, acting in an advisory capacity in the planning of Indian cliff dwelling, Alaskan and Northwest Coast Indian exhibits.

He was author of *Along Alaska's Great River* (1885); *Nimrod in the North* (1885); *The Children of the Cold* (1886); and *In the Land of Cave Dweller* (1893).

SCHWINN, FREDERICK, Attleboro, Mass.

Salesman for The Robbins Company c. 1915.

SCHOOLER, MAURICE, New Orleans, La.

(b. 1814, Wurtzberg, Bavaria; d. Apr. 25, 1900, New Orleans, La.)

j., specializing in precious stones. Designed bell for cruiser, *New Orleans*. Contemporary advertising for Louisiana pelican spoon reads, "originated and designed by Mr. Isadore Scooler, a member of the firm of M. Scooler."

SENTER, WILLIAM, Portland, Me.

Associated with his uncle, also William Senter, in jewelry, engraving, and nautical instrument business. Successor to jewelry business after uncle's death.

The elder William Senter (b. 1813, Portsmouth, N.H.; d. 1888) apprenticed in watchmaking trade under Oliver

823. From *Jewelers' Circular-Weekly*, Oct. 16, 1907. (Courtesy Noel D. Turner, Chicago, Ill.)

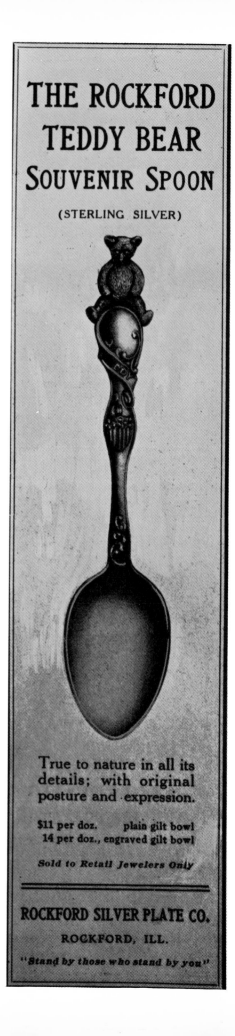

Gerrish, Portland, and from 1836-70 was in business with Abner Lowell. Elected Mayor of Portland in 1880.

SEYMOUR, JOS., MFG. CO., Syracuse, N.Y.

(b. 1815, near Albany, N.Y.)

Founder, Joseph Seymour, learned the ss.'s trade in New York City and was listed as ss. in 1835 D. From 1842-47, listed in Utica D as ss. About 1850 became a partner in Norton & Seymour (B. R. Norton), Syracuse. Firm became Norton, Seymour & Co. after 1850, and shortly after Joseph Seymour & Company when Joseph went into business for himself. Firm became Jos. Seymour, Sons & Co. in 1887 and Jos. Seymour Mfg. Co. c. 1900. Out of business before 1909.

SHANE, BEN, Milwaukee, Wis.

D 1908 department mgr. in retail store.

D 1910-20 L. F. Shane & Son hatters.

SHAW, GEORGE E., Putnam, Conn.

Firm: George E. Shaw & Co., Pomfret, Conn.

j. c. 1891-1922.

SHEPARD, CHESTER, Melrose, Mass.

(b. Sept. 17, 1838, Windham County, Scotland; d. July 10, 1902, Portland Harbor, Me.)

Worked as a carpenter c. 1857-72. Employed by Middletown Silver Company, Middletown, Conn., for 17 years. With his son, Chester B., established Shepard Manufacturing Company, Melrose, in 1893. They specialized in the manufacture of souvenir spoons, with engraving, painting, and enameling all done by hand.

SHEPARD MANUFACTURING COMPANY

(*See* Chester Shepard)

Many Shepard Mfg. Co. spoons bear the "circled S" trademark which has puzzled collectors.

SHERMAN, CAPT. JESSE T., New Bedford, Mass.

(b. Nov. 18, 1845, Dartmouth, Mass.; d. Aug. 6, 1916, Brockton, Mass.)

Capt. Sherman first shipped on a whaling vessel c. 1859. His first command was the bark *Swallow*. In 1892 sailed the bark *Progress*, one of the last of the old-time whaling vessels, to Quebec. She was cut into sections and carried through the canals for exhibition at World's International Columbian Exhibition, Chicago. With other New Bedford businessmen, established the New Bedford Tow Boat Company. Bought the first new steamer, *S. C. Hart*, c. 1896. Retired Apr., 1916.

SHERWOOD, CALDER S., Portsmouth, Va.

(b. May 22, 1846, Portsmouth, Va.; d. Sept. 11, 1919, Portsmouth, Va.)

w. c. 1861-3 in Gosport Navy Yard and aided in construction of *C. S. S. Virginia* and *Merrimac*. This experience probably led to the design of the Hampton Roads souvenir spoon. j. c. 1868 (Fig. 824). Director of Jamestown Exposition, 1907.

SHIEBLER, GEO. W., & CO., New York, N.Y.

Successors to Theodore Evans Co. prior to 1890. In 1892 negotiations were under way to combine with the Gorham company. Out of business prior to 1915.

SIEVERT, LOUIS, Fort Wayne, Ind.

D 1902 wh. & retail j. and op.

SIM, FREDERIC W., Troy, N.Y.

Firm: F. W. Sim & Co., j. In 1885 Frederic W. Sim succeeded business in which he had formerly been employed and carried it on under his own name. Firm still carries the name although no one of that family is now

C. S. SHERWOOD,
DEALER IN
WATCHES,
CLOCKS,
JEWELRY,
SILVERWARE,
DEPOT FOR DIAMOND SPECTACLES.
Special Attention given to Repairing Fine Watches and Jewelry
226 High Street, Portsmouh, Va.

824. From *Sketch Book of Portsmouth, Virginia: Its People and Its Trade.* Edward Pollock, Portsmouth, Va., 1886.

associated with it.

SIMONS BROS., Philadelphia, Pa.

j., ss. and watchmaker 1839 to date. Established by George W. Simons; Simons Bro. & Co. and Spicer, Simons & Bro. merged as Simons Bro. & Co., Jan. 1878. A 1902 design patent lists John F. Simons & Thomas Maddock, Philadelphia, Pa., Frederick M. Simons, Swarthmore, Pa., and Edwin S. Simons, Orange, N.J., trading as Sirnons Bros. & Co. (same as currently listed). Specialize inmfg. of thimbles.

SLOAN, FREDERICK H., Hartford, Conn.

Firm: Hansel (Hansell), Sloan & Co., j. w. 1890.

SMALLWOOD, DELLA GRAEME, Washington, D.C.

D 1893 school teacher.

SMITH, C. R., & SON, Philadelphia, Pa.

j. w. 1891. Founded as C. R. Smith in 1837.

SMITH, FRANK W., SILVER CO. INC., Gardner, Mass.

Founded by Frank W. Smith in 1882, manufacturing sterling flatware and hollowware principally. The Webster Company, North Attleboro, Mass., purchased all flatware tools, dies, and the tradename and trademark in October of 1958 and moved the flatware division to North Attleboro.

SNOW, RALPH L., Pawtucket, R.I.

(b. May 23, 1899, Pawtucket, R.I.; d. Nov. 13, 1960, Providence, R.I.)

Designer; graduate of Rhode Island School of Design, Providence. President and treasurer, Eastern Advertising Co., Pawtucket, c. 1913.

SOMMER, WILLIAM C. Springfield, Ill.

(b. Jan. 27, 1849, Buffalo, N.Y.; d. c. 1921-22.)

j., in business with his father in 1868. Superintendent,

Illinois Watch Company, 1881-86. j., Sommer & Pierik (John Pierik), 1886.
D 1900 Sommer & Pierik, j. and op.
D 1905 Sommer, William Co., op.
D 1921 op. & mfg. Op.

SOUTHWORTH, DEAN, Braintree, Mass.
Firm: D. C. Percival & Co., wh. j., Boston, 1892.
Firm: Dean Southworth & Co., j., Boston, 1892.

SPAULDING, HENRY A., Chicago, Ill.
Firm: Spaulding & Company, Chicago.

SPAULDING & COMPANY, Chicago, Ill.
j., established 1885 as successor to S. Heard & Co. Still in business.

SPEAR, GUY M., Waltham, Mass.
(b. c. 1864)
D 1888 Firm: American Waltham Watch Co.
D 1893 salesman.

SQUIRE & RAWSON, Bennington, Vt.
j., w. 1890.

STANLEY & CAMP, Milwaukee, Wis.
(See Arthur K. Camp)

STEVENS, JAMES R., Hartford, Conn.
Firm: Ernst Schall, j., c. 1891.

STEVENS, SYLVESTER GEORGE, Duluth, Minn.
(b. Chelsea, Ont., Canada, d. Aug. 16, 1949)
Patent attorney; invented Stevens revolving gate.

STEWART, ROBERT J., Mount Clemens, Mich.
(See George Chambers)

STOCKING, GEORGE B., Tacoma, Wash.
(b. June 12, 1853, Wesleyville, Erie County, Pa.)
Great-grandson of George Stocking (b. Suffolk, England) who emigrated to Massachusetts in 1633 and, with Rev. Thomas Hooker, went to Connecticut in 1636 and founded Hartford. Grandson of "Deacon Samuel" Stocking who helped to found Middletown, Conn.

George B. apprenticed as watchmaker in 1869. j. w. in Rochester, Minn. 187386; in Fairbault, Minn. 1886-88; j. and op. w. in Tacoma, Wash. 1893-96. Founder of the Gold Camp, Republic, Wash. General mgr., Eureka Mercantile Co.

STRAKER, JOSEPH E., JR., Attleboro, Mass.
Firm: Watson & Newell Company, designer c. 1903. Designed many souvenir spoons for them.

STROHHAKER, GUSTAVE, Wallingford. Conn.
Firm: International Silver Co., Meriden, Conn., late 1890s.

SUPE, OTTO, Sault Ste. Marie, Mich.
(b. Sept. 3, 1864, Blumfield, Saginaw County, Mich.; d. Oct. 14, 1949)
Apprenticed in jewelry trade c. 1882-85.
j. in Baraboo, Wis., c. 1885-86; in Evansville, Ind., c. 1886-87; in Sault Ste. Marie, Mich., in 1887-?.
D 1911-12 j. and op. Watch inspector for "Soo line," D.S.S. and A. Railway.
Mayor of Sault Ste. Marie, 1924-25. Retired c. 1925.

SWART, HAVERLY BROOKS, Worcester, Mass.
D 1884-90 clerk.
D 1891-92 mgr. jewelry (no firm name given).
D 1893 president and treasurer, Burbank-Swart Co., j.
D 1894 removed to New York City.

SYLVESTER, AUSTIN T., Newtonville, Mass.
D 1899-1901 j. in Boston.
Moved to Winthrop, Mass. in 1903.

THOMAS, JAMES FREDERICK, Philadelphia, Pa.
Firm: James E. Caldwell & Co. c. 1891.

THOMPSON, CHARLES C., San Diego, Cal.
D 1889-90 j. and watchmaker
D 1892-93 watchmaker, M. W. Jenks, San Diego.

THURBER, WILLIAM H., Providence R.I.
Son of Gorham Thurber, partner of John Gorham in firm of Gorham & Thurber. William H. Thurber joined firm as clerk in 1880 and became partner in 1885. In 1892 became treasurer of the company (now Tilden-Thurber Corporation). Elected president and treasurer in 1907. The Thurber family line continues in the company.

TIFFANY & CO., INC., New York, N.Y.
Established Sept. 18, 1837, as Tiffany & Young (Charles L. Tiffany & John B. Young); Tiffany, Young & Ellis in 1852; Tiffany & Co. in 1853. Electroplating added in 1870, with shop in Newark, N.J. New plant for both sterling and electroplate begun in Newark in 1893 and completed in 1897. Noted for very heavy weight of the few souvenir spoons they produced (Fig. 825). Used special marks on silverware made for international exhibitions.

TILTON, GEORGE PRESCOTT, Newburyport, Mass.
(d. c. 1965.)
Served as apprentice engraver at Towle Manufacturing Co. in 1882 at age 17. One of the most accomplished designers in company's history. Designed 5 of the 6 patterns in Towle's Colonial group which consist of Old Colonial, Old Newbury, Paul Revere, Ben Franklin, Georgian, and Lafayette. Wrote and illustrated the monographs emphasizing each period which the patterns expressed.

Also well known for his design of the monument to the First Settlers of Newbury, on Newbury Lower Green; the Civil War tablets at Atkinson Common, Newburyport, and the bronze tablets on either side of the front door of the Newburyport City Hall.

TOLER, SAMUEL HUBERT, Sweetwater, Tex.
(b. June 19, 1883, Dublin, Tex.; d. 1948)
Established Higginbothom-Harris Lumber Co., Loraine, Texas' first lumberyard, in 1905. Pioneered in automobile business as Maxwell dealer in Loraine, 1914. Established Toler Motor Co., Sweetwater. Designed the medicine spoon in his workshop at Toler Motor Co.

TOMEY, WILLIAM H., Wallingford, Conn.
Firm: R. Wallace & Sons Mfg. Co.

TOMMINS, VINCENT P., Hoboken, N.J.
D 1896-97 salesman.
D 1905-6 mining.
D 1915 investments.

TOWLE, E. J., MFG. CO., Seattle, Wash.
About 1945 Elmer James Towle purchased all tools, dies, and factory equipment of the old Joseph Mayer & Bros. company. They continue the manufacture of a complete line of religious jewelry, medals, and other presentation pieces. Have continued many of the old souvenir spoon designs and added new ones, all which bear the initials E.J.T. enclosed in the "crossed-tools" trademark formerly used by the Mayer company.

TOWLE SILVERSMITHS, Newburyport, Mass.
The Towle Mfg. Co. was established in 1882 but actually traces its beginning back through Anthony F. Towle & Son, Towle & Jones and the Moulton family of Newbury-port in which there were six generations of silversmiths.

825. From *Ladies Home Journal*, June, 1903.

In 1965, Towle Silversmiths celebrated 275 years of fine silver craftsmanship.

According to a long-time resident of Newburyport, the "T enclosing a lion" trademark was designed by Anthony Towle from the family coat of arms and has been used since c. 1880.

Their souvenir spoons have not been numerous but are noted for their fine design and workmanship.

TRUESDELL, CARRIE PATTON, Cleveland, Ohio
(d. c. Mar. 9, 1912, Youngstown, Ohio.)

ULLRICH, ALBERT H., Evanston, Ill.
(b. Apr. 24, 1869, Berlin, Germany; d. Apr. 26, 1951, Wilmette, Ill.)
Completed apprenticeship as j. in 1888 and established a business on Archer Ave., Chicago, Ill. In 1890 purchased the Lynn & Kylling Jewelry Store, Chicago. Bought controlling interest in Lord's Department Store in 1916, becoming its president.

Studied art under Gari Melchers at Chicago Art Institute. His work was exhibited in Chicago Artists and American Artists exhibitions. President of Palette & Chisel Club, Chicago.

VAN ETTEN, FRANCIS M., Buffalo, N.Y.
D 1902 commercial traveler.
D 1906-13 F. M. Van Etten & Son, mfrs. souvenir goods.

VAN SLYKE, JAMES
(*See John Larson*)

VERSCHUUR, JUSTUS, Jersey City, N.J.
Firm: Wymble Mfg. Co., 1894.
D 1890-92 artist.
D 1893-94 designer.
D 1894-95 silverware.

WALK, JULIUS C., Indianapolis, Ind.
Firm: Bingham & Walk, j. c. 1891.

WALLACE, HENRY L., Wallingford, Conn.
Son of Robert Wallace, founder and president of R. Wallace and Sons Mfg. Co. (now known as Wallace Silversmiths), Henry served in various capacities, including designer and secretary. His deep interest in nature is memorialized by a beautiful stand of trees gracing the Wallace Silversmiths' grounds.

WALLACE, R., & SONS MFG. CO., Wallingford, Conn.
Established 1834 by Robert Wallace to make spoons. R. Wallace & Co. in 1855; Wallace, Simpson & Co. in 1865; R. Wallace & Sons Mfg. Co. in 1871 and became Wallace Silversmiths in 1956.

WASHBURN, HENRY E., Plymouth, Mass.
j. c. 1895.

WATROUS MFG. CO., Wallingford, Conn.
Successor to Maltby, Stevens & Curtiss, 1896. Became part of The International Silver Co. in 1898.

WATROUS, WILLIAM H., Hartford, Conn.
(b. July 18, 1841, Hartford, Conn.)
Learned trade of electroplating silverwares in the factory of his uncles, the Rogers Brothers. In 1865 was placed in entire charge of this department of the Wm. Rogers Mfg. Co. In 1866, Watrous, Thomas Birch, and William J. Pierce joined with Rogers and Son to make goods stamped 1847 WM ROGERS & SON A1. Became the central figure in legal battles fought over the trademark that has made the name Rogers so well known. In 1871, with his uncle, Asa H. Rogers, opened a factory under the corporate name of Rogers Cutlery Company. Asa H. withdrew the next year. In 1879 Wm. Rogers Mfg. Co. and Rogers Cutlery Co. made a 25-year contract to do a joint business under the exclusive control of Watrous who became owner of one half the capital stock of the former company and president, treasurer, and sole mgr. of the united interests. In 1890 he established the Norwich Cutlery Company, Norwich, Conn. In 1894 was elected to the legislature from Hartford. In 1895, with others, formed the Eagle Sterling Company in Glastonbury, Conn. In 1896, Watrous, then president of Wm. Rogers Mfg. Co. became an important factor in the Watrous Mfg. Co. which purchased Maltby, Stevens & Curtiss Company. In 1898,

when The International Silver Company was formed, Watrous became one of the directors, a position he held until March 28, 1901.

WATSON COMPANY, Attleboro, Mass.

Successors to Cobb, Gould & Co. Became Watson & Newell Company in 1894 and Watson Company in 1919. Watson & Newell were among the largest producers of souvenir spoons in the country. J. T. Inman, also of Attleboro, bought the souvenir spoon dies when the Watson Company went out of business. These same dies were purchased in 1964 by Whiting & Davis who produced them with their own trademark.

WEISGERBER, CHARLES H., Philadelphia, Pa.

D 1881 "segarmaker."

D 1882-98 artist.

D 1899-1930 custodian, mgr., caretaker, and secretary-mgr. of American Flag House and Betsy Ross Association, Philadelphia.

WENDT, JULIA BRACKEN, Chicago, Ill.

Designer of *Cereta* pattern flatware c. 1901 which was used by Quaker Oats as a premium. (*See* Oneida Silversmiths and Fig. 804.) Later, with Grosvenor Allen developed the *Fleur de Luce* (Flower de Luce) pattern for Oneida Community (1904) and after her marriage, designed the stork baby spoon (1908).

WEST, ARTHUR, Manitou Springs, Colo.

j. c. 1891.

WETTSTEIN, OTTO, Rochelle, Ill.

(b. Apr. 7, 1838, Berman, Rhenish Prussia, Germany.) Apprenticed in jewelry trade c. 1850-56. Worked for Butler Jenness in 1857. Listed as a general merchant in Rochelle before establishing his own jewelry business in 1858.

WHELAN, FRANKLIN A., Mt. Vernon, Va.

Gardener at Mt. Vernon, 1885-1926. Maintained a souvenir business privately during this period.

WHITING, F. M., CO., North Attleboro, Mass.

William D. Whiting (b. Attleboro, Mass. 1815) was the founder of F. M. Whiting & Co. He learned the jewelers' trade with Draper & Tifft, to whom he was apprenticed at the age of fourteen. In 1840 Whiting and Albert C. Tifft founded the firm of Tifft & Whiting. About 1853 Whiting bought out the Tifft interests. He then established a New York office and began the manufacture of silver combs and hairpins, adding other silver work until this branch of the business resulted in the organization of the Whiting Mfg. Co., in 1866 with Whiting as president.

In 1875 a factory was built in New York where Whiting conducted the business for five more years. He then severed his connection with the Whiting Mfg. Co. and returned to North Attleboro and entered into the manufacture of silver jewelry and sterling silverware with his son, F. M. Whiting, who had been in that business since 1877. At that time the firm name became F. M. Whiting & Company.

The company became a division of the Ellmore Silver Company c. 1940 and has been independently owned since c. 1960.

WIDSTROM, EDWARD F., Wallingford, Conn.

(b. Nov. 1, 1903, Wallingford, Conn.)

Learned die-cutting trade which led him to interest in modelling in clay. Held position as modeller and designer for General Motors, Detroit, Mich. Studied sculpture at Detroit School of Art and also the Art Students League, New York City. Exhibited work in international and many national exhibitions, receiving numerous awards. In 1940, one of his pieces, the head of a child ("Donna"), was first accepted for exhibition in the National Academy of Design, New York City. On eight occasions since then, work has been accepted for this exhibition.

Widstrom modelled the portrait heads (Truman, Eisenhower, Kennedy) for the series of President spoons made by The International Silver Company.

WIENTGE, CHARLES C., Providence, R.I.

Designed for Howard Sterling Company, Providence, R.I., c. 1891-93. ss. w. 1893-96. Chas. C. Wientge Co., Newark, N.J. Employed by Lebkuecker & Co. in 1896.

WILKINSON, GEORGE, Providence, R.I.

(b. Apr. 13, 1819, Birmingham, England; d. Dec. 28, 1894. Elmwood, R.I.) Learned ss. trade in England and came to United States in 1854 at the request of Ames Company, Chicopee, Mass. (pioneer firm in silver industry). Later engaged in business privately as an art die-cutter and designer. In 1857 was employed by Gorham & Co., was with Went & Wilkinson, N.Y., makers of silverware for Ball, Black & Co. for a short while, then returned to Gorham. Superintendent for many years. Walter Wilkinson, a son, joined the Meriden Britannia Company as designer c. 1895.

WILLIAMS BROTHERS' MANUFACTURING COMPANY, Glastonbury, Conn.

James B. & William Williams purchased the American Sterling Co. and founded the Williams Brothers' Manufacturing Company in 1880. Manufacturers of plated silver and German silver flatware, specializing in German silver knives. Occupied the buildings formerly used by Curtisville Mfg. Co. and American Sterling Co., both of same business. Out of business in June 1950.

WILLIAMS, ROBERT D., Albany, N.Y. w. c. 1891, W. H. Williams & Sons, j., established in 1845.

WOLSTEN, JACOB, Newark, N.J.

D 1905-17 saloon keeper.

WOOD, ALBERT N. & FRED M., Boston, Mass.

Firm: N. G. Wood & Sons, j., adv. 1891c. 1920.

Registered trademarks for use on souvenir spoons in 1891.

WOODWARD, F. RUSSELL, Attleboro, Mass.

With Watson Company of Attleboro c. 1920. Later with Gorham Corporation.

WRIGHT, HENRY MARTYN, Detroit, Mich.

D 1870-71 civil engineer.

D 1872-85 Firm: Roehm & Wright (J. F. Roehm & Henry M. Wright), j.

D 1886-1905 Firm: Wright, Kay & Co. (successors to Roehm & Wright).

D 1906 President, Wright, Kay & Co. (Inc.), mfg. j.

Selected Bibliography

ALWEIS, FRASER and DRUMMOND, *Five Centuries in America.* New York: American Book Co., 1964.

American Automobile Association Tour Books. Washington, D.C.: American Automobile Association, 1966-67 edition.

American Heritage, Magazine of History. New York: American Heritage Publishing Company, Inc., 1954—1968.

American Heritage Book of Great Historic Places. New York: American Heritage Publishing Co., Inc., 1957.

American Heritage Book of Indians. New York: American Heritage Publishing Co., Inc., 1961.

America's Historylands. Washington, D.C.: National Geographic Society, 1962.

ANDERSON, PEGGY. *The Daughters.* Peggy Anderson. St. Martin's Press. New York. 1974.

Antiques Journal. Uniontown, Pa. Edwin G. Warman, 1897-1968. (Now published by Babka Publishing Co., Kewanee, Ill.)

BATCHELOR, JULIE FORSYTH, and DE LYS, CLAUDIA, *Superstitious?* New York: Harcourt, Brace & Co., 1954.

Biographical History of Pottawattamie County, Iowa. Lewis Publishing Co., 1891.

BUTTERFIELD, ROGER, *The American Past.* New York: Simon & Schuster, 1947, 1957.

Collier's Encyclopedia. New York: P. F. Collier & Son Corporation, 1964 edition.

Compton's Pictured Encyclopedia. Chicago: F. E. Compton & Company, 1960 edition.

DARLING, FLORA ADAMS, *Founding and Organization of the D.A.R.* Independence Pub. Co. Philadelphia, 1901.

Dictionary of American Biography. New York: Chas. Scribner's Sons, 1960.

Dictionary of American History. New York: Chas. Scribner's Sons, 1940.

DRURY, A. W., *History of the City of Dayton and Montgomery County Ohio.* Chicago-Dayton: S. J. Clarke Publishing Co., 1909.

EDMONDS, WALTER D., *The First Hundred Years, 1848-1948, Oneida Community.* Oneida, N.Y.: Oneida Ltd., 1958.

Encyclopedia Americana. New York: The Americana Corporation. 1959 edition.

FLYNT, HENRY N., and FALES, MARTHA GANDY, *The Heritage Foundation Collection of Silver, With Biographical Sketches of New England Silversmiths, 1625-1825.* The Heritage Foundation, Old Deerfield, Mass., 1968.

Galt & Bro., Washington, D.C.: pamphlet, no date.

Ghost Towns of Colorado. American Guide Series. New York: Hastings House, 1947.

GIBB, GEORGE S., *The Whitesmiths of Taunton, A History of Reed and Barton.* Cambridge, Mass.: Harvard University Press, 1946.

GIBBS, MARGARET, *The DAR.* Holt, Rinehart & Winston. New York, 1969.

GRIFFENHAGEN GEORGE, "Dose: One Spoonful," *Journal of the American Pharmaceutical Association.* Vol. 30, No. 4, April 1959, p. 202-5.

HARDT, ANTON, *Adventuring Further in Souvenir Spoons.* New York: Privately printed, 1965.

———, *Souvenir Spoons of the 90's.* New York: Privately printed, 1962.

History of Ogle County, Illinois. Chicago: 1878.

Hobbies. Chicago: Lightner Publishing Corp., 1933-1968.

IVES, HALSEY C., *The Dream City, World's Columbian Exposition.* St. Louis: N. D. Thompson Pub. Co., 1893.

JAMES, GEORGE B., Jr., *Souvenir Spoons.* Boston: A. W. Fuller & Co., 1891.

The Jewelers' Weekly. New York: The Trades Weekly Co., 1896-1900.

JOHNSON, J. STEWART, *Silver in Newark.* A Newark 300th Anniversary Study. Newark, N.J.: The Newark Museum, 1966.

KELLEY, LT. J. D., *Our Navy, its Growth and Achievement.* American Publishing Company.

Know the United States of America. Washington, D.C.: Capital Publishers, Inc., 1963.

LANCASTER, BRUCE, and PLUMB, J. H., *American Heritage Book of the Revolution.* New York: American Heritage Publishing Co. Inc., 1958.

The Lincoln Library of Essential Information. Buffalo, N.Y.: The Frontier Press Co., 1966.

MCGLOTHLIN, CHRIS A., *World's Fair Spoons, Volume I,* Tallahasee, Florida: Florida Rare Coin Galleries, Inc., 1985.

MILKEY, JULIUS H., ed., *New Britain Connecticut, The Hardware City of the World, 1850-1950.* New Britain, Conn.: 1950.

MORISON, SAMUEL ELIOT, *Admiral of the Ocean Sea.* Boston: Little, Brown & Company, 2 volumes, 1942.

———, *Christopher Columbus, Mariner.* Boston: Little, Brown & Company and Atlantic Monthly Press, 1955.

New York State Silversmiths. Eggertsville, N.Y.: Darling Foundation, 1965.

PLEASANTS, J. HALL and SILL HOWARD, *Maryland Silversmiths, 1715-1830*. Baltimore: The Lord Baltimore Press, 1930.

POOL, WILLIAM, *Landmarks of Niagara County*. 1897.

Portrait and Biographical Album, Sangamon County, Illinois. 1891.

The Progressive Reference Library. Chicago: The Holst Publishing Company, 1932.

The Providence Plantations for 250 Years. Providence, R.I.: J. A. and R. A. Reid, Pub., 1886.

RADFORD, E. and M. A., *Encyclopedia of Superstitions*. New York: The Philosophical Library, 1949.

RAINWATER, DOROTHY T., *American Silver Manufacturers*. Hanover, Pa.: Everybodys Press, 1966.

RAINWATER, DOROTHY T., *Encyclopedia of American Silver Manufacturers*, Hanover, Pa.: Everybodys Press, Inc., 1975.

RAINWATER, DOROTHY T., *Encyclopedia of American Silver Manufacturers*, Third Edition, West Chester, Pennsylvania: Schiffer Publishing Ltd., 1986.

ROACH, RUTH HUNTER, *St. Louis Silversmiths*. St. Louis: privately printed, 1967.

ROMAINE, LAWRENCE B. *A Guide to American Trade Catalogs, 1744-1900*. New York: R. R. Bowker Company, 1960.

SHANKLE, GEORGE EARLIE, *American Nicknames*. New York: The W. W. Wilson Company, second edition, 1955.

Souvenir Spoons of America. New York: The Jewelers' Circular Publishing Co., 1891.

Spinning Wheel. Hanover, Pa.: 1945-1968.

STOCKING, C. H. W., *The Stocking Ancestry*. 1903.

The Story of Daniel Low. Salem, Mass.: Daniel Low & Co., Catalog for 1917.

STUTZENBERGER, ALBERT, *The American Story in Spoons*. Louisville, Ky.: Privately printed, 1953.

SUTHERLAND, C. H. V., *Gold, Its Beauty, Power and Allure*. London: McGraw-Hill Book Company, Inc., 1959.

TRUMBULL, WILLIAM, *The White Canoe*. New York: G. P. Putnam's Sons, 1894.

TURNER, NOEL D., *American Silver Flatware, 1837-1910*. New York: A. S. Barnes & Co., Inc., 1972.

Webster's Biographical Dictionary. Springfield, Mass.: G & C. Merriam Co., 1957.

Western Collector. San Francisco: Western World Publishers, 1963-1968.

WESTMAN, HABAKKUK O., "The Spoon: Primitive, Egyptian, Roman, Medieval & Modern," *The Transactions of the Society of Literary and Scientific Chiffoniers*. New York: 1844.

Who Was Who in America. Chicago: A. N. Marquis Company, 1962.

Index of Illustrations by Subject